Italian
Renaissance Art

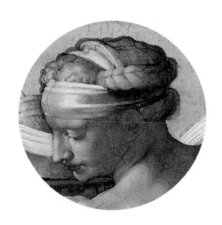

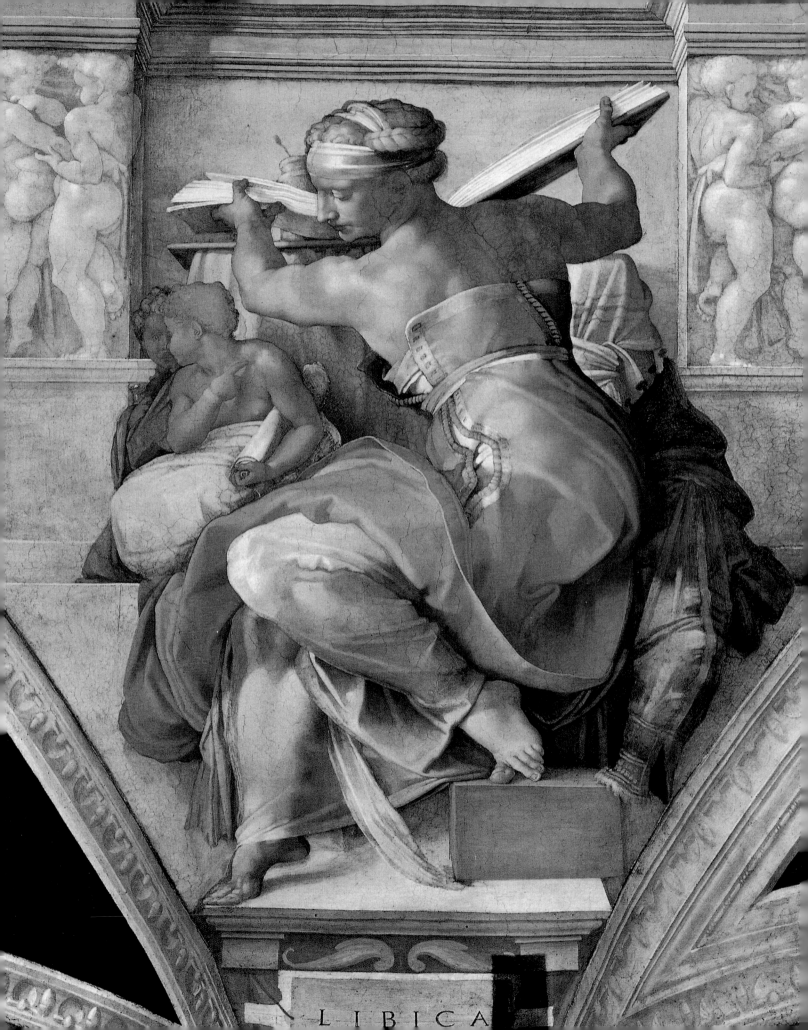

LIBICA

Stephen J. Campbell and Michael W. Cole

Italian Renaissance Art

With 817 illustrations, 703 in color

Thames & Hudson

To Our Teachers

Half-title and title pages: Michelangelo, Sistine Ceiling, detail: *Libyan Sibyl*

First published in 2012 in paperback in the United States of America by
Thames & Hudson Inc., 500 Fifth Avenue, New York, New York 10110

thamesandhudsonusa.com

Library of Congress Catalog Card Number 2011922638

ISBN 978-0-500-28943-3

Designed by Christopher Perkins

Printed and bound in China by C&C Offset Printing Ltd

Contents

CONTENTS

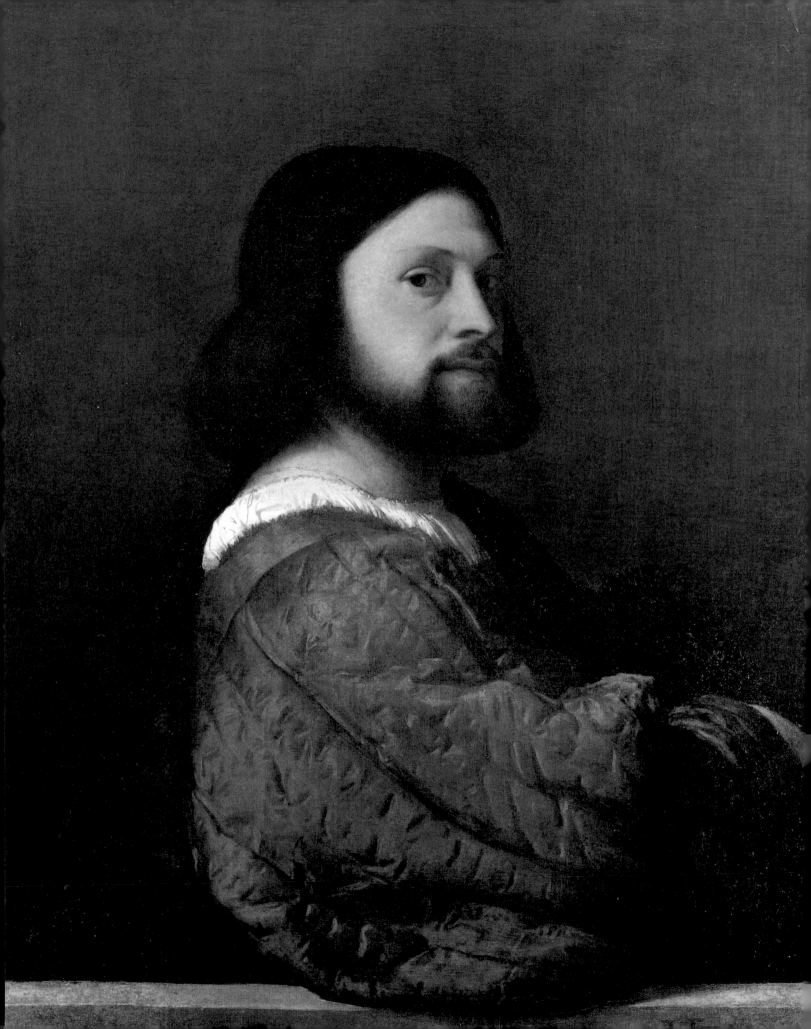

Introduction

Introduction

Looking Back, Looking Forward

The art we now present in our university courses and display in our galleries and museums is more diverse than ever before. A global, cross-cultural frame of reference, comprising the multiple traditions that represent our various roots, has largely replaced a single coherent tradition centered on Europe. Yet despite this, the art produced in Italy half a millennium ago maintains a surprisingly strong presence in our shared landscape. The painter Leonardo da Vinci, the architect Filippo Brunelleschi, and even the sculptor Bartolomeo Ammanati provide the central focus for popular films and blockbuster novels. A single restored bronze by the sculptor and painter Andrea del Verrocchio, brought to the United States, can draw crowds to museums in any city. The attribution of a new sculpture or painting to Michelangelo, however spurious, makes local newspapers everywhere. Tourists who might not frequent their local galleries will cross an ocean to look at paintings by Botticelli and Raphael. Italy's major art-history research centers today host a strikingly international community of scholars.

Artists in fifteenth-century Italy already recognized that they were doing something remarkable, and when they set out to say what it was, they frequently explained their accomplishments with reference to antiquity. Among the first post-classical art treatises, for example, is Lorenzo Ghiberti's (*c.* 1378–1455) *Commentaries*, written around 1440. Ghiberti, a goldsmith, began by compiling material from ancient authors about the famous artists of the distant past, implying that this was what provided the foundation for knowledge and study in his day. He then went on to place his own art in relation to that of the previous two centuries, when his immediate forerunners had begun to rediscover art's lost "true principles." To Ghiberti, the present could be explained by organizing history into a simple sequence: first, the period of the Greeks and the Romans, when painting and sculpture flourished in nobility and "perfect dignity;" second, a moment in the early stages of Christianity when Christian zealots, led by Pope Sylvester, sought to obliterate the idolatrous cult images of the pagans; third, the **"Middle Ages"** that followed this destruction of paintings and sculptures, along with "the commentaries and books and outlines and rules that gave instructions in so worthy and noble an art;" and finally, Ghiberti's own age. His heroic and mythic narrative provides a basis for what we call the "Renaissance" (the French word for "rebirth").

Stories like this, with their trajectory of artistic loss and cultural recovery, exercised a powerful grip on the imagination of subsequent writers. To others, however, it has seemed that the importance of Italian art after about 1400 lay not in its return to origins but in the emergence of something entirely new and characteristically modern – the idea of art itself.

Related to this was an interest in the makers of the new art. For example, long sections of Ghiberti's *Commentaries* take the form of artists' biographies. No one since antiquity had written a history of art around the lives of those who made it, though a number of later writers followed Ghiberti's lead, including Giorgio Vasari, whose 1550/1568 *Lives of the Artists* remains our single most important source of information on the entire era. In turn, Vasari's approach to history, in which he organized his account of painting, sculpture, and architecture around the experiences and intentions of individual makers, has remained the most powerful model for the writing of art history in the centuries since. Indeed, it has become difficult to imagine how we might think about the objects in our museums if we did not consider them as works created by particular individuals, though such a way of thinking may not have predominated in Europe in the centuries preceding Ghiberti, and it has been rare in many cultures around the world. The very idea of "the artist" was something to which Ghiberti and his contemporaries were giving new emphasis, even reinventing, as they thought about their own world in relation to a vanished past.

The invention of the artist has broad consequences: once we think of a painting as an "authored" work, we are apt, for example, to identify it with the style that for us defines its artist's "look," and to associate the work with specific and timely biographical circumstances. This book will frequently go down such a path, though we should remember that throughout the two centuries it covers, the idea of an art willed into being by artists competed with other possibilities: that a particular work's contents

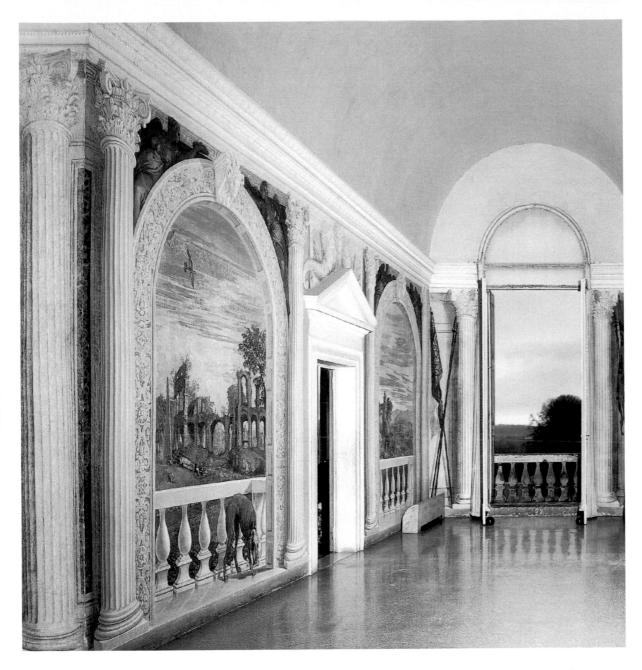

and appearance had been dictated by the patron who ordered it, for example; that the work adhered closely to shared and expected formal conventions; or that it was produced by a team or workshop in which no single maker predominated.

The artist's point of view was but one of a number of ways of understanding a painting, sculpture, or building. To many viewers, images served as important vehicles of connection with the supernatural, even as active agents of divine power. To others, they were testaments to the devotion of the people who commissioned them, commemorations of an individual or a family, soliciting prayers on their behalf from a wider public. Much of this book will focus on the ways in which individual objects crystallized these concerns, relating them to or playing them off against one another. How, it will ask,

did the artistic knowledge manifest, say, in illusionistic techniques or an awareness of the ancient past matter for the power of images, as historical viewers perceived this? How did works occasioned by devotional circumstances also express or pursue practical, worldly, and even political concerns?

New Technologies and Theories of Art

The legacy of the Renaissance lay not just in this conception of the artist but also in the chief preoccupations of the arts themselves. Fifteenth-century Italy (and fifteenth-century Europe more broadly) witnessed the introduction of a group of technologies and formats that would

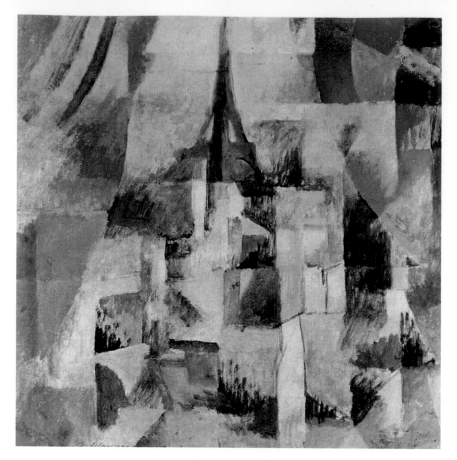

Picasso as *Brick Factory at Tortosa* of 1909 (fig. 0.4) does not so much reject a Renaissance way of doing things as quote it, making the building blocks of the Renaissance painting serve a new function.

Perhaps most importantly, the Renaissance developed a twofold sense of what all serious art had to involve, one that has shaped nearly all art since. On the one hand, it regarded art as something that originated in its maker's mind. When Raphael wrote that he started painting with a "certain idea," when Michelangelo described the sculptor pursuing the "concept" contained in the block of stone, or when Vasari reduced painting, sculpture, and architecture to a principle of "design," these artists were asserting that their labor was not merely manual but also intellectual, in some cases even that it was *primarily* a work of thought, such that the physical task of execution could be left to others. On the other hand, and to a certain extent in direct opposition to this, the Renaissance regarded art as an opportunity for manual showmanship. Every Renaissance artist went through a workshop apprenticeship that lasted for years and cultivated a degree of technical skill that his successors today have all but lost. The training focused on the student's capacity to do the same things his master could, so that the youth could disappear into the elder's projects.

By the time Ghiberti was writing his *Commentaries*, young artists had also come to recognize a value not only in advertising their skills but also in individualizing the hand behind the work, even manufacturing the work in

quickly attain a newly elevated status. These included the oil painting, executed on canvas at an easel; the drawing in ink, chalk, or pastel on paper; the medal; and the print. In some cases, these media replaced earlier ways of doing things: as we will see, oil supplanted the earlier egg-based **tempera** painting, for example, and canvas gradually took over the role of the wooden panel. Other formats with more continuous histories, such as the small bronze and the marble statue, became a focus of attention in the same years in a way that they had not for centuries before. Into the early twentieth century, being an "artist" usually meant making the sorts of things that fifteenth-century Italians had introduced.

Moreover, it was not just media that mattered to artists after the Renaissance, but what Renaissance artists did with them. For example, modern works as varied as Robert Delaunay's *Simultaneous Windows: Eiffel Tower* of 1912 (fig. 0.2) and René Magritte's *The Human Condition* of 1933 (fig. 0.3), among others, wrestle with an idea invented by the author, artist, and architect Leon Battista Alberti in the 1430s, that a painting was like a window, that one should approach its surface as something one looked through, at what lies beyond (fig. 0.1). Pablo Picasso's early Cubist works (1907–09) depend on a group of other devices – **chiaroscuro** (light/dark contrast) and **orthogonal** projection (diagonal lines that appear to recede into space) – that Renaissance painters and sculptors had used to construct illusions of three-dimensionality. Such a painting by

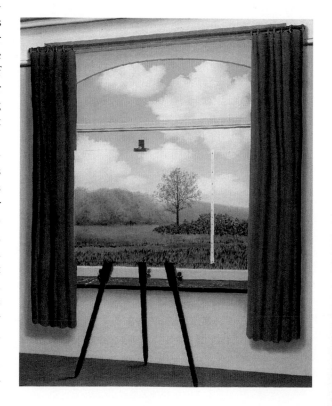

such a way as to draw attention to the process that had produced it. The colossal bronze that demanded ingenuity and finesse to cast, the unfinished marble that reminded viewers of the block from which it had come, the highly worked oil painting that indexed a confident, almost athletic handling of the brush – these, too, were touchstones of Renaissance art, and often the products of the same artists who insisted that art be a display of thought.

We might well begin, then, with both a retrospective and a prospective account of the period this book examines, with an art that claimed to replace or surpass what had been lost centuries before even as it set the stage for Modernist movements in the twentieth century. Indeed, recent scholars have debated whether the centuries this book considers are better regarded as a "Renaissance" (a period distinguished by cultural achievement from the centuries that preceded and followed them) or as the beginning of an "early modern" period that ended only with the social and technological transformations of the late 1700s. With our title we are using a conventional designation for the period rather than taking a position on this question: throughout, our text will attempt to acknowledge both perspectives.

Our main story begins in 1400. This is not a completely arbitrary choice: it is roughly the date of Ghiberti's earliest sculptures, and in part because of this, it is the moment that Vasari, looking back from around the 1550s, regarded as a watershed, when the arts finally left their "childhood." Still, the concerns we have been introducing to this point did not represent cultural novelties so much as new priorities. Some medieval painters and sculptors already looked to the distant past, and some certainly regarded themselves as "artists" of a sort that Ghiberti would have found familiar. By around 1300 some were employing such devices as **perspective**, which would become hallmarks of Renaissance art. As already noted, new technologies, such as oil painting and printing on paper, set the **Quattrocento** (the fifteenth century) apart from earlier periods, and the period covered by this book witnessed a dramatic escalation both in the production of art and in its variety. Beyond this, however, the most we can probably say is that things that were once exceptional came to be the norm – and even that is sometimes difficult to judge. We should not overlook those instances in which continuities with the so-called "Middle Ages" stand out more than any return to antiquity or heralding of the future.

Word and Image

Through the period covered by this book, images were developing as a sophisticated medium for convey-

0.4

Pablo Picasso. *Brick Factory at Tortosa, 1909.* Oil on canvas, 20 x 23¼" (50.7 x 60.2 cm). The State Hermitage Museum, St. Petersburg

ing complex ideas in a synthetic and memorable form. And this brings us to a theme that will recur frequently: the fact that artists, with encouragement from patrons and viewers, increasingly sought to explore the relationship between images and words, considering how the capacities of each might differ from, and overlap with, the other.

The Sienese painter Simone Martini was one of the first artists in Europe to be celebrated not just as a craftsman who rendered what could be seen but also as a poet who created from his imagination. The acclamation came from Francesco Petrarca (Petrarch; 1304–1374), one of the greatest poets in the Italian language, who knew Simone at Avignon in southern France and composed two sonnets on a portrait by Simone of Petrarch's dead beloved, Laura. Simone, according to Petrarch, had painted the picture with a poet's visionary power, apparently without seeing the lady herself. He also decorated the frontispiece for Petrarch's copy of the major poems by the great Latin poet Virgil (70–19 BC; fig. 0.5).

On this folio Virgil looks to the stars for inspiration, reclining beneath a laurel tree that represents at once puns on the name of the dead Laura and also the branches from which the ancients fashioned poets' crowns. To the left, Servius, a late classical commentator on Virgil, figuratively "draws the veil" away to make the poet's text more clear to various readers. An inscription paraphrases the allegory: "Servius, speaking here above, uncovers the secrets of Maro [i.e. Virgil], that they may be revealed to leaders, shepherds and farmers." Ostensibly, this identifies the poems' threefold audience, though a knowledgeable viewer would recognize that the three figures also designated the estates represented in Virgil's three great poems – soldiers in the epic *Aeneid*, shepherds in the pastoral *Eclogues*, and farmers in the didactic *Georgics*. Another inscription, finally, proclaimed an essential affinity and

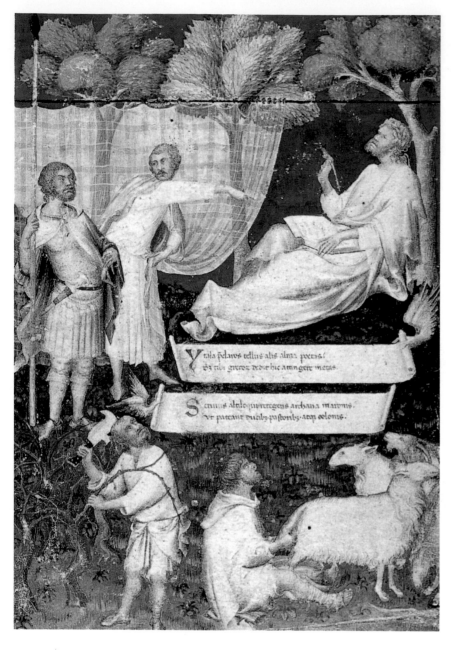

well as poets could cultivate – and well before 1400 – by associating themselves with the authority of the ancient past and with the eloquence of poetry. While many of the conventional designations that scholars have used to denote broad periods in the history of art – "Baroque," "Rococo," "Gothic" – originated as pejorative terms, Petrarch's elevation of Simone's painting into something like an emblem of an age appears to get close to the artist's own intentions. Simone's interests, moreover, were by no means eccentric, especially in the centuries that followed: Botticelli's *Primavera* (*c.* 1482; *see* fig. 9.23), Andrea Mantegna's *Parnassus* (1497; *see* fig. 11.4), Raphael's *School of Athens* (1510–11; *see* fig. 12.50), and even the Early Christian revival of the later sixteenth century, as we will see, sustain the myth of a lost origin restored in the present.

This book proposes to take that myth seriously, though not quite at face value: there is too much that it does not account for. The dramatic rise of artistic production in the fourteenth and fifteenth centuries followed from a complex set of economic, political, religious, and other causes, many of them remote from any imperative of cultural renewal. Few observers of the arts in the two centuries after 1400 would have agreed that the primary purpose of painting, sculpture, or architecture was to proclaim the progressive skills and ingenuity of artists, a basic aspect of the Renaissance myth. Most truly misleading, perhaps, is the myth's theme of a "return" to the past; more often than not, the appeal to ancient origins was a means of seeking sanction for doing something decidedly new. It is probably more valid to consider the art of the 1400s and 1500s as establishing an agenda, setting in motion a series of concerns about representation and about art that persist into the present. The most fundamental legacy of Renaissance art, more than the principle of "revival," is the idea of a work of art pointing beyond itself to other objects and images, some of them located in an imaginary and largely invented past: the idea of art as a dialogue, where works always show a consciousness of other works, with which they actively compete. This demanded beholders who were capable of making the comparisons, an interested public that could comprehend art as a field of non-professional knowledge.

The Book and Its Structure

This book is a survey, a history of art in Italy and art made by Italians abroad over the two centuries beginning in 1400. We have aimed to be comprehensive though not encyclopedic; we have made choices in, and set limits to, what we cover so as to be able to focus on individual objects and monuments.

0.5

Simone Martini, frontispiece to Petrarch's Virgil, *c.* 1336. 11⅜ x 7⅝" (29.5 x 20 cm). Biblioteca Ambrosiana, Milan

equivalence not only between painting and poetry but also between Virgil and Simone: "Mantua made Virgil, who composed such verses; Siena [made] Simone, whose hand painted them."

In the eyes of cultivated witnesses like Petrarch, the heirs of the great ancient poets were the great artists as well as the writers of his time. Although he sometimes took a more negative view, stressing the limitations of an art that he saw as working through the sense of sight rather than through the intellect, Petrarch suggested that painters could communicate through images just as a poet could through metaphors and other figures of speech.

Such images as Simone's frontispiece demonstrate that the idea of a "Renaissance" was one that artists as

One of the reasons we have organized the book as we have, following a neutral chronological sequence of decades rather than building chapters around the careers of the leading individuals, is to underscore the limits of the biographical approach and to allow attention to the alternatives. We wish to emphasize that the writing of history is the making of a narrative, and that different stories can be told about any of the works we discuss: the life of its author, the interests of its buyer, or patron, the tradition behind its subject matter, the responses of its audience, and so on. Dividing the book into chapters that each cover a single decade has posed challenges – some decades simply seem more important than others, for example, requiring chapters of unequal length – but the approach also offers a number of advantages. For one thing, the arbitrariness of a decade-by-decade story allows us to avoid the impression that retrospectively constructed periods (the "High Renaissance," "Mannerism") had some determining influence on human behavior. For another, it allows us to compare works produced simultaneously in different Italian cities, characterizing what is most distinctive in local traditions and practices while also highlighting essential common ground – for instance, the striking and seldom examined tendency of regional cities in the mid **Quattrocento** (1400s) to emulate Rome, or the building and ornamentation of city squares throughout Italy in the mid **Cinquecento** (1500s). Our approach enables us both to underscore the significance and meaning of particular architectural sites and to track the changing artistic geography in a given period.

Finally, by following a neutral chronological sequence of decades rather than building chapters around leading individuals, we hope to emphasize the limits of the biographical approach and allow attention to the role of patrons, the importance of expected formal conventions, and the teamwork exemplified by the workshops of major artists. Thus, anyone wanting to read about Donatello, who lived from *c.* 1386 to 1466, will need to look at several different chapters of the book. Whereas it might seem more convenient to present his work together, there will be a clear gain in understanding the sculptor's work in relation to artistic and historical transformations over time, and to a shifting series of contexts: public and domestic, sacred and secular, the city of Florence and the Venetian territorial state.

Each chapter aims to bring out the circumstances and expectations that define the historical moments at which works were made, the issues and concerns that even quite different contemporary objects and monuments shared. Thus, every chapter has a theme, one that the works made in a particular decade lend themselves particularly well to exploring. We do not mean to suggest, however, that the issues identified in our titles are the only ones that mattered at that moment, or that such issues have only momentary relevance. Indeed, the topics of our chapters more often than not point to key aspects of art across the period; highlighting a single broad theme in each chapter enables us to observe historical patterns and to introduce complex topics to which later chapters will return. Occasionally we have loosened the chronological boundaries of a chapter for the sake of drawing connections between material, though we have resisted the temptation to do this often.

The thematic structure prohibits the book from giving an entirely neutral account of the art, or from approaching objects with a consistent set of questions from one chapter to the next. We do hew closely throughout, however, to issues that are central to our own scholarly interests and to what we regard as the most vital tendencies in contemporary scholarship on Renaissance art. These include the status of the image: the lingering importance of the icon, the invention of the *historia*, the allure and dangers of the idol. They include the Renaissance concern with place and placelessness, the significance of site to meaning, and the changing geography of the period. We look at ways in which makers and patrons came to regard art as a kind of knowledge, whether they understood it as a place for empirical record-making or as an aspiring science, one related to other emerging modes of visual description. We consider how works of art addressed or enfolded an anticipated beholder.

Most of all, perhaps, we describe objects as examples of *artifice*: we focus on the technical skill and the very art of making them. We suggest that objects and their *madeness*, the nature of their physical workmanship – their media, materials, and handling – became the subject of some of the most notable works of Renaissance art, frequently to a degree that reinforces and enriches other meanings of the work. The production of images in Renaissance culture was driven by the memory of previous images and controlled by often unspoken assumptions about format, genre, and type. Historical transformation played out not only as a sequence of discoveries and innovations, but also as a gradually changing notion of the relation of the Renaissance artist to the work at hand, a changing sense of what authorized or legitimated the act of making (variously, divine truth, truth to nature, emulation of the ancients, and the fashioning of the artist as an author). This self-reflexive dimension to works of art sustains a rich historical narrative of its own, which we seek to bring into view alongside narratives about patrons, institutions, and religious practice.

1490–1500
From the Margins to the Center

1490–1500
From the Margins to the Center

A Fugitive Boundary

Much of what looks truly new in late fifteenth-century art expands on what had previously been minor elements of artistic practice. Artists had, for example, been embellishing religious paintings with background landscapes and cityscapes for decades, but by the end of the century, the Florentine painter Baccio della Porta (1472–1517) – known as "Fra Bartolomeo" (brother Bartholomew) after he joined the Dominican order – began to make independent drawings of outdoor vistas (fig. 11.2). These extend Leonardo's practice of studying the observable world (*see* fig. 10.39), but they also show that painters were beginning to regard such material as interesting in its own right. In the same years, Venetians like Gentile Bellini and Vittore Carpaccio would increasingly depict architectural and natural spaces that dwarf and envelop the sacred subject.

As we shall see, portraiture in these years underwent a comparable shift: although images of the patron and elements of his or her world had frequently made appearances in religious painting, now that world and its contemporary inhabitants become the actual set-

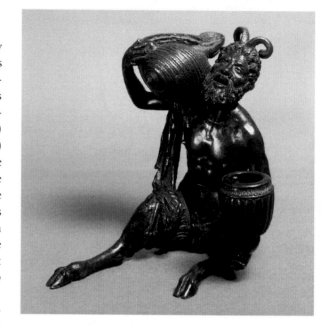

ting for the Biblical episode or saint's life being depicted. Similarly, themes from pagan mythology migrate from painted furniture and from the borders of manuscripts to become the subjects of panel paintings and sculptures. Andrea Mantegna and Antonio del Pollaiuolo had already treated similar secular and profane subjects in their engravings (*see* figs. 10.8 and 10.6), where the possibilities for experiment had a lot to do with the fact that printmaking was still a marginal rather than mainstream practice. Both artists, though, also began treating related material in other media, setting examples for their immediate followers. When the humanist scholar Pomponius Gauricus complained in a 1502 Latin treatise on sculpture that the artists in his native Padua were wasting their time in the trivial production of "little satyrs, hydras, and monsters, the likes of which no one has ever seen," instead of devoting "mind and hand" to the representation of the human figure, he must have been thinking of the sort of object that the "collectable" bronzes of Pollaiuolo, and before him Filarete, had inspired: Bertoldo di Giovanni in Florence, Antico in Mantua, and Andrea Briosco, known as "Riccio," in Padua all served a rising market for intimately scaled and fanciful bronze statuettes with which wealthy Italians adorned their homes (fig. 11.1).

In these years, interest in "the antique" largely manifested itself in images of hybrid mythological creatures. Some of the patrons who displayed them must have been following trends in fashion and taste, though at their most sophisticated, such creatures could also represent an endorsement of art based on poetic invention. Owners who used them to ornament domestic spaces demonstrated their cultivation and learning, though increasingly such images crept into more public and more sacred arenas as well. Around 1489 to 1492, the Venetian sculptor Tullio Lombardo (1460–1532) and his workshop commenced work on a monumental tomb for Doge Andrea Vendramin (fig. 11.3). Although the design was modified when the tomb was moved to its present location in the nineteenth century, the overall conception followed standards by now long in place, with an effigy of the deceased lying on a bier and Virtues below (*see* figs. 4.1, 4.2, 10.25). Tullio expanded this basic sculptural program with elements derived from a Roman triumphal arch, as well as with an *Annunciation* that frames a lunette showing St. Mark presenting Vendramin to the Virgin. What claims the most attention, however, is the startlingly prominent classical and mythological imagery. A younger and an older warrior stand guard, with expressions doleful and severe. *Tondi* showing passionate and violent pagan scenes (one of them apparently an abduction), reminiscent of those in Mantegna's San Zeno altarpiece (*see* fig. 8.18), appear over their heads; below, little cupid-like sprites cavort with a sea-horse and a sea-goat. A beautiful marble Adam (removed in the nineteenth century and now in New York) does not suggest the fallen sinner so much as a nude hero from the ancient past. Crowning the entire structure is a *clypeus* of the blessing Christ Child, supported by two marine monsters in the form of voluptuous winged Sirens. Tullio's particularly "Venetian" version of classical antiquity gave mythical sea creatures an understandable but still surprising prominence.

The *Studiolo* of Isabella d'Este and Mythological Painting

Isabella d'Este, the wife of the lord of Mantua, created a celebrated suite of rooms to house her collection of antiquities and modern art and to serve as a *studiolo*: functionally a private space, but also a showpiece that proclaimed the marchioness's literary interests and good taste to members of the court and privileged visitors. Like much of the art these rooms contained – which included several small bronzes by Antico – the *studiolo* was self-consciously marginal, detached from the serious business of ruling a state and the formality of life at court. Isabella

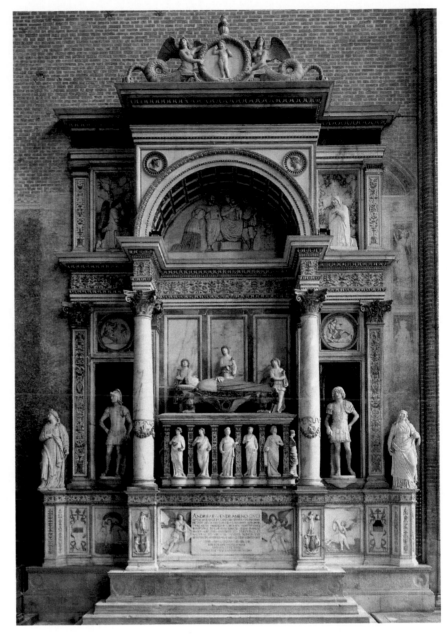

and her contemporaries regarded it as a room for reading and meditation, necessary to heal the spirit from the cares and perturbations of everyday life; in many ways the *studiolo* represented a "profane" version of a private chapel or oratory.

The emergence of such spaces coincided with a parallel change in the workshops of artists, as painters and sculptors, too, began to organize their homes so as to include a dedicated area (sometimes a furnished room, sometimes nothing more than a desk) where they could read, draw, and think through new inventions in solitude. When Isabella resolved in 1496 to decorate the walls of her *studiolo*, she turned to Mantegna among others; he is documented to have had two *studioli* himself.

11.3

Tullio Lombardo, tomb of Doge Andrea Vendramin, *c.* 1490–1505. Santi Giovanni e Paolo (originally installed in Santa Maria della Vita), Venice

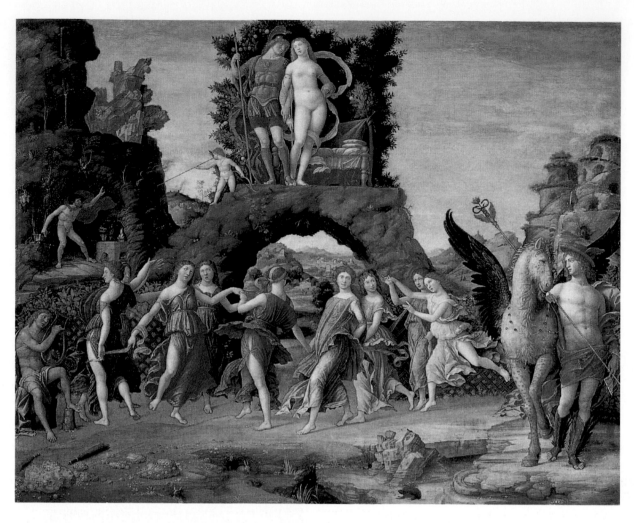

Though artists outside of Mantua received detailed sets of instructions from the marchioness for the "fable" that she wanted to have painted, Mantegna – already known from his print designs as an inventor of mythological imagery – probably went to his books and devised his own subjects.

Viewers may have recognized the various protagonists of Mantegna's mythological paintings, but understanding the unfamiliar and often ambiguous compositions required an unusual level of engagement and reflection: the paintings demanded, in essence, to be read as poems. Thus, in the so-called *Parnassus* from 1497 (fig. 11.4), the viewer would have recognized Apollo and the nine Muses – the latter a common theme of *studiolo* painting. Yet unlike Cosmè Tura (*see* fig. 8.3), who rendered his Muses as enthroned goddesses, Mantegna turns his into dancers, in a form more reminiscent of the maenads or nymphs of classical relief and more comparable to the figures in Sandro Botticelli's *Primavera* (*see* fig. 9.23). They represent one of the artist's most inventive essays in recapturing what he saw as the spirit of antique art: clearly, he was most impressed by that art's evocation of graceful and rhythmic motion. In the lower right of the painting, Mercury, the god of eloquence, stands with the winged horse Pegasus, who taps his hoof to make the inspiring waters of the Hippocrene flow. Decades earlier, Leon Battista Alberti in *On Painting* had encouraged artists to include in their *historie* a character that "admonishes and instructs us on what is happening": Mercury and Pegasus (i.e. eloquence and poetry) would have alerted the beholder that the painting is not only a new composition based on familiar poetic themes, but also a commentary on such compositions. This is not just a painted poem, but a poem about poetry.

At the top of the picture, the lovers Mars and Venus stand defiantly on top of a rocky "triumphal arch" while to their right Venus's cuckolded husband, the blacksmith god Vulcan, rages (and prepares revenge) in his forge. What is this most profane of Homer's pagan tales doing at the center of such a self-reflective work? A number of writers, both ancient and contemporary, had pointed to the trio as an example of gods behaving improperly and had used the example of their actions to discredit the art of poetry altogether. One Bolognese humanist, for

example, tried first to find symbolic value in the union of Venus and Mars, only to reject the effort, concluding that Homer's purpose had been nothing more than an attempt at bawdy humor. Similarly, the fiery Dominican preacher Girolamo Savonarola (whose importance is addressed later in this chapter) complained that young girls in Florence knew more about the love of Mars and Venus than they did about scripture. Mantegna's inclusion of the three gods may make an ironic nod to such critics, though he, Isabella, and most other readers must have had a less conflicted attitude toward the subject. Mars and Venus crown Mantegna's Parnassus because love and its complications were the main matter of art and the basis of its appeal.

Isabella undertook a series of negotiations with the leading artists of the time, including Giovanni Bellini, Leonardo da Vinci, Raphael, and Perugino, to produce additional paintings for the series. These were mainly unsuccessful, though Mantegna did make her a second picture as well (fig. 11.5). Here, another of the artist's kinetic *all'antica* heroines, the goddess Minerva (or Pallas), on a mission to rescue Wisdom (the mother of the Virtues) from a stone vault, scatters a swarm of mythological creatures and other monstrous beings labeled as Vices (a scroll with words acts as a "speech bubble" to indicate her cry for help). In visualizing the centaurs, male and female satyrs, and other creatures of ancient art, together with the maiden turned into a tree and the clouds assuming the form of human profiles, Mantegna displayed his inventive prowess to the full. The satyr mother with her children evoked the Roman Pliny the Elder's description of a celebrated lost work by the

11.5

Andrea Mantegna, *Pallas Expelling the Vices from the Garden of Virtue*, before 1503. Tempera on canvas, 5'3¼" x 6'3⅛" (1.6 x 1.9 m). Musée du Louvre, Paris

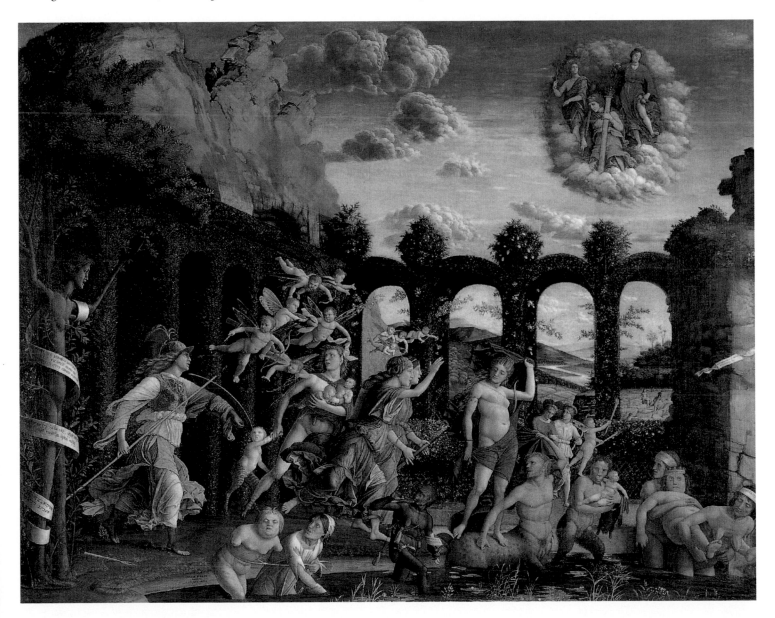

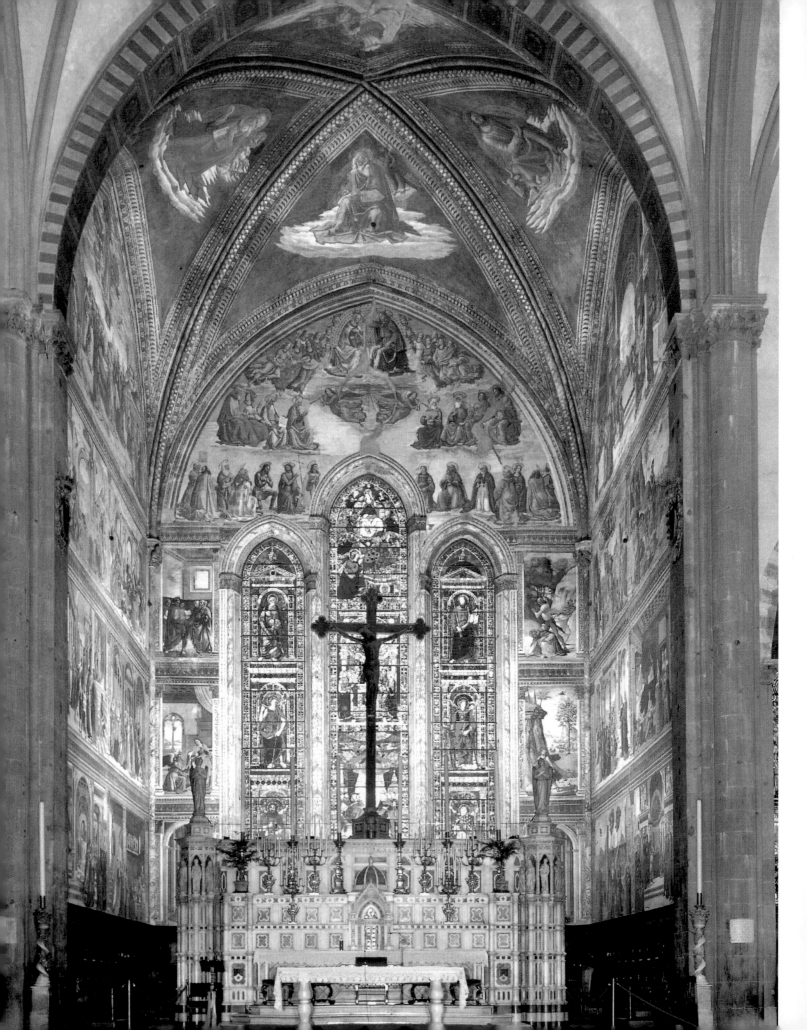

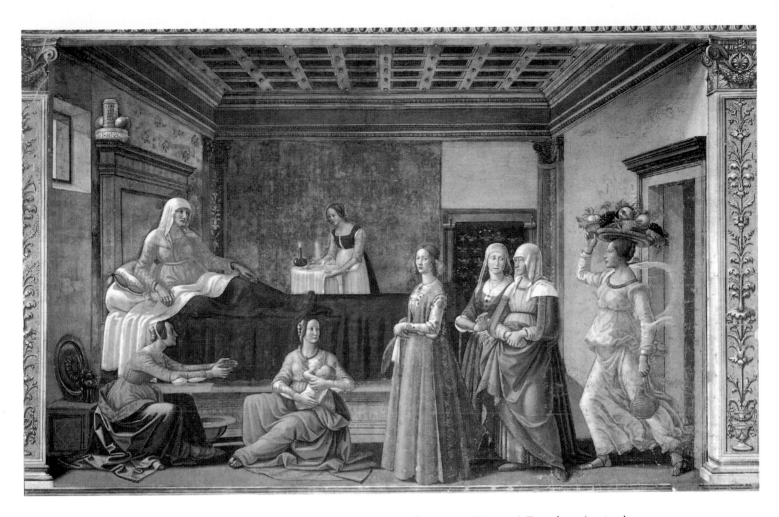

painter Zeuxis showing a centaur family, but Mantegna, professing invention, paints satyrs instead. At the same time, the painting presents a warning about the dangers of artistic fantasy, suggesting that it may take one on the path of unreason and delusion. It counsels prudence, personified by Pallas.

Corporate Devotion

Ghirlandaio's Tornabuoni Chapel

In religious works of the 1490s, elements from the contemporary world increasingly overwhelm the rest of the image. Emblematic is the chapel (fig. 11.6) that Domenico Ghirlandaio (1449–1494) unveiled three days before Christmas in 1490 in the Florentine church of Santa Maria Novella. Covering every surface of wall and ceiling in the large choir zone, Ghirlandaio's team had spent five years producing frescoes, an altarpiece, and even stained glass. The result can have left little doubt that Ghirlandaio fulfilled the requirements of his contract, which required him to make "noble, worthy, exquisite" images.

The chapel's patron, Giovanni Tornabuoni, stated that he had commissioned the fresco cycle to show his piety and to enhance the church, one of the most prestigious in the city, as well as for "the exaltation of his house and family." Ghirlandaio's works give an indication of just what "house and family" might include. The chapel had two dedications, to the Virgin (the patron of the church) and John the Baptist (Giovanni's own name saint), but although John's prominence in the decorations and the space's function as Giovanni's burial site both singled out the patron's distinctive role in its origin, most of the decorations emphasize the collective over the individual. The *Birth of John the Baptist* (fig. 11.7) takes place in what looks like a modern Florentine interior, with a coffered ceiling and ornamented pilasters in the corners. The women attending St. John's mother, Elizabeth, include a nursemaid of the kind that Renaissance Italians entrusted with the care of their newborns. All the women wear contemporary fashions, and several appear to be portraits; one or more members of the Tornabuoni family may well figure in the painting.

Giovanni did not instruct Ghirlandaio to include this portrait merely out of sibling affection. Lucrezia was the

11.7
Domenico Ghirlandaio, *Birth of John the Baptist*, 1489–90. Fresco. Tornabuoni Chapel, Santa Maria Novella, Florence

OPPOSITE
11.6
Domenico Ghirlandaio, Tornabuoni Chapel, 1489–90. Santa Maria Novella, Florence

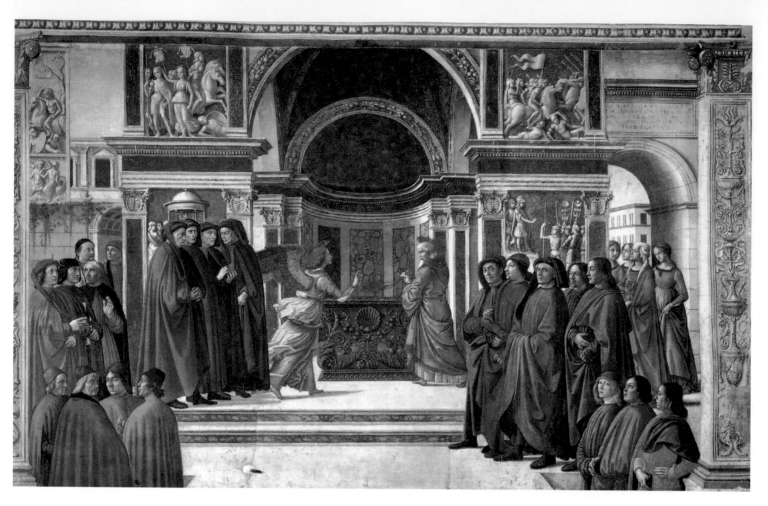

11.8

Domenico Ghirlandaio, *Annunciation to Zacchariah*, 1490. Fresco. Tornabuoni Chapel, Santa Maria Novella, Florence

wife of Piero de' Medici and the mother of Lorenzo the Magnificent, and she thus represented the most important Tornabuoni tie to the city's most powerful family. Giovanni himself worked as a manager in the Medici bank, and he could not have obtained the right to decorate such a prominent location without Medici support. (In fact, the Sassetti family, whose chapel Ghirlandaio had also recently decorated, had tried and failed to lay claim to this very chapel a few years earlier.) In other frescoes, Giovanni makes his membership in the Medici entourage unmistakable. At eye level on the right-hand wall of the chapel, an angel announces to Zacchariah (fig. 11.8), Elizabeth's husband, that his wife has miraculously become pregnant. The setting could be taken for an Italian church, were it not for the shell and garlands on the altar and the pagan reliefs on the walls. Flanking the episode, if not exactly witnessing it, are several groups of Florentine men, including male Tornabuoni relatives on the right and several of the most prominent Medici literati – the philosopher Marsilio Ficino, the translator and commentator Cristoforo Landino, the poet and philologist Agnolo Poliziano – at the lower left. A surviving drawing by Ghirlandaio (fig. 11.9) labels a number of the figures in the scene, making it clear that these inclusions were not mere pictorial novelties, and that the patron wished to approve the design in advance. Giovanni

wanted his chapel to be the one in the most prestigious position, adjacent to the high altar of the church, but he had no desire to flaunt this honor on his own. His status in the city and even his career depended on family connections and the relationships they allowed, and he welcomed company in his space of prayer. Ghirlandaio's paintings are sacred images, but they are also political works, and the role they give to portraiture underscores the degree to which Florence was a culture of networks. Not everyone, as we shall see, found this harnessing of religious art to the ends of negotiating social status to be acceptable or legitimate.

Bellini's Paintings for the Scuola di San Giovanni Evangelista

Structurally, Ghirlandaio's images eliminated the careful demarcation between the space that the kneeling donor had long occupied at the edge of the *sacra conversazione* and the center of the picture's action. It is instructive to compare the combinations of portraiture and history emerging in Venice around the same time. Gentile Bellini had returned from Constantinople in 1481, and he spent much of the next decade repainting the (subsequently destroyed) Great Council Hall pictures in the Ducal Palace. By the early 1490s, he was at work on a large cycle of

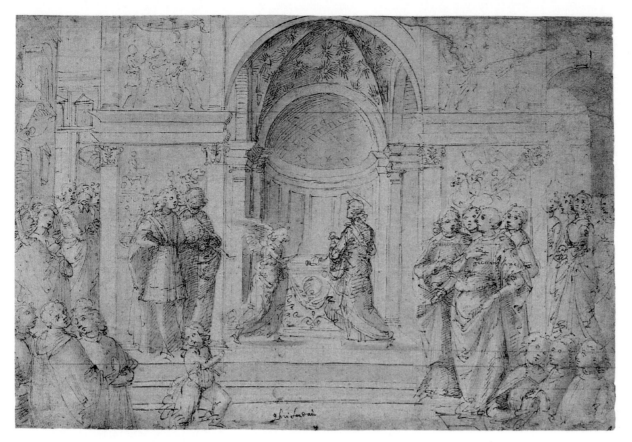

11.9
Domenico Ghirlandaio,
study for *the Angel
Appearing to Zacchariah*,
1489–90. Pen and brown
ink with wash over
metalpoint, stylus, and
black chalk on paper, 10⅛
x 14¾"(25.7 x 37.4 cm).
Graphische Sammlung
Albertina, Vienna

decorations for another common space, the "Hall of the Cross" in the Scuola di San Giovanni Evangelista. The Venetian *scuole*, as we saw in chapter 6 (*see* p. 159), were the devotional confraternities to which most members of the city's patriciate belonged: the word *scuola* can refer both to the group and, as in this case, to the architectural space where that group conducted its activities. The confraternity dedicated to John the Evangelist counted among the largest and wealthiest in the city, and its members had the clout to convene the city's best painters, including not just Bellini but also his young protégé Vittore Carpaccio.

If Ghirlandaio's frescoes showed the bonds that extended from an individual patron, Bellini's canvasses emerged as more direct expressions of collective interests. The painter did not merely insert contemporary faces as witnesses or participants into historical scenes but began with group portraits, then activated these around narrative episodes, all of them having to do with the Scuola's prize relic. The Scuola owned what it took to be a piece of the "True Cross," the wood on which Christ had died; this was the only miracle-working relic owned by any of the large Venetian confraternities, and the picture cycle documented its powers. Bellini's 1496 *Procession with the Relic of the True Cross* (fig. 11.10) shows a ritual performance that took place annually on the Feast Day of

St. Mark, when citizens would gather to watch the men parade before the saint's eponymous basilica. Arrayed in the near foreground, in white robes with red crosses, are the members of the Scuola di San Giovanni. At the picture's center, nearly on axis with the main portal of the basilica, is the confraternity's reliquary, borne beneath a baldachin. There is a documentary quality to the scene, which includes little that residents could not witness personally in the piazza year after year on this day – it so emphasizes the typical, in fact, that the uninitiated viewer of the painting would miss the miraculous event at hand if it were not brought to his or her attention. A Brescian merchant named Jacopo de' Salis, who had learned the previous evening that a skull fracture had left his son in critical condition, kneels down just behind the confraternity members at center right, praying for his son's recovery. Immediately afterward, though "offstage," his son's injury will vanish. The canvas is enormous, twelve feet high and more than twenty-four feet wide. All viewers must have recognized that only an event of great civic import could justify a picture on this scale. For the members of the confraternity, however, seeing this in their headquarters, the picture would have contributed to a sense of group identity.

Bellini's second picture for the cycle, the *Miracle of the True Cross at the Ponte San Lorenzo* (fig. 11.11), takes a

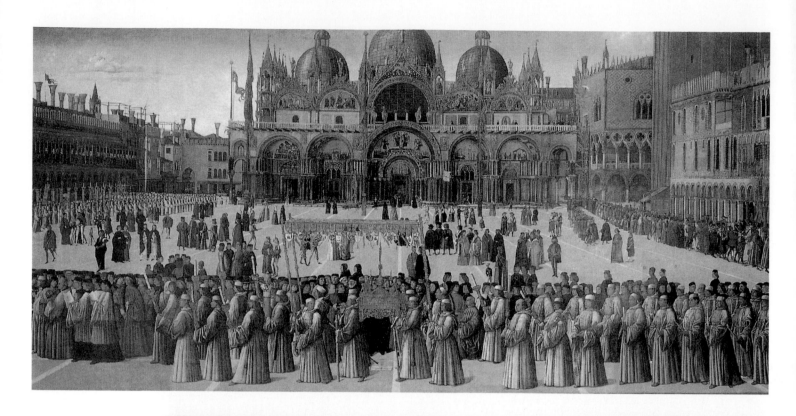

ABOVE

11.10

Gentile Bellini, *Procession with the Relic of the True Cross*, 1496. Oil and tempera on canvas, 12' x 24'5" (3.67 x 7.45 m). Galleria dell'Accademia, Venice

RIGHT

11.11

Gentile Bellini, *The Miracle of the True Cross at the Ponte San Lorenzo*, 1500. Oil on canvas, 10'7" x 14'1" (3.23 x 4.3 m). Galleria dell'Accademia, Venice

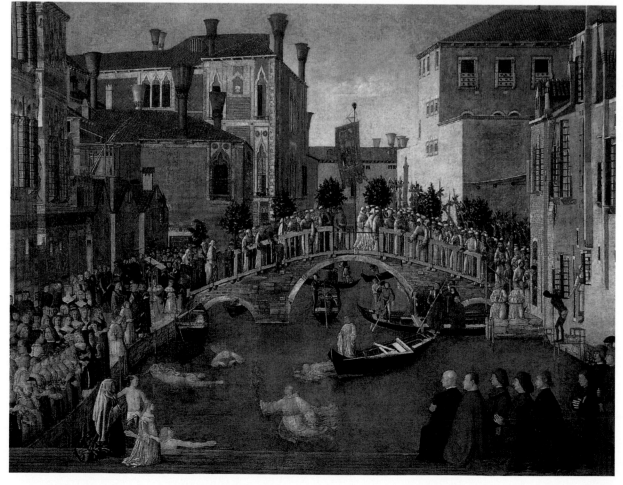

different approach. This time the artist moves the members of the Scuola to the background, positioning them as spectators. The arrangement allows the painter to depict his patrons frontally, and thus again to portray specific individuals, but it also puts the confraternity in the role of directing attention to the main event taking place in the water below. During another procession, the Scuola's reliquary fell into a canal. Onlookers dove into the water to try to save it, but whenever one approached, the Cross fled his grasp. Only when Andrea Vendramin, Grand Guardian of the Scuola (and ancestor of the recently deceased doge of the same name), threw himself into the canal did the holy object allow itself to be rescued.

Occupying the foreground this time is a strange stage-like platform that bears no relationship to anything at the actual site and serves only to support the figures who kneel in profile at the sides. These, too, must be portraits, and though it is uncertain just whom they represent, they take over the parts typically played by the donors in devotional rather than narrative images (compare, e.g., fig. 9.7). In giving less pictorial space to the confraternity and more to the kneeling citizens in their finery, the novel image of corporate devotion shifts back toward a more traditional assertion of family precedence. It is as though Bellini has used the miraculous event as a pretext for a scene that transcends history altogether, as though he has made a *sacra conversazione* but substituted the True Cross relic for the Madonna and Child. Or perhaps we should put things the other way around: Bellini has found an appropriate holy episode that could accommodate the members of the confraternity as spectators.

The World Ends

As earlier chapters of this book have shown, fifteenth-century images were nearly always conventional in subject, yet they were also often "customized" to acknowledge their patrons; painters had long added incident from the world around them to scenes that did not come from that world. With Bellini and Ghirlandaio, however, something different seems to be happening. Their pictures present themselves as "paintings of modern life," as though the lived world had elevated itself sufficiently to become a primary topic of monumental art. We might note that the most significant architectural change to the Piazza San Marco in the decade Bellini painted it was the addition of an enormous clock tower to the north-west side (fig. 11.12). Its face included not only the twenty-four hours, but also a rotating group of zodiacal signs and a disk indicating the phases of the planets; above, arabic numerals would change every five minutes. At the top of the tower, Cain and Abel struck a bell once every hour;

twice yearly, Magi and an angel emerged to pay homage to the statue of the Madonna. The astronomical data the clock provided allowed consideration not only of the hour but also of the characteristics of any particular day. The skillful viewer would be able to "read" the stars as well as the time. The venerable basilica and the ritual activities that the piazza hosted lent the square a strong connection to the past, but this technological marvel – occupied by the engineers charged to maintain it – made the space seem modern, a product of the present, as well.

Other contemporary productions probably had more of a far-reaching impact on the way both artists and patrons regarded the moment in which they were living. In 1498, the German painter and printmaker Albrecht Dürer (1471–1528), who had himself returned from Venice only a short time before, put out the first ever "artist's book": the earliest bound and printed volume conceived and executed by an artist rather than a publisher. It was issued in a Latin as well as in a German version, for Dürer sought an international audience. The book, comprising a series of fifteen woodcuts, brought to life the prophecies regarding the end of the world (or Apocalypse) that John the Evangelist had recorded in the Book of Revelations.

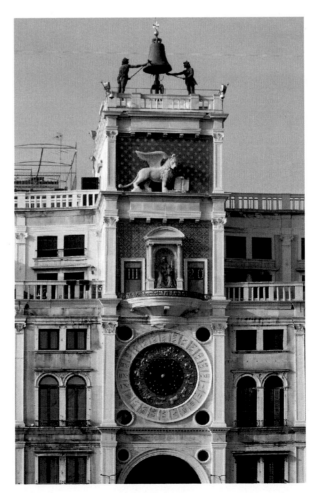

11.12

Mauro Codussi, Torre dell'Orologio (clock tower), 1496–99. Piazza San Marco, Venice

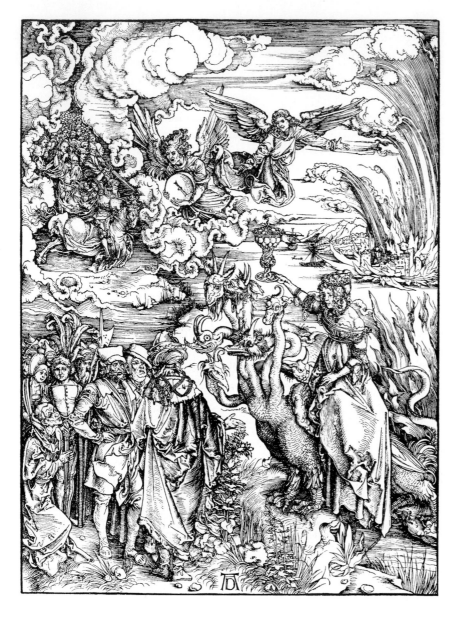

11.13

Albrecht Dürer, *The Whore of Babylon*, 1496–98.

Woodcut from

The Apocalypse

Babylon's vanities but also his dependence on Mantegna's mythological prints for his inventive approach. They would certainly have found the subject matter of the book topical, for in Italy, no less than in Germany, the approach of the year 1500 brought fears that Apocalypse might be just over the horizon, that the end of the century would also be the end of time.

Savonarolan Florence

In Tuscany, the charismatic Ferrarese preacher Girolamo Savonarola (1452–1498) had ascended through the ranks of the Observant Dominican Order. Made prior of Florence's convent of San Marco in 1491, he persuaded the Pope to allow him to reorganize the local system of religious houses according to a severe regimen that involved self-mortification and the renunciation of worldly goods. Savonarola's sermons, which frequently focused on the Apocalypse, drew ever larger crowds; he attacked both the traditional clergy and the Medici, and his followers took him to be a prophet. When the French army defeated the Florentine forces in 1494, the city expelled the Medici and declared Christ to be "King" of a new theocratic government, with Savonarola transmitting Christ's will.

The political and religious transformation of the city under Savonarola's influence included "bonfires of the vanities" during the carnival season: in place of traditional annual amusements, citizens publicly burned their fancy clothes, secular books, musical instruments, and works of art. Savonarola also made artists a target in some of his sermons against luxury. In many ways, his denunciation sounds familiar, recalling the attack on curiosity and worldliness in the writings of an earlier prior of San Marco, Fra Antonino (*see* p. 132). Savonarola's oratorical skills added force to his charges, though, and he went further in his account of abuses: he deplored the fact that rich Florentines who would donate only the smallest of sums for the relief of the poor would invest lavishly on chapels. "You would do it only in order to place your coat of arms there," he berated them, "and you would do it for your own honor, and not for the honor of God." He complained that painters would sometimes include portraits of contemporaries under the guise of saints in religious painting, and the young would go around saying to this girl and that, "She is the Magdalene, that other girl St. John." He disparaged the sensual and elegant depictions of the Virgin Mary that the Medici and other wealthy patrons had sought from such artists as Botticelli and Filippino Lippi: "Do you believe the Virgin Mary went dressed this way, as you paint her? I tell you she went dressed as a poor woman, simply, and so covered that her face could hardly be seen, and likewise St. Elizabeth. You would do well to obliterate these figures

Through the pictures, terrifying conquerors on horseback ride over the dead, the sun turns black, angels stop the wind from blowing, blaring trumpets cause hail and blood to fall from the sky. In the penultimate plate, "The Whore of Babylon" (fig. 11.13), a group dressed in contemporary German garb looks at a woman seated upon a seven-headed monster and holding up the cup that John describes as being "full of the abomination and filthiness of her fornication." The woman, too – John's "harlot who sitteth upon many waters" – wears a modern costume, though in her case that costume is Venetian.

The reliance on images rather than text to convey John's predictions ensured that even Italians into whose hands the book fell would have little trouble comprehending its topic. Many would have noticed not only Dürer's use of Italian fashion to embody the Whore of

that are painted so unchastely, where you make the Virgin Mary seem dressed like a prostitute."

Some painters appear to have responded to Savonarola, and would work in a more sober style for patrons who were close to the friar. Such is the case with the son of the painter Fra Filippo Lippi, Filippino Lippi (1457–1504), who painted an altarpiece for Francesco Valori in 1498 (fig. 11.15) that adopted an archaic gold ground format and included the emaciated penitential figures of St. John and the Magdalene, which stand in marked contrast to the exquisitely refined figures in Botticelli's or even Ghirlandaio's work. Yet Savonarola's call for a new pious simplicity in religious images was also part of a wider tendency in the late 1400s. Perugino, for example, already worked in a "devout" style in which Savonarola would have found nothing of which to disapprove. His serene and contemplative *Virgin with St. Sebastian and St. John* from the mid 1490s (fig. 11.14) was commissioned by Cornelia Salviati for San Domenico at Fiesole, an Observant Dominican foundation strongly linked to San Marco.

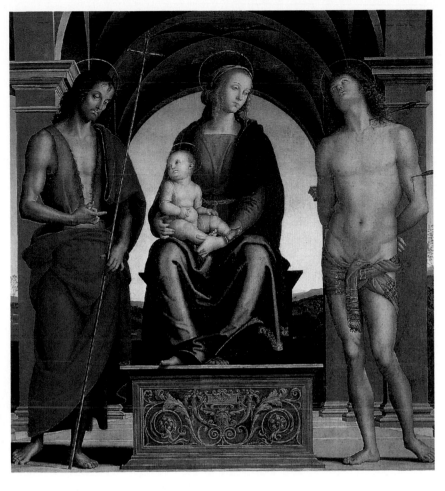

Savonarola's impact on the arts is immediately visible at the monumental heart of the city. Donatello's *Judith and Holofernes* (*see* fig. 6.25) took on new meaning when Florentines raided the palace where the Medici had formerly lived, removed the statue from its garden, and erected it in front of the old Palazzo dei Priori, where it became both an image of God's agent striking down the overindulgent and a physical trophy of victory over Medici tyranny. The building itself became a new focus of patronage, too, with the construction of a spacious room (fig. 11.16) to seat the large and now truly empowered "great council." The architects Antonio da Sangallo (c. 1453–1534) and Simone del Pollaiuolo (1457–1508), called "Il Cronaca") designed a chamber like the one on which Bellini had worked in Venice: anxious to extirpate every trace of Medici oligarchic rule, Savonarola had directed the Florentines to take the Venetian Republican government as their model. The woodcarver Baccio d'Agnolo (1462–1553) added balustrades, paneling, a frame for a large altarpiece commissioned from Filippino Lippi, and a loggia for the council's officers. Successive occupants continued to work on the room for decades afterwards.

ABOVE

11.14

Pietro Perugino, *Virgin with St. Sebastian and St. John, c.* 1492. Oil on panel, 5'10" x 5'4⅞" (1.78 x 1.64 m). Uffizi Gallery, Florence

LEFT

11.15

Filippino Lippi, *St. John the Baptist and Mary Magdalene*, from the Valori altarpiece, 1498. Oil on panel, each 53½ x 22" (136 x 56 cm). Accademia, Florence. **The panels originally framed a** *Crucifixion*, **now destroyed.**

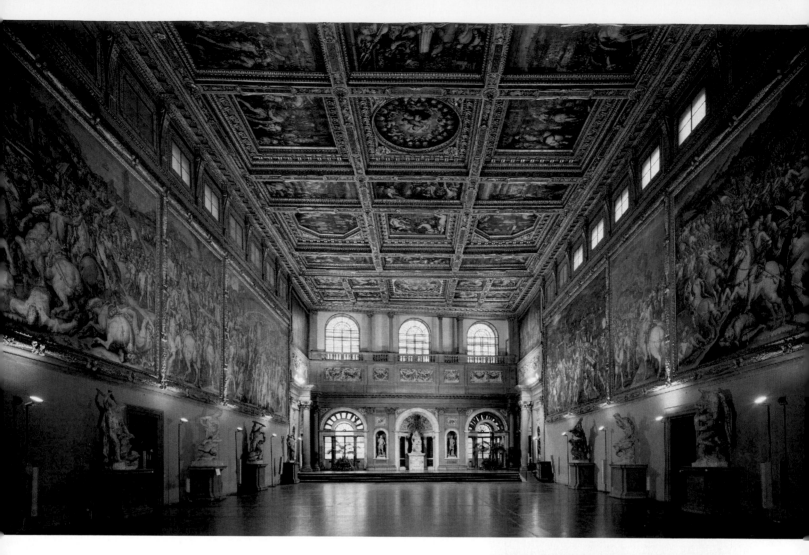

Ultimately, the great square overlooked by the Palazzo dei Priori proved to be the site of Savonarola's end. The preacher's close association with the Republican council and his open support of French military intervention aroused the ire of Pope Alexander VI, who forbade him from preaching. The friar not only defied the order, but attacked the the Pope's luxurious lifestyle and abuse of his office. Alexander responded with excommunication, a sentence that Savonarola claimed to be fraudulent: he continued to distribute Communion. Meanwhile, the local tide turned against Savonarola as Florentines tired of the rigors of his moral crusade and grew skeptical of his mystical claims. Medici partisans were quick to capitalize on the discontent. Eventually, the Pope found enough support to have the Dominican friar arrested, tried, and hanged by the Florentines, who burned his body in the Piazza della Signoria, a few steps from Donatello's *Judith*.

None of this dissuaded Savonarola's most ardent followers; in their eyes, on the contrary, it only made him a martyr. In fact, the impact that Savonarola had on Florentine visual culture may show itself most strongly in the paintings made just after his death. These include a haunting portrait (fig. 11.17) that Fra Bartolomeo painted

11.18

Sandro Botticelli, *Mystic Nativity, c.* **1499.** Tempera on canvas, 42¼ x 29½" (108.6 x 74.9 cm). National Gallery, London

after he joined the monastery where Savonarola had lived. The profile format lends the image an old-fashioned air, rejecting the plasticity and the effects of "presence" that Leonardo and other locals had pioneered more than two decades earlier (*see* fig. 9.20), as though these were frills inappropriate for an ascetic. With his wide-eyed stare, Savonarola appears almost to be in a trance. The inscription at the bottom of the picture, "Girolamo of Ferrara, the image of the prophet sent by God," affirms the visionary powers the preacher claimed.

Roughly contemporary with the portrait of Savonarola is a devotional painting by Botticelli that goes by the name of the *Mystic Nativity* (fig. 11.18). At its center is a motif comparable to the one Fra Filippo Lippi painted for the private palace chapel of the Medici (*see* fig. 8.30), with the Virgin looking down at the Child laid out on the ground. Little else in the picture, though, is expected. A strange architectural hybrid of primitive hut and natural cave provides cover to the Holy Family while also separating two groups who kneel at the sides in devotion.

the Apocalypse." This suggests that Botticelli was among those who believed that the turn of the century he was witnessing fulfilled one of the prophecies in Revelations. His choice to add this comment in Greek might remind us of the humanist circle around Lorenzo the Magnificent, of which Botticelli had been an important member. By the late 1490s, though, the painter seems to have embraced the message of the man who sought to destroy everything that Lorenzo represented.

Filippino Lippi between Rome and Florence

Filippino Lippi, on the other hand, tended to adapt his style according to whether the patron employing him was a follower of Savonarola – as in the case of Francesco Valori – or of the old Medici oligarchy. The most powerful family in the precinct around Santa Maria Novella was the Strozzi, and in 1487, the banker Filippo Strozzi had commissioned Filippino to decorate in the church a chapel that could serve as his place of burial. The painter began work two years later, then broke off the project almost immediately to go to Rome, where he was sent by Lorenzo the Magnificent to work on a burial chapel (fig. 11.19) for Cardinal Oliviero Carafa. The Roman space, extravagant for a man of Carafa's rank, set painted stages into an elaborate illusionistic framework, including a fictional marble arch on the rear wall. The image on the right side celebrates St. Thomas Aquinas's triumph over heresy (fig. 11.20). Carafa, a man of real learning with a taste for novelty, saw no inconsistency in celebrating the notion of religious orthodoxy while embracing the legacy of the pagan past. Surrounding the Aquinas scene are Christianized versions of the decorations recently discovered in the ancient palace, known as the "Golden House," of the Roman emperor Nero. That site's explorers at first thought that the "house," discovered underground, was a cave, or "grotto," and decorations of this sort – featuring animals, plants, humans, architecture, and hybrids of these – came to be called "grotesques." Their appeal would be enormous, and they would eventually stand as a byword for "invention," allowing artists to demonstrate both their power of imagination and their acquaintance with a genuine ancient art form.

Filippino finished the project and returned to Florence in 1493, where he discovered that things had changed. To begin with, Filippo Strozzi had died, leaving the painter to fulfill the commission under the supervision of the banker's heirs. With the expulsion of the Medici, moreover, Lippi found himself working on the city's most monumental Dominican commission at the height of Savonarola's sway. Presumably following the wishes of both the Strozzi and the friars, he dedicated the facing side walls of the chapel (fig. 11.21) to two

It is as though the artist has transformed the landscapes that had recently become settings for such scenes (*see* fig. 8.30) back into a kind of late medieval triptych. At the bottom of the picture, three pairs of angels embrace, and above, angels in a ring hold olive branches beneath a gaping golden sky. These figures relate to imagery propagated by Savonarola in his sermons – one sermon the friar delivered seven years earlier interpreted the advent of Christ as the birth of Truth into the world and imagined a nativity in which "Righteousness looked down from the sky" – though they follow the practice Botticelli had adopted in his earlier mythological paintings, of composing a new subject rather than illustrating a single text.

An inscription at the top of the painting that announces itself to be in Botticelli's own hand dates the image to 1500, "in the half time after the time according to the eleventh chapter of St. John in the second woe of

DECLARATIO SERMONON
TVORVM ILLVMINAT

ET INTELLECTVM
DAT PARVVLIS

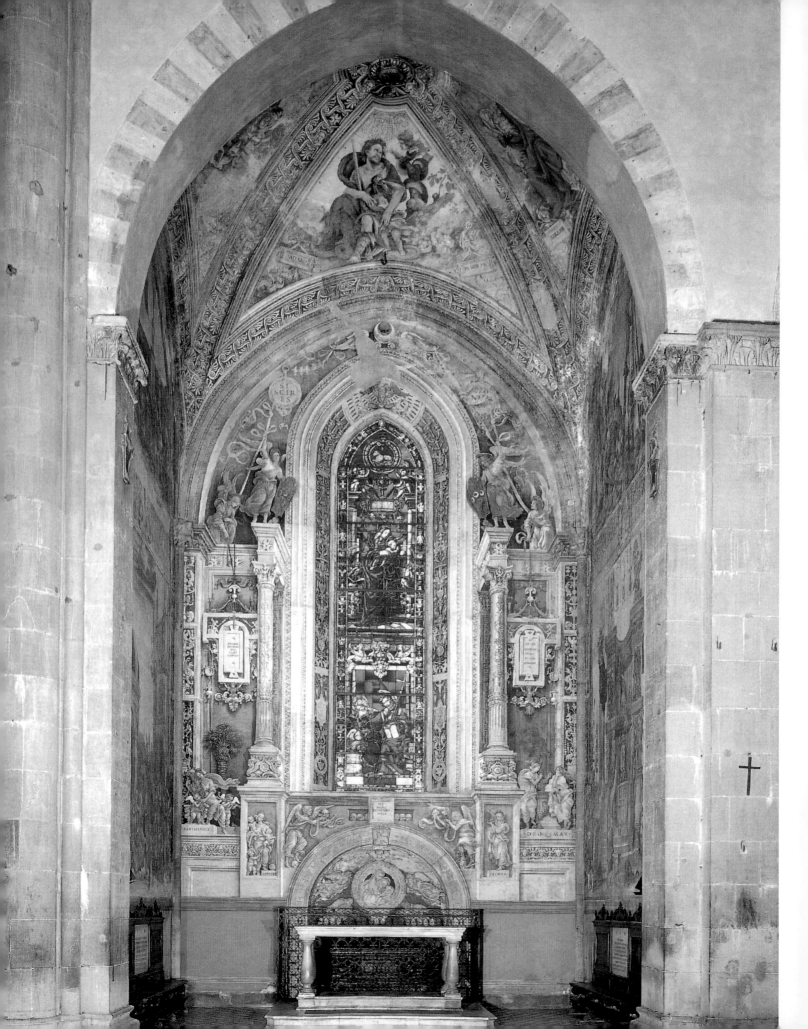

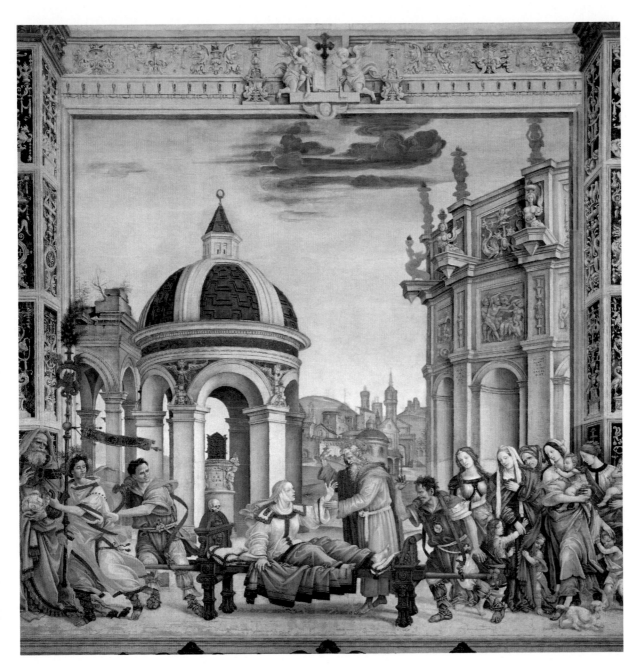

11.22

Filippino Lippi, *Raising of Drusiana*, 1493–1502. Fresco. Strozzi Chapel, Santa Maria Novella, Florence

saints: Philip, his patron's name saint as well as his own, and John, the author of Revelations. The main fresco on the south wall (fig. 11.22) shows John encountering a funeral procession for a woman named Drusiana on his return from the exile during which he wrote his Revelations. The deceased was a Christian, but her people, led by a priest with a woman on his arm, take her to be buried before a city filled with exotic pagan buildings. John raises her from the dead, implicitly promising a similar boon to those who show the right faith.

But there is a twist: the miracle occurs before a temple of the moon goddess Diana, which is adorned with a crescent. The crescent moon was the central feature of the Strozzi family coat of arms, which is itself displayed in the chapel with a prominence that would have outraged Savonarola. The fresco cycle starts with a story that confronts the true faith of the Christian missionary with the false belief of the pagan, but it also hints at the kind of knowledge, preserved in pagan imagery, that so fascinated Lorenzo the Magnificent and the humanist circle around him. Filippino presents Drusiana's people as doomed and fallen predecessors to Christianity, but it is that alien world that most allows the painter's imagination to run free, to the point that we might ask whether the scene really rejects the pagan world at all.

OPPOSITE

11.21

Strozzi Chapel, Santa Maria Novella, Florence, with frescoes by Filippino Lippi dating from 1493 to 1502. The crescent moon at the top of the window refers to the Strozzi coat of arms.

Across from this scene Filippino depicted another confrontation between pagans and Christians (fig. 11.23). The Apostle Philip, captured by people who wished him to worship the demonically animated statue of Mars on their altar, instead causes the demon, in the form of a dragon, to break out of the bottom of the statue and slay the pagan priest's son. Philip has his back to us, just as a Catholic priest would at Mass in every church; the groups on either side lament the death of the boy or hold their noses at the dragon's sickening odor. The altar itself is a fantastical assemblage, though it resembles no real ancient building so much as the altar zone of a Christian church, as though Filippino had taken a familiar architectural form and rendered it exotic and strange. Behind the statue, an accumulation of vases, weapons, banners, and other objects top the architrave and crowd the ledges behind the statue. The "bad" devotion imagined here involves the dedication of objects to the worshiped god, just as Catholics would have left **ex-votos** at their own altar. The statue, for its part, would have had its own strong local associations; not only did Florentines believe that their own baptistery had originated as a temple dedicated to Mars, but an inscription on the city's most central bridge, the Ponte Vecchio, also recorded a statue of Mars that had led the city into idolatry. Philip's expulsion of the dragon is thus also a kind of exorcism directed at Florence more widely. As a counterweight to the idol, Lippi added in the border of the

11.23

Filippino Lippi, *St. Philip and the Demon*, 1493. Fresco. Strozzi Chapel, Santa Maria Novella, Florence

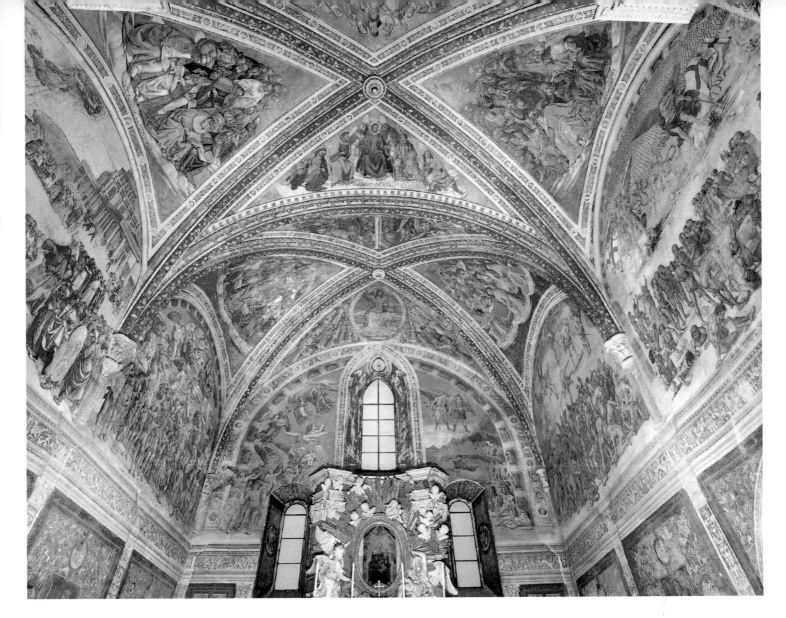

fresco the "Veronica" — the true image of Christ produced miraculously when a woman of that name wiped his face during the Passion.

Before the expulsion of the Medici and the rise of Savonarola, it would have been hard to imagine any patron or painter associating the physical remains of antiquity, even ornament itself, so magnificently and menacingly with the demonic. And indeed, the chapel of the Strozzi – long-time Medici rivals, even if Filippo himself had built bridges with the family – represents a radical departure both from the neighboring Tornabuoni project of a few years before and from the chapel Filippino had recently painted in Rome. There are no portraits here, no assertions of mundane political ties, just the marvelous and slightly frightening works of God on earth, uneasily associated with the compelling splendors of a lost pagan antiquity. The preaching of Savonarola and his brethren only exacerbated the conflict felt by many Christians between the wisdom and beauty of the ancient world and the demands of orthodox belief and morality,

and it is hard to know where in the end the painter himself stood. The pictures bring a completely unrestrained vision of pagan culture to the center of the stage, but to what end?

Judgment Day in Orvieto, "Last Things" in Bologna

Filippino Lippi's chapel in Santa Maria Novella is not explicitly apocalyptic. It imagines false religion and dwells on themes of death and resurrection, but it sets all of these in a distant past. More terrifying must have been a chapel that Filippino's near contemporary, Luca Signorelli (c. 1445–1523), painted to the south of Florence in the cathedral of Orvieto (fig. 11.24). Signorelli came from Cortona, a small town subject to Florentine dominion. In the 1480s he had painted alongside Botticelli and Perugino in the Sistine Chapel in Rome, and around 1492 he had produced a monumental panel on a pagan

11.24

Cappella Nuova (San Brizio Chapel), Orvieto Cathedral. The frescoes in the altar end of the vault are by Fra Angelico; those on the walls by Luca Signorelli.

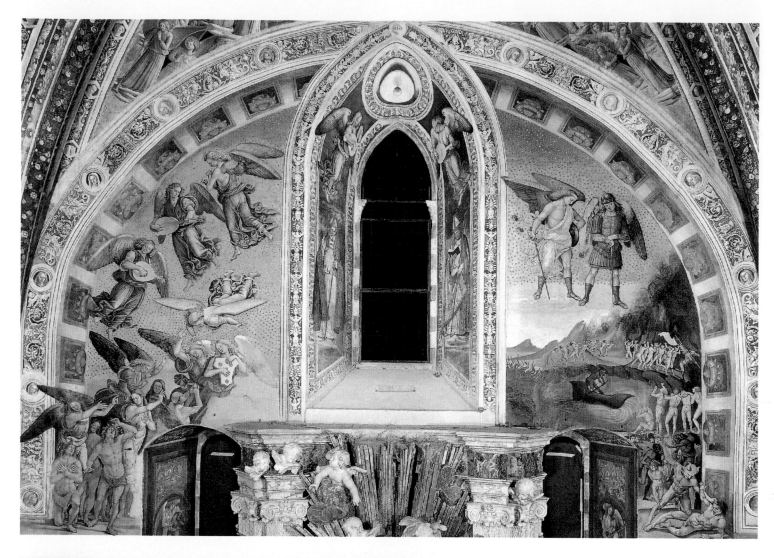

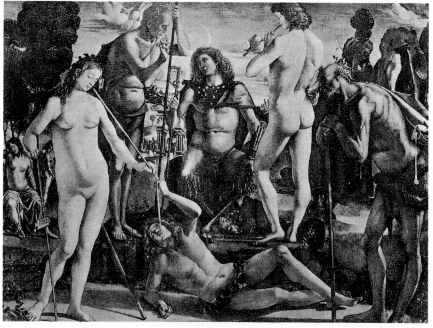

LEFT

11.26

Luca Signorelli, *Court of Pan*, c. 1492. Panel, 6'4½" x 8'5" (1.95 x 2.56 m). Formerly Berlin, destroyed 1945

ABOVE

11.25

Luca Signorelli, *Last Judgment*, 1499–1502. San Brizio Chapel, Orvieto Cathedral

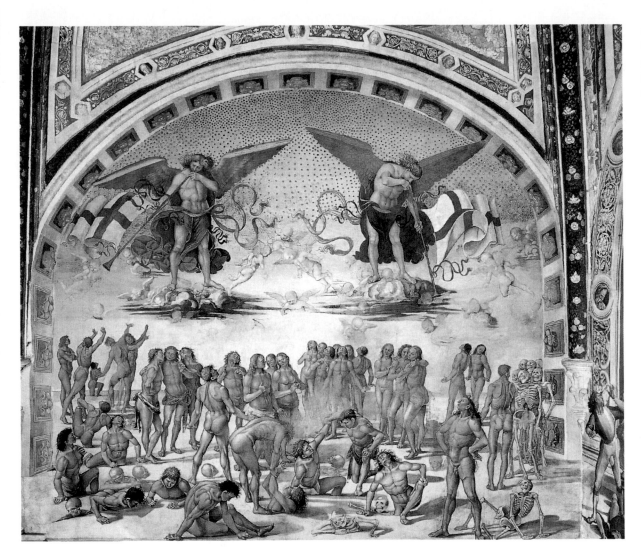

11.27
Luca Signorelli, *The "Plain of Dry Bones,"* 1499–1502.
Fresco. San Brizio Chapel, Orvieto Cathedral

theme, the *Court of Pan*, for Lorenzo the Magnificent: that extraordinary work (fig. 11.26), destroyed during the Second World War, showed the god Pan flanked by nude shepherds, nymphs, and rustic divinities in a manner that deliberately recalled the standard Christian theme of the Virgin surrounded by saints. Early in the decade, at least, Signorelli seems to have been able to suggest that Christianity and the ancient fables that preceded it both pointed to a common truth.

Signorelli had been outside of Florence during Savonarola's rise to power, and he may never have heard the friar preach. Nevertheless, he showed himself even more capable than Botticelli of pivoting from the production of secular art for a humanist elite to visualizing how the world might end. Signorelli's point of departure in Orvieto was a group of figures that Fra Angelico and Benozzo Gozzoli had painted on the ceiling of the chapel in the 1440s, showing prophets and, in a mandorla over the south-east windows, a seated Christ, his right arm raised, his left hand on a globe. Signorelli used the figure of the Savior as the fulcrum for a *Last Judgment* (fig. 11.25), which he added to the wall below. On the left, angels play music and direct the elect upward to the heavenly realm they will join; in the foreground, before a fictive arch and seemingly in the space of the chapel itself, a man kneels in wonder and adoration. On the right, the naked damned flee and wail and a devil leads the way to a point of embarkation, where a demonic boatman will ferry them to the Underworld. Two archangels look down from above, ready with drawn swords to prevent anyone below from trying to pass upward.

This was already a fairly unusual subject for the altar wall of a chapel. More extraordinary still, though, are Signorelli's other murals. On the side walls of the first bay, he extended his depictions of the saved and damned. The elect now grow to a crowd of nudes striking graceful poses as they enjoy an angelic concert and the sight of Christ. The damned, opposite them, are a tumultuous pile, twisted into tortured poses by demons, whose weirdly

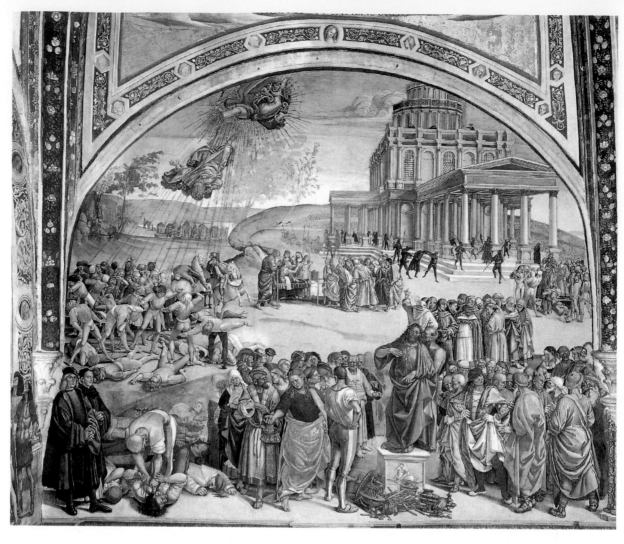

11.28

Luca Signorelli, *Deeds of
the Antichrist*, 1499–1502.
Fresco. San Brizio Chapel,
Orvieto Cathedral

colored bodies create a visual cacophony that represents the very opposite of the harmony across the way. Next to these scenes, on the larger walls that first confront the entering viewer, are two prophetic visions. That on the right (fig. 11.27) derives from the description in Ezekiel 37 of the "plain full of dry bones" that hear the word of God: "I will send spirit into you, and you shall live. And I will lay sinews upon you, and will cause flesh to grow over you, and will cover you with skin: and I will give you spirit and you shall live, and you shall know that I am the Lord." In Signorelli's version, a mix of skeletons and fully recomposed bodies climb out of the ground; nude men and skeletons look at one another, taking stock of their different conditions. The image heralds the Resurrection initiated by Christ on the altar wall. At the same time, no subject could better offer the opportunity to push one of Alberti's compositional principles to its logical extreme. In book 2 of *On Painting*, Alberti recommended that painters "first sketch the bones…then add the sinews and muscles, and finally clothe the bones and muscles with flesh and skin." He conceived this as a practical way of ensuring anatomical accuracy when experimenting with the body's various possible poses, but Signorelli aligned

the technique with the divine, as though to suggest that God himself would create an Albertian picture at the end of time.

Opposite the image of the "plain of dry bones" is the densest painting in the chapel, *Deeds of the Antichrist* (fig. 11.28). Its protagonist is a Christ-like figure who stands on an ancient rostrum and speaks to an assembled crowd. His words and even his body, though, do not appear to be his own, and a devilish creature emerges from his own form and speaks into his ear. This must be the creature that Revelations describes as the "second beast," who "had two horns, like a lamb" but who "spoke as a dragon." The followers of this Antichrist have heaped gifts at his feet, not unlike the pagan ex-votos in Filippino Lippi's *St. Philip* (*see* fig. 11.23), and one prominent listener appears to receive (or borrow) money from a Jew (identifiable by his swarthy complexion and yellow robe). In the background, a false saint appears to raise the dead from a bier, suggesting that even scenes like Lippi's *Drusiana* (*see* fig. 11.22), encountered during the Antichrist's reign, are not to be trusted. The left middle ground promises the eventual casting down of the false prophet

and the killing of his followers. In the foreground left, beside a scene of murder, walk two men in black. They may be the "two witnesses" of which John writes in Revelations 11:3, though some have also taken them for portraits of Signorelli himself and his dead artistic predecessor Fra Angelico. Would Signorelli be in a position to suggest that the whole event was something he himself had somehow "seen"?

Such a conceit could simply suggest that the episodes he shows unfold according to his own imagining, that he and Fra Angelico had witnessed what they painted in their own heads before rendering it on the wall. Signorelli, who may or may not have been following a brief approved by his patrons, here staged bold claims about the visionary power of poetry, and the identification of painters with visionary poets. In roundels in the lower zone of one wall, he showed the circumstances according to which the poet Dante claimed to have written the *Inferno* (fig. 11.29): the ancient Roman poet Virgil, Dante's key predecessor, guided the Italian through the

11.31
Lorenzo Costa, *Triumph
of Fame*, 1488–92. Fresco.
Bentivoglio Chapel,
San Giacomo Maggiore,
Bologna

Underworld, revealing to him the sights that the *Divine Comedy* would then describe. It is as if Signorelli now wished to present himself as a new Dante: just as Virgil led the poet through the *Inferno* he would describe in verse, so Fra Angelico accompanies him on a tour of the world he would paint. Another possibility is that Signorelli wished to connect the events of the Second Coming to *other* things he had personally observed. The friars that stand in the group behind the orator on the rostrum wear Dominican robes: they are members of Savonarola's Order. In the years after the preacher's death, his defenders and enemies debated whether he had been a true prophet, as he claimed, or a false one, like the Antichrist himself. Did Signorelli mean to suggest that recent history in Florence had fulfilled the Bible's own prophecies of how things would end?

11.32

Lorenzo Costa, *Triumph
of Death*, 1488–92. Fresco.
Bentivoglio Chapel,
San Giacomo Maggiore,
Bologna

Whatever the case, the image he gave to viewers leaving the chapel was the most ominous of all (fig. 11.30). To the right of the passage leading back into the cathedral proper, a prophet in a turban and a sibyl with a book foretell the destruction of the world, and what they describe unfolds behind them, as buildings crumble, the sky darkens, and the moon and sun go into eclipse. To the left, demons breathe fiery rays onto a helpless crowd, which collapses toward the front of the picture plane. If Dürer and Savonarola brought the Apocalypse into the viewer's time, Signorelli brought it into their space.

In Bologna a decade earlier, between 1488 and 1491, the Ferrarese painter Lorenzo Costa (1460–1535) decorated a chapel for the leader of the city's dominant faction, Giovanni II Bentivoglio (1443–1508), which also gave visual form to "last things." Costa, like Signorelli,

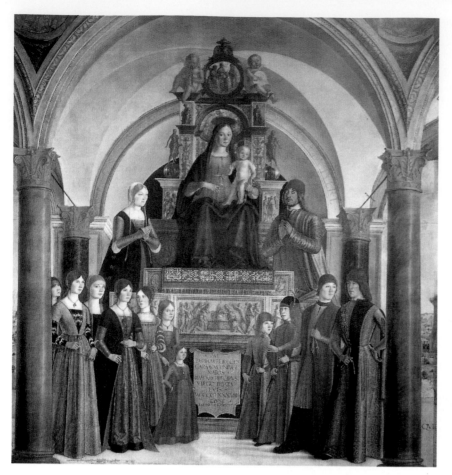

Leonardo in Sforza Milan

The enormous amount of wall space that Signorelli, Costa, and Lippi gave over to poetical fiction and antiquarian fantasy helps explain why Savonarola and others might have felt that sacred narrative was under threat. And as Leonardo's work from the 1490s shows, competition came not just from secular poetry but also from the new investigations into the natural world, as well as from the expectations of a courtly audience.

During Leonardo's first decade in Milan, where we left him at the end of the last chapter, his patron Ludovico Sforza employed him primarily in the production of entertainments. The painter staged plays, conceived ephemeral wedding decorations, and helped to organize tournaments. He invented emblems and heraldic devices. He wrote fables and satires. He composed *paragoni*, witty reflections on the nobility of painting relative to other arts such as sculpture, music, and poetry. Most of all, he drew. The description of Leonardo's volumes as "notebooks" and his famous backwards writing can give the impression that these were private affairs, research that served no end but the advancement of his own knowledge. Still, just as many of the problems that occupied Leonardo took their start in painting or engineering

ABOVE

11.33

Lorenzo Costa the Elder, *Virgin and Child with Giovanni II Bentivoglio and His Family*, 1488. Oil on canvas. San Giacomo Maggiore, Bologna

RIGHT

11.34

Leonardo da Vinci, *Study of the Principal Organs and the Arterial System of a Female Figure*, c. 1508–10. Pen and brown ink, brush and brown wash, over black chalk, 16⅞ x 13" (47 x 32.8 cm). Royal Library, Windsor

drew on Italian poetry, but in this case the poetic material has assumed monumental form, and there is no trace of the terrifying imagery of the Book of Revelation. Costa's frescoes, like Lo Scheggia's childbirth tray from half a century earlier (*see* figs. 6.27–6.28), took as its starting point the Triumphs of Petrarch, a poem describing a dream vision in which a series of allegories passes the poet in a spectacular procession. Its vivid images had been popular subjects for domestic decorations, but the appearance of the *Triumph of Fame* and *Triumph of Death* in a chapel is unprecedented. The two paintings (figs. 11.31 and 11.32) are larger than the chapel's altarpiece, a *Virgin and Child with Saints* by the painter Francesco Francia (1450–1517), and correspond in scale to another, equally extraordinary image by Costa, the *Virgin and Child* (fig. 11.33), this time accompanied by portraits of Giovanni, his wife Ginevra Sforza, and their sons and daughters.

The innovative character of the Bentivoglio Chapel's decoration is indicative of the improvisatory character of Giovanni's regime. He was not the legitimate prince or lord of Bologna, but his patronage and ceremonial style imitated the rulers of Mantua, Ferrara, and Milan, with whom he cultivated ties of marriage and friendship, as he did with the Medici. Yet the support of such powers, and his very public attempts at emulating princely style, could not save the regime, which was swept away by the conquering Pope Julius II in 1506.

FAR LEFT

11.35

Johannes de Ketham,
*Anatomy of a Pregnant
Woman*, woodcut
illustration from
Fasciculus medicinae, 1491.
Fondazione Giorgio Cini,
Venice

LEFT

11.36

Leonardo da Vinci, study
of a human skull, *c.* 1489.
Pen and dark brown ink
with leadpoint (?) on paper.
Royal Library, Windsor,
19058r

assignments, so must many of his drawings presume an audience. Throughout his later career he would produce drawings (fig. 11.34) that imitated and corrected the anatomical studies he encountered in this period, such as the woodcut illustrations in the small book Johannes de Ketham published in 1491 (fig. 11.35). The carefully ruled blocks of text accompanying the skull drawings (fig. 11.36) now in Windsor Castle imitate the tidy organization of illuminated manuscripts meant for preservation and distribution, and other notes suggest that Leonardo, too, considered publishing a book on the human body.

Other drawings on poetic and allegorical themes aimed at delight no less than at science. A sheet now in Oxford, for example (fig. 11.37), shows the artist experimenting with ways to represent "Envy" in pictorial form. As the elaborate inscriptions explain, the female personification on the left rides a figure of Death to show that envy never dies. An arrow of laurel and myrtle, symbols of virtue, strikes her ear, indicating that the envious are offended by good deeds. With her left hand, Envy makes an obscene gesture toward God. On the right, a male figure of virtue discovers Envy as a kind of Siamese twin, for "as soon as virtue is born, it gives birth to envy against itself" and because "one would sooner find a body without a shadow than virtue without envy." He pokes an olive branch into her eye, showing that the very sight of virtue hurts her. Explaining the meaning of such pictures

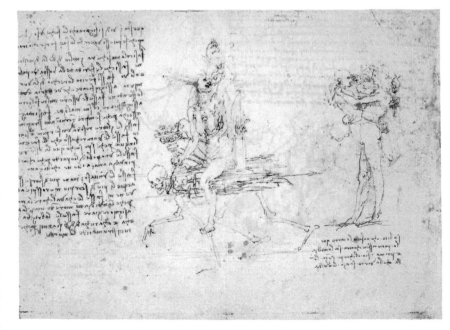

11.37

Leonardo da Vinci, *Two
Allegories of Envy, c.* 1483–85.
Pen and brown ink, traces of red
chalk, 8¼ x 11⅜" (21 x 28.9 cm).
Christ Church, Oxford

11.38
Leonardo da Vinci, *Group of Five Grotesque Heads,* *c.* 1494. Pen and brown ink, 10¼ x 8" (26 x 20.5 cm). Royal Library, Windsor

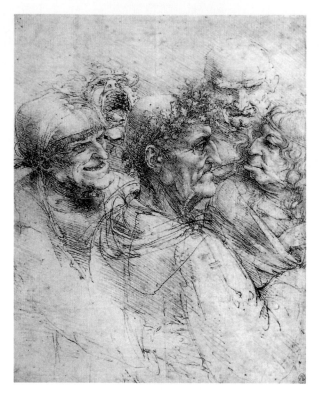

OPPOSITE
11.39
Leonardo da Vinci, *Lady with an Ermine (Cecilia Gallerani),* before 1490. Oil on panel, 21¼ x 15¾" (54 x 40 cm). Czartoryski Museum, Cracow

would have functioned as a kind of courtly game, though the drawings also point in the direction of Leonardo's writings on art: "Painting is a poem that is seen and not heard, and poetry is a painting that is heard and not seen." "If you call painting mechanical because at first it is manual, the hands figure what is found in the imagination, and you writers draw what you find in your minds manually with the pen."

A series of grotesque heads may reflect Leonardo's role as a purveyor of wonders for the Milanese courtly elite (fig. 11.38). Today it is tempting to dwell on the disturbing humor in the drawings, the curiosity about human deformity that they attest. Leonardo, however, probably had at least partly a more serious purpose. Some of the drawings appear to be caricatures of pompous courtiers, lascivious monks, delirious old people, and other types Leonardo would have seen around him in Milan, though they also testify to his increasing interests in the relation between the mind (or soul) and the body. He observed on several occasions in his writings that the human soul, which established an individual's character and guided his movements, also left a permanent imprint on his physical form. The viewer supposedly knows what the people in such drawings are like simply from the way they look.

It is in the spirit of these interests – Leonardo's study of human nature and his courtly audience's fascination with the wonders of art – that we should approach Leonardo's portrait of Cecilia Gallerani (fig. 11.39), which probably dates from around 1490. The correlative to

Leonardo's fascination with extreme human deformity was his ability to generate absolute and alluring beauty – a capacity that for Leonardo demonstrated the power of art itself. The sitter, a Milanese noblewoman, was also the favorite of Duke Ludovico. Like Ginevra de' Benci, whom Leonardo had painted in Florence around 1478–80 (*see* fig. 9.20), Cecilia was famous in her day as a poet, writing in both Italian and Latin. She had a dominant position in courtly life, especially before Ludovico's marriage to an Este princess and her own to another man in 1491. The ermine she holds alludes to the duke himself, as the animal had featured in one of Ludovico's *imprese*. It also flatters the sitter, however, for writers had long associated the white creature with purity and moderation. The portrait thus belongs in the emblematic tradition to which Leonardo had already contributed while living in Florence, in that it incorporates elements taken from nature that also symbolize the sitter. As earlier portraitists had done, the painter idealizes the sitter's features to such a degree that it may have been difficult to identify her. This, too, helps explain the inclusion of the animal, which puns on her name: *galee*, the Greek word for ermine, is nearly the root of "Gallerani." The joke is itself flattering, for only one of Cecilia's learning would have caught it.

Another of Ludovico's courtiers, the poet Bernardo Bellincioni, wrote a sonnet in praise of Leonardo's picture, rhapsodizing that the painter had made Gallerani's eyes so beautiful as to obscure the sun, that he had made it difficult to distinguish nature from art, that he made her "appear to listen." He cast the artist's achievement as one of attributing a psychology to his figure, suggesting that Cecilia seemed to look, to hear, not merely to be the subject of an adoring gaze. However conventional the verse may be, it draws attention to the difference between Leonardo's conception of the portrait and the almost subjectless profile views that had not yet gone out of vogue (compare, for example, fig. 9.26). The conceit also conforms with Leonardo's own research interests; in his anatomical studies, Leonardo had been attempting, among other things, to find the location of the soul inside the body.

Leonardo's new mode of portraiture evidently appealed to Italy's courtly elites. Isabella d'Este, the marchioness of Mantua, sought to borrow the Gallerani portrait in 1498; her attempts to have Leonardo paint her own portrait after the fall of the Sforza a few years later never got further than a profile drawing, which suggests that she wanted the portrait to conform with the princely idiom of the portrait medal (fig. 11.40). No one has yet managed to identify the woman portrayed in the so-called "*Belle Ferronnière*" (fig. 11.41), but she was certainly a person of distinction. The turning of her body almost into profile, her sober expression, and the fictive

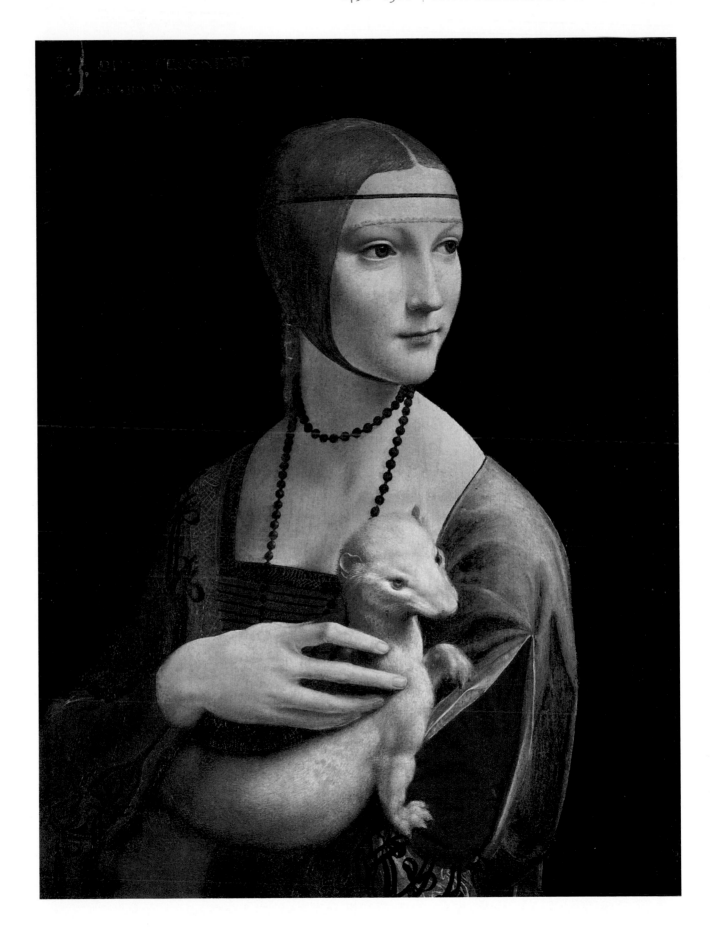

11.40

Leonardo da Vinci, *Isabella d'Este*, 1500. Black, red, and white chalk, and yellow pastel (?) over leadpoint, on paper prepared with a bone-colour dry pigment, 24⁷/₈ x 18¹/₈" (63 x 46 cm). Musée du Louvre, Paris

11.41

Leonardo da Vinci, *Portrait of a Lady ("La Belle Ferroniere")*, c. 1495–99. Oil on panel, 24³/₄ x 17³/₄" (63 x 45 cm). Musée du Louvre, Paris

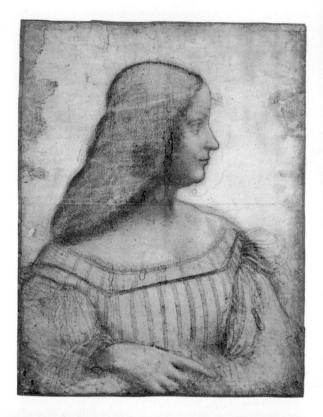

11.42

Giovanni Antonio Boltraffio, *Idealized Portrait of Girolamo Casio*, 1490s. Oil on panel, 16³/₄ x 11¹/₈" (42.5 x 28.3 cm). The Duke of Devonshire Collection, Chatsworth

balustrade separating her from the viewer all give the portrait a formality that distances it from the Gallerani picture. This may have seemed more appropriate for a married woman of high status, or it may simply indicate that Leonardo completed the painting in collaboration with a less gifted assistant. Both possibilities would suggest that Leonardo had become a commodity of limited availability for which prospective patrons would have to compete. This, as much as the inherent appeal of his manner, must account for the rise in these years of a circle of "Leonardesque" painters in Milan, including some, like Giovanni Antonio Boltraffio (1446/7–1516), who specialized in portraits. In paintings like the one now in Chatsworth (fig. 11.42), Boltraffio captured the hallmarks of Leonardo's Milanese style – black background, *sfumato* to soften the face, expressive gesture of the hand – but he dulls the expression and avoids the time-consuming and intellectually challenging task of unifying tones, favoring a more Flemish attention to surface and texture.

Leonardo and Sacred Painting

Was Leonardo's way of painting appropriate for all tasks? Ludovico Sforza is documented as having commissioned only one altarpiece, the *Pala Sforzesca* (fig. 11.43) made for the church of Sant'Ambrogio ad Nemus in Milan and now in the Brera Gallery. Scholars have yet to provide a convincing attribution for the piece: it

was certainly made by an artist familiar with Leonardo's painting, though what is striking is the degree to which it rejects that example. The squirming Christ Child suggests knowledge of Leonardo's experimentation with compositions that would link the infant to the Virgin in novel ways, but compared to a work like the *Virgin of the Rocks* (*see* fig. 10.39), the picture is quite conservative in conception, placing all the characters in perfect symmetry. Though the gestures indicate that the saints in the back advocate for the donors in the front, every figure seems drawn into itself; Mary in particular sits in a kind of meditative trance; she interacts neither with her child nor with her worshipers nor with the beholder. The black background and the treatment of the Virgin's drapery – up-modeling the blue and down-modeling the red – pick up devices from Leonardo, but the fierce expressions, the hardness of the forms, the fantastic classicizing furniture, and the profusion of ornament rather follow the manner of Andrea Mantegna. Did the duke favor a different pictorial mode for ritual settings?

Certainly Leonardo himself in these years also sought to take on larger projects connected to the Church. In 1490, he competed for (and lost) the commission to design the spire of Milan Cathedral. Two years later, he helped create a new square before the cathedral of Vigevano (fig. 11.44), a small town south-west of Milan: this, along with the cathedral square in Pienza, was among the first planned *piazze* of the Renaissance. One year after that, Leonardo was again thinking about Milan Cathedral, and contributing decorations for the wedding of Ludovico's niece. Leonardo's most important work in these years, however, turned out to be for the refectory, or dining hall, of the church of Santa Maria delle Grazie.

Ludovico had chosen this as his burial site and had consequently commissioned the painter-architect Donato

ABOVE

11.43

Master of the Pala Sforzesca, *Pala Sforzesca*, 1490s. Tempera on panel, 7'6⅞" x 5'5¼" (2.3 x 1.65 m). Pinacoteca di Brera, Milan

LEFT

11.44

Arcaded square in Vigevano, with Ludovico Sforza's ducal palace behind. The renovations, carried out in the 1490s, are sometimes attributed to Leonardo.

317

11.45
Crossing and choir by
Bramante at Santa Maria
delle Grazie, Milan

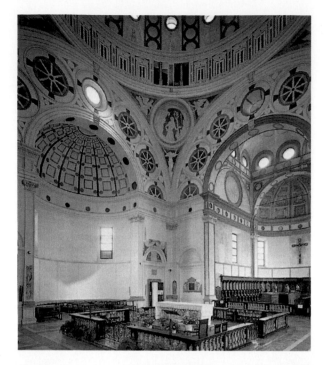

BELOW
11.46
Leonardo da Vinci, *The Last
Supper*, 1494–98. Mural.
Refectory of Santa Maria
delle Grazie, Milan

Bramante (1444–1514) to add a huge domed crossing to the church and a choir extending behind the high altar (fig. 11.45). Leonardo may have had an unofficial role here too: he seems to have exchanged ideas for centralized, domed structures with Bramante, a friend who would take the theme to new heights at St. Peter's in Rome a decade later. The duke envisioned the new choir as a setting for his own tomb; the site is comparable in position to the tomb chapel that Ghirlandaio's patron Giovanni Tornabuoni had unveiled just a few years before (*see* fig. 11.6), though in scale the duke's vision sooner rivaled Pope Nicholas V's unexecuted project for St. Peter's from nearly half a century earlier (*see* p. 179).

Leonardo, meanwhile, focused on the church's refectory. *The Last Supper* (fig. 11.46) belonged to a larger cycle of decorations, including a *Crucifixion* on the opposite wall with a portrait of Ludovico and his family. Above the scene with Christ and the Apostles, Leonardo painted monumental images of the Sforza family arms, giving its members a presence in that history, too, and a letter from Ludovico states that he additionally planned to

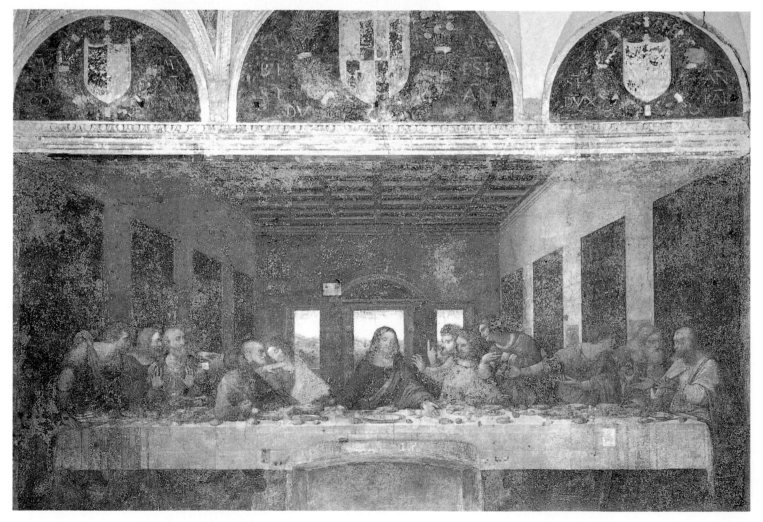

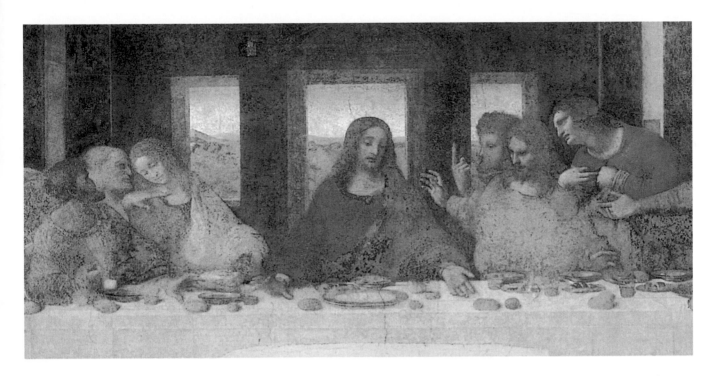

have Leonardo paint a third wall of the room. *The Last Supper* was a conventional subject for painted refectories, especially in Florence, where Leonardo trained. The duke chose a subject that corresponded to the function of the room, though he also wished to turn the space into something more personal than a monastic dining hall. The imaginary room in which the Apostles eat extends

the upper level of the space in which the duke himself sometimes came for meals.

The Florentine convention, as we saw earlier with Andrea del Castagno (*see* fig. 6.16), was to place all the dining Apostles except the traitor Judas on the far side of a long table. Leonardo, too, adopted an arrangement that allowed all his characters to face the beholder; but here even Judas joins the rest of the company. This approach made it easier for the painter to use the assignment, the largest work he would ever complete, as an opportunity to translate experiments he had undertaken in other media. Leonardo treated each of the figures as an individual problem of human expression, a topic that had fascinated him at least from the beginning of the decade, as we saw with the grotesque heads. One intense ink and **metalpoint** drawing on blue paper (fig. 11.48), for example, imagines St. Peter as a scowling character who turns and raises his arm as though in response to something taking place outside the picture field. Peter's physiognomy centers on a furrowed brow that in turn implies a mind in motion. In the mural itself (fig. 11.47), Peter directs the same brow and the same grotesque nose toward Christ, providing contrast both with Judas, who leans away from Christ, and with John, whose youthful sweetness (entirely conventional in *Last Supper* imagery) distinguishes his expression from Peter's anger.

Confrontations like this reveal the artificial, staged quality of the composition. On the whole, though, Leonardo resisted supernatural effects. At the rear of the space are three windows looking out onto a landscape. The illumination these provide, and particularly the

11.47
Leonardo da Vinci, *The Last Supper*, detail of central group. Mural. Refectory of Santa Maria delle Grazie, Milan

LEFT
11.48
Leonardo da Vinci, *Bearded Old Man in Half-Length, Three-quarter View Facing to the Right (St. Peter).* Metalpoint, reworked with pen and brown ink, on blue prepared paper, 5¾ x 4½" (14.5 x 11.3 cm). Graphische Sammlung Albertina, Vienna

central one before which Christ sits, frames the heads of the holy personages in a way that suggests a radiating aura; the windows in this way take over the traditional role of haloes. And in the hope of achieving the same kinds of atmospheric effects he had developed in his panel paintings, Leonardo worked not in true *fresco*, but in an experimental oil-based medium. Surely he knew the risks this involved, though he must also have been reluctant to work with the speed and regularity a more traditional approach would have required. A writer at the court, Matteo Bandello, reports that Leonardo:

> used to climb the scaffolding early in the morning…and from the rising of the sun until its setting, not once let the brush leave his hand, forgetting to eat and drink and painting continuously. Then there would be two, three, or four days when he would not set his hand to the picture, but would remain in front of it, and for one or two hours a day just contemplate, consider, and, examining them together, judge his figures.… I have also seen him come directly to the church and, having ascended the scaffolding, take the brush, apply one or two strokes to a figure, then leave.

Ultimately, Leonardo's approach had disastrous effects, as the paint did not bind to the surface as true *fresco* would have; a writer in 1560 reports that the picture by that time was already in ruinous condition. The wrecked state of the wall invited subsequent users of the room to treat it badly. The monks cut a door into the mural in 1652, its eighteenth-century caretakers had the scene extensively repainted, and Napoleon's troops used the painting for target practice. Despite a careful recent restoration, the traces of Leonardo's own hand no longer let themselves be easily read.

In a sense, moreover, the work's illegibility is not merely a matter of its condition. The "response" of the sitter in the Cecilia Gallerani portrait (*see* fig. 11.39), along with Leonardo's physiognomic drawings and a number of his theoretical statements, encourage us to see the mural in terms of internally motivated actions and interactions, bodies whose gestures reveal a specific purpose. But just what is Christ, at the very center of the picture, doing? In John 13, Christ announces at the meal that one of his disciples will betray him; "the disciples therefore looked one upon another, doubting of whom he spoke." When asked, Christ replied only: "He it is to whom I shall reach bread dipped." Is Leonardo, then, showing the Apostles responding in confusion and dismay to Christ's words, as he gestures toward the bread and reaches for the wine in which he will dip it? Perhaps, but here as throughout this book, it becomes clear that paintings do not simply illustrate texts. In Matthew 26, which tells a variation on the same story, the episode concludes with Christ taking bread, blessing and breaking it, giving it to his disciples, and saying: "Take ye, and eat. This is my body." Catholics took this act to institute the ceremony of Communion. If the viewer understood Christ's hand to be indicating the bread he tells his troubled followers to eat, it would lend a ritual aspect to every meal that the monks in the refectory took before the painting. With the end of the century on the horizon and Ludovico's French enemies already threatening his territory, the image of Christ blessing the assembly may have appealed to him as well.

Michelangelo: Early Works in Marble

Florence

Some artists, as we have seen, were deeply taken by Savonarola's sermons in Florence. For others, however, it must have been the fall of the Medici as much as the rise of the Dominican that most affected them. Lorenzo the Magnificent had earlier invited the young Michelangelo Buonarroti (1475–1564), then a teenage apprentice to Ghirlandaio and perhaps an assistant on the Tornabuoni Chapel (*see* fig. 11.6), to join his household in Florence. It was probably Michelangelo's interest in ancient sculpture, more than his precocity with the brush, that attracted the

11.49

Michelangelo, *Battle of the Lapiths and Centaurs*, *c.* 1492. Marble, 33¼ x 35⅛" (84.5 x 89.2 cm). Casa Buonarroti, Florence

patron's attention. Beginning in 1489, the fourteen-year-old had kept company with a group of young artists who worked and studied in the garden of a Medici property in the northern part of the city, little more than a block from where Savonarola would live and preach – indeed, one early biographer reports that Michelangelo taught himself to sculpt after borrowing the tools of a mason working at the church of San Marco. The head of the garden clique was the aged Bertoldo di Giovanni, whose works included not only small statuettes like the *Pegasus* group (*see* fig. 10.4), but also at least one bronze relief on a classical theme. Among Michelangelo's earliest surviving works is a marble in a similar format (fig. 11.49), showing a mythical fight between a group of centaurs and the human tribe of Lapiths who had invited them to a wedding.

The episode, known from the Roman poet Ovid, was one whose significance the humanist Poliziano is reported to have explained. Michelangelo's interest in the subject thus points to his connection with the philologists and other literary figures who surrounded Lorenzo the Magnificent; in this respect, it is as close conceptually to Botticelli's *Birth of Venus* (*see* fig. 9.25) as it is to anything from the 1490s. The actual story Michelangelo shows, nevertheless, is difficult to decipher. In contrast to Donatello, whose influential reliefs depended on the use of perspective to create illusionistic depth, Michelangelo simply filled up the available space with a tangle of bodies, covering the field from bottom to top in the manner of a Roman sarcophagus or a pulpit by Giovanni Pisano (*see* fig. 1.40). Nor are the identities of the characters Michelangelo depicts entirely clear. At the bottom of the scene, just left of center, is the haunch of a centaur, and elsewhere we get glimpses of a horse's leg or a tail, but it is not always easy to say which characters are centaurs and which are human. Other artists sometimes characterized the centaurs as enemies of civilization, giving their opponents modern weapons as the hybrid beasts fought with debris from the banquet, but the most prominent fighting instruments in Michelangelo's version are the large rocks wielded by the figures to the left, and these appear to be Lapiths.

Michelangelo may have modified the story to bring it closer to his own intellectual concerns. The choice to explore the expressive potential of the nude male body, even at the expense of legible narrative, reflected the lessons Michelangelo had learned from studying antiquities. What distinguished his work from the creations of other workshops of his day, however, even those with similar interests in the ancient past, was his devotion to a narrow range of media, the properties of which he made into objects of reflection in their own right. Across the top of the *Centaurs* relief is a wide band of partially worked marble, scored with a claw chisel, the tool that a marble sculptor would use to rough out compositions before

proceeding to smaller chisels and files. The passage contrasts dramatically with the highly polished torsos of the central characters; the whole work draws attention to the process by which it was made, the degrees of finish a slab would pass through as the sculptor used finer and finer instruments. That large depicted stones should be put on such prominent display reminds the viewer that they are Michelangelo's own instruments no less than his characters' and suggest that he conceived his own art as a kind of battle. This is a conceit that would return in his *David* – another hero who uses a stone to fight – a decade later.

Lorenzo the Magnificent died in 1492, and the Medici household now headed by Lorenzo's son Piero seems not to have held the same appeal for the artist. In 1494, Michelangelo began traveling, first to Venice and then to Bologna, where he carved three small stone figures for a shrine. By the time he returned to Florence in 1495, the Medici had been expelled. The artist remained only briefly in the city, producing a marble *Cupid* so persuasively similar to an ancient work of art that an acquaintance allegedly managed to pass it off as an actual antiquity to Raffaele Riario, a cardinal living in Rome. Riario invited Michelangelo to the papal city, where he would complete his two most important early marbles.

ABOVE LEFT AND RIGHT
11.50
Michelangelo, *Bacchus*, 1496–98. Marble, height 6'7½" (2 m). Museo Nazionale del Bargello, Florence

Rome

The first, which Michelangelo started in 1496 and completed in 1498 while living with Riario, was a marble *Bacchus* (fig. 11.50). This lifesized mythological work seems to have been intended from the outset for display in a sculpture garden, like the one owned by the Medici in Florence where the artist had begun his career: it is hard to imagine any other context that could accommodate such a blatantly pagan and sensual image. Riario himself had a sculpture garden, as did the banker Jacopo Galli, whom Giorgio Vasari names as the work's patron. Carved in the round, the statue invites the viewer to circle it: only from the side and the back do we get a proper view of the little satyr that accompanies the wine god. Marble sculptures of this size cannot stand on narrow stone supports with the diameter of human legs; Bacchus literally needs the second figure to stay on his feet. The question of whether he will stand or topple, on the other hand, is also central to the work's theme. From the time of Donatello, sculptors who conceived free-standing figures in imitation of the antique tended to

show a shift of weight from one foot onto the other. This seemed to be a principle to which the ancients had all adhered, and it gave the figure itself a graceful form. Michelangelo, however, pushes this to an absurd extreme, hinting that Bacchus leans back and to the side – onto the satyr – because he is staggering drunk. Whereas Leonardo explored the possibility of bringing depicted people to life by showing not just a surface appearance but some kind of interiority, Michelangelo carved a figure that seemed to be inhabited by spirits of a different kind. As the satyr chomps into a grape, Bacchus tries to steady his cup to prevent his drink from spilling.

The *Bacchus*, though displayed from the beginning in a private setting, must have attracted much attention in the city, for shortly thereafter, the French Cardinal Jean Villiers de La Grolais asked Michelangelo to carve a *Pietà* (fig. 11.51) for a chapel dedicated to the Virgin on the side of St. Peter's. The space itself, circular in plan, was unusual, and its subsequent destruction makes it difficult to say with certainty just how the work was originally displayed. It may have functioned as an altarpiece, with the Virgin presenting Christ's flesh to the celebrant at the altar

BELOW LEFT

11.51

Michelangelo, *Pietà*, 1498–99. Marble, height 5'8¼" (1.74 m). St. Peter's, Rome

BELOW RIGHT

11.52

Baccio da Montelupo, *Crucifix*, 1496. Polychrome wood, 5'6½" (1.7 m) (Christ); 11'6½" x 6'4"(3.5 x 1.95 m) (Cross). San Marco, Florence

table, or it may have rested directly on the ground as a tomb marker – Villiers, already in his late sixties, intended the chapel to serve as his place of burial, no doubt in emulation of the burial sites that counterparts like Cardinal Carafa were beginning to construct (*see* fig. 11.19).

Lifesize sculpted images of Christ were quite common in Michelangelo's day, though most were *Crucifixions*, done in wood: the workshop of Baccio da Montelupo (1469–*c.* 1523), a sculptor who had studied alongside Michelangelo in the Medici garden, turned out nearly two dozen of these. Baccio was a devout follower of Savonarola, who seems especially to have liked what the sculptor made: in 1496, the year Michelangelo began his *Bacchus*, the preacher had Baccio produce a lifesize Crucifix (fig. 11.52) for the church of San Marco in Florence. The sculptor employed a more vivid polychromy than Donatello and Brunelleschi had in their analogous works of the early fifteenth century: red blood pours from disturbingly real-looking nails and thorns across the flesh-colored body of Baccio's Christ. The sacral quality of the roughly hewn wooden cross may have seemed all the more insistent at a moment when sculptors were regularly responding to marbles of the pagan past. Against such a tradition, Michelangelo's *Pietà* group could not have looked more alien.

The white Carrara marble in which Michelangelo carved may have seemed especially suitable for the representation of deathly pallor; it also lent his figures an unreal beauty. The artist does not really treat them as living presences: like the increasingly well-known pagan statues of the ancients, the pair seem to belong to another time and place. Michelangelo opted for a version of the Pietà theme that centered not on Christ presented iconically by attendant angels (compare fig. 9.8), but rather on the Virgin's grief at her son's death. Her monumental drapery, itself a tour de force, adds mass and helps unify the horizontal male body with her own; this disguises the work's narrative disjunctiveness. Michelangelo gave Mary the face not of a woman who could be the mother of a thirty-three-year-old man, but of a teenage girl. He breaks with historical plausibility to elicit our sympathy, but also to show the Virgin in what contemporaries would have regarded as her most perfect state.

Ironically enough, Michelangelo's signature hinted at the work's *imperfection*. The inscription in the band that runs across the Virgin's chest (fig. 11.53) reads "Michelangelo Buonarroti of Florence was making this," using the Latin imperfect "faciebat" rather than the more common "fecit" ("he made this"), again to draw attention to the process and duration of the carving. Little of what is visible here, by comparison with his *Lapiths and Centaurs* (*see* fig. 11.49), could be said to be unfinished, even if the pair sit on a distinctly rocky base, but

the fact that Michelangelo wanted viewers in 1499 to think about his labors in connection with a devotional act suggests that he, too, may have had some trepidation about the century to come. Later in life, Michelangelo is said to have remarked that he could still hear the voice of Savonarola thundering in his head. With the exception of a historical bust and the sculptures that originated in other tomb projects, he would never again sculpt a work like the *Bacchus*, nor any other marble on an explicitly pagan theme.

11.53

Michelangelo, *Pietà*, detail.
St. Peter's, Rome

1500–1510
Human Nature

12

1500–1510
Human Nature

The Heroic Body and Its Alternatives

If art in the years leading up to 1500 returned repeatedly to images of catastrophe and the end of history, this corresponded with a lived experience of rupture with the past. In 1499, the French invaded the region for the second time in a decade, toppling Duke Ludovico Sforza in Milan. Naples, which had had four kings in six years, fell to France the following year. Venice, newly at war with the Ottoman empire, lost several major sea battles, the first in a series of military misfortunes that before the end of the decade would leave the city not only weakened on the water but also stripped of much of its huge territorial state in northern Italy. Florence, following the overthrow of the Medici and the revolt against Savonarola, entered the new century as a reborn republic, without the Medici pulling the strings. Pope Alexander VI was encouraging his son, the *condottiere* Cesare Borgia, to seize territory in central Italy, ousting the Malatesta in Rimini and the Montefeltro from Urbino, among others. Alexander himself would die after a violent illness in 1503, leaving his successor, Julius II, as the head of a militarized papal state, aimed at the domination of central Italy.

Many Italians in these years, seeing all of this through the lens of the prophecies and astrological predictions that the half-millennium had inspired, feared that worse disasters were yet to come. Some, however, maintained a sense of possibility, even of optimism.

The Florentine civil servants Niccolò Machiavelli and Francesco Guicciardini, both of them political thinkers and historians, were among those who set aside the idea that history revealed the unfolding of a divine plan, with apocalypse or salvation as its climax; these men looked to history as a guide, wondering whether events that took place in the past provide reassurance of an orderly and positive outcome for the unsettled present. Did history teach us that outcomes could be shaped by the inspired actions of heroic human beings? Or, more pessimistically, did history reveal no more order than the random growth and decay visible in the natural world, in which human beings acted out of instincts hardly more rational or noble than those of other living creatures, and probably less so?

Michelangelo's *David* from 1504 (*see* fig. 12.3) seems to answer the first of these questions in the affirmative; while Piero di Cosimo's (*c.* 1462–1521) contemporaneous *Stories of Primitive Man* series corresponds to the latter

12.1

Piero di Cosimo, *Hunting Scene, c.* 1500. Oil and tempera on panel, 27³/₄ x 66¹/₄" (70.5 x 169.5 cm). Metropolitan Museum of Art, New York

12.2

Piero di Cosimo, *The Return from the Hunt*, *c.* 1500. Oil and tempera on panel, 27³/₄ x 66¹/₂" (70.5 x 168.9 cm). Metropolitan Museum of Art, New York

point of view. Piero's *Hunting Scene* (fig. 12.1) and *Return from the Hunt* (fig. 12.2) are believed to have been painted for the house of the wealthy anti-Medicean Francesco Pugliese. Like Botticelli's *Primavera* (*see* fig. 9.23), they were *spalliere*, and they drew their imagery from ancient poetry. The subject matter here, however, is not the idealized world of the ancient gods and heroes, the "Golden Age" described by the poet Ovid when the gods dwelt upon the earth. Piero's human figures, not to mention the half-human hybrids that appear in one of the panels, seem in addition worlds away from the delicate beings who populate the paintings of Andrea Mantegna and Filippino Lippi (*see* figs. 11.4–11.5 and 11.20–11.23), and the physical world they inhabit is distinctly harsher. Piero was a skilled landscape painter; he had been taught by Cosimo Rosselli, who was probably also the teacher of the pioneering draftsman Fra Bartolomeo (*see* fig. 11.2). Piero used landscape, however, to envision the most basic conditions of human life within the natural world. The series created an explicit alternative to the Golden Age mythologies of the Medici era, as if these were no more than lies that had sustained the rule of tyrants. Piero presents a far from idealizing view of the origins of man, reminding the viewer of the instinctual and violent creatures that the first human beings actually were. He drew freely upon the great philosophical poem *On the Nature of Things* by the first-century BCE Roman writer Lucretius. Lucretius was a "materialist," that is, he believed that there was no reality beyond the physical universe, which obeyed its own laws without divine intervention, and that human beings possessed no immortal souls. All natural phenomena, Lucretius maintained, could be explained through the movement of atoms. Gods did not inter-

vene in terrestrial affairs; what people called gods were mere metaphors for natural processes: Venus for sexual compulsion and the desire to reproduce, Mars for rage and aggression, and so on. History began with humanity's desperate struggle for survival in a world for which it was ill prepared, and to which it had to adapt by mastering tools and weapons and by harnessing the element of fire.

Italian humanists had rediscovered Lucretius' poem in 1415, but its shockingly un-Christian view of human nature prevented it from having much impact until its publication in Venice in 1495 and 1500, when it began to become the model for a new genre of scientific and didactic poetry. By that point, the Lucretian view of human nature corresponded with the "realist" historical and political analyses of Machiavelli, who as a youth had copied out Lucretius by hand.

Michelangelo's *David*

In this respect, both Lucretius and Machiavelli represented something completely at odds with the idealizing attitude behind Michelangelo's *David* (figs. 12.3 and 12.4). The very perfection of the hero's muscular body, his gigantic scale, and even the exaggerated proportions of his head and hands show that his actions manifest the will and power of God. The boy-warrior David had long been established as a symbol of the Florentine Republic, as we have seen in sculptures by Donatello and Verrocchio (*see* figs. 2.24 and 9.15). The revival of that symbol, in the commission given to Michelangelo (1475–1564), co-incided with the revival of a long-suspended project for Florence Cathedral: an assignment that Agostino di

12.3

Michelangelo, *David*,
1501–04. Marble, height
(incl. base) 13'5½" (4.1 m).
Accademia di Belle Arti,
Florence. **The statue stood
for centuries to the left of the
main entrance to the Palazzo
dei Priori, where a copy can
be seen today.**

12.4

Michelangelo, sheet with
verses and studies for a
David, 1501. Pen and ink
on paper, 10 x 7⅜" (28 x
17.8 cm). Musée du Louvre,
Paris

Duccio (1418–*c.* 1481) had begun and abandoned in the
1460s, to replace Donatello's marble *David* of 1416, which
had ended up in the Palazzo dei Priori. Michelangelo
received Agostino's decades-old block with the elements
of a figure, including the pose and the proportions,
already roughed out, limiting the possibilities for dra-
matic revision; what Michelangelo produced, in fact, is
only really successful from the front and from the right.

We know from a document that Michelangelo had
studied Donatello's bronze *David* (*see* fig. 6.23), and
his awareness of that figure is reflected in a surviving
drawing (*see* fig. 12.4). There is nothing retrospective or
backward-looking about the figure itself, however, except
perhaps in Michelangelo's self-conscious bid to outdo his
Florentine predecessors. Beyond the exponential increase
in scale, Michelangelo's *David* differs most strikingly
from the previous versions in the action it depicts. The

sculptor needed to include some element on the base to brace the marble leg, and the obvious choice would have been the head of Goliath, a standard feature in such statues. Instead, Michelangelo included a cut-off tree, perhaps an allusion to fallen leaders and the prospect of renewal – and thus a symbol in the spirit of the "Golden Age" myths that Piero di Cosimo rejected. This David has no sword, nor even, more surprisingly, a rock. Staring into the distance, he is either preparing for his battle or, more likely, surveying what he has just accomplished. The conceit of the boy looking at what must, proportionally, be a truly towering Goliath on the horizon, seems to have carried particular symbolic weight for the artist. On the Louvre sheet, he wrote "David with his sling and I with my bow – Michelangelo" (*see* fig. 12.4). The "bow" to which the artist refers is probably the tool sculptors used to turn a drill when cutting marble, but the point is that Michelangelo saw his own task as one that bore direct comparison to his hero's.

The idea that David and Michelangelo alike were looking at giants is a reminder of the stunning size of the figure, and of the single block from which the sculptor carved it: nothing like this had ever been seen in Florence. Many would immediately have recognized that Michelangelo was vying with sculptors of antiquity. Rome, where he had been working in the years preceding 1501, preserved two famous examples of the colossal male nude in the *Horse Trainers* on the Quirinal Hill, and David's massive head and hands would have recalled the great fragments (also a head and hands) of the colossus of Constantine on the Capitol. Florentines were also aware that Leonardo da Vinci (1452–1519), who had returned to Florence in 1500, had tried and failed to complete a colossal bronze statue in Milan. Michelangelo's success may have marked the beginning of a public rivalry with Leonardo.

At the completion of Michelangelo's *David*, the Florentine government balked at the prospect of hoisting the colossal marble up onto the cathedral's exterior and consulted with artists and other experts (including Leonardo, Botticelli, Filippino Lippi, and Piero di Cosimo) on an alternative placement. Then, contrary to the advice of most of the artists, the Signoria had it erected outside the Town Hall. This was a highly charged location: everyone knew (and the recorded discussion indicates) that here it would replace Donatello's *Judith and Holofernes* (*see* fig. 6.25) and compensate for perceived inadequacies in Donatello's bronze *David*, then in the courtyard immediately behind. According to the Florentine official overseeing the meeting, it was "not considered proper that a woman should be shown cutting off the head of a man," and the statue had been "erected under an evil star" that had led to Florentine setbacks in the war against Pisa. Regarding the bronze *David*, the official is more laconic – the criticism of

it had something to do with the appearance, from behind, of one of the legs.

Michelangelo's *David* sent all the right messages: the figure was not only male, as opposed to the threateningly female *Judith*, but also swaggeringly masculine and physically powerful, unlike Donatello's androgynous and still childlike figure. The location to the side of the entrance to the seat of government had one further effect: it activated David's frowning gaze, which he turns on an enemy to the south, coming from the direction of Rome: that is where the exiled Medici had established themselves in readiness for their planned repossession of Florence.

Leonardo and Michelangelo in Florence

Depicting the Holy Family

Leonardo's work on his return to Florence in 1500 also responded to the appetite for the new and the

12.5
Leonardo da Vinci, *Virgin and Child with St. John and St. Anne*, 1507–08. Black and white chalk on tinted paper, 4'8" x 3'5¼" (1.42 x 1.05 m). National Gallery, London

12.6

The Muse Terpsichore,
Roman, second century.
Marble, height 19¾" (50
cm). Museo del Prado,
Madrid

Medici adherent, did not mention was that Anne was an important patron saint of the Florentine Republic, one associated with the defeat of tyrants ever since the regime of the Duke of Athens collapsed on her feast day in 1348; Anne was also the subject of the altarpiece that the new republic had commissioned Filippino Lippi to make for its council hall in 1498. Leonardo's design, that is, was more than a generic, contemplative image of the Virgin and Child and the Holy Family, because it conveys a series of emotional states as ephemeral as the play of muted light and transparent shadow that reveals the powerful forms, or the fluid movement of the limbs of these intimately intertwined figures. Its historical theme, like that of Leonardo's *Adoration* twenty years before (*see* fig. 10.37), is the incarnation of God in human form as a momentous historical turning point. Anne's heavenward pointing gesture signals her understanding of the union of the human with the divine. The genealogy of Anne, Mary, and Christ – the ascent from human to divine – is figured in the curious fusion of the three bodies, the sense that together three separate individuals form a mysterious whole.

The effect is quite different from that produced through the use of voids and linking gazes in the grouping of figures in the *Virgin of the Rocks* (*see* fig. 10.39). There is more of a sense of a unified whole, one that reflects Leonardo's engagement with sculpture over the preceding decade. Following the abortive eques-

FAR RIGHT

12.7

Leonardo da Vinci,
Vitruvian Man, 1492. 13½
x 9⅜" (34.3 x 24.5 cm).
Galleria dell'Accademia,
Venice

"marvelous." Receiving a commission for the high altarpiece of Santissima Annunziata in early 1501, Leonardo made a full-scale drawing for the painting, which characteristically he would never complete. However, the *Virgin and Child with St. John and St. Anne* had an impact scarcely less dramatic than Michelangelo's *David* would three years later. The drawing was one of the first works of art we know of to be placed on public exhibition. For two days, according to Giorgio Vasari, everyone came to "gaze at the marvels of Leonardo, which caused all those people to be amazed." The cartoon now in London (fig. 12.5) is not the one displayed by Leonardo on that occasion, but it is a closely related version and conveys something of what must have impressed the Florentines.

Vasari singled out Leonardo's ability to represent inner character, such as the modesty of the Virgin, as well as fleeting effects of emotion: the Virgin's joy in seeing the beauty of her son, St. Anne's happiness in "beholding her earthly progeny becoming divine." What Vasari, a

trian statue project in Milan and the collapse of the Sforza, Leonardo had gone briefly to Rome. His notebooks record a visit to Rome and to the nearby hillside town of Tivoli in March 1501, where he would have seen the sculptures of Hadrian's Villa, among them a group of lifesized Muses, seated female figures with powerful bodies, their laps covered with richly carved cascades of drapery (fig. 12.6). As is the case with Michelangelo's *David*, ancient Roman sculpture is here a key element of the "modern" style being developed for Republican Florence.

Classical sculpture defines the body as a normative ideal, a fixed canon of proportions. But when a Renaissance artist depicted the body he also had to demonstrate an empirical knowledge grounded in life drawing and in dissection. Leonardo's earlier drawing of the "Vitruvian Man" (fig. 12.7) showed, for the younger artist, that the normative and the empirical approaches entailed no necessary contradiction. Just as all the forms of nature itself were variations on the fundamental geometric forms of the sphere, the cube, the pyramid, so – following the Roman writer and architect Vitruvius – the human body could express an ideal geometry, even though the individual bodies that an artist measured and dissected might fail to correspond to this. Yet Leonardo's anatomical studies in the 1500s (*see* fig. 11.34), which consumed his interest far more than painting did, would become more absorbed in the process of growth, ageing, and physical decay than in Vitruvian norms. For all of Leonardo's interest in classical sculpture, it is by no means apparent that the figures in the London cartoon (*see* fig. 12.5) would manifest ideal proportions if they were to stand on their feet. One consequence of the effect of unity achieved by Leonardo is that we do not notice right away that the Virgin is prodigiously tall, and that her head is small relative to her body. Just as the interlocking of figures suggests a composite single figure, so too each body seems hybrid in character, as if each limb had been designed individually before being merged with the larger whole.

Michelangelo, despite evoking an ancient colossus with his *David* (*see* fig. 12.3), also maintained a non-Vitruvian and subjective approach to human proportion: later in his career he would state that an artist needed no other compasses than his own eyes. As is the case with Leonardo, the bodies in Michelangelo's art, while reminiscent of antiquity and of drawing from the model, are something else again: they are imaginary constructions, more beautiful and powerful than bodies in everyday life. It is as if both artists studied the natural body in the form of human models and dissected cadavers in order to surpass nature. In a similar manner, Michelangelo's study of antique sculpture paradoxically distanced him from the ideal proportions of the ancients.

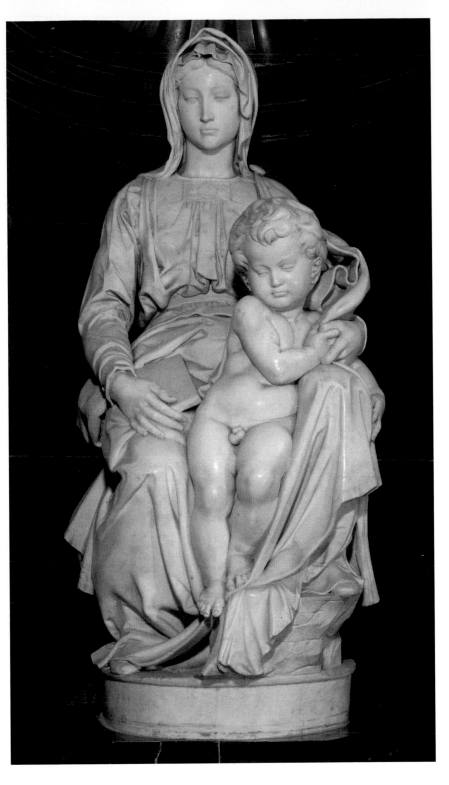

The *Virgin and Child* he carved between 1503 and 1506 (fig. 12.8) illustrates the extraordinary license he was willing to adopt. Though the Virgin is a variation on the figure of the Rome *Pietà* from the previous decade (*see* fig. 11.51), the child who seems to slip from her lap combines the proportions of a nursing infant (especially in the ratio of head to body) with the physical dimensions of an older child. Clearly, Michelangelo understands his figures to belong to a reality above ordinary experience.

12.8

Michelangelo, *Virgin and Child, c.* 1503–06. Marble, height (incl. base) 48" (1.2 m). Onze Lieve Vrouwekerk, Bruges

12.9
Michelangelo, *The Holy Family* ("Doni Tondo"), *c.* 1506. Wood panel, diameter 47¼" (120 cm). Uffizi Gallery, Florence

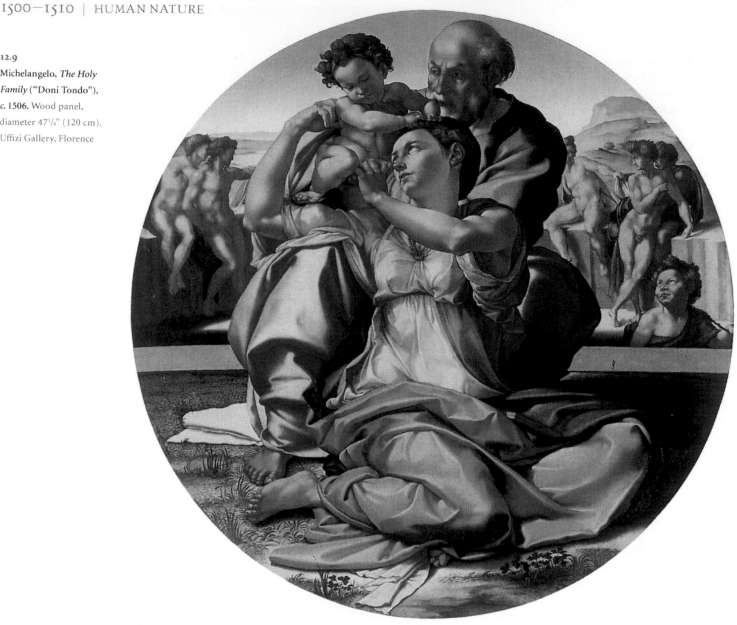

The artist's allusion to his own *Pietà* seems deliberate: the gravity of the mother and child here, combined with the sense that Christ is stepping away from the Virgin, makes the pair into an intensely dramatic anticipation of his future death and of her sorrow. In its solemn character, the work contrasts markedly with the quiet rapture of Leonardo's *Virgin and Child with St. John and St. Anne* (*see* fig. 12.5). The marble may originally have been intended for the monumental tomb of Pope Pius III in Siena, but by 1503 a Flemish cloth merchant had taken over the commission; he transported it to Bruges, where it can still be seen in the church of Notre Dame.

Very different in character is the *tondo* made for the wool merchant Agnolo Doni around 1506, which shows Michelangelo adapting the heroic and powerful bodies that appeared in his sculptures to the world of private devotional painting (fig. 12.9). Even when the format was large (in this case just under four feet in diameter), images of the Holy Family for people's homes usually project quiet, unassertive intimacy. Far from being static and contemplative, however, Michelangelo's figures manifest dynamic energy to an almost athletic degree. The artist had closely studied Leonardo's project for the Annunziata altarpiece (a drawing marked "lenardo" survives in his hand), observing both the harmonious integration of monumental bodies and the psychological interaction of the figures. In his composition, however, Michelangelo has rethought the principles according to which the bodies are combined with each other, and produced a new way of dealing with the *tondo* format.

The powerful figure of Mary, seated upon the ground, turns her shoulders and waist as she receives the child from the lap of St. Joseph, whose imposing body seems to cradle hers. The rotation of her upper and lower limbs in contrary directions establishes a great circular arc and harmonizes with the round form of the

painting. Although the motion is complex, entailing a supreme artistic mastery of foreshortening, the effect is majestic and heroic. Using just the motions of the body, Michelangelo conveys how the Virgin invests her whole being in her historical role as bearer of the incarnate God. By placing her on the ground, Michelangelo recalls the traditional theme of the "Virgin of Humility," characterizing Mary as obedient to historical destiny. In his version, though, the Virgin is far from passive. The grouping of Mary, Joseph, and Christ, in other words, is traditional, but Michelangelo re-stages it as an action and an event, one invested with momentous importance.

What did Michelangelo intend with the array of naked young men who gather on the low ledge in the background, or the child Baptist who, turning his back on them, looks toward the Holy Family? Perhaps Michelangelo, whose art itself depends on the symbolic richness of the human body, wanted to allow for multiple associations, leaving it to the viewer to determine their meaning. The nudes could signify the world of pagan antiquity before the coming of Christ and of Christ's predecessor St. John the Baptist, or they could represent Christian initiates disrobed in order to receive the sacrament of baptism from the young saint. Whatever their iconographic role, they also function as a kind of artistic signature of Michelangelo, who was now celebrated for his mastery of the male nude. We have seen that images of the well-formed adolescent male body were in any case an established part of Florentine visual culture, a phenomenon that no one seems to have felt the need to justify: they could evoke the virtue and vigor of the Republic, or its fertility and prosperity, or the pride the city took in its actual handsome young citizens. So, too, the masculinity of the Virgin here (and of many of Michelangelo's female figures) reflects a common association between *virtue* and the virile body. Galen – the ancient medical writer whose books were central to the teaching of medicine – regarded the female body as an underdeveloped male, formed when an embryo lacked sufficient heat. The androgynous female in Michelangelo's art shows the artist seeking to restore to certain heroic women, like the Virgin, a measure of the perfection that they merited but physically lacked.

Leonardo vs. Michelangelo: Battle Paintings for the Great Council Hall

The idea of the vigorous male body as a symbol of the Republic operates in Michelangelo's next important project for the city of Florence as well, a fresco painting that placed him in open competition with Leonardo. By 1498 construction on the Great Council Hall in the Palazzo dei Priori had proceeded far enough that the

sculptor Baccio d'Agnolo could begin working on a framework for the monumental altarpiece that was to go at one end of the room, as well as on a **loggia** (gallery), inlaid paneling, and balustrades. Filippino Lippi was to paint the altarpiece, and Andrea Sansovino was to make a sculpture of the Resurrected Christ to go opposite this. The walls of the room were to be adorned with battle scenes, again following the example of the council hall in the Doge's Palace in Venice. Among the paintings commissioned for the hall, only the altarpiece would be taken to an advanced stage of completion. After the death of Filippino in 1504 it was given to Fra Bartolomeo, but abandoned incomplete in 1512 (fig. 12.10). The friar had been to Venice, and, drawing from the example of

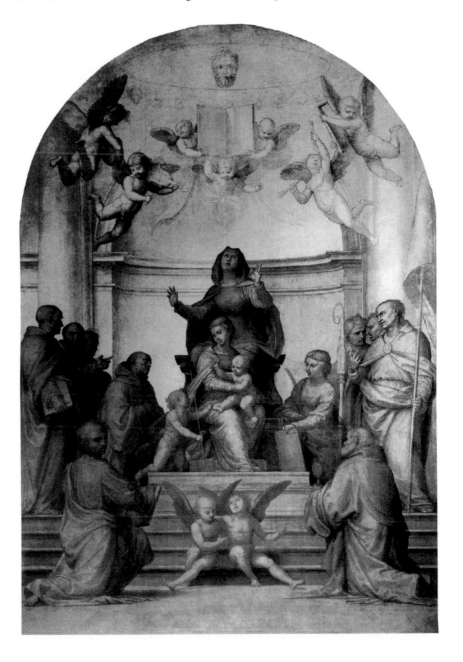

12.10

Fra Bartolomeo, *Virgin and Child with St. Anne*, 1510–13. Oil on panel, 4'6½" x 3'5" (1.4 x 1.04 m). Museo di San Marco, Florence

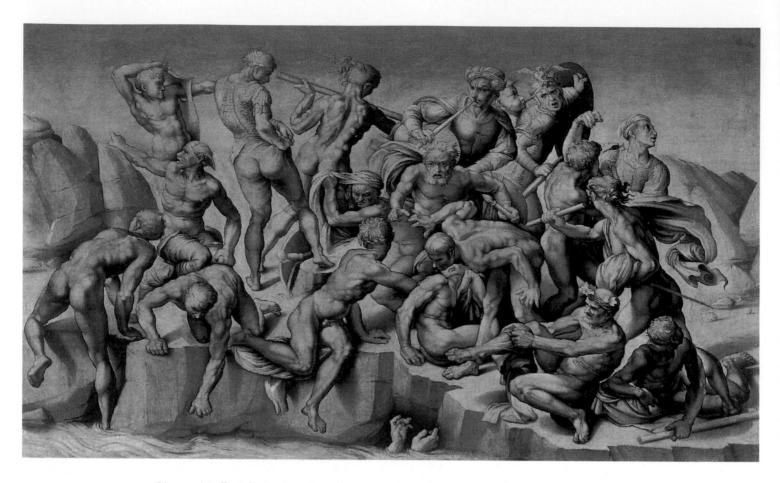

12.11

Aristotile da Sangallo, copy of Michelangelo's *Battle of Cascina, c.* 1542. Oil on panel, 30 x 52" (76 x 132 cm). Leicester Collection, Holkham Hall, Norfolk

Giovanni Bellini, he designed a tall rectangular painting with a vertical composition of figures in a lofty architectural setting, which stands in marked contrast to Leonardo's cartoon (*see* fig. 12.5). St. Anne looks ecstatically toward the Trinity and the Scriptures emanating from heaven, while the infant St. John and other patron saints of the city and its government are arranged below.

In 1503, Leonardo received the commission to paint one of the murals, and by early 1504 the government had decided to have Michelangelo do another. The paintings, conceived on a colossal scale, were to depict two historical battles in which the Florentine Republic had been victorious against its enemies: Leonardo was assigned the *Battle of Anghiari*, in which Florentine forces had defeated Milan in 1440, and Michelangelo the *Battle of Cascina*, an episode from a 1364 war against Pisa. The commission was a way for the Republic to create a patriotic yet also post-Medicean vision of its past, aligning itself with republican imagery from other places. The particular episodes selected by the Florentines reflected a priority of the new Republic, representing the heroic achievement of Florentine citizens acting in a body against the enemies of the state. This was a principle advocated by the chancellor – at that time Machiavelli – who argued pas-

sionately that Florence's own citizens should defend their city as soldiers, obviating the need for notoriously untrustworthy mercenary companies.

In the event, neither work got very far. Leonardo, perhaps as yet unaware of the quickly deteriorating condition of his recently completed *Last Supper* in Milan (*see* fig. 11.47), began to paint with a medium of linseed oil. Unable to get this to dry, he undertook extraordinary experiments, at one point going so far as to light a fire under what he had painted. After completing a small portion on the wall, he abandoned the project and returned to Milan. The mural he left was enclosed in a frame a few years later, and at mid century it still drew tourists, but Vasari then either destroyed or covered over whatever remained when he oversaw the redecorating of the room. Michelangelo's design, for its part, did not progress beyond the cartoon stage before he too left the city. Both projects are now known only from preparatory drawings that the artists made and from sixteenth-century copies after their designs, all of which record only portions of the overall compositions. The copies themselves, however, attest to the enormous influence that both works, though unfinished, ultimately had. The goldsmith Benvenuto Cellini (1500–1571) recalled half a century later that Michelangelo's cartoon had been "the school of the

world," the memorization of which had become an essential part of the education of younger Florentine artists. It appears, in fact, that the cartoon actually disintegrated from excessive handling. Some of the figures Leonardo invented for the wall, for their part, became illustrations in his posthumously assembled *Treatise on Painting*, one of the most widely studied theoretical writings on art of the later Renaissance.

The Florentine head of state who presided in the room had the title of *gonfaloniere* (standard-bearer), and the two battle scenes were related in theme: Leonardo's central event was a group of men on horses trying to retain or take possession of a standard; Michelangelo's seems to have included, in the back center, a man attempting to raise a flagpost. This implies that the two artists received at least some instruction as to what they were expected to feature. At the same time, the two frescoes had the character of competing manifestos, as if each artist had decided to emphasize the principles that most distinguished him from the other. Michelangelo designed a relief-like composition of muscular naked figures, which he spread across and above the surface rather than setting within pictorial depth. The crisp barren landscape provides nothing that would distract from the figures, each studied independently, and a body of drawings in a variety of graphic media provides a better indication than Aristotile da Sangallo's (1481–1551) painted copy of how the original cartoon might actually have looked (figs. 12.11–12.12). As false news of an impending attack interrupts their swimming, Michelangelo's soldiers rush to clothe and arm themselves – though the episode may well have appealed to the artist for just the opposite reason, the opportunity it presented to strip his figures down and show them as nudes and near nudes in a variety of poses. Throughout, he employed the most difficult foreshortenings, and figures thrust themselves into or out of the picture plane: notice the extreme torsion of the neck and waist of the seated figure at center, whose pose works formally to tie both halves of the composition together. It is difficult to imagine how any real person could have held these poses, and this may be part of the point: Michelangelo implies that he did not need live studio models. He worked on his cartoon in the Hospital of San Onofrio, where the prior provided him with cadavers for dissection. Figures like those in the *Battle of Cascina* draw attention to Michelangelo's power to move from a deep knowledge of human anatomy into a process of invention: as he fragments mortal and decaying bodies to understand their structure, he also constructs superior bodies in his imagination and in his art.

The various copies (for example **fig. 12.13**) give us only a partial impression of Leonardo's composition. Here, Florentine cavalry troops battle furiously to protect their flag from the Milanese forces led by the mercenary captain Niccolo Piccinino. The subject may have been assigned to Leonardo in part because of his undisputed expertise in the representation of horses, but the composition also shows his continuing interest in the rendering of extreme psychological states. His faces (fig. 12.14), largely unlike Michelangelo's, reveal inner

12.12

Michelangelo, study for
Battle of Cascina, 1504. 16⅝
x 11¼" (42.1 x 28.7 cm).
British Museum, London

12.14

Leonardo da Vinci, study of a head for the *Battle of Anghiari,* 1503. Red chalk on paper, 9 x 7³/₈" (22.6 x 18.6 cm). Szépművészeti Múzeum, Budapest

character, here bordering on outright savagery. The Florentine tradition of equestrian mercenary portraits – Hawkwood (*see* fig. 5.12), Gattamelata (*see* fig. 7.25), Colleoni (*see* fig. 10.23) – stands behind his characterization of the murderously violent horsemen. Drawings hint

that the setting for the picture would have included an elaborate river landscape: the most extraordinary aspect of the fresco might have been the range of coloristic and atmospheric effects that Leonardo planned. In his notebooks he wrote of a battlefield where the air was thick with smoke and dust, and where the predominant colors in the dusky light were the fiery red of the torches and of human blood pounded into mud. All of this would have been rendered through films of transparent paint that would have unified the figures and integrated them with their landscape. The effect of this emphasis on setting and atmosphere could not be more different from that planned by Michelangelo, whose sculptural figures were to be clearly visible, painted in the bright colors of true *fresco.*

Leonardo adorned both his Florentines and his mercenaries with fantastical armor that imitates the body parts of animals. The analogy between the human and animal condition appears to have particularly engaged him here, where horses fight vigorously alongside the warriors. In his notebooks, however, Leonardo expresses greater sympathy for the innocence of animals and disgust at human beings' barbarous appetite for destroying themselves and other living creatures. In his eyes, human beings were devourers of their fellow men:

[There is a] supreme form of wickedness that hardly exists among the animals, among whom are none

that devour their own species except for lack of reason (for there are insane among them as among human beings though not in such great numbers). Nor does this happen except among the voracious animals as in the lion species and among leopards, panthers, lynxes, cats and creatures like these, which sometimes eat their young. But not only do you eat your children, but you eat father, mother, brothers and friends; and this even not sufficing, you make raids on foreign lands and capture men of other races and then after mutilating them in a shameful manner you fatten them up and cram them down your gullet.

Leonardo's de-idealizing view of human nature corresponds with that of Machiavelli, who was managing Florentine diplomatic relations with Cesare Borgia in these years.

Motions of the Body and Motions of the Mind: *Leda* and *Mona Lisa*

Two other works made by Leonardo in this decade were destined for an extraordinary afterlife. One, *Leda and the Swan*, which was lost or destroyed after the artist's death, is only known through copies (fig. 12.15) and through preliminary drawings (fig. 12.16). The mythological tale of the god Jupiter taking on the form of a swan to seduce a mortal woman, and of the birth of their offspring (who included Helen of Troy and the twins Castor and Pollux) from eggs, probably appealed to Leonardo for its mingling of the animal, the human, and the divine. His image popularized a kind of extreme pose (one that Cosmè Tura had already used for the pagan gods in his *Annunciation* for Ferrara Cathedral; *see* fig. 8.7) that would come to be known as the *figura serpentinata*: this was because the upward-spiraling twist of the figure, who bends her hips while rotating her shoulder, resembles the fluid motion of a serpent. It was left to Michelangelo and Raphael to explore the full potential of such a figure – Michelangelo was already quoting the *Leda* in one of the nudes of the *Doni Tondo* (*see* fig. 12.9).

The other work is the portrait now generally known as *Mona Lisa* (fig. 12.17). The painting has become a byword for the romantic cult of enigma around the persona of Leonardo da Vinci, but the main historical problem with the work is less the figure's "mysterious smile" than her historical identity. The painting was first noted in France in 1517 as "a certain Florentine lady, made from nature at the instigation of the late magnificent Giuliano de' Medici." Vasari, who in 1550 discussed the portrait without ever having seen it, declared her to be the wife of Bartolomeo del Giocondo, a silk merchant involved not with the Medici but with the Republican government

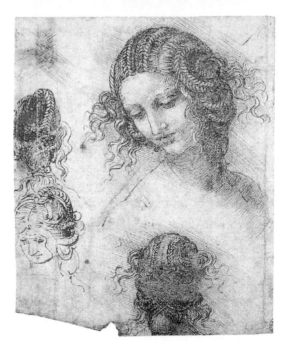

ABOVE

12.15

Cesare da Sesto after Leonardo da Vinci, *Leda*, 1504–09. Oil on panel, 38 x 29" (96.4 x 73.6 cm). Pembroke Collection, Wilton House, Salisbury

LEFT

12.16

Leonardo da Vinci, study for the head of Leda, 1505–10. 6⅛ x 5⅞" (17.7 x 14.7 cm). Royal Library, Windsor

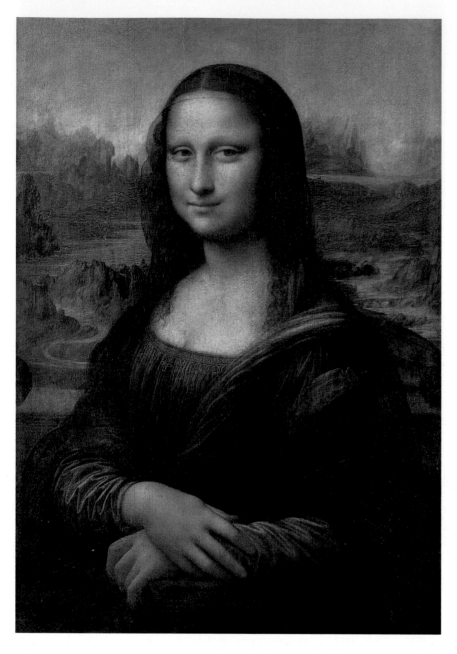

12.17

Leonardo da Vinci, *Mona Lisa*, 1503. Oil on panel, 30³/₈ x 20⅞" (77 x 53 cm). Musée du Louvre, Paris

The question of identity may finally be irrelevant, since instead of delivering the portrait to a client, Leonardo kept it in his possession, displaying it in his studio until the end of his life as a demonstration of his art. If earlier portraits had relied on emblematic imagery – a symbolic juniper bush, for example, or an ermine – to identify and characterize the sitter, here Leonardo added nothing more than a landscape, one that relates more to his notebooks and to the studies he made on his travels than to the historical Lisa Gherardini. The brownish tonality that suffuses the scene was probably not what Leonardo left: over the centuries the picture was re-varnished more than once, and the Louvre promises that it will never be "cleaned." Yet it is clear that Leonardo was aiming to shroud his figure with transparent layers in a way that he had never done in his previous portraits, as if the veil through which we see the top of her forehead and her hair were a double for the films of atmosphere through which we see the distant mountains, or the thin shadows that model her face. Leonardo seems even to extend the idea of semi-transparency to expression itself. If, when preparing his *Last Supper* (*see* fig. 11.46), he was writing of how the painter could reveal the "motions of the mind" through countenance and gesture, here he gives us an unprecedented sense of the interior person, even as it is hard to specify just what is happening in this woman's head. It is as though Leonardo wanted the central experience of seeing the picture to be that of knowing that one is being looked at by another thinking being. How far this is from the unresponsive, idealized profiles that had predominated in Florence just three decades earlier!

Raphael's Beginnings

In 1504, an enterprising young painter from Urbino arrived in Florence. Although only twenty-one years old, Raphael (Raffaello Sanzio; 1483–1520) was already well established as a maker of altarpieces and small devotional pictures. Trained initially by his father, a painter to the Urbino court who had died in 1494, Raphael formed an occasional association with Perugino, an artist much in demand not only in Florence but also in his native Perugia. The *Marriage of the Virgin* (fig. 12.18), which Raphael painted for the Albizzini family chapel in San Francesco in Città di Castello (a city near Urbino) in 1504, shows the apocryphal story according to which a group of suitors to the Virgin brought rods to the temple priest; Joseph's staff flowered, indicating his divine selection. The painting catered to a market that Perugino had established, and with it Raphael aimed to surpass the older painter in the very area in which he excelled. He not only draws on Perugino's rich and glowing color, but also employs

that had kept them in exile. Vasari's identification is now generally accepted, and other sources reveal that Giocondo's wife "Monna Lisa" (i.e. Madonna, or Lady Lisa) was named Lisa Gherardini: she was still alive when Vasari wrote his account. In 1503, the year in which Giocondo and his family moved into a new house in Florence, the twenty-four-year-old Lisa gave birth to their fourth child, a boy: either of these circumstances could have led to the commissioning of a portrait, and by Giocondo himself rather than by Giuliano de' Medici. By mid century there were thus two traditions of identifying the sitter – one Medicean and one anti-Medicean – a division that points to the fundamental dilemma of Florentine identity in the 1500s.

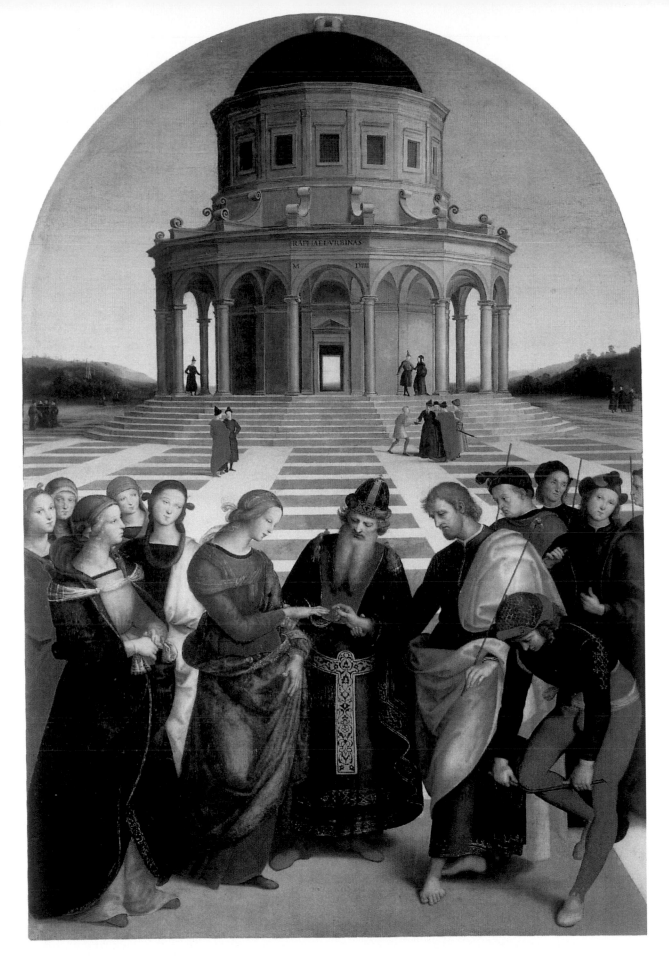

12.18
Raphael, *Marriage of the Virgin*, 1504. Oil on panel, 67 x 46¹/₂" (1.7 x 1.17 m). Pinoteca di Brera, Milan

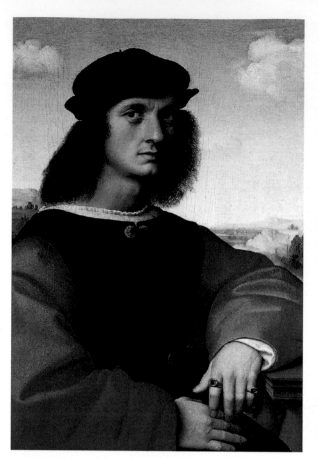
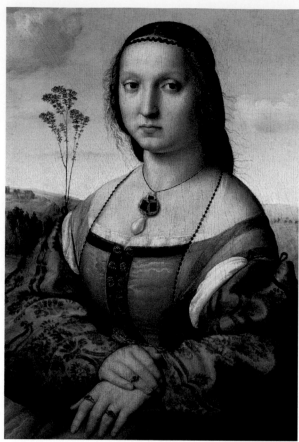

the compositional formula Perugino had first used in his Sistine Chapel *Charge to St. Peter* (*see* fig. 10.35), with its horizontal frieze of figures arranged in front of a vast paved piazza, in the midst of which rises a centralized temple with a dome. It would be easy to mistake some of Raphael's figures for Perugino's, and Raphael followed the older artist in his habit of repeating elements within a single picture: note the resemblance between the face and placid expression of the man in a black robe looking out at the viewer's right and that of the woman behind the Virgin to the left. But whereas in Perugino's group of figures there is little to disturb the sense of symmetry, Raphael has introduced an element of carefully planned disarray. Readers of Alberti's *On Painting*, who certainly included Raphael, would have recognized the young artist's concern with *varietà* (variety), which Alberti had considered essential to good painting. The priest's head is slightly off the central axis; one of the rejected male suitors to the right departs from the static assembly to balance on one leg and break a staff over his raised knee.

It was probably through Perugino that Raphael became acquainted with the leading artists of Florence, Leonardo among them, as well as with a group of wealthy clients that included Agnolo Doni, the same wool merchant who ordered the *tondo* from Michelangelo (*see* fig. 12.9). The marriage portraits that Raphael painted for Agnolo and his wife Maddalena around 1506 (figs. 12.19–12.20) show the earliest impact of the *Mona Lisa* (*see* fig.

12.17) on traditional portraiture. Raphael paid particular attention to the role of the hands in Leonardo's painting, exploring the possibility of using hands not just to create formal variety but to enrich the sense of interaction with the beholder. While Agnolo regards us calmly, his hands seem to fidget restlessly, imparting a slight sense of unease; this again invites speculation about the thoughts betrayed by the face, with its furrowed brow. Maddalena rests one hand on top of the other, self-consciously and even self-protectively. Where Raphael departed from Leonardo's example, perhaps at the patron's request, was in his simultaneous use of the hands to display the wealth and status of the family, in the form of their jeweled rings. The need to render precious objects like this, or like the enormous, eye-catching pearl that hangs around Maddalena's neck, is one reason why Raphael resisted Leonardo's *chiaroscuro* and his *sfumatura*, which would have excessively subdued the color needed to convey the preciousness of what Raphael was depicting. Far more than the *Mona Lisa*, the portrait of Maddalena conveys social meanings. This extended to the sitter's beauty, a valued attribute of young women of Maddalena's class. To make Maddalena appear more comely, Raphael relied on a process of abstraction: the contours of the shoulders and breast assume a highly artificial oval appearance, and so does the head onto which her large features are somewhat uncomfortably imposed.

Raphael quickly learned to absorb all that was new and most valued in recent Florentine art. His study of

Leonardo is evident not just in the Maddalena Doni portrait, but also in a drawing he made after Leonardo's *Leda*. The paintings most characteristic of Raphael's Florentine years were a series of private devotional images of the Virgin and Child, several also including the infant St. John, in which he responded to Leonardo's *Virgin and Child with St. John and St. Anne* (*see* fig. 12.5). In 1505–06, Raphael painted the so-called *Madonna of the Meadow* (fig. 12.22) for Taddeo Taddei, a merchant of refined literary and artistic tastes with connections at the court of Urbino. Here Raphael modeled the Virgin on her counterpart in Leonardo's cartoon, adapting especially his treatment of the head and expression; although the downcast eyes of Raphael's figure establish a more wistful mood, as if she realized that Christ's gesture, grasping the prophet John's cruciform staff, hinted at her child's impending death. The three figures interlock to form a unity that could be circumscribed by a pyramid, in accordance with the two artists' common interest in uncovering the underlying geometric logic in nature. Raphael, though, has again taken this even further than Leonardo, abstracting the Virgin's shoulders and breasts into a spheroid form, and extending the figure's right leg across the front of her body. Anatomical distortion does not impair a sense of harmony, of things fitting together; nor do abstraction and idealization undermine the emotional tenor of the work, which, with its caressing hands and soft infant flesh, solicits sentiments of tenderness from the beholder.

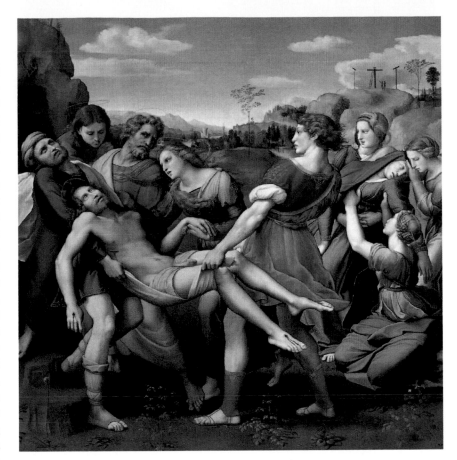

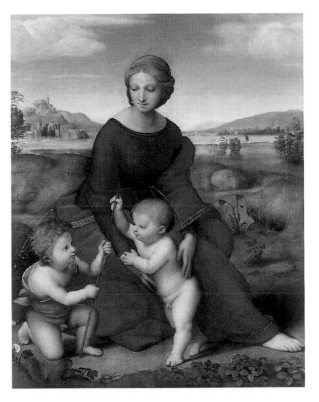

Activating the Altarpiece: The Perugia *Entombment of Christ*

While working in Florence, Raphael received only one altarpiece commission from a local client, and he never completed it. He did continue, nevertheless, to supply such works for other centers outside Florence, including Siena, Urbino, and Perugia, and it was for this last city in 1507 that he executed the first altarpiece to draw on the new art he was seeing, an *Entombment of Christ* (fig. 12.21) that he made for a chapel of the Baglioni family in the church of San Francesco al Prato in Perugia. The patron, Atalanta Baglioni, commissioned the painting in atonement for violent feuding among the male members of her family, mainly instigated by her own son, who had himself been killed after he had murdered various relatives. The patron's experience would have lent special meaning to the subject of the Virgin's farewell to the dead Christ. The commission elevated Atalanta's personal history, the events that shaped her identity, to a level of universal significance, articulating them through one of the great narratives of the Gospels. Recognizing this, Raphael made the unprecedented decision to treat the altarpiece as an *istoria*, a scene of figures performing an action, rather than as a static, iconic subject.

Early designs for the altarpiece show a Lamentation group very close to treatments of the subject by Perugino, with the figure of the dead Christ laid out on the ground

12.21
Raphael, *Entombment of Christ*, 1507. 6' x 5'9" (1.84 x 1.76 m). Pinacoteca, Vatican

LEFT
12.22
Raphael, *Madonna of the Meadow*, 1505–06. Oil on panel, 44½ x 34¼" (113 x 87 cm). Kunsthistorisches Museum, Vienna

341

and surrounded by quietly sorrowing figures. The compositional idea changed, however, when Raphael began thinking more carefully about Mantegna's great engraving of the *Entombment* (*see* fig. 10.7). Raphael's father Giovanni Santi had been an admirer of Mantegna, and he would certainly have trained his son to study the Paduan artist's prints. The death of Mantegna the previous year, furthermore, may have led Raphael to conceive the work as something of a homage. The reference to the print is unmistakable: fellow artists and even non-artists would have spotted it. They would have noted in particular how Raphael transformed Mantegna's design, making it his own. Mantegna provided the idea of the composition in two episodes: the Virgin faints and her attendants support her; two bearers, accompanied by the sorrowing Magdalene, take the body of Christ to the sepulcher. Off in the left background, the cross from which the body came is visible on a hill. Raphael does not repeat a single figure from Mantegna; the closest is the man bearing Christ's upper body. Instead, he introduces a series of adaptations of figures from works by Michelangelo: the dead Christ is close to the Christ in the St. Peter's *Pietà* (*see* fig. 11.51), the woman who turns to support the Virgin is a variation on the turning Virgin in the *Doni Tondo* (*see* fig. 12.9), and the young man in profile recalls drawings made by Raphael after Michelangelo's *David* (*see* fig. 12.3), where he modified the proportions of the head and the hands and altered the pose so as to give

more flowing elegance to the line. The one thing that remains from Perugino's treatment is the color; just as Raphael had earlier avoided Leonardo's desaturated *chiaroscuro*, so here does he avoid the shrill, metallic hues of the *Doni Tondo*, with their white highlights and dark shadows.

That he took a narrative print as the basis for an altarpiece suggests Raphael had absorbed the compositional procedure that Alberti had laid out in *On Painting*. This text was not yet easily accessible to all, since it circulated in these years only in manuscript, but Raphael's practice leaves little doubt that he knew it well. Alberti had demanded that artists pay particular attention to the convincing representation of the dead, citing the very Meleager relief that Mantegna had probably used as a model for his own print. He had also written that the ideal number of figures in an *istoria* was ten, exactly the number Raphael includes. Finally, Alberti had advocated the method of composing bodies that we saw to be of particular interest to Luca Signorelli (*see* figs. 11.25–11.30), one that would have acquired a new resonance at a time when Leonardo and Michelangelo were known to practice human dissection, first sketching in the bones, then adding the sinews and muscles, flesh and skin. In conceiving the figure of the fainting Virgin, Raphael did precisely this, using a skeleton for his first studies (fig. 12.23).

Rome: A New Architectural Language

The temple in the background of Raphael's *Marriage of the Virgin* (*see* fig. 12.18) points to the artist's close connection with another expatriate (perhaps even a relative) from Urbino, the painter-architect Donato Bramante (1444–1514). Raphael may have known something of Bramante's dialogue with Leonardo at the court of Milan, but he would have been even more aware of the new architectural language Bramante developed after his move to Rome in 1499.

At first, Bramante supported himself there by working for Pope Alexander VI, though few of the things he produced in these years survive intact. In 1502, however, through agents of King Ferdinand and Queen Isabella of Spain, he gained an opportunity to translate his Milanese experiments with centralized architecture to a remarkable new purpose. His "Tempietto," or "little temple," is a miniature church, really a free-standing chapel, designed to mark the alleged site of St. Peter's crucifixion in the monastery complex of San Pietro in Montorio (fig. 12.24). The building combined the most basic geometric elements (two cylinders with a hemisphere) in the simplest proportions (the ratio of the cylinders is 1:2) to make a work that is monumentally self-sufficient despite its small

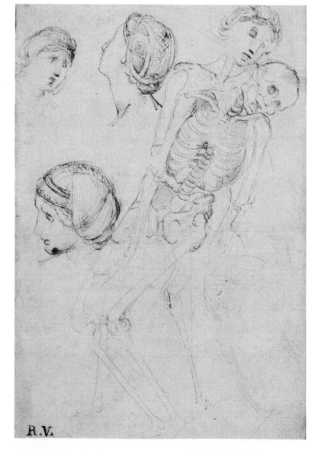

12.23
Raphael, study for *The Entombment, c.* 1507. Ink on paper, 8¼ x 12⅝" (20.9 x 32 cm). British Museum, London

scale. The Tempietto draws on ancient building types – there were several small Roman temples where a **peristyle** or ring of columns surrounded a cylindrical chamber – but the two-storey design is Bramante's invention and shows his modernity, his adaptation and translation of antiquity. The more pronounced verticality that results gives the building a heavenward orientation, providing a symbolic axis that links the site of the saint's death – the chapel preserved the hole in which Peter's cross was set – with the place of his immortal existence. As originally designed, the building was supposed to occupy the center of a round courtyard framed by another ring of columns: this indicates that Bramante, like Leonardo, had studied the remains of Hadrian's Villa at Tivoli near Rome, where the so-called Marine Theater also consists of a round structure encircled by an outer peristyle. Combined with the three shallow steps, Bramante's completed design would have conveyed the impression of a building extending its supremely refined form outward in space. Particularly influential was his exemplary use of one of the Roman orders: in this case, the Doric. Bramante was motivated by a concern to express the nature of the saint: writers on architecture regarded the Doric order as having masculine characteristics – robust proportions, relative plainness of ornament. Like Leonardo, Bramante would have held the conviction that the forms of ancient architecture in their geometric purity bore a fundamental relation to the perfectly proportioned human body.

The entablature, carefully scaled to the columns, signals once more the extent to which the Tempietto set out to be a model of Christianized antiquity: the **triglyphs** (the beveled, grooved sections of the frieze) align with the columns, as they should according to Vitruvian rules, but the **metopes** (the square panels between these) are adorned with images of liturgical objects.

The New St. Peter's

The Tempietto was scarcely begun in 1503, the year in which Cardinal Giuliano della Rovere, the nephew of Sixtus IV, became Pope, calling himself Julius II. The name, which everyone recognized as having more to do with Julius Caesar than with an early Pope named Julius, reveals political ambitions on an imperial scale. Giuliano's papal commissions recognized no difference between the public and private: ostentatious works dedicated to the glory of the papacy and the Church were also monuments of self-celebration, with no expense spared. Even large-scale, public projects for the city would bear his personal stamp: an example is the new street that was laid out to link the Ponte Sisto with the Ponte Sant'Angelo, named the Via Giulia after the Pope himself.

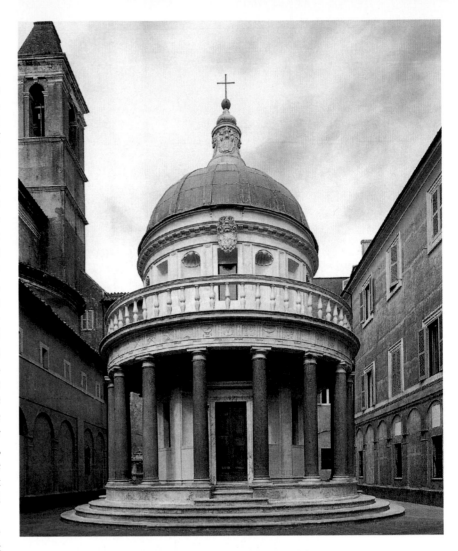

12.24
Donato Bramante,
"Tempietto," cloister of San
Pietro in Montorio, Rome,
begun 1502

The two most celebrated works of the pontificate of Julius II in many ways owe their existence to a third project that was never completed as he planned. Just as Julius, in the days when he was still a cardinal, had overseen the commissioning of Antonio del Pollaiuolo's bronze memorial for Sixtus IV (*see* fig. 10.25), so now in March 1505, scarcely two years after becoming Pope, he enlisted Michelangelo to design for him an even grander marble tomb.

According to Michelangelo's early biographers, the tomb was originally conceived as a gargantuan, multistorey, free-standing structure, with more than forty larger than lifesize marble statues. It was to be installed, like the tombs of Sixtus and most other popes, in St. Peter's basilica. But the scale of Michelangelo's plan soon led to doubts that the great basilica would be adequate to contain it while still allowing for its other ceremonial and religious functions. At first, Julius considered an extension of the building along the lines proposed the previous century by popes Nicholas V and Paul II, but by the summer of 1505 he had begun to contemplate a more drastic alternative: the complete demolition and rebuilding of the church. Old St. Peter's, which had been built in

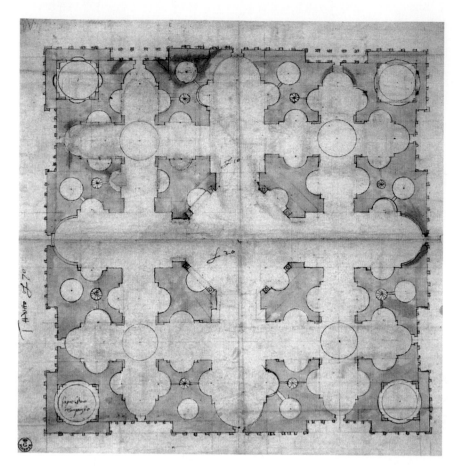

the fourth century over a venerated cemetery, was a focal point of European pilgrimage; most of the Christian world regarded its very fabric as sacred. Members of the Curia (papal court) were appalled at the Pope's idea, but Julius dismissed their protests with the insistence that the ancient building was in a serious state of disrepair. A line of defense taken up by the Pope's secretary, the humanist Sigismondo de' Conti, is particularly significant, and shows that the new sense of history entailed no uncritical reverence for the past. Conti argued that the old building, however grand and majestic, was aesthetically unworthy, having been built in an age that "had no idea of beauty and refinement in architecture." He regarded the present in which Julius and his court lived, in other words, as a time of renewal and of progress, a moment that reversed a long period of decline dating back to late antiquity.

LEFT

12.25

Giuliano da Sangallo, proposed plan for New St. Peter's, 1505. Ink and wash on paper, 16¹/₈ x 15⁵/₈" (41 x 39.7 cm). Gabinetto Disegni e Stampe, Uffizi Gallery, Florence

RIGHT

12.26

Donato Bramante, project drawings for New St. Peter's, 1505. 16¹/₈ x 15⁵/₈" (41 x 39.7 cm). Gabinetto Disegni e Stampe, Uffizi Gallery, Florence. The drawing on the other side of the page (fig. 12.25) is visible through the paper, and Bramante seems to have used that as a starting point for the chalk sketches here.

FAR RIGHT

12.27

Donato Bramante, "Parchment Plan" for New St. Peter's, 1505. Gabinetto Disegni e Stampe, Uffizi Gallery, Florence

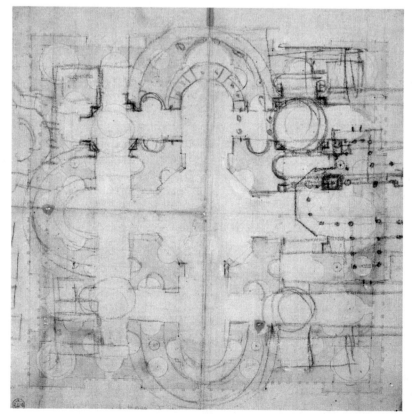

A few years later, a letter addressed to the Pope and bearing Raphael's name would make the same argument about art's decay in antiquity still more forcefully, and Vasari, around mid century, would give the idea of art's revival in modern times – a version of the myth of the "Renaissance" – its most influential form.

The most radical early suggestion for the new basilica seems to have come from Giuliano da Sangallo (c. 1443–1516), an architect who had been in Julius's service for more than a decade. (Sangallo, who had supervised the movement and installation of Michelangelo's *David*, came from a family of Florentine artists that would include his nephew, the painter Aristotile; *see* fig. 12.11). A drawing preserved in the Uffizi appears to show Sangallo reacting to the kinds of centrally planned designs that had appeared in paintings like Perugino's and Raphael's and that Bramante, with his *Tempietto*, had been the first to realize in three dimensions (fig. 12.25). It proposes a perfectly square new church, conceived as a series of interlocking Greek crosses with towers in the four corners. The large piers indicate that the roof Sangallo envisioned would have been much heavier than the wooden trusses that the columns and walls in the original church supported – presumably a group of masonry domes, connected by barrel vaults. Most remarkable is that the north and south halves of the design are not only mirror images of one another, but also identical with the east and west halves: the drawing's multiple inscriptions add to the impression that it has no "correct" orientation.

Somehow the drawing fell into Bramante's hands, and his reaction to it was as surprising as it was forceful. Turning the sheet over, he traced Sangallo's proposal in a rough sketch. He then proceeded to transform the drawing in ways that provided both a critique and a new suggestion of his own (fig. 12.26). Where Sangallo had largely flat walls on all four exteriors, Bramante punched through these, creating what would have looked more like a traditional apse on the west end of the building and two siblings to this on the north and south sides. At the east end (the right side of the illustration), he rejected Sangallo's enclosure altogether, and extended three of his predecessor's Greek-cross forms to the edge of the sheet, essentially transforming them into a more traditional nave and side aisles. Remarkably, the architect whose name would in 1505 have been virtually synonymous with the centrally planned Christian building in Rome seems to have taken a stand against it when it came to St. Peter's.

Bramante pursued further experiments: in one of these, the so-called "graph-paper plan," he juxtaposed the plans of Old St. Peter's, the Nicholas V extension, and his own Sangallo adaptation, in an apparent attempt to reconcile features of the old basilica with the new design

BELOW LEFT
12.28
Donato Bramante,
"Graph-paper plan" for
New St. Peter's, 1505. Ink
on paper, 27 x 18½" (68.4 x
47 cm). Gabinetto Disegni
e Stampe, Uffizi Gallery,
Florence

BELOW RIGHT
12.29
Caradosso, portrait
medal of Julius II: reverse,
showing project for New
St. Peter's, 1506. Diameter
2¼" (5.6 cm). Civiche
Raccolte Archeologiche e
Numismatiche, Milan

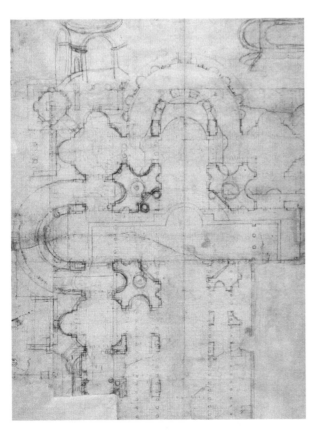

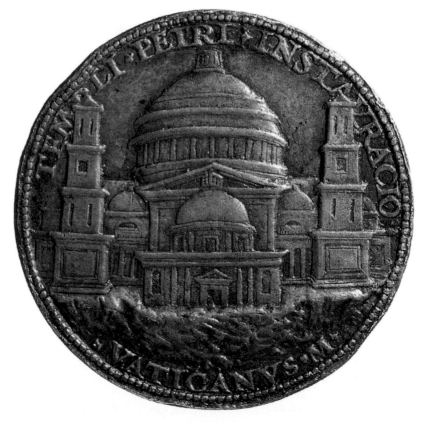

(fig. 12.28). Finally, in a drawing now known as Uffizi 1, he arrived at a simpler, more consolidated, and generally bolder idea (fig. 12.27); that he rendered this final idea with particular care on expensive parchment suggests that this was for presentation directly to the Pope. Flanking a great choir are two spaces in the form of Greek crosses – Bramante has now reconciled himself at least with these motifs, even if he minimized the masonry to provide for airier spaces. For one standing inside, the walls would barely have resembled walls at all, as they broke into a series of stepped indentations, recessed into niches, or opened into other areas. The massing indicates that they would have supported domes, much like those shown on Caradosso's foundation medal from the same year (fig. 12.29), and there is enough at the bottom of the drawing to hint that the central feature of the basilica would have been a much larger dome rising over the crossing. What Bramante does not tell us with this drawing – or rather, what he did not tell the Pope – was whether the building, when completed to the east, would be a mirror image of the portion represented in the plan, or whether the result would have a nave and look like a more traditional basilica. Perhaps he was hedging his bets here. Or perhaps he realized that this did not need to be decided in order for work to proceed. Demolition could start at the apse of Old St. Peter's, builders could begin construction on the choir, and Bramante could let his followers worry about what to do next.

Another reason why Bramante may have concentrated his proposal on the choir is because this is where Michelangelo's new tomb of Julius II was to go, on axis with the tomb of St. Peter himself to the east. Michelangelo, preparing for this project, spent much of 1505 in Carrara, supervising the quarrying of marble for the sepulcher. This was itself a hugely costly enterprise, since the marble had to be transported by river and by roads, some of which had to be newly built. One entire shipload of material was lost in the Tiber. Then, on returning to Rome in 1506, the sculptor learned that the tomb project had been cancelled. This probably resulted from the need to divert funds to Julius's wars, but Michelangelo, believing that Bramante had conspired against him, went back to Florence in disgust. Alarmed at the consequences of angering the Pope, the Florentine government sent him to plead for forgiveness at Bologna, which Julius II had conquered in 1506. The artist traveled north, was reconciled with the Pope, and then executed a colossal bronze portrait of Julius to commemorate his triumph over the subjected city – a work that the Bolognese would destroy when they regained their independence. Back in Rome in late 1508, Michelangelo found no revival of interest in the tomb he had started. Instead, the Pope had decided to encumber him with a

project for which the artist professed no enthusiasm: the redecoration of the vault of the chapel built in the 1480s by Julius's uncle, Pope Sixtus IV.

The Sistine Ceiling

The Sistine Chapel, no less than St. Peter's, was an already completed work when Pope Julius II turned his attention to it (*see* figs. 10.30–10.36). In addition to the murals on the walls, it had been furnished with a vault decorated to signify the cosmos above, with gold stars on a blue ground. In 1504, a large crack had appeared in the vault, providing an occasion for repainting and – in the eyes of Julius – an opportunity for modernization. Julius at first wanted a scheme with twelve Apostles, and one of Michelangelo's first drawings for the project showed a seated figure in a spandrel between two of the vaults, with smaller, geometrically regular fields above for less significant images. Early sources also indicate that the ceiling was to feature panels of grotesques, but Michelangelo, reconciling himself to several years of work on the fresco, persuaded the Pope to allow him to try something more ambitious. The result was the astonishing composition that Michelangelo finally completed in 1512. As Vasari later put it, the painter "used no rule

RIGHT

12.30

Michelangelo, sonnet with caricature, 1509–10. 11⅛ x 7⅛" (28.3 x 20 cm). Biblioteca Medicea Laurenziana, San Lorenzo, Florence

OPPOSITE

12.31

Sistine Ceiling, general view with vault frescoes by Michelangelo, 1508–12. Vatican

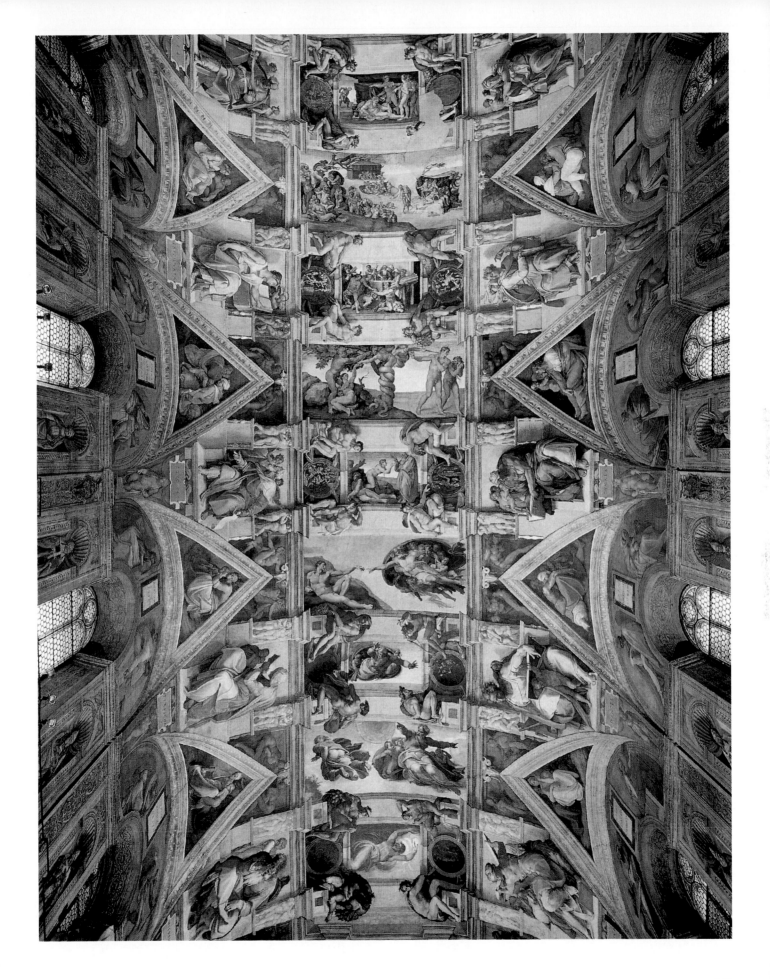

of perspectives in foreshortening, nor is there any fixed point of view, but he accommodated the compartments to the figures rather than the figures to the compartments." In other words, Michelangelo abandoned the conception of the picture as something figures occupy, and instead made the figure the primary structural unit, such that the bodies in Michelangelo's ceiling seem at once to be in as well as on the partly fictive, partly real architecture. The frequent shifts in orientation, level of illusion, and scale – including, for example, nudes that appear at once to sit gravely on pedestals and to defy the gravity of the vault over our heads, and that hold medallions bigger than the fictive marble figures below them – are dizzying. To see everything that is happening, the viewer has to turn constantly, even as he proceeds down the nave.

In painting the ceiling, Michelangelo could not have seen anything like what the viewer sees looking up at it from the floor below: he had to remain elevated on an elaborately constructed scaffolding, bending over backward and painting figures that were often much, much larger than his own body, but which he could only see face-to-face. He wrote about the hardships in a poem, describing how, with his beard pointed up to heaven, his body became uncomfortably distorted and paint dripped down on his face. In this condition, he went on, he could not properly judge what he was doing: "the thoughts that arise in my mind are false and strange, for one shoots badly through a crooked barrel." Besides, he wrote, he was not even really a painter. In the margin of the poem, Michelangelo drew an image of himself in a tortured pose, slashing a monstrous creature onto the ceiling above him (fig. 12.30). The gesture the painter makes there evokes that of the God who creates the world in Michelangelo's Genesis scenes; what this twisted artist renders, however, bears little resemblance to the beauties Michelangelo in fact produced. This owes much to his extensive use of cartoons, full-scale drawings that let him work out each of his figures on paper, then transfer them to the plaster surface. These show, among other things, that Michelangelo conceived even his draped figures initially as nudes, and that he studied male bodies to render female ones – two reasons why all of the bodies he included seem so powerful.

This is not to say that the paintings in the Pope's chapel were just about their painter. In the Sistine frescoes, Michelangelo aimed to demonstrate art's capacity to represent and even reveal Christian principles. This was

12.32
Michelangelo, Sistine Ceiling, detail: *The Creation of Adam.* Fresco. Sistine Chapel, Vatican

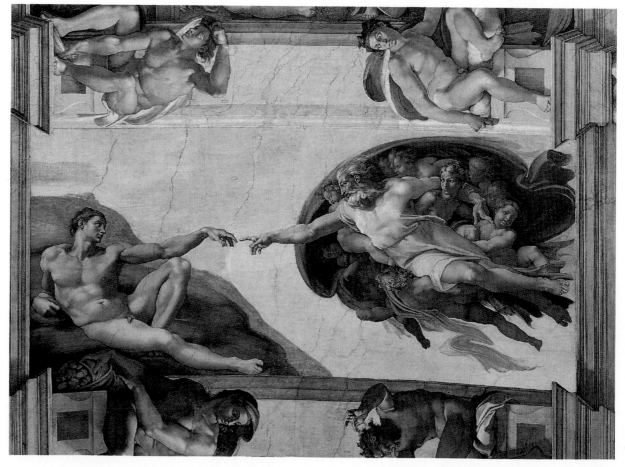

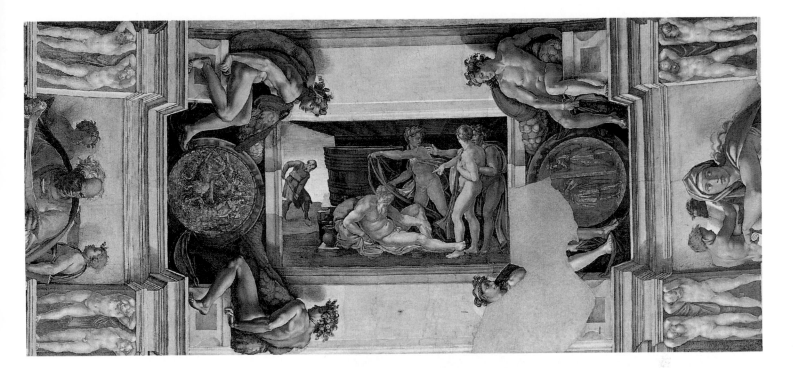

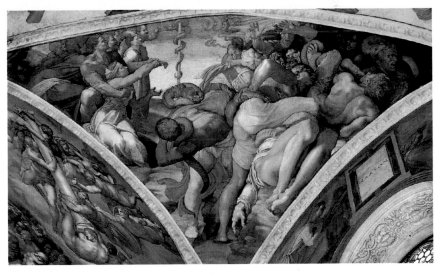

possible because of a rare confluence of interests between the artistic and theological cultures of the papal court, especially concerning human nature and the human body. The preachers in the Sistine Chapel delivered sermons in elegant Latin modeled on the Roman orator Cicero, extolling the dignity of man as the image of God and the glorification of human flesh in Christ's incarnation. This was a significant departure from a long-established tradition, one that went back to the early Christian "Church Fathers," vilifying the body as a prison of the soul. St. Augustine (354–430 CE), in particular, had taught that the body, designed by God as the soul's instrument, became mortal, imperfect, and irrational through the sin of Adam and Eve, which led the soul to sin and damnation. Christian humanists around 1500, by contrast, began to see the body's beauty as a mirror to the soul's perfection. One or more of these learned men from the papal court would have advised Michelangelo on what scenes and figures to include, and how to interpret them, although the artist, a reader of Dante's poetry, probably had a good layman's grasp of scriptural interpretation.

Like the scenes from the 1480s on the walls below, Michelangelo's images all come from the Bible, but rather than simply illustrating episodes from Genesis, Kings, and Maccabees, the ceiling frescoes reconcile Jewish Scriptures with Christian teaching. On the ceiling's central axis, a series of nine narrative scenes shows events from the Book of Genesis (fig. 12.31). These begin over the altar with God separating light from darkness, creating the sun and moon, and separating sea and sky. They continue with a triad of scenes treating the creation of Adam

(fig. 12.32) and Eve, their temptation and disobedience, and their exile from Paradise, and conclude with three episodes representing the tragic and violent course of history after the Fall of Man. Though the Jews worship God with animal sacrifice, an angered Lord nonetheless sends the deluge that destroys all of humanity except the pious Noah and his family, who protect other living species in the ark. The final scene shows the Drunkenness of Noah, mocked by one of his sons, who will in turn be punished for his transgression (fig. 12.33). In the four corners of the ceiling, Michelangelo depicted episodes from the history of the Jewish people, all of them dealing with themes of violence and retribution. In *The Brazen Serpent*, God punishes his people by sending a plague of serpents

TOP
12.33
Michelangelo, Sistine Ceiling, detail: *The Drunkenness of Noah*

ABOVE
12.34
Michelangelo, Sistine Ceiling, detail: *The Brazen Serpent*

12.35
Michelangelo, Sistine
Ceiling, detail: *The
Crucifixion of Haman*

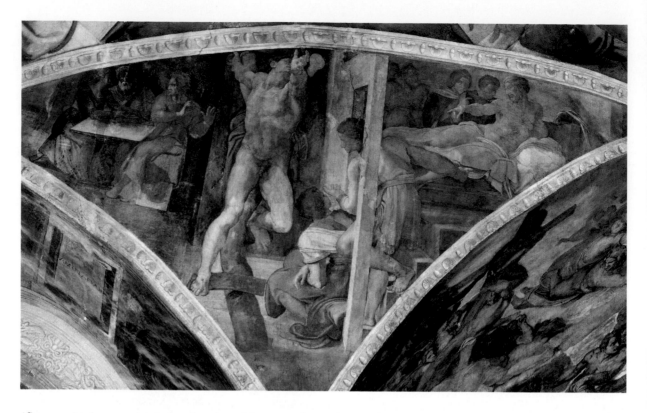

(fig. 12.34); they are healed only when Moses, commanded by God, raises a bronze effigy of a snake upon a staff. Two well-known Biblical heroes, David and Judith, appear here as instruments of justice over the enemies of the chosen people. Finally, Esther, the Jewish wife of King Xerxes of Persia, intervenes to secure the punishment by crucifixion of Haman, who had conspired to have the Jews of Persia exterminated (fig. 12.35).

As with the earlier Moses and Christ cycles below, the coherence of which depend on the Christian reading of the Old Testament as a collection of "typological" predictions related to the coming of the Virgin, Christ, and the Church, so here do the frescoes refer forward in

12.36
Michelangelo, Sistine
Ceiling, detail: *Ancestor
Group (Ozias, Ioatham,
Achaz)*

time: each is a type, at once the likeness and the antithesis of the "antitype" that would come after it. All four corner pendentives are antitypes of Christ and the Virgin: Haman, crucified for the good of the chosen people, is the precursor of Christ's Crucifixion, which offers redemption to everyone; so too is the brazen serpent. The same relationship explains the prominence of Michelangelo's Tree of Knowledge, the instrument of man's damnation; it, too, prefigures the Crucifixion, the instrument of his salvation. The newly created and sinless Adam (*see* fig. 12.32) is echoed in Noah, the figure of fallen mankind (*see* fig. 12.33). The fact that Noah's ark looks like a modern building – indeed, like the Sistine Chapel itself – implies that the salvation Michelangelo represented was like that which the Christian would find when entering a space like this one.

The need to link the time of the Old Testament with the time of Christ (and after him, the popes) explains the eventual decision not to include Apostles in the spandrels and instead to show characters who would more clearly announce a great historical transition. In the lunettes above the windows, Michelangelo painted the passing generations before the coming of Christ; in the eight pendentives above the lunettes, the ancestors of Jesus Christ (fig. 12.36 and 12.37). Michelangelo's depictions of family groups here are a tour de force: it is as though he has realized that Leonardo and Raphael had both regarded variations upon the Holy Family theme as a kind of test of their inventive powers, and showed

that he could outdo them with a sequence that avoids any repetition. Still, when compared to the Holy Family group of Michelangelo's own *Doni Tondo* (*see* fig. 12.9), the pendentive figures have a brooding and melancholy character, devoid of the flow of energy that linked his Holy Family both emotionally and formally. The theme of listless waiting, of unconsciousness to historical destiny, of preoccupation in mundane tasks or in outright personal folly, is manifest even more in the family pairings of the lunettes, where couples are so absorbed in themselves that they seem oblivious to each other. Such, the ceiling implies, is the condition of the Jewish people as they wait for the Messiah.

In sharp contrast with the melancholy ancestors of Christ are the impressive enthroned men and women, who effectively dominate the entire design from illusionistic niches that seem to protrude into the space of the chapel. These are seven of the male Hebrew prophets, representing the books of the Bible that bore their names, and five of the female prophets, known as Sibyls, from the world of pagan antiquity. The prophecies of the sibyls, forged in late antiquity and passed down through early Christian writers, had provided the theological basis for Christian readings of the Old Testament as anticipations of events fulfilled in the Church's own time. Traditionally, Christian art showed the prophets and sibyls with scrolls bearing extracts from their writings. Michelangelo, remarkably, has almost entirely eliminated the written word from his portrayals, as if the poses and gestures of the figures were sufficiently eloquent to convey the import of their prophecies. These figures, much like the prophets that Nanni di Banco (*see* fig. 2.23) and Donatello had made for Florence Cathedral a century before, channel the word of God, which now manifests itself as an animating energy or spirit. While Zechariah, the furthest from the altar, merely mulls over his book, *spiritelli* rouse Joel and Isaiah, together with the Delphic and Erythraean sibyls, to a state of ecstatic inspiration. Spirits also take the form of breath – this is particularly evident in the figure of the Delphic sibyl (fig. 12.38), whose blond hair flutters in the air as she opens her mouth to speak. A passage in Joel's own prophecy seems to provide the foundational text for Michelangelo's

OPPOSITE, TOP LEFT
12.40
Michelangelo, Sistine
Ceiling, detail: *Libyan Sibyl*

OPPOSITE, TOP RIGHT
12.41
Michelangelo, study for
Libyan Sibyl, c. 1511.
Red chalk on paper, 11⅜
x 8½" (28.9 x 21.4 cm).
Metropolitan Museum of
Art, New York

interpretation of these figures (Joel 2:28–29): "And it shall come to pass after this, that I will pour out my spirit upon all flesh: and your sons and your daughters shall prophesy: your old men shall dream dreams, and your young men shall see visions. Moreover upon my servants and handmaids in those days I will pour forth my spirit."

The poses of these visionary men and women become more elaborate as they get closer to the altar wall. The colors also become less natural, more brilliant, more self-consciously artificial and ornamental. Instead of modeling forms by changing the tone of a given hue, Michelangelo now produces a sense of light and shade by juxtaposing contrasting colors: a green turns red in the shadows, a red becomes orange in the highlights. The poses, too, suggest the transcendence of nature and the physical limitations of the wall surface: the body of Jonah (fig. 12.39), the most technically difficult of the figures, recedes in space as the vault curves outward. He himself looks up ecstatically at the image of God separating Light and Darkness on the vault above. The Libyan sibyl (figs. 12.40–12.42) is a variant of the *Doni* Madonna (*see* fig. 12.9): she exerts herself with her massive book, her body a counterpoint of turning shoulders, hips, and knees. The pose is quite impossible,

but then this figure is more than human, and the energy that transfigures her came to be identified as a property of Michelangelo's own art. When Vasari wrote that these figures "appear truly divine to whoever studies their attitudes and expressions," he was referring to a quality of superhuman inspiration available not only to the prophets but also to the painter himself. Within a few years after his completion of the ceiling, the artist would commonly be referred to as the "divine Michelangelo."

All the imagery in the ceiling is organized around the principles of divine energy or inspiration on one hand and inertia or unconsciousness on the other; Michelangelo generates meaning from different conditions of the heroic male body. The vigorous spiraling movement of God at one end of the series of narratives contrasts with the figure of Noah at the other, who has collapsed into a drunken slumber. In the almost central scene of the Creation of Adam (*see* fig. 12.32), the figure of the first man, "made in God's image," provides a more youthful variant of Noah – Michelangelo has given them similar poses and asks us to compare them. Instead of slipping, like Noah, toward sleep, Adam raises himself to consciousness, receiving an animating energy from God's

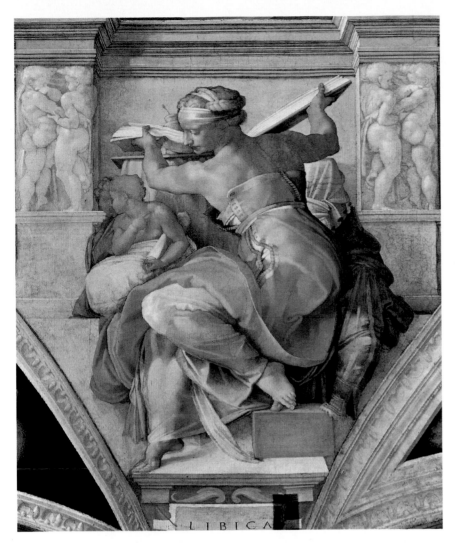

12.43

Michelangelo, Sistine Ceiling, detail: Nude male figures above *Cumaean Sibyl*

12.42

Restorers at work on the *Libyan Sibyl*. The photo illustrates the scale and challenging angles at which Michelangelo worked.

12.44
Roman or Hellenistic,
Belvedere Torso, mid-first
century BCE. Parian marble,
height 62⅝" (159 cm).
Museo Pio-Clementino,
Sala delle Muse, Vatican

12.45
Belvedere, Vatican, looking
south. The view planned by
Bramante was obstructed
by a wing of the Vatican
Library added in 1587–89;
this photograph shows an
additional transverse wing,
the Braccio Nuovo, added
in 1816–22.

right hand. (God's other hand caresses a child, the future Christ: theologians understood Adam to prefigure Christ and referred to Christ as the "New Adam," since his incarnation promised a redemption that would restore human beings to the perfect state that preceded the Fall.) The contrast between Noah and Adam expresses that between human perfection before the Fall and moral corruption afterward.

Other episodes from the Jewish Bible appear in feigned bronze reliefs. Holding these in place is a series of figures who stand as among Michelangelo's most extraordinary and influential creations – all nude, all male, some quietly pondering, others once again in states of animation and elation that tend to gain in intensity toward the altar. Sometimes they enter into an almost athletic degree of hyperactivity. Like the nudes of the *Battle of Cascina* cartoon (*see* fig. 12.12), they assume poses that could not be sustained for more than a few moments, if at all, by any human being (fig. 12.43). The model here, in fact, was not a living being at all, but an actual piece of sculpture in the collection of Julius II – a colossal seated nude, bereft of arms, legs, and head, known as the Belvedere Torso (fig. 12.44). The twenty nude figures are a set of variations on this single ancient model. They are demonstrations of the artist's resourcefulness but also affirmations that the pagan image of the body could find a new place in modern Christian art, assertions of the beauty of man, made in God's image.

The Vatican Palace

While Michelangelo was painting the Sistine Ceiling, Bramante was giving the Vatican Palace a magnificent new form. On the hillside to the north of St. Peter's and the palace complex was a papal summer retreat known as the Villa Belvedere. Bramante conceived a scheme to join the villa to the main body of the residence with two great galleries, which would gradually diminish from three tiers to one as the ground rises (*see* figs. 12.45–46). What Bramante aimed to do, in effect, was to subject an entire irregular landscape to the order and symmetry of architecture. Triple corridors were to enclose a series of terraces outfitted with gardens and a theater, as well as an arena for tournaments and equestrian events. At once showing his own study of ancient Roman remains and underscoring the dimension of spectacle, Bramante ornamented the facades of the raised corridors with repeating bays of arches and engaged columns or pilasters he based on the arcades at Rome's Colosseum.

The climax was to be a remodeled Villa Belvedere. Since the original villa angled away from the palace and the gigantic courtyard, Bramante designed for it a new

RIGHT
12.46
Giovanni Antonio Dosio, the Vatican Belvedere courtyards under construction, looking north, *c.* 1558–61. Pen and brown ink with traces of chalk on paper, 8⅝ x 13" (21.9 x 33.2 cm). Biblioteca Vaticana, Rome

BELOW
12.47
Belvedere, Vatican: Bramante's spiral staircase

Artists wishing to measure themselves against the antique now had before them a nearly intact group of figures that ancient Rome's most distinguished historian of art himself assured them had no compare.

Eloquent Bodies: Raphael and the Stanza della Segnatura

Among the most enthusiastic young students of the *Laocoön* was Raphael, who, within a year of completing the Baglioni altarpiece (*see* fig. 12.21) had himself transferred to Rome; he would eventually respond to the ancient sculpture in drawings, prints, and paintings. Bramante seems to have been an advocate and something of a protector of his fellow artist from Urbino. Like Michelangelo, Raphael would avail himself of the Pope's incomparable resources to bring previously unthinkable projects into being: unlike Michelangelo, he managed to avoid the cross-purposes and clashes of ego that would lead to years of frustration for the older artist. Raphael stayed close to Bramante, who was forty years his senior and understood how to direct the Pope's often erratic impulses as a patron.

In 1508, the same year that Michelangelo started work on the Sistine Ceiling, Julius commissioned Raphael to decorate the rooms he intended to use as his official apartment. Overlooking Bramante's courtyard, in the structure known as the Borgia Tower (after the recent Pope, Rodrigo Borgia, or Alexander VI), these included the room that came to be called the Stanza della Segnatura – well after Raphael's time, the chamber housed the papal tribunal known as the "segnatura," the activity of which involved the signing of official documents. In Julius's own day, the space served as a papal library, with books arrayed on sloping shelves below large frescoes. (The shelves are now gone, and the frescoes in the lower zone of the room are later additions.) Raphael's paintings on each wall, along with the corresponding section of vault above (fig. 12.49), visualized the four major areas of learning represented: Theology, Philosophy, Poetry, and Law. Earlier libraries and studies had sometimes been decorated with figures of Muses or Allegories of the Liberal Arts, often including imaginary portraits of their most famous historical practitioners. What was most radical about Raphael's scheme was its separation of the allegorical figures from the portraits, so that the portraits now dominate the invention. It is as though the authors of the room's books have come to life on its walls.

In designing his ceiling, Raphael must have been aware of Michelangelo's early designs for the Sistine Ceiling, for although Raphael conceived his ceiling as a series of fictive mosaics, the arrangement of the compartments is close in conception to the scheme Michelangelo

facade at right angles to the corridors, incorporating a huge niche. (The facade was built only later in the century, by which time a new gallery housing the Vatican Library had partitioned the courtyard.) Within the Belvedere itself, moreover, he introduced a pair of spiral staircases (fig. 12.47) that, once again, ran through the succession of architectural orders: ascending the spiral stairs, Doric gives way to Ionic and then to Corinthian. The highlight of the building, however, was what it housed, the increasingly impressive papal collection of ancient sculptures. It was this site that gave its name to the famous torso that Michelangelo was studying (*see* fig. 12.44), as well as to the magnificent lifesize marble, discovered in the late fifteenth century, known henceforth as the "Apollo Belvedere." The work that had made news the year Bramante went to work on the building, however, the one that occasioned exchanges of letters and bursts of poetry, was the *Laocoön* (fig. 12.48).

In 1506, a Roman curious about a sealed-up chamber in his vineyard discovered the marble, which showed a Trojan priest and his two sons devoured by snakes in divine retribution for his having warned his countrymen about the treachery of the Greeks. The depicted episode would have been familiar to all readers of Virgil's *Aeneid*, beloved at the papal court for its account of the foundation of Rome. More significantly, however, Pliny the Elder had described what the discoverers took to be this very marble in his *Natural History* (*c.* 77–79 CE), in which he not only reported that the emperor Titus had kept the statue in his house but also attested that it was greater than all other ancient paintings or sculptures.

12.50

Raphael, *The School of Athens*, 1510–11. Fresco. Stanza della Segnatura, Vatican

considered and then abandoned. The powerful female figures that in Raphael personify the branches of knowledge follow Michelangelo's prophets and sibyls in their heroic proportions. Between the personifications is a series of symbolic stories and figures, each of which corresponds to the two flanking areas of knowledge: for instance, Urania, the Muse of Astronomy, relates to both Poetry and to Philosophy (which includes all of what are now called the sciences); Adam and Eve stand between Theology and Law, since the story of Adam and Eve concerns the operation of Divine Justice.

A caption (*titulus*) defines Philosophy as CAUSARUM COGNITIO ("the knowledge of causes"). In the great lunette below known as *The School of Athens* (fig. 12.50), all of the great philosophers of antiquity gather in a grand vaulted space that probably reflects current projects for St. Peter's. Raphael did more here than simply paint a group portrait of famous people from the past: the composition is a poetic invention that stays true to the principles laid down by Alberti, through which Raphael aimed at nothing less than the representation of Philosophy itself through depicted human action. The work asks beholders to "read" it, recognizing each figure not only from conventional attributes but also from his char-

acter and his gestures. The only inscriptions are on the books held by the central figures, which serve to identify them as Plato (with his *Timaeus*) and Aristotle (with his *Ethics*). The pair are presented as the greatest of all philosophers, but also as the founders of two diverging philosophical traditions. Plato (429–347 BCE), who points to the sky, is the idealist, positing truth and reality not in the perishable material forms of nature but in the timeless, immaterial world of Ideas. His pupil Aristotle (384–322 BCE), who gestures toward the ground, inquires instead into the nature of physical reality and the world of human life and society. Aristotle had been the single most influential thinker in the universities of Europe since the 1200s, when his works were rediscovered in the West: his writings provided the fundamental texts on the study of the human mind and its capacity to know, on the natural world, and on politics and morality, as well as the basic methods of demonstrating and proving an argument. In the fifteenth century, the newly available texts and translations of Plato, edited by Greek and Italian scholars, led to disputes between self-appointed followers of the two philosophers. More recently, however, some humanist thinkers in circles close to the papal court had claimed that it was possible to reconcile the thought of Plato and

Aristotle despite their considerable differences in method and in the questions that engaged them. The principle of harmonizing differences is the generating conception of Raphael's fresco. The different schools of philosophy organized around Plato on one side and Aristotle on the other – schools that represent the widest variety of ancient cultures then known – manifest variety and difference on the individual level but together correspond to a great three-dimensional unity.

On Aristotle's side are the ancient practitioners of practical mathematics and astronomy: Ptolemy (foreground right) holds a terrestrial globe and wears a crown. (The ancient astronomer was often confused with an Egyptian king of the same name.) He is paired with the Persian prophet Zoroaster, who holds a celestial globe. Euclid appears here in the person of Bramante, who demonstrates with his compasses a theorem for a group of excited students. The young man in the black hat looking out of the fresco is Raphael himself, standing beside a figure identifiable as the Lombard artist Sodoma, who had also worked in the room: Raphael wants us to understand that painting, as a form of knowledge comprising the mathematics of perspective and the study of nature, can itself be classed as a form of philosophy. Among the philosophers on the opposite side is Pythagoras, who taught his students about the hidden mathematical ratios that organized both the motions of the planets and the notes of the musical scale. As Pythagoras writes in a large book,

the turbaned Arab philosopher and astronomer Averroes looks over his shoulder. Closer to the center of the picture is the brooding figure of Heraclitus, who held that the only reality in the universe is its process of constant change and transformation, and that all being is unstable and passes away. Raphael is generally believed to have represented Heraclitus in the person of Michelangelo, not just portraying his physical features but also imitating the style the older artist employed for the prophets and sibyls of the Sistine Ceiling. With characteristic wit, the figure's pose resembles that of the prophet Isaiah, but whereas Isaiah lifts his head from his hand with a flash of inspired energy, no such epiphany has come to the gloomy philosopher. He is also one of the few characters in the scene who interacts with no one: if Raphael, pairing himself with Sodoma, implied that his work was necessarily collaborative, he shows Michelangelo as an artist who thinks, and works, in near isolation. The portrait, seemingly painted after the rest of the fresco was complete, and certainly at a point when Raphael had finally had a chance to study what Michelangelo had been producing a few rooms away, created the indelible image of that artist as "il penseroso," the thinker. Standing to his right is Parmenides, the opponent of Heraclitus, who argued the case for stability and constancy of substance as opposed to endless transformation. Just as Raphael has portrayed Heraclitus using the style of Michelangelo, so now he models Parmenides on the figure of Leda

12.51

Raphael, *Disputà*, 1508–09.

Fresco. Stanza della Segnatura, Vatican

(*see* figs. 12.15–12.16), recently invented by Michelangelo's celebrated rival Leonardo.

The slightly earlier fresco (1508 or 1509) of Theology on the opposite wall of the Stanza is sometimes called the *Disputà* (fig. 12.51), or "disputation," since some early writers believed that it depicted a debate about the nature of the Eucharist. Although there was certainly no lack of disputation about the Eucharist in the years when Raphael was painting, the postures suggesting lively intellectual exchange probably indicate Theology in general, conceived as a great collective seeking of knowledge under the guidance of the Holy Spirit, depicted above. Whereas the architecture of *The School of Athens* evoked the nave of a great basilica, the space here is more like a vast apse: though a hill in the distance suggests an outdoor setting, the pavement, steps, and altar below rather reconstitute the ceremonial focal point in every church, and the rows of clouds and the golden beams above curve to form a colossal semi-dome, as if the world were shaping itself to welcome God's presence. On axis with the Eucharist, God's miraculous manifestation on Earth, are the three persons of the Trinity. While Christ displays his wounds, the Holy Spirit once again functions as the principle of divine wisdom: accompanying the symbolic dove are the books of the four Gospels, directly inspired by God. To either side of Christ appear St. John the Baptist and the Virgin Mary, along with an entire semicircular tier of saints and prophets. Below, an energetic group of popes, cardinals, bishops, and members of various religious orders express the wonder that leads to contemplation and enlightenment. At the edges of the crowd, heretics and dissenters turn away with their books, leaning into the space of the room itself, as a blond youth and a bearded patriarch gently direct them back toward the altar.

Having translated the abstractions of philosophy and theology into visible form in these two paintings, Raphael then tackled poetry. Here, he might have found himself on more familiar territory, since the Urbino court would have instilled in Raphael the humanist commonplace that there was a deep affinity between poetry and painting: both poets and artists communicate through images, whether descriptive or metaphoric. The wall this time presented more of a challenge, however, for Raphael had to paint around an existing window. In the *Parnassus* (fig. 12.52) he addressed the problem by using a hill as his setting, following the curve of the lunette and placing figures above and to the sides of the hole in the middle (which itself provided a view onto a real hill in the distance). Once again, Raphael composed with portraits, leaving it to the viewer to work out the principles of association linking them to each other and to a central guiding presence – in this case, the god Apollo, the patron not only of music and poetry but of inspiration and prophecy. Apollo in turn looks up at the oculus in the ceiling above where Poetry appears as a winged divinity with the caption NUMINE AFFLATUR – "inspired [or 'inflated'] by the Divine." As Michelangelo had done with his sibyls, Raphael indicates the numen, or the presence of the divine, with an effect of breath or spirit, a movement of air that ruffles the drapery of the Muses around Apollo. On the hill toward the left and in blue toga-like drapery, close to the divine sources of poetic vision, is the Greek poet Homer, whose blind but ecstatic features are modeled on the *Laocoön* (*see* fig. 12.48). Behind him, in green, is Homer's most important imitator, the ancient Roman poet Virgil, who in turn looks back to Dante, in red, the "modern" poet who took Virgil as his guide. Further down the slopes on this side, in a pointedly less lofty position, are the poets of lyric and amorous verse: the ancient Roman poet Ovid, in a flame-colored toga; Daphnis, the mythical inventor of pastoral, who points to the laurel, symbol and reward of poetry in general (his own name means "laurel"); Petrarch, the great modern poet who celebrated the poet's laurels and his own love Laura, in three-quarter profile; the bearded Theocritus; and the female poet Sappho.

On the other side of the window is the aged figure of Hesiod, the Greek shepherd poet who wrote of the nature of the gods. Hesiod's gesture of pointing into the room would have had a particular significance to its original primary occupant, since a passage in this poet's *Theogony* (II:29–35) appeared to prophesy the future greatness of Julius II: "so spoke great Zeus's ready-speaking daugh-

12.52

Raphael, *Parnassus*, 1510–11. Fresco. Stanza della Segnatura, Vatican

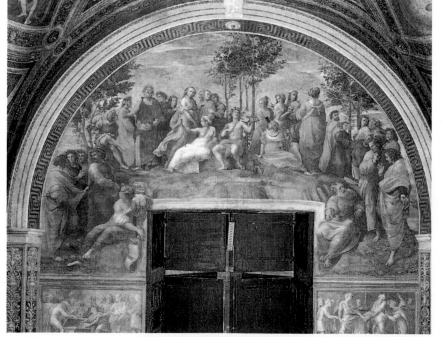

ters, and they plucked a staff, a branch of luxuriant laurel, a marvel, and gave it to me; and they breathed a divine voice into me, so that I might glorify what will be and what was before, and they commanded me to sing of the race of the blessed ones who always are, but always to sing of themselves first and last. But what is this to me, about an oak and a rock?" The stone is a familiar sign for Peter, the first Pope, whose name meant "rock"; the oak (*rovere* in Italian) is the emblem of the family (Della Rovere) of Julius II.

Venice

Pope Julius II cultivated diplomatic ties with the great powers across the Alps, in part because his nearer neighbors were more worrisome. In 1508, he entered into an alliance with the Holy Roman Empire, France, and other powers, known as the League of Cambrai, which through open warfare would succeed in curtailing Venetian influence in the peninsula. Venice's own ambitions very much correspond with the portrayal of the city by Jacopo Barbari (*c.* 1440–before 1516; fig. 12.53). This colossal woodcut celebrates the city's status as the center of an empire founded on trade and the domination of the sea. The sea god Neptune assures that nature itself protects the destiny of Venice – he bears an inscription declaring "I Neptune reside here, smoothing the waters at this port," to which Mercury answers, "I Mercury shine

favorably on this above all other trading centers," thus dignifying the sources of Venice's power. In its quality and scale – it was produced from six blocks on six sheets of paper and measures four by nine feet – it constitutes a Venetian equivalent to the other monumental projects of the decade in Rome or Florence. The *View of Venice* also marks the beginning of a gradual shift in the mechanism of print production. Whereas earlier printmakers like Mantegna and Pollaiuolo had initiated their own projects, Barbari's woodcut originated as a private commercial venture by the printer-publisher Anton Kolb. Kolb justified his request for a government "privilege" (an early form of copyright) by maintaining that the print served "principally for the glory of this illustrious city of Venice."

What is most remarkable about the image is that it is a bird's-eye view, showing the city as it might look from an imaginary point in the sky. The exchange of looks between the gods Mercury above and Neptune below enhances the viewer's sense of being physically located above the city, even of an ability to move through space as he scans the winding streets, canals, gardens, and squares. The minute precision in the rendering of buildings, public spaces, trees, and ships gives the impression of a completely faithful portrait, promising that the prints could serve as a map. In fact, the *View of Venice* combines the mathematical techniques of mapmaking, still in its infancy in these years, with those of painting in perspective. Barbari used the measurements

12.53

Jacopo Barbari, *View of Venice*, 1500. Woodcut, 4'4¾" x 9'2½" (1.34 x 2.81 m). Museo Correr, Venice

provided by a team of surveyors, while also making drawings from a number of elevated positions in the city, notably the campanile of San Marco. The overall coherence, however, is a synthesis of Barbari's, produced by intuitive as much as by empirical means: he exaggerated the scale of certain elements, such as the two central islands, and diminished others, to demonstrate their relative importance. Because the image was composed from multiple views, the angle of vision sometimes shifts – compare the receding perspective of the Piazza San Marco with the almost overhead view of the area below the Rialto bridge on the sheet above.

In the years Barbari was producing his woodcuts, Giovanni Bellini (*c.* 1430–1516) continued to dominate the painting profession in Venice. He held a prestigious state appointment as painter of the Hall of the Grand Council, and he ran the large workshop in which the major figures of a new generation would be trained: Giorgione, Sebastiano del Piombo, and Titian. The San Zaccaria altarpiece of 1505 (fig. 12.54), a work Bellini painted in his mid seventies, shows the culmination of a lifetime's investigation into the properties of light and its effects on colored surfaces. The spatial illusion and psychological impact of the world represented here make it seem continuous with our own: the architecture that houses the Virgin and saints appears to extend the architecture of the frame; the saturated red of St. Jerome's robe indicates a light falling with full intensity, whereas St. Peter's yellow mantle is revealed through illumination reflected from other surfaces. Bellini works with naturalistic effects not for their own sake but to evoke the sacred as a mood or an atmosphere that extends itself to the world beyond the painting through the sensory and emotional engagement of the beholder. This is a mirage-like place of mystical stasis and near silence: the figures seem absorbed in meditation to the degree that all motion has been suspended, and the delicacy with which the angel plays its *lira da braccio* beckons the viewer, as if, in approaching, he might actually be able to hear the music.

Foreigners in the City

Some of the younger artists who trained under Bellini were just beginning to set up independent workshops in the 1500s, years when Venice was an international crossroads for different traditions of painting and printmaking. These younger painters would have been aware that, in addition to Bellini, two of the world's most famous artists were briefly present in their city during the 1500s: Leonardo passed through in 1500 as a consultant to the government on military matters, while Albrecht Dürer (1471–1528) spent 1505 and 1506 there as an agent for a German trading company. Nothing from Leonar-

do's hand can be securely associated with his Venetian sojourn, but Dürer, in the course of his stay, produced a major altarpiece.

Even before coming south, Dürer was already an artist of considerable reputation in Italy, where his engravings and woodcuts (including the *Apocalypse* series; *see* fig. 11.13) were known to artists and collectors. Vasari reports that one of the reasons that Dürer came to Venice was to seek redress against the printmaker Marcantonio Raimondi, who had been making pirated copies of his engravings. The episode is a major event in the history of "intellectual property." At the time Dürer traveled south, it had never occurred to legal authorities that an artist's work might in some way belong to him. Copyright law did not then exist; publishers of books and prints, like Anton Kolb, were the only ones who could obtain a "privilege," or sole right of production, for a

12.56
Albrecht Dürer, *Feast of the Rose Garlands*, 1506. Oil on panel, 5'3¼" x 6'4¾" (1.62 x 1.95 m). Národní Galerie, Prague

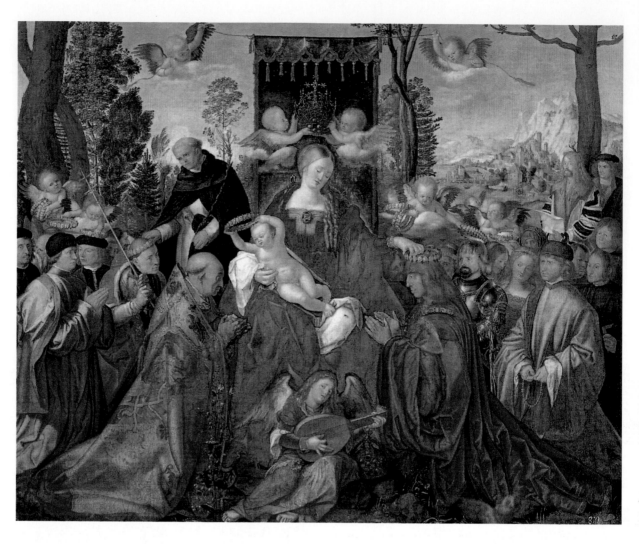

limited period. Dürer, though, won his case, obtaining a ruling whereby his own prints would be distinguishable from those of his copyists: Marcantonio was permitted to make his own versions, but not to reproduce Dürer's distinctive monogram, which now had the status of a trademark. At least in theory, customers would now be certain they were acquiring an authentic print from the hand of Dürer.

Dürer's 1505 visit to Venice was by no means his first exposure to Italian art. He may have made an earlier trip south. He was familiar, even in Germany, with the engravings of Mantegna, and in 1500 he had made the acquaintance of de' Barbari, then working in Nuremberg. According to Dürer's own account, Jacopo had shown him how to use Vitruvian proportions to draw human figures: the engraved *Adam and Eve* of 1504 (fig. 12.55) was Dürer's attempt to render the human body according to this idealized system of measurement, with the implication that only before the Fall, in bodies God himself had made, would such perfect proportions have been found in man and woman. In Germany, the print would cer-

tainly have looked Italianate; Italians like Michelangelo, on the other hand, found it labored. After arriving in Venice, Dürer changed his mind about what could be learned from Italy, and wrote to a friend at home that he now realized there were better painters than Jacopo de' Barbari. In particular, he was impressed by Giovanni Bellini, whom he befriended. Dürer's letters also suggest that he had begun to worry that his insufficient knowledge of antiquity would limit the international appeal of his works, though this did not prevent him from issuing a painted challenge to the other artists in the city.

This was the *Feast of the Rose Garlands* of 1506 (fig. 12.56), which Dürer produced for a highly visible location in San Bartolomeo al Rialto, a church that served the local German community. The altarpiece demonstrated the principles of painting that pertained north of the Alps, while also showing that Dürer could outdo the Venetians in all the artistic qualities at which they excelled: the handling of color and light, the rendering of landscape. As Dürer himself wrote in 1506: "My picture... is well painted and beautifully colored.... I have stopped

the mouths of all the painters who used to say that I was good at engraving, but as to painting I did not know how to handle my colors. Now everyone says that better coloring they have never seen." Other evidence indicates that Dürer did not lack for resistance in the artistic community: the city fined him in 1506 for practicing painting without a license from the local guild.

By presenting the Virgin and Child enthroned in outdoor light, Dürer was seeking comparison with Bellini's San Zaccaria altarpiece (*see* fig. 12.54), which he had studied closely. The arrangement of colors across the surface, the figure of the musician angel, even the two flanking trees all correspond to elements in Bellini's painting. Yet Dürer does not pursue Bellini's spatial effects, the sense of figures detached from each other in a continuous volume of light and air. The picture is packed; bustling

interaction replaces the static detachment of Bellini's composition. Dürer re-imagines the traditional formula of enthroned Madonna with votive portraits as an action or performance. While two cherubim crown the Virgin as Queen of Heaven, she and the Christ Child, along with angels and St. Dominic, distribute rose garlands to the kneeling figures around the throne: these appear to be portraits, perhaps of confraternity members, but only two are clearly identifiable. In the place of honor to the Virgin's right, Pope Julius II receives a rose crown from Christ, while the Virgin wreathes the splendidly attired Holy Roman Emperor, Maximilian. Contemporary relations between the empire and the papacy stand behind this unusual imagery. The emperor's political successes had led to considerable speculation that he would soon descend on Rome to receive the imperial crown from

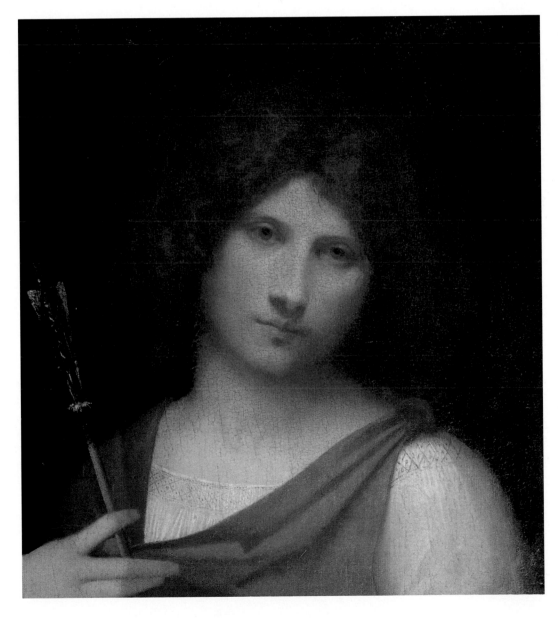

12.57
Giorgione, *Boy with an Arrow, c.* 1506. Oil on panel, 18⅞ x 16⅝" (48 x 42 cm). Kunsthistorisches Museum, Vienna

OPPOSITE

12.58

Giorgione, *The Tempest*,
c. 1509. Oil on canvas, 31¼
x 28¾" (79.5 x 73 cm).
Galleria dell'Accademia,
Venice

Julius II; Dürer hoped to join the emperor's party from Venice. In the event, this never occurred, but Dürer's altarpiece offered an optimistic vision of a unified Christendom, one that the League of Cambrai would soon shatter. Dürer himself appears in the picture as a witness to the history he was making sacred: he stands to the far right, before an Alpine landscape, holding a scroll bearing his name and the implausible assertion that he had completed the altarpiece in five months. This invited viewers to marvel all the more at the quality of labor-intensive detail, the meticulously described fabrics, furs, jewels, and flowers.

Giorgione and the Young Titian

It is by no means clear that Leonardo had allowed Venetian artists to see any of his works during his brief visit to the city. Nevertheless, one of the younger artists from the Bellini studio was working by the middle of the decade in a radical new style that later sixteenth-century viewers, such as Vasari, saw as a response to his influence. Giorgione (c. 1477/8–1510) eschewed Leonardo's practice of making serial preliminary studies, then building up paintings over strong underdrawing, preferring instead to compose with pure tone directly on the surface of the painting. Still, works like his *Boy with an Arrow* (fig. 12.57) from around 1506 recall Leonardo's practice of immersing human figures in transparent shadow from which their features seem gradually to emerge into the light. Just as the *Mona Lisa* (*see* fig. 12.17) is no conventional portrait, so Giorgione's image seems unlikely to depict an actual person, though it follows the conventions of portraiture. The work could best be described as a poetic idea, but one with a rich and alluring ambiguity that challenges the spectator to participate in making meaning more than any written poem of the period could. Who is this boy? Does the arrow signal that he is the pagan god Cupid, or does it mean that he is merely *like* Cupid, a non-divine being who also gives rise to the emotions of love?

The Venetian poet and scholar Pietro Bembo (1470–1547) in just these years reported that Giovanni Bellini, Giorgione's probable teacher, had come to insist that pictorial inventions could not simply be dictated by patrons, but had to be "suited to the painter's own imagination." Bellini, Bembo wrote, expected "always to wander as he pleased in his paintings." No disciple internalized this idea of painting more than Giorgione, who in the few years before his premature death produced a series of pictures not dedicated to prayer, commemoration, or propaganda, but simply intended for acquisition and display in Venetian private homes, where they could be exhibited alongside ancient bronzes or marble sculptures and admired as examples of the virtuosity of a great painter. Works like *Boy with a Flute* and the so-called *Tempest* did more than simply define the category "modern art." In the lush landscape of *The Tempest* (fig. 12.58), where lightning, rolling clouds, and the density of the atmosphere signal the onset of a storm, a male wanderer comes upon a semi-nude woman who nurses a child by a spring. What we are given resembles the beginning of a story, and we are invited to complete it. But what narrative or body of ideas could lead to this strange association of elements?

For some viewers, the work needed to be no more than a landscape – or, as one early witness called it, a "little landscape on canvas with a storm, with the gypsy and the soldier." As the depiction of a meteorological event, unprecedented in its rendering of rolling clouds, fitful sunlight, and even the particular visibility of air thick with moisture, it is understandable why the storm might have been singled out as a principal point of interest. But the original owner of the painting, Gabriele Vendramin (1484–1552), a man of learning from a noble family, was interested in paintings with philosophical subject matter that he could keep by him in his *studiolo* and throughout his house. Vendramin might have ascribed philosophical significance to the suggestive juxtaposition of vulnerable and exposed human beings and the unleashing of nature's fury – this was a major theme of the epic philosophical poem *On the Nature of Things* by Lucretius. In describing a natural world without divine agency, Lucretius had sought to explain the causes behind a range of physical phenomena, from weather and climate to human sensory perception. Superstitious human beings might regard such natural occurrences as thunder and lightning as actions of angry gods, he wrote, but the true philosopher understood these as the movement of atomic particles, and therefore as nothing to be feared. Lucretius celebrated the ancient Greek philosopher Epicurus (341–270 BCE), who was the first to "wander" in search of the true causes of things, and to liberate mankind from superstitious fears of the gods. If Vendramin found that the painting alluded to Lucretius, he would have understood that it was more than an illustration: Giorgione has taken pains to locate his scene in the contemporary world, dressing his male figure in the particolored hose of a contemporary Venetian libertine, and adding the coat of arms of a city in the Venetian territory over the city gate. The subject of the painting thus becomes the modern philosopher's contemplation of nature and the natural condition of man, undeterred by the storm and the gathering darkness: these in themselves may have recalled the troubles of Venice plunged into a war with the major powers of Europe, and the necessary philosophical outlook needed to confront them.

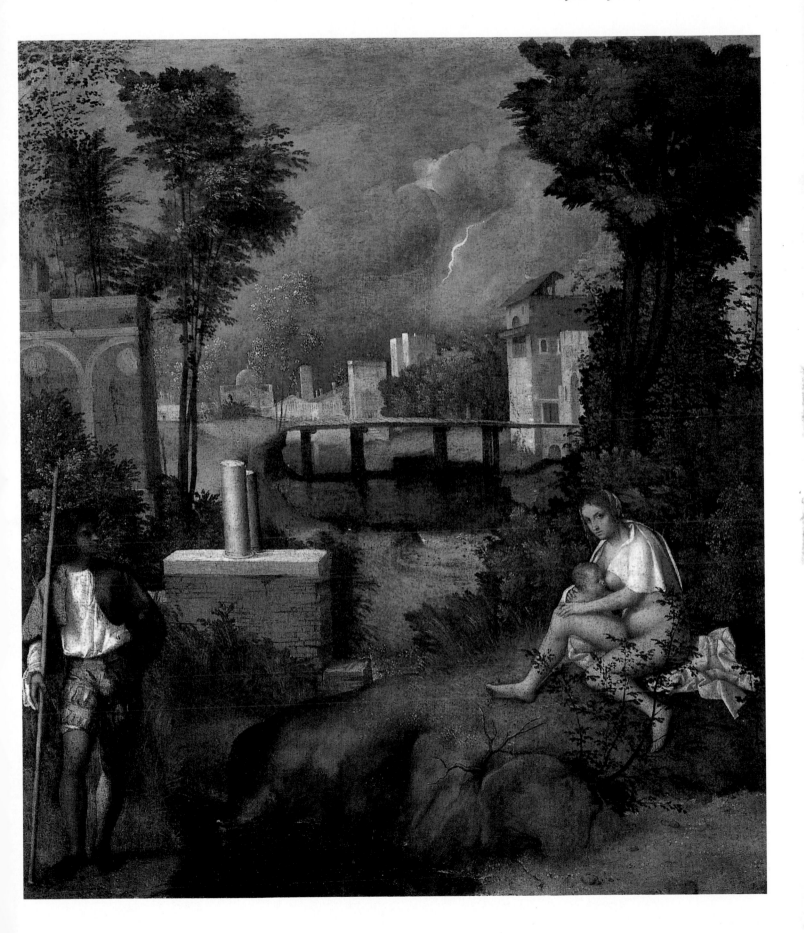

Giorgione's *Sleeping Venus* (fig. 12.59), made for the Venetian official Girolamo Marcello, is a kind of picture that we have seen before (*see* figs. 9.25 and 11.4): a mythology with the ancient goddess of love and fertility as its protagonist. Her identity would initially have been clearer, since her son Cupid originally appeared in her company (that area of the canvas, heavily damaged, was painted over in 1837). What is more unusual, however, is the emphasis on a single nude figure, who dominates the painting, and the prominence of the landscape setting. As with *The Tempest*, Giorgione wants the viewer to reflect on the relation between the body (in this case, the body of a figure who stands for human sexuality itself) and the natural world: the curves of the figure's limbs, torso, and breasts echo the gentle rolling hills of the landscape. Even a viewer who was not learned in philosophy might be moved to reflect on the nature of human beings as part of a wider continuum of physical life in the natural world. Through the senses, one comes not only to know the world but also to feel oneself as part of the world. Readers of Lucretius, Virgil, or the fourteenth-century Italian poet Giovanni Boccaccio would remember that these poets had invoked Venus to refer to the power of visual attraction and compulsion that led living things

to reproduce. Just as Giovanni Bellini used landscape and atmosphere to draw his viewers toward a state of imaginary participation in the contemplative world of his saints and Madonnas, so Giorgione now offers a parallel experience, one pursued by secular philosophers and poets, and no less dignified.

Little is known about Giorgione himself, beyond the fact that he received a commission to fresco the facade of the warehouse-office complex of the German community in Venice in 1506, and that he had died by 1510. Around that time, another artist produced a work that seems to be an attempt to continue Giorgione's specialization in sensuous and ambiguously evocative secular subjects. The so-called *Pastoral Concert* (fig. 12.60) has often been attributed to Giorgione, but most art historians now regard it as an early work by Titian (1488/90–1576), the painter who would dominate the profession in Venice for the next sixty years. It was Titian, in fact, who had probably completed the *Sleeping Venus*, and the *Concert* shows us that Titian now saw himself as both the heir and interpreter of Giorgione's pictorial experiments. Like *The Tempest*, the *Concert* responds to the recent vogue for landscapes with figures – both paintings juxtapose naked females with clothed males, and the seated female is a

12.59
Giorgione and Titian?,
Sleeping Venus, c. 1510. Oil
on canvas, 42¼ x 69" (1.1
x 1.75 m). Gemäldegalerie
Alte Meister, Dresden

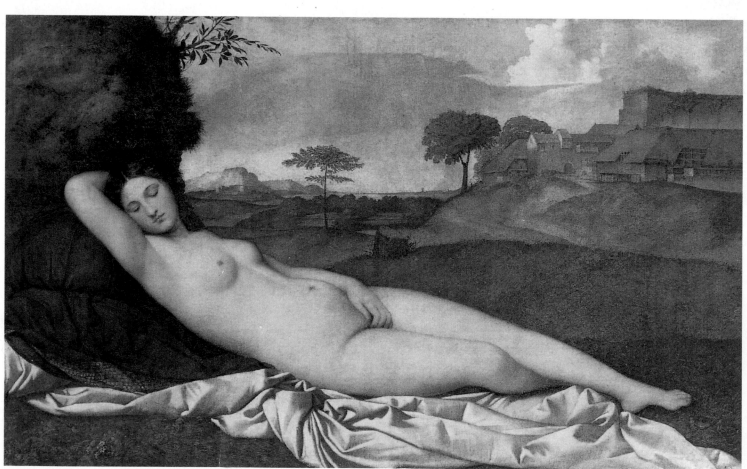

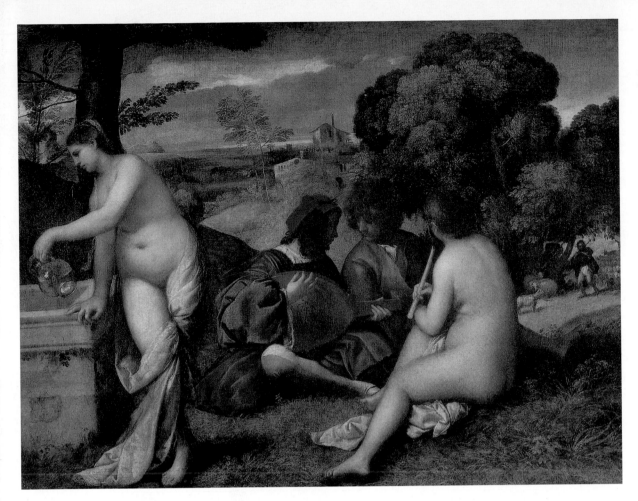

12.60
Titian, *Pastoral Concert*,
c. 1510. Oil on canvas,
approx. 3'7" x 4'6" (1.09 x
1.37 m). Musée du Louvre,
Paris

variation on the woman in *The Tempest*, in a similar pose but viewed from a different point of view. The technique of rendering the softness of flesh by constructing figures in light and dark tones directly on the canvas itself is also similar to the method Giorgione used. By comparison with Leonardo or Dürer, whose *Leda* (*see* figs. 12.15–12.16) and *Adam and Eve* (*see* fig. 12.55) demonstrate the study of anatomy or ideal proportion, Titian merely suggests the structure of the body. Arranged in the foreground plane like Giorgione's Venus, the two nudes appeal to the sense of touch as well as sight. The landscape, with its grassy slopes and patches of alluring shade, has a density and sense of substance that is reinforced by the thickness of the paint, the visibility of brushstrokes, and of the canvas support.

Who are these figures? What is their relation to the men, who do not seem to register their existence? Titian assigned the men themselves social identities: the lute player is an affluent city dweller, whereas his singing companion wears the coarser clothing and unkempt hairstyle of a farmer or a shepherd. (A shepherd appears with his flock on the same diagonal recession into the pictorial space.) This suggests that the painting should be understood in a literary context: the presence of shepherd musicians immediately evokes the classical and modern tradition of the "pastoral," a genre of poetry that celebrated the escapist or therapeutic pleasures of the countryside. It is a predominantly male world, where women are generally evoked as absent love interests, as Muses or as nymphs – natural spirits of the trees or the fountains. Titian here is composing a pastoral in paint, rather than illustrating a particular text, and already in his lifetime, contemporaries referred to works like this as *poesie*, "pieces of poetry."

We have already seen these mythological symbols of poetry (the Muses, the fountain), which appeared in Raphael's contemporary painting of *Parnassus* (*see* fig. 12.52), but the tone of Titian's work is very different: it is more intimate and even more modern. It seems more concerned to produce an alternative to the classical tradition than to proclaim continuity with it, which is the point of Raphael's gathering of ancient and modern poets, all garlanded with laurel. Titian here is working out the principles of Venetian painting as it would come to be understood later in the century – as a rival tradition to that of Florence and Rome, characterized by a greater immediacy of appeal to the senses, as well as a certain elusiveness that demanded the active imaginative involvement of the spectator.

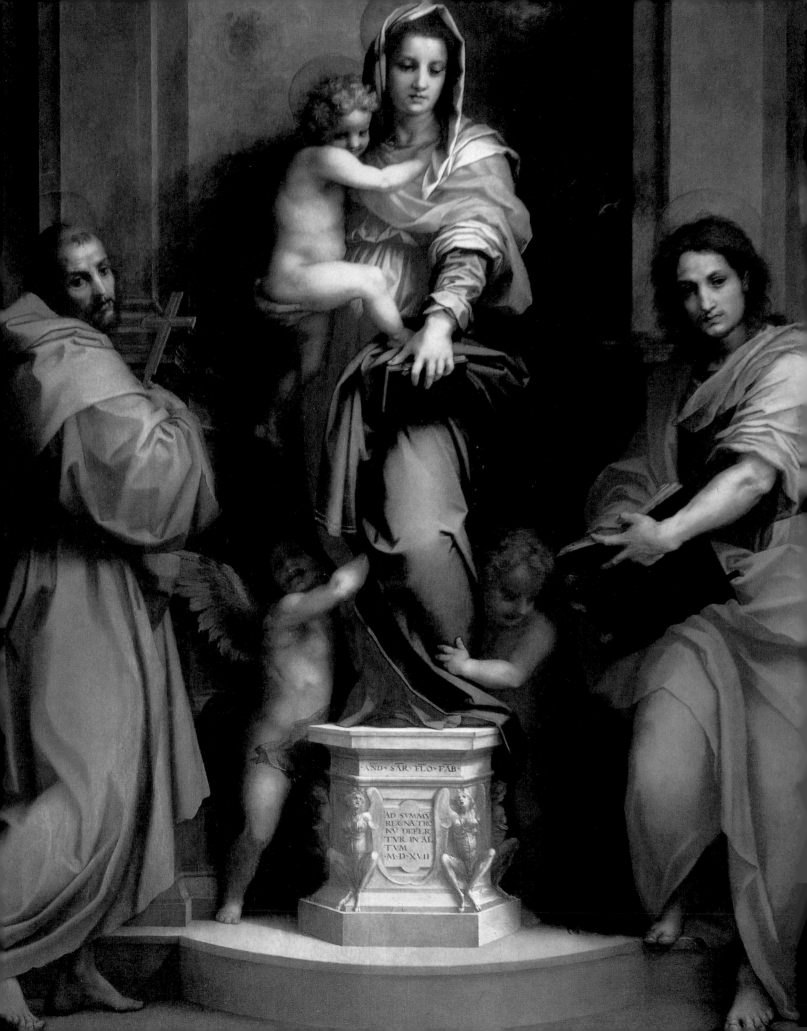

AND · SAR · FLO · FAB ·

AD · SVMMV
REGNA · TRO
NV · DEFER
TVR · IN · AL
TVM
· M · D · XVII

13
1510–1520
The Workshop and the "School"

Raphael and His Team 1512–20

The Villa Chigi

13.1

Raphael, *Galatea*, 1512.
Fresco. Villa Farnesina
(formerly Villa Chigi),
Rome

In 1512, having completed work on the Stanza della Segnatura murals in the Vatican (*see* figs. 12.49–12.52), Raphael undertook a series of other fresco projects for the papacy and for other prominent Roman clients. For the entrance loggia to a suburban villa owned by the fab-

ulously wealthy papal banker Agostino Chigi, he painted *Galatea*, a sea nymph whom the Roman poet Ovid had celebrated for her beauty, her coldness, and her speed (fig. 13.1). Raphael cleverly re-imagined Galatea as a sibling to Botticelli's Venus (*see* fig. 9.25), tearing across the ocean on a chariot drawn by dolphins, chastely wrapped in a grand red drapery as other maritime lovers frolic about her. Raphael gives her the serpentine pose of Leonardo's Leda (*see* figs. 12.15–12.16), but accentuates the contrary arrangement of head, hips, and shoulders to suggest a graceful rotation of the figure. He also shows us why she is turning: Galatea has heard the serenade of the monstrous one-eyed giant Polyphemus – depicted in an adjacent bay by the Venetian Sebastiano del Piombo (*c.* 1485–1547) – whom she will proceed to ridicule for his clumsy ways (the circle of cupids tells us that she is, in any case, in love with someone else, the shepherd Acis). The sophisticated society that frequented Chigi's villa – where the banker kept his mistress – would have grasped the point that success in love depended on facility of speech and manners.

In 1513 Raphael designed and decorated a burial chapel for Chigi in the church of Santa Maria del Popolo (fig. 13.2). The chapel is one of the most lavish ever commissioned by a private patron: it takes the form of a domed Greek cross, thus making reference to the centralized plans for New St. Peter's, albeit on a vastly reduced scale. The coffered dome (with a pseudo-oculus) alludes to the Pantheon. Colored marble and mosaic sheathe the rest of the interior. Raphael himself in this case acted principally as an architect, coordinating a team of craftsmen working in different media: he designed the mosaics in the dome of God and the eight spheres of heaven (fig. 13.3), a series of bronze reliefs depicting Gospel scenes, the bronze and marble tombs, marble sculptures of prophets, and an altarpiece. Raphael's coordinating of all parts of the design ran counter to standard practice, whereby patrons would enter into independent contracts with different individuals and workshops for different components of related projects; at St. Peter's, such an approach had led to tension between Michelangelo and Bramante over the design and siting of Pope Julius II's tomb. In the Chigi Chapel, Raphael's approach had the advantage of allowing

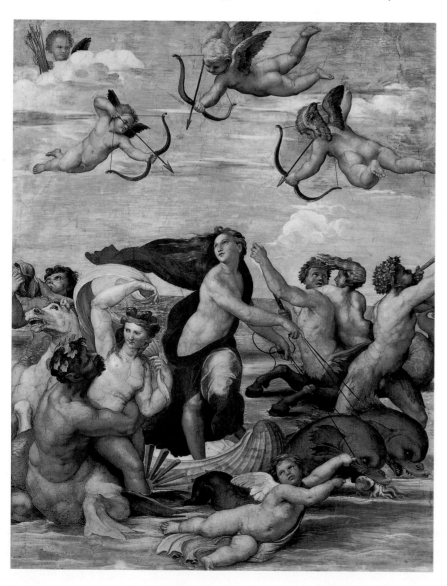

RIGHT

13.2

Raphael, Chigi Chapel,
begun 1513. Santa Maria
del Popolo, Rome. Interior.
The chapel was completed
after Raphael's death
and modified in the
next century.

BELOW

13.3

Raphael, Chigi Chapel,
begun 1513. Santa Maria
del Popolo, Rome. View
into dome.

assistants to carry on work even after the master's death in 1520, though it was Raphael's sometime rival Sebastiano del Piombo who ended up executing the altarpiece showing the Birth of the Virgin, probably to a new design, and two of the prophets would not see completion until the seventeenth century.

Toward the end of his short career a few years later, Raphael returned to the Villa Chigi to paint another mythological love story in the vault of a garden loggia, one based on the legend of the beautiful mortal Psyche, her love for the god Cupid, and the jealousy of his mother, Venus (fig. 13.4). Here, Raphael's conceit was to limit the episodes he showed on the ceiling to those that take place in the heavenly realm of the gods. The viewer looks up at a series of alluring and statuesque nudes depicted from below, at a flock of Cupids whose evident theft of the weapons of the gods demonstrates the universal dominion of love whether in heaven or on Earth, and at two monumental relief-like compositions, presented as illusionistic tapestries showing the story's happy ending: Cupid's appeal to the gods to allow him to marry Psyche, along with the marriage feast itself. Although the painted portions of Raphael's *Galatea* were largely a solo performance, the artist could rely in the Loggia of Psyche on the services of a large workshop of talented younger painters. As in the Chigi Chapel, his involvement was largely as designer, providing studies in red chalk for individual figures and a few compositional studies. These drawings, such as the *Three Graces* (fig. 13.5) now in Windsor Castle, show Raphael abstracting and refining individual human figures, giving them the smooth surface and near geometric body parts of ancient sculpture. What they do not show is the overall composition of the vault, perhaps because Raphael could by now count on his principal assistants to finalize the composition. Nor did he design the borders of flowers, fruit, and birds, since he had several painters working under him who excelled at this kind of naturalism. In the final decade of his career, "Raphael" is very much a composite entity, produced from the collective efforts of highly skilled collaborators who pursued a seamlessness in the final product and a common stylistic ideal.

TOP LEFT

13.4

Raphael, Loggia of Psyche, 1517. Fresco. Villa Farnesina (formerly Villa Chigi), Rome

LEFT

13.5

Raphael, study for Loggia of Psyche: *The Three Graces*, 1517. Red chalk, 8 x 10¼" (20.3 x 25.8 cm). Royal Library, Windsor

Later Frescoes in the Vatican Stanze

Trumping all of his other works in Rome, at least in scale, were Raphael's decorations for the Vatican palace. By 1512 at the latest, he was at work on another papal audience chamber, the one now called the Stanza d'Eliodoro (Room of Heliodorus; fig. 13.6) after the mural in which "a horse with a terrible rider" and "two other young men beautiful and strong" (2 Macabees 3) defend a priest from the pagan commander Heliodorus, who had been sent to gather treasures from the Temple of Jerusalem. By contrast to the Stanza della Segnatura (*see* figs. 12.49–12.52), all the scenes in this room show subjects from history, in which miraculous interventions sanction the authority of the Roman Church. Like the pictures on two of the other walls, the *Expulsion of Heliodorus* includes the anachronistic presence of the Pope himself, here observing the events from atop a litter in the left foreground, with Raphael as one of the litter bearers. This suggests that the selection of the rarely depicted subject depended on Julius II's own personal circumstances. In

fact, the Pope was at war in 1512 with France, whose king Louis XII had forbidden the payment of taxes to Rome, cynically remarking that the Pope used the income for "wars proceeding only from arrogance and a desire to dominate." The papal court consequently regarded the king as a modern-day Heliodorus. The frescoes, for their part, present him as a villain who deprives the priesthood of revenue that should go to widows, orphans, and other needy people (represented in the fresco by the group of mainly women and children to the left). All point to the career of the Pope who commissioned the cycle.

The lunette over the window on the adjacent wall, the *Mass at Bolsena* (fig. 13.7), centers on a consecrated wafer that bled when a German priest had expressed doubt about the doctrine of transubstantiation (the Catholic belief that during the Mass the host actually became the physical body of Christ, rather than just symbolizing it). The event had taken place in a small town called Bolsena more than two centuries earlier, but Raphael added a portrait of Pope Julius to this scene, too, kneeling opposite the priest and watching intently;

13.6

Stanza d'Eliodoro, with Raphael's *Expulsion of Heliodorus* and *Mass at Bolsena*. Vatican

375

during his military campaigns in 1506, Julius had venerated a bloodstained cloth preserved in the cathedral of Orvieto as a relic of the event. His focused concentration, along with the chronological distance of what he sees, allows the impression that the whole history has been called forth from the Pope's own meditations on it. In the right foreground, reinforcing the temporal discrepancy of the scene, is a group of Swiss Guards (protectors of the Pope), whose organization had only recently come into existence.

On the window wall opposite the *Mass at Bolsena*, Raphael produced a stunning *chiaroscuro* scene, *The Deliverance of St. Peter* (fig. 13.8). Like his predecessors, Raphael painted his frescoes directly into the wet *intonaco*, and as we saw with Fra Angelico (*see* fig. 6.8), it could be tempting for painters working in this way to exploit the whiteness of the plaster within the pictorial composition. What Raphael demonstrated was that the fresco painter did not need to restrict himself to the highest of tonal keys. The overall field in this mural is a deep gray, the few bright parts being those in which an angel brings his own illumination: at the center, the angel appears in a vision to the imprisoned Peter – every Pope's archetype – and the light he radiates reflects off the armor of sleeping guards. On the right, the pair reappear, now walking from confinement past other dozers. If Raphael's earlier scenes had shown his willingness to

amplify historical relationships by conjoining in the same scene characters who lived at different times, now he returns to the kind of continuous narrative that Lorenzo Ghiberti and Masaccio had favored, but that more recent mural painters had on the whole abandoned, with architecture dividing not just space but time.

In 1513, before Raphael could complete the decorations for the Stanza d'Eliodoro, Pope Julius II died. He was succeeded by Giovanni de' Medici, a son of Lorenzo the Magnificent, who took the name Leo X on his election. The change in regime is registered in the fourth wall Raphael painted for the room, which returns to the military theme of the *Heliodorus* episode, now showing Peter and Paul, the patron saints of Rome, appearing in the sky and repelling Attila the Hun, who had tried to invade the Italian peninsula in 452 CE (fig. 13.9). If the angels on the *Heliodorus* wall seem to have been called down by the prayers of the priest in the middle distance, here the saints enforce the gesture of benediction by the Pope on horseback at the left: Leo X, shown as his namesake Leo I, Attila's adversary.

By the measure set in the Sistine Chapel and the Stanza della Segnatura, the Stanza d'Eliodoro was finished in record time, and Leo X immediately assigned Raphael the decorations for yet another room in the same suite, colloquially called the Stanza dell'Incendio (Room of the Fire), after the scene of the Fire in the Borgo that

ABOVE
13.9
Raphael, *The Meeting of Attila and Leo the Great at the River Mincio*, 1514. Fresco. Stanza d'Eliodoro, Vatican

OPPOSITE, ABOVE
13.7
Raphael, *The Mass at Bolsena*, 1512. Fresco. Stanza d'Eliodoro, Vatican

OPPOSITE, BELOW
13.8
Raphael, *The Deliverance of St. Peter*, 1513–14. Fresco. Stanza d'Eliodoro, Vatican

decorated one of its walls (**fig. 13.10**). The scale of these projects alone points to a shift in the way that the popes were approaching decorative ensembles. When, several decades earlier, Sixtus IV had determined to add frescoes to a room, he assembled a team of painters to carry out the assignment. They worked side by side, and each painter was responsible for his own individual picture. Raphael's rooms certainly had no fewer laborers at work on them, but the difference was that these men now all worked for a single individual. One of the most distinctive aspects of Raphael's operations in Rome was his reconception of the scale on which a workshop could function. The extensive use of highly detailed preliminary drawings, including full-scale cartoons, made collective participation possible in the execution of the mural.

Printmaking and Tapestries

Raphael's detailed drawings in this collaborative environment also allowed him to control the design of works in media he was himself not capable of executing. These included prints, where Raphael's chief partner was the young Bolognese engraver Marcantonio Raimondi. Raimondi, whom we encountered plagiarizing Albrecht Dürer in Venice (*see* p. 363), had also spent time in Florence before arriving in Rome at the beginning of the decade, and he and Raphael quickly developed a mutually beneficial relationship. We have seen that printmaking appealed

to painters because the reproducible image enlarged their reputation and provided a tool for artistic training and study; Raphael had studied the prints of Mantegna and adapted them in his earlier works. Raimondi's engravings, similarly to Mantegna's, were done for a market rather than on commission, and they allowed Raphael to design subjects, including secular subjects, that he otherwise had few opportunities to tackle. Although it is likely that Mantegna had also employed an engraver to make his plates, the identity at issue in the finished product was that of the painter alone. In the case of Raimondi, by contrast, some of the prints now bore the engraver's monogram as well as Raphael's name. The printmaker would win no less credit than the designer for particularly successful or admired plates, and Raimondi could turn to Raphael to supply him with original ideas for new works. Raphael also encouraged Raimondi to help disseminate his inventions to a mass audience. In some cases, as with the *Parnassus* wall of the Stanza della Segnatura (*see* fig. 12.52), this involved circulating an alternative version of an entire composition (fig. 13.11). In others, Raimondi extracted individual figures. His *Apollo* (fig. 13.12), for example, is based on the figure that appears in the niche in the left background of Raphael's *School of Athens* (*see* fig. 12.50). One who did not know the original fresco could be forgiven for thinking that the print was a record not of a painting but of an actual sculpture. Later in the century, Raimondi's engravings would serve as models for sculptors themselves.

Another major area of collaboration was tapestry. In 1515, Leo X commissioned Raphael to design a series of these to hang in the lowest zone of the Sistine Chapel. The room's decoration by that point comprised the chronological narrative that ran from the ceiling downward, with Michelangelo's scenes from Genesis succeeded by prophets and sibyls, followed by the cycles featuring Christ and Moses that Sixtus IV had commissioned. Leo decided to continue the pattern, now focusing on the lives of Peter and Paul, Rome's patron saints. Using the Acts of the Apostles as a primary textual source, Raphael and his assistants prepared ten enormous drawings, each done in gouache on sheets of paper that had been glued together to form massive supports measuring ten by sixteen feet. These were then sent north to Brussels, where Pieter van Aelst, Europe's best tapestry maker, executed the large hangings to ship back to Rome. Because tapestries are woven from the back, Raphael had to envision each of his designs in reverse. His experience with printmaking may have helped with this, since there, too, the printing of the plate reverses the image engraved on it. By contrast to his print designs, however, the tapestry cartoons had to indicate color no less than contour – though the tapestry maker also reserved the right to alter them,

adjusting for greater clarity and contrast, and choosing from among the actual range of hues at his disposal.

In his mural paintings, Raphael generally divided the viewer's attention among figures disposed across the picture surface. He organized each of the tapestry scenes, however, around an individual identified by his gesture as a speaker. *The Miraculous Draft of Fishes*, for example, shows the episode from Luke 5:1–11 in which Christ tells Peter (aka Simon), James, John, and their partners, who had fished all night but caught nothing, to recast their nets (figs. 13.13–13.14). Finding that they could now pull in so many fish that their boats almost sank, the laborers turned in astonishment to Christ, who said: "Fear not: from henceforth thou shalt catch men." The three then left their boats to become Christ's followers. *The Healing of the Lame Man* (fig. 13.15) shows a later episode (Acts 3:1–8) with two of the same characters, when Peter and John encounter the title character at the gate of a temple. When the man asks for alms, Peter replies: "Silver and gold I have none; but what I have, I give thee: In the name of Jesus Christ of Nazareth, arise, and walk." Raphael's scene collapses Peter's utterance, indicated by his raised left hand, with the text's next lines, which describe how Peter took the man by the hand and

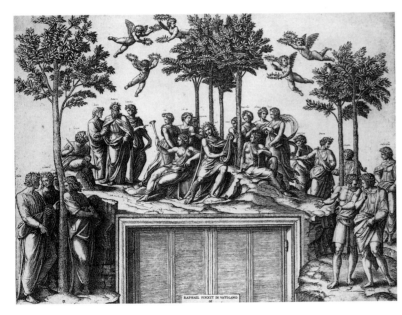

ABOVE

13.11
Marcantonio Raimondi after Raphael, *Parnassus*, *c.* 1514–20. Engraving, 14 x 18¼" (35.8 x 47.2 cm). Ailsa Mellon Bruce Fund, National Gallery of Art, Washington, D.C.

RIGHT

13.12
Marcantonio Raimondi after Raphael, *Apollo*, 1512–15. Engraving, 8 x 3¾" (20.5 x 9.4 cm). ETH Print Collection, Zürich

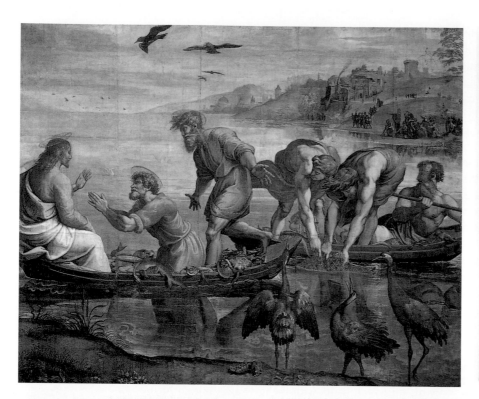

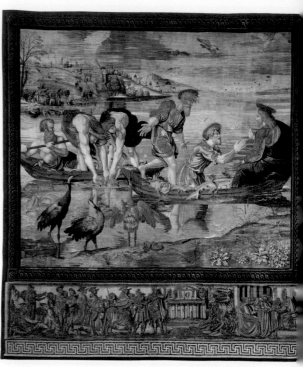

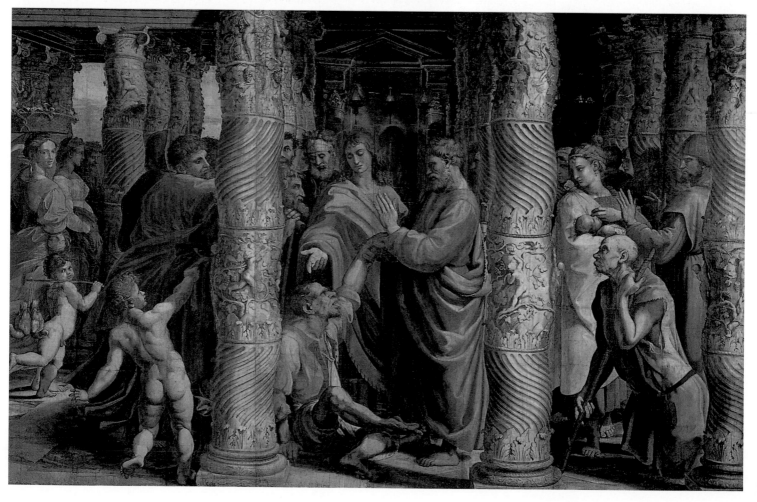

lifted him to his feet, his disability now gone. In both scenes, the words that Christ and his representatives speak accompany wondrous acts, and listeners respond with astonishment. Whereas the Sistine Chapel ceiling Michelangelo had completed just a few years earlier had more to do with theological dogma, especially that of the Incarnation and of prophetic inspiration, the tapestries seem more directly related to *preaching* per se, Christ's and the Apostles' performances setting the ineffable model for the clergy expected to deliver powerful sermons in the chapel itself.

Sculpture and Architecture

The spiral columns that mark the gate in Raphael's tapestry of *The Healing of the Lame Man* divide the space in a way that recalls the Sistine Chapel's earlier murals (*see* fig. 10.24), but they also make a more specific historical reference to the spiral columns thought to have ornamented the temple that King Solomon had built in Jerusalem, and to have been incorporated in the by now partially demolished fourth-century basilica of St. Peter's. Raphael here has treated the columns as authoritative works of ancient art and models for his own practice: the cavorting putti carved into the columns' surfaces inspired his own running little boys, with their un-childlike musculature. Raphael's awareness of and interest in ancient sculpture and architecture, moreover, was not limited to what he put in his pictures. In this period, he made careful drawings of Trajan's column, the Pantheon (fig. 13.16), and other Roman monuments, and he refers to the study of such buildings in his most famous piece of writing, a letter he co-authored with Baldassare Castiglione, author of *The Book of the Courtier*, and sent to Pope Leo X in 1517. In the letter, Raphael wrote of having acquired "at least some knowledge of ancient architecture," and went on to lament that architecture's destruction, laying blame for this on earlier popes as much as on the invading armies that his Vatican frescoes depicted. The letter refers to a map Raphael had begun to make of the ancient city, showing all of its lost edifices, and its last pages aim to characterize the difference between "Greek" (i.e. ancient) and "Gothic" (i.e. medieval) architecture. As he was writing the letter, he was collaborating on a new edition of Vitruvius (*see* p. 201), and this project, no less than the buildings he depicted in paint, placed Raphael among the earliest Renaissance artists to think through systematically the use of architectural orders.

Raphael's large studio allowed him to *practice* architecture as well; indeed, one might even say that he organized that studio more on the model of the master builder than on that of the traditional painter. Significantly, his undertakings as an architect and as a figural artist coincided on many of the same sites: for Agostino Chigi's villa, he not only painted the *Galatea* (*see* fig. 13.1) but also designed a set of stables, and the Chigi Chapel in Santa Maria del Popolo included marble sculptures, painting, pyramidal tombs, and a coffered dome with mosaics (*see* figs. 13.2–13.3). Bramante had recommended that, on his death, Raphael be named chief architect of St. Peter's, and the Pope followed this advice, giving the painter the new charge in April 1516. Characteristically, Raphael opted to work on this project with a partner, and up until his death, he and the professional architect Antonio da Sangallo the Younger together oversaw construction. Scholars generally agree that Raphael's vision for the building is best captured in a later print by Sebastiano Serlio (1475–c. 1554), which shows a boxy form comprising an ambulatory with columns and a series of interlocking Greek crosses (fig. 13.17); it follows what may have been Bramante's intention of extending a nave to the east, toward the city. Work began during Raphael's lifetime on the south *tribuna*, or transept arm, though nothing built there under his supervision lasted beyond mid century.

Among Raphael's surviving buildings is one that he designed in Florence for Giannozzo Pandolfini, the Bishop of Troia, in 1514 (fig. 13.20). This is usually referred to as the Pandolfini Palace, though the family's primary residence was in the center of the city, and Raphael's building, on what was then the edge of town, shows more formal and conceptual affinity to Chigi's suburban Roman villa. The facade pushes the rustication that the Medici had made the hallmark of noble Florentine architecture (*see* fig. 6.20) to the corners of the main block (**quoins**), favoring a plainer, Roman look with bold but carefully proportioned windows and an elegant inscription wrapping around the frieze. The alternating pediment form is adapted from the tabernacles inside the Pantheon.

More influential was the palace Raphael designed in Rome for the papal notary Giovanni Battista Branconio d'Aquila (completed in 1520), which was demolished in

OPPOSITE, TOP LEFT

13.13

Raphael, tapestry cartoon for *The Miraculous Draft of Fishes*, 1515. Bodycolor on paper, mounted on canvas, 11'10" x 13'2" (3.6 x 4 m). Victoria and Albert Museum, London

OPPOSITE, TOP RIGHT

13.14

Pieter van Aelst after Raphael, *The Miraculous Draft of Fishes*. Tapestry in silk and wool, with silver-gilt threads, overall 15'11⅝" x 14'5⅝" (4.9 x 4.41 m). Pinacoteca, Vatican

OPPOSITE, BELOW

13.15

Raphael, tapestry cartoon for *The Healing of the Lame Man*, 1515–16. Bodycolor on paper, mounted on canvas, 11'3" x 17'7" (3.4 x 5.4 m). Victoria and Albert Museum, London

13.16

Raphael, study of the interior of the Pantheon, *c.* 1509. Pen and ink, 11 x 16" (27.8 x 40.6 cm). Uffizi Gallery, Florence

RIGHT

13.17

Sebastiano Serlio, plan of
St. Peter's. Woodcut, 13³/₄
x 9³/₄" (34.9 x 24.8 cm). *Il
terzo libro d'architectura*
(Venice, 1540), p. 37

RIGHT, CENTER

13.18

Raphael, Palazzo Branconio
d'Aquila. Engraving, 1655,
by Pietro Ferrerio

RIGHT, BELOW

13.19

Bramante, Palazzo Caprini
in Rome. Engraving by
Antonio Lafreri

OPPOSITE

13.20

Giovanni Francesco and
Bastiano da Sangallo (from
Raphael's design), Palazzo
Pandolfini, *c.* 1520. Florence

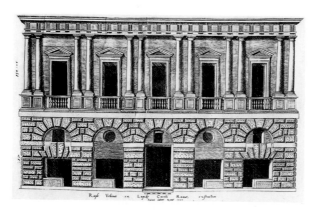

1665 (fig. 13.18). The painter-architect modeled this palace on Bramante's nearby Palazzo Caprini (fig. 13.19), which Raphael then owned, but took a very different approach to the architecture. Bramante had used heavy rusticated blocks and the classical Doric order to express both the principles of load and support and the progress in refinement from street level to *piano nobile.* Although Bramante's columns had no real structural function (they were molded from *stucco*, a durable mixture of lime, water, and sand), they were aligned with the main supporting sections of wall. Raphael seems to have deliberately undermined these principles: he moved the Doric order to the lowest level and visually aligned each column not with another vertical supporting element but with a niche over a projecting pedestal – effectively an architectural void. In the *piano nobile*, he employed a diminished Ionic order that framed the windows and created an alternating rhythm with the Doric below. The *piano nobile* has no entablature; rather, the sections above the windows were filled with a riot of *stucco* swags and medallions. The third storey was a stripped-down, compressed version of the second. Raphael treated the architectural orders here, in sum, not to indicate the bearing of weight but to decorate surfaces. The architectural elements became a language more than a structural necessity, and Raphael's vocabulary is always ancient.

Raphael's most admired villa is the one he designed in 1518 for Pope Leo's cousin Cardinal Giulio de' Medici, just to the north of the Vatican. Now known as the Villa

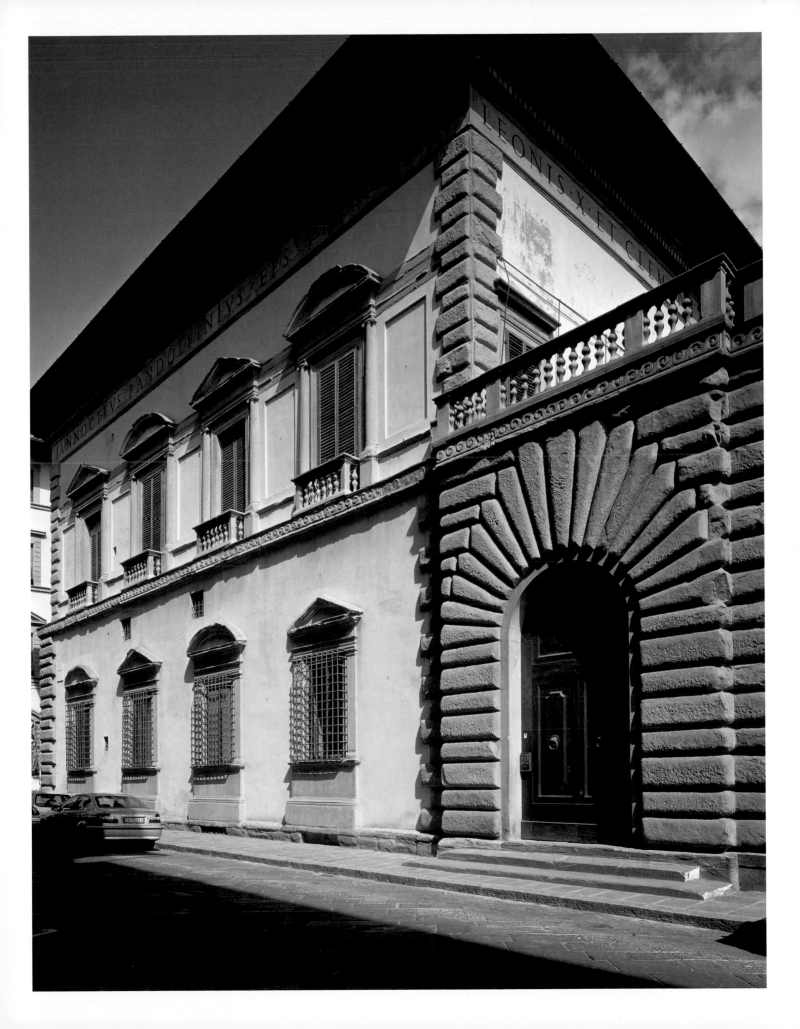

13.21

Gianfrancesco da Sangallo the Younger, after Raphael, plan for the Villa Madama (drawing). Pen and brown ink on paper. Gabinetto Disegni e Stampe, Uffizi Gallery, Florence

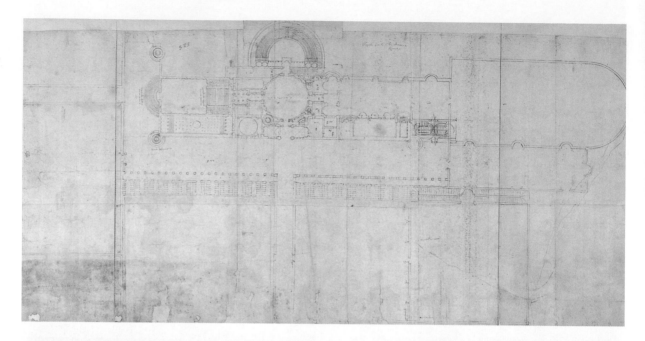

13.22

Raphael, Villa Madama, 1515–21, Rome. Courtyard

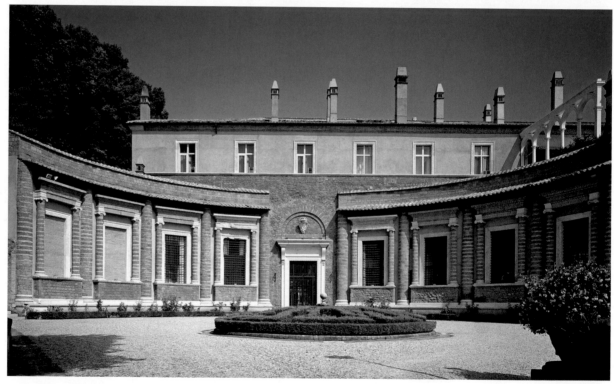

Madama, it was built into the hill, high enough to provide views, but low enough to allow water to flow into it for various purposes. Though the cardinal's family would typically have come to the relatively isolated residence from the city to the south, Raphael oriented the building to the north-east, aligning it with a bridge that crossed the Tiber and protecting the living areas from direct exposure to the summer sun. The main block of the building centered on a round courtyard set into a square perimeter of rooms (figs. 13.21–13.22). Flanking this were to be two wings, the dominant elements of which were likewise courtyards. Though large parts of the space served to house the cardinal, his guests, and his staff, some of its most notable features were conceived to encourage conversation. For the winter months, there was to be a circular room in the eastern corner of the building, glassed in all around, allowing a panoramic view out onto the city. In a letter describing the villa, Raphael referred to the

room with a term he took from a description of a Roman villa by the Roman writer Pliny the Younger (*c.* 61–*c.* 112 CE), calling it a *diaeta* (little apartment) and explaining that it was to serve as place for residents of the villa to meet and talk; they would be kept warm by the sun passing across the windows over the course of the day. For the summer months, a loggia in another part of the building served as a second *diaeta*. Facing north-west so as to remain shady throughout the day, this looked onto an enclosed, terraced garden. In another corner of the garden, neighboring a fish pond, was an area for outdoor dining.

Raphael's Plinian vocabulary suggests that he was consciously modeling the villa on ancient forms. In designing the project, though, Raphael did not just look to the surviving remnants of ancient residences, but also used the commission to bring together what he knew about a range of ancient constructions. The villa was to include a number of fountains, for example, as well as an elaborate bath complex: its sequence of spaces was to comprise changing rooms, an open space for applying oil, a sauna, one room with hot and one with warm water, and a third with a cold pool, large enough for swimming. The villa was also to feature a grand semi-circular theater, complete with actors' dressing rooms and an orchestra space. This was the most elevated part of the complex, and following the examples of Roman theaters that Raphael could have seen in the vicinity, it would have provided the audience with a view out over the landscape, closed off with scenery only when necessary for acoustical reasons during performances.

These elements give a sense of the villa's grandeur; so does Raphael's specification that those entering it would pass between stables housing four hundred horses. The whole enterprise was envisioned on a scale that evokes the papal projects of the previous decade, and like them, it was never completed as its patron and architect intended. Raphael, the mastermind behind the villa, could never have conceived it as he did had it not been for his close contact with the city's expert antiquarians and for the extensive help of his artistic team. Tellingly, the drawn plans that constitute the best records of Raphael's changing vision for the complex come from the hands of collaborators like Giovanfrancesco and Antonio da Sangallo the Younger rather than from Raphael himself. The decoration of the interior fell almost entirely to Giulio Romano and Giovanni da Udine, inheritors of Raphael's Vatican projects. They filled the vault of the loggia with stuccoes and paintings of stories from Ovid, inspired by the ancient Roman decorations of the "Golden House" (*see* p. 300).

Altarpieces

Collaborations of this kind allowed Raphael to preserve time for the kinds of more public commission that would enhance his reputation as a painter, especially altarpieces.

13.23
Raphael, Villa Madama, loggia, begun 1516

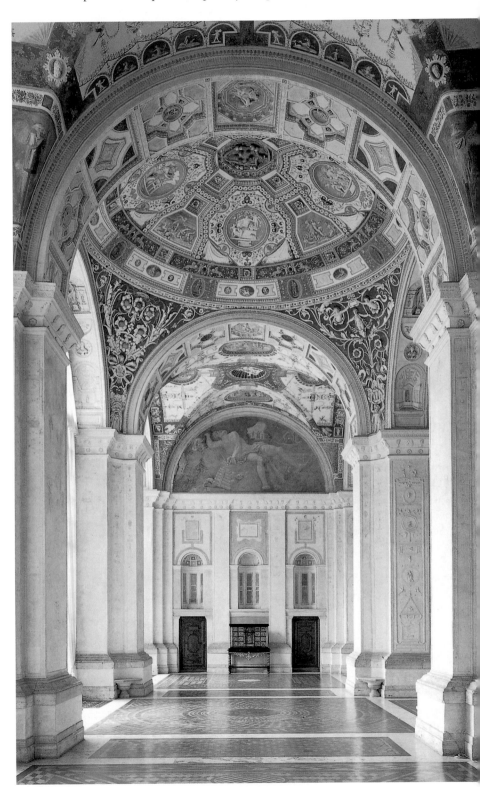

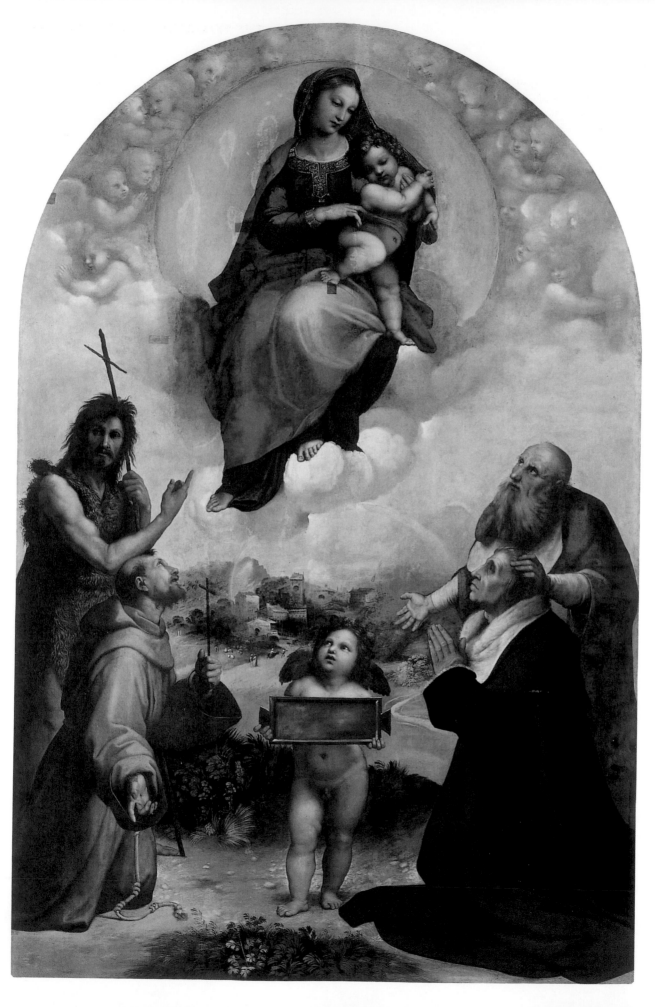

13.24
Raphael, *Madonna of Foligno*, 1511–12. Tempera and oil on panel, transferred to canvas, 10'1¼" x 6'6" (3.08 x 1.98 m). Pinacoteca, Vatican

Among the first of these that he undertook in Rome was one he painted in 1511–12 for the high altar of Santa Maria in Aracoeli but which was subsequently taken to Foligno, the home town of its patron, Sigismondo de' Conti – the papal secretary and humanist we encountered in the last chapter (*see* p. 344) as a defender of the demolition of Old St. Peter's. The *Madonna of Foligno* (fig. 13.24) gives an imaginative new kind of form to the traditional theme of Virgin and saints as heavenly intercessors for the devout. The lion peeking out at the lower right identifies the standing saint as Jerome; he presents the picture's kneeling patron to the Virgin. Opposite this group kneels St. Francis, the patron of the order whose church the altarpiece was to grace, while John the Baptist addresses the viewers who stand before the painting, directing them to look where the picture's occupants do. An angel in the foreground holds a tablet that was presumably intended to bear an inscription recording the circumstances in which the painting was made. (The meteorite that falls in the background landscape may also recall an event of special significance for the patron.) And the Virgin herself, meanwhile, appears as a vision, surrounded by clouds that condense into a throne and a company of angels. Her position may be a nod to the painting's intended site, a church dedicated to the "Virgin of the Altar of Heaven," but it is also a remarkable variation on the conventions of the *sacra conversazione*. Like the analogous characters in most central Italian paintings done after the time of Fra Angelico, those who act as intercessors between the beholder and the Virgin both occupy her space and stand apart from it. In Raphael's picture, the Virgin seems so close that those in the lower part of the painting could reach out and touch her; at the same time, the painting's implication that she is but a vision of those blessed enough to see her suggests that she is not physically present at all, that we are not even really seeing her so much as we are seeing what the intercessory figures see. The viewer's access to the Virgin depends on them to an unprecedented degree.

Raphael developed a variation on these themes two years later, in 1513–14, when he painted a canvas now known as the *Sistine Madonna* (fig. 13.25) for the high altar of a church dedicated to St. Sixtus in Piacenza, near Milan. The number of characters this time has been reduced, and the painting includes full-length figures only of Sixtus, of St. Barbara (identifiable from a glimpse of a tower, her attribute, behind her right shoulder), and of the Virgin and Child. With no patron to depict, Raphael could build the painting around the relationship between the central characters in the picture and the worshipers he expected to stand or kneel before it in the church. As in the *Madonna of Foligno*, there is the suggestion that the Virgin we see is a vision, this time a vision of Sixtus. And the Sixtus in

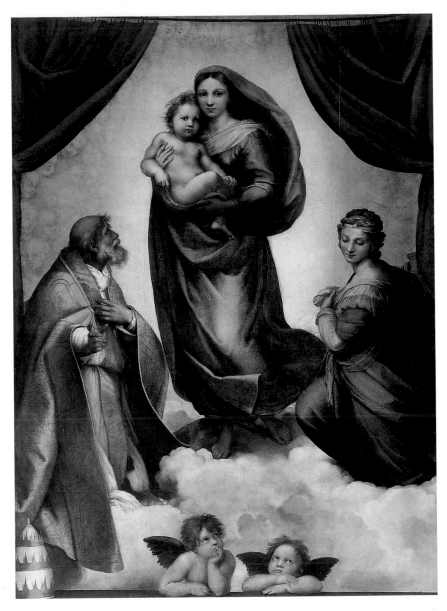

this painting – whose features are close to those of Pope Julius II – seems able not only to offer the churchgoer a glimpse of the apparition that he sees, but also to cross the threshold of the image itself. Raphael insistently, even redundantly, calls attention to that threshold and its violation by including curtains that seem to have been drawn back "in front of" the painting; Sixtus's robe, which casts a shadow on the clouds behind, implying an exterior light source; the ledge that constitutes the bottom edge of the picture, on which the saint's tiara sits and on which two angels lean. The boundary between the viewer and the Virgin and Child in this instance is permeable, and the viewer's advocates – Sixtus and the angels – will cross it on his or her behalf.

Raphael's last altarpiece, *The Transfiguration* (fig. 13.26), was commissioned in 1516 by Giulio de' Medici, the

13.25

Raphael, *Sistine Madonna*, 1513–14. Canvas, 8'8¹⁄₂" x 6'5" (2.7 x 1.9 m). Gemäldegalerie Alte Meister, Dresden

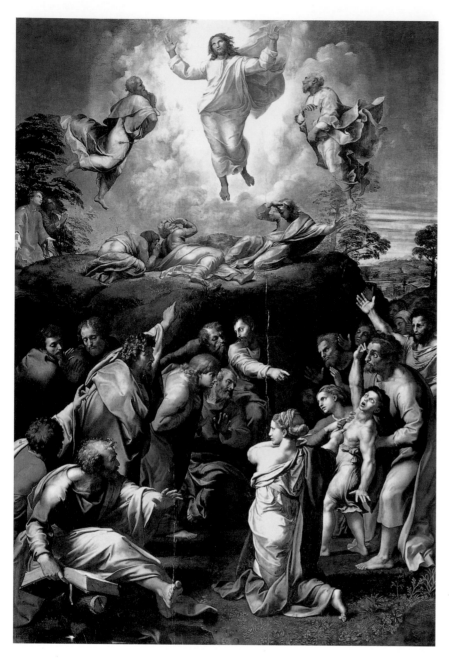

13.26

Raphael, *The Transfiguration*, 1518–20. Oil on panel, 13'4" x 11'7¾" (4.05 x 3.52 m). Pinacoteca, Vatican

The accounts of the event in Matthew, Mark, and Luke all go on to recount that when the four descended the mountain, they learned that in Jesus's absence a man had brought his demonically possessed son to the remaining Apostles, asking them to cure him; with Jesus gone, they could not do it. The father must be the man in green at the lower right of Raphael's painting, holding the half-naked boy with rolling eyes to whom the surrounding crowd reacts with such distress. The painting, which counterposes the Transfiguration itself with the story of the possessed boy, is constructed around a series of antitheses: as light, "white as snow," radiates above, the lower scene is unusually dark and shadowy; as God lifts and speaks through Christ, a demonic force twists the young lunatic, whose eyes roll toward the Savior above; as the group above moves into a symmetrical, iconic arrangement, centering on the figure of the divine son, the despairing group below forms a circle with nothing but empty darkness in the middle. It is a powerful imagining of the difference between the presence and absence of Christ in the world, and even between the heavenly promise greeting believers and the haunted Underworld that awaits others. That is the reason, no doubt, that when Raphael died in 1520, it was this painting that was placed above his body during its official viewing.

Raphael, Sebastiano del Piombo, and Michelangelo

The unusual composition of *The Transfiguration* may have had an additional motivation as well, for Raphael executed the painting in rivalry with another artist, the Venetian Sebastiano del Piombo (who we noted was also to paint the altarpiece for the Chigi Chapel; *see* fig. 13.2). Cardinal Giulio had commissioned Sebastiano to paint an altarpiece, also for Narbonne, of similar scale and format to Raphael's, *The Raising of Lazarus* (fig. 13.27). Sebastiano, as was expected, displayed his command of the atmospheric Venetian landscape and lighting effects he had acquired in the circle of Giovanni Bellini and Giorgione; he also had help from Michelangelo, who provided drawings for some of the figures. The lower (godless) half of Raphael's panel in particular seems intended to compete with Sebastiano's, in its dramatic *chiaroscuro* effects and even in its theme: Sebastiano's shows Christ raising Lazarus from the dead, and in St. Mark's account of the possessed boy, Christ's eventual expulsion of the demon actually kills the child, at which point "Jesus, taking him by the hand, lifted him up; and he arose." Given Raphael's status in Rome by this point, he would hardly have worried about Sebastiano as a challenger, but Michelangelo was another story, and the most Michelangelesque part of Sebastiano's design is the muscular Lazarus, who resembles an ancient ath-

same cardinal for whom the artist was designing the Villa Madama (*see* figs. 13.22–13.23). Intended for the cathedral of Narbonne in France, where Giulio was archbishop, the painting shows two narrative episodes that the Gospels imply took place simultaneously. The upper half, which gives the painting its traditional name, shows Christ's Transfiguration, when, having accompanied Jesus up a mountain, Peter, James, and John watch as "his garments became shining and exceedingly white as snow.... And there appeared to them Elias with Moses; and they were talking with Jesus.... And there was a cloud overshadowing them: and a voice came out of the cloud, saying: This is my most beloved son; hear ye him." (Mark 9:1–6.)

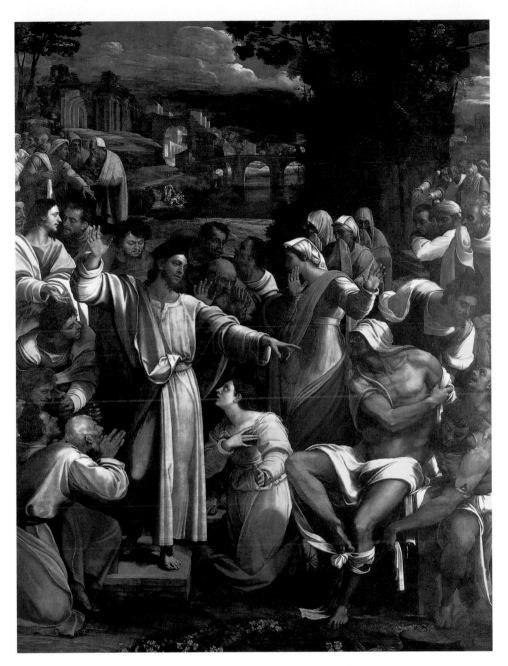

13.27
Sebastiano del Piombo,
The Raising of Lazarus,
1517–19. Oil on canvas
(transferred from wood),
12'6" x 9'6" (3.81 x 2.9 m).
National Gallery, London

lete more than a wasted corpse. In context, the contorted, insane semi-nude in Raphael's painting begins to look like a parody of one of Michelangelo's stylistic hallmarks – the vigorously moving "inspired" (or in this case possessed) youthful male figure.

By 1520, Sebastiano was completing a chapel decoration at Rome's San Pietro in Montorio that included a mural altarpiece of the *Flagellation of Christ* and, in the dome above, a *Transfiguration* (fig. 13.28). The patron, a Florentine merchant named Pierfrancesco Borgherini, encouraged the participation of Michelangelo, who provided designs before leaving for Florence in 1516 and continued to send these at Sebastiano's request: his

involvement is conspicuous in the heroic musculature of Christ and the vigorous turning poses of the tormentors. Early sixteenth-century viewers admired the work for its joint authorship, for its realization of Michelangelo's idea in an innovative Venetian technique. We have seen in the case of Leonardo how working in an oil-based medium on a wall surface could lead to unsatisfactory results (*see* fig. 11.46). Yet Sebastiano by now had discovered a method of painting in oil on stone and plaster, enabling a richness of color and a tonal unity beyond the reach of previous mural painting: the gleam of the golden dome in the background of the *Flagellation* (*see* fig. 13.29) invites comparison with Bellini's altarpieces. It is hard not to see the

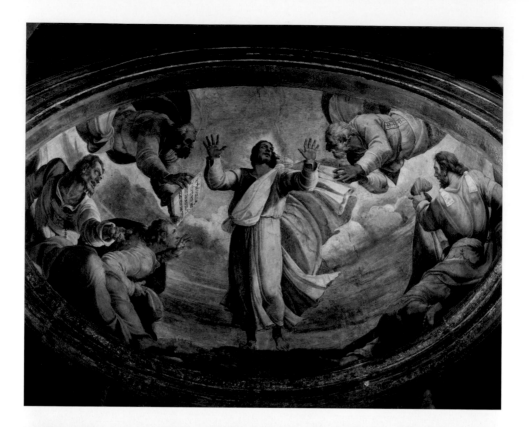

13.28
Sebastiano del Piombo,
Transfiguration of Christ,
1516. Fresco. Borgherini
Chapel, San Pietro in
Montorio, Rome

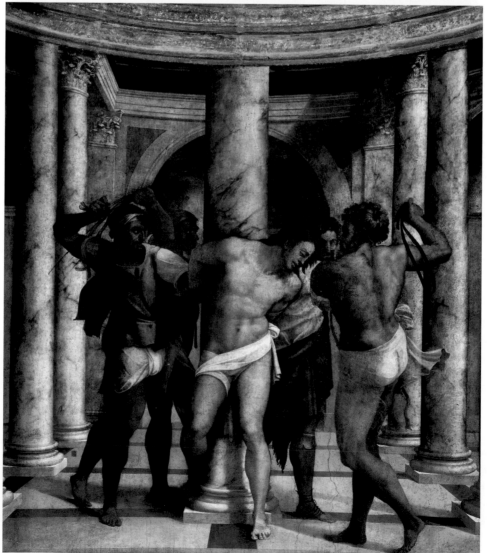

13.29
Sebastiano del Piombo,
Flagellation of Christ,
1519–20. Fresco. Borgherini
Chapel, San Pietro in
Montorio, Rome

Transfiguration above as a rejoinder to Raphael – instead of a serene and radiant Christ raised in the air, Sebastiano and his collaborator produced a standing figure with boldly foreshortened arms, gazing rapturously upward as Moses and Elijah descend in postures of characteristic Michelangelesque difficulty.

Raphael and the Portrait

The other type of painted work to which Raphael continued to devote himself in these years was the portrait. In 1518 he produced a group portrait showing Leo X seated with two of the Medici cardinals, his cousins Giulio de' Medici (the patron we have been following) and Luigi de' Rossi (fig. 13.30); the Pope handles a magnifying glass and looks up from perusing an illuminated Bible, open at the beginning of the Gospel of St. John – the Pope's namesake (he was born Giovanni de' Medici). An exquisitely painted gold and silver bell bears the Medici coat of arms. The portrait thus refers both to Leo's priestly leadership of the Church and to his leadership of the Medici family, while also characterizing him as a person of refined and luxurious tastes. Here, the human being and the spiritual office coincide in a single person. Raphael's portrait was sent to Florence in 1518 and displayed in the Palazzo Medici when Lorenzo, the Duke of Urbino, married a French royal princess; during the ceremony, it functioned as a surrogate for the Pope himself. The painting's extraordinary vivacity would have let it play that role especially well: Raphael's management of light effects continues the explorations of luminosity and shadow in the Stanza d'Eliodoro (*see* fig. 13.6). Of greater importance for its initial audience, however, was the way the work enhanced the status of two members of the Medici family whose legitimacy was questionable, despite official recognition by the Pope himself.

Though Michelangelo used assistants, he preferred to be thought of as a man who worked alone, cultivating a reputation as being inimitable in his display of the difficulties of art and his awesome grandeur ("terribilità"). The unusual history of Raphael's portrait, by contrast, illustrates the various ways in which his art emerged as a "collective" creation. Giulio Romano (*c.* 1499–1546) later claimed that he had worked on the painting in Raphael's studio. When in 1524 the Duke of Mantua asked the Medici to give him the portrait as a gift, the Florentine Andrea del Sarto (1486–1531) made a copy, counterfeiting Raphael's manner so well that the Medici passed it off successfully as the original – and Giulio himself took it for the original when he saw it in Mantua. Vasari, who tells this story, had studied in Sarto's workshop, and claims that he proved otherwise by showing Giulio Andrea's secret mark of authorship.

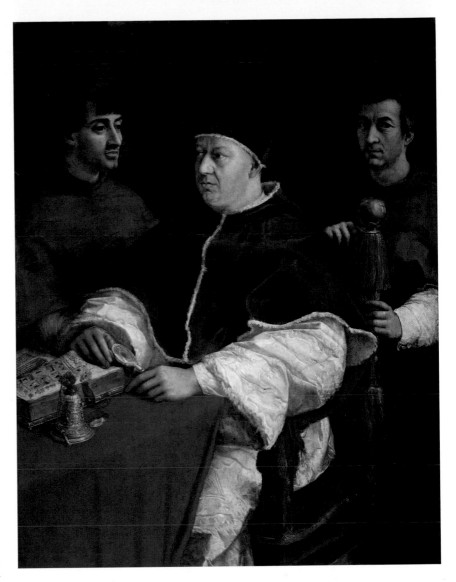

Raphael painted friends and collaborators as well as patrons, using the genre of the portrait not just to create occasions to chat with the cardinals and popes who commissioned career-making works from him but also to record and even to convey more personal affections. Raphael specialized, in fact, in the new sub-genre of the "friendship portrait," a single image showing two (male) friends together. An early example is the *c.* 1516 canvas of Andrea Navagero and Agostino Beazzano (fig. 13.31), two poets Raphael painted for their mutual friend, the scholar, poet, and cardinal Pietro Bembo. The arrangement of the figures, with bodies oriented toward one another but heads turned toward the viewer, recalls that of the Doni portraits Raphael had painted in the previous decade (*see* figs. 12.19–12.20). It is as though he has put two men in the positions of the spouses, then removed the frames that separated them.

The portrait as surrogate presence is an important consideration here as well. Hanging on Bembo's wall, the painting would have compensated for the absence of Raphael himself no less than the men it showed, and it is

not surprising that the artist played a more direct part in his second experiment with this format (fig. 13.32). This one, as we know from the inscription on a later print, shows Raphael himself as a standing bearded man of about thirty-five. The seated man at the center of the picture, who turns back to look up at Raphael, has never been identified – one whimsical legend, based on nothing but the fact that the man wears a sword, suggests that he was Raphael's fencing master. What can be said is that it was someone to whom Raphael had the closest of ties, for the painter places one hand on the man's shoulder and the other on his waist. The man's gesture, directed out of the painting like that of St. Sixtus in Raphael's contemporary altarpiece (*see* fig. 13.25), may indicate that this picture, too, once addressed a third member in a circle of intimates. Or perhaps it invites another reading: Raphael would have used a mirror to generate his own self-portrait, and his friend's gesture may therefore be drawing his attention to the importance of self-scrutiny. This could refer to the philosophical maxim "Know Yourself," which was sometimes inscribed on mirror frames,

yet also to the prudent control of one's appearance that was essential to surviving in courtly society. Portraits like these serve as testaments to Raphael's sociability. They give at least a glimpse of a personality alongside of whom both scholars and other artists gladly worked. In fact, Raphael's more personal relationships and professional collaborations were not as distinct from one another as we might expect.

A late portrait shows a woman with a nearly bared torso drawing a transparent veil across her stomach (fig. 13.33). The arrangement of the two arms evokes a *pudica* ("modesty") gesture from ancient statuary, but since these arms hide nothing more than the gauzy drapery, this does less to indicate modesty than to compare the woman's beauty to the Venus with which such gestures were associated. Most viewers have taken the armband bearing Raphael's name to imply that the sitter was, in one way or another, the artist's possession; in the nineteenth century, a myth arose that she was the daughter of a baker (a "Fornarina") whom the painter had taken as a mistress. Such stories encour-

13.31

Raphael, *Portrait of Andrea Navagero and Agostino Beazzano, c.* 1516. Oil on canvas, 30⅜ x 43⅝" (77 x 111 cm). Galleria Doria Pamphilj, Rome

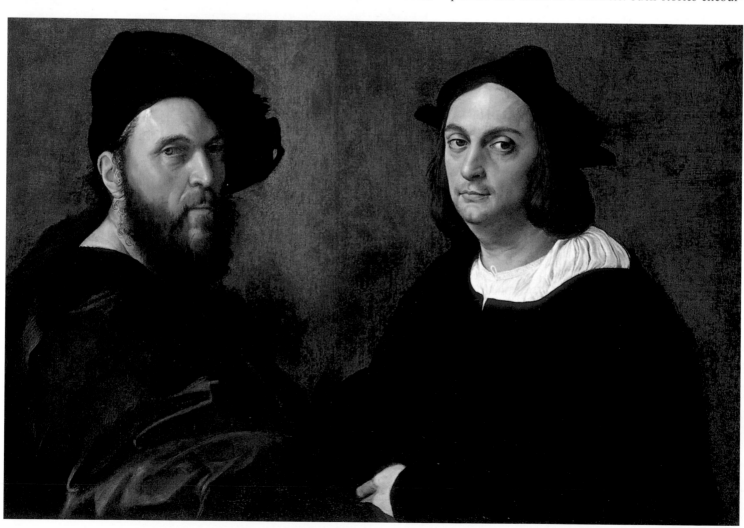

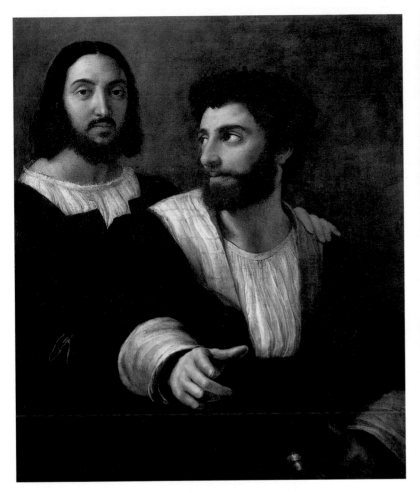

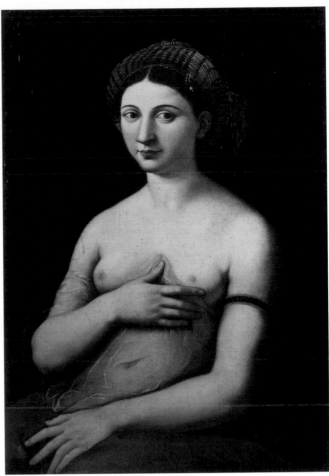

ABOVE LEFT

13.32

Raphael, *Self-Portrait with his "Fencing Master,"* c. 1518. Oil on panel, 39 x 32¹/₂" (99 x 83 cm). Musée du Louvre, Paris

ABOVE RIGHT

13.33

Raphael and Giulio Romano, *"La Fornarina,"* c. 1518. Oil on panel, 33¹/₂ x 23²/₃" (85 x 60 cm). Galleria Nazionale di Palazzo Barberini, Rome

age us to view this as the most intimate of images, yet recent scholars have observed that many passages in the picture are closer stylistically to Giulio Romano than to Raphael. It may be that this, too, was a collaborative work, that even the pictures that came to look private and personal were, in the studio of Raphael, an opportunity to cultivate and disseminate a shared ideal of pictorial beauty.

Michelangelo's Sculptures for the Julius Tomb

Raphael seems to have been well disposed toward working with others, even if the kinds of collaborations into which he entered after his move to Rome were to a large extent necessitated by the scale of the popes' ambitions. Such ambitions consumed the attention of Michelangelo as well, and he was an artist much less temperamentally inclined to participate in or even oversee a team of the kind Raphael tended to assemble. Michelangelo's own way of handling papal projects in these years only throws into relief how distinctive Raphael's enterprise was.

In the last chapter we noted that Michelangelo had been brought to Rome in the first place so that he could work on a massive tomb for Pope Julius II. Now, with the painting of the Sistine Chapel ceiling complete and the other Vatican murals in the capable hands of Raphael and company, Michelangelo was put back to work on the tomb's sculptures. A group of drawings appears to record this phase of the project, the features of which correspond to later descriptions by Vasari and by the rival biographer Ascanio Condivi. Around the bottom storey there was to be a series of niches with statues in them: a design in Berlin shows winged female Victories, each with one arm raised, standing in triumph over a recumbent body (fig. 13.34). Flanking the niches are herms, to each of which was bound a nude male slave or prisoner. Unifying this whole story was a cornice, above which were larger, seated figures: Moses, St. Paul, and allegories of the Active and Contemplative Life, each flanked by what appear to be bound putti. In the center, on a giant bier, was an effigy of the Pope; above him, the Virgin and Child. Both Vasari and Condivi suggest that the tomb would have included other figures, ornaments, and reliefs as well.

13.34
Follower of Michelangelo, study for the Julius Tomb. 22³⁄₈" x 15¼" (56.8 x 38.6 cm). Kupferstichkabinett, Berlin

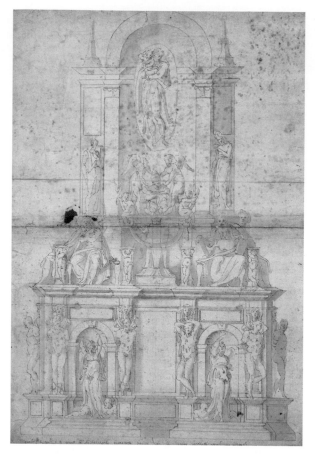

13.35
Michelangelo, *Dying Slave*, 1513–16. Marble, height 7'6" (2.28 m). Musée du Louvre, Paris

tues were prisoners of death together with Pope Julius, as they would never find another to favor and foster them as he did." The idea of surrounding the dead Pope with the arts he had patronized is one that Michelangelo would certainly have known from Pollaiuolo's Sixtus IV tomb (*see* fig. 10.25), and one prisoner, which centuries later came to be called the *Dying Slave*, includes a half-carved attribute at the figure's feet: a monkey, probably a reference to the expression "art, the ape of nature" (*ars simia natura*).

Michelangelo does not make interpretation particularly easy, however. If the *Dying Slave* (fig. 13.35) had been installed on the tomb as projected in the 1513 drawing, its lone attribute would have been difficult to read, and would hardly have seemed decisive in the context of the larger series of figures. Here as elsewhere, the artist developed open-ended, multivalent figures that lent themselves to competing interpretations of the kind Condivi and Vasari would later exemplify, as well as to more private and self-referential meanings. Working his way into the tomb project, in fact, Michelangelo not only selected the parts of it that were most consistent with his developing artistic interests, but also focused on aspects of it that, like David's confrontation with the giant a decade earlier (*see* fig. 12.3), allowed him to reflect on his own art. The most prominent of the *Dying Slave*'s ligatures is a cloth that wraps around his chest. Raised just

Julius's death in 1513 saved Michelangelo from actually having to carry out the gargantuan amount of carving that designs like this promised, but the Pope's heirs did commit the sculptor to complete something, and a contract from the same year allowed for a slightly reduced plan: rather than a free-standing structure, Michelangelo would be permitted to make a wall tomb. This eliminated one whole side of the monument, though what remained still went far beyond the wall tombs of the Quattrocento: the contract called for a structure that would project some twenty-five feet out in space. It was with this in mind that Michelangelo went to work. In what would prove to be characteristic of him, he avoided setting the chisel to the portrait that had been the defining feature of every earlier tomb. Instead, he worked on two of the prisoners from the lower zone. These gave him the opportunity to continue exploring the motif that had most occupied him on the Sistine Chapel ceiling, that of the nude male body. Vasari maintained that the prisoners represented "provinces subjugated by that Pontiff and rendered obedient to the Apostolic Church," but the often more reliable Condivi writes that they rather "represented the liberal arts, such as painting, sculpture, and architecture, each with its attributes so that it could easily be recognized for what it was, signifying thereby that all the artistic vir-

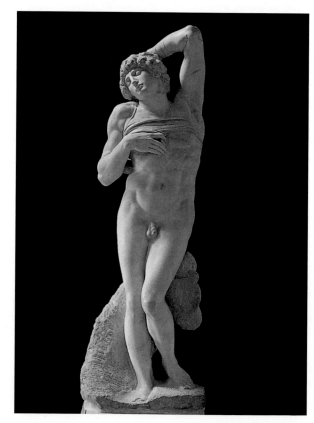

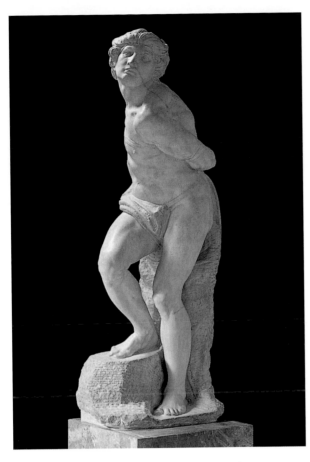

colossal undertakings required the coordinated labor of an army, Michelangelo wanted his sculptures to be seen as the result of more laborious and solitary work. The *non-finito* (unfinished) portions may or may not represent what Michelangelo intended as a final state, but they in any event evidence a non-collaboration that distinguished him from his Roman contemporaries. In the end, he would have imitators, but no disciples.

The single most spectacular figure Michelangelo produced for the tomb was his colossal *Moses* (fig. 13.37). This occupies a plain pedestal, and the absence of impediments like a chair arm or back allows the figure to command the surrounding space. Though Moses is seated, the pose, with the left leg stepping back to press against the most distant corner of the block, evokes the stride of an ancient athlete. Under his right arm Moses holds the Tablets of the Law, while his massive hands finger the strands of a seemingly endless beard. The scowling face,

13.36

Michelangelo, *Rebellious Slave*, c. 1513–16 (?). Marble, height: 7'1³/₄" (2.16 m). Musée du Louvre, Paris

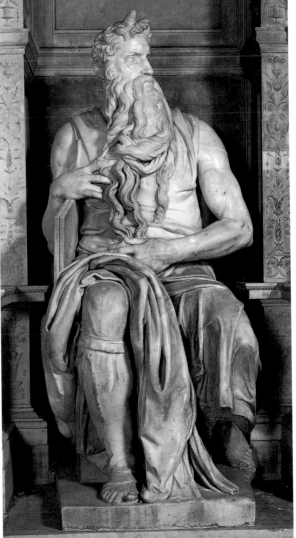

13.37

Michelangelo, *Moses*, c. 1515. Marble, height 7'8¹/₂" (2.36 m). San Pietro in Vincoli, Rome

enough to expose his left breast, it draws attention to the flesh revealed beneath as much as it suggests bondage, advertising Michelangelo's command of the nude but also evoking the process of sculpting a figure, which involves the removal of outer layers of the stone block to unveil the body inside. That the second of the three figures Michelangelo carved showed another slave – also in the Louvre, and now commonly called the *Rebellious Slave* (fig. 13.36) – suggests that the theme of imprisonment especially interested him. In the case of this second figure, Michelangelo not only broke off work before polishing the face and working the hair of the figure, but also left a shell of barely carved marble that extends more than halfway up its body, enclosing its backside. Already in the Renaissance, viewers were tempted to see these works of Michelangelo not just as statues that he had not had time to complete, but as works whose unfinished state itself carried meaning. The earlier *Pietà* (*see* fig. 11.51), after all, had been signed "the Florentine Michelangelo Buonarroti was making this;" the jarring contrasts between the marks of the claw chisel and the sheen of the polished surface, no less than the binding theme and the monkey's explicit reference to the arts, point less to the Pope the statue was to serve than to the act of making itself. Whereas early commentators recognized that Raphael's

13.38

Michelangelo, Raffaello
da Montelupo, and others,
tomb of Pope Julius II
(as ultimately installed),
1542–45. San Pietro in
Vincoli, Rome

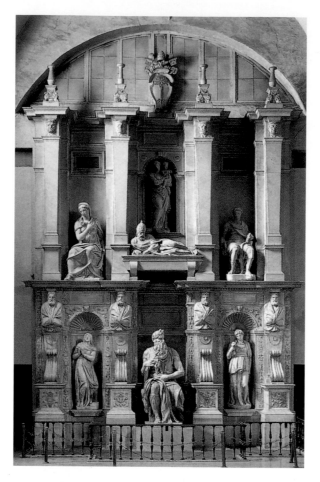

ther with the sculptures, and by 1518 he was in Florence. Charged by the new Pope, Leo X, with adding a facade to the church of San Lorenzo, Michelangelo was unable to work on the tomb. A complicated series of subsequent negotiations resulted in the Slaves being dropped from the tomb program altogether; Michelangelo gave the two he had carved in Rome to a friend, who in turn gave them to King Francis I of France. The *Moses*, once intended to be part of a series of relatively marginal adornments to the tomb's second storey, became its centerpiece, placed on axis with the reclining portrait of Julius and flanked by smaller figurations of the Active and Contemplative Life, in the persons of the Old Testament exemplars Rachel and Leah. As with the paintings Sixtus IV had commissioned for the Sistine several decades earlier, the ancient priest and lawgiver Moses would become a double for the Pope himself. Little of the tomb as it was finally installed in San Pietro in Vincoli in the 1540s (fig. 13.38) is by Michelangelo himself, and the monument's disjunctions in style and scale, its gathering of figures that do not really belong together, in the end present a bathetic deflation of what might have been the greatest tomb of the modern age. Eschewing Raphael's workshop model in pursuit of individual, more personally meaningful subjects ultimately determined not just the look but also the fate of Michelangelo's sculpture.

The Florentine "Schools"

The School of San Marco: Fra Bartolomeo and Mariotto Albertinelli

Elsewhere in Italy, there was not yet anything quite comparable to Rome, with its top-down coordination of artists undertaking vast works involving the widest variety of media. Still, the associations into which an artist did or did not enter could be decisive for his formation. Benvenuto Cellini, as we have seen, referred to the artists studying the cartoons for the Great Council Hall in Florence as a "scuola" or "school," and Leonardo da Vinci was at the center of an informal group of literati he or others referred to as an "academy." These were concepts that pushed education beyond the traditional idea of the workshop apprenticeship.

One of the city's major collaborative enterprises was based in the monastery of San Marco, where Fra Bartolomeo oversaw a team of assistants and also worked in partnership with the master painter Mariotto Albertinelli (1474–1515). The painters' 1512 *Mystic Marriage of St. Catherine* (fig. 13.38), produced as an altarpiece for the church of San Marco, illustrates their complicated relationship to recent local developments. On the

like that of Michelangelo's *David* (*see* fig. 12.3), implies the presence of something else in the figure's space, and early art historians (along with Sigmund Freud) fantasized that this Moses was looking wrathfully at the idolaters dancing around the golden calf as described in Exodus 32. The age, scale, pose, and high finish of the sculpture contrast starkly with the two slaves, yet Michelangelo's interests in those two figures carry over unmistakably here. The material that wraps Moses's feet – is it cloth? the leather straps of sandals? – constitutes just one of the binding motifs that appear here, too, from the cinched garment below his right knee to the curious strap that wraps his left shoulder. The arrangement of the drapery, meanwhile, piled so as to expose the figure's leg, echoes the denuding of the body that the *Dying Slave* (*see* fig. 13.35), too, dramatized. The impression the statue gives is that Michelangelo was using the assignment to pursue his own interests as much as he was responding to a patron's requirements.

Michelangelo seems to have worked on these figures for over three years. Finally, in 1516, probably recognizing how unreasonable the scale of the assignment still was, Julius's heirs drew up a new contract that reduced the already revised tomb project by nearly two-thirds. Even this, though, was optimistic. Michelangelo did little fur-

OPPOSITE

13.39

Fra Bartolomeo and
Mariotto Albertinelli,
*Mystic Marriage of St.
Catherine* (Pitti altarpiece),
1512. Panel, 11'8¼" x 8'9"
(3.56 x 2.7 m). Galleria
Palatina, Palazzo Pitti,
Florence

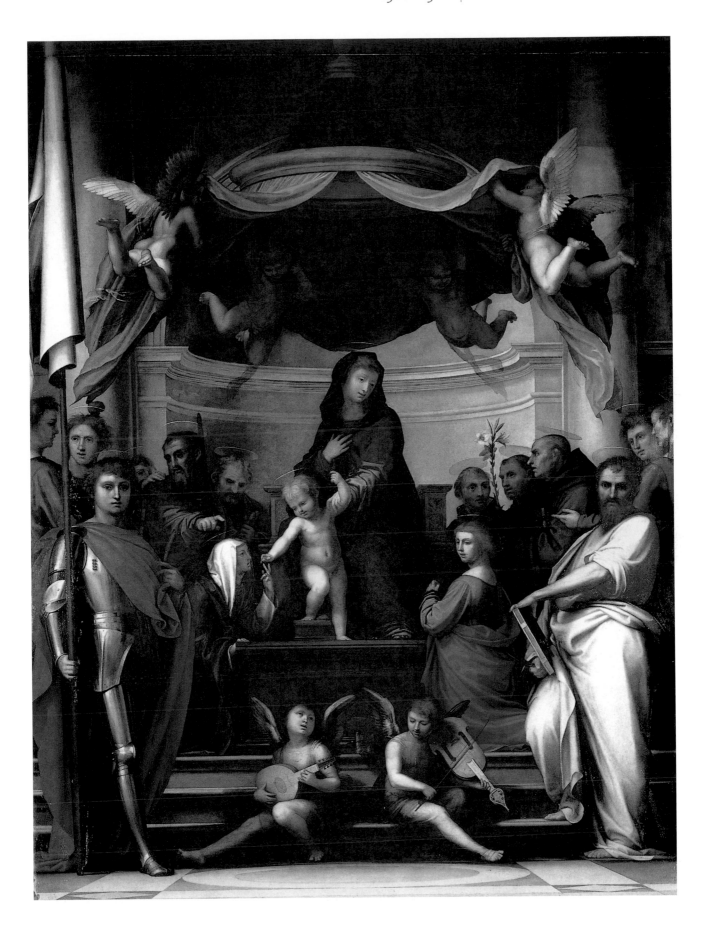

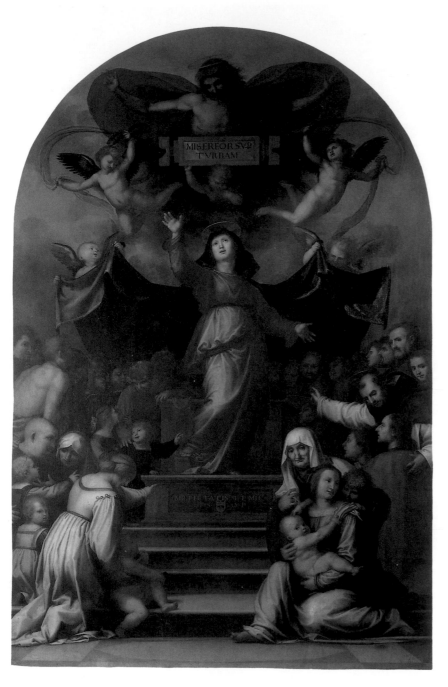

13.40

Fra Bartolomeo, *Virgin of Mercy*, 1515. Oil on canvas, Museo di Villa Guinigi, Lucca

lar nude angels in virtuoso foreshortening. Yet even as these figures' dynamic poses and idealized anatomy leave no doubt that Bartolomeo and Albertinelli were aware of modern art in Rome, they avoid the complexity of altarpiece design as it was developing in the hands of Raphael and Sebastiano. The painters have transformed the episode of the Mystic Marriage, when St. Catherine (the woman in white and black Dominican garb at center left) had a vision of receiving a ring from Christ, into a conventional *sacra conversazione*, as though to ensure that it would work as an altarpiece and a focus of devotional meditation. Though assembling a painting with more than twenty characters, they pursued compositional clarity through a rigorous symmetry whereby every figure on the left has a partner, in something close to the reverse pose, on the right. To minimize distraction from the Virgin, Child, and Dominican saint at the center, finally, Bartolomeo and Albertinelli gave most of the remaining gathering a generic quality. We might recognize St. Dominic's lily or St. Paul's sword, but little individualizes the others in the group.

It is this caution that has stood out most to recent writers on the "School of San Marco," and Bartolomeo in particular. He is the rare artist about whom we can say something fairly concrete when it comes to his religious life, and writers have consequently been tempted to see his orderly, simplified compositions as the natural product of an adherent to the dour Girolamo Savonarola (see chapter 11). The devices Bartolomeo adopted from Leonardo and Michelangelo, however, give his figures a surprisingly sculptural presence, as though the goal of devotional painting were to create a literal "object" of devotion. And Bartolomeo pushed his art still further along these lines when he painted for clients outside of Florence, indicating that the apparent conservatism of his Florentine works was a response to the expectations of a clientele used to Perugino and early Raphael. His 1515 *Virgin of Mercy* (fig. 13.40), painted in the service of a fellow friar for a chapel in the church of San Romano in Lucca, is in some ways even more restricted in its colors, more ascetic-looking, more bound by an all-pervasive *sfumatura*. Yet the rigorous symmetry of the composition focuses attention on the powerful and dramatically gesturing Virgin, who, protecting a congregation that extends not just beside and before but also *behind* her, comes to seem almost like a cult statue, a figure one could look upon from all sides.

The School of the Annunziata: Andrea del Sarto, Jacopo Pontormo, Rosso Fiorentino

The rival "school" in Florence in these years formed just about a block away from San Marco, when the three

one hand, few contemporaries so unreservedly embraced Leonardo's *sfumato* and his pursuit of tonal unity. Here the brown undertones with which Leonardo characteristically began pervade the whole picture. Bartolomeo and Albertinelli restricted their palette to the most basic range of hues, then blended these with whites and blacks, sacrificing coloristic intensity in favor of dramatic *chiaroscuro* effects. The painters' "sculptural" approach, with its emphasis not just on coherence but also on a sense of volume and relief, is evident especially in the canopy miraculously borne over the Virgin by muscu-

painters who would establish the most important local early sixteenth-century idiom worked side by side in the Chiostro de' Voti (Cloister of the Vows), the atrium that introduced the church of the Santissima Annunziata. The leader here was the son of a tailor who went by the nickname Andrea del Sarto (*see* p. 391). He had copied the works made for the Great Council Hall and he must have known the early paintings of Raphael, too, since his first pictures include Madonnas in that manner. (Later, as we have seen, Sarto would also copy Raphael's portrait of Pope Leo with his cardinal nephews; *see* fig. 13.30), demonstrating that he, the city's senior painter, commanded Raphael's manner.) Assisting Sarto were Jacopo Pontormo (1494–1557) and Giovanni Battista di Jacopo (1494–1540), called "Rosso Fiorentino" (literally, "the red-headed Florentine"); the two are sometimes referred to as Sarto's "students," but they were only eight years his junior. Pontormo seems to have joined up with Sarto after working briefly with a series of other older painters, which suggests that he sought him out after experiencing dissatisfaction elsewhere. Vasari says similarly of Rosso that he drew after Michelangelo's *Battle of Cascina* cartoon (*see* fig. 12.12), but that he "would study art with but few masters, having a certain opinion of his own that conflicted with their manners." The trio, in other words, were opinionated men who seem to have found an affinity with one another; though each was in charge of his own painting for the cloister, what they made there was in dialogue with one another.

The paintings themselves, frescoes showing scenes from the life of the Virgin, could never be mistaken as works of the same hand. Sarto's 1514 *Birth of the Virgin* (fig. 13.41), unlike the murals of Pontormo and Rosso, sets its figures in a deep, perspectively defined space. Arrayed across the foreground are attendants to Mary's mother Anne, a figure, as we have seen, of particular devotion in Florence. Anne's melancholic husband Joachim, excluded from the rest of the group, leans on a ledge at the back, and a doorway opens onto yet another room beyond. The rather old-fashioned arrangement comes across as a rejection of Rosso's probably slightly earlier

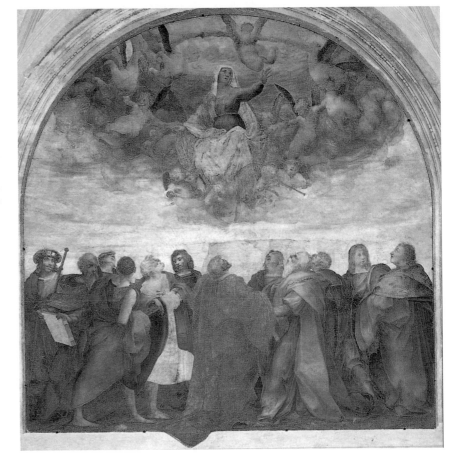

RIGHT, ABOVE

13.41

Andrea del Sarto, *Birth of the Virgin*, 1514. Fresco. Atrium, Santissima Annunziata, Florence

RIGHT, BELOW

13.42

Rosso Fiorentino, *Assumption of the Virgin*, 1513–14. Fresco. Atrium, Santissima Annunziata, Florence

Assumption of the Virgin (fig. 13.42), which has almost no space at all, jamming a frieze of comically grotesque figures right up against the picture plane and separating them with near blankness from the vision they see above of the Virgin ascending, uncorrupted and undying, into heaven. Pontormo's *Visitation* (fig. 13.43), probably not completed until 1516, is something of a compromise between the two. He preserves Rosso's monumentality and even translates his contemporary's foreshortened heavenly oculus, recapturing it as a curved architrave. Like Sarto's, though, his space is resolutely architectural, but with the aim of opening it up to the spectator. Pontormo has several characters respond to the presence of the viewer, and, perhaps noticing how the drapery of Rosso's central character comes right out of the picture, he defines the bottom edge of his own fresco with a staircase that seems to invite the viewer to climb right in. More strikingly, he includes several characters who seem to have little connection with the Gospel story of the Visitation, and who do little more than draw atten-

tion to the artist's command of beauty and his inventive power. The little boy seated on the stairs, for example, is an animated and ornamental descendant of the putti in Donatello's *Cantoria* (*see* fig. 5.20). Such figures appear almost like a signature of Pontormo, Sarto, and Rosso in these years.

For all of their differences, the painters shared a radical approach to color, one that abandoned both Leonardo's unifying *chiaroscuro* and the more luminescent palette of their Quattrocento predecessors. Given Sarto's family background, it may not be surprising that textiles play such a vital role in the paintings of his circle. In all three frescoes, draperies serve as elemental units, and not only their hues but also their juxtaposition is often surprising: Pontormo, for example, works with unexpected sequences of orange, purple, and green. In all three paintings, the colors, limited in number, repeat across the picture plane, to the extent that naturalism seems subordinated to an almost abstract composition. Rosso's draperies are completely out of scale with the

13.43

Pontormo, *Visitation*, 1514–16. Fresco. Atrium, Santissima Annunziata, Florence

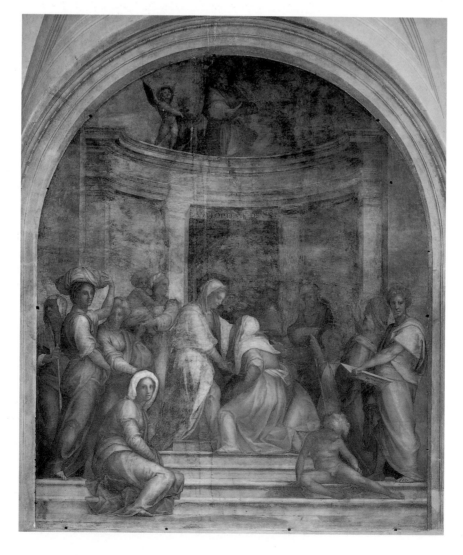

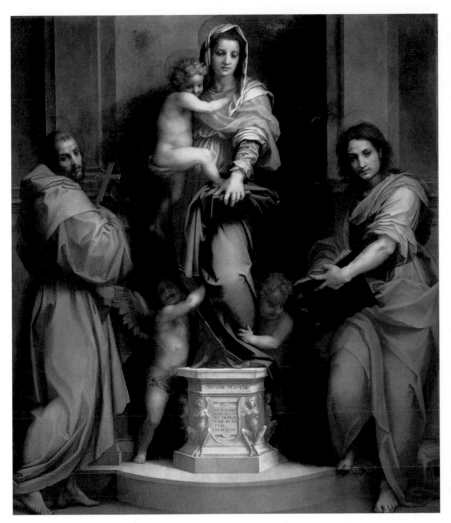

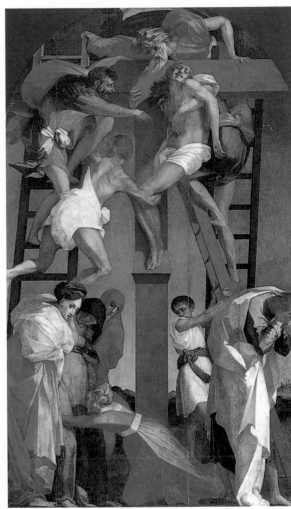

bodies implied by the figures' heads, and Sarto paints a doorframe and bowl the same lavender as one midwife's dress, balancing the design rather than trying to describe specific materials.

Color would continue to occupy the three after they separated, as they moved on to different projects. Sarto's later works of the decade were perhaps the most subtle. In his *Madonna of the Harpies* from 1516 (fig. 13.44), he seems to start with one of Fra Bartolomeo's symmetric, sculptural, *sfumato*-laden compositions (*see* fig. 13.40) and then to animate his characters with thorough infusions of color. This is especially the case with the Virgin, whose pose and whose placement on what appears to be a marble pedestal – the monstrous ornaments of which give the painting its conventional title – make her look more like a statue miraculously coming to life than like the regal human being at the center of the conventional *sacra conversazione*. (Sarto's studio in Florence was next door to that of the sculptor Jacopo Sansovino, who sometimes produced wax models for Sarto to paint after.) The smoke that appears to enter the painting from some

unspecified external source likewise nods to Bartolomeo's *sfumatura*, while also evoking the honorific acts one might perform before an image, such as the burning of incense. It is as though color itself has given the figure the capacity to respond, enlivened, to the presence of a reverential viewer. For Sarto, unlike Leonardo and Bartolomeo, color was a means rather than an impediment to pictorial unity. Mysterious blue tinges in the lower part of St. Francis's robe and in the drapery over St. John's shoulder pick up the hue from Mary's drapery; this repetition binds the painting together, reining in the character of John in particular, whose intense orange and lavender garb might otherwise leap off the surface. In this respect, Sarto's mature approach to color could not have been more different from the experiments Rosso would undertake, the most dramatic of which was the *Deposition* he painted in Volterra around 1521 (fig. 13.45). Here, overscaled draperies of the kind he used in his *Assumption* (*see* fig. 13.42) incorporate abrupt shifts in hue or tone that make it difficult to read them as objects at all. The colors obey no rationalized lighting system, and their

ABOVE LEFT

13.44

Andrea del Sarto, *Madonna of the Harpies*, 1516. Oil on panel, 6'8¾" x 5'10" (2.07 x 1.78 m). Uffizi Gallery, Florence

ABOVE RIGHT

13.45

Rosso Fiorentino, *Deposition*, c. 1521. Oil on panel, 12'4" x 6'5" (3.75 x 1.96 m). Pinacoteca, Volterra

concentration at the edges of the picture pulls the composition apart rather than bringing it together, as though they embody in themselves the trauma that the death of Christ has inflicted.

Later sixteenth-century viewers would forget that Pontormo, Rosso, and Sarto had started in much the same place. Seeing the direction in which the disciples of Sarto – not just Pontormo, Rosso, and their own students, but also later painters like Giorgio Vasari and Francesco Salviati – had taken painting, these viewers would point to Sarto's misunderstood example as the key to the "naturalistic" principles that later painters had lost. To a certain extent, though, the goal of finding an individual style that differed from that of one's immediate contemporaries was a consequence of the competitive practice encouraged by projects like the Annunziata cloister. Florentine patrons took pleasure in recognizing that the contemporaneous paintings next to one another in a public space were the products of related but distinct hands. This particular kind of variety, by contrast, did not appeal to the popes, who preferred the unified style of the Vatican *stanze*. Raphael and Michelangelo's Roman patrons sought the monumentality that came with unifying a program under a single vision.

Titian and the Camerino of Alfonso d'Este

Collaborative and competitive enterprises of the kind we have been looking at did not always require artists to work in the same physical place. Around the time that Sarto and his young colleagues were painting in the Annunziata in Florence, Duke Alfonso d'Este was attempting to adorn the rooms he used as a meditative retreat in his palace in Ferrara with a small collection of pictures, representing the leading "schools" of Florence, Venice, and Rome as well as his home city. The idea for such a collection had come from his sister Isabella's particularly splendid study and collecting space, and Alfonso began by borrowing one of her key advisors, the humanist and art theorist Mario Equicola.

13.46
Giovanni Bellini, *The Feast of the Gods*, 1514 (landscape repainted by Titian in 1529). Oil on canvas, 5'7" x 6'2" (1.7 x 1.88 m). Widener Collection, National Gallery of Art, Washington, D.C.

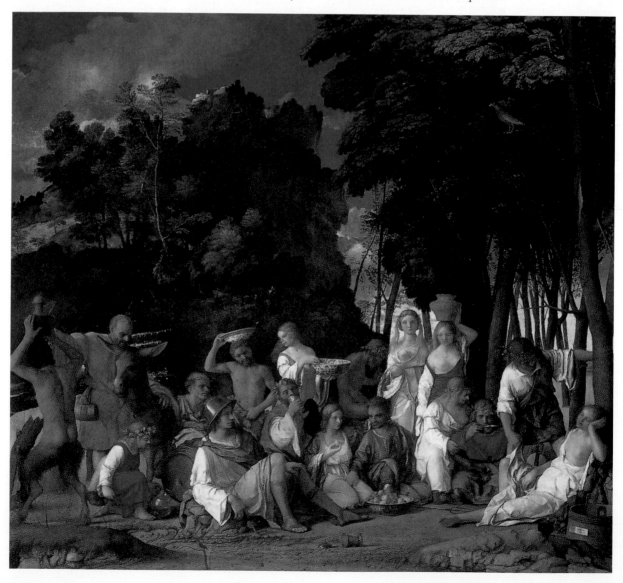

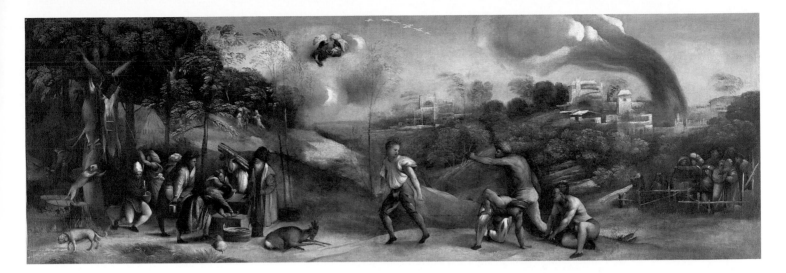

By 1514, Alfonso had achieved something even his sister had not. As we saw in the previous chapter (*see* p. 366), the poet Pietro Bembo had explained Giovanni Bellini's reluctance to paint for Isabella d'Este by reporting that the artist did not like to take on subjects dictated by others, preferring to follow his imagination. For Alfonso's Camerino, however, Bellini had agreed to paint a subject that Equicola had drawn from Ovid's *Fasti*, "The Feast of the Gods." The literary episode itself is a raucous one: the fertility god Priapus attempts to rape the sleeping nymph Lotis, who is awakened by the braying of Silenus's ass just in time to save herself. Bellini's picture (fig. 13.46), classical but rustic, organized as a frieze that reads from right to left, might well be compared to Botticelli's *Primavera* (*see* fig. 9.23), but there is a surprising quietness to Bellini's treatment: his nymph is still sleeping, his ass has not yet brayed, and there are few hints of the revelry one might expect in characters who, like these, have devoted the day to drinking. This may seem characteristic of the Venetian manner of the early sixteenth century, the kind of painting one would expect from the circle that had produced the *Pastoral Concert* (*see* fig. 12.60) a couple of years before. The reflective tone, though, is also appropriate to a study setting, with a hush that politely avoids distracting Alfonso from his reading.

Bellini's picture was to inaugurate a series of six paintings for the Camerino, sometimes called "Bacchanals" since they are all connected to themes of wine and love – and, more broadly, to a philosophical interest in human instinct and bodily sensation. A telling signal of the room's priorities is the frieze that the local painter Dosso Dossi (*c.* 1490–1542) installed over the Bacchanals, *The Sicilian Games* (fig. 13.47). Though the frieze paintings might first appear to be decorative landscapes with figures, closer inspection reveals that they depict episodes from Virgil's epic poem *The Aeneid*. There is a certain witty irony in the diminution of epic, the most important of poetic genres, to the marginal idiom of a landscape border, while fables of drunkenness, revelry, and love are enlarged to an heroic

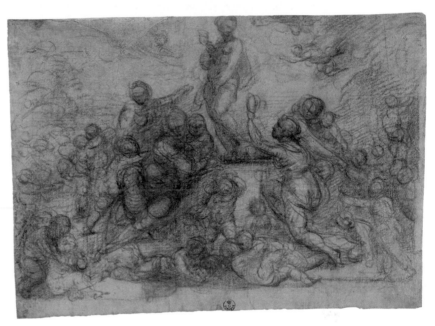

scale. The disjunction emphasized that the Camerino was a space for the duke to withdraw from the world of politics and warfare to that of leisure and sensory delight.

Dosso also painted a *Bacchanal with Vulcan* for the main series, but that picture has been lost. So, too, was the cartoon that Raphael sent from Rome in 1517, after agreeing to paint a *Triumph of Bacchus*, then stalling for several years. The cartoon became the basis for a painting by the little-known artist Pellegrino da San Daniele (1467–1547) – it too, lost, though the composition comes down to us through the later version made by the Ferrarese painter Garofalo. In Florence, Fra Bartolomeo had accepted a commission to paint a *Worship of Venus* (fig. 13.48), but died in 1517 before he could deliver the picture.

Titian's Bacchanals

With the death of Fra Bartolomeo, Duke Alfonso turned not to another Florentine but to Titian (1488/90–1576),

THE ORIGIN OF THE GHETTO

Histories of how Italian cities developed in the fifteenth and sixteenth centuries tend to focus on the introduction of straight streets and orderly squares, but Renaissance urbanism had a darker side as well. In 1516, the Venetian Senate compelled the city's Jews to live in an area called the Ghetto Nuovo after a former foundry. (The word *ghetto* derives from the verb *gettare*, "to cast.") The new Jewish Ghetto had guarded gates, which were opened at sunrise and closed at sunset each day; Christians could only enter during daylight, and Jews exiting the ghetto had to wear a special hat. Even inside the ghetto, activities were regulated. There as elsewhere in the city, Jews could deal in *strazzaria* (second-hand goods) and could practice the suspect profession of moneylending, but they were not allowed to teach or learn traditional crafts. If they needed, say, a decorative or ceremonial object in precious metal, they had to buy it from a Christian shop or import it from outside the city.

Other laws prohibited Jews from owning real estate, but these were unevenly enforced, and residents of the ghetto exploited loopholes. Permitted to make improvements to their residences, many added new storeys to existing buildings. This made the most of the zone's confined space, but it also gave residents de facto ownership of at least some structures. The ground or first floor tended to be the most important in other Venetian buildings, but that was not always so in the ghetto, and some of the new upper storeys were used as synagogues. Though the confinement laws ended in the late eighteenth century, the result of these strategies is still visible, and buildings in the former ghetto are on the whole taller than those elsewhere in the city.

Italian cities generally built churches for maximum visibility, placing them strategically at the end of major streets, opening squares in front of them, raising bell towers high into the air. Where the ghetto was concerned, however, Venice sought just the opposite. When the ghetto was expanded in 1541, roughly doubling in size, one of its new edges bordered the Fondamento della Pescaria, a route used to transport the sacrament from churches to the homes of ailing Christians. Worried that Jews would mock or somehow contaminate the holy wafer, a committee recommended the bricking up of windows and balconies that looked onto that quay. At other times over the course of the century, the city considered building high walls to prevent even visual contact between the Jews inside the ghetto and the Christians outside it. Though this was not carried through, the discussions demonstrate how fears of the sort that Paolo Uccello rendered in his Urbino predella could have consequences even for city planning (*see* figs. 9.4–9.5).

In the later sixteenth century, other Italian cities began to follow Venice's practices. Pope Paul IV's 1555 bull *Cum nimis absurdum* not only legislated a closed, gated ghetto for Jews in Rome but also similar spaces in all papal cities. And because of this history, the word "ghetto" still today refers to the regions of a city where ethnic minorities predominantly reside.

then in his late twenties. The Venetian artist was at that moment in the process of completing what would be his greatest altarpiece of the decade, an *Assumption of the Virgin* for the Venetian church of the Frari (fig. 13.49). In comparison to Rosso's nearly contemporary painting of the same subject in Florence (*see* fig. 13.42), or Fra Bartolomeo's Council Chamber altarpiece (*see* fig. 12.10), which it resembles in some respects, Titian's work is more compositionally dynamic, more heroic in its treatment of the human figure, richer and more unified in color. The clouds and angels that accompany Mary extend the arc at the top of the altar frame into a nearly perfect circle,

at the center of which is the Virgin's head. This suggests an awareness of the central Italian convention of associating the Virgin with the *tondo* form, but it also evokes the plan of the apse end of the church for which the picture was made. What most foreshadows the way Titian would depart from Bellini's earlier models in his work for Alfonso, though, is the disposition of the characters at the bottom of the painting. Titian's Apostles do not, like Rosso's, gaze sedately up at what is transpiring above; rather, they reach toward, pray to, and apparently even debate about what they see. They are engaged intercessors acting on behalf of contemporary worshipers, just as the Virgin herself asks the God she sees above her to be merciful to the people in her charge.

The Frari painting delayed Titian's fulfillment of the Camerino assignment, which he delivered only in 1519. The painting he finally sent (fig. 13.50), like Bellini's (*see* fig. 13.46), was based on a classical text, though the text in this case, from *Imagines* (Pictures) by the ancient Greek author Philostratus, itself described an imaginary painting. If the context of the Camerino was a competitive one, then, Titian's own competition was threefold: he would have had a mind not only to the Venetian and Florentine masters of the previous generation, but also to the best evidence available of how the ancients themselves imagined the painter's art. The picture Philostratus described contained *erotes* (literally, "loves," or cupids) collecting apples in baskets, and the signature details from the ancient text all make their appearance in Titian: jeweled baskets, blue wings, cupids that fly to pluck apples from branches, other cupids that play with a hare. Fra Bartolomeo's surviving compositional drawing (*see* fig. 13.48) shows a gathering of cupids around a statue of Venus on a column, highly reminiscent of his *Virgin of Mercy* (*see* fig. 13.40) or Sarto's *Madonna of the Harpies* (*see* fig. 13.44). Where Titian shifts the emphasis is in the adult figures on the right. These are the nymphs who, in Philostratus's text, proclaim a silver mirror, gilded sandal, and golden brooches hung at a shrine to Aphrodite (Venus) to be their gifts to her, while *erotes* "bring first-fruits of the apples, and gathering around pray to her that their orchard may prosper." The shrine itself was one element that Philostratus did not describe, but Titian follows Bartolomeo by embodying it as a towering statue, to whom the nymphs and the *erotes* make offerings. Like Bartolomeo, Titian thought of the ancients themselves as the progenitors of the sacred image. The devotion that motivates Titian's scene is devotion around and for an artwork, and the composition, now with a decentralized divine figure who nevertheless addresses the beholder, anticipates the innovations Titian would introduce into the altarpiece shortly thereafter.

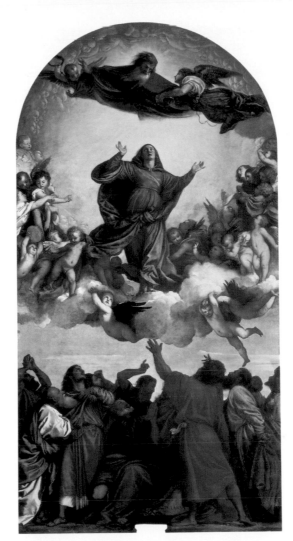

13.49
Titian, *Assumption of the Virgin*, 1516. Oil on panel, 22'8½" x 11'10". (6.9 x 3.6 m). Santa Maria Gloriosa dei Frari, Venice

BELOW
13.50
Titian, *Worship of Venus*, 1516. Oil on canvas, 5'7¾" x 5'9" (1.72 x 1.75 m). Museo del Prado, Madrid

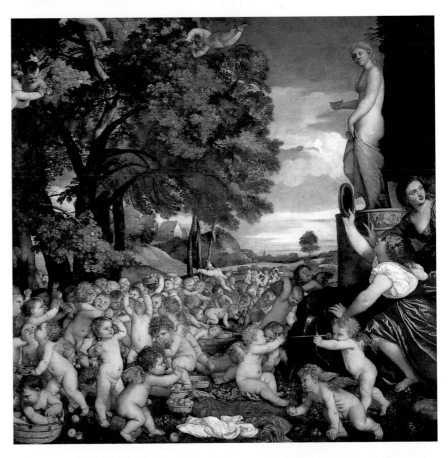

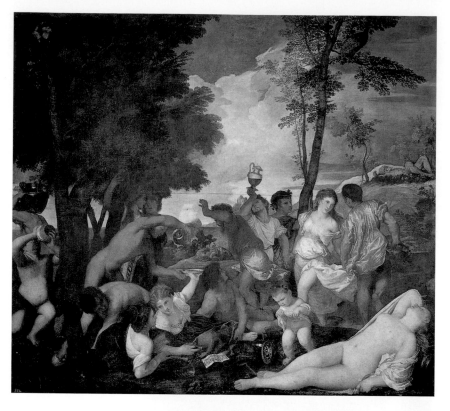

At the same time, the stark contrast between the cool statue and the animated flesh-and-blood characters allows Titian to mark a difference both from a tradition like Rome's, which would make statuary the basis for modern painting, and from the legacy of Bellini, with its staid, placid protagonists. When Duke Alfonso gave Titian the opportunity to paint two more works for the Camerino in the early 1520s, the artist would amplify Bellini's coloristic intensity and add to it a figural dynamism that was all but unknown in Venice. The *Bacchanal of the Andrians* (fig. 13.51) alludes directly to Bellini's earlier invention for the rooms, with its sleeping nymph anchoring the lower right corner. Here, though, there is no peace: Titian foreshortens the characters on the ground, projecting them dramatically forward in space, and those above whirl in dance. In the *Bacchus and Ariadne* (fig. 13.52), Titian places the wine god in the iconic central position, designating him as the elevated star of a triumphal procession, then gives him the least god-like action imaginable, of hurling himself over the side of his chariot. His turned head and rotated left leg, together with the

ABOVE

13.51

Titian, *Bacchanal of the Andrians*, 1523–24. Canvas, 5'9" x 6'4" (1.75 x 1.93 m). Museo del Prado, Madrid

RIGHT

13.52

Titian, *Bacchus and Ariadne*, 1522–24. Oil on canvas, 5'9" x 6'3" (1.72 x 1.88 m). National Gallery, London

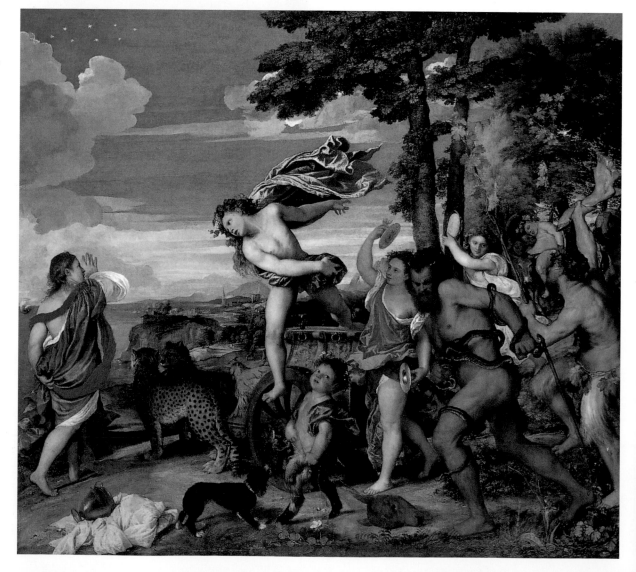

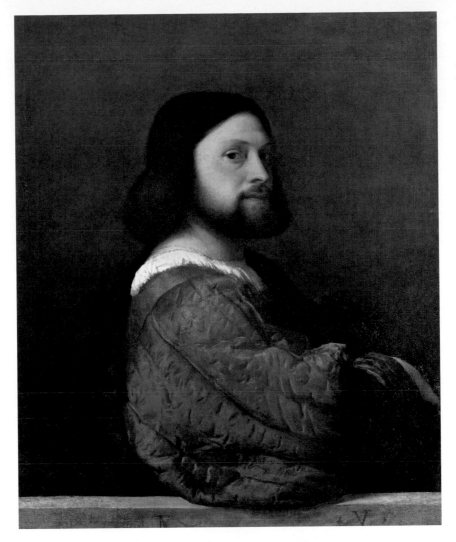

13.53
Titian, *Man with a Blue Sleeve, c.* 1510. Oil on canvas, 32 x 26¹/₄" (81.2 x 66.3 cm). National Gallery, London

empty air beneath his right foot, raise doubts about how this patron of drunkenness will land (as well as fears for the innocent dog below). The pose of Bacchus's beloved, shown on the left, is the absolute antithesis to his own, and the stark contrast promises no happy resolution to the scene: in the end, Ariadne will be turned into the constellation known as Corona, which already appears in the sky above her. This is a painting with none of Bellini's hush. Still, appropriately for a space of study and recreation, the painting displays the marvels of art and nature. Alfonso himself owned cheetahs, exotic animals that he used for hunting, and the satyr with the snakes alludes to the most spectacular of recent archaeological finds, the *Laocoön* in the Vatican (*see* fig. 12.48). What must most have astonished viewers, though, was the color, for Titian painted almost half the canvas, six feet on a side, in ultramarine, the most intense and expensive pigment on the Venetian market. One might compare the effect to Titian's aggressive use of blue in a *c.* 1511 portrait, in which a still unidentified sitter presses an arm wrapped in padded blue satin, virtually the only color in the picture, out into our space (fig. 13.53).

With Titian in the end having taken over three of the commissions for the Camerino and with the works that actually did get carried out by other artists now lost, the series looks much more homogeneous than it was initially intended to be. Perhaps Titian, feeling himself to be an understudy now permitted to collaborate and compete with more established elders, aspired to a commanding court position that was closer to what Raphael had achieved in Rome. Then again, the patron, too, may in the end have appreciated the attractions of a series that seemed to feature one hand above all, for Duke Alfonso ultimately had Titian partially repaint Bellini's *Feast of the Gods* (*see* fig. 13.46), adding the verdant background and the deep blue sky we now see. The changes bring the earliest picture in the series closer to the images with which Titian completed it. Ultimately, no other individual contribution to Alfonso's Camerino emerged as a strong individual alternative to Titian, and a century later, artists as different as Peter Paul Rubens and Nicolas Poussin would take the pictures he produced as basic models in forging their own individual styles.

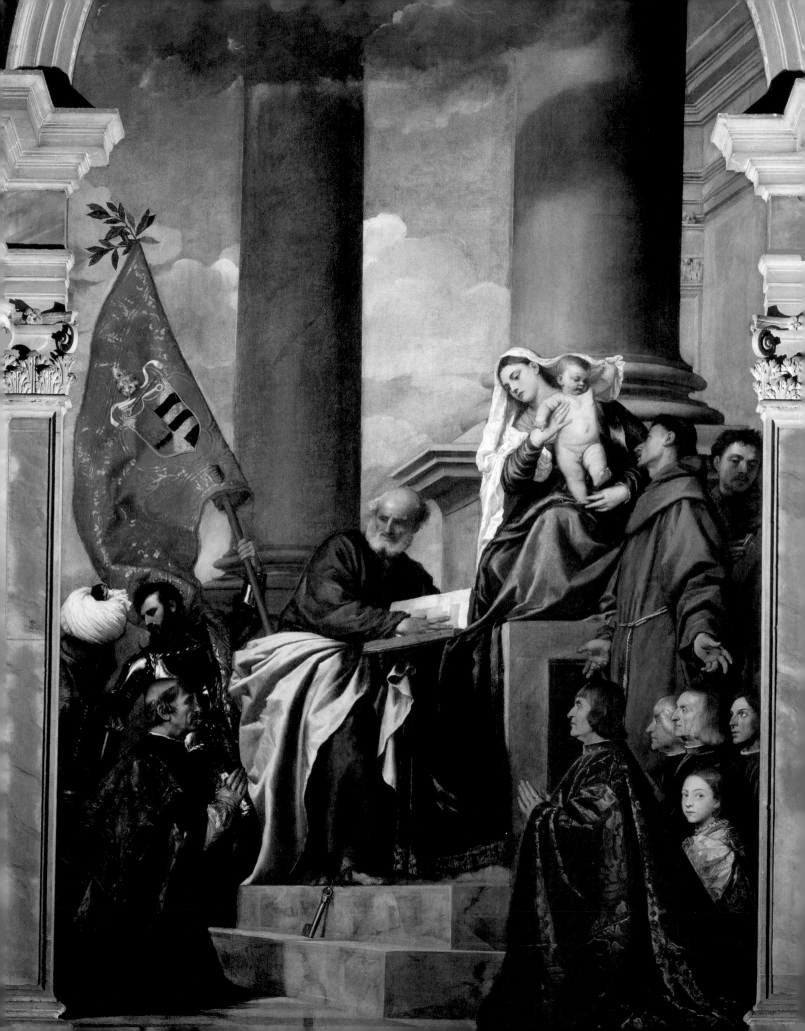

1520–1530
14
The Loss of the Center

14

1520–1530
The Loss of the Center

The 1520s saw the rise of a generation of artists whose training took place in the shadow of Leonardo, Bramante, Raphael – all of them dead by the beginning of the decade – and Michelangelo. Continuing what those figures had begun was a daunting challenge, and it raised the stakes of what it meant to become an artist. Rivalry and the emulation of powerful forerunners gave artists an increasing critical sophistication and self-consciousness. They reflected on and quarreled about questions of imitation and originality, of the relative value of taking nature as their model or grounding art in an abstract ideal of beauty that nature could never achieve by itself. A term that recurs in discussions of art from the 1520s onward is *maniera*. The word (the root of which is *mano*, or "hand") can be translated straightforwardly as "style." Viewers understood all of the major artists to have cultivated an individual *maniera* that other artists, especially those who were more junior or less gifted, could take up. Yet *maniera* also had another meaning: "stylishness" or "extreme refinement," which stood as one of the chief goals of art in Rome after the death of Raphael. Because of the preoccupation with *maniera* in both senses, some more recent writers have applied the term "Mannerism" to Italian artists who followed Raphael and Michelangelo. If we use this label today, we must do so with extreme caution: first, artists preoccupied with *maniera* did not employ a single style or set of characteristics, or even a common aesthetic attitude: we could associate the idea with painters as different as Jacopo Pontormo and Giulio Romano. Second, the term "Mannerist" originated as a pejorative label, intended to convey a negative judgment about this entire generation. The scholars who invented the category regarded art after Raphael as a decline into bad taste or the perversion of an original standard of perfection. The English word "mannerism" predominantly means "affectation," and to call a certain art "Mannerist" can simply mean that it looks "affected" – though this is to apply a historically inappropriate standard of judgment.

Art-historical debates about Mannerism have often focused on the art of the most cosmopolitan locales: especially Rome, but also Florence and Venice. Yet part of what makes the 1520s distinctive is the renewed importance of the other regions. If, from 1505 to 1520, St. Peter's and the Vatican made Rome seem like the center of Italy's artistic culture, this was no longer the case. In part that was a consequence of new challenges to Rome's political and spiritual centrality. In 1517, the German friar Martin Luther had published his famous ninety-five theses attacking the Pope's sale of indulgences and the use of the income from them to support the building of St. Peter's. After three years of indecision Pope Leo X formally condemned Luther, but the protests this occasioned in the north only revealed the extent of the reformer's support and the widespread hostility toward the papacy. When Leo died in 1521, the College of Cardinals elected as his successor an austere Dutch theologian, who took the name Adrian VI. Adrian, the only Renaissance Pope to have come from northern Europe, had served as tutor to the young prince who would become the Holy Roman Emperor Charles V in 1530. The new Pope found that Leo X's extravagances had hopelessly bankrupted the Church. Though later papal apologists blamed him for it, he broke ranks with his predecessors in his realistic assessment of the papacy's financial state and his attempt to curb expenditures. Only in 1523, when Adrian's death led to the election of a second Medici Pope, Clement VII, did artists again see hope for the sort of patronage that had been possible in the previous two decades. Clement was none other than Cardinal Giulio, who had commissioned the lavish Villa Madama (*see* figs. 13.22–13.23) from Raphael. Even this promise of better times to come, however, would be short lived.

Further contributing to Rome's diminished status was the disappearance of its two leading artists. Raphael had died in 1520 at the youthful age of thirty-seven. Michelangelo had, since 1516, been in Florence, working on the church of San Lorenzo. When Clement ascended the papal throne, he ordered Michelangelo to stay there, making Medici family tombs. With Rome no longer functioning as center of gravity, a number of the best artists simply chose to work elsewhere. Vasari tells us that Pietro Bembo, Leo X's secretary, had pressed Titian to come from Venice to Rome, and that he had declined. The great Lombard painter Correggio seems to have accepted commissions only in Parma and neighboring towns, while among the other northerners, Pordenone and Lorenzo Lotto worked largely in Lombardy, the Veneto, and the Marches; Dosso Dossi in Ferrara, Pesaro,

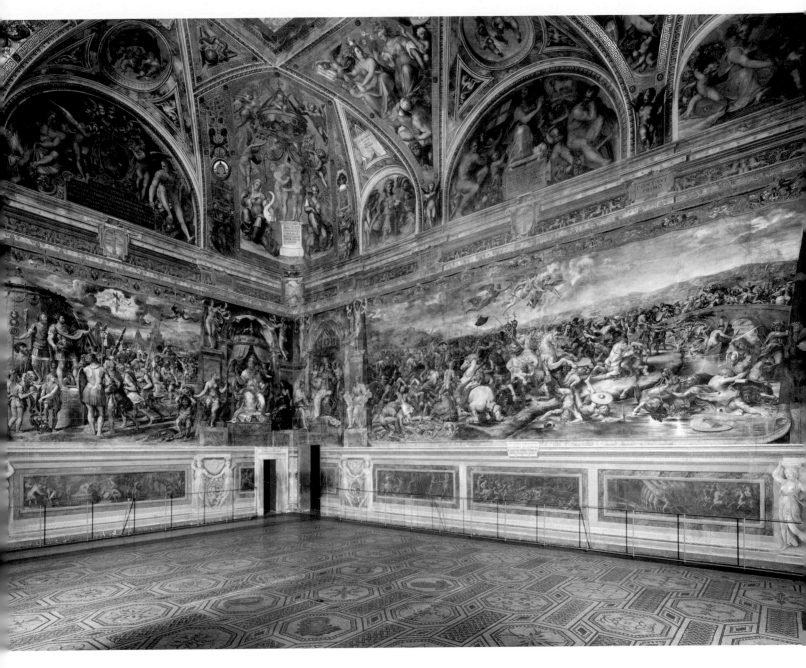

14.1

Giulio Romano, Sala di
Costantino, 1519–24.
Vatican Palace. The vault of
the room was constructed
and decorated in the 1580s.

and Trent. In Rome, the artistic community organized itself into factions that laid claim to the heritage of Raphael and Michelangelo, yet Correggio, Pordenone, Lotto, and Dossi did not claim any allegiance to either Florence or Rome.

The *Sala di Costantino*

The followers of Michelangelo were most often Florentine expatriates who had come south to Rome hoping to benefit from the two Medici papacies. The followers of Raphael, by contrast, were the surviving members of

his own studio. Giulio Romano (*c.* 1499–1546) and Gian Francesco Penni kept the Raphael workshop going, executing paintings commissioned before the painter's death and marketing themselves as his living legacy. Giulio in particular would provide the standard of what it meant to paint like Raphael for much of the rest of the century.

The most important project Giulio completed before Federico Gonzaga lured him from Rome to Mantua in 1524 was the Sala di Costantino (fig. 14.1), or the Hall of the Pontiffs, the culminating room in the papal suite that Raphael and his workshop had been decorating for more than ten years. The painting of this room had begun in 1519, the year before Raphael died, and it continued until

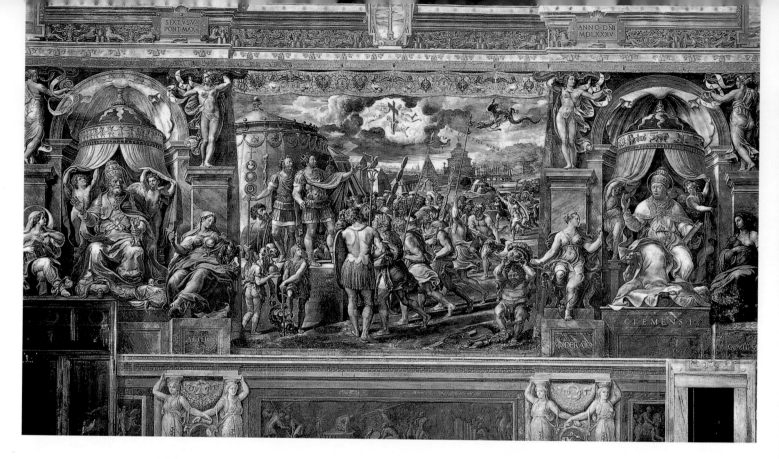

14.2

Giulio Romano, *Vision of Constantine*, 1519–24. Fresco. Sala di Costantino, Vatican Palace

Adrian VI suspended work in 1522. By this time, Giulio Romano and his team had completed two of the four large narrative scenes, working from a series of designs prepared or at least approved by Raphael. In 1523 Sebastiano del Piombo, making a rival bid as representative of the absent Michelangelo, tried to have himself appointed to complete the room. His ultimate decision to reappoint Raphael's team may have been a practical one, but it does suggest that the Pope was interested in proclaiming continuity with the reign of Leo X, resuming the projects begun by his Medici predecessor.

The spacious hall served as an anteroom to the papal apartment: it provided for papal audiences and for the briefing of ambassadors. Its overtly propagandistic program reflects its function as a place where the Pope confronted and addressed the other powers of Europe. The scheme established earlier by Raphael consisted of portraits of the first eight popes, all of them saints, beginning with St. Peter. Pope Clement I bears the features of Leo X (fig. 14.2, right), thus stressing the theme of descent to the point of rendering the modern papacy almost identical with the first successors of Christ. The popes are surrounded by a bureaucratic profusion of allegorical figures, identified by labels but also by more arcane symbolic devices: Eternity holds a pen and a phoenix, Comity (the virtue of "mildness") appears with a lamb. The arrangement is highly reminiscent of Michelangelo's prophets on the Sistine Chapel ceiling (*see* fig. 12.31). Repeated Medici devices like the diamond ring and the yoke with the motto SOAVE (alluding to the scriptural

text "My yoke is gentle") assume an almost mystical importance.

Raphael's project of 1519 centered on the history of Constantine, the first Christian emperor. The four scenes were to show his Conversion (fig. 14.2), the victory over his rival Maxentius at the Battle of the Milvian Bridge, and two others concerning a "presentation of prisoners" and the miraculous healing of the emperor before his conversion. When the team headed by Giulio returned to the room in 1522, the Pope had them drop the latter two in favor of the *Baptism of Constantine by Pope Silvester* and the *Donation of Constantine* (fig. 14.3). Rather than merely celebrating Constantine as champion and defender of Christendom, the room would now insist on imperial subordination to papal authority. The change in program came about because of escalating tensions between papacy and empire over the Luther controversy, and because Luther's followers had begun to employ a new ideological weapon: Lorenzo Valla's exposé of the *Donation of Constantine* (see p. 176). Ulrich von Hutten, a supporter of Luther, had reprinted Valla's text in 1518, 1519, and 1520, alleging in the last edition that the treatise offered support for Luther's attacks. The frescoes, in response, not only insist on the supremacy of the Pope over a conquering emperor, but also imply that papal authority derives from a divine dispensation that supersedes human knowledge and historical evidence.

The two scenes completed in the first campaign present the story of Constantine as a moment of harmony between the Roman and Christian worlds. The

story is conceived in epic terms, seeking to dazzle the viewer with its profusion of antiquarian detail and its virtuoso illusionism. The narrative scenes of human history are shown as fictive tapestries, thus as less permanent and less "real" than the robust and vigorous enthroned popes that appear between them (Peter is flanked by personifications of the Church and Eternity). At the same time, the apparent tapestries recalled the actual ones that Raphael had produced, the true prestige objects from Leo X's court. As with real tapestries, the function of the frescoes is to provide a decorative overall covering for a large area of wall surface, favoring a profusion of figures and of ornamental detail across the picture plane. Giulio also enriched the tapestry aesthetic by evoking ancient Roman reliefs. While Raphael's designs had employed perspectival effects, the reference to relief enabled an emphasis on the three-dimensionality of figures through modeling and strong outlines (*see* fig. 13.13).

The scenes are dense with quotations from monumental carvings still visible in the city. The battle scenes on the Columns of Trajan and of Marcus Aurelius provided the models for the *Battle of the Milvian Bridge*. The *Vision of Constantine* adapted a well-known relief showing the emperor Marcus Aurelius addressing his troops, which had been re-incorporated in the Arch of Constantine. Raphael knew the relief to be a surviving earlier

work that the Christian emperor had incorporated into his arch: in his letter to Leo X, Raphael distinguished between the sculptures made specially for this arch, "which are quite ridiculous, without any sense of art or good design," and "the spoils of Trajan and Antoninus Pius, [which] are most excellent, and perfect in style." He translated the prototype with the emperor raised above the listening soldiers into a scene of miraculous revelation, where Constantine, before the fateful battle, sees a Cross with the message "Under this sign will you have victory." The landscape offers a panorama of the ancient city, restoring monuments such as the Castel Sant'Angelo (initially built in the second century CE as a mausoleum for Emperor Hadrian) to their ancient form.

Throughout the frescoes, the painters aimed to show their wit. Whatever their seriousness of theme and purpose, the paintings also resemble a courtly entertainment aimed at producing pleasure and pleasurable horror. Virtuoso illusionism coexists with the insistence that everything is art: in the Milvian Bridge scene we are looking not at a battle, but at a painting of a tapestry after a relief of a battle (*see* fig. 14.1). The tumult of the conflict, with its severed hands and limbs, is a carefully choreographed set of variations on a fairly limited number of warrior figures. The pattern of internal near-repetitions produces a consciously contrived effect, enhanced by the crystal-like

14.3

Giulio Romano, *Donation of Constantine*, 1519–24. Fresco. Sala di Costantino, Vatican Palace

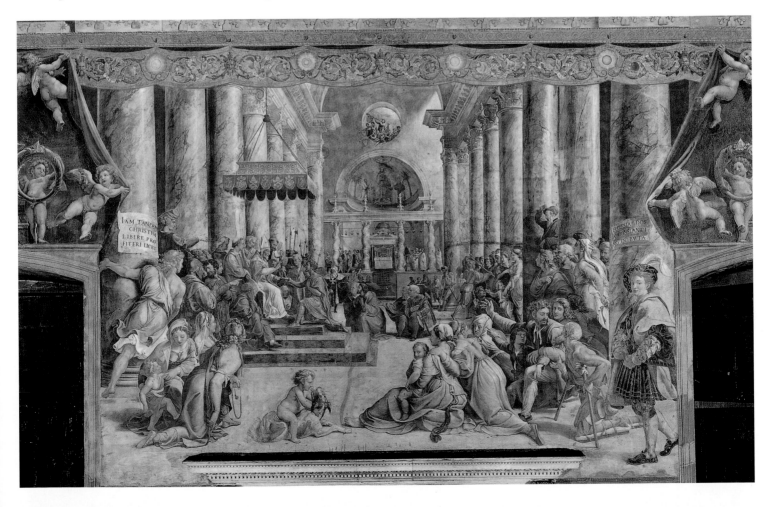

14.4

Giulio Romano, *Virgin and Child with Saints* (Pala Fugger), 1522–24. Oil on panel, 6'6¾" x 8'8" (2 x 2.64 m). Santa Maria dell'Anima, Rome

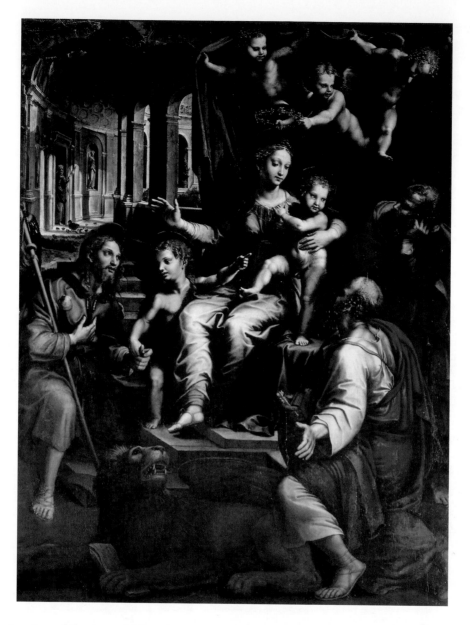

surface of the river, which registers none of the turbulent action within it. In the *Vision of Constantine*, the sublimity of the emperor's conversion contrasts with the laughing dwarf who casts a sidelong glance out into the room; he is the only figure attempting to make a connection with the viewer. The later scenes, perhaps reflecting the Pope's sense of urgency in his struggle with secular powers, aim emphatically at persuasive engagement with the visitor to the room (*see* fig. 14.3). More figures solicit the viewer, and there are more explicit allusions to the contemporary world. As in previous papal commissions, Rome's recognizable topography and the early Christian buildings of the city provide historical support for ideological claims. St. Peter's is clearly the setting for the Donation, enacted by a kneeling Constantine in the presence of contemporary representatives of the Christian powers of Europe.

Rome after Raphael: Making a Reputation

Giulio Romano

In working on such projects as the Hall of Constantine, Giulio Romano acquired an unrivaled knowledge of Roman topography and art that would ensure his considerable future success. He was also an active collector: in 1520, when the pursuit of ancient sculptures among the elites of Italy was becoming ever more competitive, Giulio was able to purchase part of the extensive antiquities collection of Giovanni Ciampolini. When Giulio finally left Rome to work for the Gonzaga of Mantua in 1524, he could claim to be transporting a vital part of

"Rome" – now meaning the heritage of Raphael as well as of antiquity – to a provincial city that had long styled itself as a "new Rome."

Giulio's altarpieces reveal an adaptation of the same principles to the demands of a traditional Christian format: whatever their liturgical or devotional theme, his religious works always in some way introduce the subject of Rome. An example is the altarpiece he painted for the German and Dutch community church of Santa Maria dell'Anima (1522–23), to which Adrian VI belonged (fig. 14.4). The patrons here were the Fuggers of Augsburg, the richest merchant bankers in Europe. It is Giulio's first wholly independent altarpiece commission, yet it elaborately proclaims its continuity with the late Virgin and Child paintings of Raphael. With their flickering highlights and deep shadows, the figures of the Virgin, Child, St. John, and angels resemble marble sculpture viewed by candlelight in a dark church. Where Quattrocento paintings would have relied on architectural divisions to establish hierarchies, here the warmer and more saturated colors of St. James, St. Mark, and St. Peter place them in a different order of reality from that of the Virgin, who gleams like polished marble. While the figure of the Virgin unfolds itself outward, emphasizing the relief-like character of the surface, the three saints and St. Mark's lion establish a semicircular formation around her, giving the entire group an almost architectural aspect. The arrangement echoes a theme established by the magnificent ruins of a circular-plan structure in the background, which evokes ancient Roman temples dedicated to virgin goddesses such as Vesta or Minerva Medica. Adorning the temple are fragments of stucco relief, reminiscent of Nero's Golden House (*see* p. 300) and broken sculptures in niches. In a mundane intrusion very typical of Giulio, a majestic elderly woman appears at a doorway, apparently engaged in feeding chickens. We might take the Virgin's appearance against such a background to signal the triumph of the true faith over paganism, but the picture equally represents the renewal of pagan art and culture in its re-dedication to Christian ends. The temple stands as a metaphor for the Virgin, yet she is not fully aligned with it: the axis of the circular temple (and of the painting) bisects her body between her right breast and her left knee; her upper body forms an alternative off-center axis, and it is around this that the alternative "structure" formed by the saints appears to rotate. The instability creates the kind of dynamic tension and visual interest that would become a defining element of the art of Giulio's generation. In this case, the suggestion that the spiritual center does not fully coincide with the fabric of Rome itself also enriches the meaning of the work, revealing an ambivalence about Rome's pagan heritage that had shadowed Renaissance art since the previous century.

Parmigianino

Giulio's departure for Mantua in 1524 meant Raphael now had no clear single successor in Rome. A few painters, looking from outside at the city and its new pontiff, seem to have seen the situation as an opportunity such as had not existed for decades. One of these was Francesco Mazzola, known as "Parmigianino" (1503–1540) after his home town of Parma, who arrived in Rome the year Giulio left and sought immediately to win the attention of Clement VII with his utterly unconventional *Self-Portrait in a Convex Mirror* (fig. 14.5). The twenty-one-year-old painter used a curved panel to reinforce his illusionistic rendering of mirror distortion. The portrait offers a witty twist on the commonplace that painting is a "mirror of Nature." So it might be, Parmigianino's portrait seems to claim, but in "reflecting" nature, painting also transforms it into something that nature could not produce by itself – something stranger, rarer, and more beautiful. The painting gives particular prominence to the artist's hand, the sign of his artistic identity, and its elongation – both monstrous and graceful – exhibits the exquisite exaggerations that would be the trademark of the painter's "manner."

Contemporaries hailed the new arrival as a "second Raphael," and Pope Clement initially considered him for the completion of the Hall of the Pontiffs. Parmigianino approached each project through a lengthy process of

14.5
Parmigianino, *Self-Portrait,* c. 1522. Oil on convex panel, diameter 9⅝" (24.7 cm). Kunsthistorisches Museum, Vienna

14.6

Parmigianino, *Virgin and Child with St. John the Baptist and St. Jerome* (Bufalini altarpiece), 1527. Oil on panel, 11'3" x 5'11¾" (3.43 x 1.52 m). National Gallery, London

with the Christ child in her arms, along with St. John the Baptist and St. Jerome; apparently the patron expected a rather conventional *sacra conversazione*. For the work that was supposed finally to launch his career in Rome, Parmigianino made a typically extensive series of preparatory designs, exploring widely different possibilities, until he arrived at a solution that fulfilled the terms of the contract in the most surprising way, essentially inventing an entirely new subject. Without any iconographic or theological precedent, and largely through a process of experimental drawing, he transformed the vision of St. John the Evangelist, who wrote in the book of Revelations of a "woman clothed with the sun and moon," into an ecstatic dream of St. Jerome, who sleeps in an abandoned posture in a grassy glade. The child, no longer an infant cradled by the Virgin, seems to levitate between her legs. John the Baptist, another hermit saint whose camel-hair tunic has here been accessorized with a luxurious leopard-skin mantle, dominates the foreground. His extraordinary pose shows the deliberate primacy of art over nature in Parmigianino's work: John faces the viewer, yet his shoulders swivel backward so that he can point to the subject of his prophecies: "Behold the lamb of God."

Parmigianino conceived the work to demonstrate his knowledge and thorough command of recent art: the child standing between the Virgin's legs recalls Michelangelo's *Virgin and Child* in Bruges (*see* fig. 12.8), while the gesticulating saint is a delicately slender descendent of Michelangelo's male nudes. The Virgin enthroned on the moon recalls Raphael's *Madonna of Foligno*, which also featured a gesturing St. John (*see* fig. 13.24). At the same time, the work competes with Giulio's Santa Maria dell'Anima altarpiece (*see* fig. 14.4), especially in the dramatic lighting of the Virgin, her gracefully elongated proportions, and her placement above the other figures. Like Giulio, Parmigianino has identified the Virgin with the perfect geometry of the circle: the segment of half moon completes the curved top of the panel. Yet for an ambitious outsider to the Roman and Florentine traditions, mere assimilation was not enough: he sought to bring a more intense emotional tenor to the Roman altarpiece. Giulio's saints are decorously pious in their veneration of the Virgin; Parmigianino's are in states of visionary ecstasy. The emphasis on superhuman bodily beauty raises the specter of the erotic: the Virgin and Child seem not that far away from a Venus and Cupid, especially with the Virgin's demure downcast eyes and the mischievous and seductive glance of the child. Parmigianino reconceived the coexistence of the Christian and pagan as an equivalence between awakened devotional contemplation and the arousal of human desire.

experimental drawing – those for the Vatican project survive – and it may have been this that taxed the patience of his patron, persuading the Pope to transfer the project to Giulio. Parmigianino's slowness of approach, together with the local domination that Perino del Vaga, Polidoro da Caravaggio, and other Raphael pupils exercised, precluded the artist from receiving any significant work until 1526, when the widow Maria Bufalini commissioned an altarpiece for her husband's funerary chapel at San Salvatore in Lauro (fig. 14.6). The contract specified a Virgin

Rosso Fiorentino

Parmigianino's calculations and inventions bear comparison to those of Rosso (1494–1540), another outsider who moved to Rome the year Giulio left. The young Florentine made a strong impression on contemporaries, who recorded (often disapprovingly) his opinions about art. Not only did Rosso insult the Raphael faction by criticizing the master's work, but he also offended Michelangelo, declaring on seeing the Sistine Chapel that he himself would never work in such a manner (*maniera*). Rosso's first major Roman assignment was a fresco project in Santa Maria della Pace with scenes from Genesis, and like Parmigianino's first commission, it appears to have gone badly. His friend Benvenuto Cellini reports that he had personally to protect Rosso when the Raphael followers attempted to murder him, and to lend Rosso money when the unsuccessful artist was reduced to near-starvation. Finally, at some point between 1525 and 1527 a fellow Florentine, Lorenzo Tornabuoni, bishop of Sansepolcro, commissioned a *Dead Christ with Angels* (fig. 14.7). The work was probably intended to serve as an altarpiece in a church in Tornabuoni's diocese: the subject of Christ at the tomb had long been a civic emblem of Sansepolcro.

The painting attests to Rosso's intensive study of Michelangelo. The main figure of the dead Christ, which shows the artist's knowledge of the nude male figures on the Sistine Ceiling, responds more directly to the *Pietà* in St. Peter's (*see* fig. 11.51), especially to its qualities of irony and paradox. Although it evokes the dead Christ in Michelangelo's sculpture, the body in Rosso's painting appears mysteriously alive. The figure is beautiful and serene, even though Christ has been killed by slow mutilation. Although strongly corporeal and intensely developed in illusionistic relief – the legs appear to project from the picture plane – the placement of the body in space is difficult to grasp. Rosso recognizes no distinction between the requirements of a devotional image and the pursuit of a sensual and artificial beauty that exceeds the limits of the natural.

The theme of the Pietà, whether with the Virgin or with angels, posed a particular challenge for Renaissance artists, especially with regard to determining the appropriate emotional tone. The artist had to acknowledge the mortal suffering of Christ in the Passion, yet also convey the momentous significance of Christ's death – a significance that lay in the mystery of the Eucharist, not the Passion. Only when we draw close to Rosso's work do we realize that the angels are meditating on his wounds, hidden in the shadows that shroud portions of the limbs and torso. The mood seems more one of rapture than of tragedy or even sorrow, and the viewer would be forgiven for concluding that what the angels really contemplate

is Christ's physical beauty. The intense and paradoxical illusionism of the figure, his physical emergence at the altar table, would have reinforced the belief in Christ's "real presence" in the bread consecrated during the Mass, a doctrine by now under attack from various reformed Christian sects, which in the wake of Luther had modified the doctrine or rejected it outright.

The Allure of Printmaking

Like Parmigianino's altarpiece (which Maria Bufalini's family had taken to Città di Castello in northern Umbria), Rosso's work was never delivered. And in the end, the most significant completed works associated with both artists' Roman period were not paintings but prints. Raphael's death had also affected the market for engravings in Rome, since the painter had helped establish a system

14.7

Rosso Fiorentino, *Angel Pietà (Dead Christ with Angels)*, completed 1527. Oil on panel, 52½ x 41" (133.5 x 104.1 cm). Museum of Fine Arts, Boston

417

ABOVE

14.8

Anonymous sixteenth-
century printmaker,
woodcut copy after
Marcantonio Raimondi's
engraving after Giulio
Romano's lost drawing,
scene from the series
I Modi.

RIGHT

14.9

Giovanni Jacopo Caraglio
after Rosso, *Pluto and
Proserpina*, 1525?
Engraving, 6³/₄ x 5¹/₄" (17.5
x 13.3 cm). Graphische
Sammlung Albertina,
Vienna

drawings to engravers, usually with a publisher acting as a go-between.

The few prints generally associated with Parmigianino in Rome were, with one possible exception, of religious subjects; Rosso, by contrast, designed no fewer than thirty-one engravings in the 1520s, all of them on mythological or poetic subjects. Rosso's distinctive path illustrates the unusual opportunities printmaking allowed. As they had for Andrea Mantegna (*see* fig. 10.8), mythological prints allowed the artist to demonstrate his originality, since there was no well-established visual tradition for the material he depicted, but they also let him show his command of a modern Roman style that claimed to ground itself in the study of antiquity. Designers were also coming to realize that a more flexible decorum governed poetic and mythological subjects executed in a cheaper and more ephemeral medium, and by Rosso's day printmakers were producing outright erotica. The earliest known post-classical pornographic images – that is, mass-produced, sexually explicit pictures made for the open market – can be traced back to Giulio Romano and Marcantonio Raimondi. Shortly before Giulio left Rome in 1524, Marcantonio issued a series of engravings depicting couples engaging in a variety of sexual acts, based on a set of Giulio drawings called *I Modi* (*The Positions*) that had been circulating privately (fig. 14.8). In response to the publication, the Roman authorities clapped Marcantonio in jail, confiscated his plates, and destroyed as many copies of the prints as they could seize. Giovanni Jacopo Caraglio's series called the *Loves of the Gods*, to which Rosso, Perino, and Polidoro all contributed, probably aimed at the same market, but it is more soft-core and legitimated by the mythological subject. The series must have been at least as appealing for its humor – even the gods are subject to the sometimes humiliating passions of love – as for its prurient subject matter. Rosso's *Pluto and Proserpina* (fig. 14.9) seems to poke fun at the elevated claims made for Michelangelo's art: the male and female figures locked in the throes of passion are based on two of the (male) *ignudi* from the Sistine Ceiling. Far more disturbing is the print known as *The Fury*, a nightmarish image of an emaciated, castrated madman riding on the back of a monster in a dark wood, and wielding a human skull (fig. 14.10). Rosso appears to have based his figure on a desiccated body, probably of the kind used to teach anatomy to medical students. Yet he has raised the cadaver to frenetic life, placed him in a pose similar to the *Laocoön* (*see* fig. 12.48) and, once again, recalled the animated *ignudi* of the Sistine Ceiling. Rosso here caricatures Michelangelo and the art of antiquity, but he also plays off the conceit that art has the power to make dead things come to life, a frequent theme in the praise of the "divine" Michelangelo. The print may have responded to,

by which painters would supply professional printmakers with ideas and designs. Raphael's own engraver, Marcantonio Raimondi, remained active, but he was now joined by Agostino dei Musi, Giovanni Jacopo Caraglio, and Marco Dente, among others. Rosso and Parmigianino, together with the Raphael followers Perino del Vaga and Polidoro da Caravaggio, all earned incomes by providing

and it certainly fed, the popular perception that the study of anatomy, so central to Michelangelo's art, was a ghoulish and necromantic enterprise. (Leonardo's anatomical researches in the Vatican had been terminated in 1516 after a workshop assistant accused him of sorcery.)

Florence

Michelangelo's Return to Sculpture

Though based in Florence, Michelangelo was hardly removed from the conditions of patronage that surrounded the Pope. Even while away from Rome, he continued working first for Leo and then for Clement on Medici commissions, and the heirs of Julius II, who had yet to receive the promised figures for their tomb (*see* fig. 13.38), competed for his time. Among the few works Michelangelo actually sent from Florence to Rome in the 1520s was the *Risen Christ*, a marble completed in 1521 and erected in the Dominican church of Santa Maria sopra Minerva (fig. 14.11). The figure had been commissioned seven years earlier by two brothers of the Vari family and by Bernardo Cencio, a canon of St. Peter's. Michelangelo had had to abandon a first version because of a flaw in the block of marble. He made a second attempt in Florence in 1519–21, and dispatched it to Rome before it was

complete, with the idea that an assistant could see to the finishing touches. Sebastiano del Piombo reported that the task greatly exceeded the assistant's capabilities: "I must tell you that he has ruined everything, above all the right foot...and he has also ruined the fingers of the hands, chiefly the one that holds the cross.... They don't appear to be works of marble, and look rather like the product of a pastry-maker." The remark may reinforce the impression that the only authentic "Michelangelo" works – by contrast to those of "Raphael" – were the ones he produced by his own hand. Especially in Florence, however, Michelangelo often resorted to such a division of labor, and the figure was warmly received by the patrons, who declined his offer to carve another. All sixteenth-century commentators praised it, and even Sebastiano conceded that "the knees alone are worth all of Rome."

The figure presently stands exposed on a high base, and can be seen from all sides. This was not how the

LEFT

14.10

Giovanni Jacopo Caraglio after Rosso, *Fury*, 1525? Engraving, 9⅝ x 7¼" (24.5 x 18.2 cm). British Museum, London

BELOW

14.11

Michelangelo, *Risen Christ*, 1519–21. Height 6'8" (2.05 m). Santa Maria sopra Minerva, Rome

statue was intended to be viewed, nor how it was origi-
nally placed: Michelangelo conceived the *Risen Christ* for
a shallow niche. From the right, the viewer sees the swiv-
elling of the figure's neck, shoulder, and hips around the
vertical axis. From the left, the figure becomes more pla-
nar, more similar to the face of the cross he directs at
us. This point of view makes the swing of Christ's hip
more evident, and also reveals the other instruments of
his Passion: the rope that bound him, the vinegar-soaked
sponge he was given in his thirst, the reed (here regularly
notched to emphasize the sculpture's proportions) with
which he was beaten.

The 1514 contract for the *Christ* specified a nude fig-
ure, something rare in Christian art and unprecedented
in a work of this scale and prominence. The statue would
surely have reminded contemporaries of the naked gods in
ancient sculptures, and that may have been the point. The
new Pope Adrian VI would refer to such images as "idols
of the pagans," yet like the nudes in the Sistine Chapel,
the *Risen Christ* announced that the perfect naked human
form was now no longer the exclusive preserve of the pre-
Christian world: in this case, the nudity itself celebrates
Christ, who by his incarnation raised the human body from
its fallen and sinful condition. Such beliefs may have been
widespread among the cultivated members of the clergy
and curia in the 1500s, even if they were destined to be of
short duration. By 1600, when the figure was illustrated
in Girolamo Francini's guidebook to Rome, it had been
modestly covered with a drapery. While the figure was dis-
played in its original uncensored state for much of the late
twentieth century, in 2000 one of its seventeenth-century
coverings was restored so as not to offend pilgrims visiting
Rome for the Holy Year. This is one work by Michelangelo
that has resisted full assimilation by the category "art" and
retains its function as church furnishing.

Roughly in the same years, Michelangelo was work-
ing on figures where the demands of beauty were taking
precedence over the normal constraints of human anat-
omy. In the unfinished *Victory*, an oak-garlanded youth
forces a bearded figure into a posture of agonized submis-
sion beneath him (fig. 14.12). Whereas the older victim is
shown under extreme constraint, the youth twists him-
self into an extraordinary yet effortless pose. His chin,
right shoulder, right hand, and left knee establish an
axis around which the body forms a dynamic spiral. The
face, however, is placid except for a glimmer of heroic
(or despotic) satisfaction. The title *Victory* was bestowed
by Vasari, who took the work from Michelangelo's stu-
dio after his death and installed it in the Great Council
Chamber of the Palazzo Vecchio, incorporating it into
a new post-Republican program that celebrated the
military triumphs of Florence's current autocrat. What
would Michelangelo himself have understood the group

to depict? Although the subject originated in a design for the tomb of Julius II, where it was allegedly to show either the subjection of personified cities captured by the Pope or Virtue triumphing over Vice, Michelangelo produced a more general and personal meditation. The paradoxical linking of ideal beauty with violent physical force is characteristic of Michelangelo's love poetry, which he began writing in just these years, and which frequently describes the power of the beloved's beauty to bind, enslave, or annihilate the beloved. Michelangelo may also have wished to show his artistic mastery of the body in the most difficult poses and actions through an allegory of domination. If, as it appears, the bearded man is a self-portrait of Michelangelo, then he could even represent the artist "mastered" or possessed by his own ability to create beauty. It is as if the experience of inspiration had come to seem sinister and even demonic. The compacted richness of meaning guaranteed the group a long afterlife in the sculpture of the later sixteenth century, especially outside of Rome.

Pontormo

Working at San Lorenzo, Michelangelo was a magnet for the city's young and ambitious artists, notably Jacopo Pontormo. Michelangelo more than once collaborated with the younger painter by providing him with drawings; Pontormo often worked in a style that represented his own very personal interpretation of the new Roman manner. In the princely villa of the Medici at Poggio a Caiano, employed by the future Pope Clement VII, Pontormo completed the so-called *Vertumnus and Pomona* in 1521 (fig. 14.13). The painting knowingly refers to the Roman *maniera* of Michelangelo, especially in the poses

of its athletic male nudes, but it deliberately avoids the epic and solemn character of the Sistine frescoes, as well as the ceiling's superhuman anatomies. Inspired energy has given way to a relaxed hedonism. Vasari reports that the fresco depicted a story from Ovid's *Metamorphoses* concerning the Roman nature god Vertumnus, who disguised himself as an old woman so as to get closer to Pomona, goddess of gardens. Certainly the women in the picture, who cast bemused looks in our direction, invite speculation on their identities, though the real subject of the painting is *villagiatura*, the simple summer lifestyle of the country retreat. Befitting the rustic setting, the male figures here are suntanned farm workers resting in the noonday heat, and their female counterparts wear contemporary clothing.

Florentines liked to believe that they shared the practice of *villagiatura* with the ancient Romans. This implied a repeating cycle of time, which was becoming an important theme in the dynastic symbolism of the Medici family. The motto GLOVIS inscribed beneath the scene is a rebus-like reversal of the Italian "Si volge": "It (i.e. time) turns (back)." Some of the figures clutch the branches of a laurel tree, from which one or two limbs are missing; one of the girls has a pruning hook. As early as the 1480s, Lorenzo de' Medici had adopted the pruned laurel with new green shoots springing forth as a symbol of renewal, the return of the Golden Age. His heirs had added a motto from Virgil's *Aeneid* (VI:143), "uno avulso, non deficit altera" ("as soon as one is torn away, another takes its place"). The specific reference here is probably to recent catastrophic deaths in the Medici family – Giuliano, Duke of Nemours, in 1516, and Lorenzo, Duke of Urbino, in 1519, both of whom Michelangelo himself would soon portray. The accent on youth,

ABOVE
14.13
Jacopo Pontormo,
Vertumnus and Pomona,
c. 1520–21. Fresco. Villa
Medici, Poggio a Caiano

OPPOSITE
14.12
Michelangelo, *Victory*,
c. 1530. Marble, height
8'6" (2.61 m). Salone di
Cinquecento, Palazzo dei
Priori, Florence

14.14
Capponi Chapel, with paintings (fresco and panel) by Jacopo Pontormo, 1525–28. Santa Felicita, Florence

sexuality, and the fertility of the laurel promises the inevitable continuation of the Medici lineage and its power over the city. Another line from Virgil displayed in the fresco, "studium quibus arva tueri" ("whose care it is to look after our fields"), referred in *Georgics* (I:21), its original context, to the gods of nature, whom the fresco conceivably depicts. Here, however, the more obvious allusion is to the Medici and their "care" of Florence, suggesting that the rustics are but a guise for past and future Medici "immortals."

In 1525–28 Pontormo painted a chapel newly acquired by the papal banker Ludovico di Gino Capponi in the church of Santa Felicita (figs. 14.14–14.15). The chapel, designed by Filippo Brunelleschi in the previous century, was dedicated to the Annunciation, and Pontormo depicts this subject on the counterfacade of the building, on either side of a stained-glass window

by Guillaume de Marcillat showing the *Entombment*. Unusually, the altarpiece does not follow the chapel's dedication, focusing instead on Christ's Passion, and in the most unconventional way. A drawing indicates that Pontormo originally conceived his composition as a *Deposition*, but in the finished work, the Cross, originally to be visible in the upper left, has disappeared. The carrying of Christ's body rather suggests an *Entombment*, but no tomb is visible, and the stained-glass window would in any case have made such a picture redundant. Pontormo's painting can be best understood as an unconventional treatment of the Pietà theme: it includes the sorrowing Virgin and the serene body of Christ, both highly reminiscent of Michelangelo's sculpture for St. Peter's in Rome (*see* fig. 11.51): the boyish creatures who carry the body are probably angels, like the attendants Rosso added to his own *Angel Pietà* (*see* fig. 14.7). Christ's body seems to present no burden, and the angels themselves, on tiptoe, appear weightless. Yet if Pontormo's and Rosso's pictures include comparable protagonists, Pontormo's departs from all earlier tradition in dramatizing the static and iconic theme, imagining the never previously depicted action of the dead Christ borne away from the Virgin. Like the works of Michelangelo and Rosso, Pontormo's *Pietà* subdues any references to Christ's suffering and to the violence of the Passion. The mourning figures show an appropriate degree of sorrow, but this is a vision of unearthly and uplifting beauty, designed to reassure the viewer of Christ's victory over death, fulfilling the promise of the joyous *Annunciation* nearby. Christ's bodily resurrection and ascension into heaven would have been anticipated by the original decoration of the dome, in which the figure of God the Father looked down upon the event.

Beauty, even a beauty achieved by self-consciously artificial means, here provided a fully adequate vehicle for religious meaning. Pontormo has dispensed with many standard components of the Florentine Renaissance picture, in the interests of an intricately balanced formal design. The rules of perspective have been suspended. Overlapping figures form an interwoven pattern without any regard for their logical position in space, and the proportions of limbs and torsos have been arbitrarily elongated. Gravity exerts little force: bodies seem to float upward through space. The colors consist almost entirely of blues and pinks, with a few passages in green, yellow, and orange. The palette is in the highest of keys, the *chiaroscuro* Leonardo had introduced to Florence just a few decades earlier now entirely rejected. Pontormo takes his cue once more from the luminous and variegated Sistine Ceiling; he thinks of color as a decorative and artificial addition to a wall rather than as a natural aspect of forms themselves.

14.15
Jacopo Pontormo, *Pietà
(Entombment)*, 1525–28.
Oil on panel, 10'3¼" x
6'3⅝" (3.13 x 1.92 m).
Capponi Chapel, Santa
Felicita, Florence

Lombardy and Venice

Correggio in Parma Cathedral

Florence since 1512 had been ruled as a possession of the Medici papacy: it was in essence a province of Rome through most of the 1520s, as the very presence there of Michelangelo attested. In far-flung centers of the peninsula, too, the power and authority of Rome was a major concern. In 1521 the city of Parma in Lombardy, under French occupation for several years, returned to the rule of the Church. The following year, the canons of Parma Cathedral hired the painter Antonio Allegri (now bet-

14.16

Nave, Parma Cathedral, with dome fresco by Correggio, *Assumption of the Virgin*, 1522–28

ter known as Correggio, after his birthplace) to decorate the cathedral dome with a fresco of the *Assumption of the Virgin*. Correggio was already an artist of some distinction, having worked for noble and monastic patrons in and around the cities of Correggio, Mantua, Modena, and Parma over the previous two decades. Despite his association with patrons interested in reform, Correggio's paintings in the cathedral served the interests of ecclesiastical authority at its most conservative and traditional. The very subject of the Assumption, and Correggio's lavishly triumphal treatment of it, is a glorification of the church and a celebration of Parma's return to papal rule (figs. 14.16–14.18). Like the *Coronation of the Virgin*, the Assumption relates fundamentally to the idea of a "marriage" between Christ and the Virgin, understood symbolically as the loving union of Christ in heaven with his Church on earth. This is the drama that unfolds in Correggio's dome fresco. From directly underneath, the fresco looks strangely off-center (*see* fig. 14.17); it is difficult to take in. This is because it was designed to be seen gradually, with the experience of the moving observer in mind. Entering the cathedral, we are first aware of a blaze of light at the far end of the nave (*see* fig. 14.16); advancing toward it, we soon discern the figures of two of Parma's patron saints, St. Hilary and St. John the Baptist. We then see colossal figures of Apostles, apparently standing on the actual parapet of the cathedral, and responding with intense emotion to the spectacle overhead (*see* fig. 14.18). As we advance further, the ascending figure of the Virgin comes into view, surging upward with the support of golden heavenly clouds and smiling angels. Adam and Eve along with other Old Testament figures appear next, and finally the beardless and youthful Christ becomes visible as we reach the stairs.

The idea of Rome as center certainly affected Correggio's conception of the great fresco. In particular, it demanded that the painter consider his own relationship to the papal projects of Michelangelo and Raphael. At the same time, however, Correggio had grander ambitions: his great fresco would be no mere provincial homage to the art of the Roman Renaissance. He saw himself as the bearer of a tradition that was not that of Rome and Florence, nor for that matter of Venice, but which was rooted in the achievements of other north Italian artists, like Andrea Mantegna. From the study of Mantegna, whose sons Correggio befriended in Mantua, he learned the technique of foreshortening figures as if viewed from below – the device of *sotto in sù* composition visible in Mantegna's frescoes (*see* fig. 7.22) in Padua and in the *Camera Picta* (*see* fig. 8.19) in Mantua. Equally important was the north Italian work of Leonardo da Vinci, above all that artist's attention to

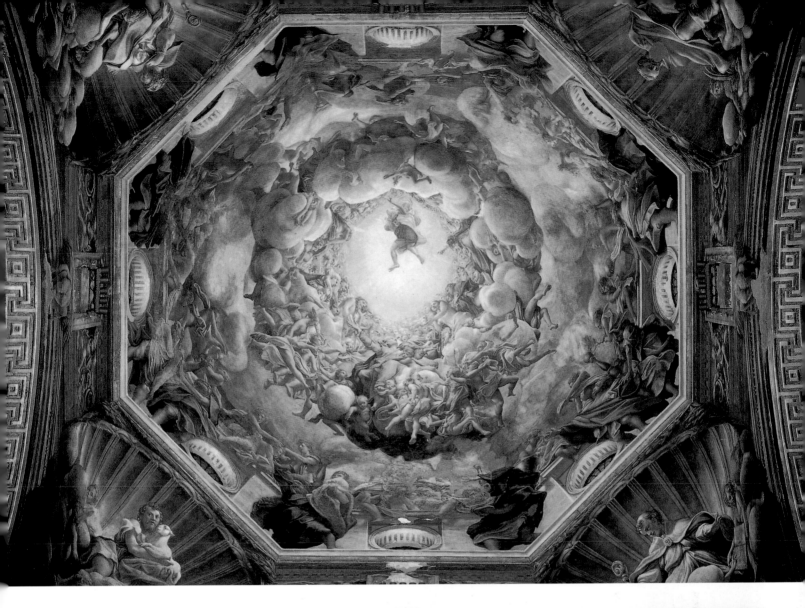

the expression of figures and his technique of *sfumato* modeling, which imparted such delicacy of texture to flesh and draperies. Correggio went far beyond Leonardesque *sfumato*, however, in his use of color for decorative and expressive ends. He sought to adopt the rich hues of Perugino and his north Italian peers Francesco Francia and Lorenzo Costa, while simultaneously pursuing, like Leonardo, a much greater effect of unity, in his case by bathing his figures and their setting in a golden light. In the cities of the Po valley Correggio quietly created a revolution that would polarize artistic theory and practice in later generations.

Did Correggio ever travel to Rome? His very partisan followers, like Ludovico Carracci at the end of the

14.19

Correggio, *Virgin and Child with St. Mary Magdalene and St. Jerome*, 1528. Oil on panel, 7'8½" x 4'7½" (2.35 x 1.41 m). Galleria Nazionale, Parma

century, would deny that he did or that he had any need to, as if Correggio's art was an autonomous product of "Lombard" soil. Although there were major paintings by Raphael in nearby Piacenza and in Bologna, Correggio's painting shows a knowledge of Roman Renaissance art that he could not have obtained at a distance through prints and drawings, or by studying local examples. Parma's political connection to Rome would itself have encouraged Correggio to conceive his treatment of the *Assumption* as a response to the Sistine Chapel, which was also dedicated to the Assumption and displayed the subject in a fresco by Perugino on the altar wall. The Sistine served more as a stimulus, however, than as a source of borrowed form. Early project drawings for the Apostles standing on the parapet of the dome show that Correggio originally intended to paint seated figures on thrones, on either side of the round windows, in a manner reminiscent of the Sistine prophets and sibyls. In the end, though, Correggio sought to go beyond Michelangelo, having figures overlap the real architecture and treating them consistently as if viewed from below. The athletic and nearly nude angels arranged in concentric rings above, or accompanying the patron saints in the pendentives underneath, are pre-adolescent versions of Michelangelo's heroic nudes. Most astonishing is the Virgin herself. Correggio's virtuoso foreshortening invites comparison with Michelangelo's *Jonah* (*see* fig. 12.39), on the vault just above Perugino's old-fashioned *Assumption* fresco, yet no artist in Florence or Rome would have contemplated such a radical rethinking of the Virgin Mary's image, truncating her body to the point of near-caricature. Nor would they have shown Christ as Correggio does, hurtling through space as if he has leapt from the apex of the dome, with his garment rising around his hips. While most of Correggio's angels are modestly draped, one or two glaringly splay their naked legs in the direction of the viewer. Modern writers, indeed, have often wondered how Correggio got away with this, especially given the scandal that broke when Michelangelo used similar devices in his Sistine *Last Judgment* a decade later. Conservative as Correggio's patrons may have been, it appears that they had fewer preconceptions than the Florentines and Romans about how sacred figures in the "modern" style ought to look.

The official meaning of the fresco is the triumph of the Church, and its role as the mediator of salvation: there is no redemption without the clergy, the Virgin, and the saints. The fresco, in other words, defends theological positions that were now under attack from Luther and other reformers. But Correggio allows an involvement that opens the possibility of other kinds of understanding. The ecstatically ascending Virgin anticipates the

lay viewer's own bodily resurrection and ascension into Heaven; the Virgin's passionate impending union with Christ raises the possibility that the viewer's relation can be equally direct, emotional, and unmediated.

Correggio and Lorenzo Lotto: Altarpieces

The same emotional tenor characterizes Correggio's altarpieces, among them the *Virgin and Child with St. Mary Magdalene and St. Jerome* (fig. 14.19). The work was commissioned by a lady of Parma, Briseide Colla Bergonzi, and installed in the church of St. Anthony Abbot in Parma in 1528. The humanist scholar Desiderius Erasmus (1466/9–1536), whose works were popular in the social circles to which Bergonzi and other Correggio patrons belonged, had written in his book *Enchiridion Militis Christiani* (*Weapon of the Christian Knight*) of the necessity of devotion shaped by both learning and piety. The good Christian should study the scriptures and the writings of the saints and Church fathers, but should also recognize the role of the emotions in awakening the conscience and achieving a state of joyous humility in relation to the divine. In Correggio's painting the gaunt figure of the scholar-saint Jerome devoutly offers his translation of the Bible to the Christ child, with the assistance of an angel who seems to recite the words of the text. With the Virgin smilingly looking on, the Christ child reaches for the book – thus accepting his own destiny, while caressing the hair of Mary Magdalene, who passionately kisses his feet. Unlike the Virgin and Child images of Giulio Romano (*see* fig. 14.4) and Parmigianino (*see* fig. 14.6), where the Virgin is a remote otherworldly object of veneration, the emphasis is on the intense rapport between the figures, expressed through sight and through touch. Both the lion and a little angel look out toward the spectator, and the angel smells the fragrant ointment in the Magdalene's jar, as if inviting the beholders to project themselves into the sensual experience described here. The saints traditionally signify mediation and intercession; here, however, they stand in for the possibility of a more direct and immediate experience of divinity.

Correggio may have known the paintings of Lorenzo Lotto (*c.* 1480–1556), an older Venetian artist who also pursued an itinerant career. He had worked in the Stanza della Segnatura with Raphael, executing a fresco on the Jurisprudence wall, but afterward he remained further north in the smaller centers of the Veneto, Lombardy, and the Marches. Lotto was capable of painting in a range of styles, depending on the requirements of a given commission, but at times his atmospheric play of reflected light, his soft shadows, and his directness come close to Correggio's. His altarpiece for the Franciscan church of San Bernardino in Bergamo, *Virgin and Child with Saints*

(fig. 14.20), signed and dated 1521, creates an almost overwhelming sense that the painting is aware of the viewer. An angel dressed in a burnt-orange vestment looks up suddenly, turning away from his writing as if distracted at our approach. Above, the Virgin in shimmering scarlet leans forward with her palm outstretched, as if beckoning us to come nearer. The soaring angels who support her canopy seem to draw the great billowing cloth over our heads, recalling the traditional theme of the "Virgin of Mercy," where the Virgin shelters a community beneath her cloak. Lotto painted the work for a confraternity, and the engulfing impact of the canopy would have created a sense both that the Virgin protected its members and that they participated in a special way in the devotion shown to her. Lotto's color is highly untypical of Venetian, Roman, or even Florentine painting: he favors decorative contrasts of flowery pinks and lime greens, oranges and purples. The grandeur of design reflects his experience of Rome and direct acquaintance with Raphael's work. At the same time, his figures reject the ideal and superhuman types by now common in that tradition. Lotto seems

14.20

Lorenzo Lotto, *Virgin and Child with Saints* (San Bernardino altarpiece), 1521. Oil on canvas, 9'5" x 8'9½" (2.87 x 2.68 m). San Bernardino in Pignolo, Bergamo

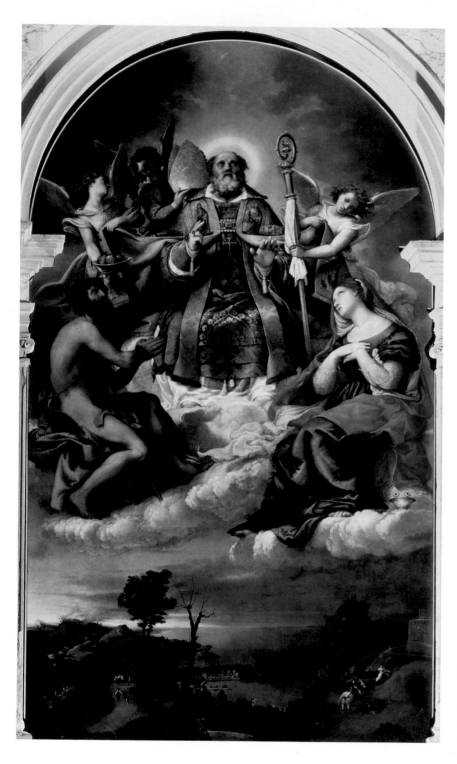

14.21

Lorenzo Lotto, *St. Nicholas in Glory with St. John the Baptist and St. Lucy*, 1527–29. Oil on canvas, 10'11⅞" x 6'2" (3.35 x 1.88 m). Santa Maria del Carmine, Venice

deliberately to have conceived his protagonists as everyday characters lacking in aristocratic sophistication and grace: Bernardino ogles the child, while the angel's bare foot juts awkwardly off the marble step.

The San Bernardino altarpiece may show a sophisticated artist promoting a new conception of "popular" devotion, though other altarpieces introduce more refined and idealized human types. For a merchant confraternity at the Carmelite Church in Venice, Lotto executed a *St. Nicholas in Glory with St. John the Baptist and St. Lucy* in 1527–29 (fig. 14.21). The composition, with its ideally beautiful figures, remind us that Lotto had worked in the same room as Raphael's *Disputà* (*see* fig. 12.51) twenty years before, yet the rich color has little to do with the Raphael school or indeed with any other contemporary painter in Venice: it has more affinity with Correggio and the younger artists working to the west, in the cities of Emilia Romagna and Lombardy. The atmospheric landscape with its clouds looming over a harbor is closely modeled on a painting of the *Drowning of Pharaoh's Armies in the Red Sea* by Jan Van Scorel, a Dutch artist who had come to Italy and enjoyed the favor of Pope Adrian VI. Here again, by drawing on a Netherlandish example, Lotto challenges the dominant tradition of modern Venetian painting, that of Giorgione and Titian. This may have cost him: the critic Ludovico Dolce, one of Titian's admirers, later ridiculed the Carmelite altarpiece, citing it as "a very notable example of a bad use of color."

Lorenzo Lotto as a Portraitist

One of Lotto's most inventive portraits is that of Andrea Odoni (fig. 14.23), made in 1527 for Odoni, a rich Venetian government official and art collector. Possibly conversing about a collection of Roman sculpture and other objects, he proffers a small statuette of Diana of Ephesus, the many-breasted divinity understood in the Renaissance to personify Nature; with his other hand, he points to his chest and clutches a small gold cross (now difficult to see). Lotto's Odoni seems to direct an answer to those who condemned the acquisition of ancient sculpture as idolatrous and wasteful. (Adrian VI, in fact, was only one of many who thought so, and not all of them were clerics.) Through the contemplation of art, the painting implies, a collector learns something of his own nature as a human being motivated by pleasure and feeling. At the same time, the sculptures that surround Odoni seem humorously alive: a head of the Roman emperor Antoninus Pius nuzzles a headless Venus, while a urinating Hercules seems to have eroded the leg of a bathing goddess on the shelf beyond. Themes like this had no parallel in Venice or Rome, but again

correspond with the interests of artists and patrons west of the Veneto: Parmigianino, around 1523, produced a portrait of a collector vividly characterized not only by his nervous physiognomy but by his sculptures, coins, and books (fig. 14.22).

Titian: Two Altarpieces

Two of Titian's most important altarpieces from the 1520s bring out the differences between his practice and Lotto's. He completed his 1522 *Resurrection* for the church of Santi Nazaro e Celso in Brescia, a Lombard town not far from Bergamo (fig. 14.24). The patron was the bishop of Brescia, Altobello Averoldi: he had been an insider at the papal court in Rome and from 1516 to 1523 had served as the Pope's legate to the city of Venice, where he kept elite intellectual company. The altarpiece, in which Averoldi appears as a donor, would have served as a proxy in his absence. The picture adopts the very traditional format of the polyptych, now almost obsolete, but the individual panels also demonstrate the patron's cosmopolitan taste and cultural milieu. The central one is a kind of "nocturne," or night scene (Giorgione was famous for

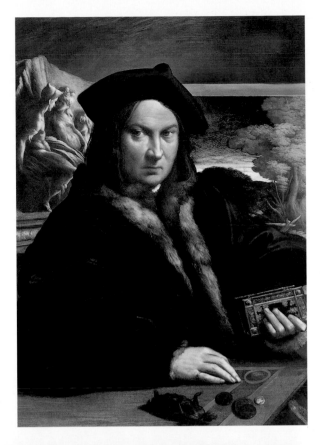

14.22
Parmigianino, *Man with a Book, c.* 1523. Oil on panel, 35$\frac{1}{4}$ x 25$\frac{1}{4}$" (89.5 x 63.8 cm). National Gallery, London

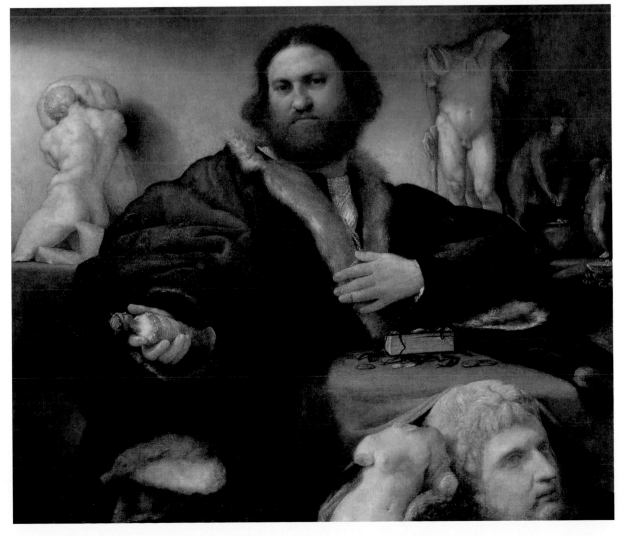

14.23
Lorenzo Lotto, *Andrea Odoni*, 1527. Oil on canvas, 3'3$\frac{4}{5}$" x 3'8$\frac{8}{9}$" (1.01 x 1.14 m). Hampton Court Palace, Surrey

429

painting these, although none of his have survived). A radiant and triumphant Christ commands the attention of the viewer, like that of the two soldiers in near darkness against the dawn sky, made visible only through light reflected in their armor. To the left, one of the soldier saints Nazarus and Celsus presents Averoldi to Christ, while the opposite panel features the martyred soldier St. Sebastian, with St. Roch far in the background. Titian made the figure of Sebastian a particular focus of his own calculated self-promotion. The saint balances his right leg on a toppled column, signed TICIANUS FACIEBAT M. D. XXII. The gesture of an angel in the background, engaged in tending St. Roch, seems to point to the signature, and when Titian showed off this canvas in his

studio, he declared that it was alone worth the price set for the entire altarpiece. Reports reached Duke Alfonso d'Este of Ferrara, who was impatiently awaiting the *Bacchanal of the Andrians* (*see* fig. 13.51), and only when he was persuaded that the Papal Legate would be offended did he desist in his efforts to buy the *St. Sebastian* portion of the altarpiece for himself.

In form, the *St. Sebastian* simultaneously evokes one of the dying youths in the ancient *Laocoön* group (*see* fig. 12.48) and Michelangelo's recently executed *Slaves* (*see* figs. 13.35–13.36) for the tomb of Julius II. Titian is asking sophisticated viewers like Averoldi, who would notice the references, to reflect on the superior capacity of painting to produce the effects associated with sculpture, and to

14.24

Titian, *Resurrection of Christ with Saints George, Nazarus, Celsus and Sebastian* (Averoldi polyptych), 1522. Oil on panel. Santi Nazaro e Celso, Brescia

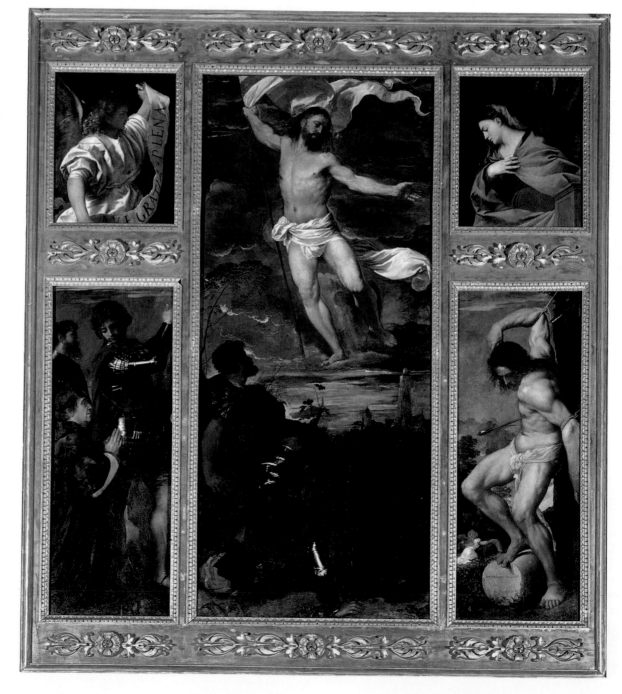

excel sculpture in depicting the vividness and pathos of the naked body. The figure of Christ in the central panel, similarly, alludes to Laocoön himself. Wittily, Titian has taken a figure identified with agony and turned it into its opposite – one who has overcome physical suffering and even death. Titian certainly knew the *Laocoön* through the circulation of drawings and miniature copies; later in life, he would design his own print caricaturing the sculpture. His knowledge of the *Slaves* is less easily accounted for, but indicates that an artist's awareness of famous inventions in centers he is not known to have visited should not be underestimated.

In 1526 Titian completed his second great altarpiece for the church of the Frari in Venice, the work that goes furthest in defining the Venetian altarpiece in terms of its differences from those in Florence and Rome (as well as Parma and Bergamo). The painting, for the family chapel of Jacopo Pesaro, combines the votive portrait – a type associated with military leaders (*see* for example fig. 7.18), where the donor and the Virgin or patron saint confront each other on a horizontal axis – with the vertical hierarchy of the *sacra conversazione* (fig. 14.25). The result is a strikingly de-centered design, restructuring the connection between figures within the altarpiece and their relation to the viewer. Like Correggio, Titian here considers the placement of the work in its spatial context and the encounter with the beholder. Knowing that it would be installed in the left-hand aisle of the church, he orientated the Virgin at an oblique angle, so that the "correct" perspective would be that of the approaching worshiper up the aisle from that direction. Viewed from directly in front, the altarpiece loses some of its dynamism, though from this point of view, significantly, the composition also reorganizes itself around St. Peter, whom Titian placed on the central axis of the painting. In this position, he appears even to control and mediate access to the Virgin Mary. Peter represents the Church, and especially in Venice he denotes the relation between the Church and the Venetian state. This would have been significant to Pesaro, who in 1502 had led the forces of the Church in a successful campaign against the Turks in the Ionian Sea. Pesaro himself, in fact, is shown with George (the soldier-saint who here holds the banner of the Church) and a Turkish prisoner. Titian's purpose in this commission is thus very different from that of Lotto in Bergamo, Pontormo in Florence, Correggio in Parma, or Parmigianino in Rome. He has created a monumental image of an ideal political order dominated by the papacy. Titian evokes the majesty of the state with the lofty space and colossal columns that dominate the composition, towering over the human figures in an unprecedented manner. The picture might even be oppressive, were it not for the presence of St. Francis, who, with Christ, is the only figure to show emotion.

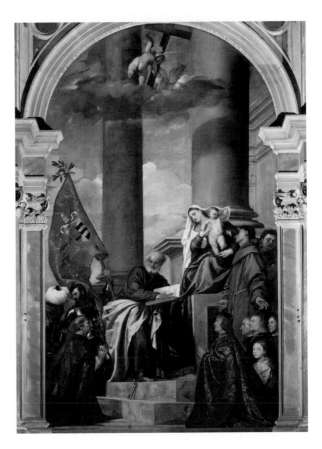

14.25
Titian, *Virgin and Child with Saints Peter, George, and Francis* (Pesaro altarpiece), 1526. Oil on canvas, 16'1" x 8'10" (4.9 x 2.7 m). Santa Maria Gloriosa dei Frari, Venice

The theme of devotion introduced by Francis arises from the fact that a confraternity dedicated to the Immaculate Conception used the altar on its particular feast day, but devotional concerns are really secondary to the political and ceremonial aspect.

Pordenone in Cremona Cathedral

Like Lotto, the Friulian artist Giovanni Antonio de Sacchis, generally known as Pordenone (*c.* 1484–1539) after his birthplace, established his reputation by working in the smaller cities and religious foundations of Lombardy and the Veneto. Within a few years, Venice itself would regard him as a serious challenge to the supremacy of Titian. Pordenone's most impressive paintings are a 1520–21 cycle of frescoes on the Passion of Christ at Cremona Cathedral, continuing a program that local painters had begun in 1515 (figs. 14.26–14.28). Pordenone's work stands in marked contrast with that of his predecessors, and signals the emergence of a new element in Italian art.

Whereas Michelangelo, Pontormo, and Rosso rendered the imagery of the suffering Christ with a certain optimism and with an insistence on the superhuman beauty of the incarnate god, Pordenone ignored all Italian precedent, seeking to shock spectators with the pain, cruelty, and horror of the event. Rather than looking south

to Rome or east to Venice, Pordenone paid closer attention to northern European art, where violent and bloody depictions of Christ's suffering and death were more typical. Albrecht Dürer's printed Passions, which are fairly restrained by northern standards, had made such imagery fairly well known in Italy. (Pontormo made use of them in a Passion series at the Certosa di Galuzzo near Florence in the mid 1520s.) In general, though, Italian spectators found the all too human vulnerability of Christ in northern Passions hard to stomach. In 1517, a cardinal's secretary, Antonio de' Beatis, described large carved crucifixions by the roadside in southern Austria, noting that to him they inspired "far more terror than devotion."

The narrative in Pordenone's frescoes lurches along with tumultuous energy. Christ seems anything but divine, while his tormentors – some of them dressed in the armor, feathered hats, and particolored hose of contemporary mercenaries – are possessed by a sadis-

14.26

Pordenone, *Scenes from the Passion of Christ*, 1520–21: *Christ before Pilate.* Fresco. Cremona Cathedral

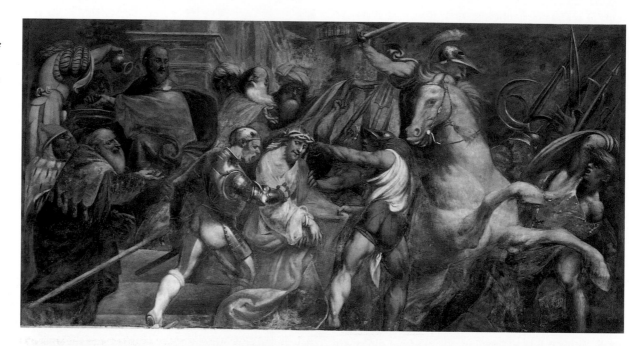

14.27

Pordenone, *Scenes from the Passion of Christ*, 1520–21: *Christ Nailed to the Cross.* Fresco. Cremona Cathedral

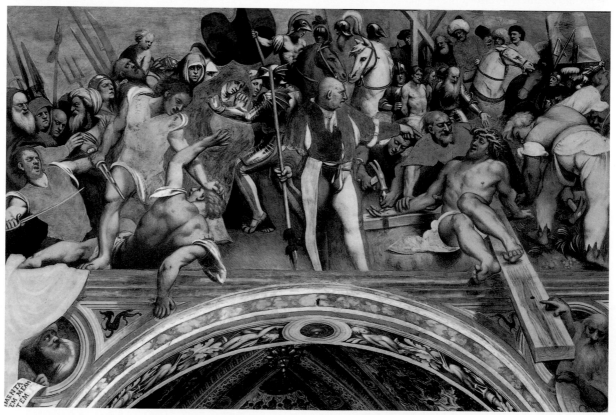

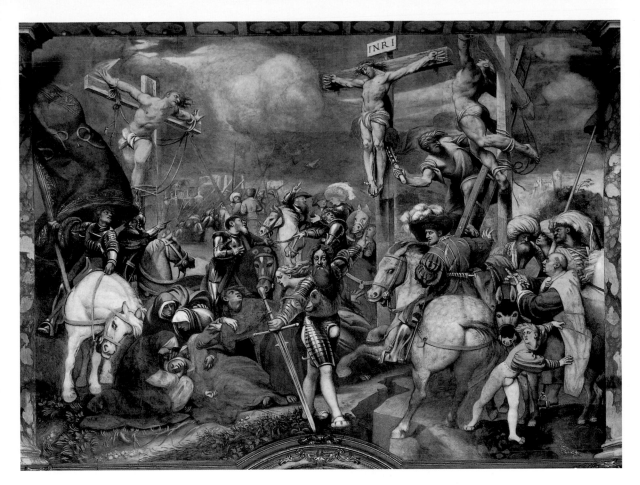

tic hatred. (Such figures would have resonated for the Cremonese, who had lived under nearly a decade of occupation first by Venice and then by invading French armies.) Each scene introduces new episodes of violence: in *Christ before Pilate* a soldier on a rearing horse charges the crowd, while in the scene of *Christ Nailed to the Cross* a murderous brawl breaks out. The broad, muscular bodies may reflect some knowledge of Michelangelo, but Pordenone exaggerates the type to near caricature in order to emphasize the gross physicality and crudeness of the soldiers. Where he does deploy the hallmarks of narrative painting in the modern manner, he develops them to hyperbole. Astonishing foreshortenings constantly break the plane of the wall: the Cross to which Christ is being nailed seems to thrust into the nave of the church, and it appears that only the nail being hammered into his hand keeps Christ himself from slipping into the viewer's space. A prophet leans urgently forth to point to the place where Christ's feet will be nailed, which is already pierced and stained with blood. In the gigantic fresco over the main entrance to the cathedral, it is the soldiers and their horses who dominate the composition, displacing the crucified Christ from his traditional position on a central axis. As a result, those leaving the cathedral are confronted with the powerful, pointing figure of the pagan centurion who, according to the Gospel of St. Matthew, converted at the moment of Christ's

death and announced "Truly this was the Son of God." The image thus urges the viewer to acknowledge the divinity of Christ: the vigorous posture of the good thief to Christ's right, no less than the rapt expressions of several other soldiers, underscores the theme of "turning to Christ" ("conversion" comes from the Latin *convertere*, "to turn toward"). To the right, the image takes up the idea of conversion explicitly, showing a group of turbaned figures who listen to a sermon preached by a tonsured figure resembling a friar. Titian, we have seen, would allude to the conversion of the Ottomans in his slightly later Pesaro altarpiece, but Pordenone's fresco shows conversion to be an urgent and uncompleted process.

The Sack of Rome in 1527

Warfare in northern Italy would worsen and become more widespread in the 1520s, with terrible consequences for its leading powers. Desiring to establish a territorial bridge between his German and Spanish possessions, the young Holy Roman Emperor Charles V invaded the French-occupied territories of the north-west in 1521 and won a massive victory at Pavia in 1525, capturing King Francis I. Pope Clement VII had initially supported the emperor – he had been elected as Charles's candidate – but he now grew anxious at the prospect of the extension

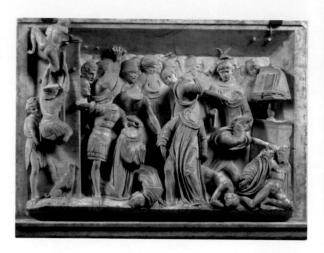

of imperial power in Italy. In 1526, Clement deserted the imperial alliance and joined with France in the League of Cognac. Charles's attempt to chastise the papacy would have a horrifying outcome. In the winter of 1526 he dispatched a company of German mercenaries, many of them Lutherans, across the Alps under the command of Georg Frundsberg. Although the princes of Mantua and Ferrara were officially bound in allegiance to the papacy, they quietly supported the imperial advance. For a time, Frundsberg met resistance from the armies of the papal alliance, commanded by the Duke of Urbino, and from the effective Medici warlord known as Giovanni delle Bande Nere. With the death of Giovanni near Mantua, however, there was little to stop the imperial forces. Bent on vengeance and plunder, and with the avowed aim of hanging the Pope, they reached Rome in May of 1527.

Here are the events as reported by a soldier with the imperial forces:

> On the 6th of May we took Rome by storm, killed 6,000 men, plundered the houses, carried off what we found in churches and elsewhere, and finally set fire to a good portion of the town. A strange life indeed! We tore up, destroyed the deeds of copyists, the records, letters and documents of the Papal court. The Pope fled to Castel Sant'Angelo with his bodyguard, the cardinals, bishops, and members of the Curia who had escaped the massacre. For three weeks we laid siege until, forced by hunger, he had to surrender the castle.... Inside, we found Pope Clement with twelve cardinals in a storeroom. The pope had to sign the surrender treaty that the secretary read to him. They all bemoaned themselves piteously and wept a lot. So here we are, all of us rich. Less than two months after we occupied Rome 5,000 of our men had died of the plague, for the corpses remained unburied. In July, half dead, we left the city to find cleaner air.... In September, back in Rome, we pillaged the city more thoroughly and found great hidden treasures. We remained billeted there for another six months.

Of Rome's 54,000 inhabitants, at least 10,000 died and an estimated 10,000 more became refugees. The engraver Marco Dente was among the dead; Marcantonio Raimondi, captured by the Spanish, survived, though he was reduced to poverty thereafter, and was apparently so traumatized by the events that he never made another print. Toward the end of the year, Emperor Charles V and Pope Clement VII, both of whom needed to resort to face-saving measures, rapidly concluded a peace. Charles agreed to receive the imperial crown from the Pope's own hands, but in order that this would not appear as a sub-

mission by the actual victor, the coronation would not be held in Rome but in Bologna, and only in 1530.

The effects of the Sack, coming on the heels of the religious crisis that began in 1517, were crushing, and partisans on both sides struggled to give meaning to the events. The Este and Gonzaga promoted the idea that the Church, in its decadence, had brought the wrath of God upon itself. In a similar spirit, many Florentines regarded the Sack as a defeat of the Medici, as if the prophecies of Savonarola had been fulfilled. In a euphoric final resurgence of Republicanism, the city exiled the remaining Medici, reconvened the council of 500, and declared Christ once again the "true Lord and King" of Florence. Then the city prepared itself for the inevitable retaliation – the massed imperial and papal forces that laid siege to Florence beginning in 1529. Michelangelo supervised the erection of new bastions and earthworks, which held the city for several months, until starvation and disease led to its surrender and the demise of the Last Republic. Andrea del Sarto was among the thousands – amounting to one third of the city's population – who died. The invading troops vandalized artworks, sometimes in pointed ways: discovering Benedetto da Rovezzano's tomb of St. Giovanni Guadalberto, for example, at the unprotected monastery of San Salvi on the periphery of the city, they left most of the sculpture intact, but cut off the heads of the two monks in the foreground (fig. 14.29). Pontormo produced a portrait that stands as a poignant testimony to a transformation in traditional values occasioned by the crisis: the sixteen-year-old halberdier Francesco Guardi, posing in front of one of the new defensive earthworks in the outfit of a citizen army that had reached the unprecedented decision of putting weapons in the hands of its own youth (fig. 14.30). The boy's militant bearing and the exaggerated masculinity of his sword and codpiece stand in dramatic tension with his youthful countenance, which registers a character still unformed.

The decimation of the artistic and intellectual culture of Rome had consequences for other centers as well. Among the city's refugees were its major artists, including the printmakers Caraglio and Musi and the sculptor Jacopo Sansovino, all of whom went to Venice. Rosso wandered in central Italy before finding his way to Venice as well; there some of his well-connected former acquaintances arranged for his departure for France, where he would spend his final lucrative and productive years in the service of King Francis I. He would soon be joined by the painter-stuccadore Primaticcio and the sculptor Benvenuto Cellini, and these three, with their witty responses to the modern *maniera* of Rome and Florence, would come to define "modern Italian art" beyond the Alps.

Parmigianino went to Bologna, where in 1530 he would make a portrait of the emperor himself. Probably both in need of income and removed from the professional engraving network that had provided some support in Rome, he taught himself a printmaking technique that had first been explored in Germany at the beginning of the century: etching. The method required less specialized training than woodblock cutting or engraving but more technical expertise: the etcher would use a stylus to scratch a design into a wax or resin ground that had been applied to a copper plate, then cover the plate in acid, which would "bite" the design into the metal. Prints could be pulled from the plate that resulted.

Parmigianino was the first artist in Europe who, despite having completed no apprenticeship with a metalsmith or professional printmaker, nevertheless attempted to execute his own printing plates, and the example he set caught on rapidly, especially in Bologna itself, where most of the major painters through the rest of the century would themselves experiment with etching. Earlier printmakers who tried etching had abandoned the medium, but Parmigianino helped establish it as the premier form of intaglio throughout the continent. The most obvious outcome of the Sack to those who witnessed it would certainly have been the massive destruction it occasioned, but one collateral effect was the ensured success of an entirely new way of making art. The temporary eclipse of Rome and Florence resulted in the spread of the modern Roman and Florentine manner, both by forcing the migration of artists to other cities, and by encouraging the European-wide dissemination of images produced in that manner, in multiple, on paper.

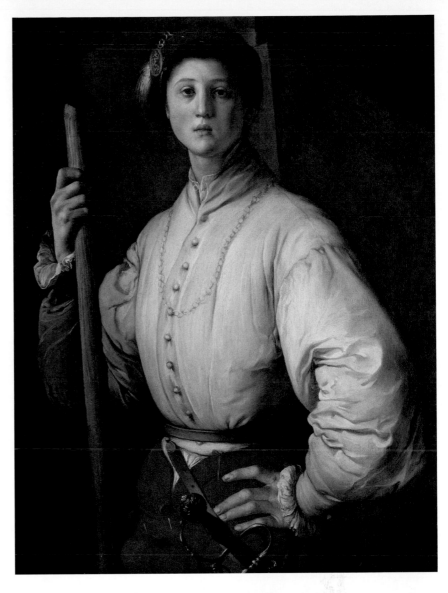

ABOVE
14.30
Pontormo, *Francesco Guardi as a Halberdier*, 1529. Oil on panel, transferred to canvas, 36¼ x 28⅜" (92 x 72 cm). J. Paul Getty Museum, Los Angeles

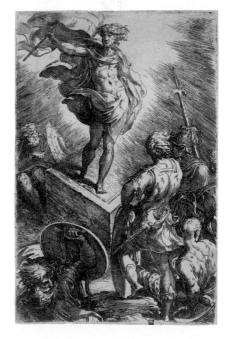

RIGHT
14.31
Parmigianino, *The Resurrection*, c. 1527–30. Etching and drypoint, 8⅜ x 5⅜" (21.1 x 13.6 cm). British Museum, London

15

1530–1540
Dynasty and Myth

15

1530—1540
Dynasty and Myth

The Sack of Rome in 1527 transformed the artistic geography of the Italian peninsula, not only compelling artists to move between cities, but also affecting the political circumstances in which they now found themselves. Some regions, including Sicily and the Kingdom of Naples, had been under Spanish control for decades. But after 1527, Spanish power extended through most of northern Italy. As families that were allied with the Spanish Crown stabilized local dominion, new networks of exchange opened, and cities and courts expanded diplomatic ties with the Holy Roman Empire. Rulers of various satellite territories, well aware of what their counterparts were doing, competed to promote their own realms as cultural centers and attempted to bring established artists and writers into their ranks. The works they sought frequently featured mythological imagery, so much so that the visual language derived from ancient Roman poetry became the common tongue of the court network. We can see how this happened by comparing patronage at a few of the most important centers.

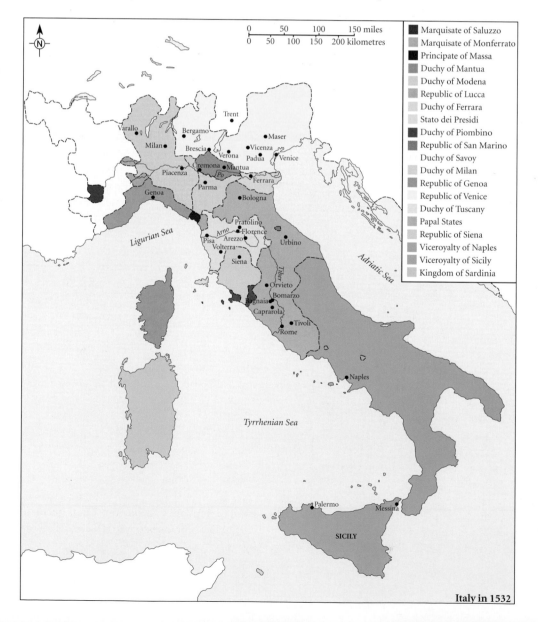

■	Marquisate of Saluzzo
■	Marquisate of Monferrato
■	Principate of Massa
■	Duchy of Mantua
■	Duchy of Modena
■	Republic of Lucca
■	Duchy of Ferrara
■	Stato dei Presidi
■	Duchy of Piombino
■	Republic of San Marino
■	Duchy of Savoy
■	Duchy of Milan
■	Republic of Genoa
■	Republic of Venice
■	Duchy of Tuscany
■	Papal States
■	Republic of Siena
■	Viceroyalty of Naples
■	Viceroyalty of Sicily
■	Kingdom of Sardinia

Italy in 1532

The Della Rovere in Urbino

Since the days of the Montefeltro rulers, the little dukedom of Urbino had lost much of its status. In the 1510s, control of the city shifted back and forth between the Medici and the Della Rovere families, and in 1524, Pesaro replaced it as the administrative center of the duchy. Through most of the following decade, Urbino was nominally ruled by Francesco Maria della Rovere (r. 1508–38), though the duke, a *condottiere* in the employ of Venice, spent much of his time on the road. Francesco Maria was a loyal partisan of Charles V, and he traveled to Bologna in 1530 to attend the Holy Roman Emperor's coronation, to Naples in 1535 to inspect Charles's fortifications, and to France in 1537 as a military ally, before dying, poisoned, in 1538.

As a patron, Francesco Maria is most important for his support of Titian. This suggests an allegiance of taste as well as politics. The duke would have known of the artist at least from the previous decade, when Titian painted Francesco Maria's brother-in-law, the Duke of Mantua. It was only after 1533, however, when Charles V officially recognized Titian's services to the imperial family by bestowing on him a knighthood, that Francesco Maria followed suit and commissioned works from the artist. For the emperor, Titian had primarily made portraits, and for Francesco Maria he did the same. A 1536 canvas shows the duke armed to the hilt, in breastplate

and gauntlets, sword at his side (fig. 15.1). Even his neck is covered with a gorget, as if he has just removed the helm, set to one side, in order to reveal his identity. Titian here pushes oil's capacity to depict particular materials, advertising his ability to capture different qualities of luminosity, from the glint of steel to the soft sheen of the velvet behind this. Adding to the technical difficulty of the painting, he dramatically foreshortens Francesco Maria's right arm and hand, which thrust a baton toward the viewer, rotating it to expose the insignia marking the duke's command of Venetian troops. It is as if the viewer, too, is expected to submit to the Republic, though the picture also reminds us that this mercenary does not serve Venice alone: two other batons, leaning against the wall in the back right, bear the papal keys and the Florentine lily, while an oak branch marks Francesco Maria's Della Rovere lineage. The exchange between the commander and his beholder is intensified by the interior setting. A drawing by Titian of the duke in the same pose suggests that the artist may originally have painted a full-length portrait. The painting in the Uffizi may derive from that, or may even constitute a copy of an earlier, now lost version; what the physical condition of the picture does confirm is that it was at some point enlarged so that it could serve as a pendant to a portrait Titian made in the same years of Duke Francesco Maria's wife, Eleonora Gonzaga (fig. 15.2).

ABOVE LEFT

15.1

Titian, *Francesco Maria della Rovere*, 1536. Oil on canvas, 44¼ x 40" (114 x 103 cm). Uffizi Gallery, Florence

ABOVE RIGHT

15.2

Titian, *Eleonora Gonzaga della Rovere*, 1538. Oil on canvas, 44⅞ x 40¼" (114 x 102.2 cm). Uffizi Gallery, Florence

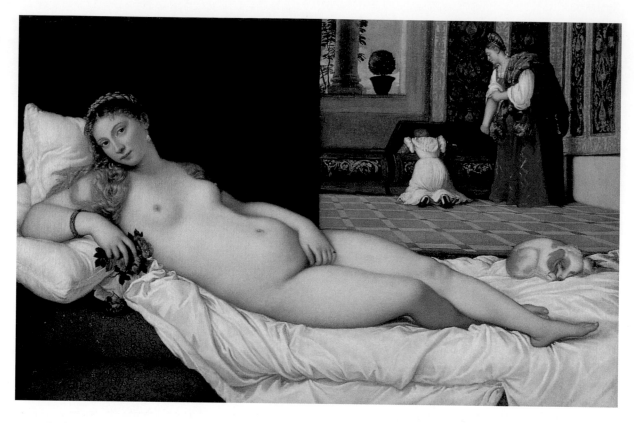

Like her husband, Eleonora is shown in what must have counted among the finest costumes she owned, in this case the sort of black dress that Spanish tastes had helped make fashionable throughout Italy in the 1530s. Its gold bows echo the golden ornaments on Francesco's armor, while the plush green tablecloth complements the backdrop of the other picture. The links between the pictures make all the more poignant the reminders of the soldier's frequent absence, precisely for occasions when he would be called upon to wear his armor. The clock before the window seems to underscore the waits that Eleonora faced while her husband was away; the sleeping dog was conventionally associated with loyalty and devotion. (The dog here is a type of spaniel, a word that both in English and Italian means "Spanish.")

The most important of Titian's paintings to enter Della Rovere hands is the one that has come down to posterity under the title *The Venus of Urbino* (fig. 15.3). Just who, if anyone, commissioned it is unclear, though a letter that Francesco Maria's son, Guidobaldo, wrote to his mother indicates that the canvas was in Titian's studio shortly before the duke's death in 1538, and that Guidobaldo desperately wanted to own it. (His mother initially refused to buy it for him.) The picture itself offers hints that the artist had his work for Francesco Maria in mind when he painted it. The woman depicted appears to be the same one who features in another painting owned by the duke's father, which Francesco referred to in a letter

as "that portrait of that woman in the blue dress [Titian's "La Bella," now in the Palazzo Pitti, Florence]." And the spaniel from the portrait of Francesco Maria's wife is back as well (*see* fig. 15.2), now at the foot of the bed. Yet these connections only tinge the *Venus* with a kind of irony. Eleonora's green tablecloth appears to have been hung up behind the nude figure, accentuating the reds in the upholstery, the flowers, her blushing cheek, and her lips. The sleeping dog that seemed an unambiguous emblem of fidelity in the marital portrait now offers a furry double both to the recumbent woman's long brushed hair and to what she covers with her hand. Even the idea of waiting in the portrait of Eleonora has been inverted to humorous effect, as Venus gazes in anticipation at the beholder. Through variations in brushwork, no less than color, Titian insists on the tactility of the items in the foreground, the smooth sheets folding where her weight presses against them. Everything about the picture invites touch. The limits of the body are marked by a seemingly continuous, gently curving brown contour, as if Titian finished the work by dragging his brush along her form, putting the entirety of his technique in the service of rendering flesh.

And what of the title? Guidobaldo referred to the picture's protagonist only as "the nude woman." It was Vasari who first called her "Venus," thirty years after the painting's completion. Certainly, the painting is reminiscent of Giorgione's *Venus* (*see* fig. 12.59), which Titian

himself had worked on. It also adopts something like the "pudica" (literally, "modest") gesture known from standing ancient statues of Venus. In this case, though, even that is ambiguous, and her address is more one of invitation than of modesty. The setting is insistently contemporary, a palace interior with modern tapestries on the wall. In the background, two women, whose costume suggests that they are domestic servants, collect a gown from (or prepare to deposit it into) a *cassone*. Descriptions of private collections, such as Andrea Odoni's in Venice (*see* fig. 14.23), indicate that paintings of the nude were often kept in bedchambers, exactly the kind of room we see in the painting itself. Even though the model may have been recognizable as a kind of "trademark" of Titian himself, it is likely that the painting was not intended as a portrait, but that its subject is human sensation – especially the erotic sensations of sight and touch.

The Gonzaga in Mantua

Palazzo del Tè

Mantua had been ruled since 1519 by Federico II Gonzaga, the son of Francesco II Gonzaga and Isabella d'Este, and the brother of the Eleonora depicted by Titian (*see* fig. 15.2). As Pope Clement VII's official standard-bearer and with troops at his disposal, Federico had been in a position to stop the Spanish march on Rome in 1527, but had declined to do so. His brother Ferrante, moreover, was a *condottiere* who had participated in the Sack. When Charles V entered Mantua in triumph three years later, Federico, long an ally of the emperor, secured not only the hand of his daughter, Julia of Aragon, but also

the title of duke, and with this a hereditary dynasty. The marriage was short-lived, but Federico's ties to Charles significantly shaped his most important works of patronage in the 1530s.

As a child, Federico had been a hostage at the papal court in Rome during the very years when Michelangelo was painting the Sistine Chapel and Raphael the Stanza della Segnatura, and the experience had left a deep impression. In 1524, upon the completion of the most important projects Raphael had left unfinished at his death in 1520, Federico persuaded Giulio Romano to move to Mantua. The appeal for Giulio must have been the role Federico promised to assign him, and from the late 1520s on, he not only worked as a painter and designer but also oversaw much of the architecture and urban planning undertaken in the city. In 1526, he was elevated to the nobility.

The most remarkable of Giulio's projects was the Palazzo del Tè (literally, "T Palace"), named after its location, an island at the outskirts of town, and built on the site of the marquess's former stables (fig. 15.4). The idea for its basic form and position derived from recent Roman buildings: Antonio Chigi's villa (*see* figs. 13.2–13.3) on the edge of that city would have been the most famous new work of architecture completed during Federico's years in the city, and Giulio himself had provided decorations for Cardinal Giulio de' Medici's villa. Both of these buildings employed engaged pilasters against plain expanses of colored *stucco*, suggesting that the villa was an opportunity to show off its designer's command of the classical orders. Coming from Rome to a small town, Giulio does not seem to have felt the normalizing pressures of the major centers. And both he and his patron must have had an interest in demonstrating that although the artist had learned the architectural principles of Vitruvius from

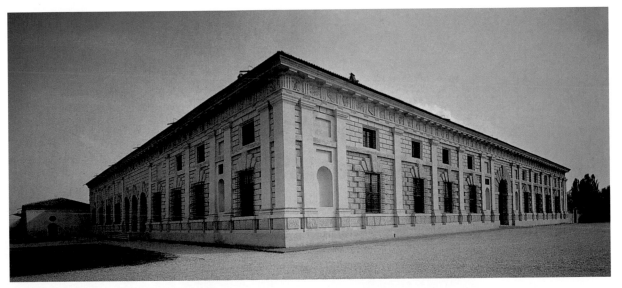

15.4
Giulio Romano, Palazzo del Tè, Mantua. View from the southeast

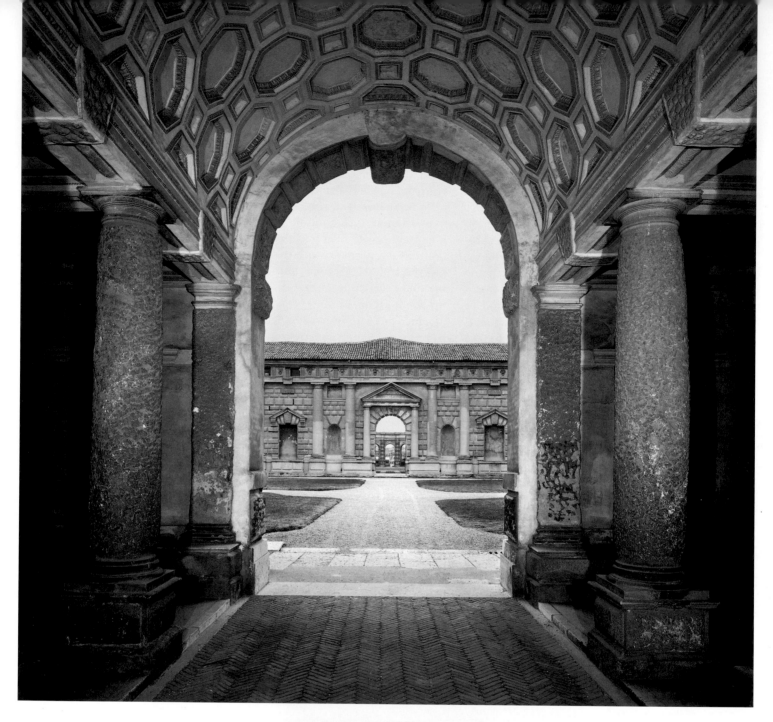

ABOVE
15.5
Giulio Romano, loggia,
Palazzo del Tè, Mantua,
1524–43

RIGHT
15.6
Giulio Romano, courtyard
of the Palazzo del Tè,
Mantua, 1527–34

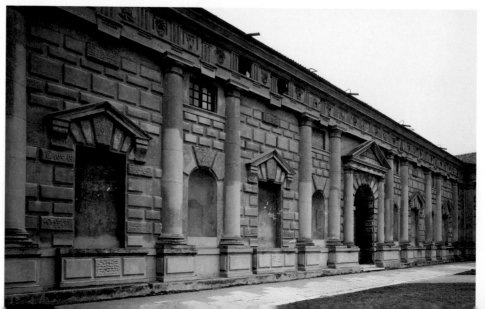

Raphael, he was not simply a passive imitator either of the ancients or of his master.

On the north, east, and west facades of the main palace block, Giulio overlaid colossal Doric pilasters onto a horizontal expanse of rusticated wall (*see* fig. 15.4). The massive unworked blocks used for the **keystones** above the windows and main portal, however, are incongruous with the columns that flank them and actually overrun the **string course** above. By contrast to buildings in the tradition of the Medici Palace in Florence (*see* figs. 6.1, 6.20, 6.22), or Raphael's much richer Palazzo Branconio in Rome (*see* fig. 13.18), which showed a progressive refinement up through the facade, and where there was even a sense that things above held things below in check – here two systems, one rougher, and one more regularized and refined, struggle for dominance. In the atrium (fig. 15.5), columns seem themselves to be growing, overflowing the rings that should establish their diameter both at the base and at the crown, their surfaces encrusted with

what looks to be living incrustation. In the courtyard (fig. 15.6), the combination of classical order and rustication returns, as does the tension between them. The *timpana* over the windows appear underscaled for the keystones they contain, and their sloping sides fail quite to meet at the top, a reminder of Giulio's design process, in which he joined unlike elements together. In the frieze, triglyphs that do not have columns beneath them slip downward. This is a knowing reference to the fact that, in their origins, triglyphs were markers of structure, the segment of the architrave that aligned with the building's supports. It also gives the impression, though, that the whole composition might collapse.

All of this, it turns out, is a fiction. The lands around Mantua provided little usable stone of any size, so Giulio ended up building nearly the entire palace from brick, covering it with *stucco* and shaping this into his rustication, columns, friezes, and so forth. The ornaments, nevertheless, lend the building a dynamism and even

15.7
Giulio Romano, Sala dei Cavalli, Palazzo del Tè, Mantua, 1528–30

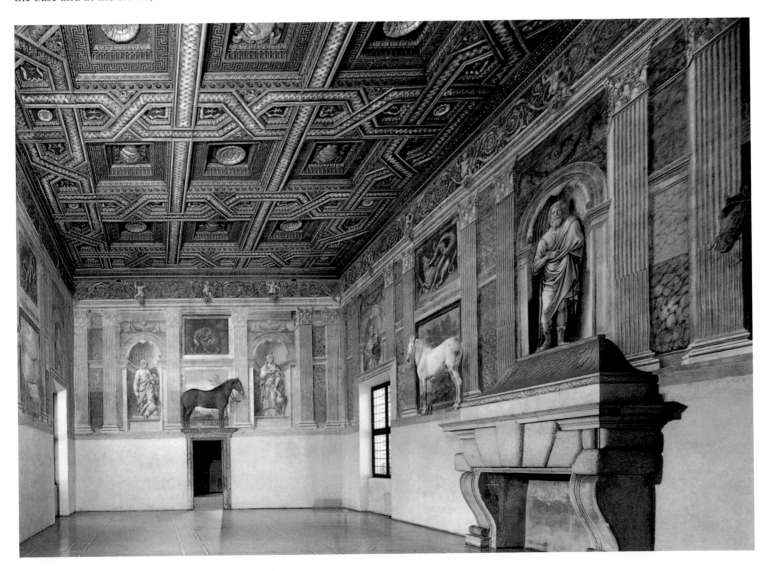

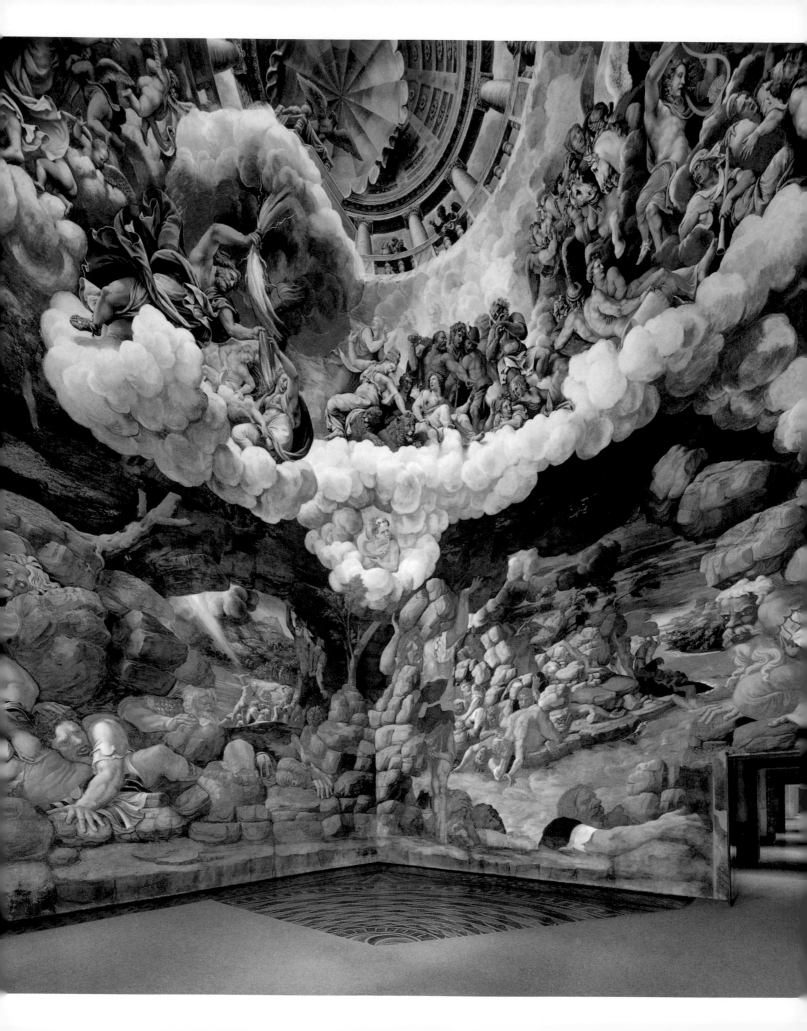

a narrative element, a sense of conflict consistent with Giulio's pictorial interests. It is an insistently Roman composition in the tradition of Bramante and Raphael, yet it is also difficult to imagine any Roman who had received his basic training in architecture rather than in the figural arts putting a palace together in quite this way.

In part, Giulio may simply be responding to the building's function, as a place of leisure, by approaching its design with wit. He brings the same kind of humor into his painted interiors, where, for example, in the Sala dei Cavalli (fig. 15.7) a giant fresco comprising illusory pilasters, statues of ancient deities, busts, and bronze reliefs of the Labors of Hercules is completed with a row of horses, apparently standing in the room, on a parapet, in front of windows onto the surrounding painted landscape. Whether they are an allusion to the stables the palace replaced or a reminder of the status that horse-ownership conferred, the horses' only connection to the rest of the decoration is that they, like the people portrayed in the busts, are actually portraits: their names are recorded below.

The room where the imagery most directly picks up the themes from the courtyard architecture, however, is the Sala dei Giganti (fig. 15.8). Here, Giulio stuccoed the space in such a way that in the upper zone the corners disappear and the ceiling becomes a dome. Then, in an illusionistic tour de force that shows his awareness of northern Italian painters like Mantegna and Correggio, he painted a temple and baldachin, seen from below, beyond a bank of clouds. The central position and the effect of the foreshortening evoke the lanterns at the apex of church domes: it is as though Giulio has decided to do a pagan version of Correggio's Parma Cathedral frescoes (see figs. 14.17–14.19), with the difference that the virtual world this time would extend right down to the floor of the room. According to Vasari, that floor originally consisted of sharp stones set on edge, exactly what Giulio painted at the bottom of the walls, so that there was no distinction between the real and illusionistic space even at foot level.

The scenes on the walls derive from Ovid's account of how a race of giants attempted to build a mountain, climb into the heavens, and overthrow the gods. Giulio shows their defeat by Jupiter, who stands at the center of a fearful Pantheon and hurls down thunderbolts handed to him by his wife Juno, toppling the giants' construction and crushing them under what they had made. Remarkably, the giants' "mountain" here includes not just oversized stones – of the sort Giulio himself used around windows and doors on the facade of the palace – but also columns. These are giants who, like Giulio's fellow Romanists, seem to have studied their Vitruvius. The viewer is thus asked to compare the giants' hubristic architecture

to the building in which he or she stands, but to what end? Is this just a visual joke on the part of the architect, making the creation of his building into an epic subject? Vasari, who saw the paintings in the company of Giulio himself shortly after their completion, asserted that the artist painted what he did simply "to show what he was worth." Still, it is difficult to ignore the political content of the motifs. Mount Olympus was one of Federico's personal emblems, so the choice of subjects would suggest his presence is implied in the ceiling of the room. Yet the program is equally flattering to Charles V, who had used the motif of Jupiter slaying the giants on one of his portrait medals; Federico received the emperor at the Palazzo del Tè both in 1530 and in 1532, and he would have been looking to impress his patron. Then there is the possibility that the true subject of the room is the Roman scene as it looked from Mantua while the building was under way. The humorous treatment of the colossal forms, the smashing of grotesquely large, excessively muscled male bodies, could well have come across as a parody of Michelangelo and the gargantuan forms favored by his followers. After all, the decoration of the Palazzo del Tè started in 1527, the year of the Sack of Rome.

Correggio's Mythologies

The imperial sympathies of Federico II Gonzaga certainly played into the other major set of mythological pictures he commissioned in the same years, this time from Correggio (1489–1534). The series, completed in the early 1530s, consisted of four paintings, all on canvas, depicting Jupiter's encounters with four mortals: the beautiful Leda, seduced by Jupiter in the form of a swan; the princess Danaë, whose chamber Jupiter entered in the form of a shower of gold; the Trojan prince Ganymede (fig. 15.10), snatched away to Olympus by Jupiter transformed into an eagle; and Io (fig. 15.9), embraced by the king of the gods in the form of a cloud. The paintings eventually entered the collection of the emperor, probably having been offered as a gift by Federico himself, and they may even have been made for that purpose. As a group, they show no less a debt to Giorgione's Venus (see fig. 12.59) than Titian's Venus did (see fig. 15.3), for all but the Danae place nudes in landscape settings. Both Giorgione and Titian, however, had isolated their goddesses, allowing the viewer the fantasy of a private encounter, while Correggio's scenes are considerably more explicit, in every case showing his characters in the midst of an erotic or even a sexual act. Correggio was certainly aware that Giulio's reputation in part rested on his production of erotica: one room in the Palazzo del Tè offered Federico and his guests a dazzlingly elaborate and strikingly lewd reworking of the story of Psyche, a bathetic

OPPOSITE

15.8

Giulio Romano, Sala dei Giganti, Palazzo del Tè, Mantua, 1528–30. The room's other walls show the giants' architecture to include colossal columns and motifs that resemble those from the palace's own garden facade.

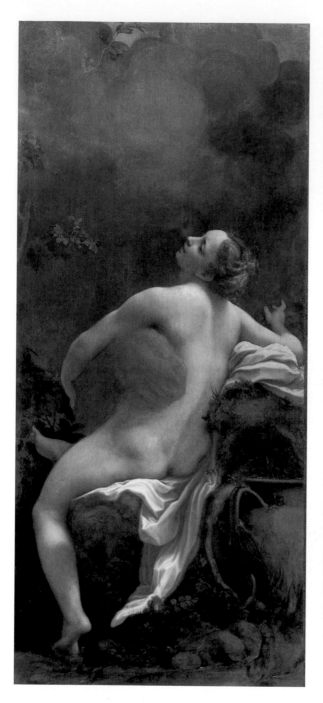

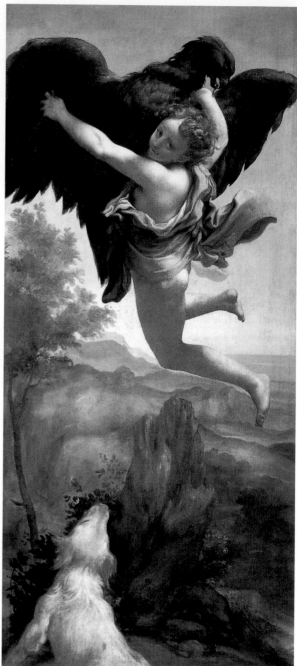

emulation of Raphael's paintings for Agostino Chigi (*see* fig. 13.4). Correggio, no less than Giulio, seems to be thinking about "positions" as much as poses, yet he avoids the statuesque anatomies and cool colors of the Roman school; his figures display soft, creamy flesh rather than muscle and bone structure, and Correggio shrouds them in a haze of muted color, reflected light and delicate shadow. Giulio may have satirized the *gravitas* and the hard-edge anatomies that these earlier painters, working for the Pope, had pursued, but Correggio rejects that tradition altogether.

To respond to Giulio in this way was to acknowledge the Roman painter's role at the Gonzaga court. Correggio sought to rival him by confronting the eroticism for which Giulio was notorious. At the same time, the paintings Correggio supplied are not a complete departure from his religious works of the previous decade. The *Virgin and Child with St. Mary Magdalene and St. Jerome* (*see* fig. 14.19) had already represented access to Christ as a kind of ecstasy, conveyed through an experience of touch. And the clouds and light in the dome of Parma Cathedral had framed the *Assumption of the Virgin* as a mystical

vision, one offered both to the Apostles standing on the parapet and to the churchgoer looking up from the pavement below (*see* fig. 14.17). The Gonzaga series, like these religious episodes, imagines unions with the divine, and the appeal of having Correggio paint them was the prospect of turning the visual language he had developed in a sacred context to an unexpectedly profane use. This is especially apparent in the *Jupiter and Io* (*see* fig. 15.9), in which the king of the gods descends earthward, like Christ in the Parma Cathedral fresco but here transformed into a cloud. The spectacular effect Correggio achieves in both paintings, of angels fading into air, or of a moist, bluish-gray vapor enveloping the nude Io, condensing into the face that kisses her and the arm that touches her contrastingly warm, soft skin, represents a stunning reinterpretation of the *sfumatura* technique that Leonardo had popularized in Lombardy and the Veneto. Whereas Leonardo used *sfumatura* primarily for naturalistic ends, aiming to reproduce, in paint, the conditions of seeing, Correggio isolates it as a device, putting it directly on display. The gauzy look to all the paintings in the Gonzaga series not only creates the atmosphere an artist would witness in deep outdoor vistas, but also suggests the dream-like world in which humans and gods can meet. Perhaps most importantly, it lends the women and the boy whom Jupiter seduces

or abducts a physical tenderness – we see why it is that the king of the gods fell for them.

The Medici in Florence

Michelangelo's New Sacristy

In the years Correggio was establishing the foundations for a decisive refutation of Michelangelo's pictorial manner, Michelangelo himself had largely turned from painting back to sculpture, and in addition had begun to establish himself as an architect. And the most unusual dynastic memorial of the century is the funerary chapel he created for the Medici in Florence (fig. 15.11). The structure was part of the extensive additions to the church of San Lorenzo that Pope Clement VII had ordered in 1519; Michelangelo had worked primarily on this project for fifteen years.

The chapel was built from the ground up to the north of the transept. In design and function, it was conceived as a pendant to Filippo Brunelleschi's sacristy from the previous century (*see* fig. 4.11), and it thus came to be known as the "New Sacristy" (and Brunelleschi's thereafter as the "Old Sacristy"). Both spaces would have provided chambers for the robing of priests cel-

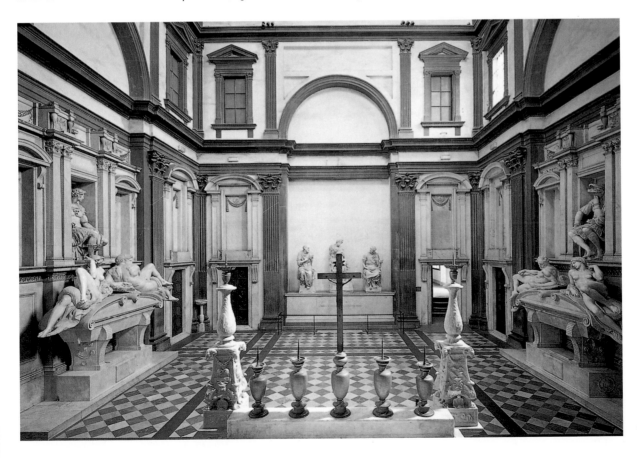

15.11
Michelangelo, New Sacristy (also known as the Medici Chapel), 1519–34. San Lorenzo, Florence

ebrating Mass in the main church; both also served as Medici family burial sites with private family altars. Still, Michelangelo's design conspicuously departs from the model established by Brunelleschi: though Michelangelo restricted his palette to his predecessor's muted grays and whites, he worked not only with the soft dark stone known as *pietra serena* and beloved by Florentines, but also with bright, sumptuous Carrara marble. Whereas Brunelleschi had articulated his dome with simple ribs, a decoration much like that he employed on the exterior of Florence Cathedral, Michelangelo's is coffered, in imitation of the Pantheon in Rome, and recalls Raphael's

15.12
Michelangelo, tomb of Giuliano de' Medici, 1524–34. Marble, height of central figure 5'11" (1.81 m). New Sacristy, San Lorenzo, Florence

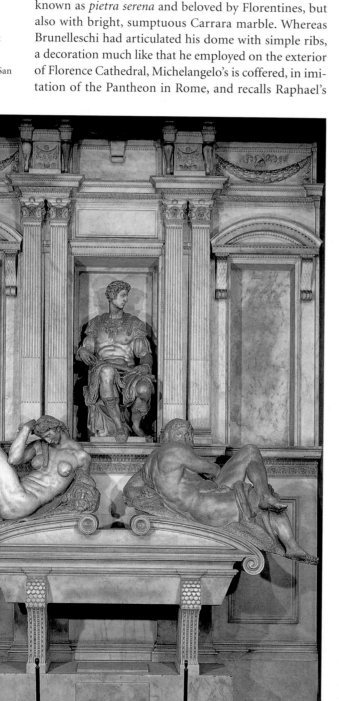

miniature imitation of the Pantheon in the Chigi Chapel (*see* fig. 13.2). Michelangelo also created a loftier space, inserting an extra storey between the pendentives and the lower zones. At one point, he planned for pictorial ornament in the dome and other areas, an idea that would have given his sacristy, like Brunelleschi's, some areas of color. A never-executed fresco was to show Christ's Resurrection, a theme obviously befitting the function of the space.

The most extraordinary portion of Michelangelo's design, however, is the lowest storey, which replaces all the walls with blind doors and empty tabernacle niches that jostle each other in the bays between the Corinthian pilasters. Only two of the eight doorways actually provide access elsewhere, a feature that adds to the deliberate sense of confusion and ambiguity. Like Bramante at St. Peter's in Rome, Michelangelo has shifted architecture from a problem of decorated surfaces to one of molded spaces. The heavily pedimented niches seem to press down on the doors beneath them, creating a sense of dynamic collision never before sought in the Renaissance revival of the classical past. In their bizarre mutation of classical pediments and pilasters, these elements completely defy the new preoccupation, common among interpreters of Vitruvius, with rules and archeological verification.

A permanent endowment was to ensure that the New Sacristy would serve as a place of perpetual prayer for deceased members of the line of Lorenzo the Magnificent. Though the two portraits ostensibly show Giuliano (*d.* 1516), son of Lorenzo the Magnificent, and Lorenzo (*d.* 1519), son of the Magnificent's brother Giuliano, the sepulchers entomb both the younger princes and their fathers. For a time, Michelangelo had contemplated a single, free-standing monument that would include portraits, statues of the Virgin and Child, and other decorations. As installed in the mid 1540s, though, a decade after Michelangelo's departure from the city, the chapel followed his later plan for paired wall tombs, with the Virgin and the Medici saints Cosmas and Damian forming a separate altarpiece for the chapel.

In his conception of the chapel, Michelangelo drew on the metaphorical possibilities of sculpture and architecture to produce a visual and spatial poem on the theme of death, the afterlife, purgatory, and redemption. The best-known and most spectacular aspects of the complex are the two wall tombs (figs. 15.12–15.13). Both lifesize portraits, enthroned in shallow niches, look toward the altarpiece group of the Virgin and Child; on the sarcophagi beneath them appear allegorical figures representing Dawn and Dusk (below Lorenzo) and Night and Day (below Giuliano). The most finished are the two

melancholy female figures of Night and Dawn. Intention-
ally or not, the lack of finish in the two male figures, Day
and Dusk, enhances their vigor; Day shows, characteristi-
cally, how Michelangelo would come close to completing
his stomachs and backs before working on heads, as if
fragments like the Belvedere Torso (*see* fig. 12.44) had
taught him that these, rather than faces or hands, were
the body's most expressive parts. Michelangelo planned
pairs of river gods for the floor on either side of the sar-
cophagi, which would have enclosed the composition in
a more stable pyramidal form. With these elements gone,
the massive marble figures threaten to slide off their con-
soles, which magnifies the unsettling qualities already
present in the design.

Both of the portrayed men had been granted ducal
titles before their deaths – Giuliano had been given the
dukedom of Nemours in France, Lorenzo the dukedom of
Urbino, following the brief expulsion of the Della Rovere.
Curiously, the tomb imagery makes no reference to their
ducal rank; in fact, the portrayal of Lorenzo and Giuliano
as generals seems to celebrate them for their republican
rather than princely offices. (Lorenzo held the old Floren-
tine office of captain general, and Giuliano held a similar
rank in Rome.) The lack of reference to ducal status may
be a result of the tombs' unfinished state, which also may
explain the surprising lack of Medici coats of arms or
indeed of any epitaphs: there is not even an inscription
designating which duke is which, and Michelangelo was
candid about the fact that both "portrait" sculptures were
ideal conceptions that bore no resemblance to the men
that they stood for, stating that in centuries to come no-
one would know (or care) what they looked like.

Michelangelo's remark implies that he took his own
art to be far more important than the two Medici, whose
careers he would hardly have regarded as illustrious. Yet
there is also a sense that reputation and glory themselves
might in the end be an illusion produced by art, charging
the entire monument with irony as a dynastic com-
memoration – the tombs, after all, are also a memorial
to dynastic extinction, the end of the principal Medici
line. The theme of falsehood and illusion abounds in
the chapel's imagery. Under the arm of Night appears
a sinister mask, with the eyes of a human skull behind
its eye sockets; masks were, by 1520, common symbols
of dreams, phantasms, and empty appearances. They
are a fitting attribute of Night, but their appearance is
not confined to this figure. Chattering masks, endlessly
varied in form, abound in the architectural friezes and
capitals, even on the cuirasses worn by the captains.
Lorenzo's helmet is itself a fantastic canine mask, and
a bat-like face appears on the money box in his hand
(another less than glamorous allusion to the foundations
of Medici glory).

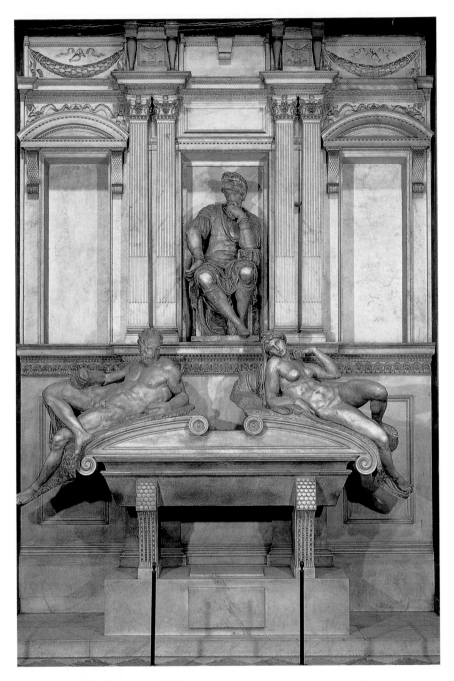

The classic function of marble sculptures was to
ensure the endurance of memory through time, to
embody the immortality that comes with posthumous
reputation. Michelangelo has added a disquieting twist,
however, where lifelike stone figures now come to sug-
gest petrification or paralysis. Lorenzo and Giuliano
appear tortuously confined by their niches; the Times
of Day strain fitfully or resign themselves to a state of
inertia or unconsciousness. Michelangelo explained the
significance of these figures in some verses he composed
while designing the tombs, a striking indication that
poetry was part of his creative process as a sculptor:

15.13
Michelangelo, tomb
of Lorenzo de' Medici,
1521–34. Marble, height
of central figure 5'10"
(1.78 m). New Sacristy, San
Lorenzo, Florence

Day and Night speak – we with our swift course have brought the Duke Giuliano to Death. It is just that he, the Duke, takes revenge as he does for this, and the revenge is this, that, as we have killed him, he, dead, has taken the light from us, and with his closed eyes has locked ours shut, which no longer shine on earth. What then would he have done with us while alive?

The tragic languishing of the Times of Day is a result of the fact that they represent the personal, allotted time of Giuliano and Lorenzo, consigned to immobility by

15.14

Baccio Bandinelli, *Hercules and Cacus*, 1525–34. Marble, height *c.* 16'3" (4.96 m). Piazza della Signoria, Florence

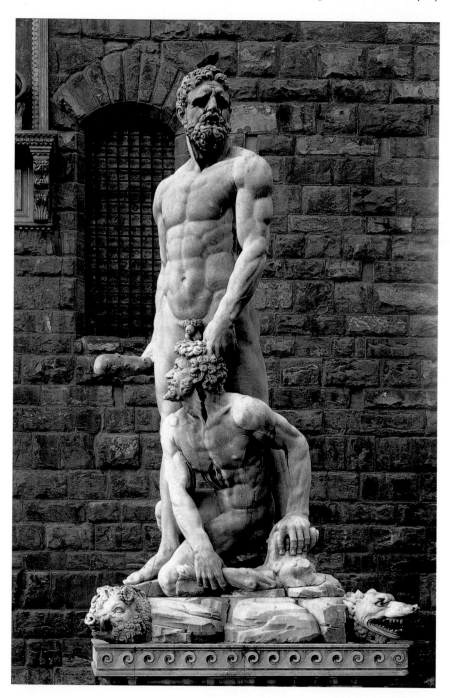

their deaths. Their blindness, an absence of light resulting from the fact that they are days without sunrises and sunsets, is underscored by the fact that none of the figures, including the captains, has drilled pupils. Giuliano and Lorenzo look toward the Virgin – but can they really see her? She certainly does not look toward them, and the Christ child turns away, as if the nursing she proffers is for him alone. The Medici, Michelangelo implies, do not yet have the beatific vision of the blessed in Paradise, and will only attain this through a period of endless waiting in Purgatory, and through the perpetual prayers of the living.

Michelangelo later underscored the political implications of the allegories, the times that "killed" the Medici, in a much-celebrated verse on the figure of Night:

> Dear to me is sleep, dearer still being made of stone,
> while harm and shame last;
> not to see, not to hear, to me is a great boon;
> so do not waken me, ah, speak but softly.

It is rare indeed for a Renaissance artist to write of the "shame" of the people he devoted fifteen years of his life to immortalizing. But Michelangelo had gladly helped the city defend itself against Pope Clement's invading armies in 1529, and he had watched with dismay as the emperor then helped Clement to install his illegitimate son Alessandro as a hereditary Duke of Florence. Like others still alive in the city after the siege, Michelangelo was faced with a dispiriting dilemma: to work for the family now in power, or to leave. He made several trips to Rome in the early 1530s, but when Clement died in 1534, the artist decided just to stay there, and he never again set foot in Florence.

The Image of the Autocrat

Michelangelo's absence from Florence may have had the most significant impact on the city's sculpture, since it was on sculptural projects that he had mostly been engaged. Among the first public monuments to go up under Duke Alessandro was Baccio Bandinelli's (*c.* 1493–1560) *Hercules and Cacus* (fig. 15.14). It was Clement VII who had initially conceived the work, and Bandinelli had begun work on it as early as 1525, but when the Medici fled the city two years later, he joined them. The block at that point went to Michelangelo, who reconceived the composition as a *Samson Slaying Two Philistines.* When the Medici returned to the city in 1530, they brought Bandinelli with them; he regained control of the marble, and returned to his earlier plan. The final pair, completed the year Michelangelo left town, showed Cacus – an evil giant and cattle thief – enslaved by the semi-divine muscleman.

It was placed to the right of the entrance to Florence's city hall, and thus became a permanent pendant to Michelangelo's *David* (*see* fig. 12.3). The patron's intention, no doubt, was to neutralize the *David*'s republican associations; the earlier statue was famous enough that it could not simply be moved or destroyed, but perhaps company would dilute its message. Bandinelli himself, put in the awkward position of distracting the attention of a hostile audience from Michelangelo's icon, did what he could to imitate his predecessor, giving his figure a similar scowl and trying to show that he, too, had studied human anatomy. Vasari writes that, once the statue was in place, Bandinelli even went back and retouched it, giving the figures' physique yet more definition. The comparison with Michelangelo could not favor him, though, and contemporaries responded with scorn. Some attached poems to the work itself, disparaging Bandinelli, his marble, and, by implication, his patron. Later, his rival Benvenuto Cellini would rehearse all the criticisms leveled at the time: if Hercules's hair were removed, viewers commented, there would not be enough head left to contain a brain; the hero is not paying attention to what he is doing; the muscles seem to have been studied not after a man but a sack of melons; the whole statue seems to be keeling forward.

More successful, or at least more beautiful, were works that Alessandro commissioned for private contexts. Around 1534, the duke had Pontormo (1494–1557), the most resolutely Florentine of artists, make a large portrait showing the prince himself as a draftsman (fig. 15.15). Here Alessandro appears in a wood-paneled space, with a door, slightly ajar, behind him. A figure that originally stood outside, looking in, was in the end deleted, but the arrangement nevertheless gives the sense that we are seeing the duke in a state of seclusion, free of the pomp and circumstance associated with his public persona. The profile of a woman that his sitter draws was the sort of thing that Michelangelo and his followers could make from memory or fantasy. If the idea of the painting is that Alessandro's drawing originated the same way, it would add to the impression that the duke is alone in this space. An almost exactly contemporary portrait by Vasari (fig. 15.16) shows Alessandro in armor, the skyline of the city he ruled as conqueror behind him. Pontormo's portrait, by contrast, suggests the duke's wish to be perceived differently – and not to be too readily regarded as an armed warlord in the mold of Titian's Francesco Maria della Rovere (*see* fig. 15.1). This may just have been a matter of audience: Alessandro gave the finished picture to a lady friend, Taddea Malaspina, and he may have

ABOVE LEFT

15.15

Pontormo, *Alessandro de'Medici, c.* 1534. Oil on panel, 39⁷/₈ x 32¹/₄" (101.2 x 81.9 cm). John G. Johnson Collection, Philadelphia Museum of Art

ABOVE RIGHT

15.16

Giorgio Vasari, *Alessandro de'Medici,* 1534. Oil on panel, 61⁷/₈ x 44⁷/₈" (157 x 114 cm). Uffizi Gallery, Florence

BELOW

15.18

Rendering by Mark Tucker
of the original composition
of Agnolo Bronzino,
*Cosimo I de' Medici as
Orpheus*, based on analysis
by infra-red reflectography
and X-radiography.

OPPOSITE

15.19

Agnolo Bronzino, *Cosimo
I de' Medici as Orpheus*,
c. 1538. Oil on panel, 36⅞
x 30⅛" (93.7 x 76.4 cm).
Philadelphia Museum
of Art

15.17

Michelangelo, *Brutus*,
c. 1540. Marble, height 29"
(74 cm). Museo Nazionale
del Bargello, Florence

wanted her in particular to see him as a cultivated man committed to the pursuit of beauty rather than blood. If this is the case, though, the picture inadvertently plays into the reputation that was ultimately the cause of the duke's demise: his notoriety for dalliances around the city. In 1537, knowing Alessandro's reputation as a womanizer, his cousin Lorenzino promised the duke a liaison with his sister Laudomia, and then had Alessandro murdered when he appeared.

In a letter, Lorenzino expressed his hope that the assassination of the first tyrant to rule Florence since the Middle Ages would lead to the re-establishment of the Republic. His hopes were shared by a number of exiles, including Michelangelo, who celebrated the occasion by carving a marble bust of the ancient tyrannicide Brutus (fig. 15.17). To their chagrin, Charles V engineered the appointment of a Medici successor, Cosimo I, who oversaw Alessandro's burial in Michelangelo's New Sacristy and then had his henchmen murder Lorenzino. Some passages in the bust featured Michelangelo's char-

acteristic roughhewn surfaces, but when Cosimo's son Francesco later succeeded in acquiring it, he treated its non-finish as symbolic, adding an inscription that read: "While the sculptor was creating the portrait of Brutus in marble, he became aware of his offense and ceased to work on it."

Cosimo, who came to power as an obscure eighteen-year-old, was a far more skilled ruler than his predecessor had been, and by the time he handed off ducal authority to his son Francesco in the 1560s, he had consolidated control of the city and of a new Grand Duchy of Tuscany. He also thought more carefully than his predecessor had about the image of himself that he wished to promote, even to semi-private audiences. From Pontormo's best student, Agnolo Bronzino (1503–1572), he commissioned a portrait (fig. 15.19) even more unusual than Alessandro's (*see* fig. 15.15). In its original form, known from x-rays, the painting showed the duke in the guise of Orpheus, playing a lyre for the three-headed dog Cerberus that guarded the gates of Hades (fig. 15.18). This

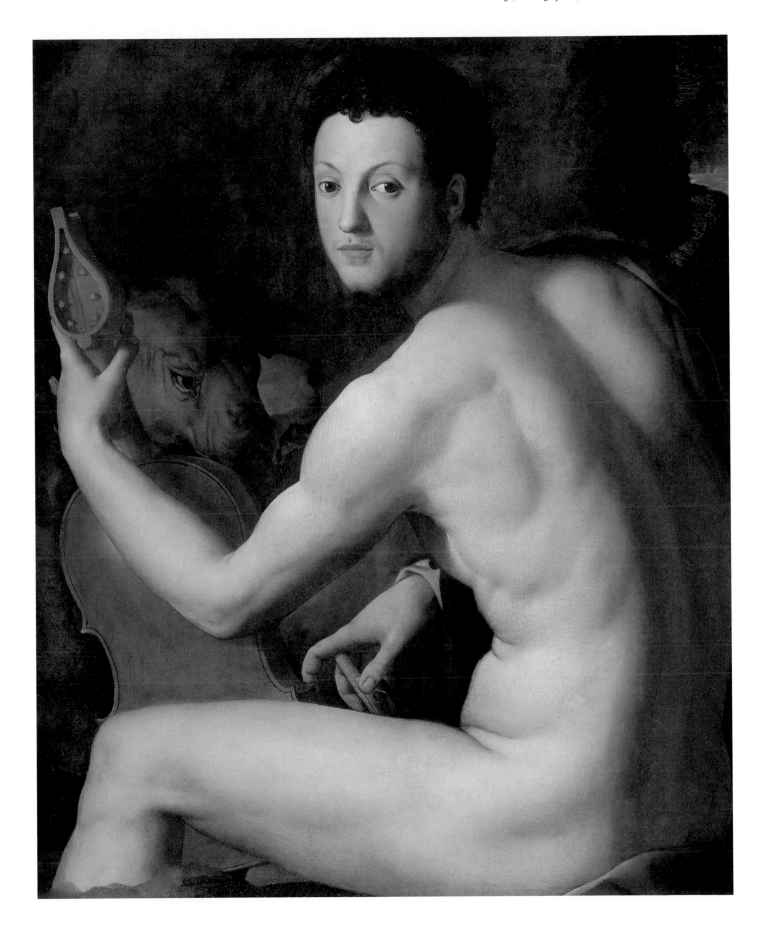

was an allusion to the ancient story of the Greek hero's descent into the Underworld to retrieve his lover Eurydice; at the sound of Orpheus's music, in the ancient poet Virgil's words, "Cerberus stood agape and his triple jaws forgot to bark." In the end, Bronzino made several significant adjustments to the composition, presumably at the duke's instruction. He eliminated the snarling mouth of Cerberus's rightmost head, making the beast completely placid before an Orpheus who no longer plays the lyre. This essentially shifted the scene from the present to the past tense: we see a hero who has *already* pacified his foe. Bronzino also underscored that the painting was no mere romance, especially by his elimination of the strap that originally covered Orpheus's left shoulder and the red garment that originally wrapped around his left thigh. The changes left the portrayed figure nearly nude, facilitating comparison with the work that served as the source for his pose, the Belvedere Torso in Rome (*see* fig. 12.44). Antiquarians in Bronzino's day generally regarded the torso as a depiction of Hercules, which suggests a second mythological type to which the duke wished to be compared. If the Orpheus conceit made Cosimo the new face of Florentine art, the Hercules conceit insisted that this was by no means at the expense of force, a point

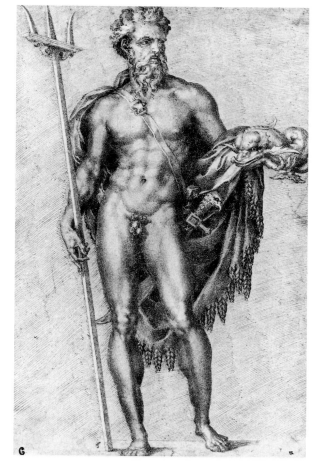

15.20
Baccio Bandinelli, study for a statue of Andrea Doria as Neptune, *c.* 1528. Pen and ink, 16¾ x 10¾" (42.5 x 27.5 cm). British Museum, London. The 1529 contract for the statue changed the material from bronze to marble, and in 1538 the project was abandoned altogether.

emphasized by the phallic repositioning of the bow in the final work.

Andrea Doria in Genoa

During the conflicts that culminated in the Sack of Rome, the naval commander Andrea Doria had been in the employ of Pope Clement VII, and as late as 1528 he was allied with anti-Spanish forces. In the summer of that year, however, he came to an accord with Charles V, who in exchange helped install him as the head of a newly constituted Genoese republic. Ostensibly, the city would have an elected government, but Doria himself would serve as "censor" for life. He remained the dominant figure in the city for the next three decades.

Court patrons in cities to the east had chosen not to rely entirely on local talent, but rather to bring in artists like Titian and Correggio who had established reputations in other centers. Doria did the same, turning to Rome (Perino del Vaga), Venice (Pordenone), and Siena (Domenico Beccafumi), but especially to Florence. One of his first major commissions went to Baccio Bandinelli, who in 1528 began designing a bronze statue of a semi-nude Doria for the square in front of the city's cathedral (fig. 15.20). The conception is remarkable in its pretensions: whereas ancient emperors had ordered up statues deifying themselves, modern rulers rarely followed this particular example, at least not so explicitly. The *Hercules and Cacus* that Bandinelli had made for Alessandro de' Medici in Florence (*see* fig. 15.14), by comparison, alluded to the duke's position of power, but neither Alessandro nor any other mid sixteenth-century ruler of that city would have displayed a portrait of himself in a public place, let alone a portrait of himself as a god.

Bandinelli's statue was not a one-off experiment; it inspired a second commission involving the Florentine Bronzino, who sometime in the late 1530s or shortly thereafter painted a slightly more subtle variation on Bandinelli's theme (fig. 15.21). The exact origins of the painting are unclear: its earliest documented owner was the humanist Paolo Giovio, and he may have received it from Cosimo I himself. In the picture as Bronzino left it, Doria stood against a ship's mast, wrapping a sail around his waist and holding an oar in his right hand. In its original form, that is, the painting took over Bandinelli's nudity, but eliminated all explicit reference to Neptune; the exaggerated musculature may have led viewers to suspect that they were seeing a pagan deity rather than a living mortal, but there was nothing in the picture itself to indicate that the depicted man was anyone other than Doria, and Bronzino even included his name in the scene, fictionally

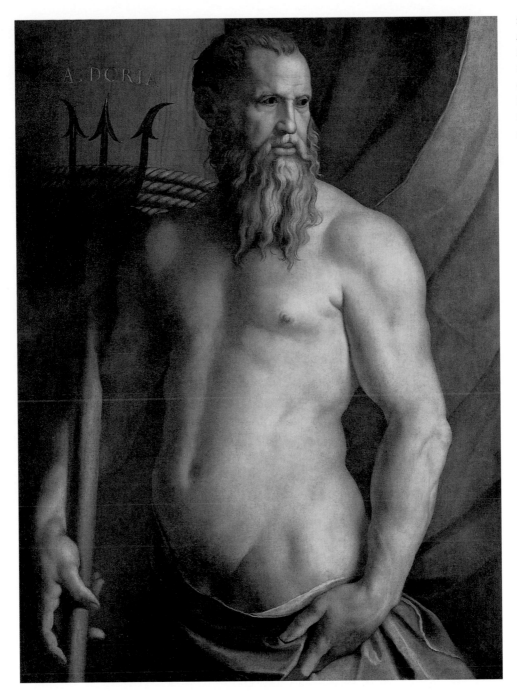

15.21
Agnolo Bronzino, *Andrea Doria as Neptune*, late 1530s or early 1540s. Oil on canvas (transferred from panel), 45¼ x 20⅞" (115 x 53 cm). Pinacoteca di Brera, Milan

inscribed in the depicted wood. In some ways, Bronzino's conception seems closer to Titian's *Venus* (*see* fig. 15.3) than to Bronzino's own *Cosimo I de' Medici as Orpheus* (*see* fig. 15.19), and if Vasari's confident naming of the nude woman in Titian's painting suggests how unaccustomed viewers were to seeing their contemporaries portrayed in this way, the subsequent history of Bronzino's *Doria* allows a similar inference. Sometime after Doria's death, and long after the image left Bronzino's hands, the oar was repainted and transformed into a trident. This eliminated the reference to Doria's role in directing his fleet, but it also rationalized the picture's most unsettling elements, including its glimpse of his genitals. If the original version allowed the conclusion that it was *just* Doria we were seeing, posing with the mundane instruments of his occupation yet bizarrely eroticized in his semi-exposure, this reading was now closed off. The picture would show nothing other than Neptune, the god who controlled the sea, there to serve as a sign of, or analogy to, Doria's potency as a commander.

THE FIRST MUSEUMS

The modern museum has a twofold Renaissance origin. On the one hand, it lies in the intimate spaces of collecting and display to be found in the palaces of the elite, where valuable paintings, sculptures, drawings, and other works acquired the status of objects of knowledge. On the other, it lies in the great assemblages of classical statuary and inscriptions that had been accumulated at sites in Rome: the grouping of the equestrian statue of "Constantine" (Marcus Aurelius; *see* fig. 5.15), the bronze "Lupa" (she-wolf), the *Spinario* (*see* fig. 2.12), and fragments of a colossal statue at the Vatican, symbolically expressed the descent of imperial to papal Rome. Other ancient works were preserved at the Capitol, the site of the city of Rome's municipal government: in 1471, Sixtus IV transferred the Lupa and the *Spinario* there as a gift to the Roman people, and in 1538 Paul III followed with the transfer of the equestrian statue. We have seen that the Vatican Belvedere built by Donato Bramante was also conceived as a dignified architectural setting for the Belvedere Torso, the *Laocoön*, the "Apollo Belvedere," and other celebrated works. Meanwhile, cardinals and Roman aristocratic families created their own independent outdoor ensembles of ancient sculpture. In 1523 the Venetian cardinal Domenico Grimani recalled the donations of Sixtus and Paul III by giving his much-admired collection of ancient marbles and Flemish pictures to the city of Venice, where they were finally housed in the San Marco library after 1586 following additional gifts from the Grimani family. In Mantua, where the *studiolo* and *camerini* of Isabella d'Este were preserved and displayed to privileged visitors, the Gonzaga rulers had by 1580 constructed a large ceremonial space, referred to as a gallery, for their magnificent collection of antique sculpture.

The word *museo* ("museum," i.e. "place for the Muses") was first used in its modern sense when the physician and historian Paolo Giovio bestowed it on his villa by Lake Como, where from 1536 he assembled a collection of portraits of famous writers, warriors, and statesmen, and dedicated it "to public enjoyment" – although access would have been limited to literate people bearing letters of introduction. Giovio's collection (now long dispersed and lost) was also distinguished

by its global and universal aspect: an array of historical curiosities included precious metal and ceramic objects, costumes, weapons, and a Koran obtained as spoils during Charles V's war on Tunis in 1535; Giovio also owned several objects from the New World.

The "museum" (also called a "theater") housed in the family palace of the Bolognese professor of Natural History Ulisse Aldrovandi had a very different emphasis, although a comparable level of ambition: Aldrovandi sought from the 1550s to assemble an encyclopedic collection of plants, animals, and minerals, essentially turning Pliny the Elder's *Natural History* into an actual three-dimensional display – and challenging the authority of the ancient writer in the process. What Aldrovandi could not acquire in the form of actual specimens he substituted with artistic renderings, notably by the Florentine Jacopo Ligozzi. Aldrovandi's "theater of nature" was accessible to students and learned people, and was regarded as a place for research; it functioned as

15.22

Bernardo Buontalenti,
Tribuna of the Uffizi,
completed 1584, here
shown with the Medici
Venus and other works

RIGHT

15.23

Hall of Maps, 1563–65.
Palazzo Vecchio, Florence.
Paintings on the cabinet
doors showed the regions
from which the valuable
objects inside had come.

a support for other enterprises, such as a botanical garden and a multi-volume encyclopedia to be authored by the naturalist himself (it was only partly published after his death). Many elite visitors came as tourists, in search of an experience of wonder or marvel: the museum could boast an "authentic" winged dragon captured in 1572, as well as basilisks and hydras fashioned from rays and other creatures, which Aldrovandi displayed as instances of the collaboration of nature and human art, and as a way of making sense of the passages regarding these monsters in Pliny.

Aldrovandi maintained close relations with the Medici in Florence, whose collecting ambitions were global in their aspiration and outdid those of all other princes of the time. The grandest enterprise of any princely collector, and the nucleus of the great museum housed to this day in the Uffizi, was the construction by Bernardo Buontalenti of the octagonal room known as the Tribuna, completed in 1584, in which the most

valuable Medici possessions were displayed (fig. 15.22): semi-precious stone vases, coins and gems, and small paintings were shown in specially designed cabinets; ancient and modern bronze statues and marbles were arranged on shelves and pedestals. An English visitor in 1594 reported seeing a nail half turned into gold by an alchemist, a clock of amber, stones called bezoars that could counter the effects of poison, and "a little mountain of pearls, wrought together by Duke Francis," among other wonders. While Duke Cosimo's Hall of Maps (fig. 15.23) and his son's *studiolo* had maintained a principle of organization founded on place of origin, the Tribuna of the Uffizi seems to have *naturalia* and works of art displayed with no principle other than the infinite variety of nature and of human ingenuity. Wonder and spectacle – and the power of those who could command these – were the primary concern.

Rome under the Farnese

In the 1530s, Rome must have been a fairly desolate place. This is the impression, at least, offered in a series of drawings by the Netherlandish painter Maerten van Heemskerck (1498–1574). Heemskerck was part of a growing stream of northerners who came to Rome with the aim of studying its antiquities. Unlike most of his compatriots, however, he made this trip not during the years of his apprenticeship but in his mid thirties, when he was already a fully formed artist. And by contrast to most other drawings of antiquities in these years, Heemskerck's seem to offer not just records of anatomy or gesture, documents that could later be drawn upon to stock paintings with figures, but also a kind of commen-

BELOW

15.24
Maerten van Heemskerck, *Belvedere Torso*, 1532–36/37. Pen and ink on paper. Kupferstichkabinett, Staatliche Museen, Berlin

tary on the condition of the works he encountered. He shows the Belvedere Torso (*see* fig. 12.44), for example, with its legs pointing up in the air, as if it has been toppled from a pedestal (fig. 15.24). A piece of obelisk behind it draws attention to what is missing from the original statue, no less than what is there. Similarly, Heemskerck places Michelangelo's *Bacchus* (*see* fig. 11.50), shown damaged, in the company of other broken bodies, framing a wrist mysteriously missing its hand against the empty sky (fig. 15.25). The idea here may just be that Michelangelo's statues are themselves like antiquities in their beauty and authority, but the drawing also suggests that modern works, no less than ancient ones, had fallen into a state of decay. Heemskerck was not above exaggerating for dramatic effect; however, a still-visible repair indicates that this is likely the state in which the work was to be encountered in those years.

Most impressive are Heemskerck's images of architecture. His sketchbooks devoted pages to the ancient Colosseum and the Septizonium, standard subjects for visiting draftsmen, but he also made a series of views of St. Peter's. A sheet now in Berlin is typical (fig. 15.26). At the left, the remains of Emperor Constantine's basilica still stand; they are the closest thing to an intact building in the landscape. Closer to the center, in the background, rises the Vatican Obelisk, a monument that had occupied the site since antiquity. Towering above everything, though, is the structure of the new basilica on the right, captured at the point at which work had broken off in the 1520s. Walls are incomplete and in places apparently crumbling, there is no roof, and plants appear to grow on every horizontal surface, as if to indicate that no workman has been here in years. The image makes the building a testament to the ambition of the project, one that was too grand, it would seem, to actually finish. Yet it is also an ironic inversion, since here it is the antiquities that have been preserved and the modern works that have been consumed by time. It is difficult not to see in the sheet a reflection on the 1527 Sack of Rome and its aftermath, as if the invasion of the city had not just interrupted but actually destroyed the very papal undertaking that had spurred the Reformation in the north and turned European sentiment so sharply against Rome.

The drawing was done from a vantage point to the north of the site, looking south. If, as it would appear, it was done on location, Heemskerck must have been standing somewhere in the Vatican complex. This gives particular resonance to the project the Pope himself was undertaking just a few feet away, perhaps at the very time Heemskerck was recording his impressions. In 1534, Clement VII asked Michelangelo to begin conceiving a new mural for the Sistine Chapel. It was to go on the altar wall, replacing Perugino's *Assumption of the Virgin*,

the frescoed altarpiece still in situ. One of the earliest references to the work indicates that the subject was to be a "Resurrection." Does this mean that Michelangelo was planning a *Resurrection of Christ*, the subject of a series of drawings he had made in recent years and one he had also been contemplating for the New Sacristy? Or was it rather to be a resurrection of the dead, along the lines of what Luca Signorelli had painted in Orvieto (*see* fig. 11.27)? Either way, the theme would have had a civic no less than a devotional reference: having witnessed Rome's near devastation, Clement envisioned its recovery.

Urbanism under Paul III

Before Michelangelo so much as picked up a brush for the new mural, Pope Clement died. His successor was Alessandro Farnese, the bishop of Ostia, who took the name Paul III on his election. Paul was the descendant of an ancient Roman family, the first in over a century to place one of its own on the papal throne, and he was not about to let his best artists work in places other than his home city. He summoned Antonio da Sangallo the Younger (1484–1546) and Baldassare Peruzzi (1481–1537), and had the two architects redesign a number of Roman streets and squares, cutting through private properties as necessary to provide beautiful processional routes and impress visitors. In the area of the Campus Martius, where earlier sixteenth-century popes had carved out a trident of streets leading from the Porta del Popolo toward the center, Paul added an east–west counterpart, later called "Via Condotti" after the water conduits that ran beneath it. This connected the Pincian Hill and the precinct around Santa Trinità to the River Tiber. Further south, close to where Julius II had introduced the Via Giulia, Paul opened up other avenues; in this case, the choice of routes related to the position of the Farnese family's colossal palace, which was itself expanded toward the river. In the space where the new streets converged, to the north of this building, Paul opened up a large piazza. All of this made the palace itself, on which

Sangallo had been working for decades, look all the more monumental, though the architect had other reasons to be interested in the neighborhood as well: in 1535, while engaged in this work, he also began building his own house in the Via Giulia.

Paul III's urbanism did not just consist in demolitions and street improvements. Perhaps his most important urbanistic act was his 1538 transfer of the *Marcus Aurelius*, the city's greatest surviving bronze antiquity, from a site near the Lateran (the city's cathedral and the second major papal residence) to the Capitoline Hill. Paul had spent part of his youth in the household of Lorenzo the Magnificent, and the move indicates his love of antiquities: he would, by the time of his death in 1549, own one of the most impressive private collections of statuary, cameos, engraved gems, and other precious objects ever assembled. Giving such prominence to a militaristic image of an emperor announced the Pope's own cultivation of an imperial alliance. In fact, transfer of the statue came just two years after an elaborate triumphal entry that Paul had hosted for Charles V. The plan for the Campidoglio also aimed to re-associate the papacy, and the new Farnese Pope in particular, with the ancient heart of the city. Just as the statue was being moved, Paul was beginning to acquire vineyards on the Palatine across the forum, assembling what would eventually become a sprawling villa estate.

The Campidoglio project, for its part, was the start of a redevelopment of the site that Michelangelo was overseeing, though work on this was slow, and by the end of the decade it would still have been the statue that most dramatically marked the transformation. Where Paul was really focusing his artists' attention through the 1530s was on St. Peter's and the Vatican. Sangallo the Younger and Peruzzi had been Raphael's successors as supervisors for the building of St. Peter's, and the Pope had them return to the project. Sangallo, who remained architect in chief until his death in 1546, oversaw the raising of the floor of the basilica. His chief accomplishment, though, was the preparation of a wooden model for the whole structure (fig. 15.27). This sprawling design attempted a compromise between a centralized and a longitudinal solution. He conceived the domed section of the basilica and the facade as separate structures, connected by a kind of corridor. The facade features colossal towers and a great benediction loggia equal in height to the main entrance. The whole reads as three separate entities, with the repeated motif of a pediment on engaged columns in the second storey serving as a unifying device. The same motif reappears in the projecting corner pavilions between the apses, intended to house sacristies. The main body of the church combines features from the Pantheon and, especially in the curving ends of the transepts

15.26

Maerten van Heemskerck, *New St. Peter's under construction, view from the North East, c.* 1535. Pen and ink on paper, 5 x 7⅞" (12.8 x 20 cm). Kupferstichkabinett, Staatliche Museen, Berlin

OPPOSITE, BOTTOM

15.25

Maerten van Heemskerck, *Jacopo Galli's Garden in Rome, c.* 1532–35. Pen and ink on paper, first volume of Heemskerck's Sketchbook, folio 72r. Kupferstichkabinett, Staatliche Museen, Berlin

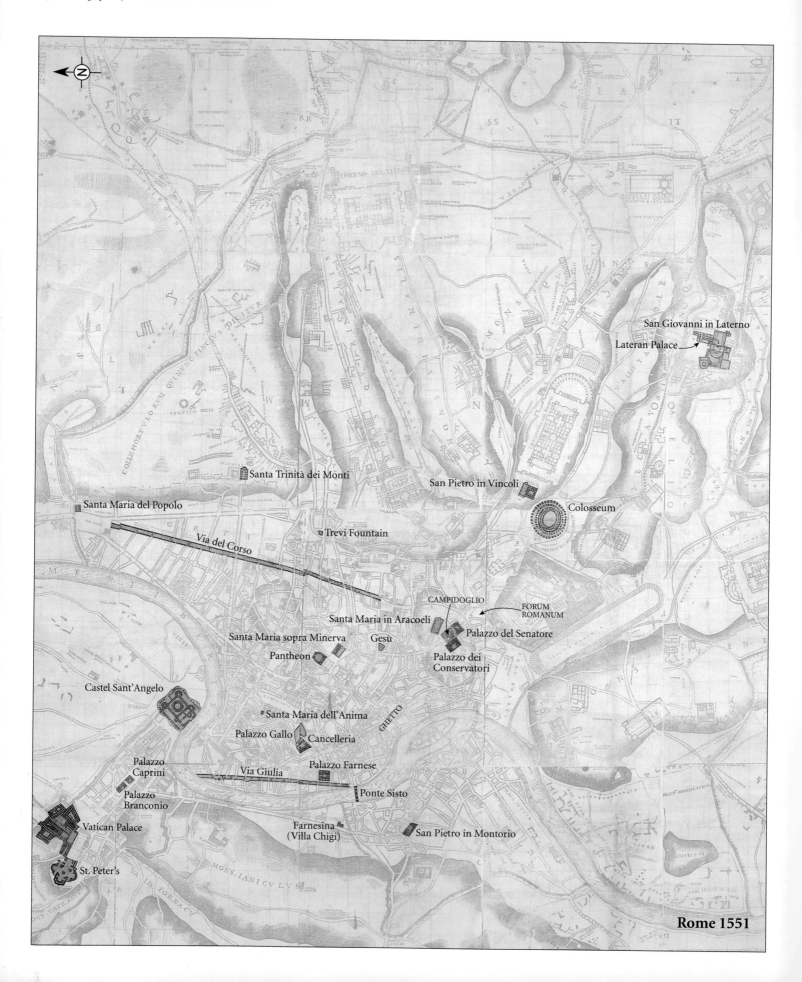

San Giovanni in Laterno

Lateran Palace

Santa Trinità dei Monti

San Pietro in Vincoli

Santa Maria del Popolo

Colosseum

Via del Corso

Trevi Fountain

CAMPIDOGLIO

FORUM ROMANUM

Santa Maria in Aracoeli

Santa Maria sopra Minerva

Gesù

Palazzo del Senatore

Pantheon

Palazzo dei Conservatori

Castel Sant'Angelo

Santa Maria dell'Anima

GHETTO

Palazzo Gallo

Cancelleria

Palazzo Caprini

Via Giulia

Palazzo Farnese

Palazzo Branconio

Ponte Sisto

Vatican Palace

Farnesina (Villa Chigi)

San Pietro in Montorio

St. Peter's

Rome 1551

LEFT

15.27

Antonio da Sangallo
the Younger, model for
St. Peter's, 1539–46. Wood.
Museo Petriano, Vatican

and choir, the Colosseum. In its horizontality, the two-storey-with-mezzanine design of the exterior suggests a palace extended to gargantuan proportions. The strongly compartmentalized effect of the plan reinforced the composite impression of the model's exterior. It comprises a nave, major and minor aisles, the domed crossing and minor domed spaces in the crossing arms, and ambulatories. Such a division of space reflects an aesthetic of complexity and enrichment reminiscent of the Villa Madama (*see* fig. 13.21), showing that Sangallo saw himself as a follower of Raphael, and that Paul III was seeking to revive the architectural grandeur of the era of Julius II and Leo X in the aftermath of the Sack.

Michelangelo's *Last Judgment*

Even as Sangallo worked on the basilica of St. Peter's, he oversaw the expansion of the palaces next door, adding a new throne room (the Sala Regia) and a new chapel (the Cappella Paolina.) And just as Pope Paul had continued his predecessor's sponsorship of Sangallo at St. Peter's, so did he reinvigorate Clement's project for a new Michelangelo painting in the Sistine Chapel. The subject was now, definitively, the *Last Judgment* (fig. 15.29). In the final fresco, completed in 1541, Michelangelo confined the "Resurrection" proper to the lower left, where skeletons come up out of the earth to dress themselves in perfect new bodies before ascending to heaven. Above, some of the blessed rise by what looks like an ecstatic levitation, others apparently through physical work and with help from others. Higher up still, the blessed gather, though just who and what this gathering involved must have surprised the fresco's early viewers. John the Baptist, rather than displaying the emaciation one might expect from a life in the desert followed by imprisonment (*see* fig. 11.15), is a massive, Herculean creature, matched in size only by St. Peter, directly opposite him. Many other characters are simply unidentifiable, for just as Michelangelo had done in the Medici Chapel, where he suppressed the

attributes of every personification except that of Night (*see* figs. 15.11–15.13), so does he here tell us the identities of only some of the saints. Even making sense of Christ was no easy matter. For one thing, this beardless Apollonian man did not *look* like Christ. And just what was he doing? Was he enthroned, having finally taken his position as King of Heaven, or was he striding menacingly toward those who would end up in hell? Traditionally, the Christ of the *Last Judgment* raised his right hand and lowered his left, causing the elevation of the saved and the fall of the damned, and in Michelangelo, too, the right is raised and the left lowered. Here, though, the address of the two hands seems reversed, as though the right were directed to sinners and the left (the "sinister" hand) to the saved. At the same time, the arrangement seems designed to draw attention to Christ's stigmata, the left hand not only showing off its own wound but also pointing to that in Christ's side, reminding the devout that it was through Christ's death that they received eternal life. It is as though the painter was trying to capture as many aspects as he could of Christ's role in human salvation and to do so by relying on pose alone, taking his investment in the signifying power of the human body and its gestures to the limit.

Michelangelo's treatment of the wall amounts to an almost complete overthrow of Leon Battista Alberti's idea of the painting as "window." Rather than giving us an opening into a perspectively defined space, where things diminish the more they recede from view, the *Last Judgment* consists of an even blue ground in front of which figures and objects project. Though the tones used to represent the distant figures in heaven and hell are darker, and though clouds seem to rise behind both the landscape at the lower left and the River Styx at the lower right, the picture is largely empty of atmospheric effects. Rather than trying to dissolve the wall into illusion, Michelangelo picks up on the actual architecture of the chapel, following its three storeys across the composition as if to show that the scene is taking place *within* rather than *beyond* the room. Presence, not space, is what Michelangelo is after here, and he augmented the effect by having the wall prepared in such a way that it physically cants forward, leaning over the visitor who looks up at its spectacle.

The central theme of the picture, the mechanics of resurrection and salvation, must have worried not just Pope Paul but also the artist himself, and Michelangelo's poems in these years are preoccupied with the topic. He even seems to have depicted himself as the flayed skin of St. Bartholomew, dangling below and to the right of Christ, over hell: the grotesque form recalls both the distorted self-portrait that Michelangelo drew in the margin of his sonnet the last time he had painted in the Sistine

OPPOSITE

Using Leonardo Bufalini's
engraving of 1551 (here
ghosted) as a base, this map
shows some of the major
sites of artistic activity
in the first half of the
Cinquecento.

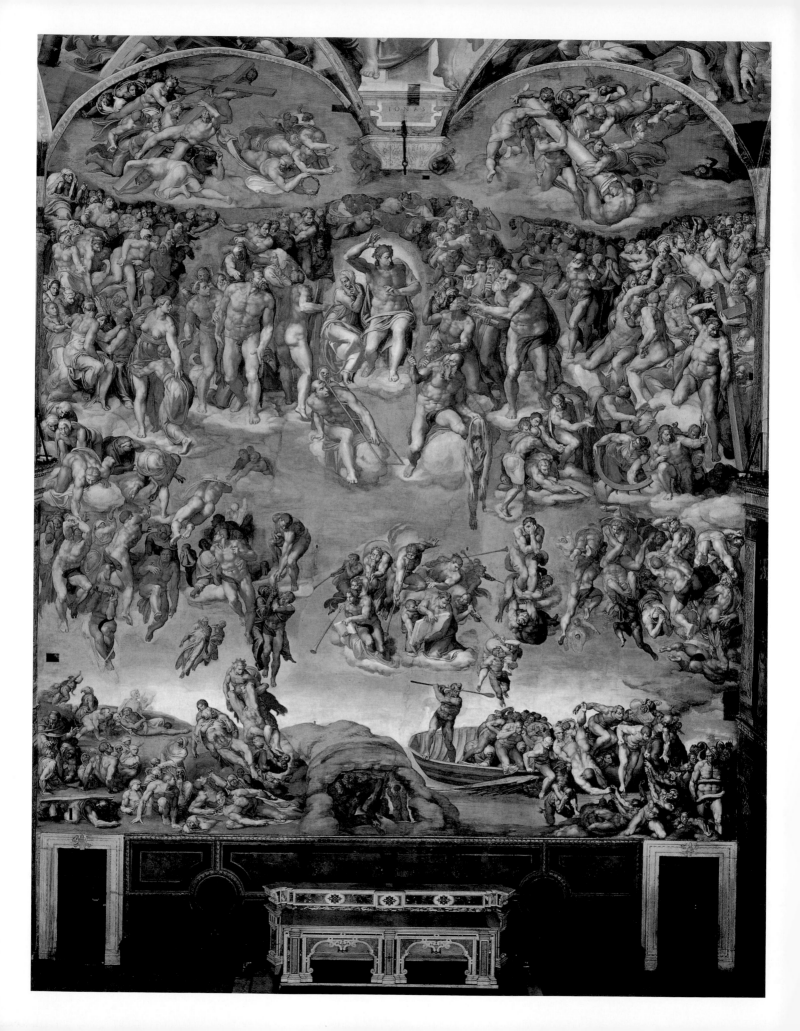

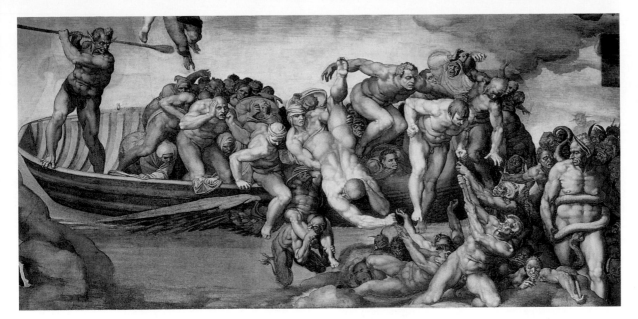

15.29
Michelangelo, *The Last
Judgment* (detail): *Minos
and Charon.* Fresco. Sistine
Chapel altar wall, Vatican

Chapel and the skins he wrote about removing from his sculptures (*see* fig. 12.30), strewing their dust on the workshop floor as he revealed the perfected beings inside. Perfected beings, for their part, are here in abundance, most of them nude or nearly nude, demonstrations of what Michelangelo had acquired in years of studying classical antiquities. The fresco gives the impression that Michelangelo by now felt that the world of Paradise could only be conveyed with the most beautiful forms history had left, and it is easy to imagine that Paul himself shared Michelangelo's sensibility. To others, though, the whole picture smacked too uncompromisingly of paganism.

Vasari reports that one of the Pope's secretaries, seeing the fresco in an unfinished state, complained that its congregation of naked bodies was more appropriate to a bathhouse than to a chapel. Michelangelo responded by painting the official into the picture at bottom right as Minos (fig. 15.29), the judge of the dead in both Virgil's and Dante's poems. In writing this, Vasari must have been thinking about a figure Michelangelo included at the lower right, coiled in a serpent that feeds on his genitals. The story and the corresponding motif may be more remarkable for what they show about Michelangelo's understanding of his overall project than for their demonstration of his spite. Dante, whose works Michelangelo is said to have known by heart, had populated his *Inferno* with actual characters from local history, as if the inspired poet had privileged access to the fate of mortals in the afterlife, and Michelangelo comes close here to making similar claims for himself. Contemporaries repeatedly associated Michelangelo's skills as a painter with the exercise of judgment: painting the wall, it must have been tempting to think of his own compositional choices, saving or damning this or that character, an analogy to Christ's own central act.

Equally significant is the fact that Minos was a pagan character, an appropriate denizen of hell, perhaps, but potentially troubling since his presence was not justified either by the Book of Revelations or by earlier depictions of the scene. The idea of an artist avenging himself in painting in this way harkens back to a work described by the ancient satirist Lucian, a painted allegory of slander that featured the ass-eared judge Midas in the role of the villain. At least in this figure, then, Michelangelo seems to have been invoking a classical literary comparison. And Minos was not alone. The damned in Michelangelo's fresco reach hell by crossing a river in a boat conducted by a monstrous oarsman; in the world of Michelangelo's painting, that is, there is a River Styx and a ferryman Charon, again familiar figures to any reader of Virgil or Dante (*Inferno* 3:82–84), but largely foreign to the Christian visual tradition. Depictions of hell had always been the place where artists let their imaginations run wild, and Michelangelo seems to have regarded this area of the wall as one where he was free not just to compose but to invent. It cannot be accidental that the artist Benvenuto Cellini, who wished to model himself on the older master, wrote later that while Michelangelo was toiling on the fresco, he himself was lying in bed, gravely ill. On the verge of death, Cellini had a dream of "a terrible old man who wanted to drag me by force into a very large boat of his." One bystander, Cellini's assistant, tried to chase the vision away. Another remarked: "The poor fellow raves, and there are but a few hours left for him." A third simply commented: "He has read Dante, and from his great weakness there has come upon him this rambling." Scenes like those Michelangelo showed could look like a dream, evidence of a kind of erudition that would fit uneasily in an increasingly conservative Church, or even of madness.

OPPOSITE
15.28
Michelangelo, *The Last
Judgment*, 1534–41. Fresco.
Sistine Chapel altar wall,
Vatican

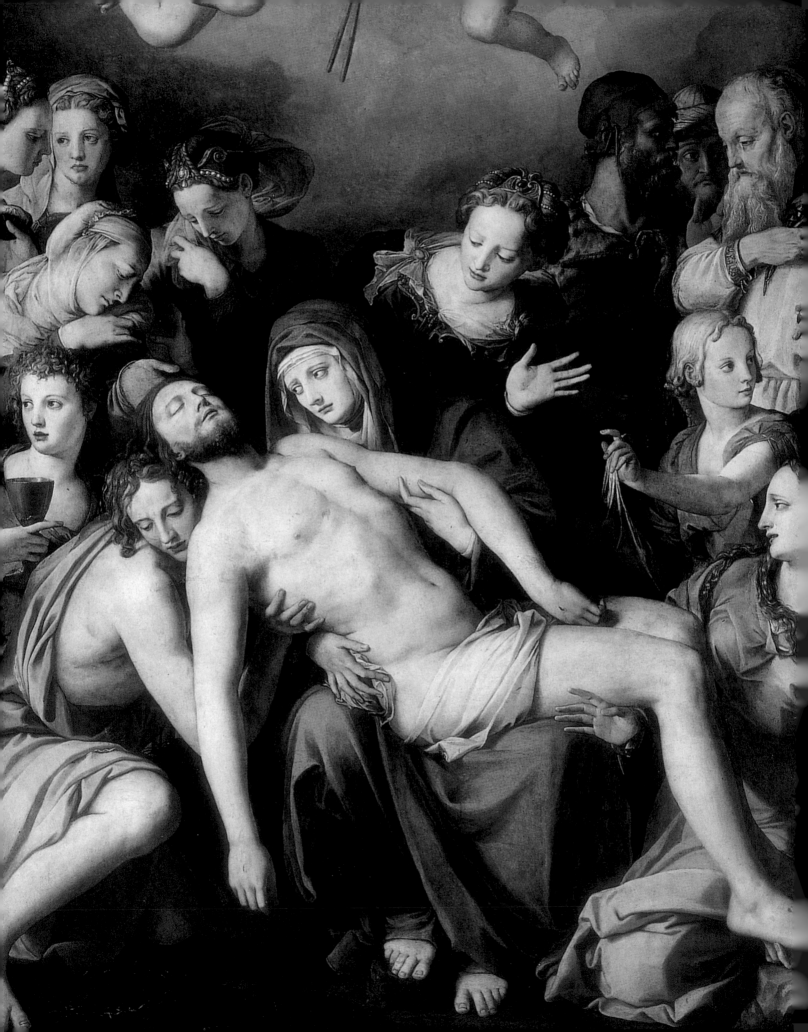

1540–1550
16
Literate Art

16 1540–1550
Literate Art

The Painting of History

We might expect that artists coming onto the scene at mid century continued to feel overwhelmed by what their predecessors had accomplished. Vasari, however, gives us a somewhat different picture in the book of artists' lives he published in 1550. It was a blessing, he wrote, to be able to study the work of Rosso Fiorentino, Sebastiano del Piombo, Giulio Romano, and Perino del Vaga – all painters who died in the 1540s – for that quartet had "rendered art so perfect and easy…that whereas before our masters took six years to make a single painting, now in a single year they make six." The comment, sounding so strange to us today, shows how much things had changed in a few short years. It is difficult to imagine any artist at the beginning of the sixteenth century, or for that matter any artist from the 1520s, suggesting that art had recently reached a state of perfection: for Leonardo da Vinci, Michelangelo, Giovanni Bellini, Titian, and others, all ideas were still provisional, and all faced strong contention from the alternatives their rivals were offering. Nor is it conceivable that any of these earlier painters would have said art was "easy."

Vasari's assertions about his fellow moderns and their relationship to the immediate past, nevertheless, were not entirely eccentric. Many of the writer's contemporaries thought that art had reached a stage where

demonstrations of learning, mastery of the immediate past, mattered more than experimentation and novelty. Through the 1540s, moreover, numerous artists did in fact treat facility and speed as virtues – a true departure from the tradition this book has been following. Michelangelo's example may have helped generate both the demand for large-scale fresco cycles and the desire among artists to undertake these, but he would have been baffled by Vasari's celebration of productivity per se as a serious goal. The single painting that Michelangelo had just completed in the Sistine Chapel, the *Last Judgment*, in fact took him not six years but seven, and as we have seen, ease had no place there. The effort that the figures in the picture exert can stand as emblems for all parties involved: the figures were difficult to make and difficult to understand, and they required real tolerance from their patron, Pope Paul III.

Michelangelo was Vasari's hero, and the writer followed the comments quoted above with a celebration of the divine artist who "transcends all." Still, the story of monumental wall painting in the 1540s is to an extent the story of artists moving away from the example of Michelangelo, toward something that, while rich and abundant, was not always so challenging. Few artists from this moment would have worked like Leonardo, meditating at length before each brushstroke. Commanding the painterly tricks not only of Michelangelo himself but also of Raphael, Giulio Romano, and the other muralists Vasari singled out was sufficient for the followers of such men to address their primary task, that of covering large expanses of wall wittily but also efficiently. Those who wished to think *seriously* about what Michelangelo represented, however, faced real perils. A telling case is that of the Florentine Pontormo (1494–1557), who in 1546 began a radically unconventional *Last Judgment* with Old Testament scenes, largely without assistance, in the basilica of San Lorenzo in Florence (fig. 16.1). The endless project cost him his once stellar reputation; critics condemned the work, and it was eventually partially destroyed and partially covered over. Vasari, writing on the fresco, expressed only bafflement: "although I am a painter, I myself do not understand it, and so I am determined to leave all who may see it to form their own judgment." Condemning Pontormo among other things for spend-

16.1
Jacopo Pontormo, study for the Deluge Fresco for San Lorenzo (detail), *c.* 1546. Red chalk, whole sheet 16¹⁄₂ x 8¹⁄₂" (41.9 x 21.6 cm). Gabinetto Disegni e Stampe, Uffizi Gallery, Florence

ing eleven years on the painting is of a piece with Vasari's boast about the major mural cycle he himself began in 1546, for a hall in the Roman Chancellery (fig. 16.2): he covered all the assigned walls in one hundred days. "It shows," Michelangelo reportedly sniffed, but Vasari's path was now the road to success.

Facility and Grace: Salviati and Bronzino at the Medici Court

One painter who puts the pictorial values Vasari espoused in a better light is the Florentine Francesco Rossi, who came to be called "Salviati" (1510–1563). Francesco had had an unusually varied artistic formation, training first in a goldsmith's studio and then in the workshops of the sculptor Baccio Bandinelli and the painter Andrea del Sarto. Following these apprenticeships, Francesco came to the attention of a Florentine cardinal named Giovanni Salviati, who invited the young artist to join his household in Rome. The relationship in this case went beyond the normal protocols of courtliness; the cardinal seems to have welcomed Francesco into his family, and the artist went so far as to adopt his patron's last name.

Giovanni helped connect Francesco with a Salviati relative, Cosimo I, the new Duke of Florence. And between 1543 and 1545, after a series of travels, Francesco

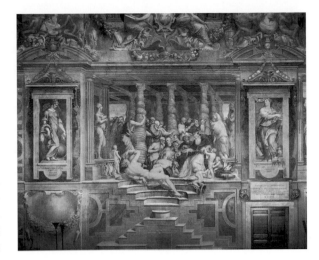

16.2

Giorgio Vasari, *Life of Paul III* (detail): *Paul III Directing the Construction of St Peter's,* 1544. Fresco. Sala dei Cento Giorni, Cancelleria, Rome

frescoed a large wall in a corner room of Florence's Palazzo dei Priori, a building Cosimo had appropriated as the new ducal palace (fig. 16.3). The subject, the *Life of Furius Camillus,* derived from the accounts by the ancient historians Plutarch and Livy of a legendary general of the Roman Republic. On the left, Camillus makes a triumphal entry into a city that the background architecture identifies as Rome. Four white horses, marching in lock step, draw a chariot, beside which walk bent, bound prisoners, while a group of priests leads the way. The scene

16.3

Francesco Salviati, *Life of Furius Camillus,* 1543–45. Fresco. Sala dell'Udienza, Palazzo dei Priori, Florence

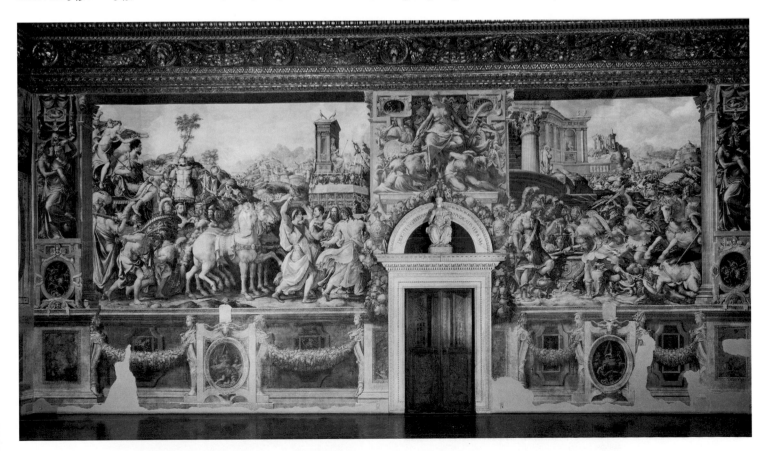

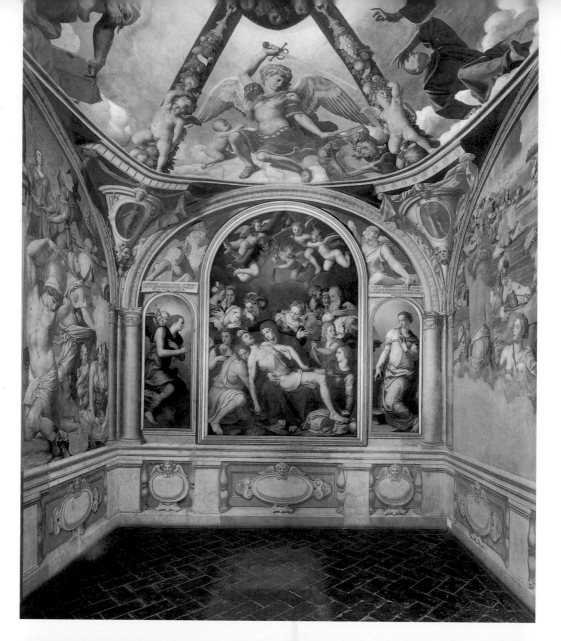

16.4
Chapel of Eleonora di Toledo, 1540–45, Palazzo dei Priori, Florence. Frescoes and altarpiece by Agnolo Bronzino

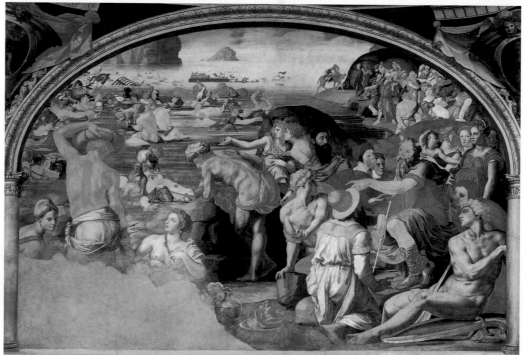

16.5
Agnolo Bronzino, *Moses at the Red Sea.* Fresco. Chapel of Eleonora di Toledo, Palazzo dei Priori, Florence

on the right collapses two episodes: the attempt on the part of the Gauls to cheat Camillus out of the gold tribute they owed him and his subsequent retaliatory attack. The busy, almost chaotic paintings require the viewer not only to identify a relatively obscure story, but also mentally to disentangle the complex ornament: both scenes unfold behind a fictive architectural opening, defined by the Corinthian pilasters that bracket them. Even as this illustrates Salviati's familiarity with Alberti's metaphor of the window and his command of perspective, however, a **grisaille** allegory of Peace burning weapons overruns the center of the space, projecting forward into the room like a sculptural relief. Overlapping this, in turn, is a full-color garland of fruit that runs down into the lower zone of the wall, drawing attention to the additional combinations of illusory sculptures, garlands, marble panels, and bronzes accumulated there. Nor has the artist used these divisions to separate things present from things past, history from fiction: an allegorical yet seemingly alive personification of Fame crowns the triumphant general, and behind the chariot, looking back over his shoulder and out at the viewer, Salviati has added a portrait of himself, as though he were a witness to the narrative he has conjured.

These were the first major murals added to a public space in the Palazzo since Leonardo and Michelangelo had broken off work almost four decades earlier, and they illustrate how much painting in the city had changed. Whereas once the city hall had brought two new and ultimately incompatible approaches to painting into confrontation with one another, now Salviati offered a kind of synthesis. Overall, the painting treats a subject reminiscent of Andrea Mantegna's *Triumphs of Caesar* (*see* figs.10.1–10.3) in the epic antiquarian mode of Raphael and Giulio Romano, adopting their shifting levels of reality and combination of allegorics and historical personalities. Within this, however, Salviati incorporated Michelangelo's powerful sense of relief and emphatic line and even Leonardo's soft *sfumato* modeling (especially in the grisaille figures) – as though there were no disharmony between any of these competing interests. The painting is a "collection," both in style and in subject matter, much of which amounts to a profusion of elaborately crafted objects in the form of spoils, armor, and trophies.

Salviati's approach is quite different in all of these respects from that taken by older Florentine painters like Agnolo Bronzino (1503–1572), who in the same years and in the same building decorated a small private chapel for Cosimo's wife, Eleonora of Toledo (fig. 16.4). On the walls and in the vault, Bronzino, like Salviati, framed narrative elements with illusory shifts of medium, including stone architecture, bronze relief, and, in the ceiling, garlands of fruit. Yet where Salviati accumulated such motifs

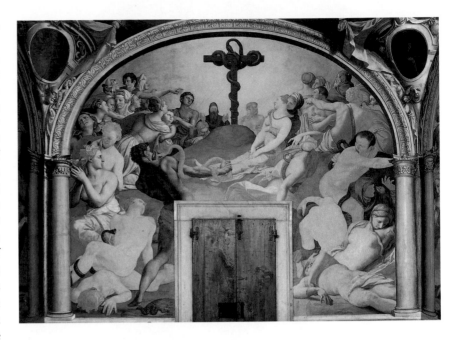

16.6

Agnolo Bronzino, *The Brazen Serpent*. Fresco. Chapel of Eleonora di Toledo, Palazzo dei Priori, Florence

to give an impression of copiousness, Bronzino clarified boundaries. The garlands, in his case, largely stay compartmentalized, and the cloths in the pendentives, while overlapping the architectural moldings, do not invade the space of the sacred narratives. Salviati delighted in displaying his ability to render horses, Leonardo's vehicle of tour de force painting. Although a scene like *Moses at the Red Sea* (fig. 16.5) provided every opportunity for similar showpieces, however, Bronzino illustrates only a couple of horses' heads, and places these in the middle ground, concentrating all of his attention on the figures. This allowed him to paint his human bodies at a larger scale than Salviati's; though the space assigned to Bronzino was considerably more intimate than the one in which Salviati worked, it paradoxically achieves a greater monumentality. Where Salviati, who had been to Venice and who particularly admired Mantegna, embraced the chance to incorporate hills and ruins in the distance, Bronzino followed Michelangelo in providing only the most token rendering of landscape: the sea that consumes the Pharaoh's men is strangely calm and flat, and on the shores there is not a plant to be seen. Both artists aligned themselves with Michelangelo in employing crisp, hard colors, but whereas Salviati then individualized the details of ornament that cover every surface, Bronzino aimed instead for clarity and immediate legibility. In his picture, the figures themselves are the primary ornaments: nude youths and women with marvelous hairstyles who adopt varied, sophisticated poses constantly challenge and engage the eye.

In his *Brazen Serpent* (fig. 16.6), as the Medici courtiers who had access to the space would have recognized, Bronzino paid conscious homage to one of the

16.7
Agnolo Bronzino, chapel of
Eleonora di Toledo, *Pietà*,
1545. Oil on panel, 8'9½" x
5'8" (2.68 x 1.73 m). Musée
des Beaux-Arts, Besançon

ian poetry, even more than the great Dante. Imitators of Petrarch sought a purity of form and a delicacy of language; although they wrote about the pains of love or bereavement, "Petrarchists" tended to curtail anything that smacked of harshness in the words or violent passion in the sentiment.

Michelangelo's painting, like his difficult verse, could be deliberately rough in its tone, expressing a complex emotional intensity. It is noteworthy, then, that Bronzino's response to Michelangelo in the Chapel of Eleonora suggests an intention to refine its model: his ivory-skinned and golden-haired figures are more slender and – despite the horror of the subjects – more delicate in their movements and attitudes. This suggests that Bronzino deliberately cultivated "Petrarchan" values in his painterly as well as his poetic practice, and that he resisted qualities in Michelangelo's art – Titanic bodies in energetic and sometimes violent motion – that were not compatible with his pursuit of elegant and fluid design. This was a way of bringing back Michelangelo from Rome to Florence, "translating" the older artist into an idiom more compatible with the Florentine poetry and painting of the generation of Bronzino, and indeed of Cosimo I.

Bronzino painted the chapel's altarpiece on canvas and attached it to the wall, as if to dispel any idea that this, like the devices with which he surrounded it, belonged to any fiction (fig. 16.7). The crowding and especially the man (or angel?) who prepares to lift the body of Christ recalls the Capponi altarpiece of Bronzino's teacher Pontormo (*see* fig. 14.15), but the central point of reference is the sculpted *Pietà* that Michelangelo had made for St. Peter's (*see* fig. 11.51). As we have seen, some viewers of that work accused Michelangelo of confusing the relationship between Virgin and Christ by making her appear younger than her son. Bronzino "corrected" this, showing an older mother whose veil now suggests the garments contemporary women wore in mourning, and shrouding the whole scene in a somber darkness. As though to demonstrate that he could equally match Michelangelo in beauty, though, Bronzino also depicted the Virgin a second time, immediately to this picture's right, now in her youthful Annunciate form.

The Monumental Fresco in Rome: Perino del Vaga

Salviati's approach to the large-scale mural, with its multiple levels of reality and its rich ornament, differed from the characteristically Florentine manner that Bronzino represented in the 1540s, but it had much more in common with contemporary painting in Rome. Best among the artists who responded to the precedent of the Vatican's Hall of Constantine was Perino del

spandrels in Michelangelo's Sistine Chapel vault. If Salviati, importing a cosmopolitan attitude back to provincial Florence, sought to show his understanding of a wide range of masters and styles, Bronzino here insists that there is only one elder who really matters: Michelangelo, the greatest painter Florence had produced. Though Bronzino idolized Michelangelo, however, what he made of the now absent master's example depended on the conventions of literary imitation. Bronzino would have thought through his painting in the manner that contemporary writers thought through their verse, evoking a well-known precedent, then ingeniously transforming and reworking its language or images. Bronzino, a poet himself, was adept in the imitation of Petrarch, who had long been the single most authoritative model for Ital-

Vaga (1501–1547), who had been born in Florence but had trained in Rome under Raphael. In 1545–48, Perino produced a spectacular adaptation of the "epic" manner in the Sala Paolina (fig. 16.8), the papal apartment of Paul III Farnese in the Castel Sant'Angelo. The Sala functioned less as a private refuge than as a stateroom, and the cycle celebrates the undying power of the Pope and his family through the figure of the second-century CE Roman Emperor Hadrian and the Greek conqueror Alexander the Great (r. 336–23 BCE). Hadrian, among the most admired of the Roman emperors, had built the Castel Sant'Angelo as a colossal mausoleum for himself; Perino portrayed him full length on one wall of the room, along with an inscription celebrating how his "successor," Paul III, "transformed the monument of the deified

Hadrian into a high Godly palace." Alexander the Great was the namesake of Paul III, who had gone by his baptismal name Alessandro until his election.

Eleven panels of simulated bronze relief told the emperor's story in an extravagantly Michelangelesque style, with robust figures wearing exotic antique armor. Nude angels – languid versions of the Sistine Chapel *ignudi* – lounge before the reliefs. Facing the portrait of Hadrian is a dynamic image of the Archangel St. Michael, for whom the Castel had been named following his apparition there during a plague. Connoisseurs like the Farnese would have recognized Perino's figure as a variation on a *St. Michael* by Raphael; it had been sent to France, although copies of the cartoon remained in Rome. What is surprising is the relatively marginal presence of the

16.9

Michelangelo, *The Fall of Phaeton*, 1533. Black chalk on paper, 16¼ x 9¼" (41.3 x 23.4 cm). Royal Library, Windsor

Pope's Biblical counterpart, St. Paul, in the decoration: only six scenes of his life appear, at a much-reduced scale in the vault of the room. Equally unexpected is the far greater prominence of pagan gods and goddesses, including Venus and Cupid near the image of Hadrian, along with allegorical figures. The Farnese prided themselves on their local ancestry, and the patron here must have thought of Venus not just as the goddess of love but also as the mother of the Romans: Hadrian had propagated her cult and founded the temple of Venus and Rome on Rome's "birthday," 21 April. The decorations remind the viewer of the history of the place, from mausoleum to angelic bastion to papal residence, and insert the Farnese into the longest of histories. Perino's manner, itself unmistakably a continuation of past practices, suited the assignment perfectly, and his team maintained a tone of levity throughout: in one vignette, a pair of baboons nonchalantly eats grapes; elsewhere, a page ceremoniously draws back a curtain from a fictitious doorway.

Perino's brief was to paint history – that of the Pope's ancient namesake, along with the historic Roman site and its memories of Hadrian and the angelic apparition. Yet the artist shared with his courtly audience the expectation that history was a form of literature, and that it could be dressed up with all the elaborate machinery of epic poetry: allegories, mythological figures, episodes of sheer dazzling virtuosity for its own sake.

Michelangelo's Gift Drawings and the *Pietà*

Bronzino's altarpiece had responded to one of Michelangelo's most youthful sculptures, the *Pietà*, a marble that dated to the previous century. Bronzino might well have known, however, that the theme had become newly topical to the older artist in just these years.

Over the previous decade, while at work on the *Last Judgment*, Michelangelo had increasingly occupied himself with a new category of artwork: the "gift drawing." Produced on paper, such objects demanded far less time than a painting or sculpture and cost nearly nothing to produce. Michelangelo could make them outside the context of his large commissions, choosing subjects that appealed to him personally and then presenting them to friends.

Italians had been using drawings as gifts at least from the time that Gentile Bellini presented to the Turkish Sultan Mehmed II one of the books of designs that his father Jacopo had produced. Leonardo is documented as having given a drawing as a gift; Raphael and Dürer had exchanged drawings as examples of their work; and other artists must have done the same. As early as

the 1510s, as we saw with Sebastiano del Piombo (*see* fig. 13.27), Michelangelo was giving colleagues from outside his workshop designs that they could use as the basis of paintings. By the 1530s, however, the artist was beginning to see a different potential in both the format and the practice. In that period, he gave several drawings to the young Roman nobleman Tommaso Cavalieri, to whom he had formed a deep emotional attachment and whom he had been giving lessons in drawing. These included a chalk on paper depiction of *The Fall of Phaeton* (fig. 16.9), a boy who overzealously attempted to drive the chariot of Apollo, his father, and whom Jupiter consequently struck down with a bolt of lightning. The theme is literary insofar as it comes from poetry (in this case Ovid), but the drawing also represents the suffering mood that typified a certain kind of verse: the dozens of poems Michelangelo wrote to Cavalieri turn on the experience of burning, of being reduced to smoke and dust, of facing weapons that heaven destined to bring about his death, of vainly longing to fly – all on account of love.

"How can it be," he laments in one, "that if fire by its nature ascends to the heavens, to its proper sphere, and I am turned to fire, that it does not carry me upward along with it?" In a real sense, Michelangelo's drawings from this period, done on pages that also contain his words, are poems; the artist has made the Roman poet Horace's notion of *ut pictura poesis* ("as is painting, so is poetry") mean something new.

In the late 1530s, Michelangelo had also become closely attached to Vittoria Colonna, the widowed grand-daughter of the Duke of Urbino. Colonna, a celebrated poet herself, belonged to a group of nobles and clerics interested in Church reform; she and Michelangelo would meet in Rome to discuss their respective arts, but also more weighty and controversial spiritual matters concerning the role of Christ in obtaining human salvation. Some members of their circle believed that faith alone, not prayer and good works, would redeem the soul because of the grace Christ's sacrifice had obtained for all humanity. This idea seems to have lain behind the

16.10

Michelangelo, *Pietà* for Vittoria Colonna, *c.* 1540. Black chalk on paper, 11½ x 7½" (29 x 19 cm). Isabella Stewart Gardner Museum, Boston

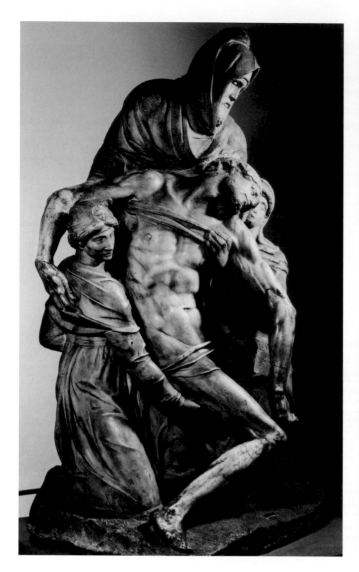
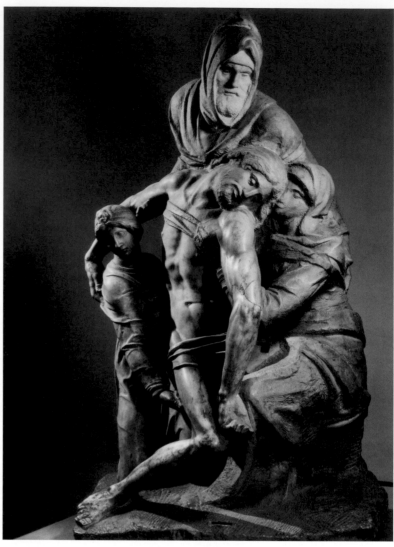

unusual *Pietà* Michelangelo drew for her around 1540 (fig. 16.10). His dead Christ, having been removed from the Cross, collapses between the Virgin's legs while two small wingless angels suspend his arms. The composition suggests a birth as well as a death, reminding the viewer why the Virgin suffered more intensely and before all others at his passing, the loss of the son made from her own flesh. Christ's downwardly turned arms adopt the form of a yoke, suggesting the Evangelist Matthew's metaphor for Christian faith: "my yoke is easy and my burden is light." The Virgin's upturned arms, meanwhile, turn her into a kind of double of Christ himself, an example of the *compassio* we first encountered with Fra Angelico. The words running up the base of the Cross – "you don't know how much blood it costs" – come from Dante. They alert us to the fact that here again the artist is attempting to generate a visual equivalent to poetry, in this case one that could both answer the poems Vittoria Colonna had given him and acknowledge her particular identification with Mary.

This new preoccupation with the meanings of Christ's death remained with Michelangelo through the decade, and when, in the late 1540s, he began contemplating an appropriate decoration for his own projected tomb in the church of Santa Maria Maggiore in Rome, he began carving a new marble on the same theme (figs. 16.11–16.12). Since completing his first marble *Pietà* some four decades earlier (*see* fig. 11.51), Michelangelo's understanding of the antique and the challenges it presented to the Christian artist had changed. He would now double the number of figures he aimed to extract from the block, so as to exceed by one the number in the famous ancient *Laocoön* (*see* fig. 12.48). (Pliny the Elder in his *Natural History* had reported that the team of artists who had carved this had used only a single block; Michelangelo would have known the report to be false, but the idea of the multifigure monolith lingered as a challenge.) To the standard figures of the Virgin and Christ, consequently, Michelangelo now added two others, one female and

one male. These probably represent Mary Magdalene, the exemplary repentant sinner whom Christ saved from perdition, and Nicodemus, a Pharisee who secretly followed Christ – though both identifications have been questioned. Sixteenth-century representations of Nicodemus are nearly indistinguishable from those of Joseph of Arimithea, a wealthy man who gave his tomb to Christ, and the latter subject would have been especially appropriate given the purpose for which Michelangelo made the statue. Nicodemus, on the other hand, had by 1550 come to personify Christians who secretly adhered to unorthodox doctrines, and Michelangelo's earlier association with Vittoria Colonna and other reformers could well have attracted him to such a character. The face he gave this man is a self-portrait.

In his earlier marble *Pietà* (*see* fig. 11.51), Michelangelo had arranged his figures so that the Virgin was on axis with the beholder who stood before the work; she offered the primary point of identification, summoning the onlooker to share her sorrow. Now, by contrast, Michelangelo rotated the Virgin forty-five degrees. Those approaching the sculpture from the left, as one would when proceeding through the nave of the church, would have found her crouching behind the body, which twists so as to display its wounded left hand, right foot, and side to the viewer. This arrangement, like the *Pietà* for Vittoria Colonna a decade before (*see* fig. 16.10), expresses a new spirituality that centered on the idea of Christ's sacrifice (rather than good human works) as the basic condition for salvation, and essentially shifted the emphasis in the *Pietà* from the Virgin's experience to Christ's gift. The view from the front, by contrast, gave Nicodemus the more active part, though this view also alerts us that the statue today is not as Michelangelo actually left it. A later follower re-carved the Magdalene, leaving a figure both smaller and more polished than the others. More curiously, Christ lacks a left leg, and Vasari tells us that this is because the sculptor himself smashed to pieces the leg he had carved. Michelangelo's composition had slung the leg across the lap of the Virgin, an arrangement no doubt intended to realize the intense proximity that makes the *Pietà*'s theme of loss and separation so touching. The pose, however, would also have recalled the convention used recently by artists to depict sexual partners. (The Rosso and Caraglio print of *Pluto and Proserpina*, itself a response to Michelangelo's Sistine *ignudi*, is one example he would certainly have known; *see* fig. 14.9.) In this case, the experimentalism that led Michelangelo repeatedly to draw on pagan motifs when rethinking sacred themes seems to have gone too far. He had pushed a mode of symbolic and corporeal expression derived from antiquity beyond what even he recognized as the limits of Christian acceptability.

The Rise of Vernacular Art Theory

Michelangelo's second marble *Pietà* shows the degree to which standards of artistic virtuosity had escalated over the last half century: no previous sculptor had managed to conceive and execute a work with four full-length figures in a single piece of marble. The composition itself drew attention to the accomplishment, pressing the characters together so that the viewer would immediately recognize the fact that the sculpture was monolithic. Counting among the few marbles Michelangelo carved in the period, it conveys the idea of sculpture that he captured in the opening stanzas of his most famous poem:

> The greatest artist does not have any concept that a single piece of marble does not circumscribe within its excess, and only the hand that obeys the intellect can arrive at that. The evil that I flee and the good to which I aspire, gracious, noble and divine lady, lie hidden in you in just this way; but that I may not live hereafter, my art goes contrary to the effect I desire.

Michelangelo had probably written the poem for Vittoria Colonna at the beginning of the decade, but it circulated more broadly, and contemporaries regarded it as a major statement of art theory. They would not have found it unusual that Michelangelo chose to convey his thoughts about sculpture in verse. This expressed the principle of *ut pictura poesis*, it matched a seriousness of thought to the most elevated mode of writing, and it allowed Michelangelo to build the kinds of comparisons he cared most about – in this case, the likeness between the difficult process of extracting a sculpture from a stone block and that of drawing favor from a beloved.

The other major voices on the arts in these years also wrote in forms we might today consider eccentric. Bronzino, the painter of Eleonora of Toledo's elegant chapel in Florence (*see* figs. 16.4–16.7), composed numerous poems, some of them turning on vulgar witticisms and adopting a knowingly "low" style. The Venetians Paolo Pino and Ludovico Dolce wrote treatises about painting in the form of imaginary conversations. In Florence, the most important figure in the development of art theory was the poet and philosopher Benedetto Varchi (1502/3–1565), and his most significant statements on the arts took a form he called "lessons" or "readings," by which he meant commentaries on poems written by others.

Varchi had come of age during the time of the Republic, and when the Medici regained control of the city in 1529, he had been among those who resisted them, going so far as to carry arms against them in battle. In 1543, however, Duke Cosimo persuaded him to

return to Florence, where he received a salary for writing Florentine history and where he became closely involved with the city's recently founded literary academy. Cosimo wished the academy to devote itself to the perfection of a Tuscan language exemplified by the poets Petrarch and Boccaccio. (The academicians admired Dante, the model so important for Michelangelo, for his thought, but regarded his language as ungainly and unsuitable for imitation). At least initially, however, the institution welcomed the membership of artists as well as of professional writers; it provided a forum for discussing the means and goals of painting and sculpture, and its members translated and commented on seminal texts as well as writing new works themselves.

These years saw the first publication in Italian of Alberti's *On Painting* (1547) and *On Architecture* (1550). In 1550, Vasari also published his first edition of the *Lives of the Most Excellent Italian Architects, Painters, and Sculptors*, a monumental history of art from the early

fourteenth century to his own day, centering on Florence and Rome. The new interest in writing about art was not limited to Florence, though even elsewhere, writers seemed to respond especially to Florentine practice. In Venice, Pino's dialogue on painting pitted a representative of the Florentine tradition against a local. In Rome, the most important tract on sacred images came in 1552 from the Dominican theologian and longtime Florence resident Ambrogio Catarino.

In Florence itself, the new literature arose as part of a new absolutist politics, one intended to promote the arts of Cosimo's court as uncommonly sophisticated and self-aware. Varchi distributed not only the Michelangelo poem and his own Aristotelian interpretation of it, but also a series of letters he had solicited from contemporaries comparing the merits of painting and sculpture. And this only encouraged the literary aspirations of his contemporaries, especially those like Bronzino and the goldsmith Benvenuto Cellini, who were friendly with him and attracted to the new academy.

Such pursuits shed light on Bronzino's pictorial interests as well, especially as witnessed in the *Allegory* now in London (fig. 16.13). Venus occupies most of the panel; central and mostly frontal, her format evokes recent Pietà imagery, though the activity she provokes is far from sacred. With her right arm she directs an arrow stolen from Cupid's quiver at her son, who caresses her head and nipple and kisses her while provocatively turning his backside to us. A younger Cupid-like figure, personifying Play (*Gioco*), steps toward the couple and smiles, preparing to strew blossoms, not noticing that he has stepped on the spiky tail of the girl-monster lurking in the shadow. To the far left, an ashen man, identified by some scholars as a syphilitic, screams, tying the sufferings caused by love to the most vicious of contemporary scourges. At the top, the old figure of Time holds a kind of curtain; he stands opposite Oblivion (missing the back of her head, where Renaissance writers believed memories to be stored). Are these two collaborating, covering up the whole seductive but ultimately unpleasant scene? Or are they, too, at odds with one another, Time exposing the inevitably painful outcome of the experiences that lovers tend to (or try to) forget?

The picture, which combines classical characters and invented personifications, represents the kind of poetic invention that artists had been making in Florence since the time of Botticelli. Just as contemporary poets began their inventions by working variations on the sonnets of Petrarch, so Bronzino here in a self-consciously analogous sense imitates a design by Michelangelo realized in paint by Bronzino's teacher Pontormo, the *Venus and Cupid* from 1532–34 (fig. 16.14). Bronzino has taken up the incestuously kissing nudes and the masks that signify

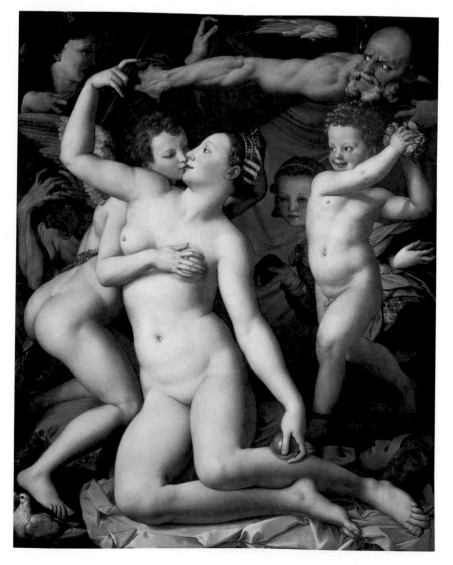

16.13

Agnolo Bronzino, *Allegory*, c. 1545. Oil on panel, 57⅝ x 46" (146.1 x 116.8 cm). National Gallery, London

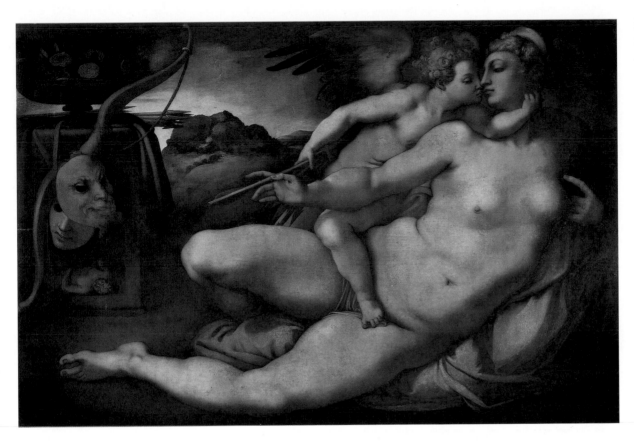

16.14
Pontormo after
Michelangelo, *Venus and*
Cupid, 1532–34. Oil on
canvas, 4'2³⁄₈" x 6'5¹⁄₂"
(1.28 x 1.97 m). Galleria
dell'Accademia, Florence

false dreams and delusions, but the tone in his *Allegory* is different: its dark humor and pessimistic view of the coy artifice, cosmetic disguise, and merciless punishments that characterized courtly life would especially have appealed to a man like Varchi. It is not surprising that Bronzino had painted nothing like this in earlier decades. Cosimo sent the painting as a gift to King Francis I of France, a gesture that may itself have involved a joke, since syphilis was known in Italy as the "French disease" (and in France as the "Italian disease").

Italians Abroad: Fontainebleau

By the time Bronzino completed his *Allegory*, around 1545, the French court at Fontainebleau had become one of the continent's major centers of modern Italian art, more important than most cities in Italy itself. Francis I (1494–1547) had succeeded to the throne in 1515, and almost from the beginning he demonstrated his cosmopolitan interests, persuading Leonardo da Vinci to move permanently to his court in 1516, and Andrea del Sarto to spend a period there two years later. However, after his defeat in 1525 at Pavia in northern Italy by Spanish imperial forces, which led to a humiliating period as a prisoner of war, Francis withdrew to a small town on the outskirts of Paris and devoted himself to a major building campaign. His court architect Gilles Le Breton helped him dramatically expand and restructure an older royal residence, and the king began to invite prominent Italians to help decorate it. The timing of the project coincided with the collapse of Roman patronage after the 1527 Sack; a number of Italian artists, faced with the choice of working for a small local court or for a foreign king, saw the move to France as a newly exciting prospect.

Sebastiano Serlio (1475–*c.* 1554), who had dedicated his 1540 book on antiquities to King Francis, accepted an invitation the following year to move to Fontainebleau, where he was given charge over the architecture of the residence. While in France, Serlio pioneered what would come to be known as the "rustic style," a mode that assembled roughly worked materials into seemingly organic, living structures. Serlio also used his court position to published a series of books on architecture (figs. 16.15–16.16), including an updated take on Vitruvian principles, a lengthy reconsideration of perspective, a full accounting (and depiction) of the architectural orders, and a discourse on theatrical set designs. In addition, he wrote a book, published posthumously, on domestic architecture, his principal focus while in France.

Serlio had appeared one year too late to work with Rosso Fiorentino, a painter whom he probably knew from their time together in Rome in the 1520s, and who had

ABOVE LEFT

16.15

Sebastiano Serlio, elevation of a palace. Woodcut. *Il quarto libro d'architectura* (Venice, 1537), 256r.

ABOVE RIGHT

16.16

Sebastiano Serlio, stage design for a tragic scene. Woodcut. *Il secondo libro d'architectura* (Paris, 1545), 45v.

LEFT

16.17

Francesco Primaticcio, *Alexander and Campaspe*, c. 1541–45. Fresco, with framing *stucco* figures. Room of the Duchesse d'Estampes, Château of Fontainebleau

16.18
Antonio Fantuzzi after
Primaticcio, design for a
frame, 1542. Engraving

depicted ruler – though the putti, fruit, and garlands more generally align the ornaments with the themes of natural fecundity that Serlio, too, was exploring, and that seem to have held particular appeal to Francis himself.

Primaticcio's grandest undertaking of the 1540s was the decoration of the Galerie d'Ulysse, a 492-foot-long barrel-vaulted space that he covered with frescoes and stuccoes. Tragically, it was destroyed in 1738, and we would know little about its appearance had Fontainebleau not also become one of Europe's major centers of printmaking. Primaticcio's team included reproductive engravers who made the same kind of things that Marcantonio Raimondi had produced with Raphael in Rome decades before (*see* figs. 13.11–13.12). The team also, however, included painter-etchers in the mold of Parmigianino, such as Primaticcio's fellow Bolognese Antonio Fantuzzi. Several of Fantuzzi's etchings after Fontainebleau paintings include the *stucco* framework along with the central image itself, physically minimizing the narrative content (fig. 16.18). And at least one 1544 Mignon etching after a passage in Primaticcio's Alexander cycle omits the painting that its figures frame altogether, leaving a blank oval in the center of the page.

The City Square

Prints like Fantuzzi's ensured that artists and patrons, even those who never left Italy, were well aware of what Francis was commissioning. Young painters and sculptors from the north, moreover, passed through Fontainebleau on their way to pursue studies in Italy and told others about what they had seen there. Diplomats traveled back and forth as well, and key families intermarried: Francis's son Henry, who would become king upon his father's death in 1547, was married to Catherine de' Medici, a cousin of Duke Cosimo.

When Benvenuto Cellini, accused of embezzlement and on the run, arrived in Florence in 1545, Cosimo saw an opportunity to bring an apparent favorite of the French court into his own employ. Cellini had been abroad for the preceding five years. Francis I had hired him on account of his skills with precious metals, and Cellini had produced for his royal patron a lifesize figure of Jupiter in the form of a silver candlestick and an (apparently uncommissioned) gold, enamel, and ebony saltcellar, with recumbent personifications of the Earth, the Sea, and their domains. While in France, moreover, Cellini had also taken inspiration from Primaticcio and begun to attempt architectural decorations featuring large, high-relief nude figures. One that survives is Cellini's massive personification of Fontainebleau itself, the reclining nymph of

been in Francis's employ for a full decade before committing suicide. Serlio's interests, however, harmonized well with those of Rosso's major collaborator and successor, Francesco Primaticcio (1504–1570), a painter and stucco-maker from Serlio's own home town of Bologna. Primaticcio, like Serlio, believed that a serious interest in and knowledge of antiquity need not preclude the artist from developing a distinctive modern manner. Between trips to Rome, where he made casts after famous ancient statues for the French king's collection, Primaticcio produced several of the century's most unusual large-scale cycles of decorations on classical themes. Characteristic are those for a room occupied by Francis's mistress, where a series of paintings depict episodes from the life of Alexander the Great (fig. 16.17). Though these are frescoes, the gilded *stucco* frames and the flanking figures that hold them suggest that the pictures are actually portable canvasses, a variation on the devices Raphael and Giulio Romano had used in the Vatican's Hall of Constantine. What sets Primaticcio's works apart from anything Roman, however, is the small scale of the painted scenes relative to the *stucco* figures that "hold" them. These subsidiary characters, who have no specific identity, evoke the *ignudi* Michelangelo had used to frame the scenes in the Sistine Chapel, except that they are truly three-dimensional and sometimes female instead of male. The change probably seemed appropriate to the function of the space – both men and women play a "supporting" role to the

16.19

Benvenuto Cellini, *Nymph of Fontainebleau*, 1542. Bronze. Musée du Louvre, Paris

RIGHT

16.20

Benvenuto Cellini, *Perseus and Medusa*, 1545–54. Bronze, originally with gilding, on ornamented marble pedestal with bronze statuettes of Jupiter (right) and Danäe and baby Perseus (left), height including base 18' (5.5 m). Loggia dei Lanzi, Florence

FAR RIGHT

16.21

Benvenuto Cellini, *Perseus and Medusa*, 1545–54, from the southwest. Loggia dei Lanzi, Florence. The photo, taken before the monument was disassembled for restoration, shows the statuettes of *Minerva* (left) and *Mercury* (right) in its base and, in the background, Baccio Bandinelli's *Hercules and Cacus*.

the fountain after which the residence was named (fig. 16.19). Collaborating with the expert founders whom Primaticcio had helped assemble, Cellini assisted in the casting of the bronze conceived as an "overdoor" to surmount the main entrance to the chateau. The goldsmith was no fan of the Medici, but on returning to Italy, where he was known only for coins, medals, and some small precious works he had produced in Rome, he recognized that Duke Cosimo had much to offer him, beginning with the opportunity to carry out a bronze that would exceed even his French works in scale.

Cosimo commissioned Cellini to make a large bronze statue of *Perseus* (figs. 16.20–16.21), the Greek hero who beheaded the gorgon Medusa. The duke wished to further beautify the main Florentine piazza in front of the former city hall where he now lived; at the same time, he was concerned to escape the public censure that had greeted Baccio Bandinelli's *Hercules and Cacus* a decade earlier (*see* fig. 15.14). Cellini, for his part, embraced the opportunity to position a statue antagonistically in relation to a rival he despised. Bandinelli worked primarily in marble, and he presented himself as Michelangelo's heir in Florence. Cellini had to make the most of what had become, under Michelangelo's influence, a less prestigious (though still far more expensive) material, bronze. One of his strategies was to add elements to the commission, including an elaborately carved marble base, showing that he could work in materials other than metal. More than this, though, he used his assigned site and subject matter to diminish Bandinelli's earlier monument. The way the Loggia dei Lanzi framed the *Perseus* might have encouraged the artist to conceive it with a primarily frontal view in mind, but Cellini extended his figure's left arm forward in space, breaking the plane of the stage and reaching out into the piazza. This made the statue more interesting when seen from an angle, but it also placed the head of Medusa directly in Hercules' line of sight. Suddenly it seemed as if Bandinelli's statue was scowling enviously at Cellini's, or worse, that the Medusa head had petrified Hercules, turning him into stone (*see* fig. 16.21).

The poets around Varchi chimed in, writing sonnets that described the relationship between the two sculptures in just this way, implying that the bronze of Cellini's *Perseus* now seemed alive when compared to the colorless marble in which Bandinelli worked. The painter Bronzino wrote a pair of especially clever poems, reminding viewers that Perseus's conception occurred when Jupiter descended as a shower of gold and impregnated Danae, so Perseus's generation began and ended in the form of liquid metal. The abundant blood that fell from the neck of Cellini's Medusa reinforced this impression, too, and the poets in his audience could well have known that when Ovid described Perseus holding the head of Medusa aloft, he described the hero turning his enemies into "stone without blood."

Contemporaries report that poets attached their satires to the statues themselves, turning the piazza into a kind of public extension of the academy. The mythological characters that the dukes of Florence had begun to assemble there invited this impression, and Cellini embraced it, too. Perhaps with an eye to the way that Primaticcio (and Rosso before him) had supplemented every significant narrative scene with a rich gathering of additional characters, Cellini decorated the base of *Perseus* not only with symbols of fertility but also with small statuettes depicting Mercury and Minerva, the god and goddess respectively of eloquence and wisdom. All of this softened the piazza's belligerent atmosphere, with its series of killers (David, Judith, Hercules, Perseus), all standing before a palace from which the Medici had expelled the city's Republican government.

The Shaping of Venetian Public Space

The decoration of the piazza kept Florence current with urbanistic trends throughout the peninsula. Serlio's *Five Books on Architecture* appeared in several installments between 1537 and 1551. Like Alberti's work *De re*

16.22
Jacopo Sansovino, Zecca (mint), Venice, 1535–47. Sansovino received the commission for the building in 1536, and by 1547 he had overseen the completion of a roofed two-storey structure. The third floor was added between 1558 and 1566. The photo also shows, on the right, the south facade of Sansovino's adjacent Library of San Marco.

aedificatoria from the 1450s, they sought to adapt the prescriptions of the architect Vitruvius and the "rules" of ancient architecture to modern use. Thanks to these books, patrons and connoisseurs widely appreciated the subtleties of much new building: in this respect, architecture, like painting, was becoming a "literate" art. We see this, notably, in Venice, where the Florentine expatriate Jacopo Sansovino (1486–1570), having fled Rome after the Sack of 1527, had become the city's *proto*, or chief superintendent of building. In 1535 Sansovino won the competition to design the city's Zecca, or mint, originally a two-storey building facing the canal (fig. 16.22). His design married the open loggias of Venetian palace architecture with Serlian rustication, binding its arcades and columns with projecting straps of rough stone. The building adapted the characteristic openness of the Venetian palace facade, but it stood out for its classical geometry, its central Italian materials, and its Roman ornament. It also illustrated a principle of architectural invention that Serlio had articulated in his writings, namely that the decoration of a building should accord with its type: the heavy stone announced that the contents of this building required defense and protection.

What additionally occupied Sansovino through the 1540s was the building adjoining the mint to the north and east (fig. 16.24). The new structure was to house government officials as well as to provide space for shops and offices; above was a grand library known as the Marciana (after San Marco), the main interior feature of which was a large, airy, brightly lit reading room that looked onto the Ducal Palace. Of at least as much concern to Sansovino, though, was the building's exterior, which gave definition to two connecting squares: the Piazza San Marco and the smaller piazza that opened onto the harbor. Here, as with the mint, Sansovino adopted a classicizing Roman vocabulary, one that moved away from the Gothic and Byzantine look that had long characterized Venetian building. The most prominent feature of both the ground storey and the *piano nobile* is a row of columns supporting a thick entablature. The statues that terminate the vertical elements relieve the sense of weight, as does the second architectural register over which the first is laid: arches at ground level, like the smaller supports above, appear to help with the heavy lifting, giving the impression that the most monumental columns are as decorative as they are functional. (The combination in each bay of an arch flanked by two lower rectangular openings forms a motif called a **serliana**, after the architect Serlio.)

Sansovino's son Francesco later reported that Jacopo had intended to extend a uniform facade around the entire piazza. In the event, the building was finished only at the end of the century, but the repetition of the motifs down its length still regularized the space before it. No single modern building anywhere had provided a sense of order and regularity to such an immense open environment. For its corner, Sansovino designed a soaring brick bell tower, and added a loggia to a ground level that would look across to where the basilica and the ducal

16.23

Jacopo Sansovino, loggetta, 1537–45. Piazza San Marco, Venice

palace met. With its three grand window bays (originally open) and its sculpted marble reliefs, this entrance to the building resembled the top half of a triumphal arch (fig. 16.23). Between 1541 and 1546, Sansovino furnished the structure with four nearly lifesize bronze statues. The figures of Mercury and Minerva represent eloquence and wisdom, virtues that they would here bring to the council that met in the palace they face. The pairing would have reminded educated viewers of ancient and modern literary academies; it cannot be accidental that the structure they ornamented stood next to the Marciana, the great state library. Sansovino's third figure, Apollo, originally held a lyre, suggesting that here, too, the world of learning has come to serve that of politics: the supervisor of Parnassus and inventor of lyric brings harmony to the state. Rounding out the group was a figure of Peace, who melts weapons with a torch, an allusion to the source of the metals often used for public bronze sculpture that advertises the fact that the Venetian Republic (like the Florentine duke in the same years) was devoting its bronze and its casters' skills to art rather than war. Sansovino's imagery suited an official space that hosted public rituals, and the statues he made signaled a broader exchange between

ambitious sculptors in different cities. His Peace may have derived from the verso of a medal Cellini made in Rome. And Cellini himself, as we have seen, would include bronze figures of Mercury and Minerva in his *Perseus* for the loggia of the Palazzo (*see* fig. 16.20).

Urbanism in Genoa

Florence and Venice were not the only cities to attend to their large urban spaces in these years. In Genoa in 1549, a group of families that had become wealthy through banking and the alum trade petitioned the city's republican government to allow the construction of an elegant new street. The plan required that the poorer people living in the area be expelled from thirty-eight houses and also called for the expropriation of gardens and a small piazza. Despite formal protests on behalf of these residents, the government consented, allowing a wide sunlit space (fig. 16.25) to replace the harbor city's dark medieval alleyways. Rather than paying for the project itself, the government auctioned off the lots, which in the end went primarily to just four powerful clans. Demolitions for the Strada Nuova ("new road") or Via Aurea ("golden

16.24

Jacopo Sansovino, library of San Marco, Venice. Begun by Sansovino in 1537, it was completed by Vincenzo Scamozzi in 1591.

483

16.25
"Strada Nuova" (today
Via Garibaldi), Genoa,
begun 1550

street") began in the 1550s, and the new property own-
ers only succeeded in erecting their palaces (the Palazzo
Podestà, the Palazzo Bianco, and the Palazzo Doria) in
the 1560s or later. By contrast to contemporary urbanistic
projects elsewhere, moreover, the street gave prominence
to no single governmental building. The absence of a
ducal palace, a great basilica, or any other colossal struc-
ture associated with local authority, however, did not
make the project any less political.

We have seen the way in which a power center could
form around a wealthy clan in Florence, the Medici; the
same thing happened in Venice, Rome, and other cities.
The conventional response of governments combating
this was to establish a central, neutral space to which all
other neighborhoods were at least nominally subordi-
nate. The Genoese government, by contrast, allowed the
families who controlled it to engineer an actual neigh-
borhood that would display their local rank, even as it
promoted an image of collaboration and civic harmony.

Rome: The Capitoline Hill

The most significant of all public spaces newly conceived
in these years may have been the Campidoglio (fig. 16.27).
Paul III had initiated the project after realizing that the

triumphal procession he had hosted for Emperor Charles
V in 1536 had no suitable terminus. Though Cellini, Sans-
ovino, and the other artists involved in the transformation
of urban piazzas in the 1530s had left Rome before work
there got much under way, Michelangelo's involvement
with the project and the prints publicizing his designs
ensured its extensive fame. The renovations began, as we
saw in the last chapter, with the transfer of the ancient
bronze *Marcus Aurelius*, Europe's most famous eques-
trian monument, to the center of the square in front of
the palace where the city's Senate met. Over the decade
beginning in 1537, Michelangelo developed a plan for
reshaping the entire piazza, with symmetrical buildings
on either side of a patterned pavement and a renovated
and regularized Senate building used as a backdrop. (The
buildings were not completed for over a century, and the
oval pavement, with its spinning labyrinth design, was
only laid in the form Michelangelo intended in the twen-
tieth century.) Like Sansovino's Marciana (*see* fig. 16.24),
Michelangelo's design included commercial and office
space, housing stalls for Roman guilds in an open loggia.
And like the Piazza della Signoria in Florence, it included
an extensive sculptural program: the artist intended
to import the colossal ancient "Dioscuri," or Horse-
Tamers, from the Quirinal hill across town. Michelangelo,

CAPITOLII · SCIOGRAPHIA · EX · IPSO · EXEMPLARI · MICHAELIS · ANGELI · BONAROTI · A · STEPHANO · DVPERAC · PARISIENSI · ACCVRATE · DELINEATA · ET · IN · LVCEM · AEDITA · ROMAE · ANNO · SALVTIS · ∞ƆLXIX

16.26
Étienne Dupérac, engraving after Michelangelo's project for the Campidoglio, 1569. 14⅝ x 21¼" (37.1 x 54 cm). Metropolitan Museum of Art, New York

like many at the time, probably believed that the Dioscuri were ancient portraits of Alexander the Great, an identification that would not have been lost on Pope Paul III, whom we saw celebrating the same ruler in the Castel Sant'Angelo (*see* fig. 16.8).

A subsequent Pope spared Michelangelo the impracticality of moving the Dioscuri when he allowed use of two other, newly discovered colossal figures with horses. And the history of the square's statuary reminds us that the Campidoglio, like the Strada Nuova in Genoa, may best be regarded as a product of collective patronage, developed over time. Michelangelo oversaw the building of the staircase on the Senate Palace facade beginning in 1544, and he would have seen at least the start of the new facade that builders began adding to the Palazzo dei Conservatori on the right in the early 1560s. Most scholars who refer to "Michelangelo's" design for the space, however, have in mind not the site left on Paul III's and Michelangelo's own deaths (1549 and 1564 respectively), but a later etching produced by Étienne Dupérac (fig. 16.26). Even at the time of the print's publication in 1569, moreover, the space lacked many of the etching's most distinguishing features. The building on the left only went up in the seventeenth century, and it was the Fascist dictator Benito Mussolini in the twentieth century

who oversaw the laying of the remarkable pavement, with its star-like shapes inscribed in a large oval.

Still, the presence of the *Marcus Aurelius* alone, standing before the remodeled Senate, would have been enough to make the Campidoglio a landmark in a city that had few real "designed" squares. The only space like it in Rome was the piazza in front of the Farnese Palace, where the gigantic stronghold of the Pope's own family continued to take shape: the death of Antonio da

16.27
Michelangelo, Palazzo dei Conservatori, Campidoglio

ABOVE

16.28

Antonio da Sangallo the
Younger and Michelangelo,
Palazzo Farnese, Rome,
begun 1517, seen across the
Piazza Farnese

16.29

Antonio da Sangallo the
Younger and Michelangelo,
courtyard of the Palazzo
Farnese, Rome

Sangallo the Younger in 1546 left Michelangelo with the
responsibility of finalizing the design: he oversaw the
construction of the third storey and the massive cor-
nice (fig. 16.28), and the completion of the courtyard.
Sangallo's building already constituted a Florentine
rejoinder to the Roman formula of Bramante and Rap-
hael, although the medium is now largely brick rather
than the stone preferred in Florence. Like Raphael's Pal-
azzo Pandolfini (*see* fig. 13.20), Sangallo's design provided
for rusticated corners and a monumental entryway. In
the courtyard (fig. 16.29), he had adopted the Roman
principle of articulating three storeys with the classical
orders in their proper sequence. Here the theme of the
arch with an engaged column recalls Bramante at the Bel-
vedere courtyard (*see* fig. 12.45), and Sangallo's massive
L-shaped corner piers visually reinforce the integrity of
each side of the courtyard as a semi-independent facade.
Michelangelo closed in what had originally been an open
arcade on the *piano nobile*, and he designed a third storey
where clustered Corinthian pilasters replace engaged col-
umns, and massive windows with segmental pediments
almost eliminate the presence of the wall.

Michelangelo's design for the twin palaces of the
Campidoglio presents a striking and deliberate contrast
with the massive planar facade of the Farnese's private

base. The open loggia of their ground floor expresses the public nature of the Campidoglio buildings. In the *piano nobile*, Michelangelo has almost completely omitted the wall, filling each bay with dominating tabernacle windows. (At the Palazzo Farnese, this effect was confined to the private inner courtyard.) More impressive than the containing wall are the massive, sculptural pilasters. Michelangelo here made the first notable use of an idea Raphael may have invented while architect at St. Peter's, that of the "giant order," where columns or pilasters (here Corinthian) rise through two storeys. He interlaced this with a second Ionic order that rises to the height of the lower storey, its minor status wittily underscored by the sculptural treatment of the Ionic capitals, with their clownishly grotesque masks. The hierarchy of orders here, and the forms of ornament, parallel the ascent from "low" literary genres like comedy or satire to more serious and refined modes like tragedy or epic: architecture, too, allowed comparisons to literature.

Painting without Poetry

Titian between Pope and Emperor

The simultaneous rise of the urbanistic projects in Florence, Venice, and Genoa, among other cities, suggests the attention that Rome was once again managing to attract, more than a decade after the Sack. Nor was the renewed interest in the Holy City limited to architects and sculptors. One artist who saw an opportunity in Paul III and his family was the painter Titian (1488/90–1576).

In 1543, Titian traveled to Bologna to meet the Pope, and three years later he made his only known trip to Rome, where he completed a *Danäe* for the pontiff's grandson, Cardinal Alessandro Farnese (fig. 16.30). Titian depicts an episode from Ovid's *Metamorphoses* in which the princess Danäe, imprisoned by her father, receives the god Jupiter as a lover in the form of a shower of gold. The idea of focusing the picture on a nude woman, placed at

16.30

Titian, *Danäe*, 1544–45. Oil on canvas, 47½ x 67¾" (120 x 172 cm). Capodimonte Museum, Naples

16.31

Titian, *Pope Paul III with His Grandsons Alessandro and Ottavio Farnese,* 1546. Oil on canvas, 6'6³/₄" x 5'8¹/₂" (2 x 1.74 m). Capodimonte Museum, Naples

the bottom left of the picture, looks like a variation on the artist's *Venus of Urbino* (*see* fig. 15.3), and an under-drawing suggests that Titian's original composition was closer still to his earlier work. If in that painting Titian aimed at turning paint into flesh, however, here he produces something much cooler, starting with a palette in which golds and browns replace reds and in which the only moment of intense color is a glimpse of the heavens through the window. The tonality suited the theme – Jupiter impregnates Danäe by transforming himself into a rain of gold (in Titian's invention, gold coins imprinted with thunderbolts) – though the pale nude and the metallic surfaces that surround her give the whole composition a more sculptural effect. This may respond to the Roman milieu, but it also nods to Michelangelo, with whom Titian would have found himself newly in competition. Danäe's pose evokes that of the Medici Chapel allegories, and the presence of Cupid, who seems to personify the

eros that the *Venus of Urbino* radiated, suggests Titian's knowledge of the *Venus and Cupid* that Michelangelo had designed for Pontormo (*see* fig. 16.14).

That Titian's approach to the Danäe represented a calculated pictorial choice becomes clear from another major painting he made for the Farnese in Rome, a 1546 portrait of Cardinal Alessandro, his brother Ottavio, and their grandfather Paul III (fig. 16.31). In stark contrast to the *Danäe*, but picking up on Raphael's example in his earlier "dynastic" portrait of Leo X and his cardinal relatives (*see* fig. 13.30), Titian painted this picture almost entirely in blends of red, the color that identified the cardinal's office. The portrait seems to make the status of the two brothers legible not only in poses, one upright and addressing the viewer, the other bowing in response to the Pope, but also in their pictorial intensity: Ottavio conforms to the curtain behind him while Titian's patron Alessandro, though set further back in

space, paradoxically projects more. The color also links the elder Alessandro more closely to his grandfather, with whom he shared a birth name and whose path into the clergy he followed.

Titian's visit to Rome had an impact on his other great portrait of the late 1540s, completed two years later, showing the Holy Roman Emperor Charles V on horseback (fig. 16.32). Few patrons had thought much about equestrian monuments in the decades after the collapse of Leonardo's project for Ludovico Sforza in 1499, but the new prominence that Michelangelo gave the *Marcus Aurelius* turned attention back to the theme, and not just as a subject for sculpture. After Charles achieved an important victory over united Protestant forces at the city of Mühlberg in Saxony, Titian painted a portrait of him

at the battle. The artist, who was by this point also trying to cultivate a relationship with Charles's son and heir Philip II, had taken the trouble of traveling over the Alps to meet the emperor in Augsburg, and he thought carefully about the scene. He stripped down the composition to its most basic elements – omitting the attendants who actually carried Charles into battle, any landmarks identifying the site, any action suggesting a fight – in order to make a more timeless image. At the same time, he maintained a sharp specificity: there is no history here, but there is no allegory either. No one had ever produced an independent equestrian painting of this kind, and if it brought the thoughts of Titian or Charles to the *Marcus Aurelius* of the Campidoglio, the comparison would have been apposite. Not only did Charles claim

16.32
Titian, *Emperor Charles V at the Battle of Mühlberg*, **1548.** Oil on canvas, 10'10¾" x 9'1⅞" (3.32 x 2.79 m). Museo del Prado, Madrid

16.33

Agnolo Bronzino, *Cosimo I de' Medici, c.* 1545. Oil on panel, 27½ x 22¼" (71 x 57 cm). Uffizi Gallery, Florence

succession to the ancient Roman imperial throne, but he had also fought at Mühlberg in the name of the Roman Catholic faith.

Bronzino's State Portraits

The continental fame of Charles V's portraits could require other painters, too, to set aside their poetic inclinations. Bronzino's skill at imparting elegance and grace to the human body, along with his judicious subordination of ornament to figure, help explain why he outstripped Salviati as the chief portraitist of the Medici court. By sharp contrast with the earlier portrait of Cosimo as Orpheus (*see* fig. 15.19), however, his later state portrait exaggerated the maturity of a sitter who was still in his twenties, and invested him with the authority of a soldier and commander (fig. 16.33). Presumably at Cosimo's instruction, Bronzino based the portrait on a woodcut by Giovanni Britto of Charles V (fig. 16.34), this itself based on a now lost original by Titian; all three pictures depicted their subject in armor and with an imperious bearing. Cosimo was the feudal subject of the emperor, who had helped place him on the Florentine throne. By the middle of the 1540s, however, Cosimo had negotiated substantial autonomy, reducing the number of Spanish troops within his territories. The political situation required a subordination of inven-

16.34

Giovanni Britto after Titian, *Emperor Charles V, c.* 1535–40. Woodcut, 19½ x 13⅞" (49.5 x 35.2 cm). Davison Art Center, Wesleyan University, Middletown, Connecticut

·CAROLVS·IMPERATOR· ·QVINTVS·

tion to other interests, above all Cosimo's desire to stage an equivocal relation to imperial authority; by recycling Titian's model, Cosimo could at once emulate and displace his protector and overlord. It is telling that when Bronzino was commanded to provide further portraits, the painter's proposal to make "more beautiful" works was overruled: Cosimo had settled on an official likeness and deemed that replicas of it alone should circulate.

By contrast, the state portrait of Cosimo's wife Duchess Eleonora allowed Bronzino to display the transforming power of his art (fig. 16.35). The artist invested an extraordinary level of care in his depiction of the duchess's sumptuous dress, itself an "art object" that would have many times exceeded in value the picture itself: it is as if he wants us to compare the art of painting with that of embroidery. At the same time, the duchess is more than a match for her costume. Her face, set off by a halo-like radiance in the background, draws our attention with its icy perfection, its bold stare, and a composure tinged with irony; clearly, these are all qualities that she has imparted to her two-year-old son Giovanni, already a cardinal in the making. The air of unreality – note how the hand seems to drift into the frontal plane of the painting with no objective except its own display – evokes not only the power of art to fascinate and to dominate, but also the otherworldly authority of the cult image. The intense blue of the landscape background comes from the extensive use of ultramarine, the same expensive pigment once reserved for paintings of the Vir-

gin. In pursuing forms of absolute and charismatic rule, sixteenth-century potentates were complicit with those artists who would turn qualities previously associated with the sacred image to new purposes.

Michelangelo: The Pauline Chapel

In the Vatican in 1546, Michelangelo began decorating the chapel that Antonio da Sangallo the Younger had built some eight years before. The "Pauline Chapel," as it is called after its patron, was to serve as a space where Paul III could meditate on the consecrated bread and wine of the Eucharist, and as a place for the conclave to meet when a new Pope was to be elected – two reminders of the death that awaited the seventy-eight-year-old patron in the not distant future. On the left-hand wall, a defiant Peter lifts his head from the Cross on which he is being crucified and rotates to stare directly at the viewer; the saint turns in precisely the opposite direction to the Cross itself, which laborers lift into the newly dug hole (fig. 16.36). The sloping ground alludes to the nearby hilltop on which Peter was believed to have been executed, the site where Bramante had built his *Tempietto* (**see** fig. 12.24). More generally, though, the composition recalls that of the *Last Judgment* (**see** fig. 15.29), completed just five years before in the Sistine Chapel next door, with figures rising on the left and descending on the right. The presiding agents in this case are the Roman commanders, whose horses seem to know more than they do: one looks away, and the other starts violently, as their riders comment on what they see.

16.35
Agnolo Bronzino, *Eleonora di Toledo and Her Son, Giovanni, c.* 1545. Oil on panel, 45¼ x 37¾" (115 x 96 cm). Uffizi Gallery, Florence

16.36
Michelangelo, *The Crucifixion of St. Peter*, *c.* 1545–50. Fresco. Pauline Chapel, Vatican

Peter had requested an upside-down crucifixion, a reminder that by contrast to Christ, who was "erect, upright, and high," the descendants of Adam were fallen and deserved to be closer to the ground. The scene opposite shows the more noble Paul, the Pope's namesake, at the moment of his conversion, when he was knocked from his horse (fig. 16.37). According to the Acts of the Apostles, "a light from heaven shined round about him./And fall-ing on the ground, he heard a voice saying to him: Saul, Saul, why persecutest thou me?" Michelangelo has Christ himself appear above, foreshortened so dramatically that he seems to tear out of the picture, while surrounding angels honor him. Just as the crucifixion of Peter showed an act of humility, this was also a humbling; though here, too, the painter invested the meaning of the scene in the twisting pose of its protagonist, an embodiment of the

"conversion" ("turning away") to which those devoted to the saint attributed particular significance. Gone from both pictures are the literary inventions that, to many eyes, had compromised Michelangelo's earlier sacred paintings. And we can only imagine that the painter, who was not much younger than the Pope and who was focused enough on his own death to be designing a tomb sculpture, would have been as concerned as his patron to

purify his painting of what contemporary critics of the Sistine *Last Judgment* had come to perceive as errors.

There is a sense that Michelangelo here is trying to rethink the conventions of sacred narrative: in their uneasy, disjunctive qualities, the two frescoes distance themselves from the seductions and allure of "poetical" forms of painting as we have surveyed them above and in previous chapters.

16.37
Michelangelo, *The Conversion of St. Paul,* *c. 1542–45.* Fresco. Pauline Chapel, Vatican

1550–1560
Disegno/Colore
17

17 1550—1560
Disegno/Colore

Titian and Rome

Contemporaries of Titian attached much significance to his trip to Rome in 1545, and it is likely that the artist did as well. The presence of Venice's greatest painter in the city dominated by the followers of Michelangelo and Raphael brought rival traditions into confrontation. Titian's *Danäe* (*see* fig. 16.30) had openly provoked discussion: in fact, no work of the mid sixteenth century seems more attuned to the central topics and controversies governing the contemporary critical discourse about art. First, the painting is a bid to turn a poem into an image, and to intensify the marvel and allure of Ovid's language in the *Metamorphoses* through the immediate sensuous appeal of paint. Second, Titian based his heroine on a nude figure of Leda by Michelangelo, one closely related to the sculpted figure of Night in the Medici Chapel (*see* fig. 15.12). Michelangelo, for his part, had based both of his figures on an ancient sarcophagus relief of the same subject, so Titian's imitation would have solicited a by now familiar comparison between painting and sculpture (the *paragone*). And third, the challenge to Michelangelo would have fanned the flames of a rising dispute about the artistic values of Venice as opposed to those dominant in Rome and Florence.

What had until this point been a general recognition and appreciation of regional differences now turned into a vigorous controversy. In 1550, the Tuscan painter-courtier Giorgio Vasari published the first edition of his *Lives of the Most Excellent Italian Architects, Painters, and Sculptors*, which vaunted the supremacy of the Florentine and Roman traditions grounded in *disegno* – the Italian word for "drawing" that also carried the sense of "design" – creating art not just by copying nature but by following a process of trained judgment and mental synthesis. A century of elevated claims for *disegno* had reached the point where the Florentine writer Anton Francesco Doni could remark in his 1549 dialogue *Disegno* that "Disegno is nothing other than divine speculation, which produces an excellent art; you cannot execute anything in sculpture or painting without the guide of this speculation and design." Such definitions, which prioritized intellectual conception over the description of optical experience, implied an ideal of perfection abstracted from what the eye could perceive in nature. In the same spirit, Vasari regarded the likes of Giorgione, Pordenone, and Titian as artists who worked intuitively, directly on the canvas, without the premeditation involved in *disegno*. As he saw it, painters in the Venetian tradition sought primarily to represent superficial appearances in nature through blended color, *chiaroscuro*, and brushwork, designating these effects collectively with the term *colore* (or *colorito*, which corresponds not just to the English word "color" but also to "paint" and its handling). In his second edition of the *Lives* Vasari would report that Michelangelo himself, on seeing Titian's *Danäe*, had praised its *colorito* and its *maniera* (style) and had commented "that it was a pity that in Venice men did not learn to draw well from the beginning, and that those painters did not pursue a better method in their studies." Vasari drives home the point: "And in fact this is true, for the reason that he who has not drawn much nor studied the choicest ancient and modern works, cannot work well from memory by himself or improve the things that he copies from life, giving them the grace and perfection wherein art goes beyond the scope of nature, which generally produces some parts that are not beautiful."

The Venetian Ludovico Dolce responded to Vasari in 1557 with a spirited publication entitled *Aretino*, after the poet and satirist Pietro Aretino (1492–1556). In Dolce's dialogue, Aretino appears as a semi-fictional character through whom Dolce voices his own views. Aretino made for a fitting mouthpiece not only because he came from Vasari's own home town (the name Pietro Aretino literally means "Peter the Aretine," i.e. "Peter from Arezzo"), but also because the historical Aretino had opportunistically denounced Michelangelo's *Last Judgment* on the grounds of decorum in a widely circulated letter. Dolce's publication does not mention Vasari by name, but its author makes the object of his attack unmistakable in the praise of Titian by the character "Aretino" and his devastating critique of Michelangelo. Dolce cleverly avoided charges of regional bias by including an enthusiastic encomium of Raphael, and by casting Titian as the equal and successor of Michelangelo's great rival. He thus associated Titian with an artist held to be the equivalent of the poet Petrarch – for the pleasurable grace of his work, and for what Dolce called the "beauties of propriety" – and opposed him to Michelangelo, whose

pursuit of difficulty, intellectual complexity, and disquieting energy identified him with Dante. (We have seen that Michelangelo solicited this kind of identification in the *Last Judgment*, but Dolce turns it against him.)

Michelangelo, according to "Aretino," excelled in only one limited aspect of art: "making a nude body muscular and elaborated, with foreshortenings and bold movements that show off in detail every artistic problem." "He does not take into account those distinctions between the ages and the sexes," however, "which Raphael handles so admirably," so that "the man who sees a single figure by Michelangelo has seen them all." By contrast, Dolce praised Titian for his masterly union of *disegno* and *colore*: the *Assumption* (*see* fig. 13.49) combines "the grandeur and awesomeness (*terribilità*) of Michelangelo, the charm and loveliness of Raphael and the *colorito* proper to nature."

Titian and the Hapsburgs

Notwithstanding Dolce's astute characterization of Titian's painting, the works from the 1550s and after might make us wonder about the extent to which the artist appreciated the identification with Raphael, or "nature," or the "beauty of propriety." Titian's mode of execution increasingly emphasized the brushstroke, the *colore* of pictorial substance, a priority that not all admired. His own greatest advocate, the real-life satirist Aretino, had sent a 1545 portrait of himself by Titian to Duke Cosimo de' Medici, remarking in a letter that undoubtedly Titian would have finished the portrait more carefully if Aretino had paid him more (fig. 17.1). This may have been no more than the characteristically unsparing wit of the satirist, but the Medici court requested no paintings from Titian. Philip II, the young king of Spain, who had sat for a portrait by the artist in 1550, expressed misgivings about the loose and apparently hasty execution that was increasingly manifest even in the official portraits Titian was supplying to the Hapsburg rulers of Europe. Philip wrote of one portrait that if there had been more time, he would have had Titian do the picture over again. The king's aunt, Mary of Hungary, was more appreciative, but she counseled one recipient of a portrait by Titian that the artist's works "do not bear being looked at too closely."

In 1553 Titian made another version of his *Danäe* (fig. 17.2), apparently as an unsolicited gift for Philip II, which suggests that he paid little heed to such criticisms. The tonality of the earlier Farnese version (*see* fig. 16.30), with its blues and golden flesh tones, has given way to a darker and warmer palette. The turbulent storm clouds that engulf the reds and whites of Danäe's bedchamber also envelop the landscape beyond; the effulgence of gold breaks forth at the point where the swirling grays meet the

rich reds. Titian takes the principle of dramatically contrasting light and color further by offsetting Danäe's pale flesh with that of a dark-skinned older maidservant who rushes forth to collect the "shower of gold" in the form of falling coins. Her effort to catch the coins, which heightens the implication of prostitution, strikes a note of erotic satire that Aretino would have enjoyed. Along with the sense of wonder and marvel, Titian has intensified the eroticism of the subject, above all in the rapturous gaze of the heroine and the omission of the drapery that covered her lower body in the earlier version.

The king was evidently impressed: over the following decade, Titian supplied the Spanish court with a series of mythological pictures, which he referred to as his *poesie* (literally, "poems," but also implying "fables" or "myths"). *Venus and Adonis* (fig. 17.3), which followed in 1554, takes its subject matter from Ovid's *Metamorphoses*, but it is clear that Titian did not consider himself

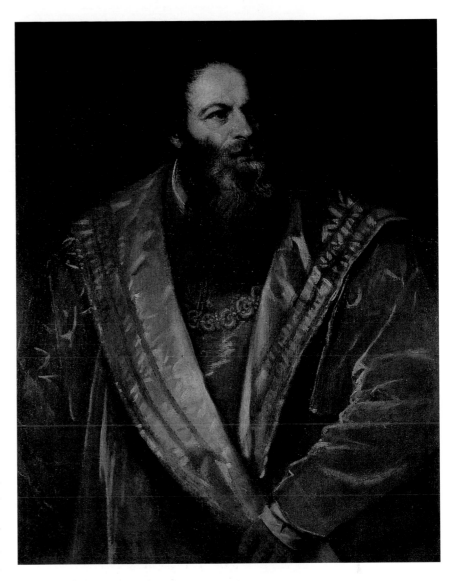

17.1
Titian, *Pietro Aretino*, c. 1545. Oil on canvas, 39 x 30¾" (98 x 78 cm). Galleria Palatina, Palazzo Pitti, Florence

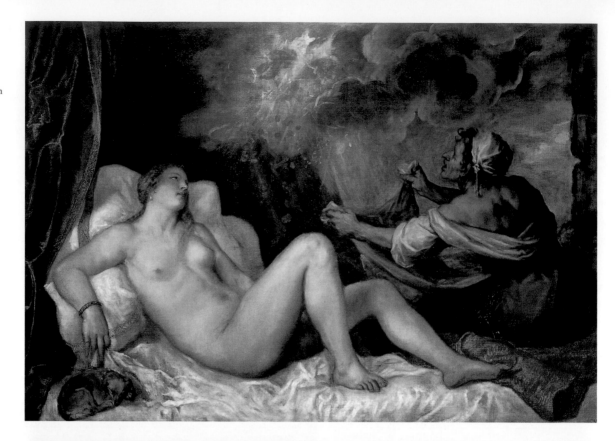

17.2
Titian, *Danäe*, 1553. Oil on
canvas, 3'11¼" x 5'7¾""
(1.2 x 1.72 m). Museo del
Prado, Madrid

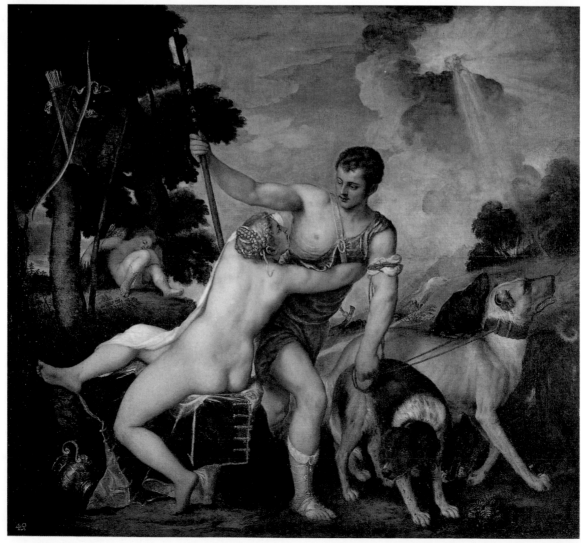

17.3
Titian, *Venus and Adonis*,
1554. Oil on canvas, 4'5½"
x 7'2½" (1.36 x 2.2 m).
Museo del Prado, Madrid

by any means to be an illustrator of the poem. The action depicted – where Venus struggles in vain to prevent her young lover from setting out on a boar hunt that will lead to his death – never occurs in Ovid: Titian conceived it as a point when an erotic idyll took a tragic turn, so that he could contrast Adonis's fatally headstrong nature with the pathos of a lovelorn Venus suddenly rendered powerless. *Venus and Adonis* is *Titian*'s poem, in which like Ovid before him he lays claim to the license to retell a familiar ancient myth using the characteristic figures and effects that distinguished his art. Once again, soft gleaming skin is offset by a somber physical setting that appears to fill with shadows; the turbulent sky and the restless dogs strike a note of unease. Again, Titian engages in the *paragone* with sculpture, Michelangelo, and *disegno* by modeling his Venus on an ancient relief known as the "Bed of Polykleitos" (fig. 17.4). Adonis, moreover, suggests an adaptation of one of Michelangelo's muscular male figures, albeit invested with a new delicacy. Dolce, in fact, praised Adonis for his androgyny (he also saw Venus as masculine in her actions). The drama of the painting lies in Adonis's attempt to break free of Venus: he rejects love as an effeminizing force, yet this rejection and the attempt to take up masculine pursuits, such as hunting, have fatal consequences.

Although one letter from Titian suggests that in devising the subject matter he observed no principle other than variety – "because the figure of Danäe…is seen entirely from the front, I have chosen in this *poesia* [i.e. *Venus and Adonis*] to vary the appearance and show the opposite side" – the combination of eroticism with

17.4
Roman relief; the so-called "Bed of Polykleitos."

17.5
Titian, *The Rape of Europa*, 1559. Oil on canvas, 6'1" x 6'9" (1.85 x 2.05 m). Isabella Stewart Gardner Museum, Boston

darker emotions and insinuated violence is characteristic of the entire series. Writers like Dolce and Aretino had characterized Titian in terms of Raphael's majestic grace and charm, but in these and other works from the period it is as if Titian was resisting such an interpretation. The most impressive painting from the series is the *Rape of Europa* (fig. 17.5) of 1559. Europa, a princess of Sidon, has mounted a beautiful white bull that she and her companions encountered at the shore. The bull, who was none other than the lovesick god Jupiter, suddenly made for the sea, to bear her away to the island of Crete. Again, the best-known account is in Ovid's *Metamorphoses*, but Titian re-casts the fable with his own repertoire of poetic effects. Again, he renders a female in a state of subjection; her powerful body has a three-dimensional volume but also a softly yielding texture. Titian realizes the setting, on the other hand, through vigorous brushwork that seems to dissolve as much as describe forms: the landscape acquires the same hazy quality as the flaming sky. This is art about art, which invites each viewer to experience anew Titian's virtuosic performance as painter: Europa's windblown scarf draws particular attention to the vigorous dragging of brilliant pigment across the can-

vas. Again, Titian has chosen to depict a pivotal moment in the story, focusing on Europa's terrifying experience: snatched away from home and family, she is also in real danger of sliding to another terrible fate in the dark sea below. As a Venetian, Titian would have been specially attuned to the lore of the sea and its lurking perils: he here makes visible the local fear of the deep in the form of two monstrous fish that show spines and fangs in the foaming waters. Finally, Titian raises the possibility that Europa's fear might be giving way to another emotion: the band of shadow across her face makes us conscious of her rolling eyes and the direction of her glance. She seems to have noticed the airborne cupids, hovering little spirits of love. The fact that a third cupid actually rides upon – and thus has mastered - one of the threatening sea creatures reinforces the idea that love will dispel fear.

Tintoretto's Challenge to Titian

Titian's works at mid century suggest that the painter may have embraced the identification of Venetian painting with *colore*, while still alluding to the tradition of *disegno*, as if to suggest that he has assimilated and sur-

17.6
Tintoretto, *St. Mark Rescuing the Slave*, 1548. Oil on canvas, 13'7" x 17'10" (4.16 x 5.44 m). Galleria dell'Accademia, Venice

17.7
Tintoretto, *The
Presentation of the Virgin
in the Temple*, 1553–56. Oil
on canvas, 14'1" x 15'9"
(4.29 x 4.8 m). Madonna
dell'Orto, Venice

passed it. The young Venetian painter Jacopo Robusti (1518–1594), who acquired the nickname Tintoretto – "little dyer" – adopted a forcefully different approach. Tintoretto appears to have been an estranged pupil of Titian who in 1548 announced his challenge to the older artist's dominance of the Venetian art world with his *St. Mark Rescuing the Slave* (fig. 17.6). Tintoretto produced the large canvas for the meeting hall of the Scuola Grande di San Marco, one of the most powerful of the Venetian confraternities. It appears that the Scuola at first rejected the painting, although its officers subsequently changed their mind and commissioned Tintoretto to provide additional works for the series.

The officers may have found the novelty of Tintoretto's approach disquieting. This is recognizably a work by a painter trained in Venice: the rich color recalls the turn-of-the-century work of the Bellini, and the vigorous brushwork is a characteristic device of younger painters influenced by Titian. Yet the blustering energy of the composition, accentuated by asymmetry, an apparently haphazard play of light and shadow, and a lack of balance, indicates that Tintoretto also had an eye on Michelangelo.

A group of figures to the left clusters around the fore-shortened body of a naked man – a Christian slave who had defied pagan authorities in his devotion to St. Mark and was miraculously preserved from torture and execution. Even more startling in its foreshortening is the figure of St. Mark who, unseen by the crowd, descends from above, his feet incongruously turned toward the viewer, his face barely visible. The figures seated under the throne recall Michelangelo's Medici Chapel allegories, which Tintoretto appears to have known from small clay replicas. Both the man clutching the column and the woman with the child take inspiration from Raphael's Stanza d'Eliodoro (*see* fig. 13.6), but the resulting formulation would never be mistaken for a work of central Italian art. Tintoretto is renewing Venetian tradition, and aggressively, even irreverently, claiming a place for himself within it, by more blatantly insisting on the reconciliation of *disegno* and *colore*.

In his *Presentation of the Virgin in the Temple* (fig. 17.7), originally a set of organ shutters for the Venetian church of the Madonna dell'Orto, Tintoretto produced a composition that looks as if it might have been designed

by a Roman or a Florentine. Statuesque women with elaborate hairstyles again recall Raphael in the Stanza d'Eliodoro (*see* fig. 13.6) or Bronzino in the Chapel of Eleonora of Toledo (*see* figs. 16.4–16.6); the painted architecture indicates that Tintoretto had some knowledge of frescoes by Francesco Salviati in Florence (*see* fig. 16.3) or Daniele da Volterra (*see* figs. 17.20 and 17.23) in Rome; and the boldly foreshortened limbs of the foreground figures were a specialty of Michelangelo's followers. Yet in other respects the painting is uncharacteristic of those central Italian artists. Especially in the ascending column of male figures, there is a conspicuous working of paint on canvas: the differential play of light and shade across the groups of figures betrays a characteristically Venetian attention to optical and atmospheric effects. Later

biographers would contend that Tintoretto composed his paintings by shaping wax figures – the same technique that central Italian designers would use to imitate Michelangelo. Yet, here, in an unusual touch, Tintoretto has decorated the steps of the temple with gold leaf, an anachronistic note that would have evoked the sparkle and gleam of old Venetian mosaics.

Design and Production: Florence and Rome

Tapestry and Goldsmithery

The artists of the Medici and papal courts demonstrated a self-consciousness about the centrality of design not just in their painting and sculpture, but in their involvement in the decorative arts. In Florence by 1554, the most prestigious and magnificent ducal commission to date was nearing completion: a series of twenty large tapestries devoted to the story of the Biblical hero Joseph, eleventh son of Jacob. Joseph, who survived his jealous siblings' attempts to get rid of him, rose to power as minister of the king of Egypt, and was finally reconciled with his humiliated family, is a characteristic substitute for the more familiar boy hero David, who in Florence by this time would have awakened too many republican ghosts. The Medici, as we saw with Leo X, had previously ordered their tapestries from the manufacturing centers of the Netherlands, especially Brussels and Antwerp. Buyers sought Flemish tapestries for their decorative profusion of naturalistic detail, for florid landscapes with animals and birds. Bishop Ricasoli, Cosimo I's agent at the imperial court in Brussels, even proposed that in sending designs abroad the duke should have the background spaces left blank, because the Flemish could supply these elements.

Now, though, Cosimo had the tapestries woven in Florence by two masters he had poached from the court of Ferrara, Nicholas Karcher and Jakob Rost. Cosimo's Florentine designers occasionally emulated the detailed landscape effects of Flemish painting, but tended in general to emphasize the idealized, sculptural body so typical of Florentine and Roman art. Bronzino's highly finished model drawing for one of the tapestries survives (fig. 17.8): in this early episode, Joseph explains his dream of future greatness to his father Jacob, while his brothers plot against him. Unlike Raphael, who had treated tapestry according to the conventions of mural painting, with bodies arrayed in deep space, Bronzino arranges his figures in relief-like formations: absent are both the architectural environments of the Raphael school and the landscapes of the Flemish. The drawing

17.8
Agnolo Bronzino, *Joseph with his Brothers* (fragment of a modello for the tapestry *Joseph Recounting His Dream of the Sun, Moon, and Stars*), c. 1548. Black chalk on off-white paper, 18¼ x 13" (46.2 x 33.1 cm). Ashmolean Museum, Oxford

17.9
Perino del Vaga, Francesco
Salviati, Giovanni Bernardi,
Manno Sbarri, the
"Farnese Casket," 1546–60.
Capodimonte Museum,
Naples

suggests that Bronzino may have wanted the tapestries to stand as exemplars of *disegno*, the sign of a local and not an imported product. In its high degree of finish, his sheet recalls the presentation drawings of Michelangelo (*see* fig. 16.9), which had set a new standard of technical perfection. Bronzino had made a trip to Rome in 1548 and almost certainly called upon the older artist, but he could also have examined some of the drawings that Michelangelo had made for Florentine recipients. As Michelangelo had with the groups in the upper zones of the *Last Judgment* (*see* fig. 15.28), Bronzino creates pictorial volume largely through the sculptural quality of the figures rather than through scale or perspective.

Equally elaborate, although more intimate in scale, was the spectacular jeweled casket produced for Cardinal Alessandro Farnese between 1546 and 1560 (fig. 17.9). This work, of staggering craftsmanship and expense, appears to have been made for no other reason than to inspire wonder. Again, the work involved the coordination of

Florentine painter-designers with a team of specialized craftsmen. The former included Perino del Vaga, who designed several of the miniature narratives – epic or historical battle scenes ironically jewel-like in size, and incised onto crystals by the gem cutter Giovanni Bernardi. The crystals were ready by 1546, and Francesco Salviati (*see* fig. 16.3) then provided designs for the silver-gilt metalwork, which was executed in the following years by yet another Florentine, Manno Sbarri. The effect of multiple orders of representation – crystal *historie* framed by garlands with *ignudi* on fields of lapis lazuli, **herms** and seated figures at the corners, broken pediments in which naked boys play with birds, a melancholy philosopher surmounting the lid, while the whole rests on legs in the form of sphinxes – follows the same principles as much larger artistic ensembles, from illuminated manuscripts, to fresco cycles (*see* Perino in the Sala Paolina, fig. 16.8), to fountains and villa architecture. Together, they thereby manifest the flexibility and adaptability of

17.10

Plan of the Villa Giulia, Rome, designed 1550 by Giorgio Vasari with contributions by Jacopo da Vignola and Bartolomeo Ammanati

0 20yds

0 20m

17.11

Jacopo da Vignola, Casino. Street facade. Villa Giulia, Rome

the decorative repertoire associated with the tradition of *disegno*. In some respects, the casket suggests a miniaturization of themes from Michelangelo's Sistine Ceiling (*see* fig. 12.31) or Medici Chapel (*see* fig. 15.11), now turned to the ends of an aesthetic of precious refinement and exquisite detail. As the images on the crystals suggest, the designers understood such effects of miniaturization and preciosity to be entirely antique in their inspiration.

Architecture of the Vasari Circle

Architectural projects demonstrate the same pursuit of variety, coordinating ornament on a small scale with a larger and more complex ensemble. Design, as well as production, was frequently a collaborative enterprise. Thus in 1550, when Pope Julius III decided to build a new pleasure villa on the slopes of the Pincian Hill in Rome, he placed the Florentine painter-architect Vasari in charge of the overall plan (fig. 17.10), while assigning individual sections of the design to the architect Giacomo Vignola (1507–1573) and the sculptor/architect Bartolomeo Ammanati (1511–1592); Michelangelo served as a consultant. One entered the complex through a building known as the Casino ("little house," although it is far from little), designed by Vignola (fig. 17.11). The imposing but austere street facade, reminiscent of the Palazzo Farnese (*see* fig. 16.28) with its rusticated portal and quoins, offers little hint

of the opulent variety within. In a startling contrast to the outer facade, the block-like form of the Casino mutates into a huge curved recess (hemicycle) on the inner face (fig. 17.12). The triple portal is recapitulated as a triumphal arch-like form, repeated with the capricious slicing off of one bay at each end of the facade. Further surprises await the visitor as he or she ascends through a series of terraced gardens and ramps: the centerpiece (fig. 17.13) is Ammanati's "Nymphaeum" (a feature of ancient Roman villas, conceived as a haunt for local nature spirits or nymphs). From across the courtyard, this appears to be a one-storey structure with a central loggia in the form of a serliana; only on arrival there does it become evident that this is really the uppermost of several storeys, which descend with an abrupt shift in ground level. The horizontal axis that has structured the whole approach suddenly intersects with a vertical one – the Nymphaeum bids the visitor to look down, as if into the depths of the earth. The descending stairs lead to statues of river gods and dank fountain grottoes with herms in the form of nymphs, until a path rises again, opening onto the hill through the gardens.

For all of its diversity, the villa complex is really a set of variations on two themes: the hemicycle and the triple arch. Vasari and his collaborators here create a connoisseur's architecture for those conversant with the recent Roman buildings of Michelangelo, Bramante, and Raphael.

ABOVE

17.12

Jacopo da Vignola, Casino. Garden facade. Villa Giulia, Rome

LEFT

17.13

Bartolomeo Ammanati and associates, Nymphaeum, 1551–55. Villa Giulia, Rome

17.14
Jacopo da Vignola,
Sant'Andrea in Via
Flaminia, 1550–54

BELOW
17.15
Giorgio Vasari, courtyard
of the Uffizi, Florence,
begun 1559

Vignola did likewise nearby in the small church of Sant'Andrea in Via Flaminia (fig. 17.14), which demonstrates how much novelty was possible even while rules and canonical models were followed. This building, too, was commissioned by Julius III, in fulfillment of a vow he made while being held captive during the Sack of Rome of 1527; it belongs to an ongoing program of restoring the city, and of bringing back through architecture the glory days of the Pope's namesake Julius II. The church is a curious mutation of the Pantheon, whereby a cube and oval dome, the latter probably a response to Michelangelo's "labyrinth" design for the Capitoline complex (*see* figs. 16.26–16.27), now replaces the combination of cylinder with hemisphere. Again, the building reflects the current taste for miniaturization, since the scale follows that of another Renaissance centrally planned structure, the Tempietto of Bramante (*see* fig. 12.24). The oval also reflects the attractions of centrally planned structures while conceding to a longitudinal design that church ceremony required.

Vasari moved back to Florence in 1554 and took over the administration of most of the Medici court's artistic commissions, including an extensive remodeling of the Palazzo Vecchio (the former Palazzo dei Priori, now the ducal palace) and a series of historical and topographical frescoes celebrating the role of the Medici family in the history of the city. In 1559, he undertook what may be his best architectural work, when Cosimo decided to re-house all the civic and guild offices formerly based in the Palazzo and elsewhere in a new building that would occupy the adjacent space leading to the river. Already in 1546, extensive demolition had cleared space between the old city hall and the Arno; before Vasari took over the project for the new office block ("Uffizi"), another architect had proposed a massive portico-lined piazza with a circular mausoleum for Cosimo in the center. Vasari's scheme was less obviously centered on the glorification of the duke, and more on the city itself. In fact, it deliberately preserved some of the site's venerable older buildings, such as the great Gothic Loggia dei Lanzi, which the earlier proposal would have sacrificed. Vasari's building sought to convey principles of efficient administration, of sobriety and order, more than ornamental complexity: it amounts to a monumental street or a long and narrow piazza, lined with two massive porticoes (fig. 17.15). The "facades" that enclose Vasari's courtyard show his Roman experience, and in particular a debt to Bramante's Palazzo Caprini (*see* fig. 13.19). The combination of gray *pietra serena* and white *stucco*, on the other hand, along with the architectural vocabulary (decorative consoles, doubled columns, the square windows of the mezzanine), aim for a more local look, one that gestures to Brunelleschi and especially to Michelangelo. Lest

anyone miss the reference, Cosimo subsequently had the sculptor Vincenzo Danti add a ducal portrait, flanked by two recumbent allegories, a direct reference to the two tombs in Michelangelo's New Sacristy (*see* fig. 15.11). Cosimo and his successors could have stood in the window behind the statue to survey activities taking place below; an identical window on the other side provided a view of the Oltrarno.

Shortly after his arrival in Florence, Vasari had summoned the sculptor-architect Ammanati from Rome to assist him with various projects. In 1559, the same year that Vasari began work on the Uffizi, Cosimo had Ammanati attend to the completion of a grand library that Michelangelo had begun in San Lorenzo while working on the Medici Chapel. Initiated by Pope Clement VII as a repository for the book collection that the Medici had begun assembling in the fifteenth century, the library would consist principally of two adjoining spaces. In the reading room (fig. 17.16), permanent desks extended from the walls; the visitor would move to whichever one held a book of interest, rather than moving the book itself. Large windows ensured sufficient illumination during daylight hours, and the elimination of columns of the sort that defined the San Marco library also limited the casting of shadows on reading surfaces. To enter this room, the visitor passed through a generous vestibule defined by an oversized set of curving stairs that seemed to flow downward from the library proper (fig. 17.17). This was the first project Michelangelo had ever taken on that involved no figural works at all, and his drawings show him imagining the architectural elements almost as human bodies, their abstract profiles turning into faces (fig. 17.18). He treated the structural members, moreover, as sculpted objects, virtual figures: the columns, rather

RIGHT, ABOVE

17.16

Michelangelo, Laurentian Library Reading Room, 1523–59. San Lorenzo, Florence

RIGHT

17.17

Vestibule of the Laurentian Library, initially designed by Michelangelo, 1524–34, completed by Bartolomeo Ammanati, 1559. San Lorenzo, Florence

17.18

Michelangelo, sketches
for the staircase of the
Laurentian Library, 1525.
Pen, red chalk, black chalk,
and wash, 15½ x 11"
(39.5 x 28 cm). Casa
Buonarroti, Florence

than supporting an entablature, occupy niches; consoles,
removed from their traditional function, protrude deco-
ratively from the wall (fig. 17.19).

Ammanati, seeing through this vision, could take
advantage not only of the drawings Michelangelo had
left, but also of an elaborate wax model the earlier archi-
tect had given him. The rooms, nevertheless, belong
as much to the artistic world of the 1550s and 1560s as
they do to Michelangelo's earlier Florentine period.
The close visual connections between the Laurentian
Library and the Uffizi show Duke Cosimo attempt-
ing to transform Michelangelo's manner into a more
widely applicable Florentine architectural idiom. What
Michelangelo, working for other Medici patrons, had
developed for a largely private space in the heart of the
family precinct now became a conspicuous "state style":
the Uffizi extended from the city's central civic square,
and Cosimo would open the Laurentian Library to
the public as well. The idea, no doubt, was to subordi-
nate individual architectural personalities to a shared
agenda, though the reality was not always so harmoni-
ous. While the Uffizi was under way, Ammanati criticized
Vasari's initial design, and proposed to have the building
terminate in a serliana. Vasari quietly absorbed this fea-
ture into his structure.

17.19

Michelangelo, Laurentian
Library, wall of vestibule

Interpreting Michelangelo

Daniele da Volterra

The assimilation of Michelangelo and Raphael into a courtly art characterized by ornamental grace, learned allusions to artistic tradition, and a complex orchestration of "main subject" with copious framing elements, was only one way in which artists positioned themselves in relation to their elderly and legendary model. Among Michelangelo's favored younger followers was Daniele da Volterra (*c.* 1509–1566), who had established himself in Rome as an assistant to Perino del Vaga. The year after Perino's death in 1548, Daniele completed a chapel for the noble Roman widow Elena Orsini at the church of Santissima Trinità dei Monti. The principal subject of the chapel's side walls was Helen, Orsini's name saint; they focused on Helen's recovery of the True Cross (the cross on which Christ was crucified), which helps explain the decision to feature the Cross on the altar wall. Daniele's monumental fresco of the *Deposition* (fig. 17.20), his most famous painting, is the only part of his decorations that now survives. As Michelangelo had done when producing a Passion picture for Vittoria Colonna (*see* fig. 16.10), Daniele made the Virgin the real protagonist of his scene. Many Catholic churchmen thought the Virgin's swoon, or *spasimo*, lacked decorum, arguing that Mary could never have displayed such public and irrational displays of emotion. Despite this the painting became one of the most admired works of religious art in Rome, and was regarded as an exemplary instance of the imitation of Michelangelo. Even the severe reformer Pope Pius V signalled his approval by seeking to have the fresco detached and moved to the Vatican. For Elena, however, the Virgin, like the patron herself, was a maternal exemplar of devotion.

Daniele made some concessions in the picture to the current taste for ornamental elaboration: the heads of the women take up the idealized female profiles with elaborately dressed hair that Bronzino and Salviati, too, liked to paint (compare, for example, fig. 16.3). Ultimately, though, these motifs derived from Michelangelo, and most of Daniele's adaptations from his still-living idol were even more direct. Despite the centrality of female characters, Daniele composed his picture from heroic and statuesque bodies, many with foreshortened limbs that recall the Sistine *Last Judgment* (*see* fig. 15.29) or Pauline Chapel (*see* figs. 16.36–16.37). And in what, in its day, was perhaps the most astonishing part of his work, Daniele added to the lower zone of the chapel's entrance a pair of stucco reliefs, now known only through drawings after them (figs. 17.21–17.22), which commented on his own work. In one, Michelangelo himself appears, his

back to the viewer and his identity only revealed by the reflection of his face in a mirror. A Greek inscription above this read "know thyself," encouraging artists to look inside and find their own way of painting. Another figure, representing Daniele's late friend and mentor Sebastiano del Piombo, holds a pair of compasses; an inscription below him reads: "My advice to all consists of nothing." The other stucco was more extraordinary still. It showed a group of satyrs inside Daniele's chapel, taking the bodies he had painted out of his altarpiece and assessing them, verifying that they were justly proportioned and showed proper "gravity." The satyr often functioned in the Renaissance as a figure of "satire";

17.20

Daniele da Volterra, *Deposition*, 1548. Fresco. Orsini Chapel, Santissima Trinità dei Monti, Rome

the joke here seems to be that when detractors came to make light of what Daniele had painted, they would in fact find nothing they could mock. The painter's self-consciousness about working in the "sculptural" mode of Michelangelo and Sebastiano del Piombo, along with the suggestion that his painting consists of measurable, three-dimensional bodies rather than of brushstrokes on a surface, align him in a bizarrely extreme way with the partisans of *disegno*.

Nearby, in the chapel of Lucrezia della Rovere, Daniele completed in 1553 a cycle on the Life of the Virgin that again made his theoretical and polemical identification with Michelangelo evident. (This chapel contained the *Presentation of the Virgin* fresco, now heavily damaged, which served as the model for Tintoretto's version

ABOVE LEFT AND RIGHT

17.21 and 17.22

Anonymous drawings after Daniele da Volterra's lost stuccoes for the Orsini Chapel. Ink on wash on paper. MS 1564, fols 787v and 285v–286r. Biblioteca Angelica, Rome

LEFT

17.23

Daniele da Volterra, *Massacre of the Innocents.* Fresco. Della Rovere Chapel, Santissima Trinità dei Monti, Rome

discussed earlier; *see* fig. 17.7.) Michelangelo, in his letter on the *paragone* to Benedetto Varchi (*see* p. 476), had asserted that sculpture was superior to painting, and that painting became the more excellent the more it strove to be like sculpture. In the *Massacre of the Innocents* (fig. 17.23) Daniele created a deep perspectival space in which a series of statuesque groups enact the extremely violent subject: robust women struggle with powerful gladiator-like soldiers; and the opening in an illusionistic balustrade creates the impression that such violence might spill over into the beholder's own space.

Pellegrino Tibaldi

Another artist who strongly identified with Michelangelo was the painter/architect Pellegrino Tibaldi (1527–1596). After assisting his teacher Perino del Vaga with the decoration of the Castel Sant'Angelo, Tibaldi executed a

number of works in Bologna for the prelate Giovanni Poggi, who had been elevated to the rank of cardinal in 1551. Among these commissions was a narrative cycle on the story of the Greek hero Ulysses in two rooms of Poggi's palace (fig. 17.24). Poggi probably expected a work that would have the multilayered visual excitement of the Sala Paolina (*see* fig. 16.8), and Tibaldi certainly complied. The larger room, known as the Sala, has elaborate framing elements in the form of stucco herms and garlands and painted grotesques. The four gesticulating nudes in the corners are variants of the Sistine *ignudi*, although their depiction *di sotto in sù*, presenting their legs and lower bodies to the viewer, undercuts the heroic character of the originals. Tibaldi, moreover, has exaggerated their athletic poses so that they assume an almost frenzied air, echoing the furiously energetic actions of the giants and gods in the narrative scenes: the Cyclops Polyphemus, being blinded by Ulysses at the center and, in the

17.24
Pellegrino Tibaldi, vault frescoes in the Sala di Ulisse, 1554–55. Palazzo Poggi, Bologna

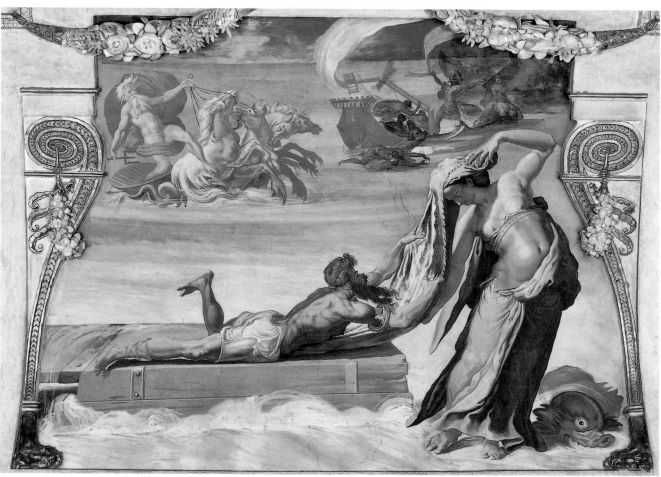

adjacent scene, vainly trying to prevent the escape of the Greeks; the suitably stormy wind god Aeolus; and the sea god Neptune, whose enmity toward Ulysses keeps the hero wandering at sea for ten years. Like Daniele, Tibaldi approaches Michelangelo with an unexpected degree of humor: in one scene from the stanza, a Greek warrior (modeled on a damned soul from the Sistine *Last Judgment*) shushes the viewer while others set about stealing some traumatized-looking cattle (fig. 17.25). In another, the shipwrecked hero kicks his legs helplessly while the nymph Ino hauls him to shore with her veil (fig. 17.26).

If Daniele satirized the critics he expected to fault him for continuing to paint in the manner of Michelangelo and Sebastiano del Piombo, Tibaldi constructs a more highbrow and allusive parody. To begin, he makes fun of the heroic epics of antiquity, by showing how little the deeds of Ulysses correspond with the ideals of exemplary conduct that ancient and modern critics often claimed for them. Pellegrino probably also sought to remind viewers of the much-loved poem *Orlando Furioso*, composed in 1518 by the Ferrarese courtier Ludovico Ariosto (1474–1533), and revised and republished several times. The *Orlando* was itself an epic, in the genre of the ancients Homer and Virgil, but it often portrayed its heroic characters in ironic terms. Moreover, Ariosto drew heavily in his subject matter on non-classical material, namely the Italian, French, and Spanish romances of chivalry. Using the precepts of Aristotle's *Poetics*, critics had faulted Ariosto for the moral ambiguity of his heroes, and the constant interruption of episodes that drifted from the main plot, several of which had to do with sorcery, monsters, and other marvels. Tibaldi's choice of magical and marvelous episodes from Homer's *Odyssey*, and his pointed neglect of the main plot (Ulysses' homecoming to Ithaca), shows that he aligned his artifice with Ariosto's. Ariosto came from a city close to Poggi's home town of Bologna, and the painter may have been especially interested in the poet as the literary manifestation of a regional identity that he himself embraced as a painter. Tibaldi's contemporaries aligned him with the *grazia* and exquisite coloring of Correggio and the "Lombard" tradition. As with Ariosto, so too with Michelangelo: Tibaldi seems to flaunt those very aspects of Michelangelo's art that had become controversial, and would become even more so.

Out of Italy

A considerable number of the works we have discussed in this and the preceding chapter were for patrons and destinations in other European centers. Cosimo had sent both Bronzino's original altarpiece for the Chapel of Eleonora (*see* fig. 16.37) and his *Allegory* (*see* fig. 16.13) to France; this, like the flow of paintings to Augsburg or Madrid from Titian's workshop, is symptomatic of a wider demand for Italian art and luxury products throughout Europe, especially at the courts. Italian artists themselves circulated as highly valued cultural property: we have already seen that the French court became a destination for Leonardo da Vinci, Andrea del Sarto, Rosso Fiorentino, and Benvenuto Cellini, and this trend would continue, becoming increasingly pronounced in Hapsburg territories; Tibaldi would join the Spanish court in Madrid in 1586.

Sofonisba Anguissola

One of the most celebrated emigrants to the Spanish court was Sofonisba Anguissola (*c.* 1532–1625), who joined the household of Queen Isabella of Valois in 1559 and remained for twelve years. Anguissola's access to the inner circles of Europe's most powerful court was facilitated by the fact that she was herself the daughter of a Cremonese aristocrat who had encouraged his son and six daughters to pursue their abilities as painters, classical scholars, and musicians. Social advantage combined with genuine talent undoubtedly helped the young Sofonisba to capture the attention of Italian elites (and the friendship of Michelangelo) in ways that other woman artists could not. Tintoretto, for instance, taught his daughter Marietta Robusti to paint, but it is not possible to identify a single work from her hand.

Among Sofonisba's earliest secure pictures is a signed and dated self-portrait now in the Kunsthistorisches Museum, Vienna (fig. 17.27). Painted on a panel of nearly 7 x 5 inches, the picture shows the sitter looking out at the viewer and displaying a book, which bears the words "Sophonisba Angussola virgo" ("The maiden/virgin Sophonisba Anguissola") and the assertion "Se ipsam fecit 1554" ("She made this herself in 1554" or "She made herself in 1554"). No man painting a self-portrait would ever have thought to mention his marital status in the inscription, and Sofonisba may have done so to alert viewers to her independence, though describing herself as a "virgo" also declared her chastity and thus her virtue. The picture celebrates both her physical beauty and the ability of her hand to capture this image. Small and portable, the picture seems designed as something the owner could take from place to place and reveal as a marvel, as much a rarity and curiosity as an unusual shell or fossil, and exactly the kind of thing that women in this period were not expected to create.

A second self-portrait, probably from about a year later, shows the artist at the easel, completing a picture of the Virgin and Child (fig. 17.28). In fact, no independent

OPPOSITE, ABOVE
17.25
Pellegrino Tibaldi, *Ulysses and his Men Steal the Cattle of Helios*, 1554–55. Stanza di Ulisse, Palazzo Poggi, Bologna

OPPOSITE, BELOW
17.26
Tibaldi, *Ulysses and Ino*, 1554–55. Stanza di Ulisse, Palazzo Poggi, Bologna

images of the Madonna from these years by Sofonisba are known, which suggests that the painting was not meant to characterize her art so much as to say something about her as an artist. Perhaps there is a pun here on the idea of the "virgo," the self-characterization she simply declared in the earlier work. If Michelangelo could claim something like "divine" status, and if he and others regarded the production of Christ's image as an act of particular devotion, Sofonisba had advantages. Her brush in this picture touches Christ's arm, suggesting that he is the one she is now painting, though of course the Christ *in the* depicted picture was generated by a different "virgo," his mother Mary. Could Sofonisba be comparing the miraculous birth with her own art?

A later self-portrait, now in Siena, shows Sofonisba on the easel rather than in front of it, in the form of a panel being painted by the man who was in fact her teacher, Bernardino Campi (fig. 17.29). The juxtaposition of the hand that paints the picture with the hand the picture shows underscores the joke, forcing the viewer to reflect on just whose "hand" is at issue here. The image of Sofonisba is physically larger than that of Campi; her head is also higher than his, and she occupies the center

of the picture, pushing him to the margin. This leaves no doubt about who the painting's true subject is, though it is unlikely that the arrangement was meant exactly to diminish Campi. Indeed, Sofonisba could well have been happy to be regarded as Campi's "creation"; just as Daniele da Volterra advertised his descent from Michelangelo and Sebastiano del Piombo, Sofonisba cleverly shows that she has learned how to make a Campi painting, which is to say that she has become the perfect product of his shop, part of his genealogy, and a master of his style. Campi was among the leading painters of the region, and in an age when the capacity to imitate was regarded as a virtue, such a demonstration as this would have impressed anyone.

Each of these individual pictures is engaging, but they are also remarkable as a group. No other Italian artist had devoted such attention to self-portraiture: Sofonisba made more self-portraits before the age of twenty-five than most Renaissance painters did in their entire lives. In part, this was a result of limited choices. Ambitious art in mid century Italy was still predominantly an art of the body, and training in *disegno* required study from the nude, whether from posed models or ancient statues. As

a woman, Sofonisba would not have been permitted to undertake such exercises; this closed off one path to her. Such an explanation of subject, however, only goes so far, for making self-portraits like this also had the advantage of taking her outside the patronage system and giving her some control over what she did. Although the works adhere to a basic template – face and body made before a mirror (or, after a point, reproduced from memory), then supplemented with a set of unexpected attributes – the results show the variety that was a hallmark of the virtuoso. In reflecting on Sofonisba's limited repertory, we should recall that Michelangelo, too, eschewed the "universality" of earlier generations in favor of a narrow range of subjects, and that male painters were also beginning to specialize, working in a single genre rather than seeking to master them all.

Sofonisba's painting also professed her attachment to an artistic tradition that had little investment in debates about *disegno* and *colore*. Although she certainly made drawings in the preparation of portraits, the self-portrait with Campi makes the claim that these artists painted directly from life, with no intermediate "design" stage. Her *Chess Players* (fig. 17.30), for example, a work much admired by Vasari, shows a lively and informal grouping of three of her gifted sisters with their chaperone. The gentle modeling of the faces, the fresh and clear color, and the atmospheric background are characteristic of an increasingly self-conscious Lombard tradition developing in the

17.29
Sofonisba Anguissola, *Bernardino Campi Painting Sofonisba Anguissola*, late 1550s. Oil on canvas, 43¼ x 43⅜" (111 x 110 cm). Pinacoteca Nazionale, Siena

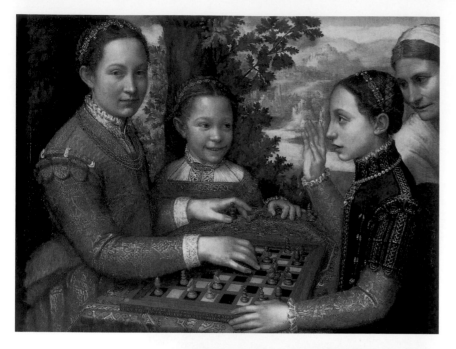

ABOVE

17.30

Sofonisba Anguissola,
Chess Players, 1555. Oil on
canvas, 27⁵/₈ x 37" (70 x 94
cm). Museum Narodowe,
Poznan, Poland

RIGHT

17.31

Sofonisba Anguissola,
*Massimiliano Stampa
(Third Marchese of
Soncino),* 1557. Oil on
canvas, 53⁷/₈ x 28¹/₈" (136.8
x 71.5 cm). Walters Art
Gallery, Baltimore

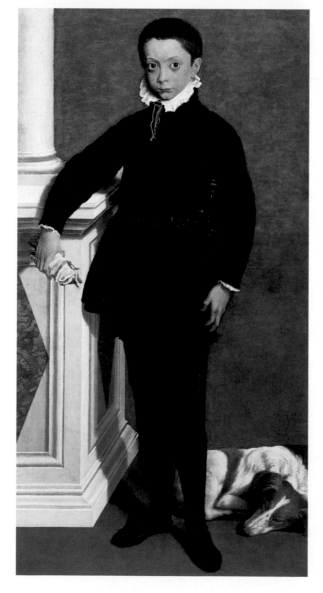

wake of Correggio, Pordenone, and Lorenzo Lotto (compare, for example, fig. 14.21 and fig. 15.10). Lotto, despite being born in Venice, worked a great deal in cities of the western Veneto and adopted the characteristic brilliant color and textural softness that would distinguish the Lombards; Dolce's *Aretino* (*see* p. 496) was openly contemptuous of Lotto and his use of brilliant and unusual hues in his Carmine altarpiece (*see* fig. 14.21). Pellegrino Tibaldi, for all his Roman training, was also associated with "Lombard" color. Lombard painters demonstrated a particular attention to naturalistic description: *Chess Players* shows a self-consciousness about Lombard proficiency not just in portraiture but also in landscape, and it adapts the portrait mode in which Sofonisba regularly worked to the emerging category of "genre painting," subjects from everyday life.

Anguissola's portrait of the Marquess Massimiliano Stampa from 1557 (fig. 17.31) is more indicative of the kind of work that helped establish her as a court portraitist. A Florentine like Bronzino would have shown the subject totally immersed in the act of posing for his social role: Anguissola, however, has caught the tension between the vulnerability of a nine-year-old and the adult formality of the pose and setting (the child had just inherited his title from his recently deceased father). Like Bronzino, she follows the practice of showing a figure clad in black against a field of brilliant color; the fall of shadow against the white marble, which gives the frail figure a dimension of volume and corporeality, is a characteristic touch of her own, while the sleeping dog seems less a princely attribute than an acknowledgment of the world of childhood concerns.

The Leoni

Among the Italian sculptors who came to work for the Spanish court in the same years, the most distinguished were, like Sofonisba, specialists in portraiture: the Aretine Leone Leoni (1509–1590) and his son Pompeo (1533–1608). Leone had been a successful goldsmith in Rome until a bloody street fight landed him in the dock. He narrowly escaped having his hands amputated in punishment and ended up instead being sentenced to a term as a galley slave. Andrea Doria (*see* figs. 15.20–15.21) intervened to have him freed, and the 1541 medal Leone produced in gratitude is a characteristic early work (figs. 17.32 and 17.33): it shows a portrait of Doria on one side and a self-portrait of Leone on the other, surrounded by a chain that both recalls his period of bondage and attests devotion to his liberator.

In 1542, through Doria's offices, Leone Leoni came under the protectorship of Ferrante Gonzaga, imperial governor of Milan, where he served a period as die-

17.32 and 17.33
Leone Leoni, *Medal of
Andrea Doria*, obverse
(right) and reverse
(below), 1541. Cast bronze, diameter
1⅝" (4.2 cm). British
Museum, London

17.34
Leone Leoni, *Charles V and
Furor*, 1550–55. Bronze,
height 5'8¾" (1.73 m).
Museo del Prado, Madrid

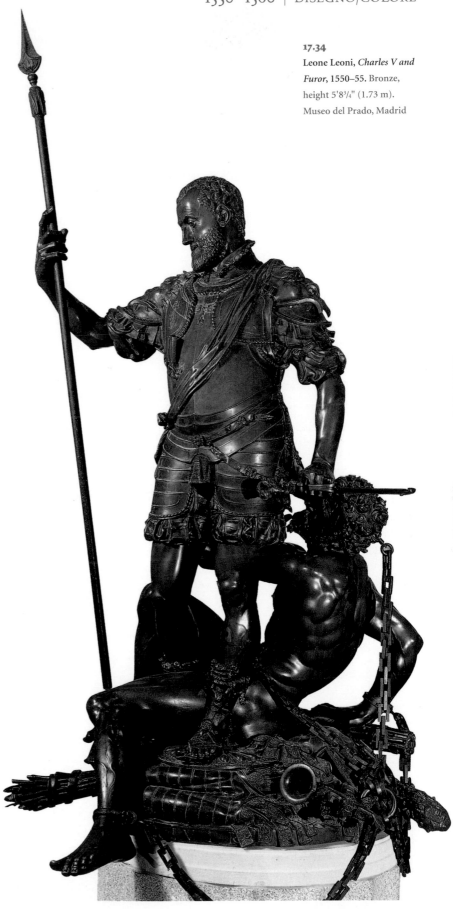

master for the city's mint. Following the example of
Cellini in Florence, however, Leone and Pompeo began
to devote themselves to objects on a more monumen-
tal scale, most of them likenesses of the imperial family.
Among the most remarkable is a work from the early
1550s showing Charles V and Furor (fig. 17.34). The idea
for the sculpture derived from the verso of a Cellini
medal Leone knew from Rome, showing a Virgilian alle-
gory in which the wrath or chaos associated with war
sits bound on a pile of arms, which a figure of Peace pre-
pares to incinerate. Leone was particularly proud of his
own composition's base, which showed a shield, a hel-
met, a trumpet, and various weapons crushed together
with the torch that would destroy them. Atop this sits
Furor, chained and twisted into a tortuous pose with a
vein bursting and disconcertingly physical beads of sweat
falling across his forehead. Standing over this personifi-
cation, however, is not the Peace we might have expected
but rather the emperor himself, Charles V. The armor
he wears is removable, giving the patron the option of
displaying the image of himself as he might appear on
the battlefield or as an implausibly beautiful nude (fig.
17.35). The idea of allowing the emperor to "dispose" of
his armor suited the principal conceit of the work: that
a ruler who promoted peace had no need of battlegear.
It also made Charles, like the Doria of Bronzino's earlier
portrait (*see* fig. 15.21), look more divine than mortal.

Our earlier comparison of Michelangelo and Titian
suggested an association of sculpture with *disegno*, and
though the overly minute detail of even the largest Leoni
statues shows that he never quite abandoned the decora-
tive sensibilities of goldsmithery, his late work asserted

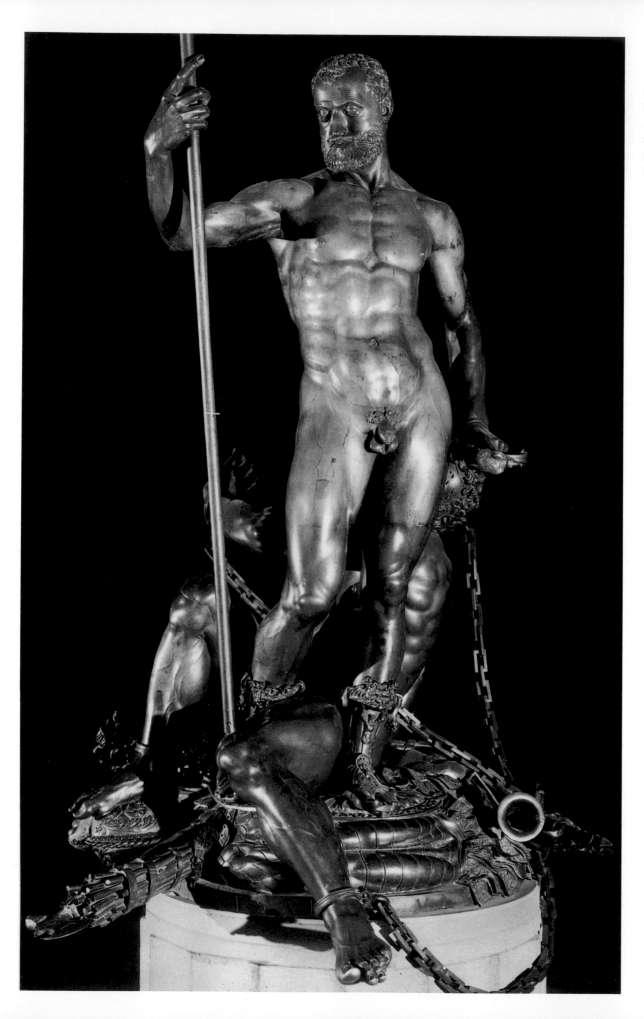

17·35
Leone Leoni, *Charles V and Furor,* 1550–55, with armor removed. Bronze, height 5'8¹/₂" (1.73 m). Museo del Prado, Madrid

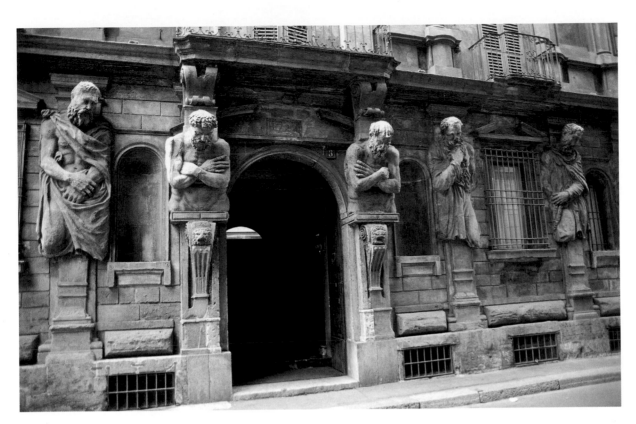

17.36
Leone Leoni, Casa degli
Omenoni, 1565–67. Milan

his possession of an abstract "design" that let him shift scale and material. While living in Milan, Leone even designed his own house (fig. 17.36), with bound prisoners on the facade and a copy of the *Marcus Aurelius* in the courtyard in direct emulation of Michelangelo's Julius tomb (*see* fig. 13.38) and Campidoglio project (*see* figs. 16.26–16.27).

Still, numerous works by Leoni – an artist based in the north and employed by Titian's patrons – caution against an easy identification of sculpture with *disegno*. The *Charles V and Furor*, for example, is not colorless: much of it is the color of the very things it depicts. Leoni's representation of bronze weapons in bronze, in fact, amplifies the work's central idea, for if Peace melts weapons, so does the patron of metal sculptures: Charles has had Leoni take materials that could have been used to produce real armor and weapons and turn them instead into art.

At least on one occasion, moreover, Pompeo Leoni did something Michelangelo would never have considered, creating a fully polychromed silver portrait head of Charles's son Philip II (fig. 17.37). By the late seventeenth century, this had been fitted into the top of an actual suit of armor, and that may have been its purpose from the beginning. The effect of encountering such a thing in the palace of the Spanish court would have been to make it seem as though the king had stepped out of a portrait by Titian and into the room.

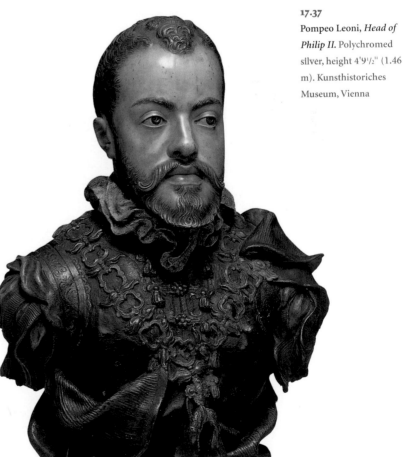

17.37
Pompeo Leoni, *Head of
Philip II.* Polychromed
sllver, height 4'9¹/₂" (1.46
m). Kunsthistoriches
Museum, Vienna

17.38

17.38

Giorgio Ghisi, *Adoration of the Shepherds*, after Bronzino, 1553. Engraving printed from two plates, 25¾ x 17⅜" (65.2 x 44.2 cm). Yale University Art Gallery

Giorgio Ghisi and Cornelis Cort

Not all artistic migrants from Italy went to the European courts. The Mantuan engraver Giorgio Ghisi (*c.* 1520–1582) had drawn attention in the previous decade with an ambitious print, on ten separate plates, after Michelangelo's *Last Judgment*. By transferring to the Antwerp-based publishing house of Hieronymus Cock in 1550, Ghisi could target his engravings after famous Italian masters more directly at markets outside of Italy. For Cock he produced five prints, including a *School of Athens* and *Disputà* after Raphael, along with a less well-known *Adoration of the Shepherds* after a Bronzino painting made for private devotion. Each of these large printed images stretched across two plates; in the case of the Bronzino, the print is identical in size with the original picture.

Ghisi's translation of *The School of Athens* (*see* fig. 12.50) into black and white required a process of editing and adaptation (fig. 17.39). So as not to detract from the individual characterizations of the figures, he simplified elements of the architectural setting, omitting the coffering of the vault and the squaring of the floor. And clearly either Ghisi or his publisher was concerned about how the Raphael composition, with its range of unlabelled characters and extracted from its original context, would be understood. A large tablet to the left supplies an entirely new iconographic interpretation, one far removed from anything that Raphael had in mind: "Paul in Athens, brought by the Epicurean and Stoic philosophers to the Areopagus, standing in the middle of the hill. Taking the opportunity from an altar he had seen, he teaches of the one great, true God, unknown to them. He censures idolatry and exhorts them to repentance. He also teaches of both the day of Last Judgment and the resurrection of the dead through the reborn Christ. Acts XVII." Raphael's Plato has now been re-cast as St. Paul, and the earlier depiction of ancient philosophy

17.39

Giorgio Ghisi, *The School of Athens*, after Raphael. Engraving, 20¾ x 32¼" (52.6 x 82.4 cm). Museum of Fine Arts, Boston

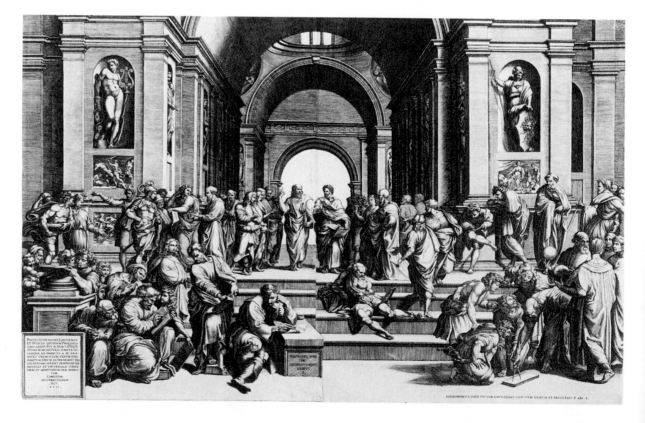

has become a confrontation between the Christian and pagan worlds. Such a re-baptism of the fresco reflects the confessional upheavals of post-Reformation Europe, but it would also have enhanced the marketability of the print to evangelical Protestants as well as to Catholics.

Ghisi excelled in the handling of light and dark, modulating his line to render subtle transitions of shadow in his version (fig. 17.38) of Bronzino's *Adoration*. A problem he had to confront was the relative sparseness of the upper part of Bronzino's composition, where an airborne circle of angels hovers in front of a heavenly efflorescence. Lacking the resources of color, which had enabled Bronzino to take an effectively restrained approach, Ghisi decided to garnish the design with additional clouds and with angels bearing inscriptions in praise of the Virgin; pointed, hard-edged rays of light replace Bronzino's heavenly glow. In addition, Ghisi enriched the background landscape with more abundant trees and a panorama of distant cities, integrating Tuscan *disegno* with the most admired qualities of Netherlandish painting.

These prints might give the impression that where a painter relied simply on color, the engraver had to make a "reproduction" that actually involved changes to the design. Cock clearly understood the *disegno/colore* debate, however, and a generation later, he and the engravers in his employ would seek out paintings distinguished by their virtuoso handling of pigments. It was from Cock's printing house that the engraver Cornelis Cort (*c.* 1533–1578) set out in the following decade for Italy, where he formed an association with Titian that resulted in the publication of several remarkable engravings. By varying the pressure of the burin as it cut into the plate, Cort produced an image with constantly swelling and tapering forms that seemed to achieve what was scarcely thought possible: the Netherlandish artist Domenicus Lampsonius wrote to Titian that Cort, with the virtuosic grace and fluidity of his line, had not only succeeded in rendering the painter's *disegno* and *invenzione*, but also captured the effects of *colorito*. Titian's *Annunciation* for the church of San Salvador in Venice (1560–62) was the painter's most assertive demonstration of the values of *colorito*, where forms appear constructed from a riot of painted strokes (fig. 17.40). Inevitably, Cort's translation into black line tends to make forms firmer and more resolved, but the engraver worked against the limits of the medium to achieve a tonal variety of rich blacks, silvery grays, and gleaming whites that is truly painterly in its range (fig. 17.41). From this point forward, the resources of print-making were no longer to be reserved for the artists who professed the supremacy of *disegno*.

ABOVE LEFT

17.40

Titian, *The Annunciation*, *c.* 1560–62. Oil on canvas, 13'2" x 7'7". (4.03 x 2.35 m). San Salvador, Venice

ABOVE RIGHT

17.41

Cornelis Cort, after Titian, *Annunciation*, published *c.* 1566 by Antoine Lafréry. Engraving, 16¼ x 10¾" (41.5 x 27.6 cm). Fitzwilliam Museum, University of Cambridge

1560–1570
18
Decorum, Order, and Reform

18

1560–1570
Decorum, Order, and Reform

Alessandro Moretto and Giovanni Moroni: Reform Tendencies on the Eve of Trent

Around 1560 Giovanni Battista Moroni (*c.* 1520–1578), an artist mainly active in the Lombard towns of Bergamo and Brescia, produced a portrait of a man in prayer before the Virgin Mary (fig. 18.1). We have seen earlier instances of religious painting that included the patron's image alongside the Virgin and the saints. All have been paintings for churches, votive images and altarpieces that provided a public commemoration of the patrons' devotion, and reminded viewers to pray for them after death (*see* figs. 4.16 and 6.10). Moroni's painting is something different. He probably made it for a private setting, where it would have served not just as a devotional image but also as a family portrait. The unusual prominence of the patron, moreover, and the disparity in scale between

the man and the Virgin, suggests that there is something else at stake here: a demonstration and promotion of the kind of experience associated with prayer before religious images themselves. The very minimal architectural setting suggests that the man is physically close to the object of his devotion, while her scale relative to his implies that this is not the Virgin per se, nor even an apparition, but rather a *work of art* representing the Virgin – it is as though the man is looking at an under-lifesized polychrome sculpture. As they appear to take on animate living form in the course of the man's devotions, the Virgin and Child also address the viewer of the painting with their gaze, making that viewer part of the same devotional exchange.

Moroni's painting underscored the value of the image as a means of communication with the divine. He produced the work at a time when church paintings and sculptures were being destroyed throughout much of Protestant Europe. The artist would have been aware that the Catholic Church, in response to Protestant attacks, was not only defending the use of images but also prescribing new guidelines on how a proper Christian picture ought to look. Moroni had been employed by the Cardinal Bishop of Trent and was in that city on two occasions, 1548 and 1551, when a great Council convened by Paul III and devoted to the reform of the Catholic Church was in session. The artist would not have been surprised by the decrees from the Council approved in 1563 by Pope Pius IV (*r.* 1559–65). These resolved questions of orthodox Catholic belief in the face of Protestant opposition. They affirmed the observance of the cult of the Virgin, as well as of the saints and their relics. While many Protestants regarded the bread and wine consumed at communion as mere symbols of Christ, the Council made it mandatory for Catholics to believe that the Eucharist was the "real presence" of Jesus Christ, and that salvation was to be obtained not just (as most Protestants believed) from Christ's grace, but through individual works. The articles from the Council also covered the reform of clerical discipline, which bound priests and bishops to a more rigorous professional conduct and a more austere style of life, as well as to proper pastoral care of the laity. Bishops were also enjoined to be vigilant regarding the character of the images placed in churches: "No image shall be set

18.1

Giovanni Battista Moroni, *Man Praying before the Virgin, c.* 1560. Oil on canvas, 23¹/₂ x 25¹/₂" (60 x 65 cm). Samuel H. Kress Collection, National Gallery of Art, Washington, D.C.

up that suggests false doctrine or that may furnish the uneducated with an occasion for dangerous error."

The Council of Trent provided a centralized and coordinated system of regulation, establishing standards of belief and practice for a Church that was now global in its reach, with Catholic missions active in Mexico, Peru, India, China, and Japan. Institutional reform of the Catholic Church, however, did not begin with the Council of Trent; bishops had initiated changes at the local level decades earlier. Moroni's formation as an artist took place in such an atmosphere of local reform. He had been trained by the Brescian artist Alessandro Moretto (1490/98–1554), who since the 1520s had aimed for clarity and directness in the representation of Christian doctrine. Brescia in Lombardy was one of a number of provincial cities where new religious orders devoted to charity and preaching began to establish communities in the 1520s and 1530s, and where there was a corresponding rise of lay confraternal organizations. The confraternities for which Moretto and his colleagues supplied altarpieces actively promoted devotion to the Eucharist and the practice of charitable works. One of Moretto's last paintings was his *Christ with an Angel* for the altar of the Confraternity of the Holy Cross in the cathedral of Brescia (fig. 18.2). As with Moroni's picture, Moretto's image of the suffering Christ has a visionary quality, intensifying elements of the everyday world and combining these with startling manifestations of the otherworldly. Christ, slumped on a staircase, stares accusingly at the beholder. His body is represented with a level of naturalistic description unmatched by any painter in Venice or Rome at that moment. Yet its livid, silvery hue forms a strange, unearthly harmony with the bluish robe held by the weeping angel and with the rose-colored stairs. It is a beautiful effect, but the element of implied violence and suffering makes the painting deeply unsettling. The picture asks the viewer to unravel the meaning of the vision, which relates to any number of the widely read printed devotional texts about personal prayer and meditation on Christ's Passion. The reddish stairway might be the way to heaven opened up through the shedding of Christ's blood; the robe exhorts the beholder to seek spiritual union with Christ by following the instruction in Paul's Letter to the Romans 13:14: "Clothe yourselves with the Lord Jesus Christ." The painting emphasizes the concreteness and accessibility of the divine, the possibility of personal union with Christ through penance, faith, and imitation.

Moroni, in his image of *c.* 1560, thus responds not just to the new demand for orthodoxy in religious painting, but also to an established Lombard tradition that prioritized the availability of the divine to the human beholder and a quiet, decorously restrained emotional character. It

18.2

Alessandro Moretto, *Christ with an Angel, c.* 1560. Oil on canvas, 7'1¼" x 4'1¼" (2.14 x 1.25 m). Pinacoteca Tosio Martinengo, Brescia

is this quality, the legacy of an earlier reformist spirit in art, that would disappear as various writers on art after Trent began to elaborate upon the Council's spare prescriptions regulating the image. The sense of unmediated communication between the sacred and the individual would give way to an imagery that tended instead to stress the mediation of priests and submission to the authority of the Church. As the clergy became more preoccupied with conformity, it viewed the reformist spirit that inspired Moretto and Moroni – the same spirit that guided Vittoria Colonna and Michelangelo – as suspect, tainted even with Protestant ideas.

Michelangelo's *Last Judgment,* Twenty Years Later

Whatever he knew about the articles emerging from the Council of Trent, Moroni would certainly have been aware of the ongoing controversy around Michelangelo's

18.3
Martino Rota after
Michelangelo, *Last
Judgment*, 1569. Engraving,
12³/₄ x 9¹/₄"(32.2 x 23.4
cm). Fitzwilliam Museum,
University of Cambridge

OPPOSITE
18.4
Martino Rota, *Last
Judgment*, 1576. Engraving,
12³/₄ x 9¹/₈" (32.2 x 23.2
cm). Fitzwilliam Museum,
University of Cambridge

Sistine *Last Judgment*. From the time of its completion in 1541, Michelangelo's followers had had to defend the fresco from a mounting chorus of disapproval, even calls for its destruction. Most attacks targeted the nudity of the figures and the lack of appropriate dignity in the poses; others criticized the artist's "errors" in scriptural interpretation. The Council itself debated an appropriate response, finally ruling that the "offending parts" should be painted over. Daniele da Volterra (*c.* 1509–1566) was given the task of adding loincloths to many of the figures shortly after Michelangelo died in 1564. By this time, the example set by the *Last Judgment* had become a pressing issue for clerics and art theorists throughout Italy, who, in the wake of the Tridentine ruling, sought to set down rules on the nature and purpose of Christian art. Artists found themselves in a position of needing to demonstrate their adherence to

these while at the same time showing their understanding of the mastery that the *Last Judgment* seemed to exemplify. One way they did this was to produce alternative versions of the painting. Moroni would paint a piously corrected version of Michelangelo's design for a rural church near Bergamo in 1577. Previously, in 1569, Martino Rota (*c.* 1520–1583) had produced an engraving that tightened and clarified the composition of Michelangelo's fresco (fig. 18.3), and some years later he made an alternative *Last Judgment* that went even further, making the various saints and Old Testament figures recognizable and assigning them an appropriate place in a heavenly hierarchy unmistakably dominated by Christ (fig. 18.4). In 1570, the young Cretan painter who would be known as El Greco (1541–1614) arrived in Rome from Venice and offered to paint an entirely new version of the *Last Judgment* for the Sistine Chapel.

The year of Michelangelo's death, 1564, saw the publication of the lengthiest and most intellectually distinguished of the attacks on the *Last Judgment*, a text "On the Errors of Painters Concerning History" by the priest and literary theorist Giovanni Andrea Gilio. Composed in dialogue form, the work employed a strict theory of pictorial genre and decorum to criticize a number of contemporary works of painting in Rome. Gilio was far from opposed to the idea of art as a cultivated liberal pursuit, or art that demonstrated license and virtuosity, provided those qualities manifested themselves in the appropriate places. He described one category of "poetic" painting, characterized by landscape, fables, and grotesque ornament, and represented in the dialogue by Raphael's Chigi frescoes (*see* fig. 13.1), which he found especially suitable for villas, the purpose of which was to provide recreation and enjoyment. A second category, a "mixed" mode that would comprise such works as Perino's Sala Paolina (*see* fig. 16.8), could also appear in secular contexts: this was a kind of mythologized history that, following the practice of epic poets and dramatists, combined past events with allegories and other poetic fictions, along with fantastic architecture and ornamental garlands. Strictly "historical" painting, however, which for Gilio meant primarily the representation of sacred scripture, was a far more serious matter. This kind of painting was not mere ornament or diversion but an instrument for making truth visible. It had to be clear, easily understood by both the learned and the unlearned, and could not deviate in any particular from authoritative texts or established pictorial conventions. Michelangelo, according to Gilio's speaker, erred greatly by incorporating figures such as Minos and Charon, inventions that came from the poets Dante and Virgil rather than from scriptural sources. The painter emphasized the display of his art over scriptural truth, leading him to unacceptable innovations, such as showing

OPVS A MARTINO ROTA INVENTVM FEREQ. EXCVLPTVM. ANSELMVS BOETIVS DE BOODT
RVDOLPHI II. ROMAN. IMP. MEDICVS SIBI ET AMICIS PERFICI CVRAVIT. Cum Pri. Sac. Cæs. Mai. Sadler 1-9

Christ beardless and angels without wings. Particularly scandalous was the nudity of all the figures, which evoked the depraved sensuality of pagan art. The gesticulations, kisses, and ambiguous couplings of Michelangelo's naked saints, finally, was undignified, even unintentionally comical. The speakers of the dialogue judged the variety of poses, long seen by more sympathetic viewers as proof of Michelangelo's copious powers of invention, as if they were real acts performed by contemporary beings: their deportment might be suitable for laborers in the marketplace or for performers at a fairground, but not for the protagonists of sacred history and not for such a dignified setting.

Gilio's dialogue was the first substantial text on the arts to spell out what the decrees from the Council of Trent might mean in practice. Its power lay in the theorist's ability to boil down the essential conflicts that the reform of art might raise. In the introduction to the dialogue, for example, the author asserted that "modern painters today, when they have to make some work, have as their first intent to twist the head, the arms, or the legs of their figures." Such artists, he worried, "think little about the subject of their story, if they consider it at all." The charge may sound extreme, but real contemporary practices reveal that it was not entirely unfounded. The very year in which Gilio was writing, the sculptor

18.5
Alessandro Vittoria, altar in the Montefeltre Chapel, 1564. Marble. San Francesco della Vigna, Venice

Alessandro Vittoria was putting the finishing touches to a marble *St. Sebastian* for an altar in the church of San Francesco della Vigna in Venice (fig. 18.5). Paolo Veronese's later portrait of the artist shows him holding a wax or clay model for the figure – revealing that he did indeed compose it by bending the head, arms, and legs into the composition he wanted (fig. 18.6). After making a bronze cast from this model (fig. 18.7), moreover, Vittoria wrote that it need not be taken as a Sebastian; it would work equally well as a Marsyas. Viewers could determine an appropriate "story," that is, sometime after the artist settled his invention. The remark implicitly draws attention to the fact that Vittoria's original marble figure omitted the arrows that conventionally identified the saint, just as the would-be bronze Marsyas omitted Apollo, the god who tied Marsyas to a tree in order to flay him after defeating him in a music contest. Vitto-

ria's sensibility, as Gilio would have recognized, depended heavily on the example of Michelangelo, who was apt, as we have seen, to omit identifying information about the characters in his paintings and sculptures, instead focusing attention especially on the represented bodies and their poses.

The Jesuits and the Reform of Church Architecture

Gilio dedicated his dialogue to Cardinal Alessandro Farnese (1520–1589; *see* p. 487), the most lavish patron of the age, and the nephew of Paul III, who had commissioned Michelangelo's *Last Judgment*. In fact, most of the works Gilio discussed in the dialogue had Farnese patrons or decorated Farnese properties. Gilio judged the moment

ABOVE LEFT

18.6

Paolo Veronese, *Alessandro Vittoria*, c. 1570. Oil on canvas, 43½ x 32¼" (110.5 x 81.9 cm). Gwyn Andrews Fund, Metropolitan Museum of Art, New York

ABOVE RIGHT

18.7

Alessandro Vittoria, *Marsyas / St. Sebastian*, 1566. Bronze, height 21⅝" (54.9 cm). Metropolitan Museum of Art, New York

wisely, since Alessandro's patronage in the 1560s shows him turning away from the secular interests evident in his earlier commissions from Titian and concerning himself increasingly with the responsibilities of a prince of the Church.

A chief example of the cardinal's reformist inclination was his support for the Compagnia di Gesù, or Jesuits, an order of preachers and missionaries devoted to guiding the spiritual life of the laity. Founded in 1534 by the Spanish ex-soldier Ignatius of Loyola (1491–1556), the order had been confirmed by Paul III in 1540; it organized itself on a military model, with a "general" reporting directly to the Pope and a central command in Rome. This eventually allowed it to operate a network active throughout Europe, Asia, and the Americas; it also affected the building of new Jesuit churches in any location, for all were supervised from Rome by a single Jesuit architect-in-chief, Giovanni Tristano.

The rapid growth of the order required the construction of new accommodations and a new mother church in Rome. The church, dedicated to the name of Jesus and referred to simply as the Gesù, distinguished itself immediately from the other buildings on its scale, the old basilicas on the outskirts of Rome, by its location in the heart of the city. Ignatius had initially envisioned a simple box-like form, one in which Roman residents could gather to hear sermons by Jesuit preachers, but soon after Alessandro agreed to finance the building in 1561, it became clear that the cardinal intended to impose his own requirements on the design. He wanted a vaulted rather than a wooden ceiling, despite the Jesuits' concern that this would result in poor acoustics, and, notwithstanding the restrictions of its downtown site, an imposing facade that would open onto a piazza, as did the nearby Farnese palace. The Jesuits consequently discarded the design they had previously approved in favor of a proposal by Farnese's own favorite architect Jacopo da Vignola (1507–1573), who began collaborating with Tristano in 1563.

The enormous, aisle-less interior of Vignola's Gesù was designed to accommodate the vast urban crowds that were now being encouraged to attend the regular services (fig. 18.8). Vignola unified the space by constricting the transepts to the width of the chapels, eliminating the deep choir that had traditionally housed the clergy during communal celebrations of the Mass. At the same time, he maintained a clear hierarchical distinction between the domain of the laity in the nave and the self-

RIGHT

18.8

Plan of the Gesù, Rome, as executed under Jacopo da Vignola. Completed 1568

FAR RIGHT

18.9

Jacopo da Vignola, project for the facade of the Gesù.
Engraving

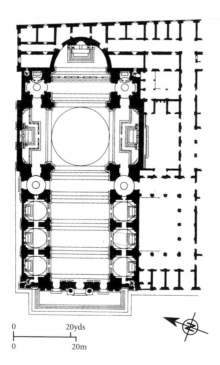

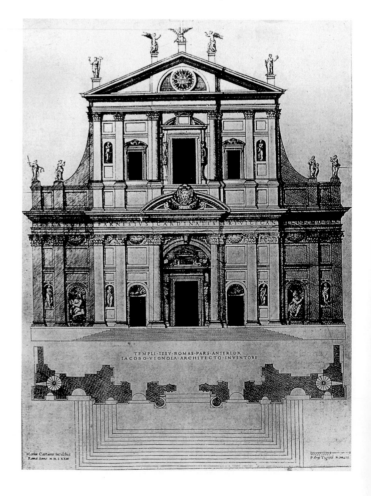

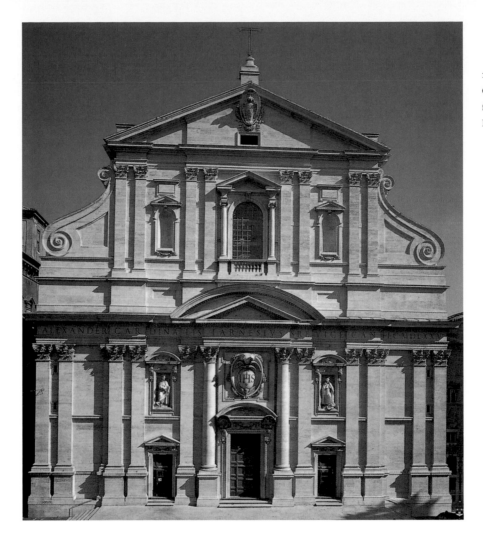

contained side chapels. A semi-dome and stage-like elevation distinguished the high altar, which was designed so that the elevation of the Eucharist would be visible from nearly every point in the church. The magnificent domed crossing provided a zone of transition between laity and the celebrant. Cardinal Farnese never fulfilled his intention to have the apse decorated with mosaics, which would have revived the sober grandeur of Rome's early Christian basilicas.

Vignola advertised his ideas for the facade in an engraving (fig. 18.9). Here, though, Farnese overruled him, instead approving a design by Giacomo della Porta, Michelangelo's successor as architect in chief at St. Peter's. Vignola had proposed a refined design with overlapping triumphal-arch motifs in the lower storey, rich ornamental relief, and abundant sculpture in the round. Porta's simpler and bolder (and more Michelangelo-like) composition layers the facade so that the central portions become increasingly three-dimensional (fig. 18.10). The main door with its segmental pediment and the monogram of the Society of Jesus is framed by a tabernacle with a triangular pediment, which is in turn compressed within a gigantic tabernacle crowned by a segmental pediment. The ingeniously organized inner tabernacle gives

particular prominence to the name of the patron FARNESIUS within the longer inscription.

The Gesù became the official model for Jesuit churches throughout the world, and it influenced the grandiose new churches that other Counter-Reformation orders built subsequently in central Rome – the Chiesa Nuova of the Oratorians, begun in 1575, the church of Sant'Andrea della Valle for the Theatines, begun in 1591. All of these churches would originally have had far more sober interiors than their present appearance suggests: the dazzling effects produced by *stucco*, gilding, and illusionistic ceiling decorations were added in the following century, by which time the Church had decided that it had paid its debt to reformist austerity and simplicity.

Princes of the Church and Their Villas

Villa Farnese

Cardinals' villas became pre-eminent spaces for formulating and testing principles of decorum. Their very purpose was to provide conditions of privileged leisure,

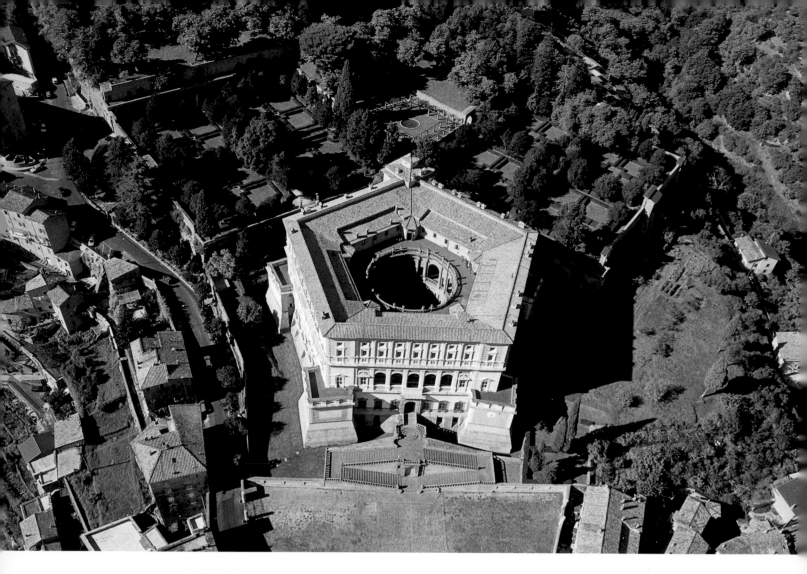

ABOVE
18.11
Jacopo da Vignola, Villa
Farnese, Caprarola, begun
1559

RIGHT
18.12
Jacopo da Vignola,
courtyard of Villa Farnese,
begun 1559

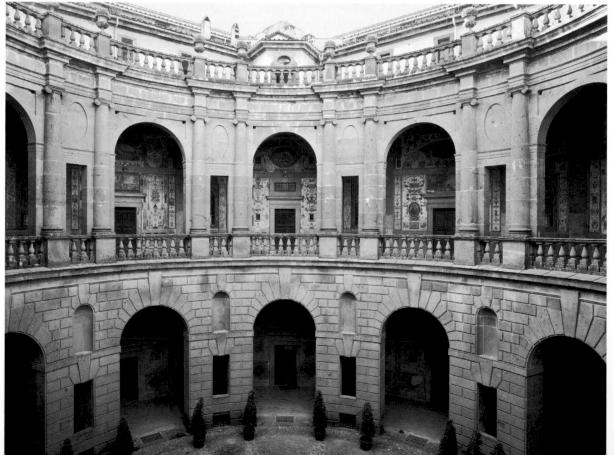

18.13
Taddeo Zuccaro, *The Council of Trent*, 1562–63. Fresco. Anticamera del Consiglio, Villa Farnese, Caprarola

and as Gilio's dialogue shows, this brought with it a more permissive attitude regarding the kind of art one could have there. But did this permissiveness have limits? Some of the elaborately programmatic decorations devised for the villas of catholic prelates during the 1560s suggest that it did. Alessandro Farnese's palatial retreat at Caprarola not far from Rome (fig. 18.11), designed by Vignola from 1555, suggests a royal citadel more than a country residence, and it provided the keystone for subsequent urban planning in the town. The massive, bastioned pentagonal structure owes its form to a fortress abandoned during the course of construction in the 1530s. Vignola's adaptation of this foundation shows how flexible and unfixed the design of villas could be, providing an opportu-

nity for experimentation with new architectural forms: he added grand flights of steps based on those in Bramante's Villa Belvedere in the Vatican (*see* fig. 12.45) and an open Ionic loggia modeled on one at the Villa Chigi. The circular courtyard (fig. 18.12), which superimposes a *piano nobile* with paired columns on a rusticated ground floor, is a princely elaboration upon Bramante's Palazzo Caprini.

The Villa Farnese was no longer expressing the virtues of a simple life on the land. The brothers Taddeo and Federico Zuccaro's painted decorations for the building regulated the various functions of the interior spaces, proclaiming a kind of exemplary order. The public rooms have frescoes depicting the history of the Farnese family

and the life of Paul III (fig. 18.13). In the private apartments, themes from ancient history and myth express the purpose each room served – allegories of dreams in the bedroom, the mythical invention of clothing, textiles and purple dye in the dressing room. In the study, or "Chamber of Solitude," ancient sages and Christian hermits surround a painting of Christ preaching. In an additional space for meditation, the "Chamber of Penitence," the chief subject is the *Elevation of the Cross*. The life of princely magnificence evoked here was increasingly questionable for a man of the Church, but at least it was an orderly one.

The Casino of Pius IV

Back in Rome, the much smaller papal retreat known as the Casino of Pius IV also represents the new preoccupation with orthodoxy, while continuing to emulate ancient Roman luxury and grandeur (fig. 18.14). Designed by Pirro Ligorio (*c.* 1510–1583) for a site near the Belvedere in the Vatican, the Casino is an imaginative reconstruction of a country villa owned and described by the Roman writer Pliny the Younger, the same source that Raphael had drawn on for the Villa Madama (*see* figs. 13.22–13.23). Raphael had composed his own design around the central courtyard's circular form, for he shared Bramante's sense of this shape's perfection. Pliny, however, had described an

oval courtyard, and Ligorio made this the principal feature of his own design. Following Pliny's idea of laying out the dwelling as a collection of distinct structures, Ligorio aligned the main residential building and a smaller building known as the *loggetta* on the short axis of the oval: an entrance portico opens at either end of the long axis (fig. 18.15). Directly at the center of the oval is a fountain; a second fountain, overlooking a fishpond, is the main feature of the *loggetta*'s garden facade, its three bays containing statues of seated divinities flanked by caryatids in the form of satyrs. The facade of the Casino proper had stucco reliefs of mythological subjects, including Apollo, the Muses, and Aesculapius, the god of medicine. The subjects celebrated the site as a place where the cultivation of the arts, in harmony with the forces of nature, nurtured mental and spiritual health.

Inside, by contrast, a different category of imagery gives the building an "inner" meaning. Here, painted subjects by the Zuccaro brothers, Santi di Tito, and Federico Barocci mainly draw from the Bible. The facade's mythic themes of time, nature, and the health of the body give way to the eternal truths of the soul, the redemption of human nature through the Incarnation, and the spiritual healing of baptism. The principle of prefiguration, one that we have otherwise seen guiding sacred spaces like the Sistine Chapel, takes on a new role here. Visitors may enjoy the pagan subjects, along with nature itself, once

RIGHT

18.14

Pirro Ligorio, Casino of Pius IV, Vatican, 1558–62. General view

FAR RIGHT

18.15

Pirro Ligorio, Casino of Pius IV, Vatican, 1558–62. Plan

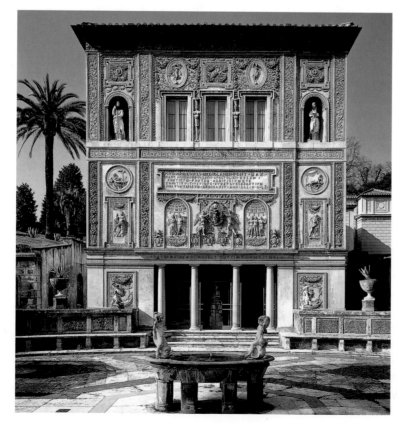

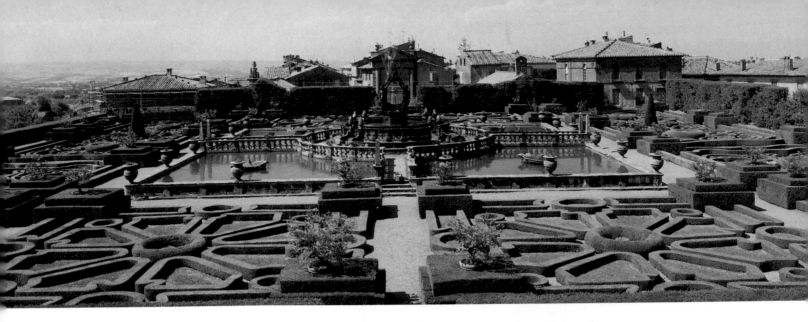

these take up their function and their assigned "place," on the outer surface surrounding a core of truth.

Villa Lante

For many sixteenth-century villas, the concern with order extended from the architecture and its decorations to the often extensive adjoining gardens. These were typically built over many years, drastically modified by subsequent owners, allowed to go to ruin in periods of hardship, and reconstructed, sometimes centuries later, as funds became available, so that it is often impossible to talk about the "original" form of a particular garden, or of a single program that guided the construction of its various parts. For example, among the most striking features today of the lower portion of Villa Lante at Bagnaia at Viterbo, north of Rome (fig. 18.16), are the stars into which boxwood hedges have been shaped, yet we know from various sources that boxwood was seldom used to make patterns of this sort in the sixteenth century. The coat of arms held up by the boys at the center of the fountain is that of Cardinal Alessandro Montalto, who took possession of the property in 1590. Yet an engraving of 1596 shows that Montalto's fountain originally lacked the nude boys, and other evidence reveals that the whole arrangement replaced an earlier configuration, probably in place by 1578, that centered not on a heraldic device but on a "guglia sudante," literally, a "sweating obelisk" (fig. 18.17). Similarly, the garden today includes a shady area with tall trees on the hill above the villa, though the sixteenth-century images suggest that the vegetation was originally much more contained.

The patron responsible for the general layout of the site and for most of the waterworks was Cardinal Gian-francesco Gambara, the Bishop of Viterbo, who began building in 1568, probably with Vignola as his chief architect. Located on a hillside just outside of Viterbo, the ancient city in the region of Latium that was the center

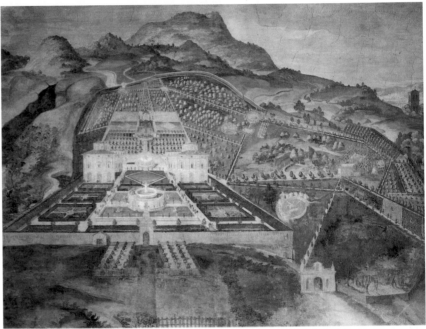

of Gambara's bishopric, the Villa Lante's gardens would have provided a place of summer respite, offering cooler temperatures and fresh air, and putting a cautious distance between the cardinal and the urban centers that were occasionally menaced by plague and malaria. The hillside arrangement, typical of Italian gardens in the period, made it possible to observe large parts of the site from a single point of view, whether that was from the palace itself or from the summit above. Most importantly, the hill allowed for complicated constructions involving running water, the motif around which every great Renaissance garden was built. To carry these out, Gambara brought in Tommaso Ghinucci, recruiting the engineer from Ippolito d'Este's villa at Tivoli near Rome, where he had designed a series of spectacular fountains (fig. 18.18).

The origin of water from inside the earth and its movement through the greenery, like the plants' own

TOP

18.16

Villa Lante, Bagnaia. The photograph shows the way the lower garden looks today: compare fig. 18.17.

ABOVE

18.17

Raffaellino da Reggio, fresco in the loggia of the Villa Lante at Bagnaia. The painting dates to the mid 1570s, and presumably shows the villa's gardens as they appeared at that time.

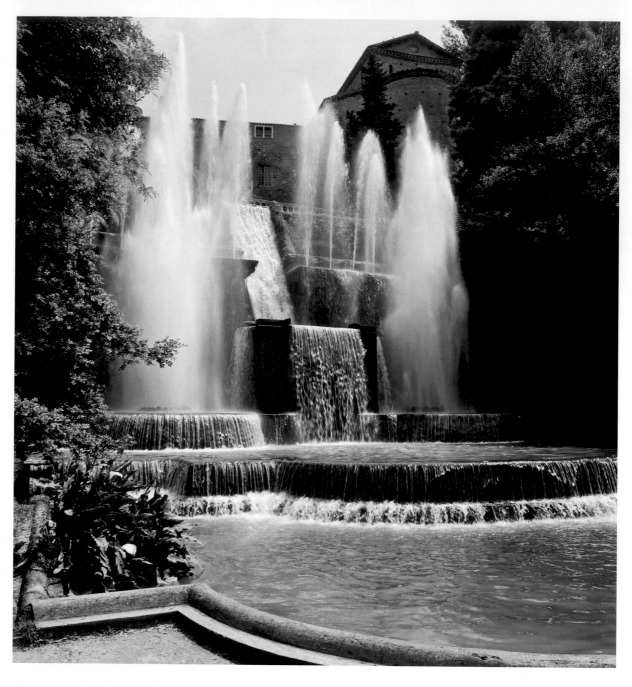

18.18

Tommaso Ghinucci,
Pirro Ligorio, and others,
fountains in the garden of
the Villa d'Este, Tivoli

changes in color, form, and scent through the seasons, reminded beholders that the prime material for the garden was nature in process, or what medieval writers had designated *natura naturans* (literally, "nature naturing"). The "art" of the garden always stood in dialogue with nature's own creative forces, making nature and its transformation into a sort of theater. Introducing exotic plants into places they had not been found previously, separating them from the rest of the world by containing walls, and arranging them in the square modules into which Bagnaia, like most gardens, was divided, drew attention to the gardener's ability to harness, encourage, or discipline the unruly inclinations that nature otherwise seemed to show. The water staircase (fig. 18.19) that descended through the first section of the upper part of

the garden, with a pattern of stone that both directed the flow and seemed to imitate the eddies that a series of waterfalls would produce, demonstrated that art, responding to nature, could simultaneously aspire to control and to imitation. At a few key points of interest, nevertheless – points announced by architectural ensembles that stopped the wanderer and commanded attention – nature's laws seemed actually to be broken, or reversed, as the forces of gravity were used, paradoxically, to spray water up into the air. At the Fountain of the Lights (fig. 18.20), water emerged from some 160 jets; its theater-like shape would have left no doubt that the movements one witnessed had the status of a spectacle.

The sculptures in the garden, at Bagnaia as elsewhere, have for the most part to do with water: even the shrimp

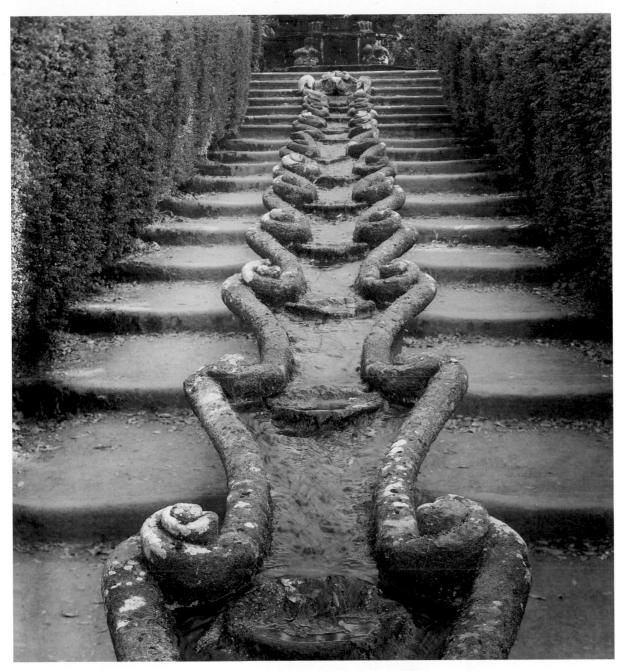

18.19
Villa Lante, Bagnaia:
Water staircase

BELOW LEFT
18.20
Villa Lante, Bagnaia:
Fountain of Lights

BELOW RIGHT
18.21
Villa Lante, Bagnaia:
Gambara emblem, from the
loggia on the upper terrace

18.22
Villa Lante, Bagnaia:
Fountain with Pegasus and
the Muses

(*gambero*), a pun on the patron's name, is a water creature (fig. 18.21). Most often, these sculptures draw attention to water's own movements, performances that the designers themselves orchestrated. River gods, personifications of streams and rivers, were meant actually to embody the streams they guided. Throughout the garden, masks with human faces appeared to exhale water, so that the liquid came to represent something else – in this case, breath – making the water itself, no less than the fountain's stones, a material from which the artist could shape figures. In a now-lost sculpture, a fat Bacchus reclining on a colossal basket regurgitated a spray of water, as if wine, into the air. On the north-west side of the grounds, greeting visitors who arrived through the gate just below, was a statue of the winged horse Pegasus (fig. 18.22), rearing to strike a rock with his hoof. It was this gesture, as we already saw with Andrea Mantegna's painting for Isabella d'Este (*see*

fig. 11.4), that created the Hippocrene fountain on Mount Helicon, the waters of which were sacred to the Muses and said to inspire poets. The Muses surrounding Pegasus and his pool suggest that Bagnaia is itself a new Helicon, an ideal place for the composition of literature.

Villas in the Veneto: Andrea Palladio

It was the Veneto that saw the most intense villa-building activity in all of Italy. Encouraged by new legislation that promoted land reclamation and supported the activity of private developers in the mainland, aristocratic families long based in Venice itself increasingly turned from Mediterranean trade to agriculture. Unlike the grand rural palaces of cardinals and the Roman nobility, Venetian villas were more often than not working farmhouses

18.23
Andrea Palladio, Villa
Barbaro, Maser, 1549–58

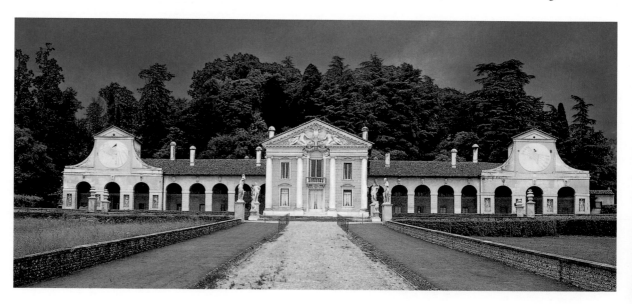

18.24
Paolo Veronese, frescoes
from the Villa Barbaro:
View through a series of
real doorways toward a
fictive one, 1560–61

as much as places for rest, entertainment, and luxurious display. By 1570, prospective builders could consult Andrea Palladio's *Four Books of Architecture*: first published in Venice that year, they formed an accessible and beautifully illustrated guide to ancient principles as adapted to modern needs. Palladio (1508–1580) wrote as a practicing architect and as an authority on Roman architecture old and new; his woodcuts include Bramante's Tempietto (*see* fig. 12.24) and Palazzo Caprini (*see* fig. 13.19). In book II, which deals with domestic architecture, he illustrated many of his own recent villa designs. Hence such works as his Villa Barbaro at Maser (fig. 18.23), designed and built 1549–58, acquired an enormous influence across Europe and eventually North America.

The most distinctive element of the Villa Barbaro formula is its hierarchical arrangement of five elements: a classical pediment and four engaged Ionic columns dis-

tinguish a stately central residential block. Symmetrical arcades link this on either side to a pair of pavilions that house kitchens, a winery, stables, and storage for feed and implements, each surmounted by a dovecote with a sundial. The Barbaro wanted to be close to the work on their estate, and their building lacks the elaborate entranceways we sometimes see in the region around Rome. At the same time, the aesthetics of classical pastoral and once again the example of Pliny the Younger mediated their relationship to the countryside. The main residence has the equivalent of a *piano nobile*, the decorations of which take it worlds away from the practicalities of life on the land. Here, illusionistic frescoes by Paolo Veronese (1528–1588) dissolve walls and ceilings into views onto imaginary landscapes. Servants, children, and huntsmen appear through opening doors (fig. 18.24). In galleries distinctly reminiscent of Mantegna and Giulio Romano's

most famous ceiling frescoes, richly attired ladies regard the viewer while the gods Diana, Ceres, and Bacchus appear as guarantors of agricultural fertility and abundance (fig. 18.25).

Daniele Barbaro was an authority on the ancient architectural writer Vitruvius, having published a thick, learned translation and commentary. Palladio had provided the illustrations for this, and Barbaro's patronage of the villa was part of a broader working relationship with the architect, with whom he shared a commitment to promoting a modern adaptation of ancient Roman ideas. The two had traveled to Rome together in 1554, when Palladio was preparing a guide to the antiquities of the city. In his *Four Books* Palladio justified many of his own architectural novelties by arguing from the practice of the ancients. Commenting on his incorporation of the ancient temple form in domestic buildings like the Villa Barbaro, Palladio admitted that the principal reason was to add "grandeur and magnificence," but he added that the ancient temple front probably in turn derived from the architecture of private houses. Although he normally respected the orders and characteristic forms of ancient architecture – as Michelangelo, for example, did not – he regarded them as elements to be used and adapted to

LEFT

18.25

Paolo Veronese, Ceiling of the Sala Olimpia, after 1559. Fresco. Villa Barbaro, Maser

BELOW

18.26

Andrea Palladio, Villa Rotunda, 1565–80, Vicenza

18.27

Andrea Palladio, Villa
Rotonda, Vicenza, 1565–80,
as shown in Book 2, page 19
of Palladio's *Four Books
of Architecture*.

design: "The site is one of the most agreeable and pleasant that can be found, because it is on a hillock with gentle approaches, and it is surrounded by other charming hills that give the effect of a huge theatre, and they are all cultivated and rich in delicious fruit and excellent vineyards. And because it enjoys the most lovely views on all sides, some screened, others more distant, and others reaching the horizon, loggias were made on each face." He does not need to state that the villa itself, with its own curved profile, provided a grand climax to the great "theater" of the landscape, especially when approached from below.

The "Sacro Bosco" at Bomarzo

The one country estate that went far beyond the bounds of convention in these years was that built by Vicino Orsini, a professional soldier who, after a period as a prisoner of war, withdrew from all military and courtly service to spend his last three decades in seclusion. Orsini had close ties to the Farnese: the future Pope Paul III, while still a cardinal, had personally intervened to secure his inheritance, and Orsini had subsequently married into that family. Bomarzo, the town Orsini ruled in the province of Viterbo, was only about ten miles from the Farnese villa at Caprarola.

In 1552, Orsini had begun developing what he later referred to as his "boschetto," or "little woods," outside of town. The shady setting distinguished this from many gardens, and the ornaments it included were striking in a central Italian context both for being carved out of the living, volcanic rock that lay under the site and for being polychromed. Still, much here was conventional: attached to a residence and constructed on a slope along a waterway, the boschetto's first major features included fountains, a statue of a river god, and a Nymphaeum, imagery familiar from the Villa Giulia (*see* figs. 17.11–17.13) and suited to the function of the site as a place of retreat. A statue of Pegasus rearing, beating his hooves, and causing the Hippocrene waters to flow, announced Orsini's attachment to literature, and his personal letters are filled with references to ancient myths and modern poetry, as well as with requests for new books.

Renaissance marriages were typically arranged with an eye to political advantage, and Orsini's was no exception. His wife Giulia was the daughter of Galeazzo Farnese, the duke of the nearby town of Latera. Nevertheless, Orsini seems to have been particularly besotted with Giulia, and when she died in 1564, he began entirely to re-conceive the landscape he had been shaping. At a level above the one on which he had primarily been building, he constructed a temple at the center of an open field (fig. 18.24). The *cella*, centrally planned and

modern circumstances. This is above all the case with the Villa Rotonda (1565–80) (figs. 18.26–18.27) at Vicenza, his most famous and his most extravagant design, one built (like most of the villas discussed in this chapter) for an official of the papal court, Paolo Almerigo, who retired to Vicenza in 1566.

In the world of secular architecture, the building might seem a response to Bramante's Tempietto (*see* fig. 12.24) – or Vignola's Sant'Andrea, which Palladio also admired (*see* fig. 17.14). Palladio has subjected the house to the rigors and refinements of the centralized plan, going so far as to incorporate a dome. The name Villa Rotonda was bestowed by Almerigo himself, and it draws attention to the origins of the design in the church of Santa Maria Rotonda, the Renaissance name for the Pantheon in Rome. Each of the four facades has an identical Ionic portico on the *piano nobile*, and each also has its own flight of steps. The four temple fronts establish axes that intersect on the interior in the magnificent domed salone.

This time, there is no pretence of architecture dedicated to the lifestyle of gentleman farmers; Palladio indeed hesitated to call the building a villa in his *Four Books*, where it appears with urban dwellings (and indeed, with its proximity to downtown Vicenza it might be more fittingly compared to Giulio Romano's Palazzo del Tè in Mantua; *see* fig. 15.4). Yet he took pains to point out that the natural landscape was the motivating principle of his

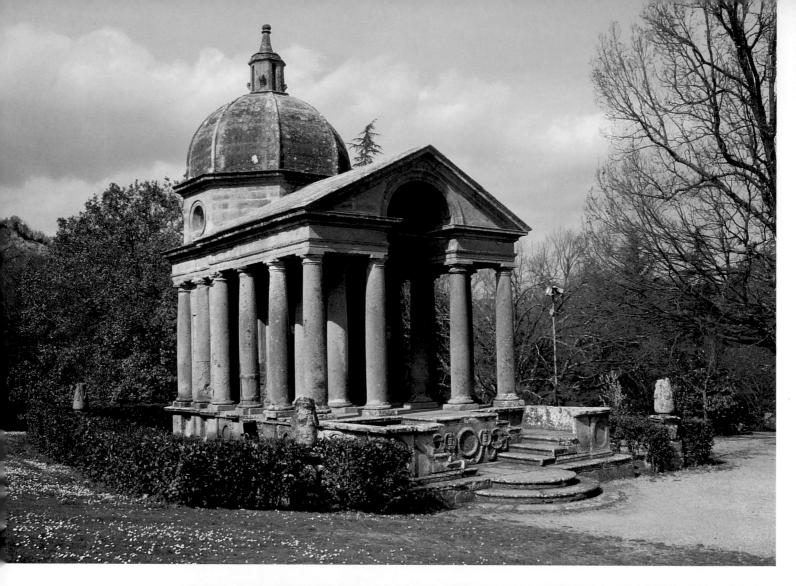

ABOVE
18.28
Pirro Ligorio and others,
Tempietto, Villa Orsini,
Bomarzo

RIGHT
18.29
Pirro Ligorio and others,
Villa Orsini, Bomarzo.
Statue of Cerberus, by
Simon Moschino (?)

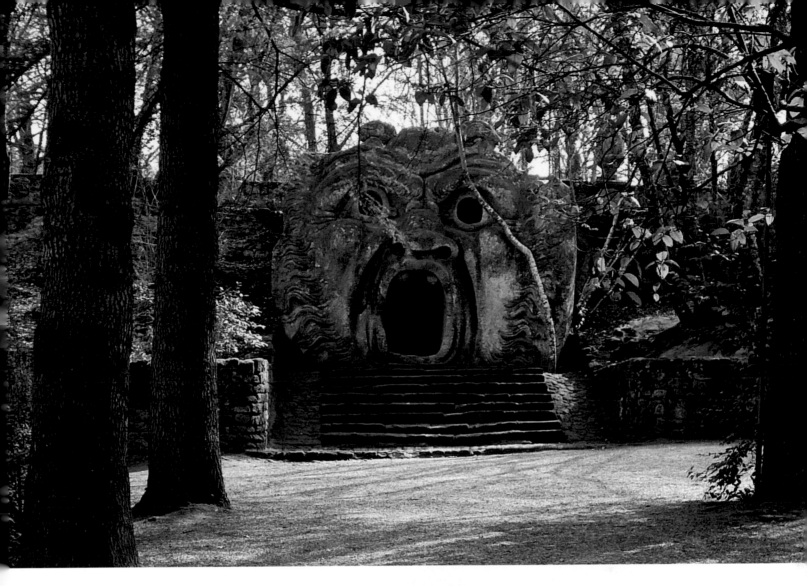

domed, evokes funerary structures, while the coffering of the **pronaos** (the porch-like vestibule) is ornamented with the three-petaled fleurs-de-lys, heraldic emblems of Giulia's family. Surrounding the building are sculptures of funerary vases on pedestals bearing skulls and crossbones. Though there is no tomb, the whole comes across as a kind of classicizing cenotaph and *memento mori*.

The temple was the first thing that would have greeted the visitor from what Orsini designated as a new entrance. From there, the visitor would have descended a staircase, only to be greeted by Cerberus, the three-headed hound that guarded the Underworld (fig. 18.29). It was as though entering further into the woods was entering an Underworld, and the statue that presided over the large open court on the second level showed Proserpina, the goddess abducted by Pluto to live with him in Hades. Pluto is there, too, and one level below this Orsini had his sculptors carve an actual mouth of hell in the mountainside, inscribing it "every thought flees" (*ogni pensiero vola*) in a paraphrase of the poet Dante (fig. 18.30).

More unsettling still is the way that death, in the redesigned park, seems to be a consuming force. Frag-

ments of statues and buildings litter the ground. A bench seems to sink into the earth. A tower, the tallest structure into which the visitor can enter, leans precariously, as though it might at any moment topple, bringing those inside down with it (fig. 18.31). At one point, the ground itself opens to expose what looks like an empty tomb, waiting for new occupants. Other sculptures, meanwhile,

ABOVE
18.30
Pirro Ligorio and others, Villa Orsini, Bomarzo, *Hell's Mouth* by Simone Moscino (?)

LEFT
18.31
Pirro Ligorio and others, Villa Orsini, Bomarzo, Leaning Tower

18.32
Pirro Ligorio and others,
Villa Orsini, Bomarzo,
Lower Garden with *Pegasus*
and other sculptures

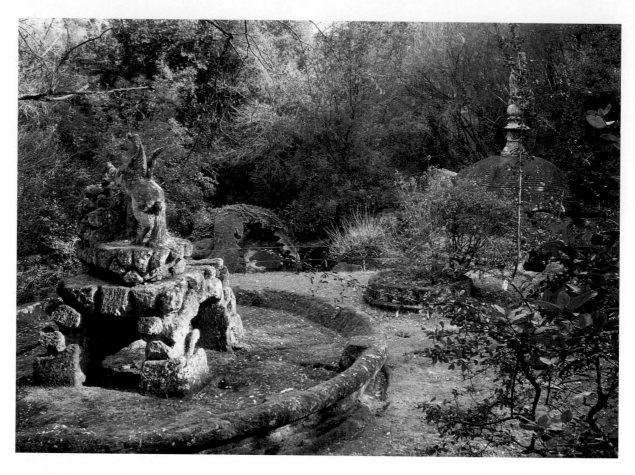

suggest that this force of death is nothing other than Nature itself, conceived as an all-powerful, fertile, yet devouring goddess. Here, the creative energies that brought the garden into being are wild, sexual, and feminine. Opposite the court with Proserpina and Cerberus is a lioness with a cub at her side: a medieval tradition held that lions were born dead and that their mothers breathed life back into them. Beside the family of lions is a siren, a nude female upper torso with twin tails that split at the bottom, suggesting monstrous birth. Most disturbing of all is a sculpture Orsini seems to have added shortly after 1570, showing an orifice filled with spiky teeth, opening just beside the pool of water that surrounded Pegasus (fig. 18.32). There is no more vivid image of the earth's threat to consume those who live above, and an uncanny occlusion of form makes it hard to tell just what body part is opening here.

One might ask, in the end, whether the complex Orsini built was really a villa at all. Certainly his writings distance him from the courtly practices on which villa life conventionally depended. At one point, he remarks that he far preferred living in the woods to being "immersed in the falsehoods and ambitions of the courts, especially those in Rome." On another occasion, he thanked a friend for sending him some fruit, then added that such foods were "too delicate for a citizen of the woods, as I am." The woods, for Orsini, became a kind of alternative to a certain type of cultivation, a controlled space of non-civility that freed him from the rules, artistic and otherwise, being applied elsewhere.

Bologna, Florence, and Rome in the Time of Pius IV and Pius V

Pius IV did not focus his attentions exclusively on Rome. In 1563, working through Pierdonato Cesi, his legate to Bologna, the Pope sponsored the creation of a new aqueduct system (the "Aqua Pia") for that city, culminating in a colossal fountain in the city's main square. Cesi left a description of the work's program, explaining its central figure (fig. 18.33):

[Neptune] holds the trident in his right hand, just as if to strike a blow, and he compresses the winds to such an extent that he frees the people who are subject to his sovereignty from fear of any tumult or agitation. Histories truly give credence, moreover, that dolphins are by nature favorably disposed toward human wit, so that it is believable that

children play with them…. No one will deny that play is a sign of greatest leisure and tranquility. Although the sirens are considered by some people as seductresses, they are used by others, not inappropriately, to signify the sweet persuasions of rhetoric…. And in truth, since our Sirens press out their breasts, they visibly indicate that they do not excel so much in the pleasing quality of their voices, but also bring forth something more material from themselves.

The point of the whole composition, Cesi added at the end, was to show the praise due to Pius, and the statue of Neptune itself was ornamented with the Pope's coat of arms. It may come as a surprise that a prelate in 1563 was so comfortable commissioning monumental and possibly seductive images of pagan gods and sirens for such an open urban space. Cesi remarked, nevertheless, that the program could be "rendered without controversy in that place," which is to say that the statue, though public, did not decorate the kind of setting that required more cautious approaches. The *Neptune*, Cesi argued, offered a demonstration of decorum, not a breach of it.

The artist who initially conceived the sculpture was the Sicilian architect Tommaso Laureti, but to carry it out the Bolognese summoned two artists from Florence, a caster named Zanobi Portigiani and a promising young Fleming named Giambologna (1529–1608). Initially the two worked together, but a quarrel led them to break off work and return to Florence. By the time Duke Cosimo ordered Giambologna to return to Bologna, now alone, to oversee the casting of the figures, Pius IV had died. His successor, a former Dominican and Inquisitor General, took the name Pius V (r. 1566–72). Pius V, though Lombard by birth, had still closer relations to Florence than his predecessor, and he allowed the continuation of the fountain. Still, he held very different ideas about the arts than his predecessor, and public nudes on antiquarian themes were the furthest things from his own patronage. Pius V disapproved in particular of the way his namesake had decorated his dwelling at the Vatican, the Casino (*see* fig. 18.14). As pontiff, he stripped the papal retreat of its antiquities and sent many of them as gifts to the Medici. The sculptures that had been assembled by Julius II in the Vatican's Villa Belvedere narrowly escaped the same fate;

18.33

Tommaso Laureti and Giambologna, Neptune Fountain, 1563–65. Bronze. Piazza Maggiore, Bologna

Pius spared them only on condition that they no longer be accessible to visitors. Work on Bramante's Belvedere continued, but Pius had its theater dismantled in 1566. Yet for his own artistic commissions in the Vatican – a series of small chapels dedicated to St. Stephen, St. Michael, and St. Peter Martyr – the Pope recruited one of Cosimo's key employees, the painter, architect, and writer Giorgio Vasari (1511–1574).

As an artist and as an author, Vasari had during the 1560s proved himself competent to address the needs of a reforming Church, even as he sought to defend the legacy of Michelangelo and the artistic values of the early sixteenth century. Both of these aims were in line with the policies of his Medici employers, who were anxious to maintain good relations with the papacy and to promote their own association with the great Florentine artist, who had opposed their rule. For such an important enterprise, Vasari revised his 1550 *Lives of the Artists* in collaboration with literary specialists close to the Medici court. Finally published in 1568, the new, longer *Lives* included a greatly enlarged version of his biography of Michelangelo, in which Vasari insisted on the Sistine *Last Judgment* as a great work of Christian art and as a testimony to the religious conviction of the artist who had painted it. The fresco, according to Vasari, was no less than the image of the "*true* judgment" and the "*true* resurrection" of the body, approved by God himself "so that [people] will see what fate does when supreme intellects descend to earth infused with grace and with divine wisdom." Nonetheless, several of the changes he made to his 1550 *Lives* show his awareness of a new climate of orthodoxy. In his 1550 life of Donatello, for instance, Vasari referred to reports that the artist had refused confession and communion on his deathbed. For the 1568 edition, he cut the passage and replaced it with an alternative deathbed scene in which the artist performs a pious act of charity to a poor servant.

Educational Reform in Florence: The Accademia del Disegno

While working on the *Lives*, Vasari helped spearhead the founding of an organization devoted to centralization and regulation, aims that paralleled and sometimes reinforced those of Catholic reform. The Accademia del Disegno, instituted in Florence in 1563, provided a new kind of corporate association for artists, who had previously met under the auspices of guilds and confraternities. Part of its purpose was to make artists aware of the intellectual basis of their profession by providing lectures on literary and artistic theory, mathematics and perspective, and human anatomy. Most of all, though, it reorganized the system of the arts, bringing together

practitioners of the three fields Vasari regarded as having their foundation in *disegno* (*see* chapter 17): painting, architecture, and sculpture. This established a clear hierarchy, enforced by membership rules, that still lingers today, between these three arts and the other excluded crafts – goldsmithery, weaving, ceramics – that we have seen play such vital roles in the preceding decades.

The Academy had two official "heads," Duke Cosimo and Michelangelo. The latter was a paradoxical choice, since Michelangelo's sensibilities at this point were if anything anti-Florentine. His political dissent was nullified after his death in Rome in 1564, when the Florentines succeeded in smuggling his body back to Florence for a state funeral to which the artist would never have consented. The role that the duke and his artistic overlord gave Michelangelo allowed that, Gilio's critique notwithstanding (*see* p. 526), he would continue to provide the primary model for the way modern art should look.

The cult of Michelangelo that the Academy encouraged is especially apparent in sculptures from the period. Before 1563, it was possible for sculptors to identify themselves pointedly as Florentine without explicitly taking Michelangelo as a model. A good example is the marble crucifix that Benvenuto Cellini (1500–1571) signed and dated in 1562 (fig. 18.34). The sculptor had been at work on the piece for nearly eight years, having conceived it initially as the central motif of the tomb he planned for himself. When he first took up the chisel, he did so as much as anything out of a sense of rivalry with Baccio

18.34
Benvenuto Cellini, *Crucifix*, signed and dated 1562. Black and white marble, height 6'3/4" (1.85 m) (figure 4'9"(1.45 m)). Monastery of San Lorenzo el Real, Escorial, Spain

REACTIONS TO VASARI

Giorgio Vasari's *Lives of the Artists* is the single most important art-historical text of the Renaissance. Running to nearly 3,000 pages in its 1568 edition, it provided a wealth of information and opinions on craftsmen and designers of whom no other biographies survive. It organized the history of Italian art into three distinct periods that underlie those still used today, and it articulated some of the central concerns of sixteenth-century artists, positing the central theoretical principle of *disegno* ("design"), the notion that every artwork should have a conceptual basis, that it should correspond to an idea in an individual artist's head. The *Lives* has exerted an almost unavoidable influence on art and writing, one that makes itself felt even now.

Yet the documented sixteenth-century response to Vasari's *Lives* was almost uniformly hostile. In Florence itself, contemporaries lamented the fact that a foreigner (Vasari came from Arezzo and had built his career in Rome) was defining what Italian art should be, and they resented his lack of regard for leading workshops and local eminences. Artisans who specialized in crafts other than painting, sculpture, and architecture attacked Vasari's reduction of "art" to a limited group of media. Outside of Florence, readers objected to Vasari's promotion of central Italian artists above all others, and pointed especially to his misunderstanding of north Italian painting.

In the end, then, the *Lives* gave rise to a series of anti-Vasarian undertakings. In Cremona in 1584, Alessandro Lamo published a discourse on sculpture and painting to defend the honor and reputation of his home territories, which he claimed Vasari had "defrauded." The painter Doménikos Theotokópoulos, called "El Greco" because he had come from Crete, wrote in the margins of his copy of the *Lives*, commenting that the author did not understand what he was talking about when he discussed the "Greek" style. The Carracci in Bologna were even more damning, strewing their copy of the *Lives* with remarks like "He lies through his teeth," "It's not true!," "Oh presumptuous and ignorant Vasari, listen to what he says." The closest thing to a sixteenth-century imitation of Vasari is the collection of artists' biographies that the Fleming Karel van Mander published in 1604, in which the author rejected both Vasari's hierarchy of the arts and his canon. When north Italian painters of the late sixteenth century began thinking of their own art in opposition to the central Italian tradition, the legacy of the *Lives* played a significant role in that orientation.

Bandinelli, who had been making his own tomb, with its own marble statue of the dead Christ, across town. By 1560, though, Cellini's sense of purpose had changed. For one thing, he had just completed successive prison terms for assault and for sodomy, and he had come to conclude that he might stand to gain political advantage by offering the work to Duke Cosimo rather than using it to celebrate himself. He had also become particularly attached to the subject, and the many poems he wrote on the image of the Crucified Christ, and on the spiritual significance of carving such an object, suggest that he was as caught up as anyone with a new Reformation sensibility. Cellini claims to have based his composition on a vision he had had, and his superimposition of the luminous white body of Christ on the deep black marble Crucifix creates a kind of aura that captures this origin. He, no less than Moroni, was aiming for an imagery that allowed for an intense meditative experience (*see* fig. 18.1). He also compared his labors on the Crucifix to Christ's own sufferings, suggesting that no one might become closer to Christ than a Christian artist.

18.35
Vincenzo Danti, *Honor Triumphant over Deceit*, 1561. Marble, height 6'2¾"(1.9 m). Museo Nazionale del Bargello, Florence

OPPOSITE
18.36
Giambologna, *Samson and a Philistine, c.* 1569. Marble, 6'10½" (2.1m). Victoria and Albert Museum, London

sculpture might be displayed, the Florentine church of Santa Maria Novella, it would have hung close to Brunelleschi's work, making the comparison inevitable.

As Vasari assumed control of the Florentine cultural scene, though, and especially in the years immediately after the founding of the Academy, a different idea of the "Florentine" emerged. Cosimo sent the Crucifix as a diplomatic gift to Spain, Cellini received no more major commissions, and the artists who took his place vied with one another to be his true successor. A good example of the new mentality is the marble allegory of *Honor Triumphant over Deceit* (fig. 18.35), which Vincenzo Danti (1530–1576) made for the duke's chamberlain Sforza Almeni in the early part of the decade. The monolithic carving is an ingenious variation on the *Victory* that Michelangelo had left behind when he permanently abandoned Florence in the 1530s (*see* fig. 14.12). The two characters included are nearly the same, with a curly-haired youth standing over a bent, bearded old man, and Danti's victor, like Michelangelo's, pulls a kind of binding over his right shoulder. Once he had announced this point of reference, though, nearly every compositional move Danti made reversed Michelangelo's original: Michelangelo's upper figure turns his torso inward, Danti's outward; Michelangelo's figure looks to the right, Danti's to the left; Michelangelo's figure pulls his left arm up and away from the victim below, Danti's presses down on it. Danti even went so far as to flip his lower figure upside down. Michelangelo's defenders imagined that he had achieved variety in the *Last Judgment* by bending each successive figure he designed in a novel way. Danti's imitation here looks like an attempt to live up to its model by repeating not just Michelangelo's forms but his artistic process.

Danti's strategy here, imitating work that dated to Michelangelo's Florentine period, was characteristic of Medicean court sculpture in these years. It is the same approach that the young Giambologna took when, having returned to Florence from working on the fountain in Bologna (*see* fig. 18.33), he began trying to establish his own local reputation. The greatest marble Michelangelo failed to complete before his definitive move to Rome in 1532 was the *Samson and a Philistine* he was making as a pendant to his *David* (*see* fig. 12.3). Every sculptor knew what the *Samson* looked like, since copies after one of his models survived. Giambologna must have been a particularly keen student of the model, for he is shown holding what is probably his own copy after it in a later portrait drawing, and he took just this subject as the centerpiece of a marble fountain that stood for a time in a Medici garden (fig. 18.36). The choice may initially be surprising for its seeming lack of decorum: Samson has no obvious connection either to water or to gardens. Perhaps Giam-

All of this, though, distanced Cellini's approach from that of Michelangelo. The appeal of combining white and black marbles, as Cellini did here, may have seemed obvious to an artist who had spent most of his career as a goldsmith or to a patron who was collecting works made in hard colored stones, but it was entirely antithetical to Michelangelo's principles: sculptures had to consist of white Carrara marble alone, and they had to be made in a single piece. Though the basic idea of placing a figure of Christ above a tomb depended on Michelangelo's Florence *Pietà* (*see* fig. 11.51), Cellini's testament explicitly refers to an earlier precedent, namely the crucifix that Brunelleschi (*see* fig. 4.5) had made at the beginning of the Quattrocento. In the place he had initially hoped his

bologna expected viewers to associate the streams of water that the fountain would have shot into the air with the breath the Philistine expels as Samson twists him into a tortured pose. This act of twisting the figure, at least, must have been the aspect of the subject that most interested Giambologna, since it was an act closely associated with Michelangelo's own process of invention. This only demonstrates, though, that the very things that troubled clerics like Gilio – Christian subjects shown as nudes and put to the ends of demonstrating art above all else – could find a home when the context itself was not a sacred one, and when they were kept out of the public eye.

Danti and Giambologna were both members of the new Academy in Florence, and it is not surprising that major works like these were both made for the ducal court. One of the things the Academy provided was a centralized work force that could be mobilized, either for discrete projects such as these or for large collaborative undertakings: a towering catafalque with painted episodes from the life of Michelangelo, prepared for his funeral in 1564; a multi-media tomb for the artist in Santa Croce celebrating the three arts of *disegno* in which he had been foremost; the triumphal decorations placed throughout the city for the marriage in 1565 of Francesco de' Medici with Joanna of Austria, daughter of Emperor Ferdinand I; the re-decoration of the council hall for which Michelangelo and Leonardo da Vinci had designed their battle scenes (*see* fig. 11.16).

The Florentine Church Interior

The collaborative academic project most directly related to the new Catholic Reformation ideals was the renovation from 1565 onward of the two great mendicant churches of Florence, that of the Dominicans at Santa Maria Novella and that of the Franciscans at Santa Croce. In accordance with the prescriptions of the Council of Trent, the interiors were reorganized to provide full visibility of the high altar and to focus the devotion of the laity on the sacrament of the Eucharist. The large architectural barriers, or "rood screens," that had for centuries separated the congregations from the altar were demolished, and fourteenth- and fifteenth-century frescoes were removed from the walls. (Portions of Masaccio's *Trinity*, *see* fig. 4.18, survived in Santa Maria Novella only because Vasari covered it with a large altar, which was removed in the nineteenth century.) For Santa Croce, Vasari replaced the main altarpiece in the church with a large ciborium, a kind of urn or reliquary container for the Eucharist, thus making the body of Christ visually central.

The new uniformity required a redesigning of the family chapels in the naves, many of the chapels dating back to the 1300s. Acting in the name of the government,

ABOVE

18.37

North side aisle of Santa Croce, with tabernacle altars designed by Vasari, 1565–72

ABOVE RIGHT

18.38

Giorgio Vasari, *Incredulity of St. Thomas*, 1569. Oil on panel. Guidacci Chapel, Santa Croce, Florence

OPPOSITE

18.39

Agnolo Bronzino, *The Martyrdom of St. Lawrence*, 1565–69. Fresco. San Lorenzo, Florence

Vasari had these stripped of their tombs and their private family devotional imagery. Families who retained their rights as patrons were required to pay for new altarpieces with standardized tabernacle frames, and patrons old and new were given no say in the subject of the replacement pictures (fig. 18.37). Most of the altarpieces in Santa Maria Novella and all of those in Santa Croce follow a program centered on the life of Christ, once again reinforcing the doctrine of the Eucharist. If all of these look like Counter-Reformatory transformations, nevertheless, Vasari's own *Incredulity of St. Thomas* (fig. 18.38), exe-

cuted in 1569 for the Guidacci Chapel in Santa Croce, shows that the Academy's notion of religious painting entailed no radical break with the past. The torsion of Christ's body manages to show an academic command of anatomy without relying on extensive nudity, and there is little to distract from the central narrative, which the Apostles observe with appropriate gravity. A figure on the staircase, modeled on the "Apollo Belvedere," adds a discreet classicizing ornament appropriate to the dignity of sacred history. Nonetheless, this is a work firmly within the Florentine tradition, characterized by firm *disegno* and a decorative approach to color. The sober architectural setting, in particular, advertises "Florentineness," recalling the tradition of Brunelleschi, of Michelangelo, and of Vasari's own design for the Uffizi (*see* fig. 17.15).

In sponsoring the renovation of the two churches, Duke Cosimo was acting in the name of Pius V and of the Council of Trent, but it is clear that this suited the interests of his own administration as well. Putting artists

to work in this way was an imposition of normalization and control, at once blurring the differences between the city's once independent and competing workshops and subordinating the old family oligarchy that had governed the pre-Medicean Republic. Cosimo's enthusiastic promotion of reform, which included banning books listed on the papal Index and licensing the capital punishment of heretics he had previously protected, brought political benefits: in 1569, the Pope elevated Cosimo to the rank of Grand Duke of Tuscany. Bronzino's last great painting, the *Martyrdom of St. Lawrence* (fig. 18.39), a fresco for the church of San Lorenzo, has been seen as a celebration of Cosimo's coronation – Lawrence the martyr receives a ducal crown, rather than the standard martyr's crown of laurel.

In style, the work is strikingly different from the new mendicant altarpieces, one of which was executed by Bronzino himself. Other works the artist produced in the 1560s decorously avoided nudity and complexity of design, yet the *St. Lawrence* did exactly the opposite: it showed a carnival of naked figures, few of them manifesting the behavior expected at a scene of execution, with the saint himself cheerfully in dialogue with the Roman prefect ordering his death. Bronzino may have regarded the location of the fresco, on a wall easily visible from the nave of the church, as an opportunity to make a final statement about his vision of painting. San Lorenzo had been a major center of the Academy's early activities; it was the church most closely associated with Michelangelo, and the wall with Bronzino's mural looked over the space that had hosted Michelangelo's elaborate funeral rituals. It was just a few steps from the ill-fated fresco cycle by Bronzino's teacher Pontormo (*see* fig. 14.14).

"Errors" that Gilio's dialogue had enumerated in Michelangelo's *Last Judgment* are openly indulged here: nudes with contorted poses abound, the angels lack wings, statues of pagan gods provide poetic amplification of the martyr's virtues, and a series of allegorical personifications mingle with the crowd, contravening any insistence that poetic fictions have no place in the representation of sacred history. While Faith, Hope, Charity, and Fortitude, the clothed women in the center foreground, seem to enjoy the spectacle of the saint's roasting, the other Virtues, who are more challenging to identify since they form part of the Roman tyrant's entourage, appear troubled by the miscarriage of Justice. These include the figure of Justice himself, who appears with an axe and a sword, and the figures of Temperance and Prudence seated beneath the throne. Not only does the imagery present difficulties of interpretation, it is also formally complex, and its frieze-like design constantly pulls the viewer's attention away from the clear communication

of the story – in this respect, too, the fresco follows precisely the things in Michelangelo's *Last Judgment* that had provoked the most controversy. In the left background Bronzino painted a self-portrait in the company of his teacher Pontormo and his student Alessandro Allori, suggesting that Bronzino conceived the work as a defense of the family workshop tradition that the Academy was suppressing. The fresco takes a stance of ironic dissent against not only the Reformist critique of Michelangelo, but also the artistic policies of the Medici regime.

The Arts in Transition

Historians sometimes refer to the period this chapter has covered as the "Counter-Reformation," characterizing it in terms of a response to Protestant challenges coming from the north while also distinguishing it from the more varied "Catholic Reformation" led by figures as varied as Savonarola and Vittoria Colonna. Although it may be useful to connect the arts to these centralizing impulses, this is not to say that the Counter-Reformation resulted in anything like a coherent style or a uniform subject matter. The Lombard tradition of Moretto and Moroni served the ends of reform, but then so did Vasari and his Florentine followers. The reformers were more intent to prescribe what Christian art should *not* be than to lay down any strict guidelines about what it should look like.

Although many historians, moreover, have seen the Counter-Reformation as the single most important force in Italian culture during the later sixteenth century, the movement was in fact a symptom of a deeper and more widespread European preoccupation with order, hierarchy, and systematization. The concern is apparent in the debates among writers and critics concerning genre and decorum. Patrons and artists would now consider every work in terms of the type or kind to which it belonged; the orthodox would observe the rules of the genre in question.

The preoccupation with systems is characteristic of a society increasingly founded on centrally organized bureaucratic states: there can be no better emblem of this than Vasari's Uffizi (*see* fig. 17.15), a monument to the new administrative apparatus created by Duke Cosimo to consolidate his control over Tuscany. In Vasari's ceiling of the Salone del Cinquecento (*see* fig. 11.16), completed by 1567, Tuscany is represented as a grid-like arrangement of allegorical figures each highlighting the natural features of a subject town or region, with Cosimo enthroned at the center (fig. 18.40). The designation of regions by river gods suggests that Medici power percolates through the domain like streams emanating from a single source.

1570–1580
19
Art, the People, and the Counter-Reformation Church

19

1570–1580
Art, the People, and the Counter-Reformation Church

Two Reforming Archbishops

Bologna: Gabriele Paleotti

Perhaps the most important effect of Catholic reform in the visual arts was the importance that it gave to the idea of ordinary viewers. The Church took a new interest in the experience of the laity: artisans and unskilled workers of modest means as well as the urban and rural poor. In the eyes of the bishops and religious orders who led Catholic reform, such audiences required constant guidance and supervision. The decrees that originated from the Council of Trent in 1563 had emphasized the responsibility of the clergy to "instruct" those in its charge, and from the middle of the century, clerical writings on the arts had distinguished two audiences for paintings and sculptures: the literate, whom the writings of heretics and dissidents threatened to seduce, and the illiterate, whom the wrong kind of religious images could lead into error or temptation. Church authorities conceived ordinary Catholics as fundamentally dependent on images, as beholders before they were readers. The bishop of Bologna, Gabriele Paleotti (1522–1597; archbishop in 1582), wrote that images served to "move men to proper obedience and subjection to God, or to penitence, or to voluntary suffering, or to charity, or to disdain of the world, or other similar virtues all of which are instruments to unite men with God, which is the true and principal end that is expected of these images." The image of "the people" became a central concern in the later decades of the sixteenth century, both as the primary audience of religious art and as its subject. Social catastrophes of the 1570s, including plague and famine, only reinforced the newly conceived relationship between the Church and the people, and art and architecture assumed a crucial role in making visible this redefinition of Christian community.

Paleotti was one of several local bishops who sought to impose a "top-down" reorganization of the religious life of the Catholic laity, through careful monitoring of parish clergy and of confraternities, and through new measures for the religious education of the young. Beginning around 1578, the bishop sought to compile a vast treatise on the proper use of images, which underlined their pedagogical and disciplinary function. Paleotti

decried not just the contamination of sacred by "profane" art, but profane art in general; he reserved particular censure for the long-established practice of private patrons who had their portraits and coats of arms displayed in chapels and altarpieces. In the course of hundreds of pages of the treatise, which he never managed to finish, Paleotti had little to say about the stylistic and theoretical questions that had preoccupied Vasari, Dolce (*see* p. 496), and others. He called for painters to design their works not for rich patrons and art-loving connoisseurs, but for the expanded "public" of Christian art: images should be clear and intelligible; they should inspire reverence, but also hope and joy rather than despondency and fear.

The choice to formulate the treatise as a "discourse" rather than a dialogue, combined with Paleotti's position as final arbiter on the actual church decoration that took place in his jurisdiction, make his book now read like a collection of rules, imposed from the top down on practicing painters and their patrons. The reality, however, was more complex. Paleotti opted to publish the first editions of his treatise in Italian rather than Latin, making them accessible to a broad audience, and essentially inviting painters to respond directly to his ideas, rather than depend on mediation or regulation from the clergy. Before publishing the book, moreover, Paleotti circulated drafts to and invited comments from a few artists whose work he particularly admired, among them the painter Prospero Fontana (1512–1597). Fontana's most distinguished painting from the years just before Paleotti began writing, his 1576 *St. Alexius Distributing Alms* (fig. 19.1) for the Orsi Chapel in the church of San Giacomo Maggiore, Bologna, exemplifies the clarity and legibility that Paleotti's discourse would in turn advocate. Most ordinary viewers would not have been familiar with the painting's fourth-century main character, the son of a wealthy Roman who abandoned his family and distributed his possessions to the poor, but no one could have missed the picture's lesson: it places Alexius on the iconic central axis and isolates his gesture of handing money to a beggar. Fontana identifies the saint he portrays entirely through that saint's act of charity, the central virtue that the post-Tridentine Church was promoting. The humble characters that surround Alexius, moreover, project an audience for the picture itself that would

19.1
Prospero Fontana,
*St. Alexius Distributing
Alms,* 1576. Oil on canvas.
Orsi Chapel, San Giacomo
Maggiore, Bologna

include Bologna's most destitute churchgoers. Though Fontana had worked with the Florentine Perino del Vaga earlier in his career, finally, there is little here that draws attention to individual manner; content takes precedence over style.

Yet for all of that, this is not a painting that ignores the interests of its aristocratic donor, the scion of one of Bologna's oldest noble families. The chapel took its name from Alessio Orsi, who had provided for its decoration in his will. The dedication of the altar and the choice of protagonists for the painting may have reflected a shared new fascination with Rome's earliest Christian community, but both depended more than anything on the fact that Alexius was Orsi's name saint. While the chapel does not include a conventional donor portrait or anything else to suggest that the Orsi family derived special benefits from its wealth, the face of St. Alexius, with his distinctive long black beard, appears to be Orsi's own. Fontana's point was that Orsi, in leaving money for a chapel, followed Alexius's own model of charity, that giving money to the church was the equivalent of giving alms to the poor. Yet in sanctifying its patron, the painting re-inscribed the kind of privileged societal differences that Paleotti wanted pictures to work against.

Milan: Carlo Borromeo

Paleotti probably began his treatise after reading the book *Directions on Church Building and Decoration* published in 1577 by Archbishop Carlo Borromeo of Milan (1538–1584). Borromeo, the nephew of Pius IV, had provided a model of rigorous centralization and charismatic leadership that would be widely influential beyond his own archdiocese. He imposed sweeping reforms of the parish clergy and religious orders and tightened clerical control on confraternities throughout Lombardy. By 1580, Milan rivaled Rome in its quantity of new religious building, in its commissions for sacred art, and in the great collective religious festivals and processions that Borromeo personally led. The city had become a sacred theater, and Borromeo himself came to be seen as a living saint (he was officially canonized in 1610). His near-assassination in 1569 by some members of the clergy opposed to his reforms gave him a martyr-like status. In 1576, while walking barefoot in a procession in honor of the Milanese relic of a holy nail believed to have been used in the Crucifixion, copious bleeding from his injured foot made him even more potent an exemplar of the "imitation of Christ." The cult of the Nail did more than reaffirm the centrality of relics to Catholic devotion, in the face of Protestant attacks: in Milan in 1576 it formed part of a great collective ritual of crisis, in which the archbishop guided the entire community in acts of penance designed to avert the wrath of God against the city. The devastating plague of 1576–77, when he worked tirelessly among the sick despite the risk of contagion, allowed Borromeo to appear as the advocate of the people, the one who could solicit both grace from God and charity from the rich on their behalf.

Borromeo's concern with the visual arts is most evident in his treatise on church building and decoration. Much of what he writes on design is familiar from Alberti's *Ten Books on Architecture* and Palladio's *Four Books of Architecture*: places of worship should be magnificent and impressive to inspire respect for the institution of the Church; they should be set apart from other buildings and raised on steps; they should be appropriately decorated using the classical orders. However, Borromeo sharply differentiated himself from the humanist tradition by insisting on the precedence of early Christian basilicas as models. He wrote that churches must be cruciform in plan, and he pronounced circular plans to be pagan. The altar had to be fully visible from all points in the church, and the Blessed Sacrament housed there in a ciborium. He required large windows with clear (as opposed to stained) glass so that congregants could see the ceremony. He provided meticulous specifications about benches, rails, confessionals, candlesticks, and other apparatus.

Like many of the treatises we have discussed, Borromeo's *Directions* codified existing practice as much as it called for anything new. We have already seen the basic elements of Borromeo's ideal church in Giacomo Vignola's design for the Gesù in Rome (*see* figs 18.8–18.10), and in fact the Jesuits built their church in Milan, San Fedele, according to similar principles under Borromeo's supervision in 1569. The painter-architect Pellegrino Tibaldi (1527–1596) had initially proposed a centralized plan based on a domed Greek cross: at Borromeo's behest, and following the acquisition of a larger site to build on, Tibaldi substituted a longitudinal design with two cubic bays for the nave and a domed choir (figs. 19.2–19.3). The elimination of aisles produces an effect of unity and visibility: clergy wishing to reach the four shallow nave chapels could do so by means of concealed corridors connecting these with the choir. Tibaldi achieved a monumental effect with a giant Corinthian order on tall bases (reminiscent of Bramante's original scheme for St. Peter's, Rome; *see* fig.12.25), which unifies the nave elevation with the choir and the apse. Six free-standing columns gave further definition to the nave, articulating the main proportional divisions of the interior without impeding the flow of space or the churchgoer's view across it.

RIGHT

19.2

Pellegrino Tibaldi, San Fedele, Milan, begun 1567. Plan

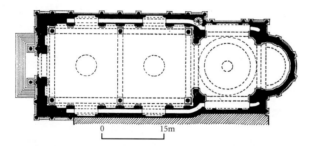

BELOW

19.3

Pellegrino Tibaldi, San Fedele, Milan. Interior

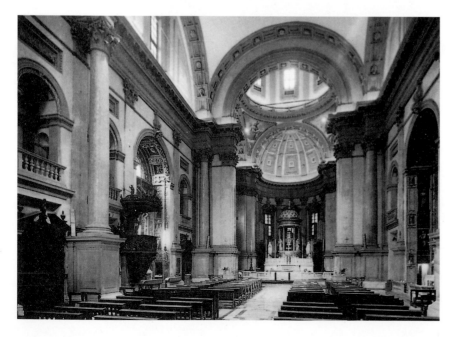

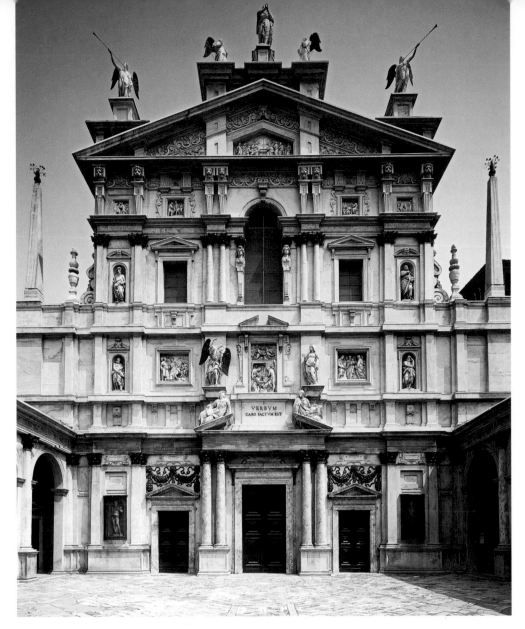

Whereas San Fedele reflects the common means and ends of Milanese and Roman church building, another great project of the Borromean era in Milan seems more free in its embrace of architectural invention. In 1570, Galeazzo Alessi, a wide-ranging architect who had worked on – among other things – a series of grand residential projects, designed a spectacular facade for the fifteenth-century church of Santa Maria presso San Celso (fig. 19.4). As executed over the following decade under Martino Bassi, its differences from a contemporary Roman church like the Gesù are striking. There is no monumental Corinthian order imposing a dominant vertical orientation: when pilasters and columns appear, they do so only as part of an encrustation of ornament that also includes reliefs and a program of figurative sculpture devoted to the life of the Virgin. There is a sense, as in palace design, of several stacked horizontal tiers: an upper and lower facade echo each other in their dominant elements, separated by a kind of mezzanine

with reliefs of the Nativity, the Adoration of the Magi, and the Presentation, along with statues of angels and sibyls. A vertical accent appears – but only as a secondary theme – in the central doorway flanked by paired colored marble columns, picked up above in the paired columns and caryatids framing a great arched window. Santa Maria housed an important miraculous image, and the splendor and novelty of the facade helped to promote the cult and to attract people to the church. Alessi's design shows that notwithstanding Borromeo's concern with rules and uniformity, architects could still exercise considerable freedom of invention, and that for the Milanese clergy and patrons it was sometimes more important to have a local and distinctive building than one that adopted the sobriety of the Gesù or San Fedele.

In the figural arts, Borromeo favored viscerally emotional, lifelike scenes. Religious painting in Borromeo's Milan began to explore effects of melodrama, reworking

RIGHT

19.5

Antonio Campi,

Decapitation of St. John the Baptist, 1570. Oil on canvas, 9'5¼" x 6'3½" (2.88 x 1.92 m). San Paolo Converso, Milan

standard themes in order to magnify effects of pathos and violence. Among the most noteworthy painters active in the city were the brothers Campi from Cremona, who made altarpieces for religious houses favored by the archbishop. (Borromeo owned works by Giulio and Antonio Campi and kept an *Agony in the Garden* by Giulio before him as he lay dying in 1584.) Antonio's (*c.* 1522–1587) *Decapitation of St. John the Baptist*, painted for an altar in the convent church of San Paolo Converso, is unprecedented in its suspense-filled narration of the subject (fig. 19.5). As John extends his neck, his eyes well up with tears: a salver waits in readiness on the floor nearby. John looks toward the opening door of the prison, where

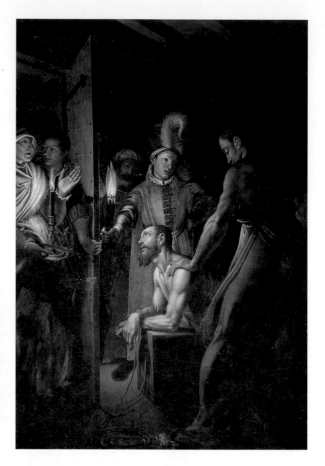

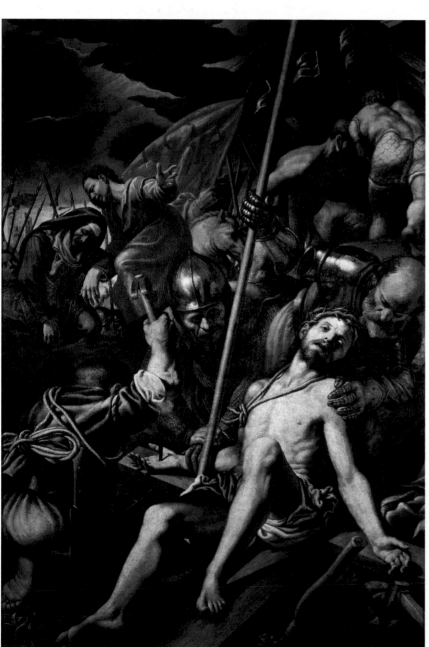

the gloating figure of Herodias enters alongside her smiling daughter Salome. The expressions and motivations of all the dramatis personae are revealed by torch and candlelight. The gloomy interior is almost monochromatic, except that the green tunic of the dandyish courtier who commands his death offsets John's livid flesh; the red sleeves of Herodias provide the other touch of color, drawing attention to her sudden intrusion into the cell.

In *Christ Nailed to the Cross* from 1577 (fig. 19.6), Antonio's younger brother Vincenzo (1536–1591) produced a harrowing image of physical torture. Like their Venetian predecessors, the Campi questioned the absolute supremacy of the Tuscan-Roman models advocated by Vasari; they sought to develop a new idiom of sacred art by studying the great figures of the local artistic past. Vincenzo here modeled his composition on the fresco of the same subject by Pordenone in the cathedral of his home town of Cremona, where Christ's foreshortened body seems to defy the picture plane itself (*see* fig. 14.27), but there is a marked difference of effect. Christ's open-mouthed stare, which at once expresses pain, tenderness, and reproach, addresses the viewer with an extraordinary intimacy, intensifying his or her involvement with the image.

Venice in the 1570s

Veronese on Trial

Publications like Borromeo's and Paoletti's ensured that the place of artistic invention in the depiction of sacred history would remain a controversial issue. Nowhere do we see this better than in Venice, where Paolo Veronese (1528–1588) found himself under investigation by the Inquisition in July 1573. The occasion was the commission of a *Last Supper* (fig. 19.7) for the refectory of the Dominican convent at Santi Giovanni e Paolo. Veronese's painting compressed the Biblical episode into the central arch of a great loggia in the style of Jacopo Sansovino (*see* fig. 16.23), against a prospect of marble buildings in a shimmering light that recalls the atmosphere of Venice and its canals. The Last Supper appears to be part of a great feast or celebration, in which sumptuously attired revelers participate along with soldiers, a dwarf, a black page, a man with a parrot, dogs, and other characters from the painter's festive repertoire.

The Inquisition took notice. They first gave Veronese the option of changing the dog in the foreground into a figure of the Magdalene, thus implicitly converting the picture into the episode (Luke 7:36) where Christ encounters a repentant prostitute while feasting in the house of a Pharisee. Veronese provoked them by argu-ing quite correctly, on the basis of pictorial decorum, that the Magdalene had no place in a *Last Supper*. At his trial, the inquisitors grilled Veronese about the inclusion of curiosities such as a man with a nosebleed and the clown with the bird. A question about the presence of "armed men dressed as Germans" attempted to attach the taint of heresy to the artist, or to allege that he was profaning the dignity of sacred painting. "Do you not know that in Germany and other places infected with heresy it is customary with various pictures full of scur-rilousness and similar inventions to mock, vituperate and scorn the things of the Holy Catholic Church in order to teach bad doctrines to foolish and ignorant people?" The question once again raises the specter of "the people," easily corruptible and led astray by images, even though a convent refectory was a setting likely to have a more restricted audience.

Veronese admitted that it was inappropriate to include "clowns, drunkards, Germans, dwarfs and sim-ilar vulgarities" in a *Last Supper*. He had painted them, he said, to add ornament to the picture. But he quali-fied this admission by stating that he was only doing what his "superiors" in the art of painting had done. In the Pope's chapel, he stated, Michelangelo's *Last Judg-ment* (*see* fig. 15.29) had included Christ, St. Peter, St. John, and "even the Virgin Mary" all naked "in different postures with little reverence." Ironically, the inquisitors

OPPOSITE, BELOW

19.6

Vincenzo Campi, *Christ Nailed to the Cross*, 1577. Oil on canvas, 6'10¾" x 4'7" (2.1 x 1.41 m). Museo del Prado, Madrid

19.7

Paolo Veronese, *Feast in the House of Levi*, 1573. Oil on canvas, 18' x 42' (5.5 x 12.8 m). Galleria dell'Accademia, Venice

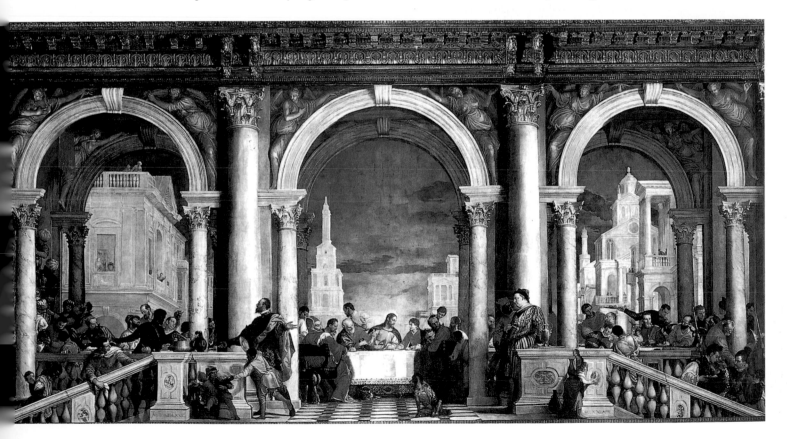

ignored the false description and defended Michelangelo, claiming that garments were not necessary in a *Last Judgment* and asserting that "in those figures there is nothing that is not spiritual." They gave Veronese three months to make changes in the painting, but he or the friars instead resorted to the expedient of simply re-baptizing it. Henceforth, it would go under the title *Feast in the House of Levi*, the episode (Mark 2:13–22) where a wealthy man in the company of "publicans and tax collectors" entertained Christ.

Veronese's painting is decidedly unconventional within the tradition of Last Supper imagery, but there is no indication that the friars of Santi Giovanni e Paolo found the painting unacceptable. Rather, the trial of Veronese indicates that in Venice, the prevailing standards of decorum differed from those of a Paleotti or a Borromeo or the Tridentine decrees. Veronese's approach responded to a particularly Venetian self-image, of the Republic founded on magnificence and luxury, famous for its carnivals and courtesans; he intentionally valorized such an image by making it the setting for events in the life of Christ. Yet more might be at stake in Veronese's decision to include buffoons and "vulgar" curiosities for the sake of ornament. Perhaps he meant to evoke a negative stereotype that attached to poets as well as painters – that both were practitioners of low and vulgar entertainment, like acrobats and fairground performers. We have seen that one of the speakers in Gilio's dialogue (*see* p. 526) had derided Michelangelo's *Last Judgment* because its figures engaged in behavior more suitable to a marketplace or a carnival than to a chapel. By playfully insinuating that painting is just a low form of entertainment, Veronese ridiculed not only the humanist assertion of painting's edifying character, but also the Counter-Reformation attempt to turn painting into an instrument of moral and doctrinal instruction.

Palladio's Redentore

At its height, the great plague of 1575–76 carried off four hundred people a day in the city of Venice; overall more than 25 per cent of the population died. As was the case in Milan and throughout Italy, the local population regarded the epidemic as an instance of God's wrath, requiring large-scale collective efforts of penance and appeasement. In 1576, the Venetian Senate voted in favor of the construction of a great new church, to be known as Il Redentore (The Redeemer) and to be located on the island of the Giudecca. The Senate commissioned the Redentore in fulfillment of a vow, thanking God for the divine favor he showed in stopping the plague. The state, the doge, and individual members of the government all committed huge sums, intending the building

to be magnificent, a further ornament to a city conceived as a great ceremonial space for the celebration of the Serene Republic's power and dignity. Every year on the third Sunday in July, the doge would lead a grand procession across the lagoon on a massive floating causeway to commemorate the Senate's vow. A prohibition against private burials, memorials, and chapels further underlined the public nature of the church.

Although Daniele Barbaro (*see* p. 540) had pressed for a centralized and domed structure, the design Palladio delivered in 1577 adopted a longitudinal solution, and in many respects attended closely to the formula recently adopted by the Jesuits in Rome and Milan (fig. 19.8). Some of the senators had wanted Il Redentore to be a Jesuit foundation with a college, but the body ultimately resorted to the less expensive option of placing the new church in the care of a community of Capuchin friars. The Capuchins, founded in 1529, followed a severe version of the Franciscan rule and counted among the exemplary religious orders in the epoch of Catholic reform (Barocci belonged to a lay branch of the Order). Like the Jesuits, who had found themselves the vehicle for Farnese ambitions in Rome a few decades earlier, the friars themselves were less than comfortable with the grandeur and sumptuousness of Palladio's church, which they saw as going against the ascetic and purist spirit of their rule. One of the friars protested that such "grandeur and magnificence" was neither "instigated nor wanted"

19.8
Andrea Palladio, Il Redentore, begun 1577.
Plan

OPPOSITE, TOP
19.9
Andrea Palladio,
Il Redentore. Interior

OPPOSITE, BOTTOM
19.10
Andrea Palladio,
Il Redentore. Facade

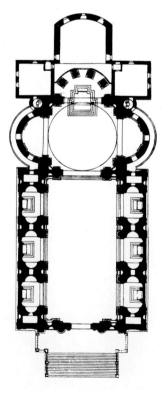

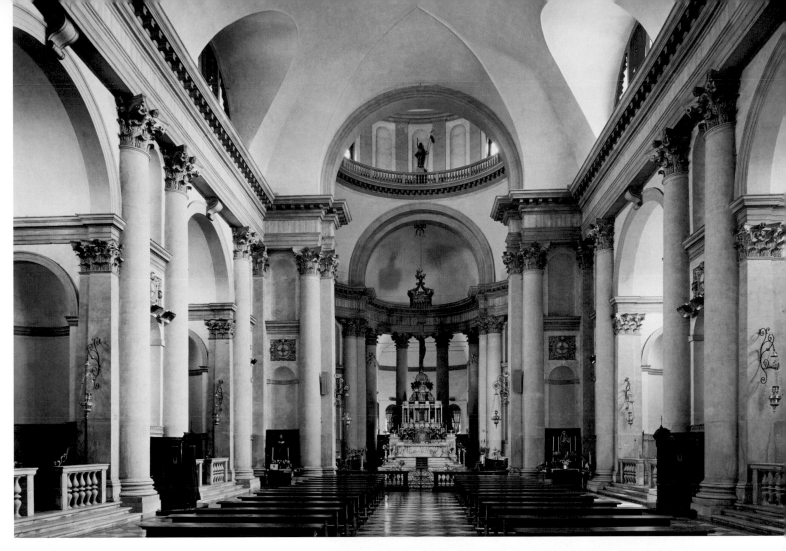

by the congregation, but that it was rather "a work of the Serene Dominion, which is made for their devotion and vow."

As with the Gesù in Rome (*see* fig. 18.4) and San Fedele in Milan (*see* fig. 19.2), the built church has no aisles; a series of three chapels joined by corridors flank the nave on each side (fig. 19.9). Instead of the Gesù's shallow transepts and choir, Palladio's design has three apses of identical dimensions framing the central dome. For the first time in Venice all of the altars follow a standardized design, in the manner of the recently renovated Santa Croce in Florence and the Gesù. The apse does not consist of a wall but of a screen of columns opening into the presbytery, which housed the church's resident clergy during services: the opening up of the wall at this point gives the interior a sense of physical lightness, of expansion rather than constriction.

The facade of the church suggests an architectural equivalent of musical polyphony (fig. 19.10). Several variations on the motif of the pedimented facade appear simultaneously in a rich and complex fusion of interpenetrating layers. The ultimate source of the design is Vignola's church of Sant'Andrea in Via Flaminia (*see* fig. 17.14), one of only two modern buildings admired

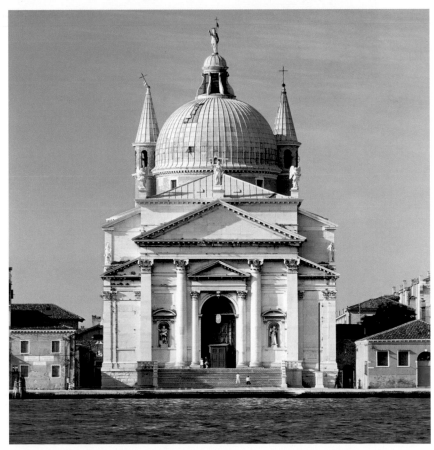

EX-VOTOS

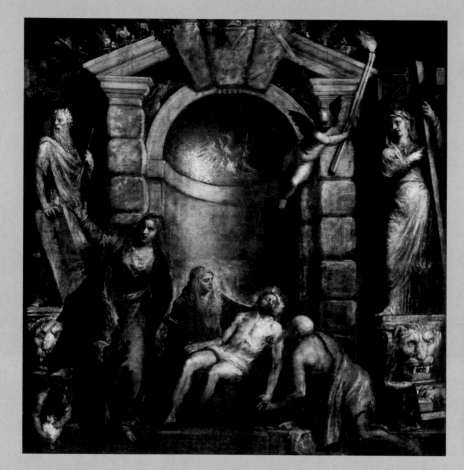

19.11

Titian, *Pietà, c.* 1576.
Oil on canvas, 12'4¾" x
11'4½"(3.78 x 3.47 m).
Galleria dell'Accademia,
Venice

19.12

Titian, *Pietà.* Detail of
ex-voto

In times of great suffering, individuals, families, and whole communities prayed to specific saints for intervention, promising to bear witness afterward and give thanks for divine aid with some tangible gift. The object that resulted, called an "ex-voto" (literally, "from the vow"), was frequently small in scale and simply rendered, though some were more elaborate. In cases of recovery from an injury, the donor might depict the tragedy itself or the afflicted body part: the goldsmith Benvenuto Cellini, for example, was briefly blinded by a splinter; when his sight returned, he presented a golden eyeball to the Roman church of Santa Lucia (St. Lucy, patron of vision). Like most Renaissance ex-votos, this does not survive, though modern silver depictions of hearts, arms, and other body parts drape chapels in

many functioning churches. When Domenico da Corella described Fra Angelico's paintings as "angelic," he was referring specifically to the doors that the friar artist had painted for a cabinet containing silver ex-votos.

The cabinet originally ornamented the shrine dedicated to the miracle-working image of the Virgin in Florence's Santissima Annunziata, the church that, through the sixteenth century, contained a dazzling collection of full-scale wax effigies. Most would have been by artisans whose names are not known to us, but occasionally, wealthier patrons called on more distinguished artists to make more striking works. After Lorenzo the Magnificent escaped an assassination attempt, for example, he had Andrea del Verrocchio produce a wax for the Annunziata, along with two others

for additional churches. Though these, too, are all now lost, they represented one of the most common forms that Renaissance ex-votos took, that of portraits. Not all votive portraits were three-dimensional, moveable objects, meant for placement in the company of a holy image. Just as often, in fact, the image was part of a larger painting. Piero della Francesca's portrayal of Sigismondo Malatesta venerating St. Sigismund shows a conventional arrangement of this type (*see* fig. 7.17), even if the exact circumstances of its making are unknown. Titian's Pesaro altarpiece, commissioned in gratitude for military victory, is another (*see* fig. 14.25). Perhaps the most sophisticated painted ex-voto of the Renaissance is a canvas Titian was preparing for his own tomb when he died (fig. 19.11). In addition to a penitent, grieving Magdalen, this includes the aged, barely clothed St. Jerome (who somewhat resembles the artist in his advanced years) praying before what appears to be a sculpted Pietà come to life in a niche. Behind the kneeling saint, leaning against the pedestal of a statue of Faith, is a painted ex-voto, showing an actual portrait of Titian, this time in the company of his son, praying before a second image of the Virgin (fig. 19.12). With this double gesture, the artist seems to be soliciting aid no less than giving thanks, hoping to ward off the plague that ultimately killed him and to be graced with salvation after his death.

The most dramatic Renaissance ex-votos are the churches that communities erected after the passing of various public emergencies. The monumental staircase that runs up the Capitoline Hill to the church of Santa Maria in Aracoeli in Rome, next to the seat of the government, was built after the Black Death in 1348, in the belief that the Virgin has driven away disease. During a plague of 1459, similarly, Ludovico II Gonzaga asked the plague saint Sebastian for help, and when the epidemic subsided, he commissioned Leon Battista Alberti to build the church of San Sebastiano in Mantua. The Venetian church of Il Redentore (*see* figs. 19.9–19.10) resulted from a comparable vow, this time on the part of the Venetian Senate, to erect a great basilica if Christ would save the city from an epidemic.

by Palladio in his guidebook to Rome (the other was Bramante's *Tempietto*, fig. 12.24, which as we saw had itself inspired Vignola's centralized design). The combination of a domed cubic volume fronted by a pedimented portico with a high attic is indebted to Vignola: Palladio adapted this to the more spatially complex form of the church, in order to reflect its interior divisions. Thus the engaged Corinthian columns of the portico correspond to the giant order of the nave, while the pilasters framing the chapels match the minor order that supports a second lower pediment, subordinated to and interwoven with the first. Another minor pediment appears above the main entrance, and segments of a fourth appear in an additional layer of facade that rises beyond the attic. The inventiveness and originality of the design suggest a desire to compete with Rome, not to comply with that city's norms.

Three Confraternities

Venice: The Scuola Grande di San Rocco

The plague also left its mark in the artistic commissions of one of the city's greatest confraternities, the Scuola di San Rocco. The confraternity's titular saint Roch, who had miraculously recovered from plague, was venerated throughout Europe as a protector against the disease. Like other Scuole Grandi, San Rocco functioned as an elite club for non-noble citizens; membership was a sign of prestige, and wealthy members were preferred (among them Titian, who had painted an allegedly miraculous *Christ Carrying the Cross* for the neighboring church of San Rocco in 1510). The purpose of the group, however, was charitable activity for the poor and the sick, and this shaped the confraternity's approach to the decoration of its property. The Scuola's Meeting House was among the largest and most imposing in the city. In two campaigns, from 1564 until 1567, and again from 1575 to 1588, Tintoretto decorated the principal interiors of this building with a remarkable series of fifty-two canvasses. It is the largest ensemble of work by a single painter to survive from the Renaissance, and it also includes one of the largest paintings on canvas ever made – the colossal *Crucifixion* (1565; fig. 19.13), which covers an entire wall of the Sala dell'Albergo (Boardroom). Tintoretto clearly sought to make the San Rocco series into a monument to himself and to his art, and he went to extraordinary lengths to ensure that he alone would fulfill the commissions. The 1564 competition held to select an artist required painters to prepare a design for a ceiling panel showing the apotheosis of St. Roch. Tintoretto prevailed against Federico Zuccaro and Veronese by making a finished painting and

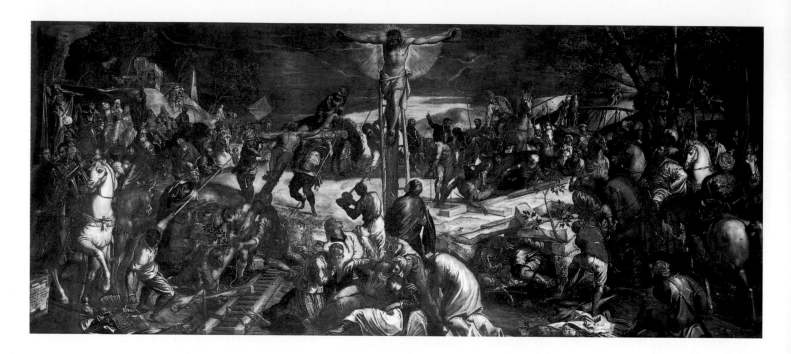

19.13

Tintoretto, *Crucifixion*, 1565. Oil on canvas, 17'7" x 40'2" (5.36 x 12.3 m). Sala dell'Albergo, Scuola Grande di San Rocco, Venice

contriving to have it installed in situ. What decided the outcome following such a blatant flouting of the rules was the painter's offer of the canvas as a gift to the Scuola, in place of claiming a fee. On other occasions in the following years Tintoretto would again resort to the expedient of gift giving, or would lower his prices so as to undercut any competition. By such means he overcame resistance among some of the Scuola's high-ranking members, who openly disliked the artist's pushy entrepreneurism and his idiosyncratic, tumultuous style.

The paintings in the Sala Superiore (Upper Hall), which Tintoretto began to contribute in 1576, follow a loose typological program with Old Testament scenes of miraculous salvation depicted on the ceiling, and episodes from the life of Christ (including the Resurrection and Ascension) on the walls. Both series share a common emphasis on the themes of food (*Israelites Gathering Manna, Adam and Eve with the Forbidden Fruit, Elijah Fed by the Angel, Passover, Christ Multiplying the Loaves and Fishes, Temptation of Christ, Last Supper*) and of healing or deliverance (*Jonah and the Whale, Sacrifice of Isaac, Daniel in the Lion's Den, Raising of Lazarus, Pool of Bethesda*). The cycle thus not only unfolds the general theme of Christian salvation and its Old Testament prefiguration, but also reflects more local preoccupations: the Scuola's care for the poor and the sick, the invocation of saintly intercession during a time of sickness. The charitable work of the Scuola is clearly signaled in the appearance of two "plague saints," Sebastian and Roch, and the central ceiling canvas, the largest in the room, depicts the episode of the Brazen Serpent (**fig. 19.14**). In Numbers 21, God punished the Israelites who "spake

against God and against Moses" by sending a plague of venomous reptiles; they killed and wounded many of the Israelites until Moses set up a talismanic image of a bronze serpent on a cruciform pole, the sight of which cured the afflicted. Viewed from underneath, as if we were looking from the base of a steep slope, the piling up of lifeless and dying bodies is horrifying, like the sight of the damned in a *Last Judgment*: Tintoretto is aiming to recapture Michelangelo's effects of awe and terror (**see fig. 15.29**), though the apocalyptic theme also responds to the Venetian belief that their own plague was a form of divine judgment.

Moses, seen through a halo of angelic light, directs the Israelites to look toward the image of their salvation, as does a woman who gestures dramatically from the center of the composition. Above, Tintoretto has added the figure of God with a glory of angels. As in the Sistine *Last Judgment*, the artist shows the divine figures on a larger scale, as if they are closer to us, even flying just above our heads. What is distinctly non-Michelangelesque is Tintoretto's organization of the pictorial space into flickering patches of light and dark, as though it were a stormy sky with light breaking through at intervals. The illumination is in large part independent of the grouping of figures, thus enhancing the sense that we encounter them not on a stage but under real conditions: the motion of bodies works as a kind of counterpoint to the dynamic play of light and dark. God is almost completely engulfed in shadow, an effect that would be unthinkable in Florence or Rome; the motif may have added to the artist's controversial reputation in Venice.

19.14
Tintoretto, *The Brazen Serpent, c.* 1577. Oil on canvas, 27'7" x 17'1" (8.4 x 5.2 m). Sala Superiore, Scuola Grande di San Rocco, Venice

RIGHT
19.15
Tintoretto, *Moses Striking the Rock*, 1577. Oil on canvas, 18' x 17'1" (5.5 x 5.2 m). Sala Superiore, Scuola Grande di San Rocco, Venice

Equally dizzying in its effect is the nearby ceiling canvas of *Moses Striking the Rock* (fig. 19.15), where great arcs of gushing water, barely caught in the pitchers and basins of the thirsting Israelites, seem to cascade in the beholder's direction. Here again the looming figure of God outstrips all the others in scale: it is as though we are looking through transparent media – water, the crystalline sphere that bears the figure of God – at a flaring sky with a great commotion of figures and horses beyond. The brushwork is even more rapid and more cursory. Such speedy execution adds to the overall sense of energy and movement, of the flickering transience of light, but in Tintoretto's case it also had an economic and ideological dimension. Painting quickly, and often as here with a restricted range of color, enabled Tintoretto to maximize his output and to lower his costs. Such a practice reinforced the image of Tintoretto, the self-styled "little dyer," as an entrepreneurial craft worker without the humanist pretensions of a Titian or a Vasari, and this could have suited the needs of the confraternity at

this moment. Both Catholic reformers and the Senate itself had criticized the Scuole for their expenditures on buildings, paintings, feasts, and ceremonies with funds that should have gone to the charitable support of the poor. Tintoretto's low costs, the plebeian values that attached to his name, and his "impoverished" technique would all have allowed the Scuola to cultivate the appearance of humility and sacred indigence.

If this was how Tintoretto's technique was understood, it did not compromise his reputation as an extraordinarily gifted artist, widely appreciated by fellow painters such as the Carracci in Bologna, and – especially after Titian's death in 1576 – sought out by the Gonzaga, Philip II of Spain, and Emperor Rudolf II in Prague, just the kind of courtly clients who collected paintings by the older artist. His success was more than a matter of his pricing strategy (as Vasari cynically implied): it lay in his power of invention, his capacity utterly to transform and revitalize a standard pictorial subject. This can be seen especially in the Marian subjects for the Scuola di San Rocco. *The Adoration of the Shepherds* (fig. 19.16) lends an uncompromisingly humble setting – the dank cowshed with its roof partly missing – a sense of hierarchical dignity. Even while reclining on straw in a hayloft, the Virgin majestically unveils the shining infant before two stately midwives (one of them, with breast bare, apparently serving also as a wet nurse). Through the beams of the roof, angels appear along with more of the crystalline substance through which Tintoretto evokes divine light. He conceives the picture as an incongruous royal presence in an unexpected setting, a point he makes by having a peacock walk among the farm animals

19.16
Tintoretto, *The Adoration of the Shepherds*, 1578–81. Oil on canvas, 17'9" x 14'11" (5.42 x 4.55 m). Sala Superiore, Scuola Grande di San Rocco, Venice

19.17
Tintoretto, *Annunciation*,
1583–87. Oil on canvas,
13'10" x 17'11" (4.22 x 5.45
cm). Sala Terrena, Scuola
Grande di San Rocco,
Venice

and racked implements. The shepherds, bearing their humble gifts in baskets, occupy this lower zone, pointedly closer to us.

The same apparent desire to recognize but also integrate social hierarchies is also manifest in the *Annunciation* (fig. 19.17), executed a few years later for the lower floor of the Scuola. Once again the painter has used architectural elements to enrich the internal space of the picture: through an open doorway flanked by a ruined classical column, the angel Gabriel thrusts himself into the bedchamber of the astonished Virgin. Equally mindful of physical and earthly boundaries, a stream of Cupid-like child angels enters through the square window above the door, following the flight of the Holy Spirit. The space outside vividly captures the clutter of a carpenter's yard, where a surprisingly young St. Joseph is hard at work. The particulars of the setting deliberately send mixed signals: the scene of manual labor, the physical decay of the doorway, and the broken rope chair within all address the Scuola's need to keep the image of deserving poverty before their eyes. At the same time, the carved and gilt wooden ceiling, like the canopied bed, suggests that this is more than an ordinary carpenter's home.

Arezzo: The Confraternity of the Misericordia

Federico Barocci (*c.* 1526–1612) had been forced to abandon his promising career in Rome following a severe illness in the late 1560s; he had returned to his native Urbino, where he would continue to live and work for another forty years. Although Urbino was not a major artistic center like Rome or Florence, and although his illness allowed him to work only at the slowest pace, Barocci would prove to be among the most successful, most sought after, and most influential artists of the later sixteenth century. The painter was famous for his devotion: he produced only a single surviving picture on a secular theme in his lifetime. He developed a signature style that appealed to the proponents of Catholic reform, yet he also dedicated himself to self-consciously artistic ends, melding an ideal grace and formal refinement reminiscent of his fellow Urbinate Raphael with a softness of texture and effects of shimmering light and color that show close study of Correggio and of Andrea del Sarto. In fact, Barocci can be credited with a rediscovery and popularization of Correggio that would continue well into the seventeenth century. Barocci recognized that

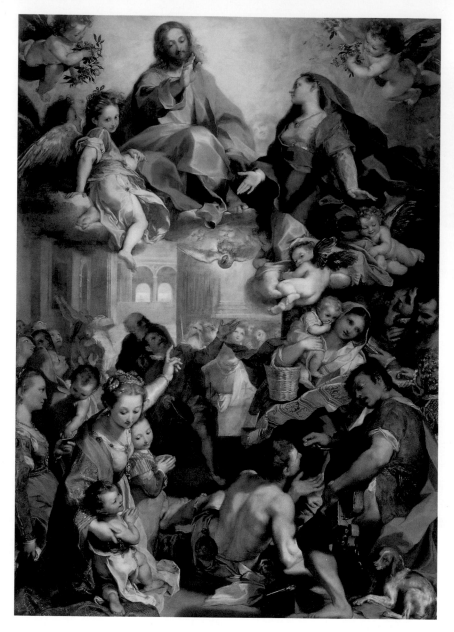

19.18

Federico Barocci, *Madonna del Popolo*, 1576–79. Oil on panel, 11'8" x 8'3" (3.59 x 2.52 m). Uffizi Gallery, Florence

19.19

Federico Barocci, study for the *Madonna del Popolo*. Black and red chalk, heightened with white chalk, with touches of yellow and pink pastel on blue paper. Yale University Art Gallery

Correggio's communicative power lay in the allure of his tender figures, their softly modeled flesh and florid harmonies of complementary colors. Barocci's own color is more artificial, with forms veiled in a haze of pastel hues. Smiles and delicate intimacy pervade their interactions, and even the adults seem to retain the fleshiness and rounded proportions of children. Where academic art theory and practice had come to turn on the dichotomy of (Tuscan) drawing and (Venetian) color, Barocci showed how Correggio constituted a "third way." Drawing still precedes color in establishing a sense of solid three-dimensional form, but it pursues effects of *sfumato* rather than the strong silhouettes of Bronzino's or Vasari's statuesque figures. Color has an ornamental and arbitrary character, as in Tuscan art, but it is richer and more intense, reinforcing the fleshy solidity of the figures. Sometimes Barocci even made drawings in oil, confounding the distinction between *disegno* and *colore* altogether.

In 1575 the confraternity of the Misericordia hired Barocci to provide an altarpiece for the church of Santa Maria della Pieve in Arezzo. Arezzo was Vasari's home town, and the confraternity had in fact originally awarded him the commission. The choice to go with Barocci rather than a Vasari follower after the older artist's death in 1574 represented a deliberate rejection of the academic values of Florentine painting, with its programmatic imitation of canonical art and its assertion of *disegno* over *colore*. This would have an impact in Florence itself, indicating a sense that the Vasarian formulas had exhausted themselves. When the work known as the *Madonna del Popolo* (*Our Lady of the People*) (fig. 19.18) was installed in 1579, the leading Florentine artists traveled to Arezzo to study it, and the duke invited Barocci to the Medici court.

Barocci began all of his works with an exhaustive process of preparatory drawing, and this painting was no exception. After working out a large compositional study (fig. 19.20), he made a series of more focused drawings of key characters. He conceived the poses of the infant at the lower left and the blind hurdy-gurdy player at the lower right as nudes (fig. 19.21) before clothing them in the final painting; both enact complicated twists worthy of Michelangelo. Barocci probably worked out the posture of the Virgin in the same way, perhaps even studying from a nude male model. Many of the drawings bear evidence of squaring, which the painter would use to transfer figures or parts of figures to the panel. They also

show a remarkable range of media: the study now in Chicago includes pen, wash, white heightening, and various chalks (fig. 19.19); many sheets employ the relatively new medium of pastel crayon, a mixture of pigment and gum arabic applied "dry" to the page. Pastel allowed the artist to adhere to the principle that painting began with *disegno*, while also permitting him to think about color and even about *sfumato* effects right from the outset.

The confraternity had proposed that Barocci paint "the mystery of the Misericordia," probably expecting him to show the Virgin protecting confraternity members under the folds of her mantle (compare Fra Bartolomeo's image, fig. 13.40). Barocci replied that such a subject was "ill suited to the making of a beautiful painting," and suggested another Marian theme – an *Annunciation*, *Visitation*, or *Assumption*. In the end, however, Barocci departed from all of these standard subjects – and thus from the insistence on the part of Counter-Reformation writers that religious painting not include anything "unusual" – in favor of something almost entirely new. He retained the theme of the Virgin's protection of her devotees; it is still possible, in fact, to read his Virgin as a Misericordia type, extending her arms to encompass her followers beneath. At the same time, Barocci focused the picture on Christ by showing the Virgin interceding with her son, who makes a gesture of blessing while the Holy Spirit descends. The lower zone characterizes "the people" who receive that blessing: an elegantly attired woman with two children, two other more modestly dressed mothers (one of whom receives alms from a child), a naked and crippled man, a blind musician. The group in profile to the right and in the background may include members of the confraternity, but the main focus is on those who benefit from

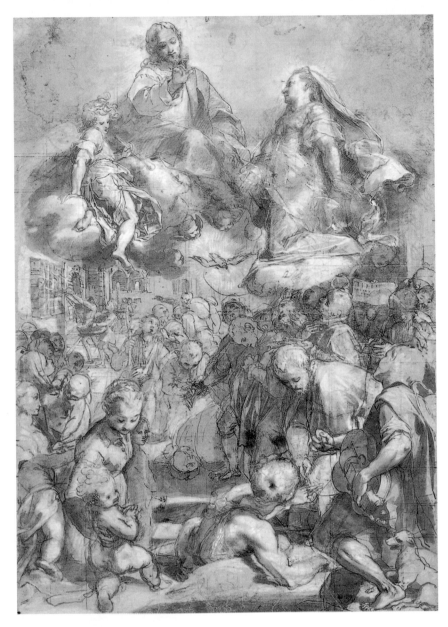

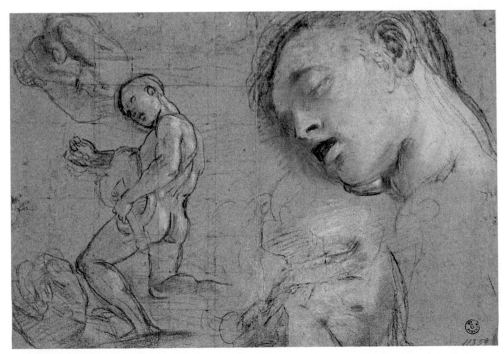

the confraternity's charity and ministry of prayer. The painting acknowledges its patron but also seems directed at a wider public, to whom it gently advocates pious acts and good works. The allure of Barocci's invention rests in large part in the anecdotal presentation of its "characters" – while the mother to the left directs her little boy to pray to the Virgin, the child seems more captivated by the street musician. The reassuring message is that such innocent pleasure in human art, far from offering vain distraction, is blameless and even blessed by the Virgin and Christ.

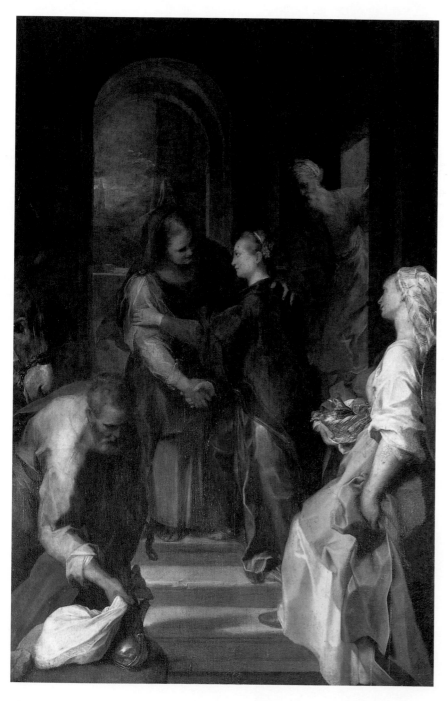

19.22
Federico Barocci, *Visitation*, 1583–86. Oil on canvas, 9'4¼" x 6'1½" (2.85 x 1.87 m). Chiesa Nuova, Rome

Barocci enjoyed enormous renown in the wake of this commission, with demand for his works in Milan, Rome, and other centers. Perhaps the ultimate endorsement came from the report that the saintly founder of the Oratorian Order, Filippo Neri – widely revered before his death and subsequent canonization – passed hours in Rome's Chiesa Nuova before Barocci's *Visitation*, in a mood of quiet contemplative rapture that the painting itself seems to set (fig. 19.22). The episode in Luke's Gospel, where the pregnant Mary is greeted by her cousin Elizabeth, whose own unborn child John "leaps in her womb," had long been a subject for altarpieces. Previous treatments tended to abstract the encounter from a narrative context, sometimes presenting the two women in the anachronistic company of Christian saints. Barocci has envisioned the scene taking place in a modest household near Urbino, whose famous ducal palace can be seen in the landscape beyond the arch. He has added the figures of the women's husbands, unmentioned in the Gospel account, and found roles for them to perform: Joachim leans out of a doorway to observe the exchange while Joseph fetches a sack. Finally, he has introduced another unnamed character, the woman with the straw hat and basket of chickens, who seems to share in the joyous intimacy of the two women. Her role is to provide a model for the same kind of empathetic involvement on the part of the beholder, whether Filippo Neri or the ordinary congregants who came to worship at the Chiesa Nuova. The case of Barocci indicates that the call for a reform of religious art could spur artistic initiative and entrepreneurism, and that the most successful solutions were devised by artists entirely independently of the prescriptions of a critic like Giovanni Andrea Gilio (*see* p. 526) or an influential bishop like Paleotti.

Rome: The Oratory of the Gonfalone

The Confraternity of the Gonfalone (the Banner) was the oldest in Rome, dating back to the 1260s. Like the Venetian Scuole Grandi, it had long drawn its membership from among the great Roman families, and it prided itself on its public rituals. For much of the confraternity's history, these had included the performance every Good Friday of a "Passion Play," a dramatic representation of the torture, death, and resurrection of Christ. But like many other organizations of its kind, the Gonfalone found itself increasingly forced to adapt to a more authoritarian spirit within the Church. After its Passion Play of 1539 worked audience members to such a zealous hysteria that they sought to murder the actors playing the Jews and then to attack actual Jews in the city, the Pope prohibited further performances. Deprived of the traditional rituals that gave it visibility, the confrater-

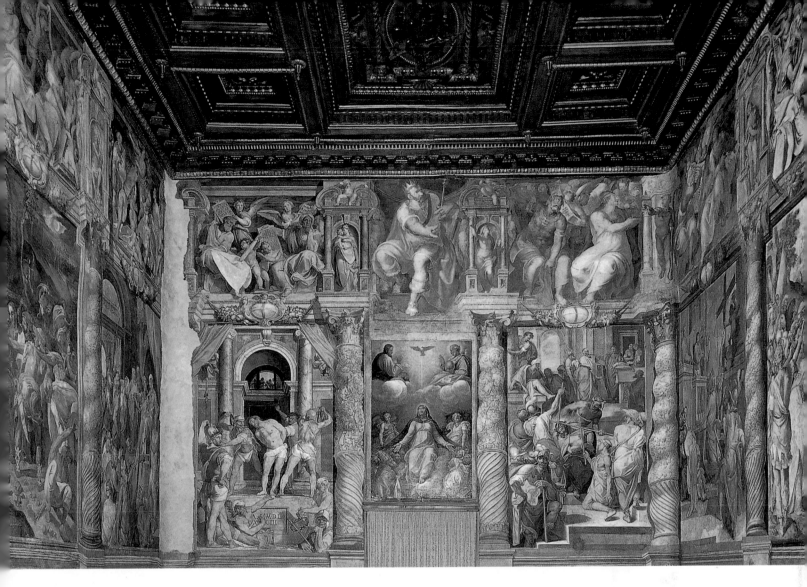

nity needed to find a means of expressing its traditional rights and prerogatives. It expanded on another of its traditions. On the day before Good Friday (referred to in English as "Maundy Thursday," or Holy Thursday), the brotherhood ceremonially enacted its charitable duties by providing twelve poor people with a feast in its oratory, and washing their feet in imitation of Christ's humble ministry to his Apostles at the Last Supper. After the suspension of its Passion Play, the brotherhood followed the ceremony with a torchlight procession from the Oratory to the Pauline Chapel, where other leading confraternities joined them. Afterwards at St. Peter's, the group venerated the most sacred of the basilica's relics: the veil on which Christ's face had left a miraculous image when Veronica wiped it during the ascent to Calvary and the spear with which the Roman centurion Longinus had pierced Christ's side while he hung on the cross. The procession drew a great deal of attention because of the bloody acts of self-flagellation performed by a number of its members, a return to the ritual action that had originally defined the company, even before it began placing emphasis on the Passion Play. Carlo Borromeo, a mem-

ber of the Gonfalone before he became archbishop of Milan and a famous exponent of self-flagellation, gave a major impetus to the practice by drawing up a general rule for flagellant confraternities that Pope Gregory XIII adopted in 1572.

Between 1569 and 1576 the company had its Oratory decorated by a team of artists that another illustrious member, Cardinal Alessandro Farnese, personally sponsored (fig. 19.23). The decoration includes an image of the Madonna della Misericordia: like Barocci's patrons in Arezzo (*see* fig. 19.18), the confraternity was devoted to the Virgin and took inspiration from her gesture of looking after the community. The dominant character in the imagery, however, is not Mary but Christ, a feature that points to the group's close identification – through the flagellations of Holy Thursday and the defunct Good Friday play – with the Passion. This emphasis on Christ's suffering and death did not preclude an exuberant, even festive atmosphere. The fictive architectural scheme refers to the so-called Solomonic Columns at St. Peter's, as well as to their citation by Raphael in the *Healing of the Lame Man* tapestry design for the Sistine Chapel (*see* fig. 13.15).

19.23
Federico Zuccaro, frescoes in the Oratory of the Gonfalone, Rome: Entrance wall

Solomon himself, modeled on the figure of Hesiod from Raphael's *Parnassus* (*see* fig. 12.52), appears above the image of the Madonna della Misericordia on the entrance wall, flanked by equally Raphaelesque groups of prophets and sibyls. The decoration manages to profess the confraternity's service to the ordinary laity of Rome, even as it adopts the ornamented idiom of the Vatican and of Roman palace decoration that would have made the confraternity's aristocratic members feel at home.

Two scenes of the scourging of Christ that flank the entrance evoke the more popular spectacle of the Holy Thursday procession. In the *Flagellation of Christ* from 1573 (fig. 19.24), Federico Zuccaro (*c.* 1542–1609) produced an inventive re-working of a fresco of the same subject designed by Michelangelo and executed by Sebastiano del Piombo in 1516 (*see* fig. 13.29). The reference to the earlier work is striking, given that Gilio, in his treatise addressed to Alessandro Farnese (*see* p. 526), had criticized that fresco for being too graceful and insufficiently violent: Zuccaro imitates the bloodlessness of the origi-

nal, along with the idealized muscular body of Christ and the athletic movements of the torturers. The artist and his confraternal audience subordinated scruples about the decorum of Passion imagery (compare the more violent treatment in fig. 19.6 by Vincenzo Campi, who followed Pordenone) to ideals of beauty and ornament that were fundamental to Roman tradition and hence to their very identity. All of this shows why Zuccaro came to be the most authoritative representative after Vasari of what can be called the "academic" tradition, basing his work on an imitation of antiquity, Raphael, and the great artists of the early sixteenth century. This was the tradition that the Farnese and the more elite confraternity members favored.

But Zuccaro's stylistic commitment to academic values did not make him indifferent to more present concerns with orthodoxy, historical accuracy, and doctrinally effective images. The short column to which Christ is tethered resembled the supposed actual column of the Flagellation, housed in the Roman church of San Prassede

since the thirteenth century but never before depicted in representations of the subject. Zuccaro's attention to "authenticity" here reflects a more general interest in promoting the cult of relics in the face of Protestant attacks, as well as an increasing concern on the part of Catholic reformers with "true" material and documentary records of the Passion and the early Church.

Architecture and Urbanism in Counter-Reformation Rome

New St. Peter's

The greatest monument to the mass culture of reformed Catholicism is the new basilica of St. Peter's. For decades after the death of Bramante (*see* figs. 12.25–12.28), work on it had barely progressed. Such calamities as the 1527 Sack of the city (*see* p. 434) and frequent shortages of money interfered with building, and successive popes constantly revised the design – sometimes destroying newly built fabric – as Raphael, Baldassare Peruzzi, and Antonio da Sangallo the Younger debated the legacy of Bramante's conception. The board of works in charge of building St. Peter's had become a corrupt, self-sustaining bureaucracy.

Still, the appointment of Michelangelo as architect in chief in 1546 had helped establish a certain consensus as to the direction the building should take. Pope Pius V had forbidden Vignola, who took over as architect in 1567 following the brief tenure of Pirro Ligorio, from modifying Michelangelo's designs in any respect. Étienne

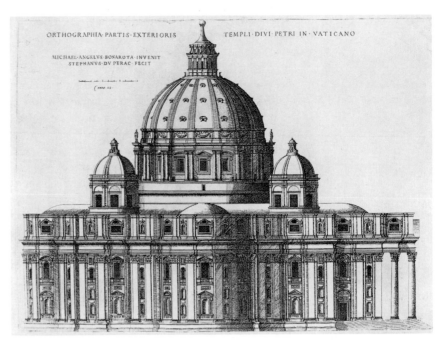

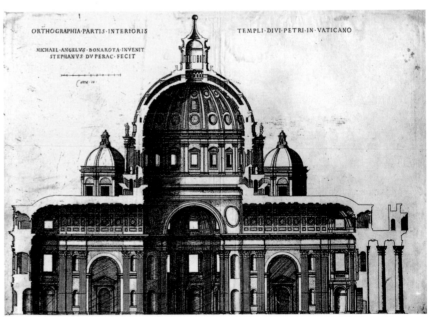

LEFT

19.27

Étienne Dupérac after Michelangelo, groundplan for St. Peter's, after 1569. Engraving. Metropolitan Museum of Art, New York

TOP

19.25

Étienne Dupérac after Michelangelo, south elevation of St. Peter's, 1569. Etching with engraving, 13³/₈ x 18¹/₈" (33.8 x 46.1 cm). Metropolitan Museum of Art, New York

ABOVE

19.26

Étienne Dupérac after Michelangelo, section of St. Peter's, 1569. Etching with engraving, 13¹/₄ x 18³/₄" (33.7 x 47.6 cm). Metropolitan Museum of Art, New York

Dupérac's 1569 publication of the plan, elevation, and section that Michelangelo had prepared before his death indicated that, changes in regime notwithstanding, these would provide a model going forward (figs. 19.25–19.27). Michelangelo's design of the Palazzo dei Conservatori on the Capitoline Hill, as we have seen (*see* fig. 16.27), had utterly transformed Bramante's formula for the use of the orders in a facade, and his designs for St. Peter's similarly returned to Bramante's early ideas. Once again, Michelangelo dealt with the problem of scale by employing the "giant order" that responded to the full height of the building rather than to a single storey. Though Carlo Borromeo had written that only the facade of a church should get ornaments in noble materials, the rest remaining unadorned, and though new large basilicas following the model of the Gesù did exactly that, Michelangelo followed Sangallo in stretching classical embellishment around the entire exterior. Michelangelo's perimeter facade is both richer than Sangallo's, in the variety of bay widths and window forms, and more unified (*see* fig. 19.25). There is a more emphatic verticality, a result of the giant Corinthian pilasters that rise to a massive entablature and a tall attic storey in which pilasters continue

their vertical ascent. The progression upward continues in the paired columns of the drum and the ribs of the pointed dome, a deliberate quotation of Brunelleschi's double-shell Florentine cupola (*see* fig. 4.6). Large tabernacle windows and niches visually minimize the amount of wall between the pilasters, which give the impression of "supporting" the entire structure; gigantic rectangular openings appear in the attic. Michelangelo also played with organic or anthropomorphic effects, treating the perimeter facade as a skin or elastic membrane. As the wall turns a corner, it gives the sense that the pilasters have momentarily gathered together, like a flexed muscle or joint.

If Michelangelo dramatically rethought Sangallo's ideas for the elevation of the basilica, he saved his most severe ridicule for Sangallo's model (*see* fig. 15.27). In a letter to the Board of St. Peter's, Michelangelo claimed that its darkness and its multiplication of spaces would simply create hiding places for all manner of sordid and illicit activity. Sangallo, he wrote, had "taken all the light from Bramante's design," and Michelangelo presented himself as the restorer of his former rival's intentions. Because he departed from business as usual in his supervision of the works, ignoring the numerous functionaries or accusing them of corruption, Michelangelo encountered much resistance: he hence adopted a strategy to which Tintoretto would resort some years later, of refusing any official payment for his work and presenting it as a pious gift. (In reality, the Pope matched Michelangelo's gift with lucrative reciprocal gifts.)

Michelangelo's plan sheared away Sangallo's nave, apse passageways, and corner pavilions, resulting once more in a centralized plan, now with bolder and smoother contours (*see* fig. 19.27). Rather than a cross set in a square, it now resembles a square turned on one corner: that corner opens the single point of entrance to the church, and would ultimately receive a great portico with a pediment. Although the plan resembles Bramante's early centralizing designs, it also considerably simplifies its supposed model: Michelangelo has reduced the subdivision of the interior space, keeping only the four great piers that support the dome. There were practical gains here, in that light now permeated the interior, while the quantity of masonry was reduced and the costs of building were considerably lowered. Perhaps the most significant effect is the emergence of a conception of architecture defined by the visitor's ability to grasp the interior space in its entirety. As pilgrims join the vast crowds who assemble there, they can experience membership of the Church as a great community, an organization defined by "the people" who constitute it. Thus Michelangelo's design lent itself to the architectural self-expression of the post-Tridentine Church.

19.28
Dome of St. Peter's, 1588–90, as executed under the direction of Domenico Fontana and Giacomo Porta

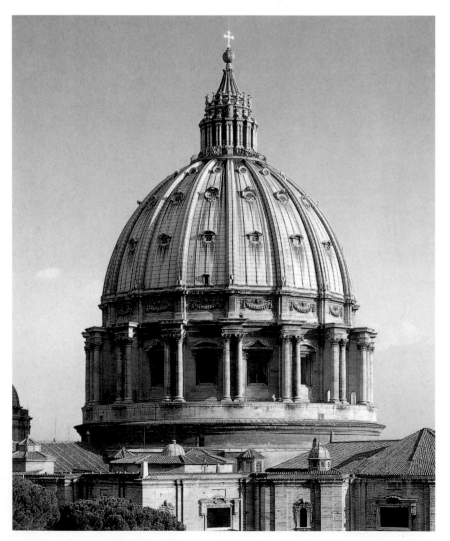

Following Vignola's death in 1573, Giacomo della Porta (c. 1533–1602) took over his post as chief architect for the building. Porta would oversee the construction of a modified version of Michelangelo's dome in 1588–91 (fig. 19.28), but his first endeavors centered on the decoration of the completed portions of the interior. At the behest of Gregory XIII, Porta outfitted a magnificent chapel under the dome of the north transept: the Cappella Gregoriana, dedicated to the Pope's namesake St. Gregory Nazianzenus, whose relics were installed under the altar in 1578 (fig. 19.29). On the same occasion, the authorities installed the miraculous icon of the Madonna del Soccorso ("Mary, Help of Christians") in the great altar tabernacle, adorned with ancient Roman columns from the Temple of Romulus. The incorporation of the icon made clear that St. Peter's was to be a church for the devotion and spiritual benefit of all Christian people, rather than elite patrons and donor families, who received no special rights in the basilica. It also signals not only the Catholic Church's approval of religious images, but the special status of older and more spiritually potent objects. No other paintings ornamented the chapel: it is faced entirely with colored marble in emulation of the Pantheon.

Streets, Squares, and Fountains

Pope Gregory had declared 1575 to be a Jubilee Year: he summoned faithful Catholics from across Europe to visit Rome and receive indulgences. To obtain these, pilgrims arriving in the holy city were expected to make repeat visits to the seven most historically significant Roman basilicas. Gregory thus initiated a project of opening new streets connecting the sites between which the masses of people would move, though the only such avenue completed in his lifetime was the street now called the Via Merulana, linking the church of Santa Maria Maggiore to San Giovanni in Laterano (the cathedral of Rome), beside which stood one of the two major papal residences in the city. What no doubt would have impressed later visitors more than the streets were the new fountains that Gregory used to mark the piazzas that framed churches and that served as the crucial nodal points for passage through the city. Fountains were important public works, since they provided fresh water for residents and pilgrims; they also demonstrated princely providence on the part of the Pope. Gregory was from Bologna and would have known the monumental fountain of Neptune erected there by Giambologna (*see* fig. 18.33); he also very likely knew of a second Neptune fountain in the Piazza della Signoria in Florence, completed in 1575 by Bartolomeo Ammanati (1511–1592) with a heroic male nude in marble at its center and surrounding figures in bronze (fig. 19.30), a grand climax to the outdoor gallery that began with Michelangelo's *David* (*see* fig. 12.3).

Realizing waterworks like this was no small feat. Whereas villa owners often took the presence of water into account when choosing where to build, in Rome the only major current was the Tiber. Areas distant from the river had once been served by a series of aqueducts, but by the Renaissance the only one of these that still worked was the Acqua Vergine (the ancient Aqua Virgo); it approached Rome from the mountains to the east, then

19.29
Giacomo della Porta, Cappella Gregoriana, completed 1578. St. Peter's, Vatican. **Interior**

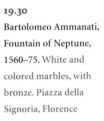

19.30
Bartolomeo Ammanati, Fountain of Neptune, 1560–75. White and colored marbles, with bronze. Piazza della Signoria, Florence

19.31

Giacomo della Porta, project for the Acqua Vergine, *c.* 1570. Vatican Library, Rome.

The drawing is oriented with east at the top and shows the water line that already came into the city from the Porta del Popolo (upper left). The extension that runs down the center of the page, below the church of Santa Trinita al Monte, corresponds to the present-day Via Condotti ("street of the conduits"). Lower down on the page, the aqueduct turns south, leading past the church of Sant'Agostino and into the Piazza Navona (lower right).

detoured around a set of hills to enter the city from the north, skirting the Pincian Hill and terminating at the Trevi Fountain. The Pope's plans involved expanding this, and he gave the task to Giacomo della Porta, the architect and engineer who had designed the facade for the Gesù (*see* figs. 18.5–18.7) and the Cappella Gregoriana (*see* fig. 19.29), as well as building bridges and repairing the city's sewer system. A surviving drawing (fig. 19.31) indicates that one of Porta's extensions of the system departed from what is today the Piazza di Spagna, ran under what is now the Via Condotti (the Street of the Conduits), turned at the Borghese Palace to run south along the side of Sant' Agostino, and ultimately fed the Piazza Navona.

What could not be missed were the ten new fountains Porta added to the squares connected by his waterworks. Most of these consist of large, simple, but finely worked stone basins, low to the ground so as not to distract from the weak jets that the limited water pressure allowed. A few, though, were more elaborate and could rival the monumental fountains already being created for Florence and Bologna. Pilgrims entering the Piazza del Popolo from the northern gate of the city would have been greeted by an impressive marble construction, built in 1573, in the traditional Tuscan form of a candelabrum, with a large basin at ground level and a smaller one higher up on the "stem." (The upper portion, ornamented with Pope Gregory's heraldic device of the dragon, can still be

19.32

Giovanni Battista Falda, view of Giacomo della Porta's fountain in Piazza Colonna, Rome. Etching, 7¼" x 11¼" (18.4 x 28.5 cm).

OPPOSITE, ABOVE

19.33

Giacomo della Porta and Taddeo Landini, Fountain in the Piazza Mattei, called the Fountain of the Tortoises, 1581–84, with later additions

OPPOSITE, BELOW

19.34

Jacopo Bassano, *Parable of the Sower*, 1564 (?). Oil on canvas, 4'6¾" x 4'2¾" (1.39 x 1.29 m). Thyssen Museum, Madrid

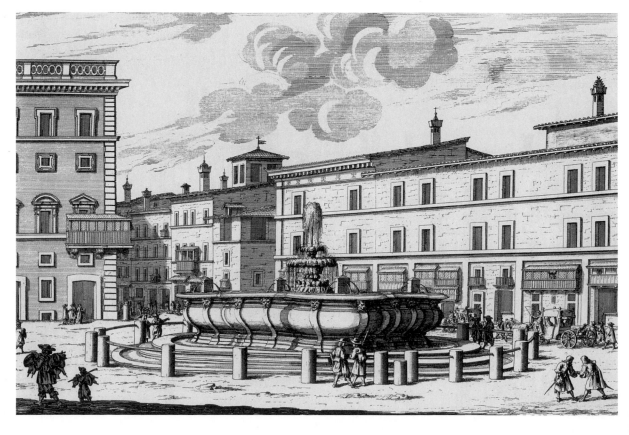

seen beside the Palazzo Borghese.) This was followed by the fountains in the Piazza della Rotunda (in front of the Pantheon) and Piazza Navona in 1575, and in the Piazza Colonna in 1576–77 (fig. 19.32).

Most charming of all, however, is the last major fountain undertaken under Pope Gregory, the Fontana delle Tartarughe, or Fountain of the Tortoises (fig. 19.33), now named for the bronze animals added to the structure in the seventeenth century. In its earliest form, collaboratively created by Porta and the Florentine Taddeo Landini in 1581–84, its truly distinctive feature would have been the four nude boys with dolphins, the first three-dimensional figures to appear on a Roman fountain since antiquity. The figures in fact comprise two types, virtual mirror images of one another, each of which is repeated once, giving passers-by the impression that they are seeing a single figure reflected and rotated in space, and inviting inspection from all sides. Porta planned the fountain for a communal location on the Piazza Giudea, at the entrance to the Roman ghetto (the walled sector where Jews were ordered to live, established under Pope Paul IV in 1555). The Mattei, an old aristocratic clan who owned several properties near the piazza, managed to persuade the civic authorities to erect it closer to their three main family palaces, in return for a commitment to pave and police the area. This was effectively an act of privatization aimed at enhancing the family's prestige within their ancestral neighborhood. They, like Gregory himself, wanted to be perceived as benefactors who brought clean water, law and order, and artistic distinction to the city.

The Image of the People

The Rise of Genre Painting

At a time when the Church increasingly promoted the idea that religious art should address the greater number of the Christian people, a new image of "the people" was beginning to emerge in art made for elite secular patrons. Depictions of the laboring poor had appeared in Christian art during the previous two centuries, especially north of the Alps. The Portinari altarpiece by the Flemish Hugo van der Goes (*see* fig. 9.2), with its unidealizing portrayal of the shepherds who adore the Christ child, is typical. Such imagery had long been a stimulus to painters in Italy, but in the late sixteenth century it gave rise to new forms of artistic specialization. One such specialist was Jacopo Bassano (*c.* 1510–1592), the head of a successful family workshop in the town of Bassano del Grappa near Venice. Jacopo painted altarpieces for local churches as well as for Venice itself, but he was best known for canvasses like the one generally called *Parable of the Sower*

(fig. 19.32). A cluster of figures, mainly women and children, huddle in the corner of a field: a man and a young girl attend to sheep and cattle, while an older woman sets out bread and milk on a white cloth. A younger woman with braided hair turns away in a delicate *contrapposto*, displaying her bare foot and shoulder to the viewer. Beyond her, a careworn figure scatters seed on the ground, some of which birds devour.

Early viewers, seeing the image, may have thought about a story told by Christ (Matthew 13:3–23; Mark 4:3–20; Luke 8:5–15), in which the seed eaten by birds served as a simile for the word of God that Satan snatched away from its recipients, while that which grew into corn represented the fruitful word that entered the hearts of those who attended to it. Yet there is rather little in the painting to reinforce that understanding: it is as if Jacopo wanted to encourage the association with the Gospel passages, yet also prevent the simple conclusion that he was illustrating scriptural parable. The reference to scripture, in other words, amounts to a poetic allusion; the momentary resonance with the word of God suggests that everyday life may possess a richer and deeper significance than might at first be apparent. The figures who dominate the foreground have nothing to do with the parable told by Christ, yet they are hardly insignificant to the composition – they are, effectively, its subject. Jacopo has focused on their absorption in the actions they perform, and on a lack of

self-consciousness with regard to the fact of being looked at. Their turning away from the beholder reinforces their quiet autonomy. Perhaps, the painting suggests, the fruits of the sower in this instance are not the spiritual gifts promised in the Gospel, but the more simple and mundane ones of bread, fertility, and family.

In the 1570s and 1580s, Vincenzo Campi painted several versions of a much sought-after series of market scenes: one set decorated the dining room of a Fugger castle in Augsburg. Here, the depiction of market stall proprietors is more confrontational as well as more comical, at least at first sight. There is no scriptural pretext: instead, the pictures would have allowed audiences to find comedy in labor and the laboring classes. In *The Fishsellers* (fig. 19.35), a suntanned man spoons beans into his mouth while talking with a smiling woman. Distracted from feeding her child, she also fails to notice that a crayfish has bitten the infant. Perhaps Campi meant this as social satire, as a comic meditation on vulgarity, gluttony, lust, distraction, and negligence: an author named Gabriele Faerno of Cremona had dedicated a book of moral fables to Carlo Borromeo in 1567, which presented the story of a boy bitten by a scorpion as a cautionary allegory about discriminating right from wrong. If the painting reminded viewers of this fable, however, it could also have emptied it of moral significance, turning the story into a random everyday event. A moralizing reading

19.35
Vincenzo Campi, *The Fishsellers, c.* 1580. Oil on canvas, 4'9" x 7'¹⁵/₈" (1.45 x 2.17 m). Pinacoteca di Brera, Milan

seems inadequate to the experience of the composition as a whole, which displays Campi's ambition to provide a copious spectacle of the natural and social world in their surprising coexistence. Here, the mundane world of the market is also a showcase for marvelous, even monstrous creatures of the deep.

The Universe of Labor in the *Studiolo* of Francesco I

Campi's paintings responded to a rising "culture of curiosity" among elite European viewers who took a learned interest – grounded in their reading of Roman writers like Pliny the Elder and Lucretius – in the diversity of the natural world, and increasingly also in the human social order. Human society now meant not just the different classes and occupations of the contemporary city and country, but the wider world and the diverse peoples of which Europeans had become newly conscious. The *studiolo*, which had housed marvels of art and nature along with books, was now turning into the more elaborate spaces for collecting to which the name "Museum" was sometimes applied. Those who assembled classical antiquities, modern works of art, and preserved specimens of plant and animal life, installed them all together as if in an attempt to represent the diversity of the world in miniature.

The most remarkable of the *studioli* constructed in the 1570s was the one put together by the Florentine Grand Duke Francesco de' Medici. This assembly, as it happened, was short-lived, and its dismantling in the early 1580s has presented challenges for attempts at reconstruction (fig. 19.36), but it is clear from the surviving architecture and from contemporary letters that the space was to reflect the order of nature, each of its walls being dedicated to one of the four elements (fire, air, earth, and water). For paired niches at the top of each wall, the best sculptors in central Italy had made bronze statuettes showing deities who presided over that element: the "Fire" wall, for example, included the sun god Apollo and the master smith Vulcan; the "Earth" wall included Pluto, god of the Underworld, and the Earth goddess Ops. Below the sculptures were cabinets containing rare artifacts, both natural and artificial, that could be associated with the same element. These cabinets, in turn, had doors and overdoors decorated with paintings, many of them landscapes, linking the contents to the geographical site of their recovery, to a classical myth about their origin, or to a "place" in a classical text that discussed the substance or object. On the "Water" wall, for example, over the cabinet containing amber, is Santi di Tito's depiction of the *Fall of Phaeton* (*see* also fig. 16.9): according to Ovid, the tears of Phaeton's sisters, mourning at his death, turned into amber.

Such mythological themes had been typical of the decoration of the princely *studiolo* for more than a

ABOVE

19.36

Studiolo of Francesco I, Palazzo Vecchio, Florence. General view of reconstructed room, 1556–61

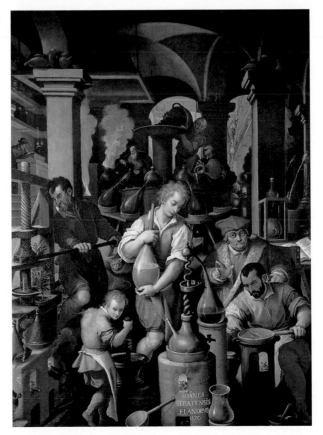

LEFT

19.37

Johannes Stradanus, *The Alchemist's Studio,* c. 1571. Oil on slate, 46 x 33½" (117 x 85 cm). *Studiolo* of Francesco I, Palazzo dei Priori, Florence

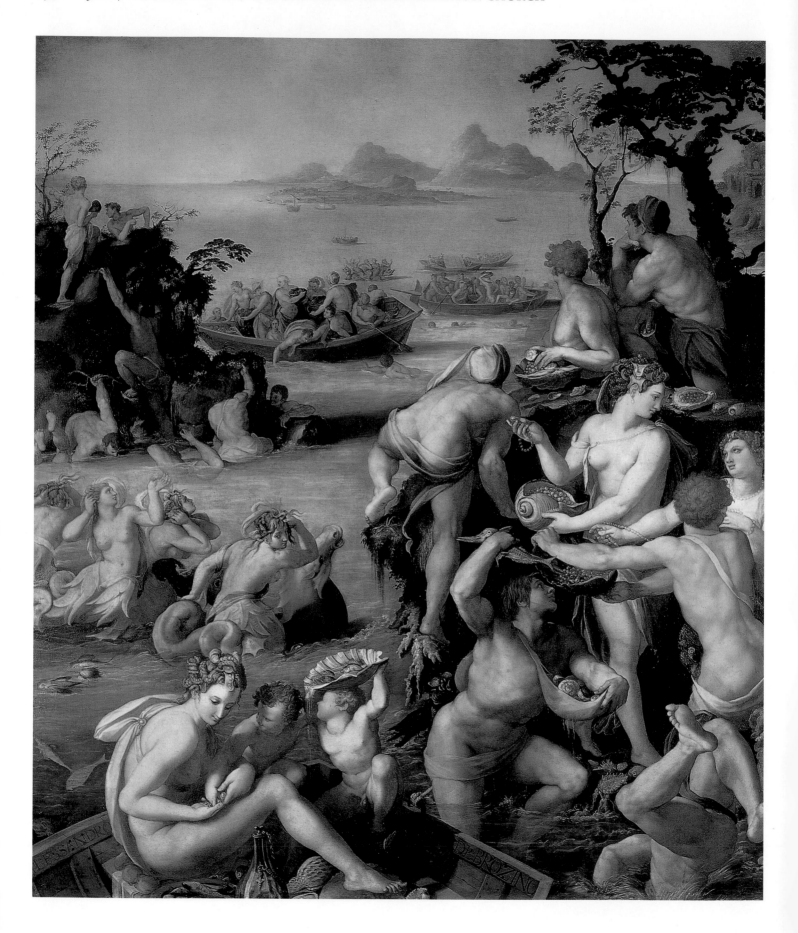

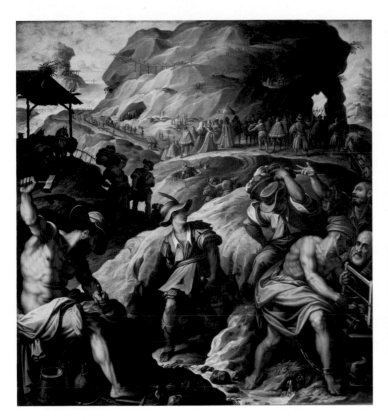

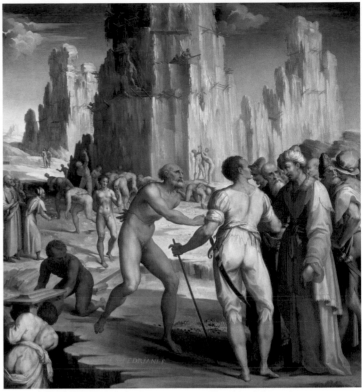

century, but what is surprising here is the appearance of several scenes depicting industrial labor and craft workshops: alchemists, glassblowers, a wool factory, a gunpowder factory, a bronze foundry, sometimes very contemporary in appearance: in one scene the Grand Duke actively participates in the work of the alchemists (fig. 19.35), as he did in reality; in another, he supervises glassblowers and goldsmiths (he himself had invented a method for making fake precious stones). The cabinet with the wool factory would have contained asphalt and chemical salts used in the preparation of wool; the cabinet with the alchemists contained mercury and other substances used in the laboratory, along with precious samples of the alchemist's art. The emphasis on craft and on industry signals the new importance to rulers of a culture of experiment and technological discovery that begins in the workshop of the artisan.

For the cabinet containing pearls, Alessandro Allori (1535–1607) contributed *The Banquet of Cleopatra*, a story recorded in Pliny the Elder's *Natural History*: in order to impress the Roman general Mark Antony with her enormous wealth, the Egyptian queen dissolves a priceless pearl in vinegar and drinks it. The story would have fascinated the Grand Duke, a practitioner of alchemy and a collector of recipes for the transformation and even fabrication of precious substances. On the wall over the same cabinet containing pearls appears *The Pearl Fishers* (fig. 19.38), also by Allori; the picture adapts the monumental bodies

of Michelangelo's *Battle of Cascina* cartoon (*see* fig. 12.12) into exquisitely ornamental figures in order to illustrate Pliny's description of pearl collecting in the ninth book of his *Natural History*, but the result can also be seen as a fanciful genre scene, an evocation of exotic lands now linked to Europe by trade and discovery.

Two of the paintings on facing walls show how the room stands as a kind of miniaturized representation of the world and everything in it. The Earth wall features a painting of native labor at the Potosi Mines in Peru, with the arrival of a Hapsburg administrator (Francesco was married into the Hapsburg family through his first wife Joanna of Austria) (fig. 19.39). The Air wall has a depiction of diamond mining by slaves at Bisnagar in India (fig. 19.40). The global, even "cosmic" imagery follows the practice of playing on the name of Cosimo, Francesco's father. Yet for all of its differences from earlier *studioli*, with their emphasis on the liberal arts, the short-lived Medici *studiolo* was fundamentally an image of consolidation, announcing the ruler's literal and figurative oversight of everything that happened in the world around him. The *studiolo* allowed Francesco to meditate on the diversity of the natural world, but fittingly enough, given its location next to the Great Council Hall in the Ducal Palace (which had formerly housed the government of a free republic), it also offered a metaphor of rule.

ABOVE LEFT

19.39

Jacopo Zucchi, *The Mines of Potosi*, 1570–71. Oil on panel, 45¹⁄₂ x 33⁷⁄₈" (116 x 86 cm). *Studiolo* of Francesco I, Palazzo dei Priori, Florence

ABOVE RIGHT

19.40

Maso di San Friano, *The Diamond Mines of Bisnagar*, 1570–71. Oil on panel, 45¹⁄₂ x 33⁷⁄₈" (116 x 86 cm). *Studiolo* of Francesco I, Palazzo dei Priori, Florence

OPPOSITE

19.38

Alessandro Allori, *The Pearl Fishers*, 1570–72. Oil on slate, 45¹⁄₂ x 33⁷⁄₈" (116 x 86 cm). *Studiolo* of Francesco I, Palazzo dei Priori, Florence

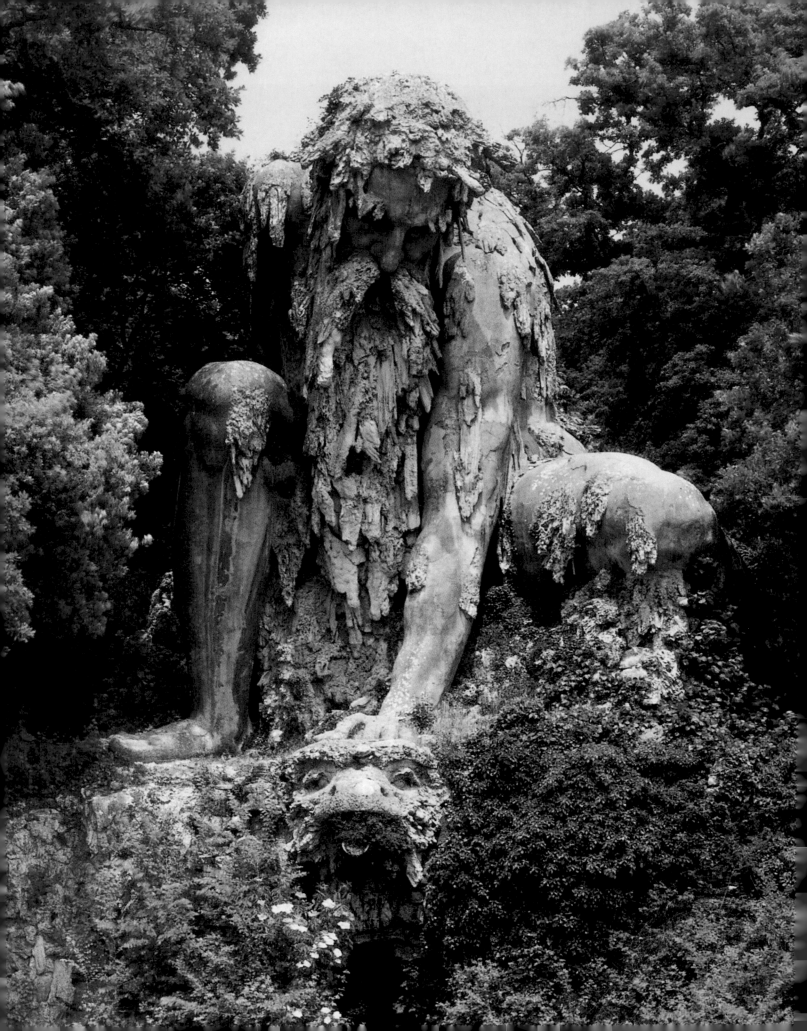

20

1580–1590
A Sense of Place

1580–1590
A Sense of Place

The previous chapters' discussion of the Counter-Reformation has returned repeatedly to the issue of decorum: the requirement, increasingly enforced by the Church, that artists approach their assignments with a sense of suitability and fittingness. The ceiling of a church required a different decorative approach from that of a palace, and the "extras" one could insert in an image of a wedding festival differed from those that belonged in a Last Supper. Often, the question of decorum turned on one of place, or rather of keeping things in their *proper* place. We should not, however, think of such considerations merely as a restriction. By the 1580s, artists and patrons were thinking through the relationship of art to place in creative ways.

Gardens and Grottos

Consider the towering marvel that Giambologna (1529–1608) built, beginning in 1580, on the hill by a pond behind the Medici Villa at Pratolino, just north of Florence. The *Appenine* (fig. 20.1) is a work that produces astonishment, even bafflement: is this a building or a sculpture?

20.1

Giambologna, *The Appenine*, 1580–83. Villa Medici (now Demidoff) at Pratolino

In fact, it is both. An entrance in the back led to a series of chambers distributed over multiple floors, which served as a retreat for Grand Duke Francesco de' Medici and his duchess: one could even sit in the head and fish from the eyeholes while looking out over the park. At the same time, the structure was also a figure, a personification of a mountain. This evoked the literary culture that all villas favored: it recalled the poet Virgil's description of the Titan Atlas ("fallen snow mantles his shoulders, while rivers plunge down the aged chin and his rough beard is stiff with ice"); and it emulated the legendary statues of the ancients, especially the colossus that, according to Pliny the Elder, the sculptor Deinocrates (*fl.* 370 BCE) proposed to carve from a mountain. Most obviously, though, it was an enormous, three-dimensional toponym, an embodiment of the actual location in which the visitor walked. The *Appenine* seemed to be made not from a quarried block, but from the hill itself. Constructed by attaching various types of mineral and stone to an architectural core, it encouraged the visitor to draw comparisons between the rising form of the giant and the origins of the real hill on which it was encountered, as well as between the massive strength the giant seemed to expend – pressing out water that turned into the pond before him – and the still bigger living force, unseen beneath the ground, that provided the garden's actual streams.

The visitor to the garden might at first be amazed by the figure, but the statue presents itself as nothing more than an aspect of nature. The sculpture attuned the viewer to a sense of animate life that runs through the whole park. In this respect, the *Appenine* was entirely characteristic of garden sculpture and the way this encouraged those who looked upon it to reflect on where they were. Gardens might evoke a variety of distant worlds – the Garden of Eden, or the Islamic gardens of Spain, known from travel accounts – but they drew especially on ancient Greek and Roman literature. Architectural forms reflected structures described in ancient sources, and statues showed ancient gods. Even the engineering was an antiquarian exercise, since the conception of the waterworks themselves was nearly contemporary with the earliest translations of Hero of Alexandria's *Pneumatics*, the fundamental ancient study of hydrology, probably written in the second century BCE. By the end of the 1580s, visitors to gardens like those at Pra-

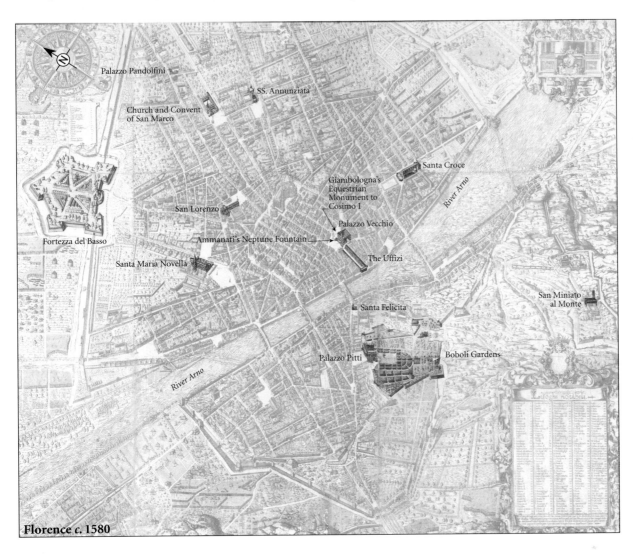

Florence c. 1580

Labels on map:
Palazzo Pandolfini
SS. Annunziata
Church and Convent of San Marco
Santa Croce
Giambologna's Equestrian Monument to Cosimo I
San Lorenzo
Palazzo Vecchio
Fortezza del Basso
Ammanati's Neptune Fountain
Santa Maria Novella
The Uffizi
River Arno
San Miniato al Monte
Santa Felicita
Palazzo Pitti
Boboli Gardens
River Arno

This map, based on Stefano Bonsignore's 1584 engraving (here ghosted), highlights some of the major sites of recent artistic activity in Florence.

tolino, the Villa Lante at Bagnaia (*see* figs. 18.16–18.17), or the Villa d'Este at Tivoli (*see* fig. 18.18) could have looked there for modern illustrations of Hero, or of the new vernacular literature that attempted to outdo him: Agostino Ramelli's 1588 book, entitled *Diverse and Ingenious Machines*, included scores of ideas for how to make water defy the pull of gravity (fig. 20.3).

In the garden, an evocation of ancient locale and an engagement with the immediate natural world regularly coincided. Nowhere is this more explicit than in the genre of garden architecture known as the grotto (from the Italian *grotta*, meaning "cave"), one of the best-preserved examples of which is the one Bernardo Buontalenti (*c.* 1536–1608) built in the Boboli Gardens behind the Pitti Palace in Florence beginning in 1583 (fig. 20.2). With their dripping water and their representations of mud oozing from walls and ceilings and congealing into rock formations, grottos gave the impression that the visitor was walking into the womb of the earth, seeing first-hand how contemporary scientists understood nature to operate: the earth was a massive living force that "gave birth" to plants, minerals, and animals.

All grottos consisted of imagery geared to the depiction of what happened in a subterranean world that villa owners or visitors would otherwise never see. The ornamentation of the Buontalenti grotto furthermore drew specific connections between natural creation and human art, incorporating into the walls of the first chamber four of the unfinished *Slaves* that Michelangelo had left in his Florentine studio on his death in 1564 (fig. 20.5). In their new role, the partially formed figures would have seemed to have been created by nature itself, as if Michelangelo had been magically attuned to what a "naturally" generated human form might look like, or as if a statue by him was merely the completion of a work that nature herself had begun. By the time Giambologna's *Venus* (fig. 20.4) was added to the innermost chamber of the grotto in 1592, the grotto included a series of painted and modeled pastoral scenes as well as Vincenzo de' Rossi's *Theseus and Helen*, a work the sculptor had made in Rome years before. Together, the images designated the grotto not only as a site of generation, but also a place for love, recalling, for example, the grotto where Hercules and Omphale dallied in Ovid's *Metamorphoses* (2:315).

587

20.2
Bernardo Buontalenti,
Grotta Grande ("Great
Grotto"), 1583–88. Boboli
Gardens, Florence

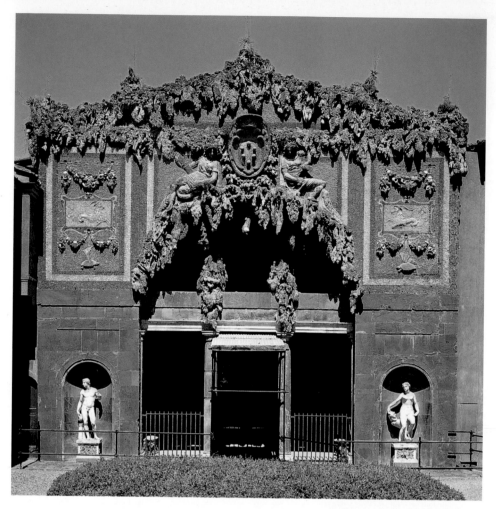

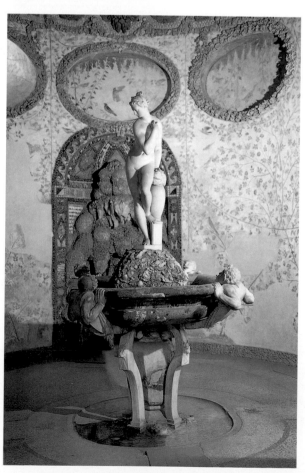

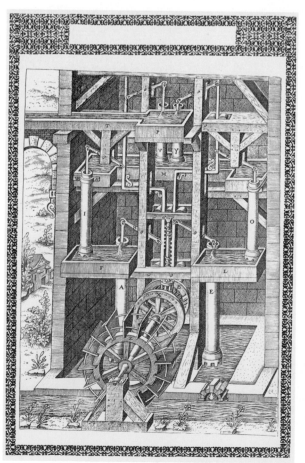

20.3
Agostino Ramelli, plate
from *Diverse and Ingenious
Machines*, 1588. Device for
raising water. Engraving

OPPOSITE
20.5
Bernardo Buontalenti,
Grotta Grande,
1583–88. Interior of
the first chamber, with
Michelangelo's *Slaves* (now
copies), embedded in the
walls. Boboli Gardens,
Florence

BELOW
20.4
Giambologna, *Venus of the
Grotticella*, 1592. Grotta
Grande, Boboli Gardens,
Florence

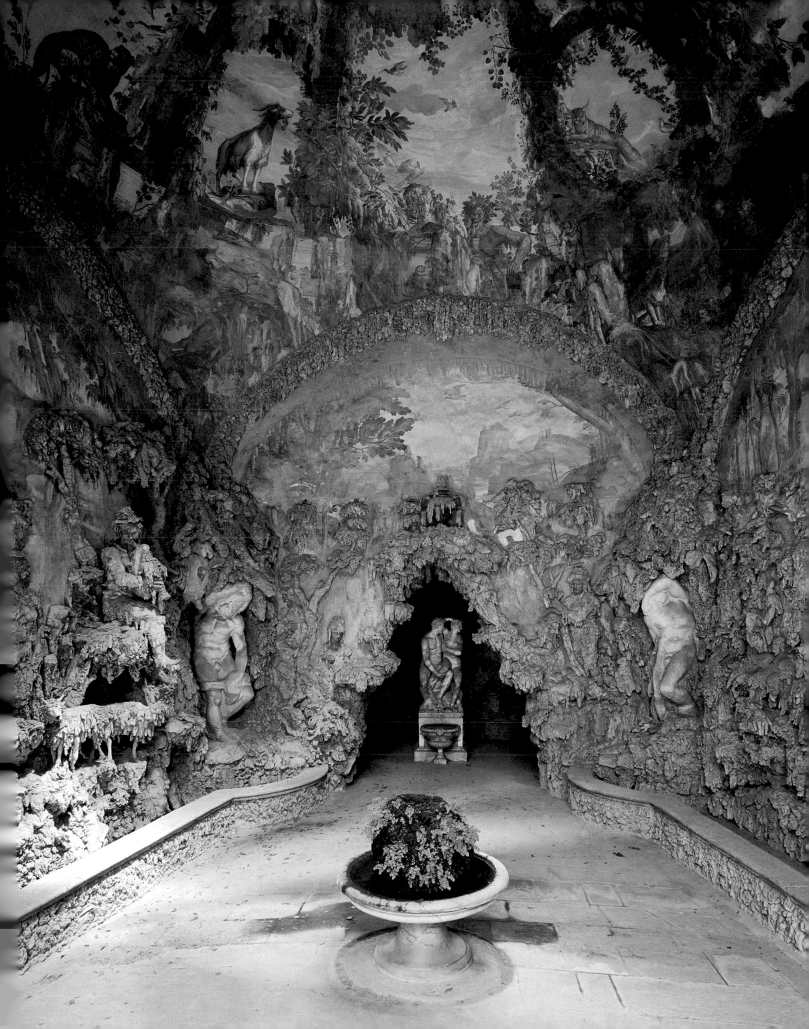

The Bolognese New Wave

The Carracci Canon

One consequence of the *disegno/colore* debate was a heightened awareness of styles of painting found in various cities and of the differences between them. The chauvinism that Giorgio Vasari demonstrated in his *Lives of the Artists*, which presented the modern Florentine manner as the culmination of all art history, provoked a backlash across the northern part of the Italian peninsula, as writers added angry marginalia to their copies of Vasari's books or even wrote rebuttals. Nowhere did artists devote more attention to the implications place might have for the way one painted than in Bologna, where the Carracci family in the 1580s founded an academy that at once emulated and opposed its Florentine predecessor.

 When we refer to the Carracci, we typically mean three people: Ludovico, his younger cousin Agostino, and Agostino's younger brother Annibale. Ludovico (1555–1619), the son of a butcher, seems to have begun his education as a painter in 1567, one year before Vasari published the second, definitive edition of the *Lives*. Ludovico's teacher was Prospero Fontana (*see* fig. 19.1), a painter who had served as Vasari's assistant, and who represented precisely the approach that Ludovico would eventually turn against. After about a decade in the Fontana shop, when Ludovico was in his early twenties, he began traveling. He went first to Florence, to see for himself what Vasari was

writing about, then to Parma, Venice, and Mantua before returning to Bologna. That path would have introduced him to many of the leading figures of his time, yet it was curious in one obvious respect: it omitted Rome, the city where the followers of Michelangelo and Raphael reigned, the center of Italy's antiquarian culture, and the primary destination of nearly all other painters who had undertaken study travels in the preceding decades.

 By the early 1580s, Ludovico was back in Bologna, where he established the independent family business he would refer to as an "academy." His insistence on this term – an unusual description to use in conjunction with a for-profit enterprise unconnected to any literary society or state institution – suggests he had Florence on his mind. The education that the Carracci academy espoused aimed at formulating an alternative to Florentine and, by extension, Roman, principles. Ludovico understood his challenge to the dominance of Vasari, Fontana, and Zuccaro as a reform of art; he also clearly considered this reform to align with the interests of reformers like archbishops Gabriele Paleotti and Carlo Borromeo (*see* pp. 556 and 558). In his religious paintings he pursued clarity of communication and avoided flourishes of *difficoltà* and *maniera*. Paleotti would very likely have approved of the *Annunciation* that Ludovico painted in 1583 for a Blessed Sacrament Confraternity (fig. 20.6), where, at the behest of Paleotti, rooms had been set aside for the instruction of local children in Christian doctrine. The picture is direct and simple: the Virgin adopts an exemplary attitude of devotion, and both she and the angel Gabriel seem to share a quiet joyfulness at the unfolding of the mystery of the Incarnation. There is little to distract the viewer in the plain domestic interior of the Virgin's house. The painting's direct appeal to understanding and to sentiment relies on Ludovico's careful study of earlier art in northern Italy: in particular, he imitates Correggio's soft modeling of the flesh and gentle palette, but in its old-fashioned Albertian perspective the painting also evokes the artistic world of the previous century, to the point of being deliberately archaic. Knowing audiences would have associated such archaism both with pious simplicity and with a rejection of the sophistications of "modern" art.

 Ludovico and his two talented cousins sought to base their reform on earlier moments in the formulation of the "modern manner": Correggio was important to them, but so was Raphael and his Roman workshop. Already in 1579, Agostino Carracci (1557–1602) – who would emerge as the most accomplished Italian engraver of his generation – had dedicated to Paleotti a large print (on seven sheets) of the *Adoration of the Magi* (fig. 20.7), based on a design by Raphael's associate Baldassare Peruzzi: it is as if, aware of the archbishop's interest in the reform of religious art, the

20.6
Ludovico Carracci, *Annunciation*, 1583. Oil on canvas, 6'1½" x 7'3" (1.83 x 2.21 m). Pinacoteca Nazionale, Bologna

20.7
Agostino Carracci after
Baldassare Peruzzi,
Adoration of the Magi,
1579. Engraving, composite
image on seven sheets.
Fitzwilliam Museum,
University of Cambridge

Carracci themselves were attempting to steer the cleric's
sense of acceptable artistic performance toward an ideal
drawn from the past that they themselves embraced.

Ludovico served as a mentor in these years to his
cousins, who in the course of the decade became his
chief collaborators. When Ludovico sent Annibale Car-
racci (1560–1609) on his own study trip in 1580 or 1581,
the youth went to Parma and to Venice, as Ludovico had
before him, but now skipped not only Rome but Florence
as well. What did Ludovico hope Annibale would learn
on these travels? A painting like the *c.* 1585 *Mystic Mar-
riage of St. Catherine* allows some inferences (fig. 20.8).

The strong modeling of the figures, the sense that faces
have been built up through *chiaroscuro* against a base of
brown middle tones, demonstrate a solid understanding
of the means Leonardo da Vinci had developed in Milan
for creating sculptural effects (compare, for example,
fig. 10.39). The *sfumatura* that envelopes the figures –
they are surrounded, indeed, by clouds, bodies of air
– might likewise have come from Leonardo, but the mys-
tic rather than naturalistic quality this lends the picture
sooner evokes Correggio's work in Parma (*see* fig. 14.19),
an impression reinforced by the softness, the youth-
ful tenderness, of the whole group. Where Annibale

591

them. Whereas earlier masters had often taught drawing by having students copy other drawings, or prints, or fragments of ancient statuary, the Carracci emphasized the study of the live model. This allowed students not only to learn the look of real bodies – atypical and unidealized forms (fig. 20.9) alien to most earlier artworks – but also to understand the way the anatomy of those bodies operated, to grasp the complexity of even casual poses and gestures from everyday life. Sometimes Annibale made drawings of figures from unusual angles, to practice foreshortening. Other times, he produced what appear to be portrait drawings, studies of faces – though in nearly all of these cases, the faces are of lower- to middle-class subjects whose names have not come down to us. Many of these portraits Annibale probably made by leaving the studio and traveling around the city with paper and chalk in hand. Drawings of landscapes confirm that he sometimes worked out of doors, and some sheets seem to show him working in other settings.

A red-chalk drawing in Windsor Castle, for example, depicts a man weighing meat (fig. 20.10). Evidently done from life, it functions as a study of pose and balance: Annibale is learning how to elide facial features on a head tipped slightly forward, how to treat an arm projected toward the viewer. It also works as a study of the costume and activities associated with a characteristic neighborhood profession, in this case the one that Ludovico's own father practiced. A number of Annibale's drawings seem to have been ends in themselves, but the meat-weigher makes a second appearance, as a main character in

departs both from Leonardo and from Correggio is in his attention to surfaces, especially textiles. The crossed velvet panels that form the borders of the angel's robe have a tactility worthy of Titian; Annibale differentiates this sharply from the silk of the robe itself, from the gold and pearls in Catherine's crown, and from the elaborate brocade she wears. The painting shows the artist mastering the means of the best painters from the north Italian tradition, and bringing them all together in a single picture. The very pursuit of such a synthesis amounted to an anti-Vasarian position, for it called into question the idea that in the wake of Michelangelo, one could learn all one needed from a single artist or in a single place.

Art from Life in the Carracci Academy

This is not to say that the Carracci rejected the principle of *disegno*. On the contrary, they proved to be some of the most avid draftsmen of the sixteenth century. They embraced drawing, however, not so much because it served as a vehicle for translating ideas into compositions as because it allowed the study of the world around

592

AMMANATI'S LETTER TO THE ACADEMY

In 1582, the sculptor-architect Bartolomeo Ammanati wrote a public letter to his colleagues at the Accademia del Disegno in Florence, with the purpose, he announced, of unburdening his conscience. In his earlier works, Ammanati stated, he had followed the practice of his predecessors and represented the human figure in the nude. Since it was now impossible for him to convey his regret for what he had done by covering these sculptures up, his only option was to confess his mistake and to warn those who came after him to avoid falling into the same error.

The letter points in particular to the new emphasis the Catholic Church placed on confession. Ammanati composed it at a time when he and his wife, the poet Laura Battiferri, had become particularly attached to the Jesuits, and were devoting time and money to the construction of a Florentine church for the Order. Still, in writing that artists should stop making nudes, Ammanati was surely aware that he was going against the most fundamental principles of Renaissance art, the expectation that artists would place the human body at the center of their concerns, and learn to render it by studying ancient sculptures and live models. To address his letter to the Academy was to challenge central principles of late sixteenth-century educational practices: the letter goes on to outline an alternative pedagogy. Ammanati encouraged his readers to pay particular attention to Michelangelo's *Moses* in Rome (*see* fig. 13.37), and thus implicitly to turn their eyes away from that sculptor's local masterpieces, including the *David* (*see* fig. 12.3) and the Medici Chapel *Times of Day* (*see* figs. 15.11–15.13). And Ammanati insisted that sculptors seeking to show virtuosity in the achievement of difficult things could as easily focus their energies on drapery as on the body itself, since this, too, required art and grace.

The shift of concerns corresponds to changes in Ammanati's own practice: by the late 1570s, he himself had indeed stopped making the kinds of nude figures that featured in his Neptune fountain (*see* fig. 19.30). The fact that local rivals like Giambologna largely ignored the letter's injunction suggests that Ammanati, in his old age, had become something of a reactionary. Yet Ammanati was writing in the wake of Giovanni Andrea Gilio's dialogue *On the Errors of Painters Concerning History* and contemporaneously with Gabriele Paleotti's *Discourse on Sacred Images*. Those texts, published by priests, had framed the issue of Counter-Reformation art in terms of a conflict between license and decorum, artistic freedom and respect for convention. Whereas Gilio and Paleotti believed it to be the patron's role to see that artists stayed in line, Ammanati rather surprisingly saw this as the artist's own responsibility. The sculptor maintained "that most men who employ us give us no invention whatsoever, but rather leave things to our judgment, saying 'here I would like a garden, a fountain, a nursery, and so forth.'" When such patrons commanded artists to make dishonest and ugly things, Ammanati asserted, artists should simply not obey.

The Counter-Reformation involved a rethinking of what the artist was and did. The precedent set by Michelangelo, particularly in the Sistine Chapel (*see* fig. 12.31), appeared to be one of an artist deciding for himself what subjects to paint or sculpt. However little this appearance may have corresponded to reality, the very idea worried clerics, who sought more authoritarian control over what artists did. By claiming the initiative of reform, Ammanati paradoxically suggested that the artist could still work as the greatest of all Renaissance masters had – provided that artist was a good Christian.

ABOVE LEFT

20.10

Annibale Carracci, *A Man Weighing Meat, c.* 1582–83. Red chalk on beige paper, 11 x 6¾" (27.8 x 17 cm). Royal Library, Windsor Castle

ABOVE RIGHT

20.11

Annibale Carracci, *Butcher Shop, c.* 1582–83. Oil on canvas, 6'2¹³⁄₄" x 8'10¹⁄₄" (1.9 x 2.71 m). Christ Church, Oxford

RIGHT

20.12

Annibale Carracci, *The Bean Eater*, 1580s. Oil on canvas, 22½ x 26¾" (57 x 68 cm). Galleria Colonna, Rome

Annibale's painting of a butcher shop (fig. 20.11). This figure alone nearly suffices to convince us that we are witnessing a collection of habitual labors, observed from life – or at least he would, were it not for the soldier standing to the man's right, wearing a foppish feather and a giant codpiece while moving his limbs in a senseless, seemingly random way. The intruder turns the whole picture into a commentary on the difference between the natural and the posed, between gestures that seem motivated by a purposeful activity and those that pursue nothing but gratuitous variety. At the same time, Annibale frames this distinction in terms of the local and the foreign, as though a character from a distant place, or a backward painting, had just stepped into a family workplace. An interest in

the everyday has become a means of opposing the values of art Annibale associated with other Italian centers.

Much the same can be said of Annibale's *Bean Eater* (fig. 20.12). This, too, probably began with a drawing from life – there is a drawing in the Uffizi of a boy eating. And it, like the *Butcher Shop* – and for that matter like the Vincenzo Campi paintings we saw in the previous chapter (*see* figs. 19.6 and 19.35) – raises questions about the intentions behind it. Is this a comic image of a worker, depicted according to stereotypes of the poor as ruled by their appetites, and devoid of grace and refinement in their manners? The window frame suggests a cross, as if ironically alluding to the non-Eucharistic character of the depicted meal. An elite patron who owned this image, or Campi's, would never have himself portrayed in this way. And yet there is more going on here than comic realism: there is an element of confrontation and disquiet in the attitude of the bean eater himself, as if he had suddenly noticed us. We seem uncomfortably close to him, almost as if we are seated at the other side of the table. He somehow refuses to be cast as a figure for our amusement: rather, we are prompted to think about his posture, about the act of eating, and through empathy and projection we become somehow "like" him. In painting him, Annibale may have had other intentions than exploiting the rising market for genre pictures. The anti-Vasarian revolution of the Carracci academy deliberately distanced itself from the courtly etiquette of the Florence Academy. The deliberately unrefined subject, and the brisk mode of rendering (Annibale had studied

the works of Tintoretto, Titian, and Veronese, although this is pointedly not like a Venetian painting), give the work the character of an artistic manifesto, reminding us that the Carracci professed to portray the physical world "in living flesh."

Altarpieces and the Question of Portraiture

In 1588 Ludovico completed an altarpiece for the Bargellini family in the convent church of the Convertite nuns in Bologna (fig. 20.13), a painting that illustrates how the Carracci insistence on direct portrayal from life could rejuvenate the principles of altarpiece design while also respecting its conventions and requirements. Ludovico refers conspicuously here to two early sixteenth-century masters: the delicacy of the figures, as well as the approach to color, evoke Correggio, whom the Carracci promoted as the iconic modern painter of Lombardy; the composition, on the other hand, derives from Titian's *Virgin and Child with Saints Peter, George, and Francis* (*see* fig. 14.25), although with a tighter composition to facilitate a greater sense of psychological intimacy between the Virgin and Child and the saints. In borrowing from Titian's Pesaro altarpiece, Ludovico did not merely wish to demonstrate his familiarity with a canonical predecessor. Rather, he recognized the similarity between Titian's assignment and the one he had received, that of conveying a family's collective devotion. Such a commission all but required the painter to include the family's leading members, and Ludovico's patrons may even have made this explicit. Yet here Ludovico departed from Titian's example: rather than adding the family to a group of saints, he portrayed his models as saints, rendering the two men as St. Dominic and St. Francis, and the two women as St. Martha and Mary Magdalene.

So well do the Bargellini family members blend with their roles that the presence of portraits hardly imposes on us today: a later report by the Carracci biographer Carlo Cesare Malvasia claims that the painter "was assisted by the lucky circumstance that the two brothers were rather wan, pallid, and haggard of mien…and it would never have been possible to fit a more devout appearance and action to each one of them while retaining their own physiognomy, in which Ludovico showed as fine an imagination as could ever be desired." Malvasia, that is, explains Ludovico's approach as a demonstration of his ingenuity. In reducing the impact of the portraits, however, Ludovico may also have been responding to considerations of decorum, attempting to keep things in their proper place. In his treatise on the reform of art, Paleotti had ultimately targeted the kinds of devices that his friend and adviser Prospero Fontana had used in the previous decade, writing that painters should not only avoid por-

traiture in religious paintings but also never portray saints with the features of other recognizable individuals.

Ludovico, it seems, was caught here between the wishes of an employer and the precepts of a reforming cleric, and he opted for a solution much like his teacher's from a decade before. The episode shows that even for a painter invested in reform, such reform was not a simple matter of top-down supervision and control. Church authority could run up against the expectations of lay patrons, and in such cases, the painter had finally to use his own judgment. Ludovico's unusual decision to include a "portrait" of the city of Bologna in the background is likewise a gesture that negotiates the

20.13
Ludovico Carracci, *Virgin of the Bargellini Family*, 1588. Oil on canvas, 9'3" x 6'2" (2.82 x 1.88 m). Pinoteca Nazionale, Bologna

interests of multiple parties. On the one hand, it commemorates the patron's and the artist's identification with a particular place, reminding viewers that the Carracci, no less than the Bargellini, were among the prominent citizens who lived in and identified with the city in 1588 (the painting is one of the few by Ludovico to bear a date). On the other hand, a local leader of the Church like Paleotti could only have approved of the motif's inevitable religious significance – that the saints implore the Virgin's protection of Bologna.

Lavinia Fontana

Among the most admired artists of Bologna in these years was Lavinia Fontana (1552–1614), daughter and pupil of Prospero Fontana, who had been the teacher of Ludovico. As had been the case with Sofonisba Anguissola (*see* p. 513), collectors sought to acquire her self-portrait. In 1579, at the age of twenty-six, Fontana painted one on copper for a Spanish priest named Alfonso Ciacón (fig. 20.14), who also asked her to make a drawing of the then Bishop Paleotti. The collector was assembling a gallery of portraits of famous people that he planned to have reproduced in engravings, and he had promised Fontana that her self-portrait would hang next to one by Sofonisba. Fontana rose to the challenge, producing an image quite different from any of Anguissola's self-representations. She shows herself seated with pen in hand in a *studiolo*, magnificently attired and surrounded by bronze statuettes and by casts or statue fragments in a cabinet. If we did not know that she was a painter, we might think that she was a scholar and a collector in her study – and indeed, this is the place that Fontana is claiming for herself. She has elided the artist's studio with the scholar's

studiolo, making the polemical claim that a woman could occupy both spaces – and in fact Fontana probably learned what she knew of the human figure from sculptures rather than from live models. She demands to be seen as a *learned* woman artist, as likely to write as to draw.

The "Holy Mountain" at Varallo

When Giambologna's *Appenine* (*see* fig. 20.1) and Annibale Carracci's *Butcher Shop* (*see* fig. 20.11) took "place" as a primary concern, the place at issue was that where the work was made. This was not the only possibility of the moment, however: the work of painters, sculptors, and architects could be used to simulate a pre-existing place in an entirely new location. In the late Quattrocento, an Observant Franciscan named Bernardino Caimi, having returned to northern Italy after a stay in the holy city of Jerusalem, decided to establish a surrogate city for pilgrims who wished to visit the Holy Land but who were prevented from doing so by the difficulties and dangers of the trip. On the mountainside behind his monastery in the north Italian town of Varallo, Caimi began to erect a series of chapels, each constituting a site associated with a key event from the infancy and Passion of Christ. Caimi died in 1499, but followers expanded on his scheme. In the 1520s and 1530s, Gaudenzio Ferrari added paintings to many of the chapels. These, in turn, became backdrops for a series of spectacular sculptural tableaux featuring dozens of lifesized figures (fig. 20.15).

Shortly before his death in 1572, the architect Galeazzo Alessi had produced a master plan for reorganizing the whole site, and in the early 1580s, while work on the Alessi modifications was underway, Archbishop Carlo Borromeo – a theorist of sacred architecture – began visiting the site and encouraging others to do the same. Borromeo seems to have been responsible for hiring the Milanese architect Martino Bassi (1542–1591) as the overseer of the project in that decade. Bassi ensured, among other things, that the renovations preserved Caimi's original chapels.

Though we tend to think of Italian sculpture as a tradition that emphasizes materiality, encouraging the viewer to think about marble or bronze as much as about the characters it depicts, the sculptures at Varallo were entirely the opposite: fully and realistically polychromed, and often outfitted with real human hair and dressed in real clothes. This maximized their integration with Ferrari's painted backdrops, creating literal and often graphically violent total environments that enhanced the pilgrim's experience of "being there." Franciscans throughout Italy had long helped to popularize the "devotio moderna," which involved imagining oneself into the events of Christ's life and death, and the Jesuit Ignatius Loyola's widely read

20.14

Lavinia Fontana, *Self-Portrait in the "Studiolo,"* 1579. Oil on copper, diameter 6¼" (15.7 cm). Uffizi Gallery, Florence

Spiritual Exercises (1522–24) had ensured the endurance of such practices into the late sixteenth century. The "Holy Mountain" (Italian *Sacro Monte*) turned this kind of meditational drill into theater, such that even the illiterate could participate. So strongly did the chapels at Varallo resonate with Counter-Reformation spirituality that the 1580s saw at least two imitations at other north Italian sites, the Sacri Monti at Crea and Orta.

Mapping Rome

The Sacri Monti remind us that no one had a stronger sense of place in sixteenth-century Europe than the pilgrim, who traveled hundreds of miles, usually on foot, to reach destinations the very visiting of which could lead to salvation. Italy's new "Jerusalems" notwithstanding, the city of Rome continued to be the peninsula's chief destination for devout voyagers, and by the 1580s, pilgrims to Rome found themselves in the company of other kinds of wanderers. Artists from all over Europe now came in large numbers to study both the antiquities unearthed by the previous century's archaeologists and the famous paintings of Michelangelo and Raphael. Joining them, perhaps for the first time, were regular tourists, visitors who came to Rome just because they had heard and read so much about the city and wanted to see it with their own eyes.

20.15

Passion Group, Sacro Monte di Varallo. The chapel was constructed and decorated in 1600–16 by the painter Il Morazzone and the sculptor Giovanni d'Enrico, but adhering closely to the precedents established at the site by Gaudenzio Ferrari a century before.

597

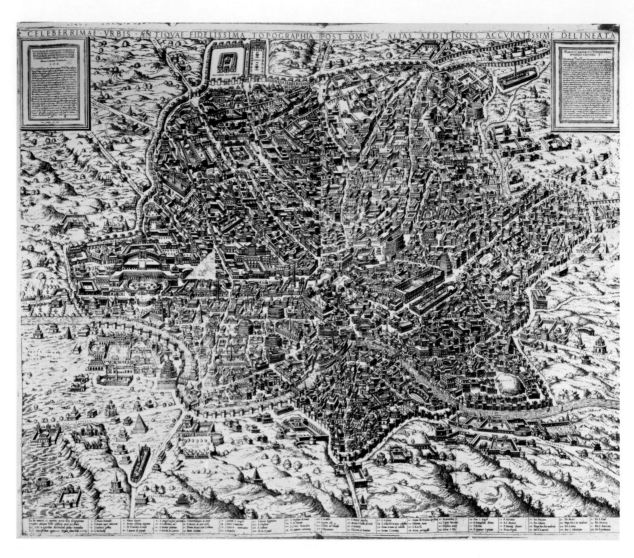

Anyone arriving in the Eternal City in the 1580s would
have been able to find and identify the major historical
sites with two relatively new kinds of printed tool, the
guidebook and the map. Among guidebooks, the most
useful in those years would still have been the two that
Andrea Palladio had written: the *Antiquities of Rome* and
the *Description of the Churches, Stations, Indulgences, and
Relics of Rome* (both 1554, though the immensely popu-
lar *Antiquities* had gone through many more editions by
1580). Palladio's *Fourth Book*, also largely on ancient Rome,
gave more weight to illustrations than to text, which elimi-
nated a barrier for foreigners who could not read Italian
and for locals who could not read Latin or who could not
read at all. The most recent map of the ancient city, mean-
while, was the multi-sheet engraving that Mario Cartaro
(*c.* 1540–1620) had executed in 1579 (fig. 20.16).

The desire to map Rome dated at least to the time
of Raphael, though the century's single most important
cartographic achievement was no doubt the 1551 map
by Leonardo Bufalini, who for the first time showed the
city in an ichnographic plan (i.e., from directly above;
see p. 460). Cartaro's map, the first version of which he
published in 1575, abandoned this scheme in favor of a
perspectival rendering, which allowed depiction of the
monuments it featured, and not just of their footprints.
The inscription at the right declares that Cartaro under-
took his project with the most advanced archaeological
means at his disposal, measuring the ruins personally
by using appropriate modern tools, verifying that every-
thing he depicted was correctly scaled, and consulting both
learned locals and the available printed reconstructions of
ancient buildings to glean information he might be able to
use. At the same time, the map acknowledges the modern
experience of the city as much as it aims at history. It is ori-
ented with north to the left, so that the most natural way to
read the map, left-to-right, accords with the movements of
visitors coming to the city from Florence or Pisa or from
across the Alps. It makes no attempt to indicate how Rome
looked under any single ancient ruler, but rather works up
a compact reconstruction of each important ruin that sur-

vived to the author's day. The question "what was here?" takes precedence over any interest in how the city looked at any particular moment in its history.

Most surprising, perhaps, is the key at the bottom of the page, with entries corresponding to small numbers distributed across Cartaro's sheets. Rather than using this key to label or give information about the things he actually depicted, Cartaro listed and located the major churches that had grown up on top of the pagan ruins. None of the items in the key is actually shown in the image: rather, the user of the map is invited to match ancient sites to modern places, to find buildings that could no longer be seen in places known from lived experience. When Cartaro's inscription underscores his accomplishment of putting "each monument in its proper place," he means that the relative positions of these monuments are clear, but also that the map makes visible the continuity between ancient and modern Roman worlds.

The Vatican Hall of Maps

The scale of maps like Cartaro's, which stretches across four folios, along with their emphasis on the sometimes literally buried histories of places, must have appealed not only to those who did not know Rome well, but also to

its most prestigious residents. For decades, palace owners had followed the advice they read in Alberti and what they regarded as the examples of the ancients, and commissioned painted city views as decorations for public rooms. In the early 1580s, however, the mural map reached an unprecedented level of grandeur.

A key actor in this development was a mathematician by the name of Ignazio Danti (1536–1586). Brother of the sculptor Vincenzo Danti, Ignazio had been living in a Dominican monastery in Bologna and working as a math professor when, in 1577, he was summoned to his native Perugia to survey the city. The drawings he produced during his sojourn there so impressed Cardinal Iacopo Boncompagni, the son of Pope Gregory XIII, that the cardinal invited him to extend his work to the entirety of the Papal States, assembling portraits of Romagna, Umbria, and the Latium, among other regions. Beginning in 1578, Danti filled one sketchbook after the next with ink drawings representing mountains and roads, waterways and significant buildings. In 1580, Pope Gregory himself took notice of Danti's activities, and summoned him to Rome to transform his studies, in combination with other, similar sources, into monumental decorations.

Under Danti's supervision, a group of painters frescoed in its entirety one of the grand corridors Bramante

20.17

Antonio Tempesta, map of Rome, engraving, 1593, modified to highlight sites under discussion.

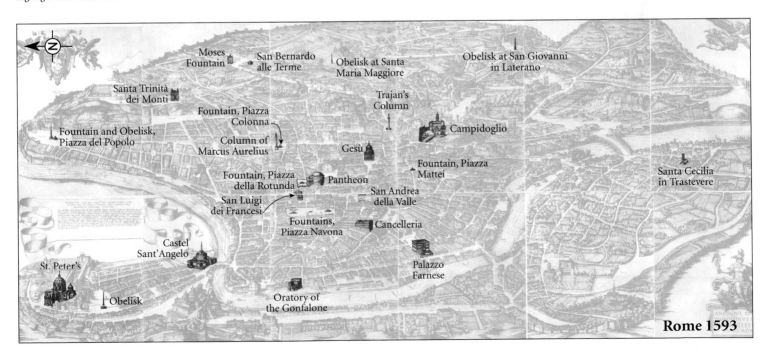

Rome 1593

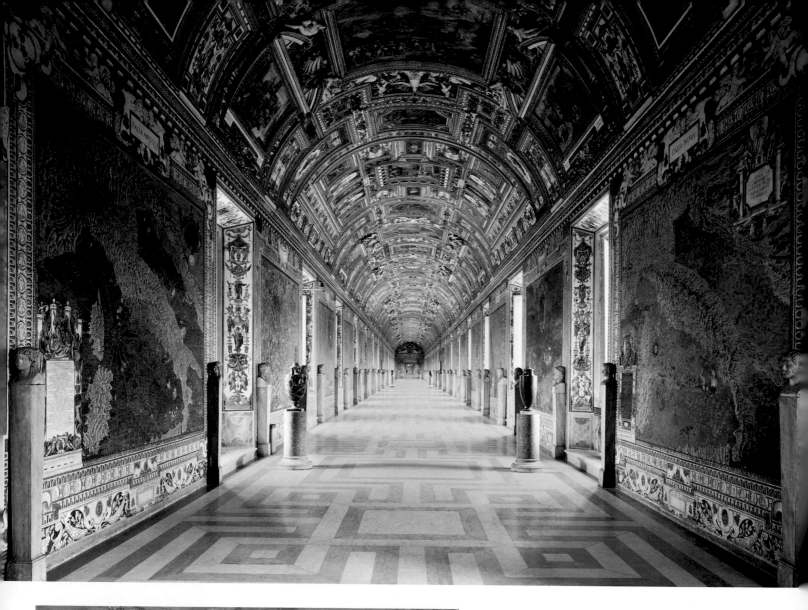

LEFT

20.19

The Lombardy Region
(detail). Fresco. Hall
of Maps, Vatican. The
photograph shows one
example of the way the
paintings overlay historical
moments: it features the
town of Piacenza (Latin
"Placentia"), newly
important from a Roman
perspective because it
was governed by the
Farnese family. The cross
suggests a Christian era,
but the inscription and the
elephants commemorate
Scipio's defeat of Hannibal
in the third century BCE.

ABOVE

20.18

Hall of Maps, Vatican,
begun 1580. Frescoes
designed and supervised
by Ignazio Danti, executed
by Paul Bril, Girolamo
Muziano, Antonio
Tempesta, and others.

had designed to connect the older parts of the Vatican Palace to the papal villa on the hill above. The team was an international one, and notably brought together three of the best landscape painters then active in Italy: the Brescian Girolamo Muziano, the Florentine Antonio Tempesta, and the Fleming Paul Bril. On the walls, the artists created colossal maps of the various regions of Italy, marking on these the sites of important battles and miracles; in the vault above, they showed site-specific episodes from Church history (figs. 20.18–20.19). To a certain extent, the frescoes captured the experience of moving through the different regions of the Italian-speaking world. Like the chapels at Varallo, however (*see* fig. 20.15), they also made history a function of place, organizing space according to where events had happened.

In contrast to the frescoed depictions of Bologna that Pope Gregory himself had commissioned in another part of the Vatican just a few years before, the Hall of Maps did not limit itself to the home territory of a Pope, or even to the Papal States. Nor did it aspire – like the painting of the Guardaroba Nuova (see p. 457) that was still under way in the Palazzo Vecchio in Florence, a project Danti himself had earlier helped to conceive – to any kind of global reach. Rather, the new artists took advantage of the felicitous congruence between the shape of the long gallery and the peninsular form of Italy itself to line up regions and cities in the order that a traveler would encounter them.

Collecting permanent, historically anchored maps in this fashion was something that only a potentate would do, and the Pope's motives must have been varied. When Leonardo made an aerial view of Imola, a small town near Bologna, in 1502, he was working for Cesare Borgia, a mercenary with military interests in the region; and when, still earlier, the Venetian Council of Ten commissioned a series of maps of their territories, these were for tax purposes. Although no one, before the age of flying machines, could see in person the kinds of views that maps provided, the height at which they positioned the spectator implied a sort of surveillance. The regions shown in the Vatican's Hall of Maps did not all fall within the Pope's temporal jurisdiction, but they did represent a united Catholic bastion, an unintentional reminder of the fragmentation that the Reformation had wrought on Europe. The maps have less to do with real strategic interests than with a sense of the past; concentrating on the Italian peninsula made it possible to point to where the Pope's Church still governed. In effect, the gallery inverted the conception of the Cartaro map, showing not what had become of ancient places but what had happened before in modern ones.

The scale, medium, and location of the decorations also bear comparison with Giulio Romano's Sala di Cos-

tantino (*see* figs. 14.1–14.3), as if the Pope and his artists aimed to outdo their predecessors by using places like the Mulvian Bridge, rather than warriors like Constantine, as their subjects. In this respect, the Hall of Maps marks a shift from explicit propaganda justifying papal legitimacy to something less direct; the papacy displays its power by proclaiming its control of knowledge. The knowledge involved was in part geographical and in part technical, since only an expert like Danti, with sophisticated mathematical skills, could project aerial views. Yet the "naturalism" of the imagery, particularly its close relationship to the emerging genre of landscape, is also suggestive. Constructions involving the natural world provided one of the most common ways that local potentates conceived and conveyed their dominion, as if their rule existed within the order of nature itself.

Urbanism in Rome under Sixtus V

Center and Periphery

The Hall of Maps was not the only room in the Vatican to feature cartographical imagery. In 1585, Felice Peretti-Montalto succeeded Gregory XIII as Pope, taking the name of Sixtus V. For his library, the Salone Sistino, Sixtus commissioned a fresco showing the city of Rome, offering a simplified picture of the transformations he was by then well into the process of introducing, with a web of straight avenues running through the city and little evidence of the irregularity that characterized the islands of buildings these divided (fig. 20.20). Sixtus had another map, this one by Giovanni Francesco Bordino, printed in multiple, so as to be available to pilgrims; this one suggested that the new streets Sixtus projected were not just a practical way to facilitate travel between destinations, but an attempt to fashion the entire urban grid into a kind of emblem to himself: the star the streets seem to form was one of his family's heraldic devices (fig. 20.21).

The actual streets laid out by the time of the Pope's death in 1590 included the Via Felice, which took travelers from the Pincian to the Viminal Hill, the Via Panisperna, which ran west from there to the Campidoglio, and the Strada di Porta San Lorenzo, which led to a city gate and then to the church outside the city walls from which it took its name. All these roads are related in location, in that they are concentrated at the eastern edge of the city. In part, this reflects the ease of building in unpopulated as opposed to truly urban zones; with the modern development of the city, it is easy to lose sight of the fact that one of the reasons Sixtus managed to build longer straight streets than anyone before him is because fewer existing structures had to be demolished to make way for

them. It is striking, nevertheless, that the finished roads
reinforce the impression given by the frescoed map in the
Salone Sistino (*see* fig. 20.20) but not by earlier maps of
the city, that the center of Rome was no longer the Cam-
pidoglio, but the church of Santa Maria Maggiore. It was
in this church that the Pope wished to be buried, con-
structing a magnificent chapel that featured not only his
tomb but also a set of shrines containing what were long
believed to be the manger of Christ and the body of St.
Jerome. And it was directly adjacent to this church that
the Pope had his villa, its lands stretching over the space
now occupied by the Termini train station.

The mix of public and private interests is also evi-
dent in the way Sixtus took over Gregory's waterworks
projects. Unlike Gregory, Sixtus did not aim to add foun-
tains to a sequence of piazzas that had formerly had none,
but he did undertake something no less ambitious: he
virtually introduced a whole new aqueduct system. For
this, he ultimately turned to Domenico Fontana (1543–
1607), the architect who would become his right-hand
man. They restored a group of aqueducts still standing
from antiquity, uniting them into a course that entered
the city from the east near the Porta Maggiore, then ran
through the site of the Baths of Diocletian, turned west
toward the Quirinal (allowing for the Quattro Fontane,
the "Four Fountains," that would give their name to a
famous church by Francesco Borromini), then all the way

to the Campidoglio and the Aracoeli. These aqueducts made it possible for people to move into or live more comfortably in parts of the city that had previously been difficult to inhabit, though we should not overlook the fact that the course of the new system, named the "Acqua Felice" after the Pope himself, traveled right through his own garden, conveniently offering him a private, fresh water supply.

About two blocks to the north of the walls surrounding his villa, Sixtus had a group of artists led by Fontana build a *mostra*, or "show" fountain, of a sort only possible where the flow of water was strongest and made for the most dramatic effect (fig. 20.22). Architecturally, this fountain took the form of a triumphal arch, and the inscription in its attic zone advertised the Pope's accomplishment in bringing new waters into the city. The central figure was Moses, ostensibly striking the rock and miraculously causing waters to flow, but the fact that no rock is to be seen makes the suggestion of narrative loose at best; the statue emphasizes the comparison between the Pope and Moses more than it illustrates any Biblical text. The statue, executed by Prospero Bresciano, no doubt in the vain hope of rivaling the *Moses* by Michelangelo on the tomb of Julius II in San Pietro in Vincoli (*see* fig. 13.37), was lampooned by contemporaries, and has for centuries been considered one of the ugliest in Rome; but it established a genre of papal commission that generations of followers would imitate.

Obelisks and Columns

The top of the Moses fountain is ornamented by a group of obelisks, which would have reminded viewers of further Sistine transformations of the city. In antiquity, Rome had been famous for the obelisks it had imported from Egypt, but by Sixtus's time only one of these was still standing, marking the site of the former Circus of Nero just south of St. Peter's. As far back as Nicholas V, popes had dreamed of moving the monument to a more prominent location in front of the basilica, but none had the technical means to pull this off. In 1585, Sixtus announced a contest, challenging architects and engineers to come up with ways to transport the stone. Though his seems not to have been the plan the judges deemed the best,

20.22
"Mostra" of the Acqua Felice, constructed 1585–89 under the direction of Domenico Fontana, with central statue of Moses by Prospero Bresciano.

ABOVE LEFT

20.23

Vatican obelisk, as re-erected under the direction of Domenico Fontana in St. Peter's Square, 1586

ABOVE RIGHT

20.24

Leonardo Sormani, Tommaso della Porta (model), and Bastiano Torrigiani (casting), *St. Peter*, placed atop the Column of Trajan, 1588–89. Bronze, height of statue 13'1½" (4 m)

RIGHT

20.25

Domenico Fontana, plate from *Del Modo Tenuto nel trasportare l'obelisco vaticano.* Rome, 1589

Fontana, the papal favorite, ended up with the commission, and in 1586 he successfully laid the obelisk on its side, moved it to the open space in front of the church, and re-erected it in what would become the center of a new piazza (fig. 20.23).

Fontana was justifiably proud of his accomplishment, and he published an enormous book, complete with lavish illustrations, boasting of what it had involved: the labors of 140 horses, 800 men, and many complicated machines (fig. 20.25). The Pope must have been pleased as well, for in the years that followed he ordered that other obelisks lying abandoned or buried in the city be recovered and erected. In 1587, a surviving obelisk from the tomb of Augustus was moved to the piazza facing the apse of Santa Maria Maggiore – a location very close to the main gate leading into Sixtus's villa. And in 1588, two obelisks were dug up in the Circus Maximus and erected at the Lateran and in the middle of the Piazza del Popolo. All of these were key locations for travelers, for they marked the terminal points of the straight streets

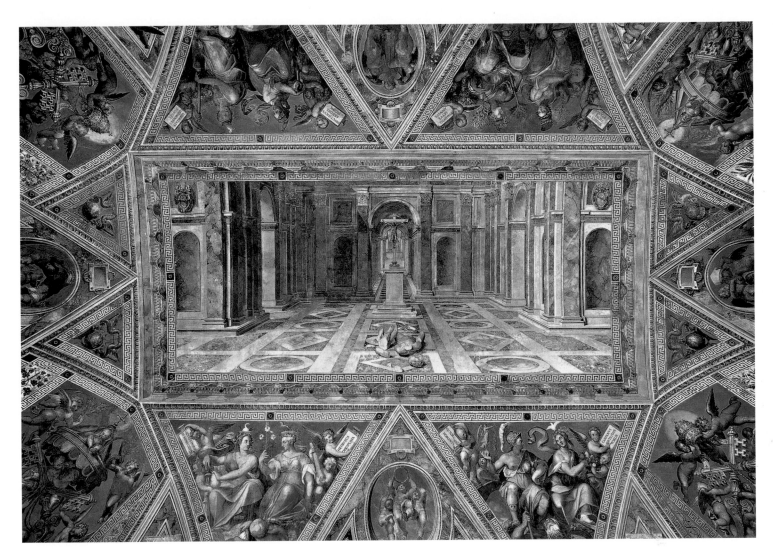

that led visitors entering the city's northern gate to and between the major churches. Walking from Santa Maria Maggiore toward the Lateran, or up the Via Felice toward the northern gate of the city, one would know exactly how far one had to go before reaching the next stop.

This is to cast the obelisks in the friendliest light; they also had a more belligerent aspect. In each case, the Pope's engineers added a gilded bronze cross to the top of the stone. This echoed his treatment of two other monuments that survived from Roman antiquity, the Column of Trajan, which had originally stood in the forum named after the emperor it celebrated, and the Column of Marcus Aurelius, believed in the 1580s to be the Column of Antoninus Pius. These two columns had, seemingly miraculously, survived largely intact through the centuries. Though they were missing the figures that originally topped them and though some of the reliefs showing ancient military campaigns were damaged, the engineering operations required to resurrect them were only slightly more modest than that undertaken at

St. Peter's. Already in antiquity, the columns, covered as they were with victory imagery, were understood to be triumphal forms; to restore them in the spirit of the obelisks or the Moses fountain, Sixtus merely needed to return them to their original purpose. This he did by having a team of marble sculptors replace the sections that were missing from the serial reliefs, and commissioning another group of statue-makers, overseen by Fontana, to place a bronze statue of Peter on top of the Column of Trajan (fig. 20.24) and one of Paul atop that of Marcus Aurelius. Henceforth, those moving through the city would look up to find Rome's patron saints looking protectively over the scene.

Like the bronze statues on the columns, the gilded crosses that topped the Egyptian stones turned them into trophies of sorts. Their own role, nevertheless, was even more complicated. While the obelisk projects were underway, Sixtus had Tommaso Laureti – the Sicilian impresario whom we last encountered as the designer and engineer of the Neptune fountain in Bologna (*see*

20.26

Tommaso Laureti, *The Triumph of the Cross over Idolatry*, 1585. Vault fresco. Sala di Costantino, Vatican

OPPOSITE

20.27

Giovanni Bologna, *The Abduction of the Sabine.* Marble, height 13'6" (4.1 m). Loggia dei Lanzi, Florence. The statue was installed in 1582; the bronze relief added to the front of the base *c.* 1584.

fig. 18.33) – add a fresco to the ceiling of the Sala di Costantino, depicting a bronze cross standing over a broken stone idol (fig. 20.26). The image changed the emphasis in Giulio Romano's frescoes below (see figs. 14.1–14.3), making the cross itself, rather than Constantine, the protagonist – we might now notice that in Giulio's *Battle of the Milvian Bridge* the emperor's enemies simply collapse before the sign of the cross born on Constantine's standards. The frieze Laureti added between these murals and his new ceiling featured portraits of the obelisks, with their crosses, that Sixtus was erecting around the city. The room casts the urbanistic projects in a more militaristic light. The inscription added to the front of the pedestal supporting the Vatican obelisk reads: "Behold the cross of the Lord! Flee, you who are his enemies! The Lion of the Tribe of Judah has conquered!" The phrase was used in the exorcism ritual Sixtus conducted after the re-erection of the obelisk, a ceremony intended to banish any evil spirits that still inhabited the idol. As one approaches the obelisk, however, the inscription seems directed not so much at the stone itself as at the visitor to St. Peter's. It is as though the positioning of the obelisk were intended to defend the basilica, much as Michelangelo's *David* (see fig. 12.3) and Baccio Bandinelli's *Hercules and Cacus* (see fig. 15.14) had been positioned to defend the Palazzo dei Priori in Florence. We might notice the northward orientation of the other obelisks Sixtus placed around the city: one greets those passing through the main city gate to the north, and the one at Santa Maria Maggiore occupies not the piazza in front of the church facade, but the northern piazza behind the church. Collectively, the monuments suggest that the Sack of 1527, when armies from the north destroyed the city, had not altogether vanished from Roman memory.

The Place of Giambologna's *Abduction of the Sabine*

We began this chapter with a look at Giambologna's *Appenine* (see fig. 20.1), a sculpture whose form seemed to depend on its location. But the new attention sculptors were expected to devote to a statue's place, especially following the systematically urbanistic conception of the monuments now on display in Rome, could also allow the opposite approach. In a dialogue on art entitled *Il Riposo*, Raffaele Borghini reported of Giambologna's large marble group (fig. 20.27) that the artist had made it not on commission but "only to show the excellence of his art," and that it was only after the work was nearly completed that Grand Duke Francesco de' Medici, "admiring its beauty, decided that it should be placed where we now see it." Borghini went on to report that Giambologna

had conceived the statue not only without a conventional function in mind, but also without a "story." The city's poets were challenged to come up with subjects and titles that suited the three-figure group, and only later was the work officially baptized as a portrayal of an episode in the early history of Rome when the city's warriors carried off the young women from a neighboring tribe known as the Sabines.

Surely Borghini was correct in suggesting that Giambologna intended, with the sculpture, to show his "art." It took up the challenge of extracting a complex, three-figure composition from a single block of stone; it included bodies of different ages and types and a range of expressive gestures; it allowed for multiple points of view; and its action required a careful consideration of balance and statics. More intriguing is the question of whether Giambologna could really have conceived the work without a notion that it might find its way into the Piazza della Signoria. In place, the *Sabine* seems to fit neatly with the works that preceded it: like Bandinelli's *Hercules and Cacus* (see fig. 15.14), Donatello's *Judith and Holofernes* (see fig. 6.25), and Cellini's *Perseus and Medusa* (see fig. 16.20) it shows a triumph, with one figure striding over another. With its image of the hero rescuing a woman from danger, it lends itself to political allegory: the abduction of the Sabine maidens was a central episode in myths relating to the foundation of Rome, and it would have appealed to a leader trying to make Florence over in the Roman image. At the same time, the statue may also have been conceived in a spirit that would have been all but impossible in Rome itself, where public art involved increasingly transparent programmatic schemes.

Just a year before he started work on the *Sabine*, Giambologna had written of a small bronze he sent to Ottavio Farnese, the Duke of Parma, that its pair of figures "could be taken to show the abduction of Helen and perhaps of Proserpina – or as one of the Sabines." Statues like this invited interpretation, and with the addition of the marble group to Florence's most important public square, Grand Duke Francesco may well have been allowing that the kinds of conversations that happened in gardens (Borghini's dialogue took its name from a villa called Il Riposo, or "The Retreat"), discussions on art that did not necessarily end in consensus, could take place within the city walls as well. The risk, of course, was that viewers could doubt the metaphors of Medici power that works like the Sabine should have supported. The benefit was that a city like Florence could itself pretend to the image of Parnassus, a haven for the advanced visual and literary arts in an age when reformers in other cities would rein in their most liberal forms of expression.

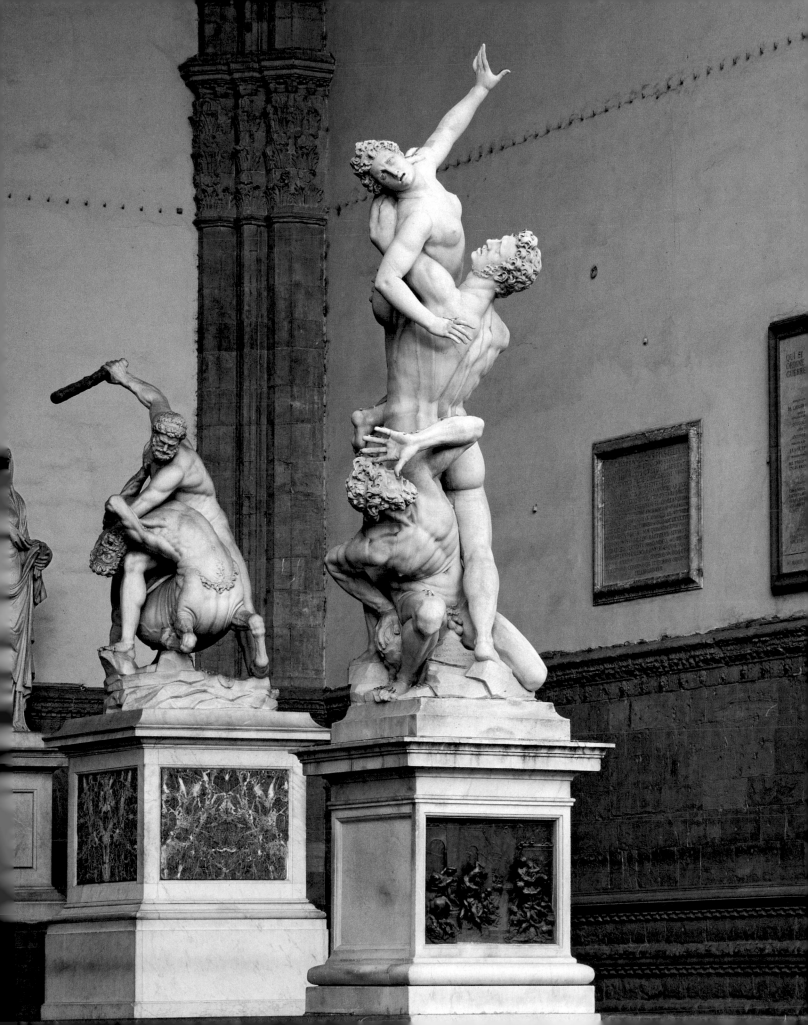

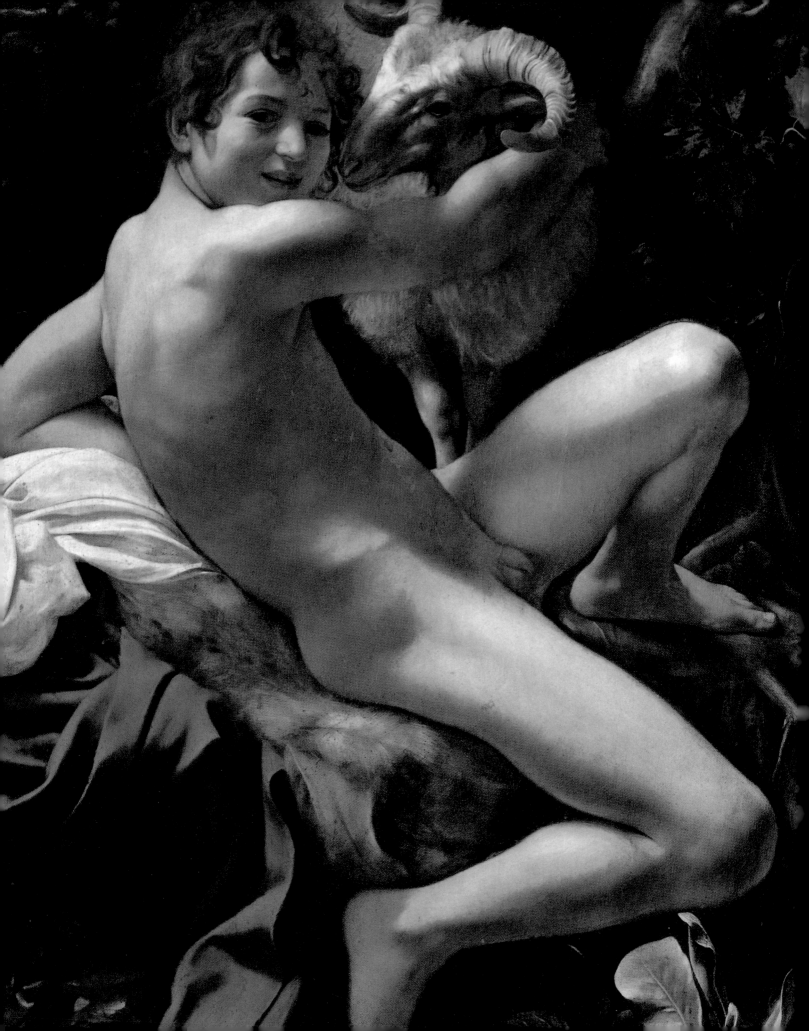

21

1590–1600
The Persistence of Art

1590—1600
The Persistence of Art

Church Humanism, Church Archeology

Histories that present the "Renaissance" as a period style, a visually coherent era in which a recognizably common project bound the arts, typically conclude with the arrival of the "Baroque." On such accounts, an age characterized by a return to antiquity gives way at the end of the sixteenth century to one determined by a triumphant Church. Exuberance replaces a more contained sense of order, and spectacles addressed to the masses take precedence over mysteries comprehensible only to an elite few.

As we have already seen, the Council of Trent led to the institutionalization of reform movements that had been under way in local circles for decades. This process, however, did not represent a turn away from the physical beauty, conspicuous artifice, or philological awareness of earlier art so much as an assignment of such values to what reformers deemed to be a proper place. In many spheres, in fact, we see the late sixteenth-century Catholic Church attempting to absorb or adapt what look very much like "humanist" enterprises to its own purposes. The circle surrounding not only the Pope but also each of his cardinals made themselves the successors of the secular courts of the Quattrocento, occupying magnificent palaces and competing to control the services of the

21.1

Subterranean burial chamber from the early Christian catacombs at St. Sebastian on the Via Appia

best artists and writers of the day. Priests began writing art treatises: in *Il Figino*, published in 1591, Don Gregorio Comanini not only engaged the philosophy of Plato and its implications for the visual arts but also adopted a vernacular dialogue form, as though his goal were to reach and entertain a popular audience with limited Latin. Comanini was following the example of earlier prelate-authors like Giovanni Andrea Gilio (*see* p. 526), but he was also composing a sequel of sorts to the Venetian dialogues on art by Paolo Pino and Lodovico Dolce (*see* p. 496), as well as to *The Courtier* of Baldassare Castiglione (*see* pp. 225 and 381).

Most of the Renaissance popes had been interested in at least some of the ancient Roman statues, buildings, and paintings that turned up under their city, but the late sixteenth century also saw the Church undertake newly serious investigations into its own archeological remains. Little excited such explorers more, for example, than the catacombs. The earliest Christian communities, following Jewish practices, had buried the bodies of their dead outside the city walls, in underground labyrinths that began in or near a church and snaked for miles and miles. After the fifth century CE, when invasions had made it seem increasingly perilous to venture into the countryside, burials began to take place directly in and around churches; the catacombs fell into disuse and were mostly forgotten. Though individuals occasionally ventured into them, few knew their locations or extent.

All of this changed in the final decades of the sixteenth century, when accidental discoveries and a new fascination with the Church's earliest practices led to systematic spelunking. Investigators found grave sites, called *loculi*, consisting of rectangular holes excavated directly from the tunnel wall, then covered with a slab or with tiles (fig. 21.1); occasionally, they came across a wealthy or particularly revered person who had been honored with an *arcosolium*, or arched recess. There were no troves of ancient sarcophagi here, no new marble statues, but those who ventured into the catacombs did encounter a subterranean world that rivaled that of the ancient forum or the Golden House of Nero, and contained the small ritual objects early Christians had buried and the paintings they had used to decorate the spaces.

The importance of these discoveries is unmistakable in a church like Santa Cecilia in Trastevere, Rome. Pope Gregory XIV (*r.* 1590–91) had assigned this building and its parish to the care of his nephew, Cardinal Paolo Emilio Sfondrato, who ordered excavations in order to throw light on the site's earlier foundations. These happened to unearth the body of none other than Saint Cecilia herself, preserved in a perfect "uncorrupted" state, though she had been beheaded more than 1200 years earlier. Sfondrato called in two witnesses to verify the find: Cesare Baronio, the leading historian of the Early Christian Church, and Antonio Bosio, who had explored, mapped, and documented the city's catacombs. The invitation to Bosio in particular acknowledged the widely shared belief that Cecilia's body had originally been interred in a catacomb at the church of San Callisto; researchers knew that Pope Pascal I had had it transferred to Trastevere in the early ninth century. The authenticity of the body confirmed, Sfondrato commissioned the sculptor Stefano Maderno (1575–1636) to replicate it in marble, at lifesize and allegedly in the very pose in which it had been discovered (fig. 21.2). The cardinal then placed this statue under the new altar of his church, in a tabernacle centering on a modern *loculus* that recreated the setting of Cecilia's first burial.

Those rebuilding houses of worship with an eye to the distant past were not interested only in Early Christian remains. Across town from Santa Cecilia, Caterina de' Nobili Sforza, the Countess of Santa Fiore, was in the same years overseeing the refurbishment of San Bernardo alle Terme. Following her husband's death, Caterina had withdrawn to a palace on the Esquiline Hill and attached herself to a reformer named Jean de la Barrière and his Order of reformed Cistercians known as the Foglianti (or Feuillants). For the monks she purchased a section of the Baths of Diocletian, and converted it into a centrally planned church (fig. 21.3). The transformation required only minor modifications: the addition of a choir, the covering of some old niches and the carving out of eight

21.2

Stefano Maderno, *Santa Cecilia*, 1600. Marble, life-size. Santa Cecilia in Trastevere, Rome

21.3

Interior of San Bernardo alle Terme, Rome, consecrated in 1600. *Stucco* statues by Camillo Mariani and others

new ones to achieve a more regular effect, and the topping of the existing dome with a lantern. More than most medieval or Renaissance churches, the space still feels very much like an ancient one.

An inscription over the door commemorated Caterina's late husband, turning the whole building into a kind of mausoleum – a tomb for Caterina herself would occupy the choir, just beyond the high altar. The most striking feature of the interior, however, is Camillo Mariani's series of colossal statues in *stucco*. The material's versatility, light weight, low cost, and resemblance to stone increasingly attracted patrons in these years. The characters Mariani included primarily represented the name saints of the patron and her family – two saints named Catherine appear.

Caterina and her artists could not have ignored the fact that Michelangelo had spent his last years working on the neighboring church of Santa Maria degli Angeli, it, too, a repurposed section of the ancient bath complex (fig. 21.4). If the project that had brought Michelangelo to Rome in 1505 began with the destruction of Europe's most venerable basilica, Old St. Peter's, the artist strove in this late work to respect a church structure that had survived the centuries relatively intact, and kept his own interventions to a minimum. Caterina's project was not so self-effacing, but it, too, responds to the existing city more than it asserts a new architectural personality. San Bernardo alle Terme resembles nothing so much as a new Pantheon. At the beginning of this book, we saw Lorenzo Ghiberti charge the Church with the destruction of antiquities (*see* p. 10), and contemporaries could still lodge similar accusations against Sixtus V in the late 1580s. San Bernardo alle Terme, however, looks more like an example of early "historic preservation."

A New Geography

Regional Distinctions: Florence and Bologna

It is difficult, in short, to sustain the idea that a "Renaissance," an era defined by its attempt to restore, recover, or vie with the art and architecture of a distant past, faded into something else at the end of the century. This is not, however, to minimize the real changes of other kinds that happened in these years. Perhaps most noticeably, once-dominant centers lost their allure, and others rose to prominence.

Parmigianino's move to Bologna more than half a century before had encouraged experimentation with print technologies, and etching in particular (*see* p. 435). The Carracci only invigorated this: though Agostino was the family professional, his cousin Ludovico and younger brother Annibale both made etchings in the 1590s.

A print by the painter Camillo Procaccini (1551–1629) offers a good example of the new possibilities that contemporaries saw in the medium. His *Transfiguration* (fig. 21.5) reads as a variation on Parmigianino's *Resurrection*

(*see* fig. 14.31), except that it activates the paper on which the image is printed, using its whiteness to represent the radiance of Christ at the moment he manifests his divine nature. Christ's face had long been a subject of particular reverence, which makes it all the more remarkable that Procaccini barely registers his features, as if to suggest that Christ's countenance is so luminous it cannot be seen; Christ's body, similarly, consists merely of stipples, lending his whole presence a ghostly effect. It is difficult to imagine a printmaker coming upon such a novel idea in an Italian city other than Bologna. And as striking as the print itself is the fact that its composition doubles that of a 1590 Procaccini painting (fig. 21.6). Either the painter used the print to attract a prospective employer, or he counts among the very first examples of an artist creating a printed reproduction of his own work in another medium.

Florence, whose traditions Bologna had made to seem backward and stultified, had gradually responded with its own reform movements. Some artists, indoctrinated with the Academy's emphasis on *disegno*, directed

new attention to the capacities of drawing. Jacopo Ligozzi (1547–1627), for example, made exquisite watercolors of plants and animals for a courtly audience interested in collecting *naturalia* (fig. 21.7). Ludovico Cigoli experimented with the kind of oil sketches that Federico Barocci and Tintoretto had made. His friend the astronomer and mathematician Galileo Galilei, who had studied drawing in Florence, would just a few years later make drawings of the moon and the sun that would transform the West's understanding of the universe. In their works on panel and canvas, too, a number of painters sought to find a path away from the manner of Salviati, Vasari, and even Michelangelo.

21.6

Camillo Procaccini, *The Transfiguration of Christ*, 1590. Oil on panel, 9'9" x 5'10⅞"(2.97 x 1.8 m). Milan Cathedral

Panoratium maritimum

21.7
Jacopo Ligozzi, *Sea Daffodil (Pancratium maritimum)*, before 1591. Watercolor and tempera over black pencil on white paper, 26¼ x 18" (68 x 45.5 cm). Gabinetto Disegni e Stampe, Uffizi Gallery, Florence

21.8
Santi di Tito, *Vision of St. Thomas Aquinas*, 1593. Oil on panel, 11'9" x 7'7" (3.62 x 2.33 m). Del Turco Chapel, San Marco, Florence

Santi di Tito's *Vision of St. Thomas Aquinas*, a picture made by an artist in his late fifties, seems intent on showing that he is not yet set in his ways (fig. 21.8). Santi (1536–1602/3), although a former pupil of Agnolo Bronzino and a contributor to the *studiolo* of Francesco de' Medici, rejects the old goal of piling up nudes in favor of a more sober composition; he employs enough color to enliven the surface and draw attention to the main actors, but not so much as to distract from the painting's meditative atmosphere. The clarity of the picture is all the more important since understanding Santi's subject requires real attention. St. Thomas Aquinas meditates on the *Crucifixion*, while St. Catherine looks on from the lower left. Catherine lived in the fourth century, Thomas in the thirteenth, and the architectural setting here is post-Brunelleschian – the painting, that is, collapses elements from at least four different historical moments. What Santi has essentially done is to return to the tradition of the *sacra conversazione*, rethinking the format as an "event" that composes itself before Thomas as he prays. The conception of the picture is deliberately old-fashioned, a throwback in its way to Fra Angelico's insertion of Dominican saints into the sacred episodes he painted at San Marco (*see* fig. 6.4).

Giambologna continued to operate not just the city's but the continent's premier sculpture workshop;

21.9
Giambologna, equestrian statue of Duke Cosimo de'Medici, Grand Duke of Tuscany, 1587–94. Bronze. Piazza della Signoria, Florence

21.10
Giambologna, *The Subjugation of Siena.* Bronze relief from the base of the equestrian statue of Duke Cosimo I

in this he depended on numerous collaborators who would soon disperse and embark on successful careers of their own. Among his major projects in these years was a colossal bronze equestrian monument that Duke Ferdinando I de' Medici dedicated to his father Duke Cosimo in 1594 (fig. 21.9). Previous Florentines, such as Donatello, Verrocchio, and Leonardo, had only been able to undertake works of this kind when patrons invited them to other cities; the old Republic, fearful of tyranny and its symbols, would not have permitted such a monument within its walls. Ferdinando was now secure enough in the Medici duchy, however, to put aside such concerns: indeed, the work's placement before the building that had housed the city council relegated thoughts of this kind decisively to the past. The great bronze horse celebrated the autocrats' unification of the Tuscan state. One of the reliefs on the side shows Duke Cosimo's triumphal entry into Siena upon the subjugation of that city (fig. 21.10), and Ferdinando had Giambologna make additional portrait monuments for the main piazzas of the other cities over which he ruled, including Arezzo, Pisa, and Livorno (fig. 21.11).

Nepotism and Networks in Rome

This newly urbanistic conception of the sculptural monument, the incorporation of public sculptures into a larger system of art and architecture that tied together one or more cities, takes up an idea introduced by popes Gregory XIII and Sixtus V in their fountains and obelisks. Ferdinando brought the new idea to Florence from Rome, where he had lived as a cardinal before the death from poison of his brother Duke Francesco – probably at his instigation – allowed him to claim the ducal throne. The new treatment of the piazza in Florence and in its satellite cities illustrates the "centrifugal" force Rome had acquired by the end of the century. At least as important is the draw it represented to artists. More than any other city, Rome displayed the multiple traditions of Italian and, increasingly, of European art to the rest of the world.

A large part of this cosmopolitan draw arose from the distinctive conditions of Roman patronage. By contrast to other centers, where dynastic regimes tended to impose a local frame of reference and support a workshop system that continued from generation to generation, each election of a new Pope shook up the city's networks. The pontiff, once enthroned, would install family members and other dependents in important positions and funnel money to them. (Since popes were supposed to be celibate, nephews like Paolo Emilio Sfondrato tended to become favorites, whence the word "nepotism.") The new Pope and his family would also call upon artists from his own region of origin. The process could dislodge both the patrons and the artists who had been in power just months before.

Caterina Sforza's support of the Foglianti at San Bernardo alle Terme (*see* fig. 21.3) illustrates a larger

21.11

Piazza dei Cavalieri, Pisa, with, at right, the Palazzo del Consiglio, enlarged and redecorated 1596–1603 following earlier plans by Giorgio Vasari. In front of this stands Pietro Francavilla's statue of Ferdinando I de' Medici of 1594.

THE MEDICI COLLECTIONS

In their accumulation of precious and rare objects the Medici in the 1400s followed the pattern of other European rulers, with many of whom they had diplomatic and financial ties. Potentates had long amassed gems and gold and silver artifacts, often as a form of fiscal reserve, but they also acquired costly and rare objects that were held to be of a value that was more than material: relics, ancient gems and coins, "unicorn horns" (narwhal tusks), exotic weapons from the Asian silk routes. While princes like the Este of Ferrara collected as well, the Medici vastly outstripped the Italian rulers in the resources available to them and their international networks. Through the Medici Bank, precious objects could be acquired as security for loans not repaid. By the later fifteenth century, one of the main attractions for foreign visitors to the Medici Palace was the collection of gems, medals, and other small-scale antiquities housed in studies and other small rooms. Ancient marble statues, some of them restored by Andrea del Verrocchio and other sculptors, decorated the courtyard and the garden. Particularly famous was the collection of vases in rock crystal and semi-precious stones acquired by Lorenzo il Magnifico. Rock crystal was greatly in demand for a degree of transparency not yet obtainable in glass production; there were only a handful of workshops in Venice and in Paris that had mastered the techniques of cutting and working it. As with the vases fashioned from sardonyx, amethyst, jade, porphyry, or other hard stones – mostly imported from Asian trading centers – these vessels were usually provided with elaborate mounts in gold and silver by local craftsmen.

With the expulsion of the Medici from Florence in 1494, the collection was partly sold and dispersed by the new government. Isabella d'Este was one of several Italian princely collectors who tried to acquire pieces: she asked Leonardo da Vinci to evaluate some crystal, silver, and agate vases for her in 1502 (the prices ranged from 200 to 350 ducats, considerably more than the 100 ducats she offered for the paintings in her *studiolo*). The vases retained by the family formed the core of extraordinary gifts by the two Medici popes to the basilica of San Lorenzo, where these objects of luxury were devoted to a new pious purpose as reliquaries: today the remnants of Lorenzo's collection can be seen at San Lorenzo and at the Silver Museum at the Palazzo Pitti (figs. 21.12–21.14), with some of the ancient pieces housed at Florence's Archeological Museum and a rare jade vessel at the Museum of Mineralogy. From being signs of a family's wealth and taste, they have over time been reclassified as church furnishing, as samples of craft, as antiquities, and as scientific specimens.

Duke Cosimo followed his fifteenth-century forerunners by keeping a collection of small objects – coins, medals, cameos, antique and modern bronze figures – installed in special cabinets in a *studiolo* outfitted by Vasari, but he also created a new and larger space for the organization and display of a collection: the Guardaroba in the former Palazzo dei Priori (*see* fig. 15.23) was a sizeable room adorned with the most accurate available maps of the world including parts only recently known to Europeans. The maps adorned cabinets in which samples of natural substances and manufactured objects from the lands in question were all stored. The room in addition housed mechanical clocks, globes of the earth and the heavens, and navigational apparatus. Cosimo's son Duke Francesco signaled the desire to assemble an encyclopedic or universal collection even in the intimate space of his *studiolo*, where cabinets were adorned with scenes of mining by slaves in India and Peru, and of pearl fishers in the southern seas (*see* p. 583). The collecting interests

21.12
Jade mask, Teotihuacan art, 250–600 CE. Jade, 6 x 6¾ x 2" (15.2 x 17.1 x 5.1 cm). Museo degli Argenti, Palazzo Pitti, Florence

of both Medici dukes were shaped by their hands-on
interests in acquiring "secrets" – that is, information
on new technological processes for the making of
armaments, or the working of such precious substances
as rock crystal and porphyry, or the mystical science
of alchemy. Francesco himself was a master of secrets
who invented new recipes for porcelain, methods for
cutting crystal, and pharmaceutical cures; he established
workshops for glass-blowing, metalwork, and the cutting
of semi-precious stones in the Uffizi.

With Spanish and Portuguese colonization of
the New World, Asia, and Africa, a market in exotic
imported objects developed in the courts and capitals of
Europe. Cosimo and his successors sought out the most
outstanding examples: cloaks of feathers from Peru; rock
crystal skulls and jade masks from Mexico; an African
elephant's tusk fashioned into a horn; Indo-Persian
shields of rhinoceros hide with golden leaf ornament;
vessels of tortoiseshell and mother-of-pearl; Japanese

LEFT ABOVE

21.13

Chinese/Florentine nautilus
cup with silver gilt mounts,
late sixteenth century.
Museo degli Argenti,
Palazzo Pitti, Florence

ABOVE

21.14

Lapis lazuli flask with gold
and enamels. Florentine,
designed by Bernardo
Buontalenti, late sixteenth
century. Museo degli
Argenti, Palazzo Pitti,
Florence

swords and other artifacts that arrived with an embassy
from Japan in 1585. Such collecting indicates the family's
sense of its importance in the world and its political
ambition – Cosimo was encouraged to believe that his
name signified his "cosmic" stature – yet it also signaled
a rising interest in ethnography, a belief that new forms
of knowledge and civilization were to be encountered
beyond Europe.

21.15

Facade of Sant' Andrea della Valle, Rome. The church was begun *c.* 1590 after designs by Giacomo Porta and Pier Palo Olivieri; the facade was designed in the mid seventeenth century by Carlo Rainaldi.

phenomenon of wealthy laywomen lending their backing to new religious orders. Across the street, Camilla Peretti – sister of Pope Sixtus V – had paid for the renovation of the convent of Santa Susanna, designed to house Foglianti nuns. In 1598, Isabella della Rovere sold her jewels so as to be able to buy two properties for the Jesuits on the Quirinal Hill. Among the major churches built on the model of the Gesù in the center of the city was Sant' Andrea della Valle, a project undertaken by the Theatines using funds left to them by Donna Costanza Piccolomini, on condition that they dedicate the building to the patron saint of Amalfi, of which she was duchess. Completed only in the next century, it became a major example of the massive churches built under the direction of newly founded religious orders in the heart of the urban fabric, and intended to serve the local populace rather than pilgrims (fig. 21.15).

21.16

Palma Giovane, *A Collector (Bartolomeo della Nave?)*, 1591–92. Oil on panel, 5'6¹/₂" x 5'1¹/₂" (1.18 x 1.03 m). City Museum and Art Gallery, Birmingham

Galleries and Collectable Art

The seventeenth-century biographer Carlo Ridolfi reports that in the years following the death of Titian in 1576, Venice came to depend on the judgment of Alessandro Vittoria "not only in things of sculpture and architecture but also in painting." Tintoretto and Veronese, Ridolfi adds, could not stand this, though whatever conflicts existed between the artists would have been brought to an end by the deaths of Veronese in 1588 and of Tintoretto 1594. Both painters, like Jacopo Bassano (*d.* 1592), had heirs who sought to continue the profitable family workshops, though these followers mainly repeated proven formulas. Vittoria himself lived until 1608, though

after the death of his wife in 1591, his production, too, seems to have faded.

The most successful Venetian artist of the 1590s was perhaps Giacomo Palma, called "Palma Giovane" (*c.* 1548–1628). Palma was a protegé of Vittoria, whom he allegedly pleased by showing an obsequiousness Vittoria welcomed after facing years of disdain from Tintoretto and Veronese. The alliance did not mean that Palma took up Vittoria's own quarrels: Palma appears to have been self-taught, though Ridolfi writes that the painter continually studied the works of Tintoretto, "whom he recognized as a father of art, and of whose supernatural virtues he preached on every occasion." Palma's attraction to Tintoretto is evident in the loose brushwork and subdued, nearly monochrome palette of a portrait from the 1590s (fig. 21.16), showing a man surrounded by sculptural fragments and plaster casts. Who does it depict? Comparison with an earlier painting, such as Lorenzo Lotto's *Andrea Odoni* (*see* fig. 14.23), a work that Palma could have known, suggests that the canvas shows a collector in his study. Then again, artists themselves in this period were developing increasingly impressive collections, and the single complete object in the room, the statue behind the collector's right shoulder, is a plaster cast after Vittoria's *Sebastian/Marsyas*. Could the man be an artist, an admirer, like Palma himself, of Vittoria's work?

The detail points to the fact that it was not just new cities but also new kinds of artworks that came into prominence at the end of the century. We have already seen that large-scale sculptures could now be made of stucco (a variety of plaster), even as permanent ornaments of important spaces, such as church interiors. The artists

the Gallery of Maps in the Vatican – but the characteristic gallery of the seventeenth century was something different, a room meant to house autonomous sculpted and above all painted objects, predominantly oil paintings on canvas. It was a room that announced its contents to be collectables, removable from whatever architectural context or other combination of objects existed beyond their frame.

A good example of a gallery picture is Palma's *Venus and Mars* (fig. 21.18). Drawn crimson curtains reveal an erotic mythological episode: a kiss from the goddess of love lays out the patron of war on a bed, as Cupid helps him strip. The group is a witty variation on the kind of subject in which Titian had specialized; Palma has essentially taken a Titian Venus and turned her over, showing her from behind. Once again, however, it is the devices Palma learned from Tintoretto that come most to the fore. The figures adopt almost acrobatic poses, and the dramatically foreshortened Mars plunges into our space. Shadows obscure the interlocking faces of Venus and Mars, the center of the action. Despite the lively color at the edges, finally, an intense *chiaroscuro* defines all three figures. The painting could never have hung

21.17
Reproduction of
Giambologna, *Hercules and the Centaur, c.* 1600.
Bronze. Museo Nazionale del Bargello, Florence

behind works of this sort tended to be professional modelers, who either worked on projects like Caterina Sforza's San Bernardo alle Terme (*see* fig. 21.3) or provided clay designs to be cast in bronze and replicated in stone. Vittoria himself illustrates a related professional turn, though one that focused on smaller objects: what Palma includes in his *Portrait of a Collector* is not the lifesize, marble version of the statue that Vittoria had made for a public church, but a copy after the model for it, or perhaps after the smaller bronze he had produced as a collectable.

The interest in modeling led to a boom in the production of small bronze statuettes – essentially permanent records of clay designs in a more durable material. The statuette, of course, was not a new format; we have seen early examples by Antonio Pollaiuolo (*see* fig. 10.5) and Bertoldo di Giovanni (*see* fig. 10.4), and earlier in the sixteenth century, Mantua and Padua had built a small industry around the production of desk-sized objects that scholars and other writers, as well as bankers and bureaucrats, could keep in their studies. At the end of the century, the center of production had shifted to workshops like Giambologna's in Florence, which were the first to develop specializations around small- to mid-size portable statues whose invention did not depend on a sense of where they would ultimately go (fig. 21.17).

Often, the collectors of such bronzes placed them in a room that was just beginning to exist as a well-defined space: the gallery. We have encountered galleries already – the Galerie d'Ulysse at Fontainebleau outside Paris and

21.18
Palma Giovane, *Venus and Mars*, 1590. Oil on panel, 4'3¹/₂" x 5'5¹/₄" (1.31 x 1.66 m). National Gallery, London

621

21.19

Federico Barocci, *Aeneas and His Family Escaping from Troy*, 1598. Oil on canvas, 5'10½" x 8'3½" (1.79 x 2.53 m). Galleria Borghese, Rome

anywhere but in a private palace. Seeing it in a secular room devoted to miscellaneous canvasses, as one now does in the National Gallery in London, is not entirely distant from the way that its original viewers must have encountered it.

The majority of Palma's paintings, like those of his contemporaries, were of religious subjects. By the 1590s, however, the demand for prestigious objects that could fill private galleries touched even artists who normally did not make such things. The version of Federico Barocci's *Aeneas and His Family Escaping from Troy* (fig. 21.19) that hangs today in the Galleria Borghese is one the artist produced in 1598 for Monsignor Giuliano della Rovere, a member of the ruling family of Urbino, where Barocci still lived and worked. The picture hewed very close to his first treatment of the subject, a now destroyed painting he had sent to Emperor Rudolph II in Prague in the late 1580s. The two versions were the only paintings (apart from portraits) that the devout Barocci executed during his entire career not to show a religious subject. Instead, its protagonist is the hero of Virgil's *Aeneid*, carrying his father Anchises away from the burning city of Troy. Both Giuliano and Rudolph would have understood the theme to relate to Aeneas's founding of Rome, a subject equally relevant (though in different ways) to a prelate expected to support the Roman papacy and to a ruler who understood his empire to have been "translated" from the ancient Caesars. Barocci would have needed not only to take up a subject of interest to two different people, but also a kind of painting that would function equally well in two different settings, at least one of which he had never seen.

OPPOSITE

21.20

Annibale and Agostino Carracci, vault frescoes in the Farnese Gallery, 1597–1602. Palazzo Farnese, Rome

Three Paths, *c.* 1600

The Carracci at the Palazzo Farnese

The greatest of all late sixteenth-century galleries was the one that Odoardo Farnese hired the Carracci to decorate in his family palace in Rome (fig. 21.20). When in 1594 Odoardo asked Ludovico Carracci and his cousins Agostino and Annibale to enter his employ, they were at the height of their success. The invitation must have caused the family to engage in real soul-searching, since it had been largely in opposition to the central Italian tradition that the painters had founded their academy in Bologna and developed their way of working; Ludovico, the head of the household, had never even been to Rome, and by design. Still, the opportunity to enter the household of one of the most powerful families in Italy, the chance to carry their idea of painting to Italy's most important center, must have been hard to resist. In the end, Annibale and Agostino decided to make the move, leaving Ludovico behind in Bologna to ensure the continuation of their academy.

In the gallery of the Palazzo Farnese, Annibale and Agostino worked on a long vaulted ceiling. This all but required the use of fresco as their medium, though the artists began with the fiction that they were not providing architectural decorations at all, but rather hanging the framed canvasses of a painting collection in the space. This recalled the approach of Pellegrino Tibaldi in the Sala di Ulisse at the Palazzo Poggi in Bologna (*see* fig. 17.24), as well as the approach Michelangelo had taken on the Sistine Chapel ceiling (*see* fig. 12.31), where every other Genesis scene looks like a framed painting set into

the vault: indeed, the gallery's inclusion of *ignudi* and gigantic medallions makes the reference to the earlier commissions unmistakable.

Tibaldi had already made humorous reference to the Sistine Ceiling in the Palazzo Poggi, and the Carracci followed him in adapting Michelangelo to a cycle of fictional, mythological subjects. This was allowable within the private, secular space of the palace; the Carracci respected the norms of decorum to which a cardinal in particular would have had to adhere. At the same time, it permitted the painters to work with heroic nude bodies in every variety of pose and gesture. The theme the Carracci took up did not suggest a safe, reformed rehashing of Michelangelo so much as a knowing satire on their predecessor; the cycle demonstrated their ability to paint on the level of Rome's greatest artist while also insisting that Michelangelo's work not be taken so seriously.

A single leitmotif, the loves of the gods, connects all the fictive "canvases" in the vault. The theme solic-ited comparison with yet a third model from earlier art, Raphael's Loggia of Psyche at the Villa Farnesina (*see* fig. 13.4); the Carracci had multiple incentives to think about this room, as the villa was just across the Tiber and had entered the possession of the Farnese family less than two decades before. In satirizing the susceptibility of even the immortals to erotic passion, the Carracci were taking up an idea Raphael had made famous and that artists since Rosso had subsequently used to make bawdy jokes about Michelangelo and his own achievement.

Some of the humor in the Farnese Gallery is purely visual. Where Michelangelo had shown a whale-sized Jonah (*see* fig. 12.39) leaning into the concave vault in virtuoso foreshortening, Annibale and Agostino adapted the angry Polyphemus from Raphael's Farnesina, and projected the character out into the gallery (fig. 21.21). Whereas the posture of Michelangelo's figure seemed calculated entirely to show off the illusionistic tricks of which the artist was capable, a legible action moti-vates the Carracci retort. (Later viewers, in fact, regarded

21.21

Annibale Carracci, *The Wrath of Polyphemus.* Fresco. Farnese Gallery, Palazzo Farnese, Rome

21.22
Annibale Carracci, *Venus and Anchises.* Fresco. Farnese Gallery, Palazzo Farnese, Rome

21.23
Annibale Carracci, *Jupiter and Juno.* Fresco. Farnese Gallery, Palazzo Farnese, Rome

Polyphemus's pose as a virtual illustration of Leonardo's motion studies.) Whereas the Jonah seemed overscaled, Polyphemus is large because he is in fact a giant. The Carracci, in other words, rationalized their own choices – or rather, they imitated Michelangelo in such a way as to cast doubt on the rationality of his approach.

The chief irony here is that all the heroes of the gallery are shown reduced to *irrationality*, overcome by love. The Farnese traced their own family roots to the city's ancient origins, and the Carracci, like Barocci, nodded to this by taking up characters from the *Aeneid*. Rather than illustrating Aeneas's valiant rescue of his father

Anchises and the beginnings of the journey that led to Rome, however, the painters went back further in time, to Aeneas's own origins in a fling between Anchises and Venus (fig. 21.22). A Latin inscription intones "whence the Latin people," as the father of all Romans undresses the love goddess and prepares her for bed. The image of Jupiter and Juno (fig. 21.23), king and queen of the gods, includes a visual commentary in the form of two accompanying birds. The peacock, Juno's standard attribute, alluringly displays her plumage while the head of Jupiter's eagle pops up between his legs. In Italian, the verb "uccellare," literally "to bird," means "to screw": the

625

21.24

Annibale Carracci, *Bacchus and Ariadne*, 1597–1602. Fresco. Farnese Gallery, Palazzo Farnese, Rome

humor here ranges from high to low, from witticisms that only those who understood Greek and Latin would pick up to gags worthy of the street.

At the center of everything, revelers lead the golden, tiger-drawn chariot of Bacchus on his return from India, his lover Ariadne at his side (fig. 21.24). Annibale's design makes a deliberate reference to Titian's *Bacchus and Ariadne* (*see* fig. 13.52), which had been snatched away from the Este of Ferrara when Pope Clement VIII annexed the city in 1598: the Este Bacchanals were now being displayed as gallery pictures in a residence of the Pope's family, the Aldobrandini, to whom the Farnese had allied themselves by marriage. If the *Venus and Anchises* presented a prequel of sorts to the episode from the *Aeneid* that artists tended to favor, the *Bacchus* constituted the sequel to the meeting of Titian's two lovers. The scheme is also strongly reminiscent of a triumphal procession, in the tradition of Salviati's *Furius Camillus* (*see* fig. 16.3), yet just what is the nature of the victory here? Leading the cortege, amidst a group of frenzied music makers, a donkey bears Silenus, so drunk that he must lean on an attendant for support. He looks down at a recumbent Venus in the lower right of the picture, who turns to meet his gaze. Giovanni Pietro Bellori, one of the most perceptive earlier commentators on the scene, took the exchange of glances as an allegory, a demonstration of the correspondence between drunkenness and lasciviousness.

The Carracci, young upstarts in a city where Michelangelo, though dead for three decades, remained a universal reference point, must have embraced the assignment for the opportunity it allowed them to paint in the great artist's own style. Few spaces invited such epic treat-ment, and the Farnese Gallery allowed them to try their hands at a grand manner that differed in mode from their down-to-earth Bolognese paintings. The humor of the scenes may distance the painters from the manner, framing the style itself more as a quotation than as an authentic individual technique. Pulling it off, however, gave evidence of their flexibility, their capacity to change the way they painted in accordance with the assignments they received.

Federico Zuccaro: Making *Disegno* Sacred

The Carracci found a kind of middle path between two other developments in late sixteenth-century painting. The fact that they drew the stories for the Farnese Gallery from literature and their imagination, borrowed heavily from earlier painting, and generally emphasized the artifice in the project moved them away from the naturalism of their earlier Bolognese practices. The groundedness they maintained even here, though, comes out if we compare the Carracci's Farnese paintings to those of the key local exponent of the Roman tradition, Federico Zuccaro.

Zuccaro was as well traveled as any artist in Europe. He had spent time in Venice in the early 1560s and had worked with his brother Taddeo (*d.* 1566) in Rome and Caprarola (*see* fig. 18.13). In the 1570s, he visited England, Spain, Antwerp, and France before coming to Florence, where he completed Vasari's paintings in the dome of the city's cathedral and began turning his own house into a work of art. After another stay in Rome, where he took over the decoration of Michelangelo's unfinished

Pauline Chapel, and a second period in Venice, where he developed a particular dislike for Tintoretto's painting (which he called bizarre, capricious, frenetic, and mad), he moved back to Madrid, where he remained three years, painting in the monastery-palace of the Escorial. He spent nearly the whole of the final decade of the century in Rome, however, and there he helped found a new painter's academy, the Accademia di San Luca.

In Florence, Zuccaro had aligned himself with the reformers, calling for the Academy there to place more emphasis on life drawing; when elected as the first president of the Academy in Rome, he set out to encourage the systematic study not just of antiquities, but also of landscapes and animal subjects. His vision of reform, nevertheless, also involved a serious interest in theoretical subjects that the Carracci never showed. A few of the lectures he gave survive in expanded, edited, printed form; the best known of these set out precisely to define the more intellectual aspects of painting, by developing an account of *disegno* of unparalleled complexity. Zuccaro distinguished what he called "internal" *disegno*, a concept formed in the mind, from "external" *disegno*, the circumscription of form without the substance of a body. We might take this starting point simply as a way of getting at the difference between an idea for a picture and a drawing for one (either of which the Italian word *dis-egno* might denote), but Zuccaro's explanation runs to well over one hundred pages, with lengthy digressions on such surprising topics as the nature of angels, the relation of design to morals and virtues, and the "metaphoric" designs of philosophy. All of this went far beyond Vasari's comparatively pithy way of describing the common denominator between painting, sculpture, and architecture; among other things, it acknowledged the religious dimension not just of most painterly commissions but also of the Roman Academy, which was attached to a church and had a patron saint.

Zuccaro also attempted to put his ideas into practice, or at least to translate the theory itself into visual form. Around 1593, he produced a series of twenty drawings illustrating his late brother's curriculum as a painter, from his infancy to his emergence as a major success as a young adult. A number of the drawings give the events of Taddeo's life an inflection that seems to correspond to Federico's later writings. The scene of his brother leaving home, for example, places the child in the care of two angels (fig. 21.25). This likens Taddeo's journey to that of Tobias (whom Zuccaro mentions in his discussion on "the internal design of the angel"), but also foreshadows a later scene of the boy's arrival in Rome, where he is greeted by creatures labeled "spirit," "design," and "grace" (fig. 21.26): the

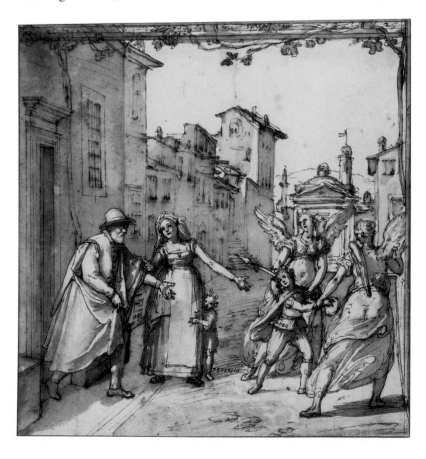

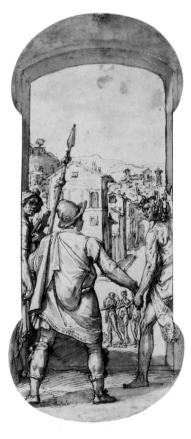

FAR LEFT

21.25

Federico Zuccaro, *Taddeo Zuccaro Leaving Home, Escorted by Two Guardian Angels*, c. 1595. Pen and brown ink and brush with brown wash over black chalk and touches of red chalk on paper, 10⁷/₈ x 10¹/₄" (27.4 x 26 cm). Getty Museum, Los Angeles

LEFT

21.26

Federico Zuccaro, *Taddeo Zuccaro Returns to Rome, Escorted by Drawing and Spirit toward the Three Graces*, c. 1595. Pen and brown ink and brush with brown wash over black chalk and touches of red chalk on paper, 16³/₄ x 7" (41.9 x 17.8 cm). Getty Museum, Los Angeles

21.27
Federico Zuccaro, Chapel
of the Angels, Gesù, Rome,
with altarpiece and other
paintings also by Federico
Zuccaro, 1592

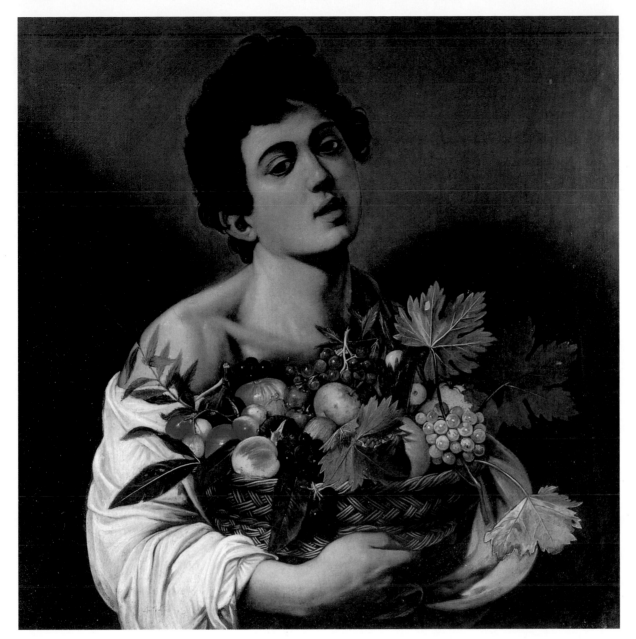

21.28
Caravaggio, *Boy with a Basket of Fruit, c.* 1593. Oil on canvas, 27⅝ x 26⅜" (70 x 67 cm). Galleria Borghese, Rome

painter's divine guides have become qualities of his art, as though it was a form of inspiration that was leading him all along. When Federico undertook a chapel for the Jesuits in the Gesù, angels were his primary subject matter: they comfort the Prodigal Son, carry Jacob's prayers to God, meditate on Christ's holy name (fig. 21.27). Federico must have found that the assignment lent itself perfectly to his arch-academic sensibility.

The Provocations of Caravaggio

The painter from the 1590s whom we might place at the furthest remove from Zuccaro's vision of art was Michelangelo Merisi, called "Caravaggio" (1571–1610) after the small town near Milan where his family lived: Caravaggio was said in the seventeenth century to have refused once to add angels to a painting, remarking that

he had never seen an angel and so did not know how to portray them. As other early biographers remarked, Caravaggio in fact painted plenty of angels. The anecdote, however, is indicative of the way in which an artist with a virtuosic command of the Renaissance tradition came to be perceived as an iconoclast and provocateur, a reputation owing as much to his tumultuous private life as to the occasionally controversial reception of his art.

Caravaggio was born in Milan and is likely to have trained there under a former assistant of Titian named Simone Peterzano. When Caravaggio arrived in Rome, probably around 1592, he seems already to have been in his early twenties. One of his biographers claims he began his career as a portraitist, a suggestive idea given that his early Roman works are nearly all half-length compositions. Another suggests that when Caravaggio first came to Rome, he worked with a slightly older artist

21.29

Caravaggio, *Young Bacchus*, *c.* 1596. Oil on canvas, 37³/₈ x 33³/₄" (95 x 85 cm). Uffizi Gallery, Florence

who only allowed him to paint "flowers and fruits." These descriptions may or may not be reliable; they certainly seem true to Caravaggio's Milanese origins, however, and to the empirical interests that ran from Leonardo to Vincenzo Campi.

The same combination of elements appears repeatedly in Caravaggio's earliest secure paintings in Rome. A canvas from around 1593, for example, shows a *Boy with a Basket of Fruit* (fig. 21.28). The subject relates to no known story or classical source, which may suggest that the work originated as a portrait or even as a self-portrait, then became a different kind of picture, one that did not call on the viewer to recognize the sitter or even the fact that the painting showed a specific individual. But what are we then to see? The boy's exposed shoulder may hint that there is more than fruit on offer here, that the primary intent of the painting is to solicit and seduce the viewer.

Then again, this is precisely the kind of picture that early critics had in mind when describing Caravaggio's uncompromising naturalism. Perhaps the painter described what he saw in the mirror; perhaps he had a model pose for him. Either way, the impression is not, as it was with the Carracci, of an artist going out to find new subjects on the street, but of a man engaged by the contents of his own studio. Even the lighting adds to this effect: painters tended to favor studios with high windows and adjustable apertures, so as to be able to control the illumination of the subjects they studied: Caravaggio's scene seems to have been set in just such a space.

A painting from about three years later includes similar motifs: a young man with exposed shoulder, a basket of fruit, a blank, dark, interior setting (fig. 21.29). The glass of wine the subject holds and the grape leaves in his hair suggest that this time Caravaggio was taking up

a conventional subject – Bacchus – though the painter approached that character very much in the way he had his earlier one. The invitation this time is explicit: Bacchus holds the bow binding closed his robe with one hand while offering the viewer a drink. It is as though Caravaggio has taken the association between wine and love that Annibale Carracci placed at the center of the Farnese ceiling (*see* fig. 21.24) and turned their effects directly on the painting's beholder. Or is there, in this case, too, another explanation for this gesture? If Caravaggio painted the picture before a mirror, he would have seen his left hand (reversed) holding the palette close to his body while his right, with the brush, reached toward the canvas (the dirty fingernails also suggest a craftsman at work). Here, too, there is a strong sense of disguise, of a painting based on a controlled rendering of models set before the artist's eyes that a substitution of attributes has transformed into something else.

Paintings like these shocked contemporary viewers, not so much for their eroticism as for their directness. Critics attacked Caravaggio for treating the human body no differently than the still-life elements in the foreground of his pictures. Bellori, a great partisan of the Carracci, wrote: "with no regard whatever, but rather with disdain for the superb marbles of the ancients and the paintings of Raphael which are so celebrated, he took nature alone as the subject of his brush. Thus when he was shown the most famous statues of Phidias and Glycon so that he might base his studies on them, his only answer was to gesture toward a crowd of people, indicating that nature had provided him with masters enough." As we have seen, the Bolognese and to an increasing extent the Florentines, too, had pursued life studies, occasionally in controlled studio environments, like those that provided the basis for Caravaggio's paintings. For anyone coming out of the academies, however, the idea of using such life studies to the exclusion of the inherited canons of beauty was completely alien. Unlike his major contemporaries, Caravaggio does not seem to have been a committed draftsman; this placed him in radical opposition to the Florentine principle that painting should derive from *disegno*, but it also distanced him from the Carracci, who regarded drawing not only as a path to naturalism but also as a means of understanding the ways of their predecessors.

Bellori, in writing what he did, was thinking in particular about a subject Caravaggio painted in two versions, *The Fortune Teller* (fig. 21.30). He explained the picture this way: "[Caravaggio] called out to a gypsy woman who chanced to be passing in the street and,

21.30
Caravaggio, *The Fortune Teller, c.* 1596–97. Oil on canvas, 39 x 51¹⁄₂" (99 x 131 cm). Musée du Louvre, Paris

taking her to his lodgings, he portrayed her in the act of telling fortunes…. He made a young man there with one gloved hand on his sword, offering the other one bare to the woman, which she holds and examines." The specification that Caravaggio took a gypsy "to his lodgings" rehearses the claim that the painter worked only inside his own studio. Still, such a description as this mischaracterizes the painting to make its point. The woman in Caravaggio's picture hardly looks like a woman taken in from the street: it is difficult to distinguish her class from that of the dandy she is with. Then there is the question of just what she is doing. Bellori's inference, that she is reading his palm, has given the picture its traditional title, though her gaze and the suggestive hilt of the dandy's sword make this, like the *Boy with a Basket of Fruit* and the *Bacchus*, look like one more image of seduction. Some later followers of Caravaggio, moreover, working

in other centers, seem to have remembered the picture as an image of a woman stealing a man's ring. Is the theme here, as it seemed to be in Caravaggio's earlier pictures of costumed boys, nothing other than deception? One contemporary, praising the picture in verse, took the deceit in the picture as a metaphor for the painter's illusionary skills: "I don't know which is the greater sorceress," he wrote, "The woman, who dissembles,/Or you, who painted her."

Caravaggio and the Church

By the turn of the century, Caravaggio had made himself famous enough through pictures of this sort that he began receiving commissions for altarpieces. In this task, the perception that his paintings involved common, unidealized reality sometimes served him well: his paintings

21.31

Caravaggio, *Basket of Fruit*, 1597. Oil on canvas, 12¼ x 18½" (31 x 47 cm). Pinacoteca Ambrosiana, Milan

for churches appeared to address the most humble members of a congregation. Still, if the Counter-Reformation principle of decorum implied that artists should change the way they painted when moving between sacred and secular material, Caravaggio ignored that, to the extent that it is sometimes difficult to place his paintings decisively in one or another category. At least one of his altarpieces, rejected by its patron, entered a private collection, where its new owner – Duke Vincenzo Gonzaga of Mantua – treated it as a gallery painting. Conversely, a *c.* 1597 painting that appears to extract a regular element from his earlier secular works served a prelate as a devotional image.

The *Basket of Fruit* (fig. 21.31) was acquired, perhaps even commissioned, by Cardinal Federico Borromeo. The nephew of Carlo Borromeo (*see* p. 558), Federico was the archbishop of Milan, and he had actively supported Federico Zuccaro in his effort to found an artists' academy in Rome. (Borromeo would go on to found an art academy of his own, known as the Ambrosiana, in Milan, where his rich collection was placed at the disposal of young artists.) A great bibliophile who assembled one of the most important libraries of his time, the archbishop also became a prolific writer, penning over one hundred books, a number of them on the arts. As a patron of painting, he turned his eye not only to Italian artists but also to northerners, notably Jan Brueghel the Elder (1568–1625). Borromeo practiced outdoor prayer so as to have immediate contact with divine rather than human creations, and his written theology involved a sense of God's glory being manifest in all living creatures; he seems to have had a particular interest in the landscape and genre pictures in which Flemish painters had come to specialize. The same tastes and devotional orientations seem to have led him to Caravaggio, whose *Basket of Fruit* represents the first independent still-life painting made by an Italian artist in Italy. Its blank background invites meditation on the details of the composition: the wilting, drying leaves provide a reminder of the transience of life; the worm-eaten apple does this too, but it is also evidence of the smallest, most humble living creatures. We are as far as we can get here from Michelangelo: Caravaggio rejects both his exclusive focus on the human form and his belief that art must represent things only in their most perfect state.

Caravaggio received his first public commission in 1598, when he was charged with providing two canvasses to adorn the walls of a chapel in San Luigi dei Francesi, the French national church in Rome. That the commission went to Caravaggio at all is surprising, given that he had no experience in producing large-scale works or representations of religious narrative, the true test of a painter's worth in Renaissance Italy. The patron, long

deceased, was the French cardinal Mathieu Cointrel (known as Contarelli), who had provided money and detailed instructions for a cycle of paintings concerning his name saint, Matthew, in a testament of 1585. As the Holy Year of 1600 approached, the cardinal's executors pressed to have the work completed; Caravaggio's protector, Cardinal Francesco Maria del Monte, lived nearby, and he may have intervened on the painter's behalf.

The *Calling of St. Matthew* (fig. 21.32), made for the chapel's left wall, departs in startling ways from the conventions of Renaissance narrative painting even as it casts a retrospective eye on the tradition examined in this book. To the left, a group of men and boys are gathered around a table laden with coins (Matthew was a tax collector before being called by Christ). Caravaggio's characters, dressed in emphatically contemporary clothing, seem to refer to his own earlier images of gypsies, alluring youths, card players, and Roman lowlife; he arranges them casually in the raking light of a sparsely furnished room, as if staging the ensemble in his own studio. Emerging from the shadows beneath the beam of light appear a haloed Christ and St. Peter, barely visible yet entirely recognizable in their costume and gesture from the previous three centuries of sacred narrative since Giotto. Caravaggio has treated Christ's pointing hand with extraordinary deliberation. We have seen this hand before: in fact, it merges the creating hand of God with that of the newly formed

21.32
Caravaggio, *Calling of St. Matthew*, 1599. Oil on canvas, 10'6³/₄" x 11'3¹/₂" (3.22 x 3.4 m). Contarelli Chapel, San Luigi dei Francesi, Rome

Adam in Michelangelo's Sistine *Creation of Adam* (*see* fig. 12.32), thus signaling the dual human and divine nature of Christ, the New Adam. The contemporary clothes might initially make us wonder which of the older men at the table is supposed to be the saint, but Caravaggio erases our puzzlement with an art-historical allusion: the face and gesture of the bearded figure who responds to Christ's gesture by pointing to himself are based on Ghiberti's statue of St. Matthew at Orsanmichele in Florence (*see* fig. 3.9).

In the chapel's facing image, which depicts Matthew's martyrdom during a baptismal ceremony, Caravaggio has constructed a typically Renaissance pyramidal composition, largely of nudes (fig. 21.33). The composition pivots on the athletic figure of Matthew's assassin, modeled directly on a classical sculpture known as the *Discobolos* (Discus Thrower). The darkness and the simplicity of the setting, with the plain cross on the altar, indicates that Caravaggio – fully in the spirit of many Roman patrons in these years – was envisioning an Early Christian context, as if the event were even taking place in the catacombs. Yet the figures in contemporary costume once again intrude. One of them – the bearded man who turns to look back at the scene of violence – is a self-portrait of the artist.

Caravaggio, in other words, throws into relief what had by now emerged as the central problem of Renais-

sance art and its chief creative dynamic: how to create an art that was self-consciously modern and of its time, while at the same time knowingly dependent on and in dialogue with the art of the past. For Caravaggio and his generation, that past was no longer only – as it had been for artists a century earlier – the art of classical antiquity, nor was it only the art of the earliest Christian tradition. For these artists, Michelangelo, Leonardo, Raphael, and the High Renaissance "canon" themselves belonged to an increasingly remote past. Whereas Zuccaro and the Carracci would present this relation in terms of harmony, Caravaggio preferred tension and disruption: Michelangelesque poses and gestures seem incongruous – and hence are more striking – when performed by unidealized models in a humble contemporary setting. Zuccaro was dismissive of the Contarelli paintings, declaring that they were no more than exercises in the manner of Giorgione. For Zuccaro, probably mindful of the painter's training with a follower of Titian, Caravaggio's refusal to abide by the academic principles of *disegno* meant that he was to be lumped in with the tradition of descriptive naturalism associated with Venetian *colore*. Yet Zuccaro may have insufficiently appreciated the depth of Caravaggio's relation to Tuscan *disegno*. Caravaggio's attention to Michelangelo in particular was charged by the fact that he shared the same first name with the distinguished Florentine. It is as if he – not unlike Annibale Carracci in the Farnese Gallery – wanted to be the Michelangelo of his time, but knew the impossibility of doing Michelangelo "over again."

The same principle of agonistic identification is at work in a gallery picture executed around 1600 for the banker Ciriaco Mattei (fig. 21.34). Caravaggio depicted a sacred subject – St. John in the Wilderness – in decidedly profane terms: the saint, who mockingly confronts us with his nude body while caressing a ram, could well pass for a shepherd boy, and thus as a lyric subject in the tradition of Giorgione. Yet Caravaggio has his figure adopt the pose of one of Michelangelo's *ignudi* from the Sistine Ceiling. This, again like the Carracci paintings in the Farnese Gallery, may be a satire of the idealizing claims of Michelangelo's art, pointing to its less than ideal basis in fleshly reality. Working through Michelangelo's inventions, even as he distanced himself from the earlier artist's principles, allowed Caravaggio to clarify the things that defined his own art. Such self-definition was of interest to his clients as well, though this particular patron – with whom Caravaggio had a particular connection, since he was living at the time in a Mattei palace – may have enjoyed one additional layer of reference. In alluding to the Sistine *ignudi*, Caravaggio selected a pose that also resembled that of the nude youths on the fountain in the Piazza Mattei (*see* fig. 19.33).

21.33

Caravaggio, *Martyrdom of St. Matthew*, 1599. Oil on canvas, 10'7" x 11'3" (3.23 x 3.43 m). Contarelli Chapel, San Luigi dei Francesi, Rome

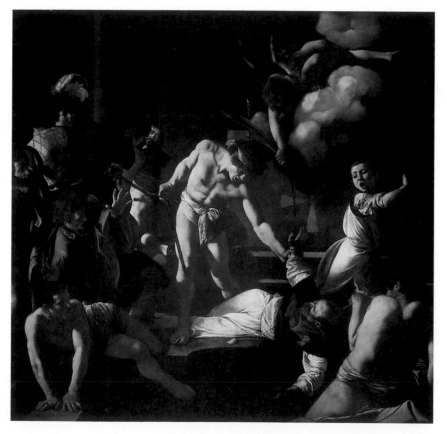

After 1600

If the Carracci forged their own surprising pictorial idiom by turning a specifically north Italian conception of naturalism against the beautiful but overly abstruse art that had come to predominate in central Italy, Caravaggio may finally seem to have turned the same strategy against them. The Carracci were concerned with the everyday, but once in Rome they also embraced the lessons of Michelangelo and Raphael. As Caravaggio replaced Vasari as their true foil, followers began to see the Carracci as something else: a modern form of classicism, the Roman manner as such. Caravaggio's own greatest impact, for its part, would be felt elsewhere, his most important successors being the Neapolitans, Frenchmen, and Dutch who only visited Rome before establishing bases back home.

Today, it is Caravaggio rather than the Carracci who is claimed as a forebear both by artists and by historians writing the history of modernity in art. Be that as it may, Caravaggio is not the only pathway between the Renaissance and the art of modern times. Such a role could also be claimed by Zuccaro, whose metaphysically refashioned theory of *disegno* anticipates a deep vein of preoccupation with the spiritual and the infinite in the art of the twentieth and twenty-first centuries, from Vassily Kandinsky to Mark Rothko and beyond. And Caravaggio shared with the Carracci the goal of speaking a language that was the proper domain of art, but that also resonated within the conditions of ordinary life: the Dadaists, Pop artists, and numerous practitioners since have still been exploring the same territory.

Sometimes, this embrace of the interests that marked the end of the period covered in our book comes across as part of a general repudiation of earlier values and goals. Modernism, on this account, defines itself against the Renaissance. Writing in the 1840s, for example, the English art critic and Italophile John Ruskin sought to demolish Vasari's view of the history of art, in which sixteenth-century Venetians and Florentines had played the central role. In Ruskin's highly influential account, Italian art from Raphael onward represented a descent into over-sophisticated decadence; modern artists, he thought, should therefore look to the directness and unaffected primitive purity of such earlier artists as Giotto and Giovanni Bellini. These were qualities that Caravaggio and to a certain extent the Carracci were already after, and views like Ruskin's have proved surprisingly resilient: an exhibition devoted to early Raphael can break records for attendance, whereas one on Bronzino or Tintoretto has rather less chance of doing so. Christianity, social privilege, painstaking craftsmanship, perspectival illusion, paintings that simulate sculpture and sculpture that

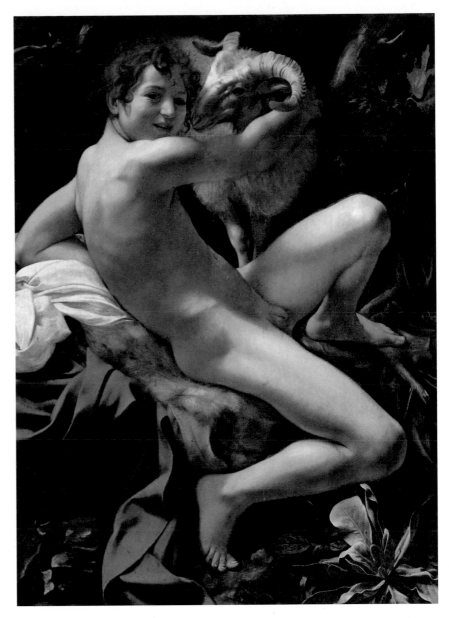

adopts painterly conventions, beauty even – Renaissance art has come to define a series of values that successive waves of modern artists have dedicated themselves to overthrowing.

Some recent critics have worried about the lack of constraint or limit in the sphere of contemporary art practice, and this was also a problem for artists who grew up under the shadow of Michelangelo. Yet at the end of the sixteenth century, generational and regional conflict gave sustenance to art theory and practice. The idea that art could address not only a series of critical problems but also public and private concerns is a defining feature of the Renaissance and an essential part of its legacy.

21.34

Caravaggio, *St. John in the Wilderness*, c. 1600. Oil on canvas, 50³/₄" x 37" (129 x 94 cm). Galleria Doria Pamphilj, Rome

Chronology of Rule 1400–1450 Key Centers

Rulers and Forms of Government	1400	1405	1410	1415	1420	1425	1430	1435	1440	1445

Ferrara
D'Este; Marquesses until 1471, then Dukes

Niccolo III d'Este 1393–1441

Leonello d'Este 1441–50

Florence
Republic, dominated from 1434 by Medici; Dukes 1532–69, then Grand Dukes

Elected Republic, headed by a council called the "Signoria," with new elections every two months

Cosimo de' Medici, though holding no official title, controls the government 1434–64

Mantua
Gonzaga; Marquesses until 1530, then Dukes

Gianfrancesco Gonzaga 1407–44

Milan
Visconti Dukes until 1447; Sforza Dukes until 1524

Giovanni Maria Visconti 1402–12

Filippo Maria Visconti 1412–47

Ambrosian Republic 1447–50

Naples
Angevin Kings until 1442; then Aragonese Kings

Ladislas of Durazzo 1400–14

Giovanna II 1414–35

René of Anjou 1435–42

Alfonso I of Aragon 1442–58

Rome
Popes

John XXIII 1410–15 and two other claimants

Martin V 1417–31

Eugenius IV 1431–47

Nicholas V 1447–55

Urbino
Montefeltro; Counts until 1474, then Dukes

Guido Antonio di Montelfeltro 1404–43

Oddantonio di Montefeltro 1443–44

Federico II di Montefeltro 1444–82

Venice
Doges

Michele Steno 1400–13

Tommaso Mocenigo 1414–23

Francesco Foscari 1423–57

Holy Roman Emperors

Rupert III 1400–10

Sigismund 1410–1437

Albert II 1438–39

Frederick III 1440–93

Key Events

1406: Venice annexes Padua

1409: King Ladislas of Naples takes Rome and Papal States

1417: Council of Constance elects Martin V

1433: Cosimo de' Medici banished from Florence

1435: Alberti writes *On Painting*

1438–39: Council of Ferrara-Florence

1440: Forgery of *Donation of Constantine* exposed

1443: Alfonso of Aragon takes Naples

Chronology of Rule 1450–1500 Key Centers

| 1450 | 1455 | 1460 | 1465 | 1470 | 1475 | 1480 | 1485 | 1490 | 1495 | Rulers and Forms of Government |

Ferrara
D'Este; Marquesses until 1471, then Dukes

Borso d'Este 1450–71

Ercole I d'Este 1471–1505

Florence
Republic, dominated from 1434 by Medici; Dukes 1532–69, then Grand Dukes

Lorenzo "the Magnificent" 1469–92

Piero de' Medici 1464–69

Piero the Younger 1492–94

Florentine Republic 1494–1512

Followers of Savonarola 1494–98

Mantua
Gonzaga; Marquesses until 1530, then Dukes

Federico I Gonzaga 1478–84

Francesco Gonzaga 1484–1519

Ludovico Gonzaga 1444–78

Milan
Visconti Dukes until 1447; Sforza Dukes until 1524

Francesco Sforza 1450–66

Giangaleazzo Sforza 1476–94

Galeazzo Maria Sforza 1466–76

Ludovico "il Moro" 1494–99

King Louis XII of France 1499–1500

Naples
Angevin Kings until 1442; then Aragonese Kings

Ferrante I 1458–94

Alfonso II 1494–95

Ferrante II/ Charles VIII of France 1495

Ferrante II 1495–96

Federico 1496–1501

Rome
Popes

Calixtus III 1455–58

Paul II 1464–71

Innocent VIII 1484–92

Pius II 1458–64

Sixtus IV 1471–84

Alexander VI 1492–1503

Urbino
Montefeltro; Counts until 1474, then Dukes

Guidobaldo I di Montefeltro 1482–1508

Venice
Doges

Niccolo Tron 1471–73

Marco Barbarigo 1485–86

Pasquale Malipiero 1457–62

Niccolo Marcello 1473–74

Agostino Barbarigo 1486–1501

Cristoforo Moro 1462–71

Pietro Mocenigo 1474–76

Andrea Vendramin 1476–78

Giovanni Mocenigo 1478–85

Holy Roman Emperors

Maximilian I 1493–1519

Key Events

1453: Ottomans take Constantinople

1475: Vatican Library established by Sixtus IV

1454: Peace of Lodi

1491: Girolamo Savonarola becomes Prior at San Marco in Florence

1465: First printing press in Italy

1478: Pazzi conspiracy against the Medici

1494: Charles VIII invades Italy

Chronology of Rule 1500–1550 Key Centers

Rulers and Forms of Government — 1500 | 1505 | 1510 | 1515 | 1520 | 1525 | 1530 | 1535 | 1540 | 1545

Ferrara
D'Este; Marquesses until 1471, then Dukes

- Alfonso I 1505–34
- Ercole II 1534–59

Florence
Republic, dominated from 1434 by Medici; Dukes 1532–69, then Grand Dukes

- Piero Soderini, elected "Gonfaloniere" for life 1502
- Medici-controlled government under Giovanni de' Medici 1512–13
- Giuliano de' Medici 1513
- Lorenzo, Duke of Urbino 1513–19
- Cardinal Giulio 1519–23
- Ippolito and Alessandro 1523–27
- "Last Republic" 1527–30
- Alessandro, first Duke of Florence 1530–37
- Cosimo I 1537–74 (Duke until 1569, Grand Duke thereafter)

Mantua
Gonzaga; Marquesses until 1530, then Dukes

- Federico II 1519–40
- Francesco III 1530–50

Milan
Visconti Dukes until 1447; Sforza Dukes until 1524

- Ludovico "il Moro" 1500
- King Louis XII 1500–12
- Massimiliano Sforza 1512–15
- King Francis I of France 1515–21
- Francesco II Sforza 1521–24
- King Francis I 1525
- Imperial Viceroys after 1525, including Ferrante Gonzaga 1546–55

Naples
Angevin Kings until 1442; then Aragonese Kings

- Spanish Rule Louis I 1501–03
- Imperial Viceroys after 1503, including Pedro Álvarez de Toledo 1532–53

Rome
Popes

- Pius III 1503
- Julius II 1503–13
- Leo X 1513–21
- Adrian VI 1522–23
- Clement VII 1523–34
- Paul III 1534–49

Urbino
Montefeltro; Counts until 1474, then Dukes

- Cesare Borgia 1502–03
- Francesco Maria della Rovere 1508–16
- Lorenzo de' Medici 1516–19
- Papal Rule 1519–20
- Francesco Maria I della Rovere 1521–38
- Guidobaldo II della Rovere 1538–74

Venice
Doges

- Leonardo Loredan 1501–21
- Antonio Grimani 1521–23
- Andrea Gritti 1523–38
- Pietro Lando 1539–45
- Francesco Donato 1545–53

Holy Roman Emperors

- Charles V 1519–58

Key Events

- 1509: League of Cambrai formed
- 1517: Martin Luther posts his 95 theses
- 1520: Papal condemnation of Luther
- 1524: French defeat at Battle of Pavia
- 1527: Sack of Rome by imperial forces
- 1528: Andrea Doria effective leader of Genoa
- 1529: Siege of Florence
- 1530: Charles V crowned by in Bologna
- 1540: Foundation of the Jesuits (Society of Jesus)
- 1545: First Session of the Council of Trent

Chronology of Rule 1550–1600 Key Centers

1550	1555	1560	1565	1570	1575	1580	1585	1590	1595	Rulers and Forms of Government

Ferrara
D'Este; Marquesses until 1471, then Dukes

Alfonso II 1559–97

Papal Rule 1597–

Florence
Republic, dominated from 1434 by Medici; Dukes 1532–69, then Grand Dukes

Francesco de' Medici regent 1564–74

Francesco 1574–87

Ferdinando I 1587–1609

Mantua
Gonzaga; Marquesses until 1530, then Dukes

Guglielmo 1550–87

Vincenzo I 1587–1612

Milan
Visconti Dukes until 1447; Sforza Dukes until 1524

Imperial Viceroys after 1555

Naples
Angevin Kings until 1442; then Aragonese Kings

Imperial Viceroys after 1553

Rome
Popes

Julius III 1550–55

Marcellus II 1555

Paul IV 1555–59

Pius IV 1559–65

Pius V 1566–72

Gregory XIII 1572–85

Sixtus V 1585–90

Urban VII 1590

Gregory XIV 1590–91

Innocent IX 1591

Clement VIII 1592–1605

Urbino
Montefeltro; Counts until 1474, then Dukes

Francesco Maria II della Rovere 1574–1621

Venice
Doges

Antonio Trevisan 1553–54

Francesco Venier 1554–56

Lorenzo Priuli 1556–59

Girolamo Priuli 1559–67

Pietro Loredano 1567–70

Alvise Mocenigo 1570–77

Sebastiano Venier 1577–78

Niccolo da Ponte 1578–85

Pasquale Cicogna 1585–95

Marin Grimani 1595–1605

Holy Roman Emperors

Ferdinand I 1558–64

Maximilian II 1564–76

Rudolf II 1576–1612

Key Events

1550: Vasari publishes first edition of *Lives of the Artists*

1556: Philip II succeeds Charles I (Emperor Charles V) as King of Spain (rules until 1598)

1562: Foundation of the Accademia del Disegno in Florence

1563: Final decrees of the Council of Trent

1565: Carlo Borromeo moves to Milan

1571: Battle of Lepanto

1577: Founding of the Accademia di San Luca in Rome

Glossary

acanthus classical architectural ornament in the form of stylized spiny foliage, used in friezes and Corinthian capitals.

aedicule from the Latin *aedicula* meaning "little temple" or shrine; a classicizing framing device consisting of paired columns or pilasters supporting a pediment.

all'antica Italian; "in the ancient manner."

apse in church architecture, the semidomed recess opening behind the high altar, or sometimes housing the high altar, usually at the east end of the structure.

architrave see **entablature**.

arriccio Italian; coarse layer of plaster, the first to be applied to the wall in the *fresco* painting process.

avant-garde "frontline" or "vanguard"; term normally used with reference to Modern Art to designate ground-breaking or pioneering achievement.

azurite crystals of decayed copper ore ground to produce a blue pigment: the cheaper alternative to *ultramarine*.

baldachin, *baldacchino* a canopy carried in processions or placed over the altar to honor the thing or person beneath; also, a permanent architectural structure made in the form of such a canopy.

baptistery a chapel or free-standing structure – often vaulted and centralized – in which the ritual of baptism is celebrated.

barrel vault an arched masonry ceiling.

basilica the most characteristic form of church design in the Middle Ages, adapted from the large Roman public building type of the same name used to house civic and legal business. A basilica is normally rectangular in plan, with a central nave divided by rows of columns or arches from paired side aisles, a second nave-like space running perpendicular to this and known as a transept, and an apse to designate the sacred precinct of the altar.

Benedictine Order the first of all monastic orders, founded in adherence to the rules of prayer and discipline composed by St. Benedict for the community he established at Monte Cassino south of Rome in 529 CE. During the Middle Ages and Renaissance, a number of other Orders followed versions of the Benedictine Rule: Camaldolese, Cassinese, Cistercians, Foglianti, Olivetans, and Sylvestrines.

Black Death the pandemic that devastated the populations of Europe and Asia in the 1340s, apparently borne from the Crimea to Genoa and other Italian port cities in merchant ships. The horrifying symptoms have been associated since the nineteenth century with the disease known as "bubonic plague," but some scholars consider the evidence for identifying this with the 1340s and later outbreaks to be inconclusive. (Modern bubonic plague kills animals as well as humans, and no fourteenth-century source records animal deaths.) Recurrences of "plague" are thought to have reduced the population of Europe by as much as two-thirds by 1420.

bole red clay substance applied to a panel painting as an adhesive for gold leaf.

burin in printmaking, the metal tool used to engrave a design into a metal plate.

buttress in architecture, a segment of arch or a heavy pier erected, usually on the exterior of the building, to counter the lateral thrust of a tall vault or dome.

Byzantine pertaining to the sphere of cultural influence of the Byzantine empire, centered in Byzantium (the ancient city of Constantinople, modern Istanbul) until the Ottoman conquest of 1453.

campanile Italian; the bell tower of a church. From *campanile* comes the term *campanilismo*, competitive pride in one's own city.

campo the Italian word for "field," used in some cities (notably Venice) to designate a public square.

Carmine the Carmelite friary in an Italian city. Carmine is the Italian for Mt. Carmel, the site in Sinai that the Carmelite Order claimed as its ancient place of origin.

cartoon from the Italian *cartone*, meaning "large sheet of paper." A full-scale drawing for a painting or tapestry, either for details (heads, hands) or for the entire composition. Cartoons for paintings allowed the transfer of the design from paper to picture surface by the process of **pouncing**.

cassone (pl. *cassoni*) Italian; a large wooden chest used as household furnishing, often richly ornamented with painted or carved decoration. Families would present well-to-do brides with *cassoni*, which would contain textiles and other luxury items identified as the bride's personal property.

cella Latin; the main enclosed space of an ancient Roman temple.

cenotaph a memorial to the dead, often in the form of a tomb, though not at an actual site of burial.

chasing the process of finishing a cast metal artifact using small chisels.

chiaroscuro Italian term meaning "bright-dark," referring to the handling of light and shadow contrasts in painting to achieve modeling or atmosphere.

choir the sacred precinct of a church, often separated by steps, a rail, or screen from the main public congregation space and containing the principal altar. In the churches attached to houses of religious orders, the clergy normally assembled for Mass and other offices in this area. These offices were generally sung, hence the modern sense of the word "choir."

Cinquecento Italian; the 1500s.

classical pertaining to ancient Greek and Roman culture.

clerestory in church architecture, a zone with windows in the upper part of a wall.

clypeus Latin; in Roman monumental and funerary sculpture, a round, shield-like frame usually carried by a pair of spirits or angels and enclosing a portrait or half-length likeness.

coffer in architecture, a module in a wooden ceiling or concrete vault defined by a recessed square panel. Originally in ancient Roman architecture coffering served to lighten the weight of the vault; Renaissance coffering was often primarily decorative.

colonnette slender column employed especially in Gothic architecture.

comune (pl. *comuni*) Italian term usually translated as "commonwealth," referring to a city as a governmental or administrative entity.

commensuration "measuring together"; the principle of carrying consistent proportions through a large architectural design or across a representation in perspective.

Composite order see **Orders, classical**.

condottiere (pl. *condottieri*) Italian; the leader of a mercenary company.

confraternity a religious organization for lay people, usually devoted to a saint, to the Virgin, or to the Eucharist, which assembled for prayer and for the organization of charitable works at a designated altar in a church or in its own headquarters. The charitable works might be on behalf of the confraternity's own members or the local poor; some confraternities escorted the Eucharist to the bedside of persons nearing death; others prepared condemned criminals for execution. Some (*disciplinati*) devoted themselves to such penitential exercises as self-flagellation. Most Italian Christian men in this period were members of at least one confraternity; membership of some confraternities (such as the larger Venetian *scuole*) carried social distinction and influence.

contrapposto Italian term referring to the principle of antithesis, or the juxtaposition of opposites. In Renaissance art, forms of *contrapposto* (placing near next to far, large next to small, light next to dark, etc.) constituted a basic compositional technique. Modern writers on classical statuary have also used the term to designate weight shift in a figure, where the body resting on one leg produces an asymmetrical arrangement in the other parts.

Conventual see **Mendicant Orders**.

Corinthian see **Orders, classical**.

cornice see **entablature**.

crenellation a low wall on the top of a defensive structure, comprising alternating screens to provide cover for bowmen and artillery and open spaces (crenels) through which they could shoot.

cruciform in the form of a cross; often used with reference to the ground plan of a church.

cupola a dome.

dome a convex ceiling, usually covered by a concave roof. Domes may rest on a cylindrical or polygonal structure known as a drum, as in the case of Florence Cathedral. More commonly, as in the case of Brunelleschi's Old Sacristy, the dome rests on four curved triangular vaults known as **pendentives**, which serve as transitions to the planar surface of the supporting walls below.

Dominican see **Mendicant Orders**.

Doric see **Orders, classical**.

drum see **dome**.

duomo from the Latin *domus*, "house," the term used in many Italian cities for the cathedral.

embossed adorned with a raised abstract pattern.

entablature in classical architecture, the sequence of horizontal elements supported by the columns. Each order has a characteristic set of entablature forms: the most basic, that of the Doric, comprises the **architrave**, a simple lintel or beam that sits directly on the columns; the frieze, a band decorated with square panels of ornament (the fluted **triglyph** alternating with the plain **metope**); and above this, the pronounced molding known as the **cornice**.

Etruscan pertaining to the ancient civilization that dominated large parts of Italy, notably Tuscany, before the rise of Rome.

Eucharist in the Mass, the real presence of the body of Christ manifest in the forms of consecrated bread and wine.

ex-voto an offering made in fulfillment of a vow.

fluting decorative vertical grooves incised in a column or pilaster.

foreshortening abbreviating the lines or forms that represent such an element as a body or limb to create the illusion that it projects outward toward the viewer; considered one of the chief "difficulties" of painting.

Franciscan see **Mendicant Orders**.

fresco Italian; technique of mural painting where paint is applied to wet or "fresh" plaster, as distinct from painting onto plaster that is dry (*secco*). See the fuller description in chapter 5.

gesso a coating of plaster and animal glue forming a smooth white surface for painting.

giornata (pl. *giornate*) Italian; a day's work on a fresco painting. See the fuller description in chapter 5.

Gothic term applied beginning in the eighteenth century to a style principally of architecture that arose in the area of Paris in the mid 1100s, characterized by pointed arches, rib vaults, and flying buttresses, as well as a repertoire of foliate ornament manifest above all in tracery patterns. The term is also applied to painting, sculpture, and decorative arts from the thirteenth to the sixteenth centuries that show comparable qualities of linear enrichment, fine detail, and elongated proportions.

grisaille a painting in monochrome.

groin vault the intersection of two perpendicular barrel-vaults.

guild an organization representing and regulating a particular trade or profession. A guild licensed the training and certification of professionals, determined who had the right to practice in its area or jurisdiction, and supervised the conduct of its members.

hatching in drawing and painting, the technique of providing shading through minute parallel strokes of the pen or brush.

herm in classical and classicizing architecture, a figure that becomes a pillar from the waist down.

Holy Roman Empire a federation initially of Germanic peoples that separated from the Carolingian Empire (the lands conquered by Charlemagne, 742–814, and his descendants) in the early tenth century and elected a common ruler. By the reign of Emperor Charles V (1519–1558), it comprised not only these territories but also Spain, Burgundy (the modern Netherlands and Belgium

as well as eastern France), and Bohemia (the modern Czech Republic).

humanist a scholar of classical languages and culture; by the late fifteenth century, humanism designated the study of the *studia humanitatis* ("humane studies") comprising poetry, rhetoric, history, philosophy, and all fields covered by classical authorities.

icon an image of a saint, the Virgin, or Christ, sometimes believed to be of miraculous origin, venerated through prayer and meditation.

iconoclast a defacer of images.

iconography the art-historical practice of identifying the "subject matter" of a work; also, the collection of familiar characteristics through which a particular subject can be identified.

indigo purple dye extracted from a shellfish known as *murex*.

indulgences reductions in the time the dead must spend suffering in Purgatory before ascending to Paradise. In the Middle Ages and the Renaissance, Christians could acquire indulgences by undertaking prescribed pious actions, such as making a pilgrimage to particular holy sites, by venerating specific relics or images, by reciting certain prayers, or by donating money and property to the Church.

intarsia Italian; decorative wood inlay; marquetry.

intonaco see *fresco*.

Ionic see **Orders, classical.**

Istrian stone white marble from the region of Istria near Trieste in the eastern Veneto.

jamb the lateral, vertical part of a doorway.

keystone the central wedge-shaped stone in an arch; the keystone acts as a lock holding the other stones of the arch together.

lantern architectural element surmounting a dome; the weight of the lantern allowed it to serve the structural function of a **keystone**, though the word refers to the fact that it was through the lantern that light entered the building interior below.

lapis lazuli blue semi-precious stone mined in Afghanistan, used in inlay work and in finely ground form as the basis for the pigment ultramarine.

leadpoint see **metalpoint.**

linear perspective see **perspective.**

loculus (pl. *loculi*) Latin; "little place." In the Roman catacombs, a horizontal recess, excavated from the wall of a passageway, into which the dead body was placed.

loggia An open arcade, usually in the lower storey of a building but sometimes in the *piano nobile.*

mandorla Italian; "almond": in painting, an almond-shaped aura designating the divine or other-worldly status of the person it encloses; in architecture, an almond-shaped frame that evokes such an aura.

maniera Italian; "manner" or "style," as in an artist's style or a period style; the word can also mean "stylishness."

Mendicant Orders priestly orders mainly founded in the thirteenth century, committed to communal living in an urban setting and an active ministry of preaching. The word "mendicant" literally means "beggar," and initially these orders were defined by a prohibition on the ownership of property – their means of living, their housing, and their churches were all donations from the laity. By the late fifteenth century, such Mendicants as the Franciscans and Dominicans had split internally: Observants pursued a more austere "observance" of the rules governing poverty, while Conventuals followed a more moderate practice, especially with regard to vows of poverty.

metalpoint a pointed stick of silver or lead used in drawing on vellum or paper. Silverpoint, which produces a dark oxide mark, was preferred for its finer line.

metope see **Orders, classical.**

Middle Ages the "medieval" period, or *media tempestas*, a description in circulation in the fifteenth century (and still current) to define the centuries between the fall of the Roman Empire in 476 CE and the era of *renovatio* or "Renaissance."

narthex in some medieval churches, a space between the main entrance and the nave, serving as a vestibule.

nave the main space of a church, on axis with the high altar.

Observant see **Mendicant Orders**.

oculus (pl. *oculi*) Latin; "eye"; a round window.

Olivetans monastic order founded in 1313 near Siena, adopting the Benedictine Rule in 1344.

oratory a small room for private prayer; in some cities, a place where confraternities held meetings or engaged in communal prayer.

Orders, classical a system of architectural forms consisting of a vertical element (column) and a horizontal element (entablature), each with distinctive, conventionalized proportions and sets of parts. The three basic Orders, known from buildings like the Colosseum in Rome and from the writing of Vitruvius, were most easily recognizable from the form of their capitals: the Doric capital has plain moldings; Ionic has scroll forms; Corinthian has stylized acanthus foliage. Later Renaissance architects and theorists sometimes introduced a fourth order, the Composite, which combined scrolls with acanthus, and a fifth, the Tuscan (or Etruscan), a simpler, stouter form of the Doric.

orthogonal in perspective, a line notionally perpendicular to the picture plane. Orthogonals appear to converge on a common vanishing point.

pala Italian; an altarpiece consisting of one major panel, usually square in form; after about 1440, the alternative to the **polyptych**, which consisted of multiple panels.

Papal States the central Italian territories directly subject to the Pope, although often ruled in practice by so-called papal vicars who founded dynasties of their own.

paragone Italian; "comparison." A term applied beginning in the nineteenth century to a literary set-piece that evaluated the relative merits and limitations of competing art forms – poetry vs. painting, painting vs. sculpture, painting vs. music, etc.

pastiglia Italian; raised relief ornament constructed in *gesso* on the surface of a panel painting, often gilded to suggest goldsmith's work in metal.

paten liturgical instrument used during Mass to hold the **Eucharistic** wafer.

pediment in architecture, a triangular element placed over windows, doors, or the main facade of a temple or church. A segmental pediment replaces the two sloping sides of the triangle with an arc.

pendentive see **dome**.

peristyle a colonnade that surrounds the *cella* of a temple or an open courtyard or square; the term can also be used to refer to the space so surrounded.

perspective from the Latin *perspicere*, "to look through"; the term now normally refers to the techniques for creating illusionistic space using geometric devices (linear perspective) or coloristic ones (atmospheric perspective).

philology the study of language and literature, especially applied to the humanistic study of ancient Latin, Greek, and Hebrew texts.

piano nobile Italian; "noble floor"; the second storey of an Italian palazzo, often given a special architectural distinction as the level frequented by the palace's principal inhabitant and used to receive important guests.

piazza (pl. piazze) Italian; the word used in most Italian cities to denote a large urban public space, typically adjacent to a church, an important civic building, or the residence of a powerful family.

pier a non-columnar vertical support. The term can refer to a pillar that is square rather than round, to an irregularly shaped concrete or masonry structure that supports a **dome** or other heavy load, or even to a section of bearing wall.

pietra serena Italian; "serene stone"; gray limestone mined near Florence, used for architectural ornament and occasionally for sculpture.

pigment colored animal, botanical, or mineral substance combined with a medium (egg yolk, lime water, or oil), to make paint.

pilaster a "flattened" column applied as relief to a wall.

polychromy in sculpture, applied color.

polyphony form of musical composition arising in the later 1200s in which different instruments or voices perform different lines of music simultaneously, the whole governed by mathematical principles of harmony and rhythm.

polyptych a painting, usually an altarpiece, consisting of multiple panels or sections. A diptych is a polyptych with two panels, a triptych with three.

porphyry a stone, red, purplish-red, or black in color and famed for its hardness, mined in antiquity and used for columns, stone inlay, and more rarely, sarcophagi. Only in the late sixteenth century did sculptors rediscover the means to carve figures in porphyry, using new varieties of tempered steel.

portico a columned porch.

pouncing the technique of transferring a design from a cartoon to a surface to be painted by pricking holes along the lines of a cartoon, then rubbing or tapping charcoal dust through them. See also *spolvero*.

predella a row of painted or carved scenes on which the main panel or panels of an altarpiece rest.

pronaos in an ancient Greek or Roman temple, the vestibule-like space that precedes the *cella*.

pumice abrasive volcanic stone used in polishing marble.

Purgatory In Christian belief, a place of temporary punishment in the afterlife. Living Christians could reduce their prospective sentences by obtaining **indulgences**; souls already in Purgatory could be delivered through the prayers of the living on their behalf. The Renaissance conception of Purgatory was largely shaped by Dante's description in the second part of his epic poem *The Divine Comedy*.

putto (pl. putti) Italian; "little boy." Term used to describe child angels, cupids, or *spiritelli* ("little spirits") in art.

quatrefoil French; "four leaf": In Gothic art, a decorative form – often used to frame an image – in which four rounded lobes alternate with four points.

Quattrocento Italian; the 1400s.

quoin stone blocks forming the corner of a building.

revetment in Roman and in Italian Renaissance architecture, fine stone that covers a wall constructed of brick or other material.

rib a raised molding defining and dividing the segments of a vault or dome.

rustication in architecture, a textural effect produced when the faces of stone blocks are left unfinished, or where the joins between the blocks are emphasized to stress their distinctness and their massiveness.

sacristy a room in a church used for the storing of vestments and liturgical objects, and where the robing of a priest takes place.

scriptorium a room in a convent or monastery devoted to writing and to the preparation of manuscripts.

scuola (pl. *scuole*) Italian; see **confraternity**.

secco see *fresco*.

serliana in architecture, a tripartite window or door consisting of an arched central opening flanked by vertical rectangular openings. Though ancient in origin, the form is named after the architect Sebastiano Serlio, whose illustrated *Books of Architecture* (1537–47) popularized the motif. Also referred to as a "Palladian motif."

serpentine a lustrous colored stone (gray, green, yellow, or brown) characterized by veins and blotches.

Servite see **Mendicant Orders**.

sfumato, *sfumatura* from the Italian *fumo*, "smoke": the blurring of edges or borders in a painting to create the effect of atmosphere or of transparent, "smoky" shadows, and to merge figures with their surroundings.

Sibyl one of the pagan prophetesses or female oracles of the ancient world.

signoria (pl. *signorie*) Italian; "lordship," referring either to a state governed by a single, unelected lord or to the elected body of lords in a republic.

silverpoint see **metalpoint**.

sinopia reddish brown pigment used to make the underdrawing for a fresco.

spalliera (pl. *spalliere*) from the Italian *spalla*, "shoulder." A painted or marquetry (wood inlaid) panel or series of panels set into a wooden wainscotting at shoulder height.

spandrel see **dome**.

spoglia (pl. *spoglie*) from the Italian *spogliare*, "to strip." An architectural element, epigraphic inscription, or sculpture removed from its original context and re-embedded in a new architectural setting, typically the exterior wall of a palace or church. The transposition sometimes signifies the triumph of Christianity over paganism, or the territorial domination of one city or state by another.

spolvero (pl. *spolveri*) Italian; charcoal dust applied to the perforations in a **cartoon** in order to transfer the outline to a wall or panel.

string course in architecture, a narrow, continuous horizontal molding running the length of a facade or entablature.

stucco (pl. *stucchi*) Italian; plaster made from lime, sand, and water, used to fashion sculptural elements for architectural decoration.

tabernacle a window treatment taking the form of a miniature building; in churches, also a container in the form of a miniature building, usually placed on an altar, designed to hold the **Eucharist**.

taccuino (pl. *taccuini*) Italian; "sketchbook."

tempera paint that uses water and egg yolk (rather than oil) as a binder.

terra verde Italian; "green earth"; greenish pigment used for the underpainting of flesh in panel painting and for **grisaille** painting on walls.

tessera (pl. *tesserae*) cube of colored stone or glass used to make mosaics.

tondo (pl. *tondi*) Italian; "round." A circular painting or relief.

tracery decorative interlaced stone moldings or framing elements for stained glass, characteristic of Gothic architecture.

transept see **basilica**.

Trecento Italian; the 1300s.

triglyph see **entablature**.

trilobe ornamental motif consisting of three linked round forms.

triptych see **polyptych**.

tympanum, timpana arch-shaped space over a door; the surface inside a pediment.

ultramarine see **lapis lazuli**.

vault a curved ceiling.

Bibliographical Notes and Suggestions for Further Reading

The following notes identify sources on which we drew for particular discussions and give further recommendations for reading in English.

Introduction

The most recent edition of the *Commentarii* is the one edited by Lorenzo Bartoli (Florence: Giunti, 1998); this has not completely supplanted Julius von Schlosser's 1912 German edition. There is no complete English translation of the text.

Chapter 1: 1300s

For some useful accounts of fourteenth-century art and society, with sections on Giotto, Duccio, and the Assisi murals, see Diana Norman, et al., *Siena, Florence and Padua: Art, Society and Religion 1280–1400*, 2 vols. (New Haven, CT, and London: Yale University Press, 1995); and Hayden B. J. Maginnis, *Painting in the Age of Giotto: A Historical Reevaluation* (University Park, PA: Penn State University Press, 1997).

John Pope-Hennessy, *Italian Gothic Sculpture* (Oxford: Phaidon Press, 1985) provides a general overview of fourteenth-century sculpture, including the Della Scala monuments and the Pisano pulpits; Anita Fiderer Moskowitz covers the same territory in *Italian Gothic Sculpture: c. 1250–c. 1400* (Cambridge and London: Cambridge University Press, 2001).

Two good discussions of the murals in the Palazzo Pubblico are Randolph Starn and Loren Partridge, *Arts of Power: Three Halls of State in Italy, 1300–1600* (Berkeley, CA: University of California Press, 1992), and C. Jean Campbell, *The Commonwealth of Nature: Art and Poetic Community in the Age of Dante* (University Park, PA: Penn State University Press, 2008). Campbell also treats Petrarch and Simone Martini.

Nicolai Rubinstein's excellent *The Palazzo Vecchio 1298–1532: Government, Architecture, and Imagery in the Civic Palace of the Florentine Republic* (Oxford: Clarendon Press, 1995) surveys the building's decorations up to the establishment of the Medici Duchy. This should be read in conjunction with Marvin Trachtenberg, *Dominion of the Eye: Urbanism, Art, and Power in Early Modern Florence* (Cambridge: Cambridge University Press, 1997). Our chronology of Giotto's travels reflects the findings in Donal Cooper and Janet Robson, "'A Great Sumptuousness of Paintings': Frescoes and Franciscan Poverty at Assisi in 1288 and 1312," *Burlington Magazine* 151 (2009), 656–62. Andrew Ladis's *Giotto and the World of Early Italian Art: An Anthology of Literature* (New York: Garland, 1998) provides a useful point of entry into the older literature on that artist and on some of his followers. On the Arena Chapel, see especially Anne Derbes and Mark Sandona, *The Usurer's Heart: Giotto, Enrico Scrovegni, and the Arena Chapel in Padua* (University Park, PA: Penn State University Press, 2008), and Laura Jacobus, *Giotto and the Arena Chapel: Art, Architecture and Experience* (London: Miller, 2008).

There is far less good English-language literature on Duccio, but see Keith Christiansen's recent *Duccio and the Origins of Western Painting* (New Haven: Yale University Press, 2008). For Trecento Siena more broadly, a good place to start is Diana Norman, *Siena and the Virgin: Art and Politics in a Late Medieval City State* (New Haven, CT, and London: Yale University Press, 2000).

The best general study on the civic and religious role of the image in the preceding centuries and through the 1500s remains Hans Belting, *Likeness and Presence: A History of the Image in the Era before Art* (Chicago, IL: Chicago University Press, 1994); for the specific case of Florence, see Richard C. Trexler, "Florentine Religious Experience: The Sacred Image," *Studies in the Renaissance* 19 (1972), 7–41.

On Orsanmichele, see Diane Finiello Zervas's bilingual *Orsanmichele a Firenze* (Modena: F. C. Panini, 1996).

The standard study on the artist and writer Ghiberti is Richard Krautheimer and T. Krautheimer-Hess, *Lorenzo Ghiberti* (Princeton, NJ: Princeton University Press, 1956).

Chapter 2: 1400–1410

There is no good history in English of the building of Milan Cathedral. Our discussion relied heavily on Carlo Ferrari da Passano, *Il duomo di Milano: Storia della veneranda fabbrica* (Milan: NED, Veneranda fabbrica del Duomo di Milano, 1998), and Giulia Benati and Anna Maria Roda, eds., *Il duomo di Milano: dizionario storico artistico e religioso* (Milan: NED, 2001). The literature on Florence Cathedral is substantial, but a volume occasioned by the 1997 centenary gives a fairly recent sense of the state of the field and includes many further references: Margaret Haines, ed., *Santa Maria del Fiore: The Cathedral and Its Sculpture* (Fiesole: Edizioni Cadmo, 2001). Charles Seymour's *Michelangelo's David: A Search for Identity* (Pittsburgh, PA: Pittsburgh University Press, 1967) informed our reading of the prophet cycle.

For the first Florence baptistery doors, see Anne Fiderer Moskowitz, *The Sculpture of Andrea and Nino Pisano* (Cambridge and New York: Cambridge University Press, 1986); on Ghiberti, Brunelleschi, and the baptistery doors competition, see Krautheimer, *Lorenzo Ghiberti* (as in chapter 1 above), and Antonio Paolucci, *The Origins of Renaissance Art: The Baptistery Doors, Florence*, trans. by Françoise Pouncey Chiarini (New York: George Braziller, 1996).

On the Fonte Gaia, see Anne Coffin Hansen, *Jacopo della Quercia's Fonte Gaia* (Oxford: Clarendon Press, 1965). The only English-language monograph on the sculptor is James Beck, *Jacopo della Quercia* (New York: Columbia University Press, 1991); a more recent resource in Italian is the well-illustrated exhibition catalogue *Da Jacopo della Quercia a Donatello: Le Arti a Siena nel primo Rinascimento*, ed. Max Seidel (Milan: Motta, 2010).

Chapter 3: 1410–1420

On contractual procedures and on the language used to describe works of art in the 1400s, see Michael Baxandall, *Painting and Experience in Fifteenth-Century Italy* (Oxford and New York: Oxford University Press, 1988). We also drew on Ulrich Pfisterer, "Civic Promoters of Celestial Protectors: The Arca di San Donato at Arezzo and the Crisis of the Saint's Tomb around 1400," in *Decorations for the Holy Dead: Visual Embellishments on Tombs and Shrines of Saints*, eds. Stephen Lamia and Elizabeth Valdez del Alamo (Turnhout: Brepols, 2002), 219–32. Christa Gardner von Teuffel notes that a "persistent convention in altarpiece commissions, and particularly those of elaborate polyptychs, was that they should 'copy' an older prototype"; see *From Duccio's Maestà to Raphael's Transfiguration: Italian Altarpieces and their Settings* (London: Pindar Press, 2005), 11.

Diane Finiello Zervas, *Orsanmichele a Firenze* (see chapter 1 above), collects the crucial documentation related to the building and ornamentation of Orsanmichele and gives a balanced and cautious chronology of the tabernacles and sculptures. Our discussions of Nanni di Banco and Lorenzo Ghiberti were informed by the study day hosted by the National Gallery in Washington during the 2005 exhibition, "Monumental Sculpture from Renaissance Florence: Ghiberti, Nanni di Banco and Verrocchio at Orsanmichele."

For the circumstances surrounding the two Lorenzo Monaco *Coronation* altarpieces, see especially Dillian Gordon and Anabel Thomas, "A New Document for the High Altar-Piece for S. Benedetto fuori della Porta Pinti, Florence," *Burlington Magazine* 137 (1995), 720–22, and Dillian Gordon, "The Altar-Piece by Lorenzo Monaco in the National Gallery, London," *Burlington Magazine* (1995), 723–27. The standard monograph on Gentile da Fabriano remains that of Keith Christiansen, *Gentile da Fabriano* (Ithaca, NY: Cornell University Press, 1982), though see also the catalogue from the major 2006 exhibition *Gentile da Fabriano and the Other Renaissance*, ed. Laura Laureti et al. (Milan: Electa, 2006).

On Renaissance hospitals, see John Henderson, *The Renaissance Hospital: Healing the Body and Healing the Soul* (New Haven, CT, and London: Yale University Press, 2006), which discusses Brunelleschi's Ospedale degli Innocenti as well as San Matteo. For more on Brunelleschi as an architect, see Eugenio Battisti, *Filippo Brunelleschi: The Complete Work*, trans. Erich Wolf (New York: Rizzoli, 1981); Christine Smith, *Architecture in the Culture of Early Humanism: Ethics, Aesthetics, and Eloquence, 1400–1470* (New York and Oxford: Oxford University Press, 1992); and Howard Saalman, *Filippo Brunelleschi: The Buildings* (University Park, PA: Penn State University Press, 1993).

Chapter 4: 1420–1430

There is little substantial literature in any language on Andrea da Firenze or the funerary monument to King Ladislao, but see the brief description in George L. Hersey, *The Aragonese Arch at Naples* (New Haven, CT, and London: Yale University Press, 1973). On foreign sculptors in Naples in the early Renaissance see also Nicholas Bock, "Center or Periphery? Artistic Migration, Models, Taste and Standards," in *«Napoli è tutto il mondo». Neapolitan*

Art and Culture from Humanism to the Enlightenment, eds. Livio Pestilli, Ingrid D. Rowland, and Sebastian Schütze (Pisa and Rome: Serra, 2008), 11–36.

The original Italian for the Ghiberti passage we quote can be found in the Bartoli edition, p. 95. Ours slightly modifies the translation in Elizabeth Holt, *Literary Sources of Art History: An Anthology of Texts from Theophilus to Goethe* (Princeton, NJ: Princeton University Press, 1947), 90.

On Brunelleschi and Renaissance perspective, see Samuel Y. Edgerton Jr., *The Renaissance Rediscovery of Linear Perspective* (New York: Basic Books, 1975); for a contrasting view, Martin Kemp, *The Science of Art: Optical Themes in Western Art from Brunelleschi to Seurat* (New Haven, CT, and London: Yale University Press, 1990). See also James Elkins, *The Poetics of Perspective* (Ithaca, NY: Cornell University Press, 1994). Our emphasis on commensuration and the incommensurate owes a particular debt to Daniel Arasse, *L'annonciation italienne: une histoire de perspective* (Paris: Hazan, 1999).

The best general monograph in English on Donatello is still H. W. Janson, *The Sculpture of Donatello* (Princeton, NJ: Princeton University Press, 1957). Nicholas Eckstein's good anthology, *The Brancacci Chapel: Form, Function, and Setting: Acts of an International Conference* (Florence: Olschki, 2007), looks at the chapel from many points of view. On both the chapel and the *Trinity*, see also Paul Joannides, *Masaccio and Masolino: A Complete Catalogue* (New York: Phaidon Press, 1993), and Janet V. Field, "Masaccio and Perspective in Italy in the Early Fifteenth Century," in *The Cambridge Companion to Masaccio*, ed. Diane Cole Ahl (Cambridge and New York: Cambridge University Press, 2002). Our account also drew on Carl Strehlke, *Italian Paintings, 1250–1450, in the John G. Johnson Collection and the Philadelphia Museum of Art* (University Park, PA: Penn State University Press, 2000).

On Alberti and his treatise, see Leon Battista Alberti, *On Painting and On Sculpture: The Latin Texts of "De Pictura" and "De Statua,"* trans. C. Grayson (London: Phaidon Press, 1972); see also the re-issue of the Grayson translation of *De Pictura* with an introduction by Martin Kemp (New York: Penguin Books, 1992). On Alberti and the culture of humanism, see Michael Baxandall, *Giotto and the Orators: Humanist Observers of Painting in Italy and the Discovery of Pictorial Composition 1350–1650* (Oxford: Oxford University Press, 1970, 1988). On Sassetta and Giovanni di Paolo, see the exhibition catalogue by Keith Christiansen, Carl Brandon Strehlke, and Laurence B. Kanter, *Painting in Renaissance Siena, 1420–1500* (New York: Abrams, 1988).

Chapter 5: 1430–1440

For Fra Angelico's Linaiuoli tabernacle, see Diane Cole Ahl, *Fra Angelico* (London and New York: Phaidon Press, 2008). Eve Boorsook offers a clear description of fresco technique in *The Mural Painters of Tuscany: From Cimabue to Andrea del Sarto* (Oxford: Oxford University Press, 1980).

On Cennino Cennini, see Cennini, *The Craftsman's Handbook (Il Libro dell'arte)*, trans. D. Thompson Jr. (New Haven, CT, and London: Yale University Press, 1933). On Cennini's relation to contemporary intellectual life, see Andrea Bolland, "Art and Humanism in Early Renaissance Padua: Cennini, Vergerio, and Petrarch on Imitation," *Renaissance Quarterly* 49 (1996), 469–88.

A valuable introduction to Pisanello that draws on a large corpus of research on the artist since the 1990s is Luke Syson and Dillian Gordon, *Pisanello: Painter to the Renaissance Court*, exh. cat. (London: National Gallery, 2001); see also Joanna Woods-Marsden, "French Chivalric Myth and Mantuan Political Reality in the Sala del Pisanello," *Art History* 8 (December 1985), 397–412.

On Uccello, see Paolo and Stefano Borsi, *Paolo Uccello* (London: Thames and Hudson, 1994). For Uccello's drawings, and for a comprehensive account of Renaissance drawing media and techniques, see Carmen Bambach, *Drawing and Painting in the Italian Renaissance Workshop: Theory and Practice 1300–1600* (Cambridge and New York: Cambridge University Press, 1999). James Watrous, *The Craft of Old-Master Drawings* (Madison, WI: University of Wisconsin Press, 1957), remains useful as well.

On the *cantorie*, see John Pope-Hennessy, *Donatello, Sculptor* (New York: Abbeville Press, 1993); and *idem*, *Luca della Robbia* (Oxford: Oxford University Press, 1980); for an interesting contextual study of Luca's work, see Robert L. Mode, "Adolescent Confratelli and the Cantoria of Luca della Robbia," *Art Bulletin* 68 (1986), 67–71. Our understanding of Donatello's frolicking children as *spiritelli* depends on Charles Dempsey, *Inventing the Renaissance Putto* (Chapel Hill, NC: University of North Carolina Press, 2001), and on Ulrich Pfisterer, *Donatello und die Entdeckung der Stile: 1430–1445* (Munich: Hirmer, 2002).

On Jacopo Bellini as a draftsman, see Bernhard Degenhart and Annegrit Schmitt, *The Louvre Album of Drawings* (New York: George Braziller, 1984). There is also useful discussion in Patricia Fortini Brown, *Venice and Antiquity: The Venetian Sense of the Past* (New Haven, CT, and

London: Yale University Press, 1996). On the Doge's Palace, see Edoardo Arslan, *Gothic Architecture in Venice* (London: Phaidon Press, 1972), and Deborah Howard, *Venice and the East: The Impact of the Islamic World on Venetian Architecture 1100–1500* (New Haven, CT, and London: Yale University Press, 2000).

Chapter 6: 1440–1450

The illustration on p. 133 uses as its basis Francesco Magnelli and Cosimo Zocchi's 1783 map of Florence, which shows the city before the dramatic nineteenth- and twentieth-century transformations of the urban grid.

Dale Kent's *Cosimo de' Medici and the Florentine Renaissance: The Patron's Oeuvre* (New Haven, CT, and London: Yale University Press, 2000) is a comprehensive account of the major Medici commissions before 1460. On Florentine families and corporations, see also Patricia L. Rubin, *Images and Identity in Fifteenth-Century Florence* (New Haven, CT, and London: Yale University Press, 2007). On Antonino, Fra Angelico, and the Dominicans, see William Hood, *Fra Angelico at San Marco* (New Haven, CT, and London: Yale University Press, 1993); on Fra Angelico and the invention of the *pala*, Carl Strehlke, *Angelico* (Milan: Jaca Book, 1998).

Our treatment of Fra Filippo Lippi draws on Megan Holmes, *Fra Filippo Lippi: The Carmelite Painter* (New Haven, CT, and London: Yale University Press, 1999). On the St. Lucy altarpiece, see Helmut Wohl, *The Paintings of Domenico Veneziano* (New York: New York University Press, 1980), and Keith Christiansen's catalogue entry in *From Filippo Lippi to Piero della Francesca: Fra Carnevale and the Making of a Renaissance Master*, exh. cat. (New York: Metropolitan Museum of Art, 2005), 190–91. For Castagno's *Last Supper*, see Andree Hayum, "A Renaissance Audience Considered: The Nuns at S. Apollonia and Castagno's Last Supper," *Art Bulletin* 88 (2006), 243–66. Our attention to the marbles follows Georges Didi-Huberman's brilliant *Fra Angelico: Dissemblance and Figuration*, trans. Jane Marie Todd (Chicago, IL: University of Chicago Press, 1995).

Two good surveys of Quattrocento sculpture, both of which discuss Bernardo Rossellino and Desiderio da Settignano's Santa Croce tombs, are John Pope-Hennessy, *Italian Renaissance Sculpture* (New York: Phaidon, 1985), and Joachim Poeschke, *Donatello and his World: Sculpture of the Italian Renaissance* (New York: Abrams, 1993). A useful collection of essays is Sarah Blake McHam, *Looking at Italian Renaissance Sculpture* (Cambridge: Cambridge University Press, 1998).

The literature on Donatello's bronzes *David* and *Judith* is vast: we relied especially on Pfisterer, *Donatello* (see chapter 5 above) and on Francesco Caglioti's monumental *Donatello e i Medici: storia del David e della Giuditta* (Florence: Olschki, 2000). In English, see the Pope-Hennessy and Poeschke surveys, as well as Janson, *Donatello* (as in chapter 4 above), and the stimulating discussion in Joost Keizer, "History, Origins, Recovery: Michelangelo and the Politics of Art" (unpublished dissertation, University of Leiden, 2008), 43–55.

On Lo Scheggia and domestic arts, see the exhibition catalogue *Art and Love in Renaissance Italy* (New York: Metropolitan Museum of Art, 2008); Luke Syson and Dora Thornton, *Objects of Virtue: Art in Renaissance Italy* (Los Angeles, CA: Getty Museum, 2001); Roberta J. M. Olson, *The Florentine Tondo* (Oxford and New York: Oxford University Press, 2000); and Cristelle Baskins, *Cassone Painting, Humanism, and Gender in Early Modern Italy* (Cambridge and New York: Cambridge University Press, 1998).

On the Pazzi Chapel, see the monographs on Brunelleschi by Battisti, *Filippo Brunelleschi*, and by Saalman, *Filippo Brunelleschi* (as in chapter 4 above); Brunelleschi's authorship is challenged by Marvin Trachtenberg, "Why the Pazzi Chapel is not by Brunelleschi," *Casabella* (June 1996), 58–77, and "Why the Pazzi Chapel is by Michelozzo," *Casabella* (February 1997), 56–75.

On Donatello's Padua altar, see Geraldine Johnson, "Approaching the Altar: Donatello's Sculpture in the Santo," *Renaissance Quarterly*, 52 (1999), 627–66. The Mascoli Chapel mosaics are examined by Patricia Fortini Brown, *Venice and Antiquity* (see chapter 5 above).

For Sassetta and Domenico di Bartolo, see the exhibition catalogue *Painting in Renaissance Siena* (New York: Metropolitan Museum of Art, 1988), and Timothy Hyman, *Sienese Painting: The Art of a City-Republic (1278–1477)* (London: Thames & Hudson, 2003). On Filarete and the doors of St. Peter's, we have profited especially from John Onians, "Alberti and 'PHILARETE': A Study in their Sources," in Onians, ed., *Art, Culture, and Nature: From Art History to World Art Studies* (London: Pindar Press, 2006), 141–66; and from Ulrich Pfisterer, "Filaretes historia und commentarius: über die Anfänge humanistischer Geschichtstheorie im Bild," in Valeska von Rosen and Klaus Krüger, eds., *Der stumme Diskurs der Bilder: Reflexionsformen des Ästhetischen in der Kunst der Frühen*

Neuzeit (Munich: Deutscher Kunstverlag, 2003), 139–76; and Helen Roeder, "The Borders of Filarete's Bronze Doors to St. Peter's," *Journal of the Warburg and Courtauld Institutes* 10 (1947), 150–53.

Chapter 7: 1450–1460

For an account of the early Renaissance papacy and its problems, see Charles Stinger, *The Renaissance in Rome* (Bloomington, IN: Indiana University Press, 1985); Charles Burroughs deals with questions of urbanism and design in *From Signs to Design: Environmental Process and Reform in Early Renaissance Rome* (Cambridge, MA: MIT Press, 1990); Carroll William Westfall's older *In This Most Perfect Paradise: Alberti, Nicholas V, and the Invention of Conscious Urban Planning in Rome* (University Park, PA: Penn State University Press, 1974) remains useful as well. The richest recent resource on the topic, however, is in Italian: Stefano Borsi, *Niccolò V e Roma: Alberti, Angelico, Manetti e un grande piano urbano* (Florence: Polistampa, 2009).

Burroughs also discusses Fra Angelico's Vatican frescoes, as does Cole Ahl, *Fra Angelico* (see chapter 5 above); in addition, see Carl B. Strehlke, "Fra Angelico: A Florentine Painter in 'Roma Felix'," in Laurence Kanter and Pia Palladino, *Fra Angelico* (New York: Metropolitan Museum of Art; and New Haven, CT, and London: Yale University Press, 2005), 203–14.

Syson and Gordon, *Pisanello* (see chapter 5 above), provide an accessible account of Alfonso's court at Naples with a focus on Pisanello; Hersey, *The Aragonese Arch* (see chapter 4 above), is the standard reference on that monument.

Our discussion of Rimini was informed by the recent catalogue *Il Potere, Le Arti, La Guerra. Lo Splendore dei Malatesta* (Milan: Electa, 2001). For the architecture, see Charles Hope, "The Early History of the Tempio Malatestiano," in the *Journal of the Warburg and Courtauld Institutes* 55 (1992), 51–154; despite Hope's critique of the attribution, we continue to recognize Alberti as the architect of the building. On the humanist programs of the San Francesco chapels, see Stanko Kokole, "Cognitio formarum and Agostino di Duccio's Reliefs for the Chapel of the Planets in the Tempio Malatestiano," in *Quattrocento Adriatico: Fifteenth-Century Art of the Adriatic Rim* (Bologna: Nuova Alfa, 1996), 177–207.

The most useful discussions of Mantegna's Padua frescoes remain Ronald Lightbown, *Mantegna: With a Complete Catalogue of the Paintings, Drawings and Prints* (Oxford: Phaidon Press, 1986), and Keith Christiansen, *Andrea Mantegna: Padua and Mantua* (New York: George Braziller, 1994). On Donatello's *Gattamelata,* see the monographs by Pope-Hennessy and Janson, as well as the more general survey by Poeschke (as in chapters 4, 5, and 6 above).

Readers can find Pius II's own account of Pienza in his *Commentaries,* ed. and trans. Margaret Meserve and Marcello Simonetta (Cambridge, MA: Harvard University Press, forthcoming), vol. 2. Charles Mack, *Pienza: The Creation of a Renaissance City* (Ithaca, NY: Cornell University Press, 1987), includes an appendix of texts in translation as well. See also Nicholas Adams, "The Construction of Pienza (1459–1464) and the Consequences of Renovatio," in *Urban Life in the Renaissance,* eds. Susan Zimmerman and Ronald F. E. Weissman (Newark, NJ: University of Delaware Press, 1989), 50–80. The standard English edition of Alberti's treatise on architecture is *On the Art of Building in Ten Books,* trans. Joseph Rykwert, Neil Leach, and Robert Tavernor (Cambridge, MA: MIT Press, 1988).

For an account of Alberti's career and a guide to the vast body of scholarship, see Anthony Grafton, *Leon Battista Alberti: Master Builder of the Italian Renaissance* (New York: Hill & Wang, 2000).

Chapter 8: 1460–1470

On court art, see Martin Warnke, *The Court Artist: On the Ancestry of the Modern Artist,* trans. David McLintock (Cambridge: Cambridge University Press, 1993), and – in response to Warnke – the collection *The Artist at Court: Image Making and Identity,* ed. Stephen J. Campbell (Chicago, IL: University of Chicago Press, 2004).

On the impact of Alberti's *De Pictura* in Ferrara, see Michael Baxandall, "A Dialogue on Art from the Court of Leonello D'Este," *Journal of the Warburg and Courtauld Institutes* 26 (1963), 304–26. For Guarino, the Belfiore *studiolo,* and Cosmè Tura, see Stephen J. Campbell, *Cosmè Tura of Ferrara: Style, Politics, and the Renaissance City, 1450–1495* (London and New Haven, CT: Yale University Press, 1997). There is little good material in English on Palazzo Schifanoia, but see Aby Warburg's pioneering essay, "Italian Art and International Astrology in the Palazzo Schifanoia in Ferrara," in *German Essays on Art History,* ed. Gert Schiff (New York: Continuum, 1988),

252–53, as well as Kristen Lippincott, "The Iconography of the Salone dei Mesi and the Study of Latin Grammar in Renaissance Ferrara," in *La corte di Ferrara e il suo mecenatismo 1441–1598: The Court of Ferrara and its Patronage*, eds. Kari Lawe and Marianne Pade (Modena: Panini, 1990).

The standard reference on art and astrology in the Renaissance, unfortunately, remains untranslated: Dieter Blume, *Regenten des Himmels: astrologische Bilder in Mittelalter und Renaissance* (Berlin: Akademie Verlag, 2000).

The literature on Filarete in Milan is large, but see Evelyn Welch, *Art and Authority in Renaissance Milan* (London and New Haven, CT: Yale University Press, 1995). On Mantegna, see Ronald Lightbown, *Mantegna* (Berkeley, CA: University of California Press, 1986); also Jane Martineau, Suzanne Boorsch et al., eds., *Andrea Mantegna*, exh. cat. (Milan: Electa, 1992); and for a review of more recent scholarship Luke Syson, "Thoughts on the Mantegna Exhibition in Paris," *Burlington Magazine* 151 (August 2009), 526–36. For the Camera Picta, see Randolph Starn, "Seeing Culture in a Room for a Renaissance Prince," in *The New Cultural History*, ed. Lynn Hunt (Berkeley, CA: University of California Press, 1989), 205–32, and Anne Dunlop, *Painted Palaces: The Rise of Secular Art in Early Renaissance Italy* (University Park, PA: Penn State University Press, 2008).

For Alberti and the Gonzaga, see Eugene Johnson, *S. Andrea in Mantua: The Building History* (University Park, PA: Penn State University Press, 1975), and Robert Tavernor, *On Alberti and the Art of Building* (New Haven, CT, and London: Yale University Press, 1998). For the palace of Urbino, Pasquale Rotondi, *The Ducal Palace of Urbino: Its Architecture and Decoration* (New York: Transatlantic, 1969), and on the library see the catalogue, *Federico da Montefeltro and his Library*, ed. Marcello Simonetta (New York: Pierpont Morgan Library, 2007).

For the Medici Palace chapel, see Dale Kent, *Cosimo de' Medici* (as in chapter 6 above), and Diane Cole Ahl, *Benozzo Gozzoli* (New Haven, CT, and London: Yale University Press, 1996). Two recommended English-language monographs on Piero are Marilyn Aronberg Lavin, *Piero della Francesca* (London: Phaidon Press, 2002), and Ronald Lightbown, *Piero della Francesca* (New York: Abbeville, 1992). Carlo Ginzburg, *The Enigma of Piero* 2nd ed. (London: Verso, 2000), deals with the contemporary context of the fall of Byzantium and the mooted crusade, although we would question the author's framing of Piero's art as an "enigma."

Chapter 9: 1470–1480

On Flemish painting in Italy, see Bert W. Meijer, "Piero and the North," in *Piero della Francesca and his Legacy*, ed. Marilyn Lavin (Washington, DC: National Gallery of Art, 1995), 143–60. We drew as well on the essays and entries in two good catalogues: *Dipinti fiamminghi in Italia 1420–1570*, ed. Licia Collobi Ragghianti (Bologna: Calderini, 1990), and *Fiamminghi a Roma: 1508–1608; artistes des Pays-Bas et de la principauté de Liège à Rome à la Renaissance*, ed. Anne-Claire de Liedekerke (Milan: Skira, 1995). Essential on the Corpus Domini altarpiece is still Marilyn Aronberg Lavin, "The Altar of Corpus Domini in Urbino: Paolo Uccello, Joos van Ghent, Piero della Francesca," *Art Bulletin* 49 (1967), 1–24. See also Dana E. Katz, "The Contours of Tolerance: Jews and the Corpus Domini Altarpiece in Urbino," *Art Bulletin* 85 (2003), 646–61.

On the introduction of oil (and for painting techniques in general), see the excellent, accessible *Giotto to Dürer: Early Renaissance Painting in the National Gallery*, ed. Jill Dunkerton (London and New Haven, CT: Yale University Press, 1991). Our understanding of Antonello da Messina benefitted from Mary Pardo, "The Subject of Savoldo's Magdalene," *Art Bulletin* 71 (1989), 67–91.

Two good, recent, and very different overviews of Bellini's painting are Anchise Tempestini, *Giovanni Bellini*, trans. Alexandra Bonfante-Warren and Jay Hyams (New York: Abbeville, 1999), and Oskar Bätschmann, *Giovanni Bellini* (London: Reaktion, 2008). See also Rona Goffen, *Giovanni Bellini* (New Haven, CT, and London: Yale University Press, 1989), and the exhibition catalogue *Giovanni Bellini*, eds. Mauro Lucco and Giovanni Carlo Federico Villa (Milan: Silvana, 2008). Within the much larger literature on the Frick panel, three stand-out studies are Millard Meiss, *Giovanni Bellini's "St. Francis" in the Frick Collection* (Princeton, NJ: Princeton University Press, 1964); John Fleming, *From Bellini to Bonaventure: An Essay in Franciscan Exegesis* (Princeton, NJ: Princeton University Press, 1982); and Emanuele Lugli, "Between Form and Representation: The Frick St. Francis," *Art History* 32 (2009), 21–51.

For the Verrocchio workshop, see Patricia Rubin and Alison Wright, *Renaissance Florence: The Art of the 1470s* (London: Yale University Press, 1999), as well as Andrew Butterfield, *The Sculptures of Andrea del Verrocchio* (New Haven, CT, and London: Yale University Press, 1997). On the drapery studies, see the essays and entries in *Leonardo da Vinci, Master Draftsman*, exh. cat., ed. Carmen Bambach (New York: Metropolitan Museum of Art; and New Haven, CT, and London: Yale University Press, 2003).

Three useful broader overviews of Leonardo da Vinci are Martin Kemp, *Leonardo da Vinci: The Marvellous Works of Nature and Man* (London: J. M. Dent, 1981); Pietro C. Marani, *Leonardo: The Complete Paintings* (New York: Abrams, 2000); and Frank Zollner and Johannes Nathan, *Leonardo da Vinci, 1452–1519: The Complete Paintings and Drawings* (Cologne: Taschen, 2003). On Leonardo's Ginevra de' Benci portrait, see *Virtue and Beauty: Leonardo's Ginevra de' Benci and Renaissance Portraits of Women*, exh. cat., ed. David Alan Brown (Washington, DC: National Gallery of Art, 2001). On Leonardo's rejection of the absolute color system, see John Shearman, "Leonardo's Colour and Chiaroscuro," *Zeitschrift für Kunstgeschichte* 25 (1962), 13–47, and James S. Ackerman, "On Early Renaissance Color Theory and Practice," in *Studies in Italian Art and Architecture*, 15th through 18th centuries, ed. Henry A. Millon (Rome: Edizioni dell' Elefante, 1980), 11–44.

Our discussion of Pollaiuolo's portraits is indebted to Alison Wright, *The Pollaiuolo Brothers: The Arts of Florence and Rome* (New Haven, CT, and London: Yale University Press, 2005). On Florence under Lorenzo, see F. W. Kent, *Lorenzo de' Medici and the Art of Magnificence* (Baltimore, MD: Johns Hopkins University Press, 2004), and Rubin and Wright, *Renaissance Florence* (as under Verrocchio above). For Botticelli's mythologies, see Charles Dempsey, *The Portrayal of Love: Botticelli's "Primavera" and Humanist Culture at the Time of Lorenzo the Magnificent* (Princeton, NJ: Princeton University Press, 1992).

Chapter 10: 1480–1490

On Mantegna's *Triumphs of Caesar*, see Stephen J. Campbell, "Mantegna's *Triumphs*: The Cultural Politics of Imitation 'all'antica' at the Court of Mantua, 1490–1530," in Stephen Campbell, ed., *Artists at Court* (as in chapter 8 above), 91–105. The standard account remains Andrew Martindale, *The Triumphs of Caesar by Andrea Mantegna: In the Collection of Her Majesty the Queen at Hampton Court* (London: Harvey Miller, 1979). On the introduction of canvas, Dunkerton, *Giotto to Dürer* (see chapter 9 above).

On the small bronze as a format, nothing in English can yet replace Hans Weihrauch, *Europäische Bronzestatuetten: 15.–18. Jahrhundert* (Braunschweig: Klinkhardt & Biermann, 1967). For Pollaiuolo's *Hercules*, see Alison Wright, *The Pollaiuolo Brothers* (as in chapter 9 above.) Our discussion of Bertoldo drew on Ulrich Pfisterer,

"Künstlerische potestas audendi und licentia im Quattrocento: Benozzo Gozzoli, Andrea Mantegna, Bertoldo di Giovanni," *Römisches Jahrbuch der Bibliotheca Hertziana* 31 (1996), 107–48; on James Draper, *Bertoldo di Giovanni, Sculptor of the Medici Household* (Columbia, MO: University of Missouri Press, 1992); and on Luke Syson, "Bertoldo di Giovanni, Republican Court Artist," in *Artistic Exchange and Cultural Translation in the Italian Renaissance City* (Cambridge and London: Cambridge University Press, 2004).

On the origins of Italian printmaking, see David Landau and Peter Parshall, *The Renaissance Print: 1470–1550* (New Haven, CT, and London: Yale University Press, 1994). Landau and Suzanne Boorsch give competing accounts of Mantegna's engagement with engraving in *Andrea Mantegna*, exh. cat., ed. Jane Martineau (Milan: Electa, 1992); on Mantegna and the goldsmith Cavalli, see Andrea Canova, "Gian Marco Cavalli incisore per Andrea Mantegna e altre notizie sull'oreficieria e la tipografia a Mantova nel XV secolo," *Italia medioevale e umanistica* 42 (2001), 149–79.

On Crivelli, see Ronald Lightbown, *Carlo Crivelli* (London and New Haven, CT: Yale University Press, 2004), which also gives a detailed account of the culture of the Marches in the fifteenth century. For Gentile Bellini's work in Constantinople, *Bellini and the East*, eds. Alan Chong and Caroline Campbell (Boston, MA: Isabella Stewart Gardner Museum, 2005); also Lisa Jardine and Jerry Brotton, *Global Interests: Renaissance Art between East and West* (London: Reaktion Books, 2000).

On the Colleoni monument, see Butterfield, *The Sculptures of Andrea del Verrocchio* (as in chapter 9 above), as well as Diane Cole Ahl, ed., *Leonardo da Vinci's Sforza Monument Horse: The Art and the Engineering* (Bethlehem, PA: Lehigh University Press, 1995). Pollaiuolo's *Sixtus IV Monument* is treated in detail by Alison Wright, *The Pollaiuolo Brothers* (see chapter 9 above).

For the architecture of the Sistine Chapel, see Roberto Salvini, "The Sistine Chapel: Ideology and Architecture," *Art History*, 3 (1980), 144–57. On the frescoes, see Leopold D. Ettlinger, *The Sistine Chapel before Michelangelo: Religious Imagery and Papal Primacy* (Oxford: Oxford University Press, 1965); for an interpretation governed by Sixtus's formation as a Franciscan and theologian, see Rona Goffen, "Friar Sixtus IV and the Sistine Chapel," *Renaissance Quarterly* 39 (1986), 218–62; for a political interpretation, Andrew C. Blume, "The Sistine Chapel, Dynastic Ambition, and the Cultural Patronage of Sixtus IV," in *Patronage and Dynasty: the Rise of the della Rovere*

in Renaissance Italy, ed. Ian F. Verstegen (Kirksville: Truman State University Press, 2007), 3–19.

On Leonardo's *Adoration of the Magi* and *Virgin of the Rocks*, see (in addition to the monographs by Kemp and Marani cited under chapter 9 above) the comprehensive accounts in Zöllner and Nathan, *Leonardo da Vinci* (as in chapter 9 above).

Chapter 11: 1490–1500

For the landscape drawings of Fra Bartolomeo, see Chris Fischer, *Fra Bartolomeo: Master Draughtsman of the High Renaissance* (Rotterdam: Museum Boymans-van Beuningen 1990); for Riccio, Denise Allen, ed., *Andrea Riccio: Renaissance Master of Bronze*, exh. cat. (London: Wilson, 2008). Alison Luchs's exhibition catalogue *Tullio Lombardo and Venetian High Renaissance Sculpture* (New Haven: Yale University Press, 2009) includes extensive bibliography on Venetian sculpture; on the Vendramin tomb in particular, see Wendy Stedman Sheard, "Tullio Lombardo in Rome? The Arch of Constantine, the Vendramin Tomb, and the Reinvention of Monumental Classicizing Relief," *Artibus et Historiae* 18 (1997), 161–79, and Sheard, "'Asa Adorna': The Prehistory of the Vendramin Tomb," *Jahrbuch der Berliner Museen* 20 (1978), 117–56, also with further references.

On the mythological paintings for Isabella's *studiolo*, see Stephen J. Campbell, *The Cabinet of Eros: Renaissance Mythological Painting and the Studiolo of Isabella d'Este* (New Haven, CT, and London: Yale University Press, 2006). For Ghirlandaio, see Jean K. Cadogan, *Domenico Ghirlandaio: Artist and Artisan* (New Haven, CT, and London: Yale University Press, 2000), and the conference volume *Domenico Ghirlandaio: 1449–1494*, eds. Wolfram Prinz and Max Seidel (Florence: Centro Di, 1996). On the Scuola di San Giovanni Evangelista canvasses, see Patricia Fortini Brown, *Venetian Narrative Painting in the Age of Carpaccio* (New Haven, CT, and London: Yale University Press, 1988). For the Bentivoglio Chapel, see Clifford M. Brown, "The Church of Santa Cecilia and the Bentivoglio Chapel in San Giacomo Maggiore in Bologna. With an Appendix Containing a Catalogue of Isabella d'Este's Correspondence Concerning Lorenzo Costa and Francesco Francia," *Mitteilungen des Kunsthistorischen Institutes in Florenz* 10 (1967–68), 301–24.

On the problem of Savonarola's influence on artists, see the different approaches by Marcia Hall, "Savonarola's Preaching and the Patronage of Art," in T. Verdon and J.

Henderson, eds., *Christianity and the Renaissance: Image and Religious Imagination in the Quattrocento* (Syracuse, NY: Syracuse University Press, 1990), 493–522, and Jill Burke, *Changing Patrons: Social Identity and the Visual Arts in Renaissance Florence* (University Park, PA: Penn State Press, 2004). On the new council hall, the best introductory overview remains Johannes Wilde, "The Hall of the Great Council of Florence," *Journal of the Warburg and Courtauld Institutes* 7 (1944), 65–81.

The standard reference on Filippino Lippi, though co-authored by an American, is unavailable in English: Jonathan Katz Nelson and Patrizia Zambrano, *Filippino Lippi* (Milan: Electa, 2004). The San Brizio Chapel has provoked competing readings: ours draws on Jonathan B. Reiss, *The Renaissance Antichrist: Luca Signorelli's Orvieto Frescoes* (Princeton, NJ: Princeton University Press, 1995); Creighton Gilbert, *How Fra Angelico and Signorelli Saw the End of the World* (University Park, PA: Penn State University Press, 2003); and Sara Nair James, *Signorelli and Fra Angelico at Orvieto: Liturgy, Poetry, and a Vision of the End of Time* (Aldershot, UK: Ashgate, 2003).

On the Pala Sforzesca and the problem of defining a "painting by Leonardo," see Luke Syson, "Leonardo and Leonardism in Sforza Milan," in *Artists at Court*, 106–23. Our discussion of Leonardo's allegories depends on Bambach, ed., *Leonardo da Vinci, Master Draftsman* (see chapter 9 above). For Leonardo's Milanese portraits, see the discussions in the monographs by Kemp, Marani, and Zollner, as well as Brown's *Virtue and Beauty* catalogue. On the *Last Supper*, see *Leonardo: The Last Supper*, with essays by Pinin Brambilla Barcilon and Pietro C. Marani, trans. Harlow Tighe (Chicago, IL: University of Chicago Press, 2001). For a controversial but stimulating account of the same work, see Leo Steinberg, *Leonardo's Incessant Last Supper* (New York: Zone Books, 2001).

For Michelangelo's early sculptures, see the essays in the first volume of William Wallace's useful collection, *Michelangelo: Selected Scholarship in English* (New York: Garland, 1995). We drew especially on Wallace's own "How Did Michelangelo Become a Sculptor?" in *The Genius of the Sculptor in Michelangelo's Work*, exh. cat. (Montreal, 1992), 151–69; and "Michelangelo's Rome Pietà: Altarpiece or Grave Memorial?" in *Verrocchio and Late Quattrocento Italian Sculpture*, eds. Steven Bule and Alan Phipps Darr (Florence: Casa Editrice le Lettere, 1992), 243–55. On Baccio da Montelupo, the only substantial study in English is John Douglas Turner's unpublished doctoral dissertation, "The Sculpture of Baccio da Montelupo," Brown University, 1997. We drew as well on the catalogue *L'officina della maniera: varietà e fierezza nell'arte fiorentina del Cinque-*

cento fra le due repubbliche 1494–1530, ed. Alessandro Cecchi et al. (Venice: Marsilio, 1996).

Chapter 12: 1500–1510

Our reading of Piero di Cosimo is indebted to Alison Brown, "Lucretius and the Epicureans in the Social and Political Context of Renaissance Florence," *I Tatti Studies: Essays in the Renaissance* 9 (2001), 11–62; see also Dennis Geronimus, *Piero di Cosimo: Visions Beautiful and Strange* (New Haven, CT, and London: Yale University Press, 2006); on Michelangelo's *David*, see Charles Seymour, *Michelangelo's David* (as in chapter 2 above), and Saul Lewine, "The Location of Michelangelo's *David*: The Meeting of January 25th, 1504," *Art Bulletin* 56 (1974), 31–49. The relation between the *Virgin and Child with St. John and St. Anne* and the Muses of Tivoli is proposed by Marani, *Leonardo da Vinci* (see chapter 9 above). For a reading of the Doni *Tondo* that emphasizes the role of the Baptist, see Andree Hayum, "Michelangelo's *Doni Tondo*: Holy Family and Family Myth," *Studies in Iconography* 7–8 (1981–82), 209–51. Our understanding of Michelangelo's Bruges *Madonna* was shaped by Leo Steinberg, "The Metaphors of Love and Birth in Michelangelo's Pietàs," in *Studies in Erotic Art*, ed. Theodore Bowie and Cornelia V. Christenson (New York: Basic Books, 1970), 231–85.

Wilde's classic article on the murals in Palazzo dei Priori, "The Hall of the Great Council in Florence" (see note to chapter 11 above), remains standard reading. See, more recently, Claire Farago, "Leonardo's *Battle of Anghiari*: A Study in the Exchange between Theory and Practice," *Art Bulletin* 76 (1994), 301–31, and, on Leonardo and Machiavelli, Roger D. Masters, *Machiavelli, Leonardo, and the Science of Power* (Bloomington, IN: University of Indiana Press, 1996). On the Leda as a "figura serpentinata," see David Summers, "Maniera and Movement: The Figura Serpentinata," *Art Quarterly* 35 (1972), 265–301.

The best general book on Raphael is Roger Jones and Nicholas Penny, *Raphael* (New Haven, CT, and London: Yale University Press, 1983). For Raphael's early career, see the exhibition catalogue *Raphael before Rome* (London: National Gallery, 2004); also Jürg Meyer zur Capellen, *Raphael in Florence*, trans. Stefan B. Polteron (London: Azimuth Editions, 1996). On the Baglione *Deposition* we have drawn on Alexander Nagel in *Michelangelo and the Reform of Art* (Cambridge and New York: Cambridge University Press, 2000), which revives the interpretation of Jakob Burckhardt, *The Civilization of the Renaissance in Italy*, trans. S. G. C. Middlemore (New York and London: Penguin Books, 1990), 35–38.

On the origins of the Julius tomb, see the essays in Wallace, *Michelangelo: Selected Scholarship*, vol. 4 (as in chapter 11 above). Our survey of the early designs for St. Peter's follows the revisionist history in Horst Bredekamp, *Sankt Peter in Rom und das Prinzip der produktiven Zerstörung: Die Baugeschichte von Bramante bis Bernini* (Berlin: Klaus Wagenbach, 2000), with extensive further bibliography. The approach to the Sistine Ceiling presented here is indebted especially to Edgar Wind, "Michelangelo's Prophets and Sibyls," *Proceedings of the British Academy* 51 (1960), 47–84, and John O'Malley, "The Theology behind Michelangelo's Sistine Ceiling," in C. Pietrangeli, ed., *The Sistine Chapel: The Art, The History, and the Restoration* (New York: Harmony Books, 1986), 92–148. On anti-Judaism and the Sistine, see Barbara Wisch, "Vested Interest: Redressing Jews on Michelangelo's Sistine Ceiling," *Artibus et historiae* 48 (2003), 143–72.

On the Belvedere, see James S. Ackerman, "The Belvedere as a Classical Villa," *Journal of the Warburg and Courtauld Institutes* 14 (1951), 70–91; on its collection of sculptures, Hans Brummer, *The Statue Court of the Vatican Belvedere* (Stockholm: Almqvist & Wiksell, 1970). For Raphael in the papal apartments, Matthias Winner, "Projects and Execution in the Stanza della Segnatura," in *Raphael in the Apartments of Julius II and Leo X* (Milan: Electa, 1993) and the same author's "Lorbeerbäume auf Raffaels Parnaß", in *L'Europa e l'arte italiana*, ed. Max Seidel (Venice: Marsilio, 2000), 197–209; David Rosand, "Raphael's School of Athens and the Artist of the Modern Manner," in *The World of Savonarola: Italian Elites and Perceptions of Crisis*, eds. Stella Fletcher and Christine Shaw (Burlington, VT: Ashgate, 2000), 212–32; and Ingrid Rowland, "The Intellectual Background of the School of Athens: Tracking Divine Wisdom in the Rome of Julius II," in *Raphael's "School of Athens,"* ed. Marcia Hall (Cambridge and New York: Cambridge University Press, 1997), 131–70. An older but still good reference is John Shearman, "The Vatican Stanze: Functions and Decoration," *Proceedings of the British Academy* 57 (1971), 3–58.

On Venetian painting circa 1500, see David Alan Brown and Sylvia Ferino Pagden, eds., *Bellini, Giorgione, Titian, and the Renaissance of Venetian Painting* (Washington, DC: National Gallery of Art, 2006). On Jacopo de' Barbari, see Simone Ferrari, *Jacopo de' Barbari: Un protagonista del Rinascimento tra Venezia e Dürer* (Milan: Mondadori, 2006); on his view of Venice, Juergen Schultz, "Jacopo de' Barbari's View of Venice: Map Making, City Views, and Moralized Geography before the Year 1500," *Art Bulletin* 60 (1978), 425–78, and Bronwen Wilson, *The World in Venice: Print, the City, and Early Modern Identity* (Toronto: University of Toronto Press, 2005). The

San Giobbe altarpiece is discussed in Bätschmann, *Giovanni Bellini* (see chapter 9 above). For Dürer's Venetian sojourn, Katherine C. Luber, *Albrecht Dürer and the Venetian Renaissance* (Cambridge and New York: Cambridge University Press, 2005), and *Renaissance Venice and the North: Crosscurrents in the Time of Bellini, Dürer*, eds. Beverly Brown and Bernard Aikema (New York: Rizzoli, 2000). On Giorgione, see Jaynie Anderson, *Giorgione: The Painter of "Poetic Brevity"* (New York and Paris: Flammarion, 1997). For a critical account of readings of the *Tempesta*, see Stephen J. Campbell, "Giorgione's *Tempest, Studiolo* Culture, and the Renaissance Lucretius," *Renaissance Quarterly* 56 (2003), 299–333; Salvatore Settis reviews the literature through 1990 in *Giorgione's Tempest: Interpreting the Hidden Subject*, trans. Ellen Bianchini (Chicago, IL: University of Chicago Press, 1990).

There are surprisingly few good general introductions to Titian; a recent one is Peter Humfrey, *Titian: The Complete Paintings* (New York: Abrams, 2007). For an account of his early career, with much debated attributions, Paul Joannides, *Titian to 1518: The Assumption of Genius* (New Haven, CT, and London: Yale University Press, 2001). On the Titian *Concert*, Patricia Egan, "Poesia and the Concert champêtre," *Art Bulletin* 41 (1959), 29–38.

Chapter 13: 1510–1520

Michael Rohlmann provides well-illustrated and comprehensive accounts of Raphael's *Farnesina* and later Vatican frescoes in Julian Kliemann and Michael Rohlmann, *Italian Frescoes: High Renaissance and Mannerism, 1510–1600* (New York: Abbeville, 2004). On Raphael's experiments in the rendering of light and shadow in particular, see Janis Bell, "Re-Visioning Raphael as a 'Scientific Painter,'" in *Reframing the Renaissance Visual Culture in Europe and Latin America, 1450–1650*, ed. Claire Farago (New Haven, CT, and London, 1995), 91–111.

The most substantial overview of Marcantonio as a printmaker is the catalogue to the exhibition curated by Innis H. Shoemaker, *The Engravings of Marcantonio Raimondi* (Lawrence, Kansas: Spencer Museum of Art, University of Kansas, 1981); on issues of collaboration and authorship, see especially Lisa Pon, *Raphael, Dürer, and Marcantonio Raimondi: Copying and the Italian Renaissance Print* (New Haven: Yale University Press, 2004).

For the Sistine tapestries, see Sharon Fermor, *The Raphael Tapestry Cartoons: Narrative, Decoration, Design* (London: Victoria and Albert Museum, 1996), and John Shearman, *Raphael's Cartoons in the Collection of Her Majesty the Queen, and the Tapestries for the Sistine Chapel* (London: Phaidon Press, 1972). The best introduction to Raphael as an architect is the catalogue to the exhibition curated by Christoph Luitpold Frommel, Stefano Ray, and Manfredo Tafuri, *Raffaello architetto* (Milan: Electa, 1984). In English, see Ingrid D. Rowland, "Raphael, Angelo Colocci, and the Genesis of the Architectural Orders," *Art Bulletin* 76 (1994), 81–104, as well as the discussion in Jones and Penny, *Raphael* (as in chapter 12 above).

Our discussion of Sebastiano drew on the catalogue *Sebastiano del Piombo 1485–1547* (Milan: Motta, 2008). The major monograph in English is Michael Hirst, *Sebastiano del Piombo* (Oxford: Clarendon Press, 1981). For the *Fornarina*, see Jennifer Craven, "Ut pictura poesis: A New Reading of Raphael's Portrait of La Fornarina as a Petrarchan Allegory of Painting, Fame, and Desire," *Word and Image* 10 (1994), 371–94, though we doubt Raphael's authorship of the painting.

Major English-language scholarship on the Julius tomb includes Charles de Tolnay, *The Tomb of Julius II* (Princeton, NJ: Princeton University Press, 1954), and volume four of Wallace, *Michelangelo* (see chapter 11 above). On the theme of the "arts bereft," see Erwin Panofsky, *Tomb Sculpture: Its Changing Aspects from Ancient Egypt to Bernini* (London: Thames & Hudson, 1964); on Michelangelo and the *non-finito*, Juergen Schulz, "Michelangelo's Unfinished Works," *Art Bulletin* 57 (1975), 366–73.

A 1996 exhibition at the Uffizi revisited the idea of the "schools" of San Marco and the Annunziata: see the catalogue *L'officina della maniera* (as in chapter 11 above). There is no modern monograph in any language on Fra Bartolomeo, though two starting points for future work will be the catalogue to the exhibition *L'età di Savonarola. Fra Bartolomeo e la scuola di San Marco* (Venice: Marsiglio, 1996) and the catalogue of the drawings by Fischer, *Fra Bartolomeo* (see chapter 11 above). On Andrea del Sarto, see John Shearman, *Andrea del Sarto*, 2 vols. (Oxford: Clarendon Press 1965); on early Rosso, David Franklin's sometimes polemical *Rosso in Italy: The Italian Career of Rosso Fiorentino* (New Haven, CT, and London: Yale University Press, 1994); for the *Madonna of the Harpies*, John Shearman, *Only Connect: Art and the Spectator in the Italian Renaissance* (Princeton, NJ: Princeton University Press, 1992). Shearman also includes a useful section on the Camerino of Alfonso d'Este. Beyond this, see Anthony Colantuono, "*Dies Alcyoniae*: The Invention of Bellini's *Feast of the Gods*," *Art Bulletin* 73 (1991), 237–56; idem, "Tears of Amber: Titian's Andrians, the River Po and the Iconology of Difference," in *Phaethon's Children: The Este Court and Its Culture in Early Modern Ferrara*,

eds. Dennis Looney and Deanna Shemek (Tempe, AZ: Arizona Center for Medieval and Renaissance Studies, 2005), and Campbell, *The Cabinet of Eros* (see chapter 11 above). A still essential discussion of Titian's *Assumption of the Virgin* is Rona Goffen, *Piety and Patronage in Renaissance Venice: Bellini, Titian, and the Franciscans* (New Haven, CT, and London: Yale University Press, 1986).

Chapter 14: 1520–1530

On Rome in the 1520s, see the essays in *The Pontificate of Clement VII: History, Politics, Culture*, eds. Sheryl Reiss and Kenneth Gouwens (Burlington, VT: Ashgate, 2005). A good overview is also provided by André Chastel, *The Sack of Rome, 1527*, trans. Beth Archer (Princeton, NJ: Princeton University Press, 1983). On mannerism, the starting point for all recent discussions is John Shearman, *Mannerism* (Harmondsworth: Penguin, 1967).

On Giulio Romano and the Hall of Constantine, see the relevant pages in Chastel, *The Sack of Rome*, and in Kliemann and Rohlmann, *Italian Frescoes* (see chapter 13 above), as well as Philipp Fehl, "Raphael as Historian: Poetry and Historical Accuracy in the *Sala del Costantino*," *Artibus et Historiae* 14 (1993), 9–76; also Jan L. de Jong, "Universals and Particulars: History Painting in the 'Sala di Costantino' in the Vatican Palace," in *Recreating Ancient History: Episodes from the Greek and Roman Past in the Arts and Literature of the Early Modern Period*, eds. Karl A. E. Enenkel, Jan L. de Jong, and Jeanine De Landtsheer (Boston, MA, and Leiden: Brill, 2001).

On Parmigianino, two essential recent works are Mary Vaccaro, *Parmigianino: The Paintings* (Turin: Allemandi, 2002), and the exhibition catalogue by David Franklin, *The Art of Parmigianino* (New Haven, CT, and London: Yale University Press, 2003).

For Rosso as a printmaker, beginning with the Roman period, the basic reference is Eugene A. Carroll, ed., *Rosso Fiorentino: Drawings, Prints, and Decorative Arts* (Washington, DC: National Gallery of Art, 1987). Our account of Rosso's response to Michelangelo in these years summarizes the fuller discussion in Stephen Campbell, "'Fare una cosa morta parer viva': Michelangelo, Rosso, and the (Un)divinity of Art," *Art Bulletin* 84 (2002), 596–620. On print culture and erotic imagery, see Bette Talvacchia, *Taking Positions: On the Erotic in Renaissance Culture* (Princeton, NJ: Princeton University Press, 1999).

For Michelangelo's *Risen Christ* we have drawn on Irene Baldriga, "The First Version of Michelangelo's Risen

Christ," *Burlington Magazine* 142 (2000), 740–45, and William Wallace, "Michelangelo's Risen Christ," *Sixteenth-Century Journal* 28 (1997), 1,251–80. Our brief comment here on Michelangelo's *Victory* and *Slaves* as figures of mastery alludes to Michael Cole, "The *Figura Sforzata*: Modeling, Power, and the Mannerist Body," *Art History* 24 (2001), 520–51. A useful reference on Michelangelo's sculpture and that of his followers is Joachim Poeschke, *Michelangelo and his World: Sculpture of the Italian Renaissance* (New York: Abrams, 1996).

Pontormo's Poggio a Caiano lunette is treated by Janet Cox-Rearick, *Dynasty and Destiny in Medici Art* (Princeton, NJ: Princeton University Press, 1984), as well as by Kliemann and Rohlmann, *Italian Frescoes* (see chapter 13 above); for his other works and for Florentine art in the 1520s, see David Franklin, *Painting in Renaissance Florence 1500–1550* (New Haven, CT, and London: Yale University Press, 2001), and the exhibition catalogue *L'officina della maniera* (as in chapter 13 above). Leo Steinberg provides a persuasive description of the Capponi Chapel frescoes as responses to Michelangelo's *Pietà* in "Pontormo's Capponi Chapel," *Art Bulletin* 56 (1974), 385–99.

Our approach to Correggio is strongly indebted to Carolyn Smith, *Correggio's Frescoes in Parma Cathedral* (Princeton, NJ: Princeton University Press, 1997), and to Giancarla Periti, "Nota sulla 'maniera moderna' di Correggio a Parma," in *Parmigianino e il manierismo europeo*, ed. Lucia Fornari Schianchi (Milan: Silvana, 2002), 298–304. For an introduction to the artist, see David Ekserdjian, *Correggio* (New Haven, CT, and London: Yale University Press, 1997).

The best recent guide to the scholarship on Lotto is Peter Humfrey, *Lorenzo Lotto* (New Haven, CT, and London: Yale University Press, 1997). For Andrea Odoni and collecting practices in sixteenth-century Venice, see Monika Schmitter, "'Virtuous Riches': The Bricolage of *Cittadini* Identities in Early Sixteenth-Century Venice," *Renaissance Quarterly* 57 (2004), 908–69.

On Titian's Pesaro altarpiece, see Rona Goffen, *Piety and Patronage in Renaissance Venice* (as in chapter 13 above), and for the Averoldi see the same author's *Renaissance Rivals: Michelangelo, Leonardo, Raphael, Titian* (New Haven, CT, and London: Yale University Press, 2002).

For contrasting views of Pordenone's Cremona frescoes, see Carolyn Smith, "Pordenone's 'Passion' Frescoes in Cremona Cathedral: An Incitement to Piety," in *Drawing Relationships in Northern Renaissance Art: Patronage and*

Theories of Invention, ed. Giancarla Periti (Burlington, VT: Ashgate, 2004), 101–29, and Charles Cohen, *The Art of Giovanni Antonio da Pordenone: Between Dialect and Language* (Cambridge and London: Cambridge University Press, 1996). There are good illustrations in Kliemann and Rohlmann, *Italian Frescoes* (see chapter 13 above).

On the Siege of Florence and Pontormo's Guardi portrait, see Elizabeth Cropper, *Pontormo: Portrait of a Halbardier* (Los Angeles, CA: Getty Museum, 1997). For Parmigianino's importance within the history of etching, see Michael Cole, ed., *The Early Modern Painter Etcher* (University Park, PA: Penn State University Press, 2006).

Chapter 15: 1530–1540

Our discussion of Titian's work for Francesco della Rovere and Eleanora Gonzaga drew especially on Diane H. Bodart's essential *Tiziano e Federico II Gonzaga: storia di un rapporto di committenza* (Rome: Bulzoni, 1998).

For the *Venus of Urbino*, see the essays in Rona Goffen, ed., *Titian's Venus of Urbino* (Cambridge: Cambridge University Press, 1997). On Titian's nudes more generally, see Mary Pardo, "Artifice as Seduction in Titian," in *Sexuality & Gender in Early Modern Europe: Institutions, Texts, Images*, ed. James Grantham Turner (Cambridge and New York: Cambridge University Press, 1993), 55–89, and Maria H. Loh, *Titian Remade: Repetition and the Transformation of Early Modern Italian Art* (Los Angeles, CA: Getty Research Institute, 2007).

On Giulio at the Palazzo del Tè, see the chapter in Kliemann and Rohlmann, *Italian Frescoes* (as in chapter 13 above). Our reading of the Medici Chapel draws on Charles Dempsey, "Lorenzo's Ombra," in G. C. Garfagnini, *Lorenzo il Magnifico e il suo Mondo* (Florence: Olschki, 1994), 341–55, and Creighton Gilbert, "Texts and Contexts of the Medici Chapel," *Art Quarterly* 34 (1971), 391–409. An intriguing but to us ultimately unpersuasive attempt to challenge the standard identification of the two *capitani* is Richard C. Trexler and Mary E. Lewis, "Two Captains and Three Kings: New Light on the Medici Chapel," *Studies in Medieval and Renaissance History* 4 (1981), 91–177. On the importance of drawing for the artist's transition from sculpture to architecture, see Cammy Brothers, *Michelangelo, Drawing and the Invention of Architecture* (New Haven and London: Yale University Press, 2008). Poeschke, *Michelangelo and his World* (see chapter 14 above) discusses Bandinelli among other mid sixteenth-century sculptors. For Pontormo's and Bronzino's portraits, see especially the essays by Carl Strehlke and Elizabeth Cropper in *Pontormo, Bronzino, and the Medici: The Transformation of the Renaissance Portrait in Florence*, exh. cat. (Philadelphia, PA: Philadelphia Museum of Art, 2004). For the Pontormo portrait of Alessandro de' Medici in particular, see also Leo Steinberg, "Pontormo's Alessandro de' Medici, or, I Only Have Eyes for You," *Art in America* 63 (1975), 62–65. For Bronzino's *Cosimo as Orpheus*, see the recent account with bibliography by Janet Cox-Rearick in *The Medici, Michelangelo, and the Art of Late Renaissance Florence*, exh. cat. (New Haven, CT, and London: Yale University Press, 2002), 153–54. The best general monograph in English is Maurice Brock, *Bronzino* (Paris: Flammarion, 2002).

On the patronage of Paul III, see Guido Rebecchini, "After the Medici: The New Rome of Paul III Farnese," *I Tatti Studies* 11 (2007), 147–200. For Heemskerck in Rome, see Christof Thoenes, "St. Peter als Ruine: zu einigen Veduten Heemskercks," in *Opus incertum: italienische Studien aus drei Jahrzehnten* (Munich: Deutscher Kunstverlag, 2002), 245–75; English translation (with fewer illustrations) in *Sixteenth-century Italian Art*, ed. Michael Cole (Oxford: Blackwell, 2006), 25–39. On the compositional origins of Michelangelo's *Last Judgment*, see Bernardine Barnes, "The Invention of Michelangelo's 'Last Judgment,'" unpublished doctoral dissertation, University of Virginia, 1986. The most balanced account of the fresco may still be Charles de Tolnay, *Michelangelo: The Final Period* (Princeton, NJ: Princeton University Press, 1960), though provocative readings of particular passages include Leo Steinberg, "Michelangelo's 'Last Judgment' as Merciful Heresy," *Art in America* 63 (1975), 49–63; Marcia B. Hall, "Michelangelo's Last Judgment: Resurrection of the Body and Predestination," in *Art Bulletin* 58 (1976), 85–92; and Bernardine Barnes, "Metaphorical Painting: Michelangelo, Dante, and the 'Last Judgment,'" *Art Bulletin* 77 (1995), 65–81.

Chapter 16: 1540–1550

There is no good study in English of Pontormo's lost San Lorenzo frescoes; the starting point for any future research is the Italian historian Massimo Firpo's *Gli affreschi di Pontormo a San Lorenzo: eresia, politica e cultura nella Firenze di Cosimo I* (Turin: Einaudi, 1997).

For a range of essays on Medici court culture, see *Vasari's Florence: Artists and Literati at the Medicean Court*, ed. Philip Jacks (Cambridge and London: Cambridge University Press, 1998).

On Salviati and the *Furius Camillus* cycle, see Melinda Schlitt, "The Rhetoric of Exemplarity in 16th-Century

Painting: Reading 'Outside' the Imagery," in *Perspectives on Early Modern and Modern Intellectual History (Essays in Honor of Nancy S. Struever)*, eds. Melinda Schlitt and Joseph Marino (Rochester, NY: University of Rochester Press, 2001), 259–82, as well as the chapter on Salviati in David Franklin, *Painting in Renaissance Florence, 1500–1550* (as in chapter 14 above).

On Bronzino and literary culture, see Deborah Parker, *Bronzino: Renaissance Painter as Poet* (Cambridge: Cambridge University Press, 2000); for the chapel in the Palazzo Vecchio, see Janet Cox-Rearick, *Bronzino's Chapel of Eleonora in the Palazzo Vecchio* (Berkeley and Los Angeles, CA: University of California Press, 1993).

For the Sala Paolina, see the chapter in Kliemann and Rohlmann, *Italian Frescoes* (as in chapter 13 above). Our preferred English translation of Michelangelo's poetry is that of Christopher Ryan (London: Dent, 1996). Our discussion of Michelangelo's gift drawings benefitted from Alexander Nagel's important "Gifts for Michelangelo and Vittoria Colonna," *Art Bulletin* 79 (1997), 647–68. Leonard Barkan, *Transuming Passion: Ganymede and the Erotics of Humanism* (Stanford, CA: Stanford University Press, 1991), includes a suggestive discussion of the drawings for Tommaso Cavalieri. Our emphasis on the ambiguity of Michelangelo's subject matter follows Wolfgang Stechow's still-important "Joseph of Arimathea or Nicodemus?" in Wolfgang Lotz and Lisa Lotte Möller, eds., *Studien zur toskanischen Kunst: Festschrift für Ludwig Heinrich Heydenreich zum 23. März 1963* (Munich: Prestel, 1964), 289–302. Two classic essays on the Florence *Pietà* are Leo Steinberg, "Michelangelo's Florentine 'Pietà': The Missing Leg," *Art Bulletin* 50 (1968), 343–53, and Irving Lavin, "The Sculptor's 'Last Will and Testament,'" *Bulletin of Allen Memorial Art Museum* 35 (1978), 4–39. Steinberg responded to critics of his interpretation in "Michelangelo's Florentine Pietà: The Missing Leg Twenty Years After; Animadversions," *Art Bulletin* 71 (1989), 480–505.

Our sense of the politics in the Varchi circle owes much to Michel Plaisance's classic study, "Culture et politique à Florence de 1542 à 1551: Lasca et les Humidieux prises avec l'Académie Florentine," in André Rochon, ed., *Les écrivains et le pouvoir en Italie à l'époque de la Renaissance* (Paris: CIRRI 1974), 149–242. Our presentation of Bronzino's London *Allegory* offers a slight variation on Robert W. Gaston, "Love's Sweet Poison: A New Reading of Bronzino's London *Allegory*," *I Tatti Studies* 4 (1991), 247–88.

Two good and recent though very different introductions to Fontainebleau are Henri Zerner, *Renaissance in France: The Invention of Classicism* (Paris: Flammarion, 2003),

and Rebecca Zorach, *Blood, Milk, Ink, Gold: Abundance and Excess in the French Renaissance* (Chicago, IL: University of Chicago Press, 2005). For Cellini, see Michael Cole, *Cellini and the Principles of Sculpture* (Cambridge and New York: Cambridge University Press, 2002).

Bruce Boucher's monograph on *The Sculpture of Jacopo Sansovino* (New Haven, CT, and London: Yale University Press, 1991) complements Deborah Howard's book on the buildings, *Jacopo Sansovino: Architecture and Patronage in Renaissance Venice* (New Haven, CT, and London: Yale University Press, 1987). On urbanism in Genoa, see George L. Gorse, "A Classical Stage for the Old Nobility: The Strada Nuova and Sixteenth-century Genoa," *Art Bulletin* 79 (1997), 301–27, with good further bibliography. Our discussion draws on the fundamental study by Ennio Poleggi, *Strada nuova: una lottizzazione del Cinquecento a Genova* (Genoa: Sagep Ed., 1972).

Our comments on the poetics of Michelangelo's architecture follow Charles Burroughs, "Michelangelo at the Campidoglio: Artistic Identity, Patronage and Manufacture," *Artibus et Historiae* 28 (1993), 85–111. The standard reference work on Titian is Harold E. Wethey, *The Paintings of Titian* (London: Phaidon Press, 1975), which treats the paintings from the 1540s; see also, more recently, Filippo Pedrocco, *Titian*, trans. Corrado Federici (New York: Rizzoli, 2001).

Two good starting points for the Pauline Chapel are William E. Wallace, "Narrative and Religious Expression in Michelangelo's Pauline Chapel," *Artibus et Historiae* 10 (1989), 107–21, and Leo Steinberg, *Michelangelo's Last Paintings: The Conversion of St. Paul and the Crucifixion of St. Peter in the Cappella Paolina, Vatican Palace* (London: Phaidon Press, 1975).

Chapter 17: 1550–1560

A useful survey of the concept of *disegno* can be found in Catherine E. King, "Disegno/Design," in *Representing Renaissance Art c. 1500–c. 1600* (Manchester: Manchester University Press, 2007). Also good is the discussion in Robert Williams, *Art, Theory, and Culture in Sixteenth-century Italy: From Techne to Metatechne* (Cambridge: Cambridge University Press, 1997).

On the concept of *colore* and *colorito* in Venetian art, see the opening chapter of David Rosand, *Painting in Sixteenth-Century Venice: Titian, Tintoretto, Veronese* (New Haven, CT, and London: Yale University Press, 1983 and 1997), and Daniela Bohde, "Corporeality and Materiality: Light, Colour, and the Body in Titian's San Salvador

Annunciation and Naples Danae," in *Titian: Materiality, Likeness, Istoria*, ed. by Joanna Woods-Marsden (Turnhout: Brepols, 2007), 19–29. See also Sydney J. Freedberg, "*Disegno* versus *colore* in Florentine and Venetian Painting of the Cinquecento," in S. Bertelli, C. H. Smyth, N. Rubinstein, eds., *Florence and Venice: Comparisons and Relations* (Florence: Olschki, 1977).

For Dolce and his dialogue, see Dolce's *"Aretino" and Venetian Art Theory of the Cinquecento*, ed. and trans. Mark W. Roskill (New York: New York University Press, 1968). On the relationship between artistic and literary polemics, see Fredrika H. Jacobs, "Aretino and Michelangelo, Dolce and Titian: Femmina, Masculo, Grazia," *Art Bulletin* 82 (2000), 51–67, and Una Roman d'Elia, *The Poetics of Titian's Religious Paintings* (Cambridge and New York: Cambridge University Press, 2005).

On the *poesie* for Philip II, the most even-handed account is Thomas Puttfarken, *Titian and Tragic Painting* (New Haven, CT, and London: Yale University Press, 2005). On the question of gender and movement in Titian's *Venus and Adonis*, Sharon Fermor, "Poetry in Motion: Beauty in Movement and the Renaissance Concept of *leggiadrìa*," in *Concepts of Beauty in Renaissance Art*, eds. F. Ames Lewis and M. Rogers (Aldershot, UK: Ashgate, 1998), 124–34.

On Tintoretto, see Rosand, *Painting in Sixteenth-Century Venice* (see above), as well as Tom Nichols, *Tintoretto: Tradition and Identity* (London: Reaktion, 1999), and the catalogue *Tintoretto*, ed. Miguel Falomir (Madrid: Prado, 2007); for the competition between Titian and Tintoretto, see Frederick Ilchman, *Titian, Tintoretto, Veronese: Rivals in Renaissance Venice* (Boston, MA: Museum of Fine Arts, 2009).

On the manufacture of tapestries in Florence, see Graham Smith, "Cosimo I and the Joseph Tapestries for Palazzo Vecchio," *Renaissance and Reformation* 6 (1982), 183–96, and the relevant entries in the catalogue by Thomas P. Campbell, *Tapestry in the Renaissance: Art and Magnificence* (New York: Metropolitan Museum of Art; New Haven, CT, and London: Yale University Press, 2002). For a recent account with good photographs of the Farnese casket, see Christina Riebesell, "La cassetta Farnese," in *I Farnese. Arte e collezionismo. Studi*, ed. Lucia Fornari Schianchi (Milan: Electa, 1995), 58–69.

On the Villa Giulia and Casino of Pius IV, see David Coffin, *The Villa in the Life of Renaissance Rome* (Princeton, NJ: Princeton University Press, 1979), and Graham Smith, *The Casino of Pius IV* (Princeton, NJ: Princeton University Press, 1977).

For the Uffizi and other large-scale projects undertaken for Cosimo de' Medici, see H. T. Van Veen, *Cosimo de' Medici and His Self-Representation in Florentine Art and Culture* (Cambridge: Cambridge University Press, 2006). Leon Satkowski, *Giorgio Vasari: Architect and Courtier* (Princeton, NJ: Princeton University Press, 1994), includes a good introduction in English to the architecture of the Uffizi. On the Laurentian Library, see the discussion in James S. Ackerman, *The Architecture of Michelangelo* (Chicago, IL: University of Chicago Press, 1986). Ammanati's role in completing the vestibule is sometimes overlooked, though not by William Wallace, *Michelangelo at San Lorenzo: The Artist as Entrepreneur* (Cambridge and New York: Cambridge University Press, 1994).

On Daniele da Volterra, see in general Paul Barolsky, *Daniele da Volterra: A Catalogue Raisonné* (New York: Garland, 1979), and the catalogue of the exhibition *Daniele da Volterra amico di Michelangelo*, ed. Vittoria Romani (Florence: Mandragora, 2003); for his work at Santissima Trinità dei Monti, see Carolyn Valone, "Elena Orsini, Daniele da Volterra, and the Orsini Chapel," *Artibus et Historiae* 11 (1990), 79–87, and *idem*, "The Art of Hearing: Sermons and Images in the Chapel of Lucrezia della Rovere," *Sixteenth-century Journal* 31 (2000), 753–777; for the destroyed stuccoes, see David Jaffé, "Daniele da Volterra's Satirical Defense of his Art," *Journal of the Warburg and Courtauld Institutes* 54 (1991), 247–252. The most comprehensive account in English of Pellegrino Tibaldi's frescoes in Palazzo Poggi is in Kliemann and Rohlmann, *Italian Frescoes* (see chapter 13 above), but we are also grateful to Morten Steen Hansen for sharing his work on Tibaldi with us before publication.

On Anguissola and other women artists, Fredrika Jacobs, *Defining the Renaissance virtuosa: Women Artists and the Language of Art History and Criticism* (Cambridge and New York: Cambridge University Press, 1997), and Joanna Woods Marsden, *Renaissance Self-Portraiture: The Visual Construction of Identity and the Social Status of the Artist* (New Haven, CT, and London: Yale University Press, 1998). For the Leoni, we relied especially on the catalogue to the exhibition *Los Leoni (1509–1608): escultores del Renacimiento italiano al servicio de la corte de España*, ed. Jesús Urrea (Madrid: El Museo 1994), and Eugène Plon's still indispensable *Leone Leoni, sculpteur de Charles-Quint, et Pompeo Leoni, sculpteur de Philippe II* (Paris: Plon, Nourrit & Cie, 1887).

An excellent and comprehensive survey of printmaking in late Renaissance Italy is provided by Michael Bury, *The Print in Italy 1550–1620* (London: British Museum Press, 2001). On the adaptation of Raphael and other artists by

printmakers, see Jeremy Wood, "Cannibalized Prints and Early Art History: Vasari, Bellori and Fréart de Chambray on Raphael," *Journal of the Warburg and Courtauld Institutes* 51 (1988), 210–20. For Ghisi, see Bury's "On Some Engravings by Giorgio Ghisi Commonly Called 'Reproductive,'" *Print Quarterly* 10 (1993), 4–19, as well as Suzanne Boorsch et. al, *The Engravings of Giorgio Ghisi* (New York: Metropolitan Museum of Art, 1985). On the means printmakers developed for translating color into line, see especially Walter S. Melion, "*Vivae Dixisses Virginis Ora*: The Discourse of Color in Hendrick Goltzius's *Pygmalion and the Ivory Statue*," *Word & Image* 17 (2001), 153–76 and the same author's "Hendrick Goltzius's Project of Reproductive Engraving," *Art History* 13 (1990), 458–87.

Chapter 18: 1560–1570

For a summary of sixteenth-century disputes concerning sacred art, see Giuseppe Scavizzi, *The Controversy on Images from Calvin to Baronius* (New York: Peter Lang, 1992). On Moroni, see the catalogue *Giovanni Battista Moroni: Renaissance Portraitist* (Fort Worth, TX: Kimball Museum, 2001). On Moroni, Moretto, and other Lombard painters the best source in English is Nicholas Penny, *National Gallery Catalogues: The Sixteenth-century Italian Paintings vol. 1: Paintings from Bergamo, Brescia, and Cremona* (London: National Gallery, 2004). On Rota and reformist responses to the *Last Judgment*, Bernardine Barnes, *Michelangelo's Last Judgment: The Renaissance Response* (Berkeley, CA: University of California Press, 1998); Barnes, "Aretino, the Public, and the Censorship of Michelangelo's *Last Judgment*," in *Suspended License: Censorship and the Visual Arts*, ed. Elizabeth C. Childs (Seattle, WA: University of Washington Press, 1997); and, specifically on prints, Barnes, *Michelangelo in Print: Reproductions as Response in the Sixteenth Century* (Farnham: Ashgate, 2010).

Our dating of Vittoria's projects follows that of Lorenzo Finocchi Ghersi, *Alessandro Vittoria: Architettura, scultura e decorazione* (Udine: Forum, 1998). Vittoria's words about the *Sebastian/Marsyas* are cited in Manfred Leithe-Jasper's very useful entry on the bronze in *La bellissima maniera: Alessandro Vittoria e la scultura veneta del Cinquecento*, eds. Andrea Bacchi, Lia Camerlengo, and Manfred Leithe-Jasper (Trent: Servizio beni culturali, 1999), 342–45.

For the Jesuits and the production of art, see Gauvin A. Bailey, *Between Renaissance and Baroque: Jesuit Art in Rome, 1565–1610* (Toronto: University of Toronto Press, 2003). On the Farnese and the building of the Gesù, Clare Robertson, *Il gran cardinale: Alessandro Farnese, Patron of the Arts* (New Haven, CT, and London: Yale University Press, 1992), and the review by Walter Melion in *Art Bulletin* 77 (1995), 324–27; James Ackerman, "The Gesù in the Light of Contemporary Church Design," in Rudolf Wittkower and Irma B. Jaffe, eds., *Baroque Art: The Jesuit Contribution* (New York: Fordham University Press, 1972), 15–28, remains important as well.

Robertson also deals with Caprarola, as does Coffin, *The Villa in the Life of Renaissance Rome* (see chapter 17 above); Loren Partridge provides a detailed account of the Zuccari's historical frescoes in "Divinity and Dynasty at Caprarola: Perfect History in the Room of the Farnese Deeds," *Art Bulletin* 60 (1978), 494–530.

The standard English-language introduction to the Italian Renaissance garden is Claudia Lazzaro, *The Italian Renaissance Garden* (New Haven, CT, and London: Yale University Press, 1990), which has a chapter on Bagnaia and also discusses a number of the other gardens and garden sculptures mentioned in this book.

On Palladio, the best places to start are the short survey by James S. Ackerman, *Palladio* (London: Penguin, 1967), the catalogue *Palladio*, eds. Guido Beltramini and Howard Burns (New York: Abrams, 2008), and Bruce Boucher, *Andrea Palladio: The Architect in His Time* (New York: Abbeville, 1998). On Veronese at Villa Barbaro, see Richard Cocke, "Veronese and Daniele Barbaro: The Decoration of Villa Maser," *Journal of the Warburg and Courtauld Institutes* 35 (1972), 226–46, and Kliemann and Rohlmann, *Italian Frescoes* (as in chapter 13 above).

There is no substantial study in English of Bomarzo and its patron. We drew especially on Horst Bredekamp, *Vicino Orsini und der heilige Wald von Bomarzo: Ein Fürst als Künstler und Anarchist* (Worms: Werner, 1985).

The late Richard Tuttle was the authority on Giambologna's Neptune Fountain; we hope that his monograph will eventually appear in English. In the meantime, the Cesi text can be found in Tuttle, *Piazza Maggiore: studi su Bologna nel Cinquecento* (Venice: Marsilio, 2001).

Vasari's revisions between the 1550 and 1568 *Lives* are treated by Patricia Rubin, *Giorgio Vasari: Art and History* (New Haven, CT, and London: Yale University Press, 1994). The best general account in English of the early history of the Accademia del Disegno is Karin-edis Barzman, "The Università, Compagnia ed Accademia del Disegno," Ph.D. dissertation, Johns Hopkins University, 1986; Barzman

later published a quite different book under the title *The Florentine Academy and the Early Modern State* (Cambridge and New York: Cambridge University Press, 2001). The standard reference for readers of Italian is Zygmunt Ważbiński, *L'Accademia Medicea del Disegno a Firenze nel Cinquecento: idea e istituzione* (Florence: Olschki, 1987). For Cellini's *Crucifix*, see Cole, *Cellini and the Principles of Sculpture*, and Lavin, "The Sculptor's 'Last Will and Testament,'" (as in chapter 16 above); our lines here on the poetry around it condense the argument in Cole, "Cellinis Grabmal – Poetik und Publikum," in Joachim Poeschke et al., ed., *Praemium virtutis: Grabmonumente und Begräbniszeremoniell im Zeichen des Humanismus* (Münster: Rhema, 2002), 175–89. On the other sculptures discussed in this and the following chapters, see now Michael Cole, *Ambitious Form: Giambologna, Ammananati, and Danti in Florence* (Princeton: Princeton University Press, 2011), with further references. For Vasari's renovations of the Mendicant churches, see Marcia Hall, *Renovation and Counter-Reformation: Vasari and Duke Cosimo in Sta Maria Novella and Sta Croce, 1565–1577* (Oxford and New York: Oxford University Press 1979). For a more extended treatment of the argument about Bronzino's last fresco as a riposte to Michelangelo's critics, see Stephen J. Campbell, "Bronzino's *Martyrdom of St. Lawrence* in San Lorenzo," *RES* 46 (2004): *Polemical Objects*, 96–119.

Chapter 19: 1570–1580

On Bishop Gabriele Paleotti and his treatise, see Pamela A. Jones, "Art Theory as Ideology: Gabriele Paleotti's Hierarchical Notion of Painting's Universality and Reception," *Reframing the Renaissance: Visual Culture in Europe and Latin America, 1450-1650*, ed. Claire Farago (New Haven, CT, and London: Yale University Press, 1995), 127–323. Luise Leinweber's *Bologna nach dem Tridentium: private Stiftungen und Kunstaufträge im Kontext der katholischen Konfessionalisierung* (Hilderheim: Olms, 2000) informed our reading of Fontana's *St. Alexius Distributing Alms*. Evelyn Carole Volker's doctoral dissertation (New York: Garland, 1977) provides a translation and commentary on Carlo Borromeo's *Instructiones fabricae et supellectilis ecclesiasticae*.

A standard reference on the Veronese trial is Philipp Fehl, "Veronese and the Inquisition: A Study of the Subject Matter of the So-Called 'Feast in the House of Levi,'" *Gazette des beaux-arts* 103 (1961), 325–54.

For the Counter-Reformation and art in Venice more broadly, see Peter Humfrey, "Altarpieces and Altar Dedi-

cations in Counter Reformation Venice and the Veneto," *Renaissance Studies* 10 (1996), 371–87. On the church of the Redentore, see Tracey Cooper, *Palladio's Venice: Architecture and Society in a Renaissance Republic* (New Haven, CT, and London: Yale University Press, 2007).

On Federico Barocci, see Stuart Lingo, *Federico Barocci: Allure and Devotion in Late Renaissance Painting* (New Haven, CT, and London: Yale University Press, 2008). On the Campi, Bram de Klerck, *The Brothers Campi: Images and Devotion: Religious Painting in Sixteenth-century Lombardy* (Amsterdam: University of Amsterdam Press, 1999). For San Rocco, see Nichols, *Tintoretto: Tradition and Identity* (as in chapter 17 above). The best access to the literature on the Oratory of the Gonfalone is Nerida Newbigin, "Decorum of the Passion: The Plays of the Confraternity of the Gonfalone in the Roman Colosseum, 1490–1539," *Confraternities and the Visual Arts in Renaissance Italy: Ritual, Spectacle, Image*, eds. Barbara Wisch and Diane Cole Ahl (Cambridge and New York: Cambridge University Press, 2000).

On the dome of St. Peter's, see *The Renaissance from Brunelleschi to Michelangelo: The Representation of Architecture*, eds. Henry A. Millon and Vittorio Magnago Lampugnani (Milan: Bompiani, 1994). No publication within the now large literature on Rome's fountains and waterworks can yet replace Cesare D'Onofrio, *Le fontane di Roma* (Rome: Staderini, 1962); the most recent book in English is Katherine Wentworth Rinne, *The Waters of Rome: Aqueducts, Fountains, and the Birth of the Baroque City* (New Haven, CT: Yale University Press, 2011).

For Bassano, *Jacopo Bassano c. 1510–1592*, eds. Beverly Louise Brown and Paola Marini (Fort Worth, TX: Kimbell Art Museum, 1993). On the rise of genre painting in Italy, see especially Tom Nichols, *The Art of Poverty: Irony and Ideal in Sixteenth-century Beggar Imagery* (Manchester: Manchester University Press, 2007); also Sheila McTighe, "Foods and the Body in Italian Genre Paintings, about 1580: Campi, Passarotti, Carracci," *Art Bulletin* 86 (2004), 301–23.

The key documents relating to the *Studiolo* of Francesco I are collected in Ettore Allegri and Alessandro Cecchi, *Palazzo Vecchio e i Medici* (Florence: SPES, 1980). The best discussion in English is Scott J. Schaefer's unpublished doctoral dissertation, "The Studiolo of Francesco I de' Medici in the Palazzo Vecchio in Florence," Bryn Mawr College, 1976. Larry Feinberg provides a shorter and more accessible overview in "The Studiolo of Francesco I Reconsidered," in *The Medici, Michelangelo, and the Art of Late Renaissance Florence* (New Haven, CT, and Lon-

don: Yale University Press, in association with the Detroit Institute of Arts, 2002), 47–65.

Chapter 20: 1580–1590

The essential study of the Renaissance grotto is Philippe Morel, *Les grottes maniéristes en Italie au XVIème siècle: théâtre et alchimie de la nature* (Paris: Macula, 1998), partially translated in Cole, *Sixteenth-century Italian Art* (see chapter 15 above).

On the Carracci, see Charles Dempsey, *Annibale Carracci and the Beginnings of Baroque Style*, 2nd ed. (Florence: Cadmo, 2000); Anton W. Boschloo, *Annibale Carracci in Bologna: Visible Reality in Art after the Council of Trent* (New York: Schram, 1974); and Clare Robertson, *The Invention of Annibale Carracci* (Milan: Electa, 2008). For Ludovico Carracci, see the catalogue by Gail Feigenbaum, *Ludovico Carracci, 1555–1619* (Fort Worth, TX: Kimball Art Museum, 1993). Essential also for Bolognese art in this period is *The Age of Correggio and the Carracci: Emilian Painting in the Sixteenth and Seventeenth Centuries* (Washington, DC: National Gallery of Art, 1986). Our reading of the Lavinia Fontana portrait develops that in the introductory chapter of Michael Cole and Mary Pardo, eds., *Inventions of the Studio, Renaissance to Romanticism* (Chapel Hill, NC: University of North Carolina Press, 2004).

On Varallo, see Alessandro Nova, "Popular Art in Renaissance Italy: Early Response to the Holy Mountain at Varallo," in *Reframing the Renaissance*. ed. Farago (as in chapter 19 above). All studies of the early maps of Rome rely on Amato Pietro Frutaz, *Le piante di Roma* (Rome: Istituto di studi romani, 1962), the beautiful plates of which can be enjoyed even by those who do not read Italian. Francesca Fiorani's excellent *The Marvel of Maps: Art, Cartography, and Politics in Renaissance Italy* (New Haven, CT, and London: Yale University Press, 2005) discusses the Vatican Hall of Maps at length. On urbanism in late sixteenth-century Rome, see Sigfried Giedion's great *Space, Time, and Architecture: The Growth of a New Tradition* (Cambridge, MA: Harvard University Press, 1941).

The best general English-language discussion of Sixtus's use of obelisks is Erik Iversen, *Obelisks in Exile* (Copenhagen: Gad, 1968). The reading presented here rehearses Michael Cole, "Perpetual Exorcism in Sistine Rome," in Michael Cole and Rebecca Zorach, eds., *The Idol in the Age of Art: Objects, Devotions, and the Early Modern World* (Aldershot, UK: Ashgate, 2009), 57–76. The quotes relating to Giambologna's *Sabine* come from Elisabeth

Dhanens, *Jean Boulogne / Giovanni Bologna Fiammingo* (Brussels: Paleis der Academiën, 1956), and Raffaello Borghini, *Il Riposo* (Hildesheim: G. Olms, 1969); Lloyd H. Ellis Jr. has published a partial English translation of Borghini under the title *Borghini's Riposo* (Toronto: University of Toronto Press, 2007). On the subject(lessness) of the statue, see Michael Cole, "Giambologna and the Sculpture with No Name," *Oxford Art Journal* 32 (2009), 337–60.

Chapter 21: 1590–1600

For accounts of additional projects of Early Christian archeology and renovation, see Alexandra Herz, "Cardinal Cesare Baronio's Restoration of SS. Nereo ed Achilleo and S. Cesareo de'Appia," *Art Bulletin* 70 (1988), 590–620, and *idem*, "Imitators of Christ: The Martyr Cycles of Late Sixteenth-century Rome Seen in Context," *Storia dell'arte* 62 (1988), 53–70; and Irina Oryshkevich's magisterial but unpublished dissertation, "The History of the Roman Catacombs from the Age of Constantine to the Renaissance," Columbia University, 2003.

Little of the fundamental literature on Stefano Maderno is in English, but see Tobias Kämpf, "Framing Cecilia's Sacred Body: Cardinal Camillo Sfondrati and the Language of Revelation," *Sculpture Journal* 6 (2001), 10–20. On Catarina Sforza, Carolyn Valone, "Women on the Quirinal Hill: Patronage in Rome, 1560–1640," *Art Bulletin* 76 (1994), 129–46, with further references.

On Procaccini as an etcher, see the important catalogue edited by Sue Welsh Reed and Richard Wallace, *Italian Etchers of the Renaissance and Baroque* (Boston, MA: Northeastern University Press, 1989). A number of major new studies of Florentine painting at the end of the sixteenth century are currently in process. For the moment, one of the few helpful publications in English is Jack Spalding, "Santi di Tito and the Reform of Florence Mannerism," *Storia dell'arte* 47 (1983), 41–52. On the Roman patronage system, see Francis Haskell, *Patrons and Painters: A Study in the Relations between Italian Art and Society in the Age of the Baroque* (London: Chatto & Windus, 1963).

Michael Fried discusses the new pre-eminence of the gallery picture in *The Moment of Caravaggio* (Princeton: Princeton University Press, 2010). On the Farnese Gallery, Charles Dempsey, *Annibale Carracci, the Farnese Gallery, Rome* (New York: George Braziller, 1995).

On Zuccaro as art theorist, see Robert Williams, *Art, Theory, and Culture in Sixteenth-century Italy* (as in chapter

17 above). Our attention to the Chapel of the Angels follows Kristina Herrmann-Fiore, "Gli angeli, nella teoria e nella pittura di Federico Zuccari," in Bonita Cleri, ed., *Federico Zuccari: le idée, gli scritti* (Milan: Electa, 1997), 89–110. For Federico Borromeo, see Pamela Jones, "Federico Borromeo as a Patron of Landscapes and Still Lifes: Christian Optimism in Italy ca. 1600," *Art Bulletin* 70 (1988), 261–72. Within the vast literature on Caravaggio, we would single out the monograph of Howard Hibbard (London: Thames & Hudson, 1983); the biography by Helen Langdon (London: Chatto & Windus, 1998); and Fried, *The Moment of Caravaggio* (see under the pre-eminence of the gallery picture, above). Steven Ostrow and Conrad Rudolph make a case against the conventional identification of the subject of Caravaggio's *St. John the Baptist* in "Isaac Laughing: Caravaggio, Non-traditional Imagery, and Traditional Identification," *Art History* 24 (2001) 646–81.

Sources of Quotations

Introduction

p. 10: Ghiberti from complete translation of Ghiberti's second *Commentary*, in *Italian Art 1400–1500: Sources and Documents*, ed. Creighton Gilbert (Englewood Cliffs, New Jersey: Prentice Hall, 1980), 75–88.

Chapter 1

p. 23: Lorenzetti inscription from *Siena, Florence and Padua. Art, Society and Religion 1280–1400*, ed. Diana Norman, 2 vols. (New Haven and London: Yale University Press, 1995), II, 167.

pp. 26, 27, 39, 41: Ghiberti from Creighton Gilbert, cit. 75–88.

p. 37: On the *Maestà*, from ibid., 55.

pp. 44, 45: Giovanni Pisano inscriptions from *Gothic Art 1140–c. 1450: Sources and Documents*, ed. Teresa G. Frisch (Englewood Cliffs, New Jersey: Prentice Hall, 1987), 85.

Chapter 2

p. 58: On the duomo 1296 from Margaret Oliphant, *Makers of Florence: Dante, Giotto, Savonarola and their City* (London: Macmillan, 1897), p. 103; translation modified, based on the Italian citation in Emanuele Repetti, *Notizie e guida di Firenze e d' suoi contorni* (Florence: Guglielmo Piatti, 1841), 330.

Chapter 3

p. 82: On Lorenzo Monaco's *Coronation* from George R. Bent, "A Patron for Lorenzo Monaco's Uffizi Coronation of the Virgin." *Art Bulletin* 82 (2000), 348–54, quoted passage on 348.

Chapter 4

p. 93: Ghiberti from *A Documentary History of Art Vol. 1: The Middle Ages and the Renaissance*, ed. Elizabeth Gilmore Holt (Princeton: Princeton University Press, 1981), 161.

p. 102: Vasari on Masaccio from Vasari, *Lives of the Painters, Sculptors and Architects*, trans. Gaston de Vere, 2 vols. (London: Everyman's Library, 1996 [originally 1916]), I, 317.

p. 109: Alberti from Leon Battista Alberti, *On Painting and on Sculpture. The Latin Texts of De Pictura and De Statua*, ed. and trans. Cecil Grayson (London: Phaidon, 1972), 79 and 97.

Chapter 5

p. 115: Cennino from *The Craftsman's Handbook. "Il Libro dell'Arte." Cennino d'Andrea Cennini*, trans. Daniel Thompson, Jr. (New York: Dover, 1960), 8 and 3.

Chapter 6

p. 132: Antonino from Creighton Gilbert, "The Archbishop on the Painters of Florence, 1450." *Art Bulletin*, 41 (1959), 75–85.

p. 147: Bruni epitaph from John Pope-Hennessy, *Italian Renaissance Sculpture* (New York: Vintage, 1985), 278.

p. 151: Epigram from Christine Sperling, "Donatello's Bronze *David* and the Demands of Medici Politics." *Burlington Magazine* 134 (1992), 218.

p. 152: Inscription from Pope-Hennessy, cit. 265.

p. 172: Filarete from *Filarete's Treatise on Architecture: Being the Treatise by Antonio di Piero Averlino, Known as Filarete*, ed. and trans. John R. Spencer, 2 vols. (New Haven: Yale University Press, 1965), I fol. 179r.

Chapter 7

p. 176: Manuel Chrysorolas from Christine Smith, *Architecture in the Culture of Early Humanism: Ethics, Aesthetics, and Eloquence, 1400–1470* (New York: Oxford University Press, 1992), 199–215.

pp. 179–80: Manetti from Ludwig Von Pastor, *The History of the Popes from the Close of the Middle Ages* (London: Kegan Paul, Trench, Trübner, and Co. 1901), II, 166.

p. 187: Pius II from *Memoirs of a Renaissance Pope: The Commentaries of Pius II*, trans. Florence A. Gragg (New York: Puttnam, 1959), Book II, 110; and from Pope Pius II, *Commentaries*, ed. and trans. Margaret Meserve and Marcello Simonetta, 2 vols. (Cambridge, MA: Harvard University Press, 2003), I, 329.

p. 191: Virgil from *Aeneid* IV, 238–59, in *Virgil*, trans. H. Rushton Fairclough, 2 vols. (London: Heinemann, 1916), I, 413.

p. 199: Pius II from Gragg, cit. Book IX, 287.

p. 201: Alberti from Leon Battista Alberti, *On the Art of Building in Ten Books*, trans. Joseph Rykwert with Neil Leach and Robert Tavernor (Cambridge, MA: MIT Press, 1991), 5, 120, 155, 195, 242.

Chapter 8

p. 211: Picatrix from authors' translation of *Picatrix* II xi, 75–76. In *Picatrix: the Latin version of the Ghāyat al-ḥakīm*, ed. David Pingree (London: Warburg Institute, 1986).

p. 214: Filarete from Spencer, cit. I, 176.

p. 219: Florentine ambassador from Evelyn Welch, "Galeazzo Maria Sforza and the Castello di Pavia, 1469." *Art Bulletin* 71 (1989), 352–75, at 362.

Chapter 9

p. 234: de Holanda from Francisco de Holanda, *Four Dialogues on Painting*, trans. Aubrey F. G. Bell (Westport, Connecticut: Hyperion Press: 1928), 15–16.

p. 238: Facio from Michael Baxandall, "Bartholomaeus Facius on Painting." *Journal of the Warburg and Courtauld Institutes* 27, 102.

Chapter 10

p. 259: Filarete from Spencer, cit. I, 320.

p. 273: Dedicatory inscription from Alison Wright, *The Pollaiuolo Brothers: The Arts of Florence and Rome* (New Haven and London: Yale University Press, 2005), 360.

p. 282: Leonardo from Edward McCurdy, *The Notebooks of Leonardo da Vinci* (London: Duckworth, 1906), 1152.

Chapter 11

p. 296: Savonarola from Creighton Gilbert, cit. 157; slightly modified with reference to the original text.

p. 308: Alberti from Grayson, cit. 75.

p. 313: Leonardo from original text in Carmen Bambach, *Leonardo da Vinci, Master Draftsman* (New York: Metropolitan Museum of Art, 2003), 401–403.

p. 314: Leonardo from Claire Farago, *Leonardo da Vinci's Paragone* (Leiden: Brill, 1991), 215 and 213.

p. 320: Bandello from authors' translation from the dedication to novella 58 in Matteo Bandello's *Le Novelle*, cited in Martin Kemp, *Leonardo da Vinci: The Marvelous Works of Nature and Man* (Cambridge: Harvard University Press, 1981), 80.

Chapter 12

pp. 336–37: Leonardo from McCurdy, cit. 84.

p. 337: On a Florentine lady from Antonio de'Beatis, quoted in Martin Kemp, *Leonardo da Vinci: The Marvelous Works of Nature and Man* (London: J. M. Dent, 1981), 268.

p. 344: On de'Conti from Pastor, cit. VI, 479.

p. 348: Michelangelo from Michelangelo Buonarroti, *The Poems*, trans. Christopher Ryan (London: J. M. Dent, 1996), 201.

p. 361: Hesiod *Theogony* (II: 29–35) from *Hesiod: Theogony, Works and Days, Testimonia*, ed. and trans. Glenn Most (Cambridge: Harvard University Press, 2006), 5.

p. 365: Dürer from *The Literary Remains of Albrecht Dürer*, ed. and trans. William Martin Conway (Cambridge: CUP, 1889), 55.

Chapter 13

p. 399: Vasari on Rosso from de Vere, cit. I, 899.

Chapter 14

p. 419: Sebastiano del Piombo quotation from authors' translation from *Il Carteggio di Michelangelo*, eds. Gio-

vanni Poggi with Paola Barocchi and Renzo Ristori, 5 vols. (Florence: Sansoni, 1965–83), II, 314.

p. 434: On the Sack of Rome from André Chastel, *The Sack of Rome, 1527* (Princeton: Princeton University Press, 1983), 91.

Chapter 15

pp. 449–50: Michelangelo from Ryan, cit. 201.

p. 450: Michelangelo from ibid.

p. 463: Cellini's dream from *The Life of Benvenuto Cellini*, trans. Robert Henry Hobart Cust (London: Bell, 1910), I, 318–19.

Chapter 16

p. 466: Vasari from de Vere, cit. I, 621.

p. 473: Michelangelo from Ryan, cit. 201.

p. 475: Michelangelo from ibid.

Chapter 17

p. 496: Doni from Catherine E. King, *Representing Renaissance Art c. 1500–c. 1600* (Manchester: Manchester University Press, 2007), 71.

p. 496: Vasari from de Vere, cit. II, 791.

p. 497: Dolce on Michelangelo from *Dolce's "Aretino" and Venetian Art Theory of the Cinquecento*, ed. and trans. Mark W. Roskill (New York: New York University Press, 1968, rep. University of Toronto Press, 2000), 171, 173.

p. 499: Titian from Charles Hope, *Titian* (New York: Harper and Row, 1980), 125.

p. 520: Ghisi's *The School of Athens* from Jeremy Wood, "Cannibalized Prints and Early Art History: Vasari, Bellori and Fréart de Chambray on Raphael." *Journal of the Warburg and Courtauld Institutes* 51 (1988), 210–20, at 213.

Chapter 18

pp. 524–25: On the character of images in churches from Anthony Blunt, *Artistic Theory in Italy 1450–1660* (Oxford: Oxford University Press, 1940), 110.

p. 528: Gilio in the authors' translation from Giovanni Andrea Gilio da Fabriano, *Due dialogi* (Rome: SPES, 1986 [facsimile of 1564 edition]), 70v.

p. 541: Palladio from James Ackerman, *Palladio* (Harmondsworth: Penguin, 1966), 70.

pp. 544–45: Cesi from Richard Tuttle, *Piazza Maggiore: studi su Bologna nel Cinquecento* (Venice: Marsilio, 2001), 183.

p. 546: Vasari from de Vere, cit. II, 695.

Chapter 19

p. 556: Paleotti from authors' translation from *Scritti d'Arte del Cinquecento*, ed. P. Barocchi, 3 vols. (Milano/Napoli: Ricciardi Editore, 1971–77), I, 334.

p. 561: On Veronese and the Inquisition, translation modified from Elizabeth Gilmore Holt, *Literary Sources of Art History* (Princeton: Princeton University Press, 1947), pp. 245–48. Original Latin and Italian text in Philipp Fehl, "Veronese and the Inquisition: A Study of the Subject Matter of the So-called *Feast in the House of Levi*," *Gazette des Beaux-Arts* 58 (1961), 349–51.

p. 563: Friar quoted from Tracey Cooper, *Palladio's Venice* (New Haven and London: Yale University Press, 2005), 240.

Chapter 20

p. 586: Virgil's Atlas from Rushton Fairclough, cit. I, 413, cited in Claudia Lazzaro, *The Italian Renaissance Garden* (New Haven and London: Yale University Press, 1990).

p. 595: Carlo Cesare Malvasia on Ludovico Carracci from *Malvasia's Life of the Carracci*, trans. Anne Summerscale (University Park, PA: Penn State Press, 2000), 127.

Chapter 21

pp. 631 and 631–32: Bellori on Caravaggio from Giovan Pietro Bellori, *The Lives of the Modern Painters, Sculptors and Architects. A New Translation and Critical Edition*, ed. and trans. Alice Sedgwick Wohl, Hellmut Wohl, and Tomaso Montinari (Cambridge: CUP, 2005), 180.

Acknowledgments

We would like to express our gratitude to our editor, Ian Jacobs, for his support of this project over the past seven years; his experience, open-mindedness, and good judgment resulted in a much better-conceived text than we would otherwise have written. We also wish to thank Richard Mason for his patient copy-editing, Mari West for her resourcefulness in the acquisition of illustrations, and Lucy Smith for her commitment to seeing the best possible book through to publication. We are aware that others behind the scenes at the press – a designer, a map-maker, a fact-checker and a proof-reader among them – devoted their considerable skills to the volume along the way, and we feel fortunate to have been able to work with the whole Thames & Hudson team.

Many colleagues provided guidance and advice about the organization of the book and our treatment of particular artists and works. We are extremely grateful to the numerous anonymous readers who drew on their art-historical expertise and on their teaching experience to comment on the proposal and on drafts of chapters. Francesco Benelli, Mauro di Vito, Morten Steen Hansen, Megan Holmes, Monique O'Connell, Mark Rosen, Luke Syson, and Madeleine Viljoen all generously answered specific questions we posed to them as the book neared completion. A group of undergraduates from Johns Hopkins University and Williams College, finally, provided valuable insight from the point of view of student readers: Trillia Fidei-Bagwell, Sofia Finfer, Hanna Seifert, and Matthew Turtoro.

Picture Credits

Collections are given in the captions alongside the illustrations.

Key: t=top; b=bottom; r=right; l=left

Index

N